" THE Quotable *Artist* "

Published by Allworth Press
An imprint of Allworth Communications, Inc.
10 East 23rd Street, New York, NY 10010

Cover and book design: Derek Bacchus, New York, NY
Page composition/typography: Susan Ramundo, Ridge, NY

Library of Congress In-Catalogue Publication Data
The quotable artist / Peggy Hadden.
 p. cm.
 Includes bibliographical references and index.
 ISBN 1-58115-226-4
 1. Art—Quotations, maxims, etc. 2. Artists—Quotations. I. Hadden, Peggy.
PN6084.A8 Q68 2002
700—dc21 2002004234

Printed in Canada

Select quotations reprinted by permission of the publishers of

The Shape of Content by Ben Shahn, Cambridge, Mass.: Harvard University Press, Copyright ©1957 by the President and Fellows of Harvard College. Copyright © renewed 1985 by Bernarda B. Shahn.

Hawthorne on Painting by Charles W. Hawthorne and *The Craftsman's Handbook* by Cennino Cennini, translated by Daniel V. Thompson, Jr. Mineola, N.Y.: Dover Publications, Inc.

TURN: The Journal of an Artist by Anne Truitt, Copyright © 1986 by Anne Truitt. New York: Viking Penguin, a division of Penguin Putnam, Inc.

Remarks on Colour by Ludwig Wittgenstein, edited and translated by G. E. M. Anscombe. Copyright © 1977 by G. E. M. Anscombe.

Master of Photography: Berenice Abbott © 1989 Aperture Foundation, Inc., texts © 1998 Julia Van Haaften.

Master of Photography: Alfred Stieglitz © 1989 Aperture Foundation, Inc., texts © 1976 Dorothy Norman.

Master of Photography: Edward Weston © 1993 Aperture Foundation, Inc., texts © 1979, 1993 Lloyd Fonveille.

THE Quotable Artist

Peggy Hadden

ALLWORTH PRESS
NEW YORK

ALSO BY PEGGY HADDEN

The Artist's Guide to New Markets: Opportunities to Show and Sell Art Beyond Galleries

The Artist's Quest for Inspiration

To Keith Glancy

" *Eternal lasts longest.* "

–Kurt Schwitters

ACKNOWLEDGMENTS

My mother was a librarian. To all of the librarians who helped me locate information for this book, my special thanks. These include the reference librarians at the Donnell Library, the New York Public Library Mid-Manhattan Branch, the New York Public Library Telephone Reference Service, the Library of the Performing Arts, the Museum of Modern Art Library, and the Thomas J. Watson Library of the Metropolitan Museum of Art. The Art Students League Library proved a haven for little-known facts. Thanks also to Edye Weissler, reference librarian at the Knoedler Gallery, and Kay Usher of the Aldrich Museum. Thanks to my sister, Jill Hadden, for making me aware of the fine quotes by Henry Moore.

" TABLE OF CONTENTS "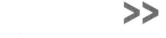

>> " # TABLE OF CONTENTS "

INTRODUCTION

" When my publisher suggested this project to me, I was intrigued by the idea of sifting through the words of artists from every era and every country, and, topic by topic, juxtaposing the thoughts and quips of disparate ages and nations.

One of the pleasures of writing this book was discovering the clarity with which artists speak, regardless of their place or time in history. I had expected the changes in language usage to make the quotes a challenge to read and understand, but was pleasantly surprised. This mix of painters, sculptors, photographers, and art admirers of perhaps the last thousand years, offers a clear picture of what is constant and what has changed in the art world.

As an artist, I have the pleasure of finding and sharing with you the words spoken by well-known artists in the face of disappointment; perhaps the knowledge that the trials of an art life are universal will make your own struggles easier to endure. Whether your work is conceptual or traditional, you will find in these quotes that every group or school of artists believed that its work was the most truthful, the most insightful, the most intelligent of its time. This commonly held belief gives us all a feeling of purpose, even when sales may be slow. And perhaps, something that has really been bothering you will be addressed in such a way that you can either find a solution or put it to bed and decide that it doesn't have to be solved. (SEE CHAPTER 6, ON STUDYING ART, PAGE 42.)

I hope this is a book that will stay with you. It contains a variety of serious, funny, and useful information. It is not gender friendly, because traditionally more men than women have been artists, which means that more quotes from men are available. Nevertheless, this is changing. I hope you enjoy *The Quotable Artist* and share it with your friends. **"**

Peggy Hadden
New York, May 3, 2002

CHAPTER ONE: *On Art*

When artists reflect on their origins, they are very honest about art and its affect on them. Reading their words, we discover real people with real nerves who were not born artists, but became artists the same way we did— by sketching, visiting museums, and by being attracted to the beautiful works of others. By seeing that other artists are real people, artists today are being encouraged to try something new, go further, explore a new medium.

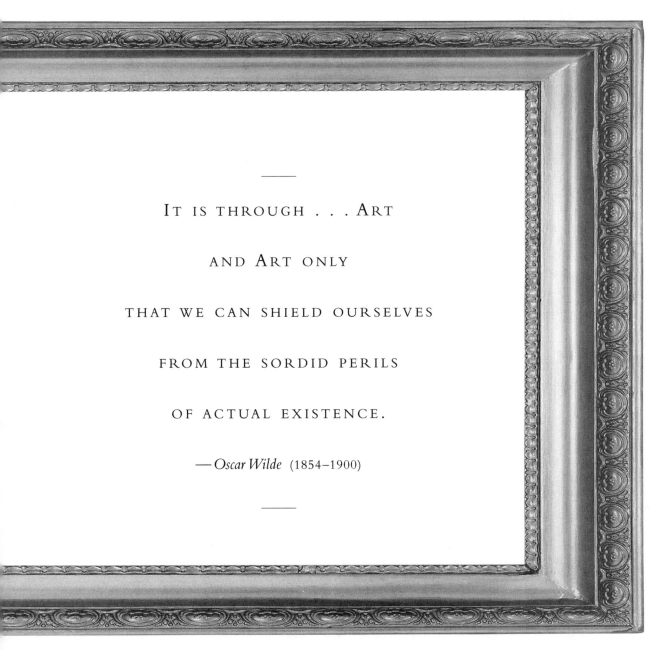

IT IS THROUGH . . . ART

AND ART ONLY

THAT WE CAN SHIELD OURSELVES

FROM THE SORDID PERILS

OF ACTUAL EXISTENCE.

— *Oscar Wilde* (1854–1900)

THE COMING INTO the presence of a piece of art you truly love causes a tremendous revolution to occur in you. —*Robert Henri* (1865–1929)

On Art

In art only one thing matters: that which cannot be explained.

— *Georges Braque* (1882–1963)

WHEN I THINK of art I think of beauty. Beauty is the mystery of life. It is not in the eye, it is in the mind. In our minds there is awareness of perfection. —*Agnes Martin* (1912–)

IN OUR fine arts, not imitation, but creation is the aim. In landscapes, the painter should give the suggestion of a fairer creation than we know. The details, the prose of nature, he should omit, and give us only the spirit and splendour. . . . In a portrait, he must inscribe the character, and not the features, and must esteem the man who sits to him as himself only an imperfect picture or likeness of the aspiring original within. —*Ralph Waldo Emerson* (1803–1882)

THE FORCE OF Art lies in its immediate influence on human psychology and in its active contagiousness. Being a creation of Man it re-creates Man. Art has no need of philosophical arguments, it does not follow the signposts of philosophical systems; Art like life, dictates systems to philosophy. It is not concerned with the meditation about what is and how it came to be. That is a task for knowledge. Knowledge is born of the desire to know, Art derives from the necessity to communicate and to announce. —*Naum Gabo* (1890–1977)

A GOOD LEGIBLE label is usually worth, for information, a ton of significant attitude and expression in a historical picture. —*Mark Twain* (1835–1910)

I HAVE READ that the ancients, when they produced a sound, used to modulate it, heightening and lowering its pitch without departing from the rules of harmony. So must the artist do in working at the nude. —*Antonio Canova (1757–1822)*

IT IS fatal for art if it is forced into official respectability and condemned to sterile mediocrity. —*Gustave Courbet (1819–1877)*

HARDENING OF THE categories causes art disease. —*W. Eugene Smith (1918–1978)*

FUTURISTS were supposed to blend art and life, to make art as important as science and politics. There has never been an art movement more grandiose and visionary, more wildly optimistic. —*Harriet Janis (1899–1963)* and *Rudi Blesh (1899–1985)*

ART for art's sake is an empty phrase. Art for the sake of the true, art for the sake of the good and the beautiful, that is the faith I am searching for. —*George Sand (1804–1876)*

ART IS MAGIC. So say the surrealists. But how is it magic? In its metaphysical development? Or does some final transformation culminate in a magic reality? In truth, the latter is impossible without the former. If creation is not magic, the outcome cannot be magic. To worship the product and ignore its development leads to dilettantism and reaction. Art cannot result from sophisticated, frivolous, or superficial effects. —*Hans Hofmann (1880–1966)*

LISTEN! There never was an artistic period.
 There never was an Art-loving nation. —*James McNeill Whistler (1834–1903)*

WHENEVER I HAVE seen art in its land of origin, I have been struck by its reliance on place. In America Japanese art looks withdrawn into itself, as if stiffened in what might poetically be thought of as self-defense; Australian Aboriginal art, unutterably powerful in Australia, loses meaning, can even be childish, decorative, when carted off that continent, losing force as visibly as a rainbow trout fades when cast onto the bank of a river. The European art I have seen in America seems anemic in comparison to what I am seeing here. . . . —*Ann Truitt (1921–)*

Art is when things appear rounded.

—Maurice Denis (1870–1943)

ART is the result of a creative impulse derived out of a consciousness of life.
—John Sloan (1871–1951)

AND SO THE arts are encroaching one upon another, and from a proper use of this encroachment will rise the art that is truly monumental. Every man who steeps himself in the spiritual possibilities of his heart is a valuable helper in the building of the spiritual pyramid which will someday reach to heaven. — *Wassily Kandinsky* (1866–1944)

THE ORGANIC laws of construction tangled me in my desires, and only with great pain, effort, and struggle did I break through these "walls around art." Thus did I finally enter the realm of art, which like that of nature, science, political forms, etc., is a realm unto itself, is governed by its own laws proper to it alone, and which together with other realms ultimately forms the great realm which we can only dimly divine.

Today is the great day of one of the revelations of this world. The interrelationships of these individual realms were illumined as by a flash of lightning; they burst unexpected, frightening, and joyous out of the darkness. Never were they so strongly tied together and never so sharply divided. This lightning is the child of the darkening of the spiritual heaven which hung over us, black, suffocating, and dead. Here begins the epoch of the spiritual, the revelation of the spirit. . . . — *Wassily Kandinsky* (1866–1944)

THE REPRESENTATIVE element in a work of art may or may not be harmful, but it is always irrelevant. For to appreciate a work of art, we must bring with us nothing from life, no knowledge of its affairs and ideas, no familiarity with its emotions.
— *Ben Shahn* (1898–1969), quoting from *Clive Bell* (1881–1964)

ANCIENT ART was the tyrant of Egypt, the mistress of Greece, and the servant of Rome. —*Henry Fuseli* (1741–1825)

SERIOUS art has been the work of individual artists whose art has had nothing to do with "style" because they were not in the least connected with the style or the needs of the masses. Their work arose rather in defiance of their times. They are characteristic, fiery signs of a new era that increase daily everywhere. . . . What appears spectral today will be natural tomorrow.

Where are such signs and works? How do we recognize the genuine ones?

Like everything genuine, its inner life guarantees its truth. All works of art created by truthful minds without regard for the work's conventional exterior remain genuine for all times. —*Franz Marc* (1880–1916)

ART ALMOST ALWAYS has its ingredient of impudence, its flouting of established authority, so that it may substitute its own authority, and its own enlightenment. —*Ben Shahn* (1898–1969)

ALL real works of art look as though they were done in joy. —*Robert Henri* (1865–1929)

I REGARD the mind itself as a tool. Most artists paint as though they had no minds. Their paintings look as though they were made from eye to hand with no intervention by the brain. That isn't art. Art is the response of the living to life. It is therefore the record left behind by civilization. —*John Sloan* (1871–1951)

THE WHOLE audience of art is an audience of individuals. Each of them comes to the painting or sculpture because there he can be told that he, the individual, transcends all classes and flouts all predictions. In the work of art, he finds his uniqueness confirmed. —*Ben Shahn* (1898–1969)

ART IS, after all, only a trace—like a footprint which shows that one has walked bravely and in great happiness. —*Robert Henri* (1865–1929)

[A WORK OF ART IS] A corner of nature viewed through a temperament.
—attributed to *Émile Zola* (1840–1902)

BEAUTY IS THE only thing that time cannot harm. Philosophies fall away like sand, and creeds follow on another like the withered leaves of Autumn; but what is beautiful is a joy for all seasons and a possession for all eternity. — *Oscar Wilde* (1854–1900)

SURELY all art is the result of one's having been in danger, of having gone through an experience all the way to the end, to where no one can go any further. The further one goes, the more private, the more personal, the more singular an experience becomes, and the thing one is making is, finally, the necessary, irrepressible, and, as nearly as possible, definitive utterance of this singularity. . . . — *Ranier Maria Rilke* (1876–1926)

On Art

ART IS THE PATH OF THE CREATOR TO HIS WORK.

—*Ralph Waldo Emerson* (1803–1882)

WHAT WE cannot express by the art of thinking, by the art of science or philosophy or logic, we can and should express by the poetic, visual, or some other arts. It is for that reason that I consider morals and aesthetics one and the same; for they cover only one impulse, one drive inherent in our consciousness—to bring our life and all our actions into a satisfactory relationship with the events of the world as our consciousness wants it to be, in harmony with our life and according to the laws of consciousness itself.
— *Naum Gabo* (1890–1977)

PROGRESS IN ART does not consist in expansion, but in an awareness of limits.
— *Georges Braque* (1882–1963)

ART TENDS toward balance, order, judgment of relative values, the laws of growth, the economy of living—very good things for anyone to be interested in. —*Robert Henri* (1865–1929)

ART is a human activity, consisting in this, that one man consciously, by means of certain external signs, hands on to others feelings he has lived through, and that other people are infected by these feelings, and also experience them. —*Leo Tolstoy* (1828–1910)

THE excellence of every art is its intensity, capable of making all disagreeables evaporate, from their being in close relationship with beauty and truth. —*John Keats* (1795–1821)

IT WAS Richepin who said somewhere: "The love of art means loss of real love." ... True, but on the other hand, real love makes you disgusted with art. —*Vincent van Gogh* (1853–1890)

EVERY ART, like our own, has in its composition fluctuating as well as fixed principles. It is an attentive inquiry into their difference that will enable us to determine how far we are influenced by custom and habit, and what is fixed in the nature of things. —*Sir Joshua Reynolds* (1723–1792)

WHATEVER IS RECEIVED is received according to the nature of the recipient. —*St. Thomas Aquinas* (1225?–1274)

THE TRAVELERS into the East tell us that when the ignorant inhabitants of those countries are asked concerning the ruins of stately edifices . . . remaining among them, the melancholy moments of their former grandeur and long-lost science, they always answer that they were built by magicians. The untaught mind finds a vast gulf between its own powers and those works of complicated art which it is utterly unable to fathom; and it supposes that such a void can be passed only by superficial powers.

And as for artists themselves, it is by no means [in] their interest to undeceive such judges, however conscious they may be of the very nature by which their extraordinary powers were acquired; though our art, being intrinsically imitative, rejects this idea of inspiration, more perhaps than any other. —*Sir Joshua Reynolds* (1723–1792)

TO BECOME truly immortal a work of art must escape all human limits: logic and common sense will only interfere. But once these barriers are broken, it will enter the regions of childhood vision and dream. — *Giorgio De Chirico* (1888–1978)

ART IS HARMONY.
 Harmony is the analogy of contrary and similar elements of tone, of color, and of line, conditioned by the dominant key, and under the influence of a particular light, in gay, calm, or sad combinations. — *Georges Seurat* (1859–1891)

ONE of the main causes of our artistic decline lies beyond doubt in the separation of art and science. Art is nothing but humanized science. — *Gino Severini* (1883–1966)

FOR ART AND Joy go together, with bold openness, and high head, and ready hand— fearing nought, and dreading no exposure. —*James McNeill Whistler* (1834–1903)

ART among a religious race produces reliques; among a military one, trophies; among a commercial one, articles of trade. — *Henry Fuseli* (1741–1825)

TASTE IS the best judge. It is rare. Art only addresses itself to an excessively small number of individuals. — *Paul Cézanne* (1839–1906)

A TRUE work of art can stand many seeings, revealing anew at each seeing. —*John Marin* (1872–1953)

LIFE IS RAPID, art is slow, occasion coy, practice fallacious and judgment partial. —*Henry Fuseli* (1741–1825)

ART IS the desire of man to express himself, to record the reactions of his personality to the world he lives in. — *Amy Lowell* (1874–1925)

I WOULD say the subtlety of my argument would be that if the aspirations of revolutionary change are for greater individuality, greater spiritual growth, for expressions that are

humanistic, or to use a more immediate, New York word, for an existence that is more *menschie,* then certainly part — and a main part — of the struggle of art has been to make an art that is direct, simple, humane, unconnected with powers that be in their essence, and so on. To the degree that it is connected with the bourgeoisie via the marketplace and so on is not necessarily an artist's problem. — *Robert Motherwell* (1915–1991)

THE SUBLIME IN art is the attempt to express the infinite without finding in the realm of phenomena any object which proves itself fitting for this representation. — *Georg Wilhelm Hegel* (1770–1831)

THE wonder of an artist's performance grows with the range of his penetration, with the instinctive sympathy that makes him, in his mortal isolation, considerate of other men's fate and a great diviner of their secret, so that his work speaks to them kindly, with a deeper assurance than they could have spoken with to themselves. And the joy of his great sanity, the power of his adequate vision, is not the less because he can lend it to others and has borrowed it from a faithful study of the world. — *George Santayana* (1863–1952)

On Art

WISE MEN
SAY
IT ISN'T ART!
BUT WHAT
OF IT,
IF IT IS CHILDREN
AND LOVE IN PAINT?

— *Georgia O'Keeffe* (1887–1986)

CHAPTER TWO: *On Nature*

Art, for artists, begins with nature. When one desires to be an artist, one is encouraged to study nature and to sketch from it. I can still remember my first college sketching class, sitting outside with a large newsprint pad beside an abandoned railroad track noting how black all of the hardware was next to the misted brown dry weeds. A tall watchtower stood to one side and some heavy black lights were strung across the track, which disappeared around a curve to the west. It was autumn; a brisk coolness pervaded and the afternoon grew short as the sun ducked behind some trees and was gone. Our assignment was to stay in

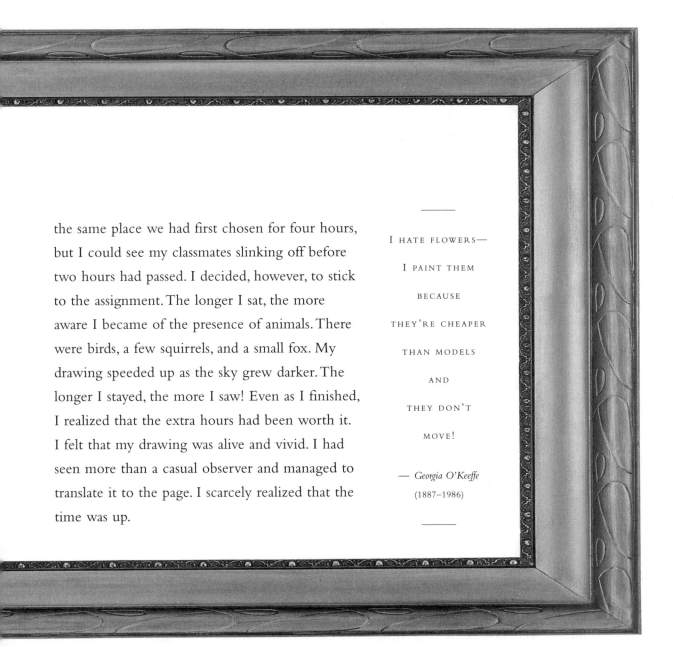

the same place we had first chosen for four hours, but I could see my classmates slinking off before two hours had passed. I decided, however, to stick to the assignment. The longer I sat, the more aware I became of the presence of animals. There were birds, a few squirrels, and a small fox. My drawing speeded up as the sky grew darker. The longer I stayed, the more I saw! Even as I finished, I realized that the extra hours had been worth it. I felt that my drawing was alive and vivid. I had seen more than a casual observer and managed to translate it to the page. I scarcely realized that the time was up.

I HATE FLOWERS—
I PAINT THEM
BECAUSE
THEY'RE CHEAPER
THAN MODELS
AND
THEY DON'T
MOVE!

— *Georgia O'Keeffe*
(1887–1986)

ART completes what nature cannot bring to finish. The artist gives us knowledge of nature's unrealized ends. — *Aristotle* (384 B.C.–322 B.C.)

NATURE, for us men, is more depth than surface. Hence the need to introduce into our light vibrations represented by the reds and yellows, a sufficient amount of blue to give the impression of air. — *Paul Cézanne* (1839–1906)

I HAVE HAD three masters, Nature, Velasquez, and Rembrandt. — *Francisco Goya* (1746–1828)

TASTE is the legitimate offspring of nature, educated by propriety: fashion is the bastard of vanity, dressed by art. — *Henry Fuseli* (1741–1825)

THE RING, the call, the surprise, the shock that you have out of doors—be always looking for the unexpected in nature, do not settle to a formula. Get into the habit of doing what you see, not what you know. Human reason cannot foresee the accidents of out of doors. Humble yourself before nature, it is too majestic for you to do it justice. — *Charles Hawthorne* (1872–1930)

On Nature

Nature is what you see plus what you think about it. —*John Sloan* (1871–1951)

IN EARLIER DAYS (even as a child), the beauty of landscapes was quite clear to me. A background for the soul's moods. Now dangerous moments occur when Nature tries to devour me; at such times I am annihilated, but at peace. This would be fine for old people but I . . . I am my life's debtor, for I have given promises. . . . Frightened, I jump up from the bank, the struggle begins anew. Bitterness has returned. I am not Pan in

the reed, I am merely a human being and want to climb a few steps, but really climb them. . . . —*Paul Klee* (1879–1940)

MAN-MADE THINGS, buildings, boats, etc., we see more decidedly than the other things in a landscape. — *Charles Hawthorne* (1872–1930)

THERE HAS never been a painting that was more beautiful than nature. The model does not unfold herself to you, you must rise to her. She should be the inspiration for your painting. No man has ever over-appreciated a human being.
—*Robert Henri* (1865–1929)

REDUCTION! One wants to say more than nature and one makes the impossible mistake of wanting to say it with more means than she, instead of fewer. Light and the rational forms are locked in combat; light sets them into motion, bends what is straight, makes parallels oval, inscribes circles in the intervals, makes the intervals active.
—*Paul Klee* (1879–1940)

I THINK THAT anyone who will take the trouble to consider the matter carefully will arrive at the same conclusion as I have, that art owes its origin to Nature herself, that this beautiful creation the world supplied the first model, while the original teacher was that divine intelligence which has not only made us superior to the other animals, but like God Himself, if I may venture to say it. In our own time it has been seen . . . that simple children, roughly brought up in the wilderness, have begun to draw by themselves, impelled by their own natural genius, instructed solely by the example of these beautiful paintings and sculptures of Nature. — *Giorgio Vasari* (1511–1576)

TRY to do ugly things so that *you* make them beautiful. These [critiquing flowers] are too pretty for words, one expects to see fairy dancers. I'd like to glaze them with mud to get a little of everyday dirt on them. Get away from preciousness—that's [a] cheap ideal. Get a little human beauty in them. The more delicate the thing is in nature the more one must look for the solemn note. Color in nature is never pretty, it's beautiful.
— *Charles Hawthorne* (1872–1930)

Study nature, love nature, stay close to nature. It will never fail you. —*Frank Lloyd Wright* (1869–1959)

THERE IS NO need to express art in terms of nature. It can perfectly well be expressed in terms of geometry and the exact sciences. — *Georges Vantongerloo* (1866–1965)

THE ARTIST submits from day to day to the fatal rhythm of the impulses of the universal world which encloses him, continual centre of sensations, always pliant, hypnotized by the marvels of nature which he loves, he scrutinizes. His eyes, like his soul, are in perpetual communion with the most fortuitous of phenomena. — *Odilon Redon* (1867–1915)

IT is not uncommon to meet artists who, from a long neglect of cultivating this necessary intimacy with nature, do not even know her when they see her—she appearing a stranger to them, from their being so long habituated to their own representation of her. I have heard painters acknowledge, though in that acknowledgment no degradation of themselves was intended, that they could do better without nature than with her; or as they express themselves, "that it only put them out." . . . *The art of seeing nature,* or, in other words, the art of using models, is in reality the great object, the point to which all our studies are directed. As for the power of being able to do tolerably well from practice alone, let it be valued according to its own worth. But I do not see in what manner it can be sufficient for the production of correct, excellent, and finished pictures. Works deserving this character never were produced, nor ever will arise, from memory alone;

and I will venture to say that an artist who brings to his work a mind tolerably furnished with the general principles of art, and a taste formed upon the works of good artists — in short, who knows in what excellence consists — will, with the assistance of models, which we will likewise suppose he has learned the art of using, be an overmatch for the greatest painter that ever lived who should be debarred such advantages. — *Sir Joshua Reynolds* (1723–1792)

THE GREAT END of all arts is to make an impression on the imagination and the feeling. The imitation of nature frequently does this. Sometimes it fails and something else succeeds. I think, therefore, the true test of all the arts is not solely whether the production is a true copy of nature, but whether it answers the end of art, which is to produce a pleasing effect upon the mind. — *Sir Joshua Reynolds* (1723–1792)

BOREDOM SOON OVERCOMES ME WHEN I AM CONTEMPLATING NATURE.

— *Edgar Degas* (1834–1917)

I AGAIN REPEAT, you are never to lose sight of nature; the instant you do, you are all abroad, at the mercy of every gust of fashion, without knowing or seeing the point to which you ought to steer. Whatever trips you make, you must still have nature in your eye . . . let me recommend to you not to have too great dependence on your practice or memory, however strong those impressions may have been which are there deposited. They are forever wearing out, and will be at least obliterated, unless they are continually refreshed and repaired. — *Sir Joshua Reynolds* (1723–1792)

NOR, while I recommend studying the art from artists, can I be supposed to mean that nature be neglected; I take this study in [addition to], and not in exclusion of the other. Nature is and must be the fountain which alone is inexhaustible, and from which all excellences must originally flow. — *Sir Joshua Reynolds* (1723–1792)

RAPHAEL AND TITIAN seem to have looked at Nature for different purposes; they both had the power of extending their view to the whole; but one looked only for the general effect as produced by form, the other as produced by color. — *Sir Joshua Reynolds* (1723–1792)

On Nature

To work from nature is to improvise.

— *Georges Braque* (1882–1963)

MATISSE was formed by Moreau. One after another of Moreau's remarks can be set, like mottos, beneath the great paintings of Matisse's maturity. "Nature," Moreau would say, "is simply an opportunity for the artist to express himself." Or again: "*Think* your color! Know how to imagine it!" — *John Russell* (1919–), on *Gustave Moreau's* (1826–1898) theories, as they influenced *Henri Matisse* (1869–1954)

MIND YOU, the most perfect steersman that you can have, and the best helm, lie in the triumphal gateway of copying from nature. And this outdoes all other models; and always rely on this with a stout heart, especially as you begin to gain some judgment in draftsmanship. Do not fail, as you go on, to draw something every day, for no matter how little it is it will be well worth while and will do you a world of good. — *Cennino Cennini* (c.1370–c.1440)

SUNFLOWERS are like people to me. —*Joan Mitchell* (1926–1992)

I CARRY MY landscapes around with me. —*Joan Mitchell* (1926–1992)

WHEN PAINTING A landscape it is desirable to walk through the clumps and around the bushes, around the trees, the houses and the rocks. Familiarizing yourself in this way with the subject, you will get a better concept of the thing and not a visual and false snapshot. —*John Sloan* (1871–1951)

I GRANT YOU that the artist does not see Nature as she appears to the vulgar, because his emotion reveals to him the hidden truths beneath appearances. —*Auguste Rodin* (1840–1917)

NATURE, THEREFORE, ENGENDERS THE SCIENCE OF PAINTING. —*Robert Delaunay* (1885–1941)

3

CHAPTER THREE: *On Color*

Color is as individual as each of us and, as one of these quotes suggests, often seems to change from day to day. Just try going shopping two days in a row and you will see how you are attracted to different shades on different days. Color is certainly connected to our moods.

Authors and artists quoted here have approached color from various angles, some more scientifically than others.

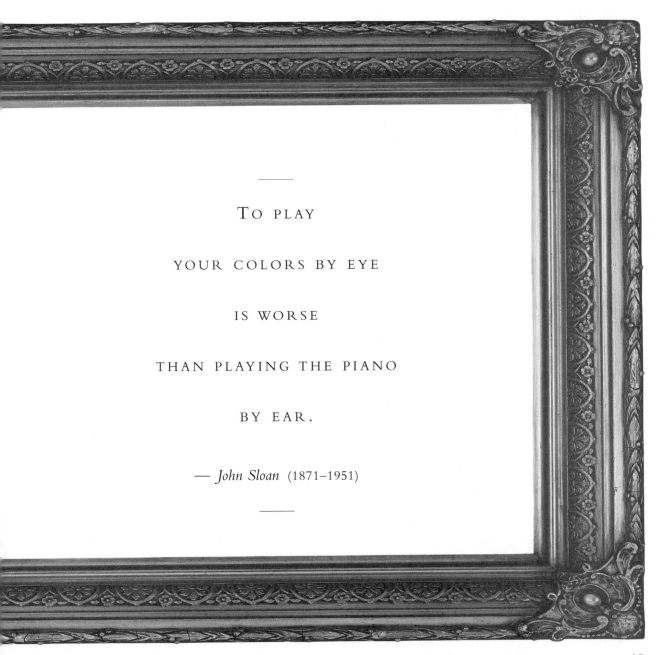

TO PLAY

YOUR COLORS BY EYE

IS WORSE

THAN PLAYING THE PIANO

BY EAR.

— *John Sloan* (1871–1951)

COLORS in painting are as allurements for persuading the eyes, as the sweetness of meter is in poetry. — *Nicolas Poussin* (1594–1665)

DON'T THINK OF sea as color. Make it a solid that can support a boat. Think of "wetness" as color-texture. — *John Sloan* (1871–1951)

On Color

Color is born of the interpenetration of light and dark

— *Sam Francis* (1923–1994)

TITIAN, Tintoretto, and Paul Veronese absolutely enchanted me, for they took away all sense of subject. . . . It was the poetry of color which I felt, procreative in its nature, giving birth to a thousand things which the eye cannot see, and distinct from their cause. — *Washington Allston* (1779–1843)

BLACK IS LIKE a broken vessel, which is deprived of the capacity to contain anything. — *Leonardo da Vinci* (1452–1519)

BEAUTIFUL colours can be bought in the shops on the Riato, but good drawing can only be bought from the casket of the artist's talent with patient study and nights without sleep. — *Jacopo Robusti,* known as *Tintoretto* (1518–1594)

HARMONY OF colouring is destructive of art . . . it is like the smile of a fool. — *William Blake* (1757–1825)

THOUGH [painting] borrows help indeed from colours, and uses them, as means, to execute its designs; it has nothing, however, more wide of its real aim, or more remote from its intention, than to make a show of colours, or from their mixture, to raise a separate and flattering pleasure to the sense. —*Anthony Ashley Cooper* (1801–1885)

A COLOURIST MAKES his presence known even in a simple charcoal drawing. —*Henri Matisse* (1869–1954)

IN VISUAL PERCEPTION a color is almost never seen as it really is—as it physically is. This fact makes color the most relative medium in art. —*Josef Albers* (1888–1976)

IMAGINE someone pointing to a spot in the iris in a face by Rembrandt and saying, "The wall in my room should be painted this color." —*Ludwig Wittgenstein* (1889–1951)

IF ONE SAYS "Red" (the name of color) and there are fifty people listening, it can be expected that there will be fifty reds in their minds. And one can be sure that all these reds will be very different. —*Josef Albers* (1888–1976)

A PIECE OF drapery is like a necktie, hot stuff to paint, and one of the easiest things for a painter to kid himself into thinking he can do. Don't be fooled by the color. Go after the shape and character. Hew the forms together with colored tones. —*John Sloan* (1871–1951)

GOLDEN IS A SURFACE COLOUR. —*Ludwig Wittgenstein* (1889–1951)

COLOR THINKS by itself, independently of the objects it clothes. —*Charles Baudelaire* (1821–1867)

...BLACK SEEMS to make a colour cloudy, but darkness doesn't. A ruby could thus keep getting darker without ever becoming cloudy; but if it became blackish red, it would become cloudy. — *Ludwig Wittgenstein* (1889–1951)

THE FIRST PROCESS in the art of the painter is the composition of colours. — *Theophilus* (mid-tenth century)

THERE ARE tonalities which are noble and others which are vulgar, harmonies which are calm or consoling, and others which are exciting because of their boldness. — *Paul Gauguin* (1848–1903)

SIMULTANEOUS contrast is not just a curious optical phenomenon—it is the very heart of painting. Repeated experiments with adjacent colors will show that any ground subtracts its own hue from the colors which it carries and therefore influences. For a proper comparison, we must see them (the two spots to be compared) simultaneously, not alternately. The latter way, a repeated looking back and forth, produces changing and disturbing afterimages, which make a comparison under equal conditions impossible. For simultaneous comparison, therefore, we must focus at a center between the two rectangles and for a sufficient length of time. —*Josef Albers* (1888–1976)

On Color

WHAT A HORRIBLE THING YELLOW IS.

— *Edgar Degas* (1834–1917)

AND HOW, THEN, could Bonnard say there could never be too much yellow? — *Anna Held Audette* (1938–), speaking of *Pierre Bonnard* (1867–1947)

EACH DAY has its own individuality of color. — *Charles Hawthorne* (1872–1930)

With the brush we merely tint, while the imagination alone produces colour.

— *Théodore Géricault* (1791–1824)

BUT TO A more sensitive soul the effect of colours is deeper and intensely moving. And so we come to the second main result of looking at colours: *their psychic effect.* They produce a corresponding spiritual vibration, and it is only as a step towards this spiritual vibration that the elementary physical impression is of importance. — *Wassily Kandinsky* (1866–1944)

THE PUREST and most thoughtful minds are those which love color the most. —*John Ruskin* (1819–1900)

KNOWING how to paint and to use one's colors rightly has not any connection with originality. This originality consists in properly expressing your own impressions. — *Thomas Couture* (1815–1879)

FIND YOUR OWN technique. Form your own color concept of things in nature. I have no rules for fine color to give you. There are some facts about the craft of painting and the use of the palette which may prove help to you. The important thing is to keep on drawing when you start to paint. Never graduate from drawing. —*John Sloan* (1871–1951)

WHITE *must* be the lightest color in a picture. — *Ludwig Wittgenstein* (1889–1951)

EVERYONE KNOWS that yellow, orange, and red suggest ideas of joy and plenty.
— *Eugène Delacroix* (1798–1863)

THE fundamental *grey* which differentiates the masters, expresses them and is the soul of all colour. — *Odilon Redon* (1840–1916)

IT ALMOST ALWAYS happens that true, but exaggerated, coloring is more agreeable than absolute coloring. — *Michel Eugène Chevreul* (1786–1889)

COLOR IS a plastic means of creating intervals. Intervals are color harmonics produced by special relationships, or tensions. We differentiate now between formal tensions and color tensions, just as we differentiate in music between counterpoint and harmony. And just as counterpoint and harmony follow their own laws, and differ in rhythm and movement, both the formal tensions and the color tensions have a development of their own in accordance with the inherent laws from which they are separately derived. Both, however, as we have stated, aim toward the realization of the same image. And both deal with the depth problem. — *Hans Hofmann* (1880–1966)

On Color | # Black is not a color.

— *Édouard Manet* (1832–1883)

THE GREAT USE of copying, if it be at all useful, should seem to be in learning color; yet even coloring will never be perfectly attained by servilely copying the model before you. An eye critically nice can only be formed by observing well-colored pictures with attention: by close inspection, and minute examination, you will discover the manner of handling the artifices of contrast, glazing, and other expedients, by which good colorists have raised the value of their tints, and by which nature has been so happily imitated.
— *Sir Joshua Reynolds* (1723–1792)

PUT VARIETY in white. —*Charles Hawthorne (1872–1930)*

GENERALLY speaking color directly influences the soul. Color is the keyboard, the eyes are the hammers, the soul is the piano with many strings. The artist is the hand that plays, touching one key or another purposively, to cause vibrations in the soul.

It is evident, therefore, that color harmony must rest ultimately on purposive playing upon the human soul; this is one of the guiding principles of internal necessity. —*Wassily Kandinsky (1866–1944)*

IT IS the eye of ignorance that assigns a fixed and unchangeable color to every object; beware of this stumbling block. —*Paul Gauguin (1848–1903)*

COLORS SHOULD BE laid out on the palette in an orderly way. I prefer to put the full intensity colors around the outside edge of a large rectangular palette. Starting with yellow-orange in the upper left hand corner and moving to yellow and yellow-green around to the right, so that orange and blue come opposite each other at the middle of either side. The neutral tones are then laid along the lines of their color scales. The spaces in between are used for mixtures with white. —*John Sloan (1871–1951)*

"DARK" and "blackish" are not the same concept. —*Ludwig Wittgenstein (1889–1951)*

BLUE IS THE male principle, stern and spiritual. Yellow the female principle, gentle, cheerful and sensual. Red is matter, brutal and heavy and always the color which must be fought and vanquished by the other two. —*Franz Marc (1880–1916)*

THE PICTURE will have charm when each colour is very unlike the one next to it. —*Leon Battista Alberti (1404–1472)*

THERE IS SUCH a thing as the *impression* of luminosity. —*Ludwig Wittgenstein (1889–1951)*

SEE WHAT YOU can do with your daring with color and your ignorance mixed with it.
— *Charles Hawthorne* (1872–1930)

IN PAINTING I want to say something comforting in the way that music is comforting.
I want to paint men and women with that element of the eternal that was formerly
symbolised by the halo, and that we try to express by the actual radiance of our colours.
— *Vincent van Gogh* (1853–1890)

On Color

. . . black is the queen of colors. — *Auguste Rodin* (1840–1917)

A COLOR which would be "dirty" if it were the color of a wall, needn't be so in
a painting. — *Ludwig Wittgenstein* (1889–1951)

WATER in swimming pools changes its look more than in any other form. The colour
of a river is related to the sky it reflects, and the sea always seems to me to be the
same colour and have the same dancing patterns. But the swimming-pool water is
controllable—even its colour can be man-made—and its dancing rhythms reflect not
only the sky but, because of its transparency, the depth of the water as well. If the water
surface is almost still and there is a strong sun, then dancing lines with the colours of the
spectrum appear everywhere. If the pool hasn't been used for a few minutes and there's
no breeze, the look is of a simple gradation of colour that follows the incline of the floor
of the pool. Added to all this is the infinite variety of patterns of material that the pool
can be made from. — *David Hockney* (1937–)

AS PARADOXICAL as it may seem a great sculptor is as much a colourist as the best
painter, or rather the best engraver. He plays so skillfully with all the resources of relief,
he blends so well the boldness of light with the modesty of shadow, that his sculptures

please one, as much as the most charming etchings. Now colour . . . is the flower of fine modelling. These two qualities always accompany each other, and it is these qualities which give to every masterpiece of the sculptor the radiant appearance of living flesh. —*Auguste Rodin* (1840–1917)

COLOR IS only beautiful when it means something. —*Robert Henri* (1865–1929)

COLOURING does not depend on where the colours are put, but on where the lights and darks are put, and all depends on form and outline, on where that is put. —*William Blake* (1757–1827)

WHO EVER HEARD of a musician who was passionately fond of B flat? Color is like music. The palette is an instrument that can be orchestrated to build form. —*John Sloan* (1888–1951)

IT SEEMS obvious that colors vary according to lights, because when any color is placed in the shade, it appears to be different from the same color which is located in light. Shade makes color dark; whereas light makes color bright where it strikes. Philosophers say that nothing can be seen that is neither illuminated nor colored. —*Leon Battista Alberti* (1404–1472)

WHETHER SOMETHING "has color" or not is as hard to define verbally as are such questions as "what is music" or "what is musical." —*Josef Albers* (1888–1976)

TRANSPARENCY painted in a picture produces its effect in a different way than opaqueness. —*Ludwig Wittgenstein* (1889–1951)

HE WHO KNOWS how to appreciate color relationships, the influence of one color on another, their contrasts and dissonances, is promised an infinitely diverse imagery. —*Sonia Delaunay* (1885–1979)

THE GREAT black and white draftsman, the sculptor, and the blind man know that form and color are separate. The form itself is what the blind man knows about the thing. Color is surface skin that fits over the form. Many great works of art have only form, the sculpture of the thing. Color as used to signify realization by men like Titian and Rembrandt, gives greater life and tactile experience to the work.
—*John Sloan* (1871–1951)

IN MY USE of color I aim to reinforce the sensation of light and dark, that is, to develop the rhythm to and from the eye by placing on the canvas the colors which, by their depressive or stimulating qualities, approach or recede in accordance with the forms I wish to approach or recede in the rhythmic scheme of the pictures. Thus the movement of the preconceived rhythm is intensified. This is what I mean by co-ordinating color and contour. —*Andrew Dasburg* (1887–1979)

WITH RESPECT to coloring, though it may appear at first a part of painting merely mechanical, yet it still has its rules, and those grounded upon that presiding principle which regulates both the great and the little in the study of a painter. By this, the first effect of the picture is produced; and as this is performed, the spectator, as he walks the gallery, will stop, or pass along. To give a general air of grandeur at first view, all trifling, or artful play of little lights, or an attention to a variety of tints is to be avoided; a quietness and simplicity must reign over the whole work; to which a breadth of uniform and sim-ple color will very much contribute. Grandeur of effect is produced by two different ways which seem entirely opposed to each other. One is, by reducing the colors to little more than chiaro-oscuro, which was often the practice of the Bolognian schools; and the other, by making the colors very distinct and forcible, such as we see in those of Rome and Florence; but still, the presiding principle of both those manners is simplicity. Certainly, nothing can be more simple than monotony; and the distinct blue, red, and yellow colors which are seen in the draperies of the Roman and Florentine schools, though they have not that kind of harmony which is produced by a variety of broken and transparent colors, have that effect of grandeur which was intended. Perhaps these distinct colors strike the mind more forcibly from there not being any great union between them; as martial music, which is intended to rouse the nobler passions, has its effect from the

sudden and strongly marked transitions from one note to another which that style of music requires; while in that which is intended to move the softer passions, the notes imperceptibly melt into one another. — *Sir Joshua Reynolds* (1723–1792)

THE LARGE White Flower with the golden heart is something I have to say about White—quite different from what White has been meaning to me. Whether the flower or the color is the focus I do not know. I do know that the flower is painted large to convey to you my experience of the flower—and what is my experience of the flower—if it is not color. — *Georgia O'Keeffe* (1887–1986)

THERE'S SOMETHING ABOUT black. You feel hidden away in it.
— *Georgia O'Keeffe* (1887–1986)

IT IS to Titian we must turn our eyes to find excellence with regard to color, and light and shade, in the highest degree. He was both the first and the greatest master of this art. By a few strokes he knew how to mark the general image and character of whatever object he attempted; and produced, by this alone, a truer representation than his master Giovanni Bellini or any of his predecessors, who finished every hair. His great care was to express the general color, to preserve the masses of light and shade, and to give by opposition the idea of that solidity which is inseparable from natural objects. When those are preserved, though the work should possess no other merit, it will have in a proper place its complete effect; but where any of those are wanting, however minutely labored the picture may be in the detail, the whole will have a false and even an unfinished appearance, at whatever distance, or in whatever light it can be shown. — *Sir Joshua Reynolds* (1723–1792)

On Color

ANY GROUND SUBTRACTS ITS OWN HUE FROM THE COLORS WHICH IT CARRIES.

—*Josef Albers* (1888–1976)

CHAPTER FOUR: *On Drawing*

Drawing is the basis for all art, and many artists believe it should be continually practiced no matter how accomplished one becomes and no matter how abstract one's art is. The medium used is unimportant, and whether it is a small sketch or a full-blown brushwork study for a mural, it is often the truest version of an idea. In its very roughness may be its genius, and many an artist has striven to reproduce a quick sketch made on scrap paper. Because spontaneity is possible, drawings can be made anywhere, when a fuller representation is not feasible.

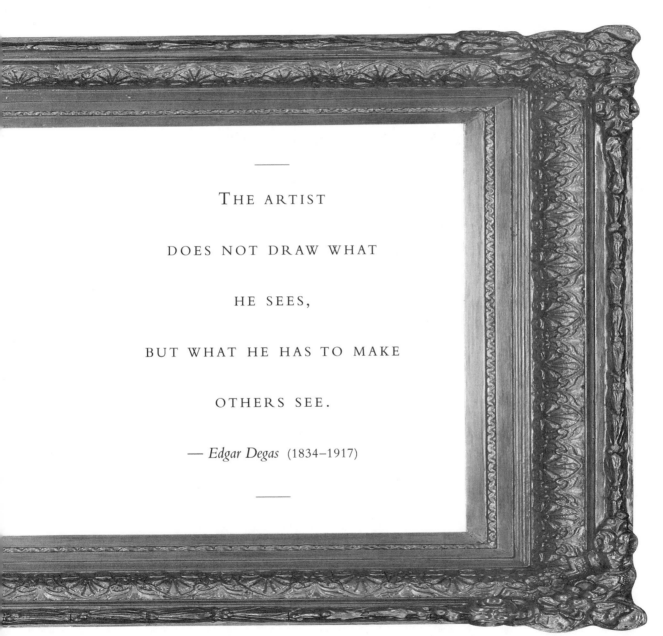

THE ARTIST

DOES NOT DRAW WHAT

HE SEES,

BUT WHAT HE HAS TO MAKE

OTHERS SEE.

— *Edgar Degas* (1834–1917)

DRAWING is the cornerstone of the graphic, plastic arts. Drawing is the coördination of line, tone, and color symbols into formations that express the artist's thought. Drawing and composition are the same thing. —*John Sloan* (1871–1951)

You can never do too much drawing.

—*Jacopo Robusti,* known as *Tintoretto* (1518–1594)

IF WE'RE TALKING about important art there's the artist's intimacy and truthfulness to himself, but an equal intimacy to the Other [the one drawn]. I think . . . Picasso drawings are like that; I think the Rembrandts are like that. I think the artist who most often did that was van Gogh. —*John Berger* (1926–), on drawing as an act of self-recognition

THOSE WHO ARE not conversant in works of art are often surprised at the high value set by connoisseurs on drawings which appear careless, and in every respect unfinished; but they are truly valuable, and their value arises from this, that they give the idea of a whole; and this whole is often expressed by a painter, even though roughly exerted— whether it consists in the general composition, or the general form of each figure, or the turn of the attitude which bestows grace and elegance. All this we may see fully exemplified in the very skillful drawings of Parmigiano and Correggio. On whatever account we value these drawings, it is certainly for high finishing, or a minute attention to particulars. — *Sir Joshua Reynolds* (1723–1792)

ALWAYS THINK of drawing, getting the forms realized, emphasizing the design. —*John Sloan* (1871–1951)

IT IS NOT bright colors but good drawing that makes figures beautiful. — *Titian Vecellio* (1483–1576)

IF YOU WISH, concentrate on a single feature (as, build all toward one eye), make all lines lead toward that eye. — *Robert Henri* (1865–1929)

WHEN YOU draw a crowd of people in a street or room or landscape, decide whether you want to say that the people dominate the place or that the place is more important than the people. — *John Sloan* (1871–1951)

DRAWING AND COLOR are not separate at all; in so far as you paint, you draw. The more the color harmonizes, the more exact the drawing becomes. When the color achieves richness, the form attains its fullness also. — *Paul Cézanne* (1839–1906)

DRAW places you have seen from memory. I used to paint things I had glimpsed through windows while riding in the elevated train. Remember the kind of place it was. Get the character of the whole room as well as the human being in it. The sturdiness of a chair, the delicacy of muslin curtains blowing in the window. The tired look of the rug on the floor. The droop of the woman's hand in her lap, the tired folds in her skirt. Get the heat of the room. — *John Sloan* (1871–1951)

IN GLEYRE'S STUDIO I found Renoir, Sisley and Bazille. . . . While we sketched from a model, Gleyre criticized my work: "It is not too bad," he said, "but the breast is heavy, the shoulder is too powerful, and the foot too big." I can only draw what I see, I replied timidly. Praxiteles borrowed the better elements of a hundred imperfect models in order to create a masterpiece," retorted Gleyre dryly. "When one does something, one must go back to the ancients." The same evening I took Sisley, Renoir, and Bazille aside: Let us leave, I told them. This place is unwholesome: there is no sincerity here. We left after two weeks of that kind . . . and we did the right thing. — *Claude Monet* (1840–1926)

A CURVE does not exist in its full power until contrasted with a straight line. — *Robert Henri* (1865–1929)

A GOOD DRAWING has immense vitality because it is explanatory. In a good drawing even its faults have become virtues. — *John Sloan* (1871–1951)

DRAWING doesn't disappoint me . . . when I succeed in doing a good drawing, it satisfies me more than anything else. . . . Another thing I can say about the way I draw is that I use charcoal a lot. Partly because it has such a fantastic range but also because it is very easy to erase. For me, drawing is a lot to do with taking out, with returning to the white of the paper. —*John Berger* (1926–)

On Drawing

HAS YOUR DRAWING THE MEANING YOU SAW IN THE MODEL AT FIRST?

—*Robert Henri* (1865–1929)

A SKETCH has charm because of its truth—not because it is unfinished.
—*Charles Hawthorne* (1872–1930)

DRAW with the brush. Carve the form. Don't be carried away by subtleties of modeling and nice pigmentation at the expense of losing the form. —*John Sloan* (1871–1951)

KEEP A bad drawing until by study you have found out why it is bad.
—*Robert Henri* (1865–1929)

THE REASON I wanted an artist like George Grosz on the teaching staff of the Art Students League was because he had that thorough training in academic drawing. It sticks out all over his work, and yet he can draw like a wise child.
—*John Sloan* (1871–1951)

YOU WILL NEVER draw the sense of a thing unless you are feeling it at the time you work. —*Robert Henri* (1865–1929)

DRAWING is the life and soul of painting: especially outline, is the hardest; nay, the Art has, strictly speaking, no other difficulty. Here are needed courage and steadfastness; here giants themselves have a lifelong struggle, in which they can never for a moment lay aside their arms. . . . — *Francisco Pacheco* (1564–1654)

WHAT do drawings mean to me? I really don't know. The activity absorbs me. I forget everything else in a way that I don't think happens with any other activity. The act banishes everything else. When I'm drawing I'm looking and trying to put together things I've found a little differently from the way they always are. — *John Berger* (1926–)

PERHAPS YOU ARE wondering about the kind of encouragement Bonnat is giving me. He tells me: "Your painting isn't bad, it is 'chic,' but even so it isn't bad, but your drawing is absolutely atrocious." So I must gather my courage and start once again. . . . — *Henri de Toulouse-Lautrec* (1864–1901), to his uncle

A DRAWING SHOULD be a verdict on the model. Don't confuse a drawing with a map. — *Robert Henri* (1865–1929)

. . . SKETCHES, or such drawings as painters make for their works, give this pleasure of imagination to a high degree. [That is] From a slight, undetermined drawing, where the ideas of the composition and character are . . . just touched upon, the imagination supplies more than the painter himself, probably, could produce; and we accordingly often find that the finished work disappoints the expectation that was raised from the sketch; and this power of the imagination is one of the causes of the great pleasure we have in viewing a collection of drawings by great painters. These general ideas which are expressed in sketches, correspond very well to the art often used in poetry. A great part of the beauty of the celebrated description of Eve in Milton's "Paradise Lost" consists in using only general, indistinct expressions, every reader making out the detail according to his own particular imagination—his own idea of beauty, grace, expression, dignity, or loveliness; but a painter, when he represents Eve on canvas, is obliged to give a determined form, and his own idea of beauty distinctly expressed. — *Sir Joshua Reynolds* (1723–1792)

It is only by drawing often, drawing everything, drawing incessantly, that one fine day you discover to your surprise that you have rendered something in its true character.

—*Camille Pissarro* (1830–1903)

THERE IS A better chance of getting an exciting painting from a laboured study with texture than from a fine drawing without it. —*John Sloan* (1871–1951)

THE DESIGNATION of my drawings by a title is often, so to speak, superfluous. A title is justified only when it is vague and even aims confusedly at the eliptical. My drawings *inspire,* and are not to be defined. They determine nothing. They place us, as does music, in the ambiguous realm of the undetermined. They are a kind of metaphor. . . . —*Odilon Redon* (1840–1916)

I LOVE DRAWING, and one of the things I wanted to try was an all-eraser drawing. I did drawings myself and erased them, but that seemed like fifty-fifty. So then I knew I had to pull back further. If it was going to be an all-eraser drawing, it had to be art in the beginning, and I went to Bill de Kooning and told him about it. When I was knocking on the door, I was hoping he wouldn't be there, so I wouldn't have to go through with it. But he was, and we went through this thing, and even though he said he didn't approve of it, he didn't want to interfere with my work. —*Robert Rauschenberg* (1925–), on the infamous erasure of a de Kooning drawing

YOU can only learn to paint by drawing, for drawing is a way of reserving a place for color in advance. —*André L'Hote* (1885–1962)

THINK OF DRAWING as a way of talking about the things that interest you. Think of those wonderful documents, drawings made on scraps of paper by the lesser Dutch masters while they were wandering around market places and sitting in saloons. —*John Sloan* (1871–1951)

CHAPTER FIVE: *On Light*

Light is one of the great mysteries. It has fascinated artists for centuries. From the great Northern Lights near the North Pole to the mystical lights that appear on the lakes in Great Britain to produce perceptions of such characters as the Loch Ness Monster—we are vitalized and inspired by light.

Artists know that the way a subject is lit can reveal much about its character and can influence the viewers' emotional response. Many times, a subject will be lighted from underneath or behind in order to play up certain features. Often light has such a strong presence in an artist's work that it becomes a signifier of the artist's style and message.

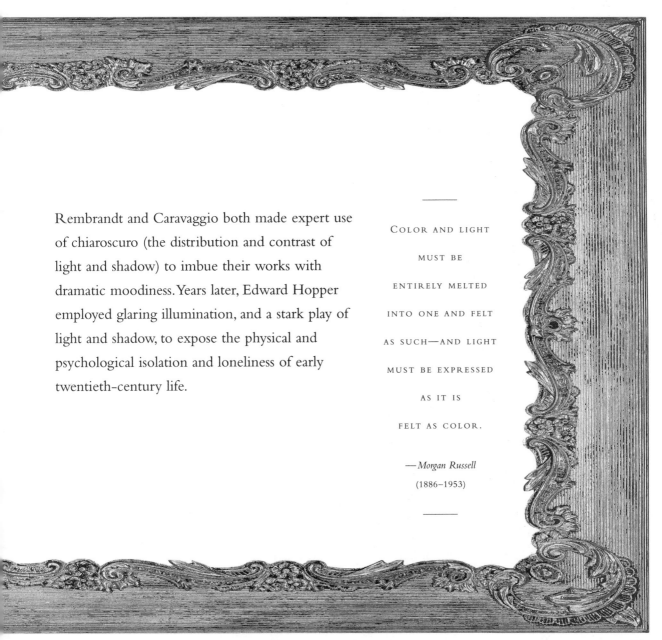

Rembrandt and Caravaggio both made expert use of chiaroscuro (the distribution and contrast of light and shadow) to imbue their works with dramatic moodiness. Years later, Edward Hopper employed glaring illumination, and a stark play of light and shadow, to expose the physical and psychological isolation and loneliness of early twentieth-century life.

COLOR AND LIGHT MUST BE ENTIRELY MELTED INTO ONE AND FELT AS SUCH—AND LIGHT MUST BE EXPRESSED AS IT IS FELT AS COLOR.

—*Morgan Russell*
(1886–1953)

THE LIGHT for drawing from nature should come from the North in order that it may not vary. And if you have it from the South, keep the window screened with cloth, so that with the sun shining the whole day the light may not vary. The height of the light so arranged as that every object shall cast a shadow on the ground of the same length as itself. —*Leonardo da Vinci* (1452–1519)

STUDY DAUMIER'S DRAWINGS. See how he expressed the feeling of light playing over the form. See how he used the light and shade to design. In the hands of a master, light and shade is one of the great qualities of art. —*John Sloan* (1871–1951)

SETS OF lines can say something about the direction and nature of the light. They are used by great fresco painters as a sign for shade. I always think of shade as being full of light. That is why I like to use the word shade rather than light and shadow. Shade seems to play over the thing, envelop it, better define it, while shadow seems to fall on the thing and stain the surface with darks. —*John Sloan* (1871–1951)

On Light

Of the original phenomena, light is the most enthralling.

—*Leonardo da Vinci* (1452–1519)

COLOURS are the deeds of light, its deeds and sufferings.
—*Johann Wolfgang von Goethe* (1749–1832)

AVAILABLE LIGHT is any damn light that is available! —*W. Eugene Smith* (1918–1978)

AN INCREASE IN LIGHT GIVES AN INCREASE IN DARKNESS. . . .

— *Sam Francis* (1923–1994)

THE VIVACITY and brightness of colors in a landscape will never bear any comparison with a landscape in nature when it is illumined by the sun, unless the painting is placed in such a position that it will receive the same light from the sun as does the landscape.
— *Leonardo da Vinci* (1452–1519)

CHAPTER SIX: *On Studying Art*

Because artists have been trained differently, they all have different methods of working in order to complete a piece of art. Artists are very proud of the methods they use and sometimes very protective of where and when they learned each step. Not only how they have been trained but where—in which country—is important.

In the 1500s, even which city an artist came from was considered significant; Venice was considered a "lightweight" when compared with Florence. Michelangelo commented that it was a shame that someone had been trained in Venice, because his training would have been so much more complete in Florence.

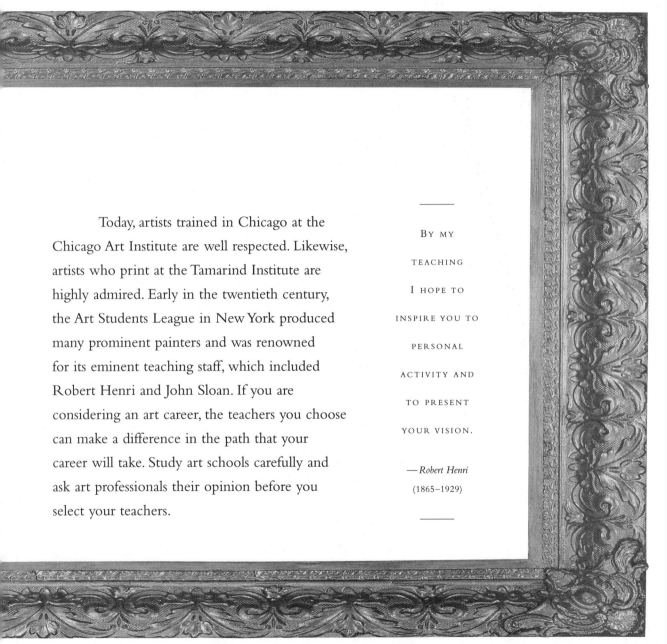

Today, artists trained in Chicago at the Chicago Art Institute are well respected. Likewise, artists who print at the Tamarind Institute are highly admired. Early in the twentieth century, the Art Students League in New York produced many prominent painters and was renowned for its eminent teaching staff, which included Robert Henri and John Sloan. If you are considering an art career, the teachers you choose can make a difference in the path that your career will take. Study art schools carefully and ask art professionals their opinion before you select your teachers.

BY MY TEACHING I HOPE TO INSPIRE YOU TO PERSONAL ACTIVITY AND TO PRESENT YOUR VISION.

—*Robert Henri*
(1865–1929)

SUPPOSING that all young people admitted to our schools were endowed with all the qualities needed to make a painter, isn't it dangerous to have them study together for years, copying the same models and approximately the same path? After that, how can one hope to have them still keep any originality? Haven't they in spite of themselves exchanged any particular qualities they may have had, and sunk the individual manner of conceiving nature's beauties that each one of them possessed in a single, uniform style?
— *Théodore Géricault* (1791–1824)

On Studying Art

Self-education only produces expressions of self. —*Robert Henri* (1865–1929)

AS BASIC RULES of any language must be practiced continually, and therefore are never fixed, so exercises toward distinct color effects never are done or over. New and different cases will be discovered time and again, and should be presented to the class again and again. In this way the study will be a mutual give and take. It will also show that all thorough study is basic, and that all education is self-education. This indicates that we expect from every student several solutions to each problem.
—*Josef Albers* (1888–1976)

I HAVE STUDIED the art of the masters and the art of the moderns, avoiding any preconceived system and without prejudice. I have no more wanted to imitate the former than to copy the latter; nor have I thought of achieving the idle aim of *art for art's sake*. No! I have simply wanted to draw from a thorough knowledge of tradition the reasoned and free sense of my own individuality.

To know in order to do: such has been my thought. To be able to translate the customs, ideas, and appearance of my time as I see them—in a word, to create a living art—this has been my aim. — *Gustave Courbet* (1819–1877)

THE FIRST TWO things to study are form and values. For me, these are the bases of what is serious in art. Color and finish put charm into one's work.

In preparing a study or a picture, it seems to me very important to begin by an indication of the darkest values (assuming that the canvas is white), and to continue in order to the lightest value. From the darkest to the lightest I would establish twenty shades. Thus your study or picture is set up in an orderly fashion. This order should not cramp either the linearist or the colorist. Always [keep in mind] the mass, the ensemble which has struck you. Never lose sight of that first impression by which you were moved. Begin by determining your composition. Then the values—the relation of the forms to the values. These are the bases. Then the color, and finally the finish . . . it is logical to begin with the sky. — *Camille Corot* (1796–1875)

REALIZE THE VALUE OF PUTTING DOWN YOUR FIRST IMPRESSION QUICKLY.

— *Charles Hawthorne* (1872–1930)

ONE of Leonardo da Vinci's suggestions for stimulating the imagination was to "look at crumbling walls, glowing embers, clouds or mold, because in these irregular shapes one can find strange inventions just as we are apt to project words into the sound of church bells." — *Anna Held Audette* (1938–)

IN FACT, you should resist the impulse to rearrange anything, because you'll probably only succeed in making forced, obviously posed, or even more ordinary relationships. (After Matisse was disappointed with a bouquet he had arranged for a painting, Renoir told him to go around to the side he had not looked at.)
—*Anna Held Audette* (1938–), telling of such an incident between *Pierre-Auguste Renoir* (1841–1919) and *Henri Matisse* (1869–1954)

TO FORM THIS just taste is undoubtedly in your power; but it is to reason and philosophy that you must have recourse; from them you must borrow the balance, by which is to be weighed and estimated the value of every pretension that intrudes itself on your notice. — *Sir Joshua Reynolds* (1723–1792)

On Studying Art

ONE MUST ALWAYS BE PREPARED TO LEARN SOMETHING TOTALLY NEW.

—*Ludwig Wittgenstein* (1889–1951)

I CANNOT FORBEAR to mention among these precepts a new device for study which although it may seem trivial and almost ludicrous, is nevertheless extremely useful in arousing the mind to various inventions. And this is, when you look at a wall spotted with stains, or with a mixture of stones, if you have to devise some scene, you may discover a resemblance to various landscapes, beautified with mountains, rivers, rocks, trees, plains, wide valleys, and hills in varied arrangement; or again you may see battles and figures in action; or strange faces and costumes, and an endless variety of objects, which you could reduce to complete and well drawn forms. And these appear on such walls confusedly, like the sound of bells in whose jangle you may find any name or word you may choose to imagine. — *Leonardo da Vinci* (1452–1519)

INTUITION in art is actually the result of prolonged tuition. The popular eye is not untrained; it is only wrongly trained—trained by inferior and insincere visual representations. —*Ben Shahn* (1898–1969)

I HAVE TAUGHT my students not to apply rules or mechanical ways of seeing. Traditionally art is to create and not to revive. To revive: leave that to the historians, who are looking backward. —*Josef Albers* (1888–1976)

NOW THEN, you of noble mind, who love this profession, come at once to art and accept these precepts: enthusiasm (love), reverence, obedience, and perseverance. As soon as you can, place yourself under the guidance of a master, and remain with him as long as possible. —*Cennino Cennini* (c.1370–c.1440)

STUDENTS WORRY too much about originality. The emphasis on original, individual work in the past years has done a great deal to produce a crop of eccentric fakes and has carried art away from the stream of tradition. Tradition is our heritage of knowledge and experience. We can't get along without it. —*John Sloan* (1871–1951)

KEEP this little canvas, it is a promise for the future. When I say "keep this canvas," I mean for the influence on yourself. When one does a good thing, I think it's well to keep it to show how foolish we are at other times. Keep this canvas and wonder why. —*Charles Hawthorne* (1872–1930)

STUDY THE GREAT brush drawings of the Chinese and Japanese. Observe their conventions for perspective, form, texture. When we try to imitate those conventions we lose the content, because those artists were part of an ancient tradition. Our tradition changes rapidly, our schools of thought come to fruition quickly and decay again. We see differently. —*John Sloan* (1871–1951)

HAVE a special interest, a positive prejudice about some clump of trees or one particular knoll, an excitement about them can spread through the whole composition, and so fire the rest of the things that you are only mildly interested in. —*John Sloan* (1871–1951)

I WISH TO be of service to the artists of our own day, by showing them how a small beginning leads to the highest elevation, and how from so noble a situation it is possible to fall to utmost ruin, and consequently, how these arts resemble nature as shown in our human bodies. — *Giorgio Vasari* (1511–1576)

On Studying Art

THE LOUVRE IS THE BOOK IN WHICH WE LEARN TO READ.

—*Paul Cézanne* (1839–1906)

AVOID distant views, paint objects close up. If the foreground is well done the distance will take care of itself. By having the big lines of the composition going out of the canvas, your imagination can wander beyond the edge. It will make it seem part of a large composition. Have as much fun as you can and don't feel that the edge of your canvas confines you—let your vision go right on. — *Charles Hawthorne* (1872–1930)

TO EXPERIENCE VISUALLY, and to transform our visual experience into plastic terms, requires the faculty of empathy. — *Hans Hofmann* (1880–1966)

MOST art students are generous till it comes to squeezing their colour on the palette. Put as much colour on your palette as you think you'll need and a little over. Don't be stingy with your paint, it isn't worth it. Many pictures haven't become works of art simply because the artist tried to save a nickel's worth of colour. —*John Sloan* (1871–1951)

IF YOU THINK of a school drawing while you work, your drawing will look like one. —*Robert Henri* (1865–1929)

HAVE THE humble attitude. To see things simply is the hardest thing in the world. When a man is sixty or seventy, he may be able to do a thing and the whole world rejoices. You can't begin too early, for this is not a thing of a month or a day. The value of a canvas depends almost entirely on your mental attitude, not on your moral attitude; depends on what kind of a man you are, the way you observe. Study continuously, developing yourself into a better person, more sensitive to things in nature. Spend years in getting ready. —*Charles Hawthorne* (1872–1930)

OF SEVERAL BODIES, all equally large and equally distant, that which is most brightly illuminated will appear to the eye nearest and largest. —*Leonardo da Vinci* (1452–1519)

AN ARTIST must educate himself, he cannot be educated, he must test things out as they apply to himself; his life is one long investigation of things and his own reaction to them. If he is to be interesting to us it is because he renders a very personal account. —*Robert Henri* (1865–1929)

[I WOULD ADVISE YOUNG ARTISTS] to paint as they can, as long as they can, without being afraid of painting badly. . . . If the painting doesn't improve by itself, it means that nothing can be done—and I wouldn't do anything! . . . —*Claude Monet* (1840–1926)

I HAVE only a few things to say to the student, but it is necessary to say them over in many ways to make the points clear. They are mostly technical: The importance of the mental attitude of seeing things; an emphasis on plastic consciousness; the fact that all things in nature are composed of variations of the five simple solids: cube, cone, sphere, cylinder, and pyramid; the significance of devices in drawing, by which we represent three-dimensional forms on a two-dimensional surface; the low relief concept of composition; the importance of foreshortening rather than visual perspective in signifying spacial projection and recession; the use of color as a graphic tool; emphasis on realization rather than realism as the essential character of reality in art. —*John Sloan* (1871–1951)

IT MAY HAVE been accidental but you knew enough to let this alone. The intelligent painter is always making use of accidents. — *Charles Hawthorne* (1872–1930)

<div style="float:left">
On
Studying
Art
</div>

The only thing is to see. —*Auguste Rodin* (1840–1917)

HE THAT would be a painter must have a natural turn thereto.

Love and delight therein are better of the Art of Painting than compulsion is.

If a man is to become a really great painter he must be educated thereto from his very earliest years.

He must copy much of the work of good artists until he attains a free hand.

To paint is to be able to portray upon a flat surface any visible thing whatsoever that may be chosen.

It is well for anyone first to learn how to divide and reduce to measure the human figure, before learning anything else. — *Albrecht Dürer* (1471–1528)

I WOULD RATHER wish a student, as soon as he goes abroad, to employ himself upon whatever he has been incited to by any immediate impulse, than to go sluggishly about a prescribed task; whatever he does in such a state of mind, little advantage accrues from it, as nothing sinks deep enough to leave any lasting impression; and it is impossible that anything will be well understood or well done that is taken into a reluctant understanding, and executed with a servile hand. — *Sir Joshua Reynolds* (1723–1792)

SUCH A detail of instruction might be extended with a great deal of plausible and ostentatious simplification. But it would at best be useless. Our studies will be forever, in a very great degree, under the direction of chance; like travelers, we must take what we can get, and when we can get it—whether it is or is not administered to us in the most commodious manner, in the most proper place, or at the exact minute when we would wish to have it. — *Sir Joshua Reynolds* (1723–1792)

...HERE I MUST observe, and I believe it may be considered as a general rule, that no art can be grafted with success on another art. For though they all profess the same origin, and to proceed from the same stock, yet each has its own peculiar modes both of imitating nature and of deviating from it, each for the accomplishment of its own particular purpose. These deviations, more especially, will not bear transplantation to another soil. — *Sir Joshua Reynolds* (1723–1792)

A MIND enriched by an assemblage of all the treasures of ancient and modern art will be more elevated and fruitful in resources, in proportion to the number of ideas which have been carefully collected and thoroughly digested. There can be no doubt but that he who has the most materials has the greatest means of invention; and if he has not the power of using them, it must proceed from a feebleness of intellect, or from the confused manner in which those collections have been laid up in his mind. — *Sir Joshua Reynolds* (1723–1792)

WE should imitate the conduct of the great artists in the course of their studies, as well as the works which they produced when they were perfectly formed. Raphael began by imitating implicitly the manner of Pietro Perugino, under whom he studied; hence his first works are scarce to be distinguished from his master's; but soon forming higher and more extensive views, he imitated the grand outline of Michael Angelo; he learned the manner of using colors from the works of Leonardo da Vinci, and Fra Bartolomeo; to all this he added the contemplation of all the remains of antiquity that were within his reach, and employed others to draw for him what was in Greece and distant places. And it is from his having taken so many models that he became himself a model for all succeeding painters; always imitating and always original. — *Sir Joshua Reynolds* (1723–1792)

ART in its perfection is not ostentatious; it lies hid and works its effect, itself unseen. It is the proper study and labor of an artist to uncover and find out the latent cause of conspicuous beauties and from thence form principles of his own conduct. Such an examination is a continual exertion of the mind; as great, perhaps, as that of the artist whose works he is thus studying. — *Sir Joshua Reynolds* (1723–1792)

Limited means
often
constitute the charm
and force
of primitive painting.
Extension,
on the contrary,
leads the arts
to
decadence.

— *Georges Braque* (1882–1963)

. . . ALL YOU EVER taught or said was so intelligent and undogmatique, you put on it all was so true that it is applicable to the practice of any art or any direction a given art may take and so serves always. You gave us also your own heat and inspired us with what I like to call the habit of creative spunk. . . .
— *Morgan Russell* (1886–1953), writing to *Robert Henri* (1865–1929)

THE MIND is but a barren soil—a soil which is soon exhausted, and will produce no crop, or only one, unless it be continually fertilized and enriched with foreign matter.
— *Sir Joshua Reynolds* (1723–1792)

THAT PAINTING IS the most praiseworthy which is most like the thing represented.
— *Leonardo da Vinci* (1452–1519)

IN ART, progress does not consist in extension, but in the knowledge of limits.
— *Georges Braque* (1882–1963)

ART SCHOOL TRAINING is not obligatory; it is only conditional. There exists a world of elementary knowledge which art school education can supply; but the highest stages of initiation are a matter of awareness in the adept. — *Ossip Zadkine* (1890–1967)

I SAY and confirm that it is far better to draw in company than alone for many reasons: the first is that you will be ashamed to be seen among the draftsmen if you are unskillful, and this shame will cause you to study well. In the second place, a feeling of emulation will goad you to try to rank among those who are praised more than yourself, for praise will spur you; a third reason is that you will learn from the methods of such as are abler than you and if you are abler than others you will profit by eschewing their faults, and hearing yourself praised will increase your skill. — *Leonardo da Vinci* (1452–1519)

CHAPTER SEVEN: *On Line*

Artists express themselves with circles, arcs, and lines. Most often lines are drawn to connect two points. While lines (at least straight lines) do not occur in nature, they are abundant in buildings and manmade cityscapes. The thickness of a line can emphasize its importance, while brokenness can imply action or movement. A line that narrows from one end to the other implies distance. Curlicues and crosshatching may signal hair or shadow. An underline suggests force or strength. Studying cartoons, where all drawing is reduced to line, may help you to see lines more clearly in fine art.

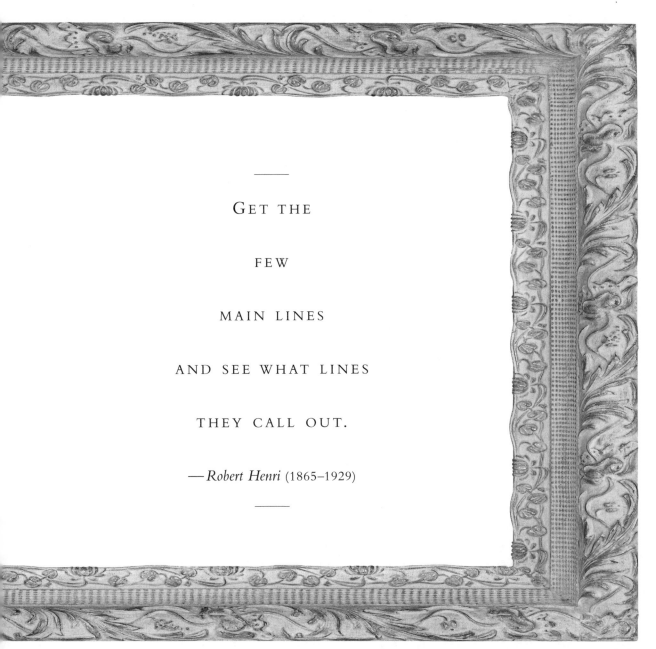

———

GET THE

FEW

MAIN LINES

AND SEE WHAT LINES

THEY CALL OUT.

— *Robert Henri* (1865–1929)

———

IT OFTEN HAPPENS that these rough sketches, which are born in an instant in the heat of inspiration, express the idea of their author in a few strokes, while on the other hand too much effort and diligence sometimes sops the vitality and powers of those who never know when to leave off. — *Giorgio Vasari* (1511–1576)

On Line

Form is the shape of content. —*Ben Shahn* (1898–1969)

FORMS in art arise from the impact of idea upon material. . . . They stem out of the human wish to formulate ideas, to recreate them into entities, so that meanings will not depart fitfully as they do from the mind, so that thinking and belief and attitudes may endure as actual things. — *Ben Shahn* (1898–1969)

ALWAYS LINES, never forms! But where do they find these lines in Nature? For my part I see only forms that are lit up and forms that are not. There is only light and shadow. — *Francisco José De Goya Y Lucientes* (1746–1828)

IT IS TO be observed, that straight lines vary only in length, and therefore are least ornamental. That curv'd lines as they can be varied in their degrees of curvature as well as in their length, begin on that account to be ornamental. That straight and curved lines can be joined, being a compound line, vary more than curves alone, and so become somewhat more ornamental. That the waving line, or line of beauty, varying still more, being composed of two curves contrasted, becomes still more ornamental and pleasing . . . and that the serpentine line, or the line of grace, by its waving and winding at the same time different ways, leads the eye in a pleasing manner along the continuity of its variety. — *William Hogarth* (1697–1764)

IN THEIR PURSUIT of the same supreme end Matisse and Picasso stand side by side, Matisse representing color and Picasso form. — *Wassily Kandinsky* (1866–1944)

COUNT on big lines to express your ideas. — *Robert Henri* (1865–1929)

. . . FORM is not just the intention of content. . . . Form is based, first, upon a supposition, a theme. Form is, second, a marshaling of materials, the inert matter in which the theme is to be cast. Form is, third, a setting of boundaries, of limits, the whole extent of idea, but no more an outer shape of idea. Form is, next, the relating of inner shapes to the outer limits, the initial establishing of harmonies. Form is, further, the abolishing of excessive content, of content that falls outside the true limits of the theme. Form is thus a discipline, an ordering, according to the need of content. — *Ben Shahn* (1898–1969)

LINE is the most powerful device of drawing. — *John Sloan* (1871–1951)

LINES ARE RESULTS, DO NOT DRAW THEM FOR THEMSELVES.

— *Robert Henri* (1866–1929)

ART IS NOTHING without form. — *Gustave Flaubert* (1821–1880)

YOU GET a linear quality from collage that is more rapid than the swiftest drawn line. — *Conrad Marca-Relli* (1913–)

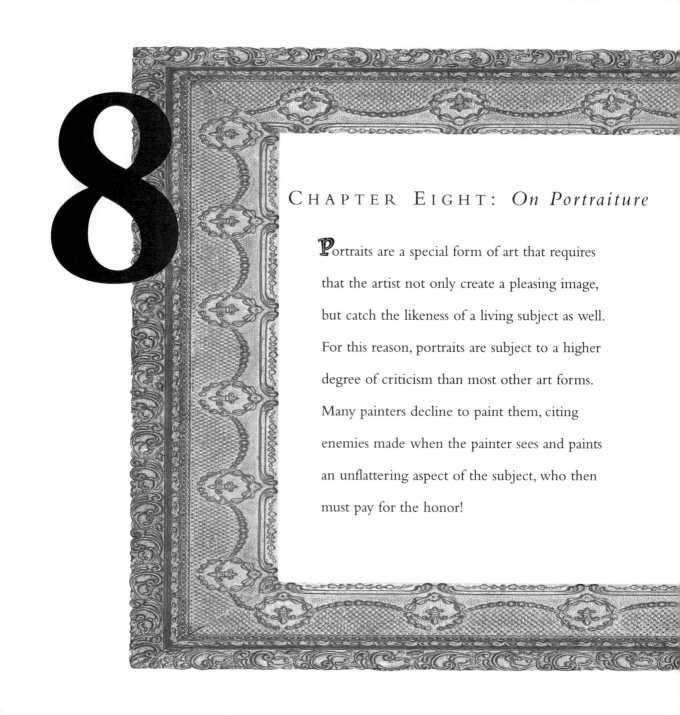

8

CHAPTER EIGHT: *On Portraiture*

Portraits are a special form of art that requires
that the artist not only create a pleasing image,
but catch the likeness of a living subject as well.
For this reason, portraits are subject to a higher
degree of criticism than most other art forms.
Many painters decline to paint them, citing
enemies made when the painter sees and paints
an unflattering aspect of the subject, who then
must pay for the honor!

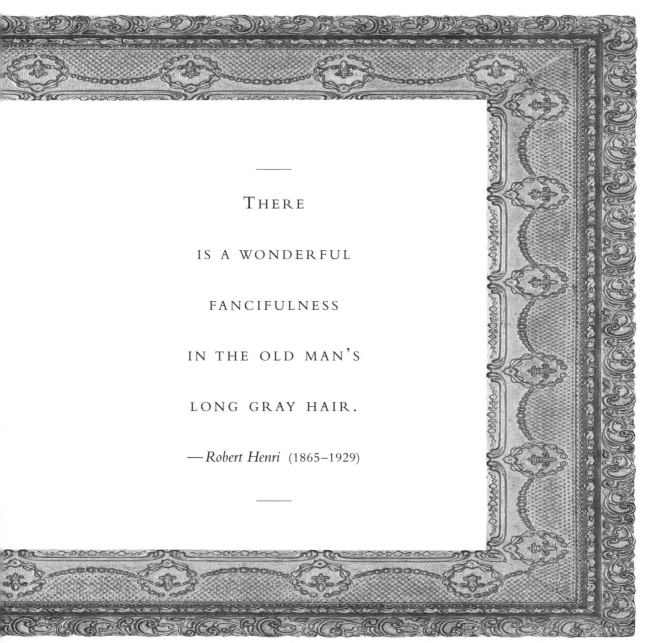

THERE

IS A WONDERFUL

FANCIFULNESS

IN THE OLD MAN'S

LONG GRAY HAIR.

—*Robert Henri* (1865–1929)

THE ARTIST does not see both eyes alike. There is always "the eye" and the other eye. But you shouldn't know that he felt that while he was working. It adds life and plasticity to the drawing if the eye in the light is darker than the one in the shadow. It gives the head vividness. The eyebrow is the last thing. It is just a color and texture accident, happening on the edge of the eyesocket. —*John Sloan* (1871–1951)

On Portraiture

All the bystanders at an event worthy of note adopt various gestures of admiration when contemplating the occurrence.

—*Leonardo da Vinci* (1452–1519)

STUDENTS find it hard to create on a portrait because they are so concerned with superficial likeness that they are afraid to use their imagination. You must find something that strikes you about the person; put it down as your point of view. Find something that is a dominant plastic gesture: the impulse of the forehead, the "forward to the nose" concept; the set of the eyes in relation to the cheekbones that may show the special character of the individual. —*John Sloan* (1871–1951)

YOU REMEMBER the fine pastel by Chardin, equipped with a pair of spectacles and a visor to shade the eyes. What a sly fellow this painter is. Have you noticed that by passing a small transverse plaque backwards and forwards across the nose, the color tones are thrown up better? Verify this fact and tell me if I am wrong.
— *Paul Cézanne* (1839–1906), in a letter to Émile Bernard (1868–1991)

IF YOU will examine the matter closely, nothing in a portrait is a matter of indifference. Gesture, grimace, clothing, décor even—all must combine to realize a character. Great painters ... Holbein, in all his portraits—have often aimed at expressing the character which they undertook to paint, with sobriety but with intensity.
— *Charles Baudelaire* (1821–1867)

NEVER MAKE the shadow under the neck as dark is it looks. The cast shadow painted by most portrait painters looks like a hammock slung under the chin. As for the high-lights which are the stock in trade of such "professional painters," the last refuge of an empty mind—I am too much in earnest at this moment to joke about them.
— *John Sloan* (1871–1951)

DON'T LOOK the shadows out of the face. If you look at any shadow long enough, it tends to grow light. Therefore keep your eye focused on the lights or on the expression, never on the shadows or background. Better have shadows black and simple than weak.
— *Robert Henri* (1865–1929)

DON'T LET THE BACKGROUND SMOTHER THE FIGURE.

— *Robert Henri* (1865–1929)

FEEL the dignity of a child. Do not feel superior to him, for you are not.
—*Robert Henri* (1865–1929)

THE EYES are set deeper beneath the brows of men than in women. The male skeleton is more angular than the female. —*John Sloan* (1871–1951)

On Portraiture

THE WRINKLES OF A CHILD'S DRESS ARE FULL OF THE HISTORY OF THE DAY. THE LITTLE CHILD SPOILS THE CLEAN DRESS AND *MAKES* IT. THE CLOTHES HAVE BECOME PART OF THE CHILD. —*Robert Henri* (1865–1929)

IT IS A good idea, particularly when you are doing the eyes, to get the sitter to look at you. In this way the portrait will look in every direction and at everyone who looks at it. This is something much praised by those who do not understand how it is done.
—*Antonio Palomino Y Velasco* (1653–1723)

THE EXCELLENCE of portrait-painting, and, we may add, even the likeness, the character, and countenance . . . depend more upon the general effect produced by the painter than on the exact expression of the peculiarities, or minute discrimination of the parts. The chief attention of the artist is therefore employed in planting the features in their proper places, which so much contributes to giving the effect and true impression of the whole. The very peculiarities may be reduced to classes and general descriptions; and there are therefore large ideas to be found even in this contracted subject. He may afterwards labor single features to what degree he thinks proper; but let him not forget continually to examine whether in finishing the parts he is not destroying the general effect. — *Sir Joshua Reynolds* (1723–1792)

Better to give the gesture than the outline of the arm.

—*Robert Henri* (1865–1929)

HE, therefore, who in his practice of portrait-painting wishes to dignify his subject, which we will suppose to be a lady, will not paint her in the modern dress, the familiarity of which alone is sufficient to destroy all dignity. He takes care that his work shall correspond to those ideas and that imagination which he knows will regulate the judgment of others, and therefore, dresses his figure (in) something with the general air of the antique for the sake of dignity, and preserves something of the modern for the sake of likeness. By this conduct his works correspond with those prejudices which we have in favor of what we continually see; and the relish of the antique simplicity corresponds with what we may call the more learned and scientific prejudice. — *Sir Joshua Reynolds* (1723–1792)

WHEN a portrait is painted in the historical style, as it is neither an exact minute representation of an individual, nor completely ideal, every circumstance ought to correspond to this mixture. The simplicity of the antique air and attitude, however much to be admired, is ridiculous when joined to a figure in modern dress. It is not my purpose to enter into the question at present, whether this mixed style ought to be adopted or not; yet if it is chosen, it is necessary it should be complete, and all of a piece; the difference of stuffs, for instance, which make the clothing, should be distinguished in the same degree as the head deviates from a general idea. Without this union, which I have so often recommended, a work can have no marked and determined character, which is the peculiar and constant evidence of genius. But when this is accomplished to a high degree it becomes in some sort a rival to that style which we have fixed as the highest. — *Sir Joshua Reynolds* (1723–1792)

A PAINTER of portraits retains the individual likeness; a painter of history shows the man by showing his action. A painter must compensate the natural deficiencies of his art. He has but one sentence to utter, but one moment to exhibit. He cannot, like the poet or historian, expatiate, and impress the mind with great veneration for the character of the hero or saint he represents, though he lets us know, at the same time, that the saint was deformed or the hero lame. The painter has no other means of giving an idea of the dignity of the mind but by that external appearance which grandeur of thought does generally, though not always, impress on the countenance and by that correspondence of figure to sentiment and situation which all men wish, but cannot command. The painter who may in this one particular attain with ease what others desire in vain, ought to give all that he possibly can, since there are so many circumstances of true greatness that he cannot give at all. He cannot make his hero talk like a great man; he must make him look like one. For which reason he ought to be well studied in the analysis of those circumstances which constitute dignity of appearance in real life.
— *Sir Joshua Reynolds* (1723–1792)

. . . YOU WOULD hardly believe how difficult it is to place a figure alone on a canvas, and to concentrate all the interest on this single and unique figure and still keep it living and real. — *Édouard Manet* (1832–1883)

I WARN YOU that this is very important. Before undertaking to draw the portrait, you must make your model stand in the most graceful posture that is natural to him and that you desire to pose him in. Thus standing you must draw him, for that is the way to catch his expression. If the portrait is full length you will keep the canvas unnailed and pinned down only with a few drawing pins. When the drawing is done, take it off and roll up the lower part, nailing the rest at that height at which you can paint sitting.

Now make your model sit down, and sit down yourself. So it is done even in the presence of the King, if His Majesty orders it. If he does not, beg him to allow you to, in order to be comfortable during your work. Begin the underpainting, fixing first the contours and the proportions of the whole and the parts. Then lay in the colors patiently, paying great attention to those of nature, without tormenting them much or defining them too precisely for the time being. — *Antonio Palomino De Castro Y Velasco* (1653–1723)

On Portraiture

A PORTRAIT,

TO BE A WORK OF ART,

NEITHER MUST NOR MAY RESEMBLE

THE SITTER . . .

THE PAINTER HAS WITHIN HIMSELF

THE LANDSCAPES

HE WISHES TO PRODUCE.

TO DEPICT A FIGURE

ONE MUST NOT PAINT THAT FIGURE;

ONE MUST PAINT ITS ATMOSPHERE.

— *Umberto Boccioni* (1882–1916)

CHAPTER NINE: *On Painting*

Painting has always been seen as more than an imitation made on a surface with lines and colors. Some have called painting a wordless poem, and many believed (and still believe) that the making of a painting entails a degree of mystery. In the fifteenth century Cennini wrote that it was "the art of eliciting unseen things hidden in the shadow of natural ones . . . and serving to demonstrate as real the things that are not." The strength of contemporary painting has often seemed superior to its actual subject matter: consider, for example, *Picasso*'s Figure in a Red Chair (1932) and *Motherwell*'s The Homely Protestant (1948). In abstract painting, the

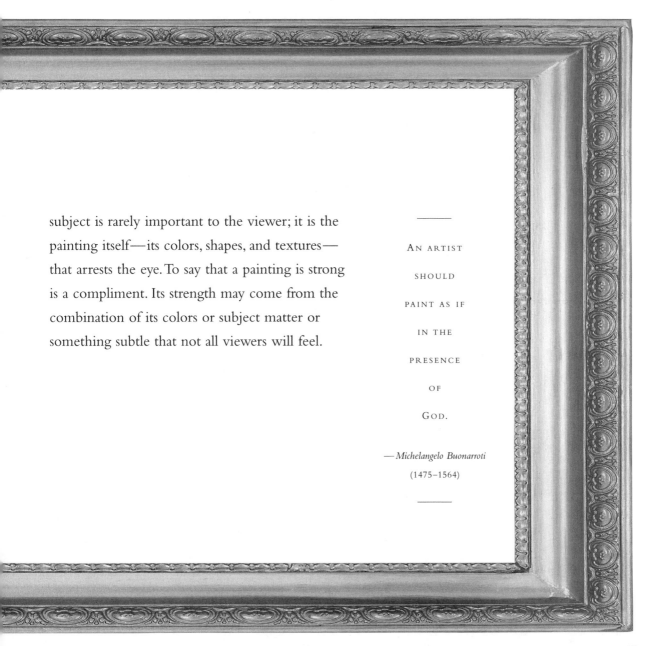

subject is rarely important to the viewer; it is the painting itself—its colors, shapes, and textures—that arrests the eye. To say that a painting is strong is a compliment. Its strength may come from the combination of its colors or subject matter or something subtle that not all viewers will feel.

AN ARTIST

SHOULD

PAINT AS IF

IN THE

PRESENCE

OF

GOD.

—*Michelangelo Buonarroti*
(1475–1564)

PAINTING is an art which, with proportionate lines and lifelike colors, and by observing perspective so imitates the appearance of corporeal things as to represent upon flat surfaces not only the thickness and roundness of bodies, but their motions, and even show visibly to our eyes many feelings and emotions of the mind.
— *Giovanni Paolo Lomazzo* (1538–1600)

On Painting

The painter must leave the beholder something to guess.

—*E. H. Gombrich* (1909–2001)

THE PAINTER can only do good things when he no longer knows what he is doing.
— *Edgar Degas* (1834–1917)

PAINTING IS NOTHING but an imitation of human actions, which alone are, properly speaking, imitable. Other actions are imitable not *per se,* but accidentally, and not as principle but as accessory parts. With this qualification one may also imitate not only the actions of beasts, but anything natural. — *Gaspard Poussin* (1594–1665)

I REMEMBER a landscape-painter in Rome who was known by the name of "Studio," from his patience in high finishing, in which he thought the whole excellence of art consisted; so that he once endeavored, as he said, to represent every individual leaf on a tree. This picture I never saw; but I am very sure that an artist who looked only at the general character of the species, the order of the branches and the masses of the foliage, would in a few minutes produce a more true resemblance of trees than this painter in as many months. — *Sir Joshua Reynolds* (1723–1792)

IT IS A given as a rule by Fresnoy that "the principal figure of a subject must appear in the midst of a picture, under the principal light, to distinguish him from the rest." A painter who should think himself obliged secretly to follow this rule, would encumber himself with needless difficulties; he would be confined to great uniformity of composition, and be deprived of many beauties which are incompatible with its observance. The meaning of this rule extends, . . . no further than this—that the principal figure should be immediately distinguished at the first glance of the eye; but there is no necessity that the principal light should fall on the principal figure, or that the principal figure should be in the middle of the picture. It is sufficient that it be distinguished by its place, or by the attention of other figures pointing it out to the spectator. . . . — *Sir Joshua Reynolds* (1723–1792)

REMEMBER that a picture—before being a horse, a nude, or some sort of anecdote— is essentially a flat surface covered with colours assembled in a certain order. — *Maurice Denis* (1870–1943)

PERSPECTIVE IS TO PAINTING WHAT THE BRIDLE IS TO THE HORSE, THE RUDDER TO THE SHIP.

— *Leonardo da Vinci* (1452–1519)

PAINTING is that universal idea which includes in itself all the things of the universe. And since natural objects, due to the imperfection of their material, are full of defects, it is the unique aim of painting to bring them back to their first state, as they were when made by the immortal creator. — *Carlo Ridolfi* (1594–1658)

I ARRANGE MY subject as I want it, then go ahead and paint it, like a child. I want a red to be sonorous, to sound like a bell; if it doesn't turn out that way, I add more reds and other colors until I get it. I am no cleverer than that. I have no rules and no methods; anyone can look at my materials or watch how I paint—he will see that I have no secrets. I look at a nude; there are myriads of tiny tints. I must find the ones that will make the flesh on my canvas live and quiver. Nowadays they want to explain everything. But if they could explain a picture, it wouldn't be art. Shall I tell you what I think are the two qualities of art? It must be indescribable and it must be inimitable. . . . The work of art must seize upon you, wrap you up in itself, carry you away. It is the means by which the artist conveys his passions; it is the current which he puts forth which sweeps you along in his passion. . . . — *Pierre-Auguste Renoir* (1841–1919)

On Painting

ATMOSPHERE IN A PAINTING IS NINE-TENTHS FEAR. —*John Sloan* (1871–1951)

POETRY IS superior to painting in the presentation of words, and painting is superior to poetry in the presentation of facts. For this reason I judge painting to be superior to poetry. — *Leonardo da Vinci* (1452–1519)

PAINTING isn't so difficult when you don't know. . . . But when you do . . . it's quite a different matter! — *Edgar Degas* (1834–1917)

A SHADOW IS always affected by the colour of the surface on which it is cast. — *Leonardo da Vinci* (1452–1519)

THE VERY ACT of making a painting is an intending one . . . the values of man, . . . reside in his intentions, in the degree to which he has moved away from the brute, in his intellect at its peak and in his humanity at its peak. — *Ben Shahn* (1898–1969)

THE properties of all objects, as far as the painter is concerned with them, are the outline or drawing, the color, and the light and shade. The drawing gives the form, the color its visible quality, and the light and shade its solidity. — *Sir Joshua Reynolds* (1723–1792)

ÉMILE DE ANTONIO: A long time ago, when I first met you, you said, "Painting relates as much to life as it does to art." Do you still believe that?

Rauschenberg: I may have said that, but I think I said you couldn't make either life or art, you had to work in that hole in between, which is undefined. That's what makes the adventure of painting. — *Robert Rauschenberg* (1925–), to *Émile de Antonio* (1922–1989)

PAINTING is just like making an after-dinner speech. If you want to be remembered, say one thing and stop. — *Charles Hawthorne* (1872–1930)

MEN AND WORDS are ready made, and you, O Painter, if you do not know how to make your figures move, are like an orator who knows not how to use his words. — *Leonardo da Vinci* (1452–1519)

NOT EVERY painter has a gift for painting, in fact, many painters are disappointed when they meet with difficulties in art. Painting done under pressure by artists without the necessary talent can only give rise to formlessness, as painting is a profession that requires peace of mind. The painter must always seek the essence of things, always represent the essential characteristics and emotions of the person he is painting. . . . — *Titian Vecellio* (1477–1576)

CHARLES DEMUTH said it very well: "They (the paintings) must be understood through the eyes, and that's not the word either. No writing, no talking, no singing, no dancing will explain them. They are the final, the nth whopee of sight." — *Anna Held Audette* (1938–), quoting *Charles Demuth* (1883–1935)

I HAVE A predilection for painting that lends joyousness to a wall. — *Pierre-Auguste Renoir* (1841–1919)

Every painter paints himself. — *Cosimo de Medici* (1389–1464)

THEY who are compelled to paint by force, without being in the necessary mood, can produce only ungainly works, because this profession requires an unruffled temper. — *Titian Vecellio* (1483–1576)

IF DECEIVING the eye were the only business of the art, there is no doubt, indeed, but the minute painter would be more apt to succeed; but it is not the eye, it is the mind which the painter of genius desires to address; nor will he waste a moment upon those smaller objects which only serve to catch the sense, to divide the attention, and to counteract his great design of speaking to the heart. — *Sir Joshua Reynolds* (1723–1792)

I AM just beginning to understand what it is to paint. A painter should have two lives, one in which to learn, and one in which to practice his art. — *Pierre Bonnard* (1867–1947)

THE GREAT END of (the) art is to strike the imagination. The painter, therefore, is to make no ostentation of the means by which this is done; the spectator is only to feel the result in his bosom. An inferior artist is unwilling that any part of his industry should be lost upon the spectator. He takes as much pains to discover, as the greater artist does to conceal, the marks of his subordinate assiduity. In works of the lower kind everything appears studied and encumbered; it is all boastful art and open affectation. The ignorant often part from such pictures with wonder in their mouths and indifference in their hearts. — *Sir Joshua Reynolds* (1723–1792)

I CERTAINLY agree that abundance and variety of colors contribute greatly to the charm and beauty of the picture. But I would have artists be convinced that the supreme

skill and art in painting consists in knowing how to use black and white. And every effort and diligence is to be employed in learning the correct use of these two pigments, because it is light and shade that make objects appear in relief. And so black and white give solidity to painted things.

In agreement with the learned and the unlearned, I shall praise those faces which seem to project out of the picture as though they were sculptured, and I shall censure those faces in which I see no art but that of outline. — *Leon Battista Alberti* (1404–1472)

A GOOD PAINTER is to paint two main things, namely, man and the workings of man's mind. The first is easy, the second difficult, for it is to be represented through the gestures and movements of the limbs. And these may best be learned from the dumb, who make them more clearly than any other sort of men. — *Leonardo da Vinci* (1452–1519)

I HAVE ALWAYS said, or at least thought, that literary poetry in a painter is something special, and is neither illustration nor the translation of writing by form. In painting one must search rather for suggestion than for description, as is done in music. Sometimes people accuse me of being incomprehensible only because they look for an explicative side to my pictures which is not there. — *Paul Gauguin* (1848–1903)

I WORK on all parts of my painting at once: I always look immediately to see the effect. I am like a child who blows up a bubble of soap. At first the bubble is very small, but it is already spherical. Then the child blows the bubble up very softly, until he is afraid that it will burst. Similarly, I work on all the parts of my painting at once, improving it very gently until I find that the effect is complete. — *Camille Corot* (1796–1875)

BE VERY CAREFUL, in painting, to observe that among the shadows there are other shadows that are almost imperceptible as to darkness and shape. This is proved by the third proposition, which says that the surfaces of globular or convex bodies have as great a variety of lights and shadows as have the bodies that surround them. — *Leonardo da Vinci* (1452–1519)

PAINTING seems to me all the better the nearer it approaches to relief, and relief to be all the worse the nearer it approaches painting. —*Michelangelo Buonarroti (1475–1564)*

WELL, I MADE you take time to look at what I saw and when you took time to really notice my flower you hung all your own associations with flowers on my flower and you write about my flower as if I think and see what you think and see of the flower—and I don't. — *Georgia O'Keeffe (1887–1986)*

TO MY MIND, expression is not a matter of passion mirrored on the human face or revealed by a violent gesture. When I paint a picture, its every detail is expressive. The place occupied by figures or objects, the empty spaces around them, the proportions, everything plays a part. —*Henri Matisse (1869–1954)*

WHEN people read erotic symbols into my painting, they're really thinking about their own affairs. — *Georgia O'Keeffe (1887–1986)*

FINE PAINTING is nothing other than a copy of the perfections of God and a remembrance of his painting, and lastly a music and melody which only the intellect is capable of hearing, with great difficulty. —*Michelangelo Buonarroti (1475–1564)*

A PAINTER paints a picture with the same feeling as that with which a criminal commits a crime. —*Edgar Degas (1834–1917)*

CHARLES SHEELER'S work is representational, but he wrote, "I had come to feel that a picture could have incorporated in it the structural design implied in abstraction and be presented in a wholly realistic manner." —*Anna Held Audette (1938–)*, on a theory by *Charles Sheeler (1883–1965)*

DO NOT let it look as if you reasoned too much. Painting must be impulsive to be worth while—if you are a painter there is an aesthetic excitement about painting which is one of the most beautiful experiences that can be. Put things down while you feel that joy; I'd like to see you register it, and then I know some day there will be an artist born. — *Charles Hawthorne (1872–1930)*

THE FIRST VIRTUE of a painting is to be a feast for the eyes.
—*Eugène Delacroix* (1798–1863)

JUST DASH something down if you see a blank canvas staring at you with a certain imbecility. You do not know how paralyzing it is, that staring of a blank canvas which says to the painter: you do not know anything. . . . — *Vincent van Gogh* (1853–1890)

A PAINTING requires a little mystery, some vagueness, some fantasy. When you always make your meaning perfectly plain you end up boring people. — *Edgar Degas* (1834–1917)

PAINTING is possessed of a divine power, for not only, as is said of friendship, does it make the absent present, but also, after many centuries, makes the dead almost alive, so that they are recognized with great admiration for the artist, and with great delight.
—*Leon Battista Alberti* (1404–1472)

PAINTING IS DRAWING, with the additional means of color. —*John Sloan* (1871–1951)

PAINTING, because of its universality, becomes speculation.
—*Domenico Theotocoupolos,* called *El Greco* (1541–1614)

On Painting

THE MIND OF THE PAINTER
SHOULD BE LIKE A MIRROR
WHICH IS FILLED WITH
AS MANY IMAGES AS THERE
ARE THINGS PLACED BEFORE HIM.

—*Leonardo da Vinci* (1452–1519)

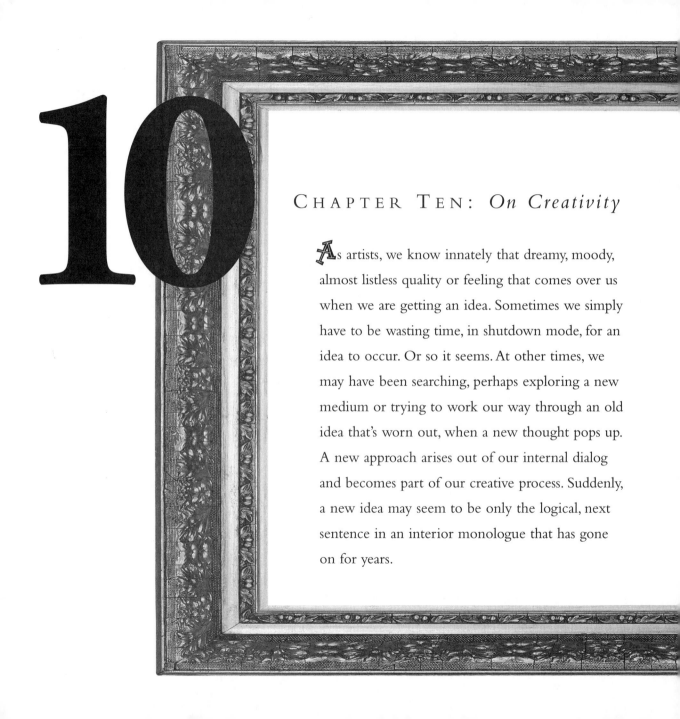

10

CHAPTER TEN: *On Creativity*

As artists, we know innately that dreamy, moody, almost listless quality or feeling that comes over us when we are getting an idea. Sometimes we simply have to be wasting time, in shutdown mode, for an idea to occur. Or so it seems. At other times, we may have been searching, perhaps exploring a new medium or trying to work our way through an old idea that's worn out, when a new thought pops up. A new approach arises out of our internal dialog and becomes part of our creative process. Suddenly, a new idea may seem to be only the logical, next sentence in an interior monologue that has gone on for years.

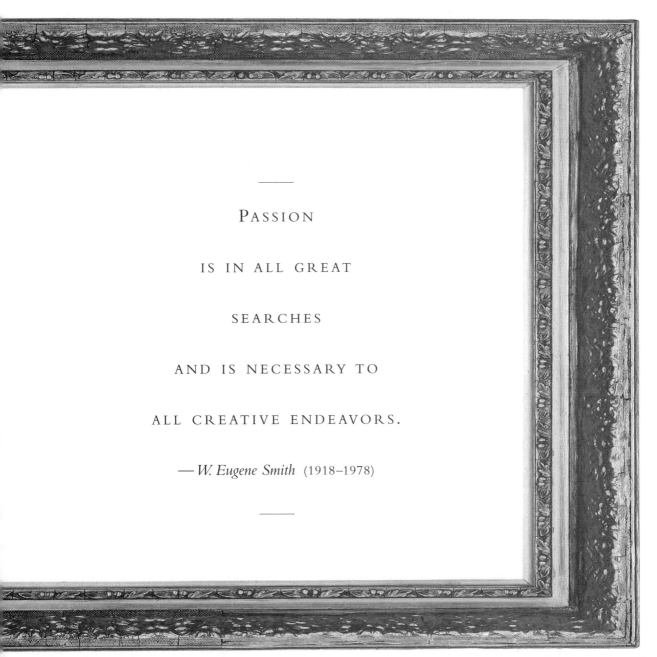

PASSION

IS IN ALL GREAT

SEARCHES

AND IS NECESSARY TO

ALL CREATIVE ENDEAVORS.

— *W. Eugene Smith* (1918–1978)

THE ESSENTIAL ingredient to creativity is wasting time.
—*anonymous,* quoted from *Wired* Magazine (1999)

On Creativity

The truth is more important than the facts. —*Frank Lloyd Wright* (1869–1959)

THE CREATIVE impulse suddenly springs to life, like a flame, passes through the hand on to the canvas, where it spreads farther until, like the spark that closes an electric circuit, it returns to the source: the eye and the mind. —*Paul Klee* (1879–1940)

THE OBJECT must act powerfully on the imagination; the artist's feeling expressing itself through the object must make the object worthy of interest; it says only what it is made to say. —*Henri Matisse* (1869–1954)

I BELIEVE THAT the artist yields often to the stimuli of materials that will transmit his spirit. I am certain about what I will never do; but not about what my art will render. I await joyous surprises while working, an awakening of the materials that I work (with) and that my spirit develops. The good work proceeds with tenacity, intention, without interruption, with an equal measure of passion and reason and it must surpass that goal the artist has set for himself. —*Odilon Redon* (1840–1916)

WE SHOULD ALSO understand the qualitative difference between concentration and attention. . . . To concentrate implies bringing all your energy to focus on a certain point; but thought wanders away and so you have a perpetual battle between the desire to concentrate, to give all your energy to look at a page, and the mind which is wandering, and

which you try to control. Whereas attention has no control, no concentration. It is complete attention, which means giving all your energy, the energy of the brain, your heart, everything, to attending. . . . When you do attend so completely there is no recording and no action from memory. — *J. Krishnamurti* (1895–1986)

I AM not limiting myself to theories, so I never question the rightness to my approach. If I am interested, amazed, stimulated to work, that is sufficient reason to thank the Gods, and go ahead! Dare to be irrational!—keep free from formulas, open to any fresh impulse, fluid. — *Edward Weston* (1886–1958)

WE MUST HOLD enormous faith in ourselves: it is essential that the revelation we receive, the conception of an image which embraces a certain thing, which has no sense of itself, which has no subject, which means *absolutely nothing* from the logical point of view—I repeat, it is essential that such a revelation or conception should speak so strongly in us, evoke such agony or joy, that we feel compelled to paint, compelled by an impulse even more urgent than the hungry desperation which drives a man to tearing at a piece of bread like a savage beast. — *Giorgio de Chirico* (1888–1978)

TRY, for example, to paint what you see when you close your eyes! And yet you can *roughly* describe it. — *Ludwig Wittgenstein* (1889–1951)

AS OUR ART is not a divine gift, so neither is it a mechanical trade. Its foundations are laid in solid science; and practice, though to perfection, can never attain that to which it aims unless it works under the direction of principle. — *Sir Joshua Reynolds* (1723–1792)

I LIKE an empty wall because I can imagine what I like on it.
— *Georgia O'Keeffe* (1887–1986)

WHEN INSPIRATION doesn't come, I go halfway to meet it.
— *Sigmund Freud* (1856–1939)

I REMEMBER one vivid winter's day in Versailles. Silence and calm reigned supreme. Everything gazed at me with mysterious, questioning eyes. And then I realized that every corner of the place, every column, every window possessed a spirit, an impenetrable soul. . . . — *Giorgio de Chirico* (1888–1978)

EXAGGERATION and modification are the undisputed prerogative of the creative artist. — *Charles Sargeant Jagger* (1885–1934)

On Creativity | # Creation begins with vision. — *Henri Matisse* (1869–1954)

ANYTHING under the sun is beautiful if you have the vision—it is the seeing of the thing that makes it so. The world is waiting for men with vision—it is not interested in mere pictures. What people subconsciously are interested in is the expression of beauty, something that helps them through the humdrum day, something that shocks them out of themselves and something that makes them believe in the beauty and the glory of human existence. — *Charles Hawthorne* (1872–1930)

IT IS AN intimately communicative affair between the painter and his painting, a conversation back and forth, the painting telling the painter even as it receives its shape and form. — *Ben Shahn* (1898–1969)

THE THINGS one experiences alone with oneself are very much stronger and purer. — *Eugène Delacroix* (1798–1863)

CREATIVITY can be described as letting go of certainties. — *Gail Sheehy* (1937–)

LIFE IS finding yourself. It is a spirit development. — *Robert Henri* (1865–1929)

IT IS NOT emotion, the sincerity of one's feeling for nature, that draws us, and if the emotions are sometimes so strong that one works without knowing one works, when sometimes the strokes come with a sequence and a coherence like words in a speech or a letter, then one must remember that it has not always been so, and that in the time to come there will again be heavy days, empty of inspiration. — *Vincent van Gogh* (1853–1890)

IMITATION is not inspiration, and inspiration only can give birth to a work of art. The least of man's original emanation is better than the best of a borrowed thought. —*Albert Pinkham Ryder* (1847–1917)

THE MAN WHO arrives at the doors of artistic creation with none of the madness of the Muses, would be convinced that technical ability alone was enough to make an artist . . . what that man creates by means of reason will pale before the art of inspired beings. —*Plato* (427 B.C.–347 B.C.)

THE TEMPLE of art is built of words. Painting and sculpture and music are but the blazon of its windows, borrowing all their significance from the light, and suggestive only of the temple's uses. —*J. G. Holland* (1859–1981)

MANKIND was never so happily inspired as when it made a cathedral: a thing as simple and specious as a statue to the first glance, and yet on examination, as lively and interesting as a forest in detail. — *Robert Louis Stevenson* (1850–1894)

EVEN VAN GOGH who was forced to work under the most rudimentary conditions, wrote, "I have taken some [prints] for my little room to give it the right atmosphere, for that is necessary to get new thoughts and new ideas." —*Anna Held Audette* (1938–), quoting *Vincent van Gogh* (1853–1890)

INSPIRATION demands the active cooperation of the intellect joined with enthusiasm, and it is under such conditions that marvelous conceptions, with all that is excellent and divine, come into being. — *Giorgio Vasari* (1511–1576)

UNCONSCIOUS insights or answers to problems that come in reverie do not come hit or miss. They may indeed occur at times of relaxation, or in fantasy, or at other times when we alternate play with work. But what is entirely clear is that they pertain to those areas in which the person consciously has worked laboriously and with dedication. *Purpose* in the human being is a much more complex phenomenon than what used to be called will power. Purpose involves all levels of experience. We cannot *will* to have insights. We cannot *will* creativity. But we can *will* to give ourselves to the encounter with intensity of dedication and commitment. The deeper aspects of awareness are activated to the extent that the person is committed to the encounter. — *Reece "Rollo" May* (1909–1994)

YOU CANNOT govern the creative impulse; all you can do is to eliminate obstacles and smooth the way for it. — *Kimon Nicolaides* (1892–1938)

YOU KNOW IN my case all painting—and the older I get, the more it becomes so—is an accident. I foresee it and yet I hardly carry it out as I foresee it. It transforms itself by the actual paint. I don't in fact know very often what the paint will do, and it does many things which are very much better than I could make it do. Perhaps one could say it's not an accident, because it becomes a selective process what part of the accident one chooses to preserve. — *Francis Bacon* (1902–1992)

INVENTION depends altogether upon execution or organization; as that is right or wrong so is the invention perfect or imperfect. — *William Blake* (1757–1827)

. . . TO BRING US entirely to reason and sobriety, let it be observed, that a painter must not only be of necessity an imitator of the works of nature, which alone is sufficient to dispel this phantom of inspiration, but he must be as necessarily an imitator of the works of other painters. This appears more humiliating, but is equally true; and no man can be an artist, whatever he may suppose, upon any other terms. — *Sir Joshua Reynolds* (1723–1792)

I WORK under these assumptions: that no one is contained by his own skin, but shares his birth, living and death with others; that a private symbolism is not even possible; that my painting will occupy others as it has me; that whether it does, and how soon, depends on things we cannot know—the ultimate power of the painting and the need felt for it;

the manipulation of meaning to assure an audience would destroy the reality of the work and debase the concept of communication; that good painting as always is a door opened to man's spirit; that it will not repel because of its obscurity, but may because of its directness. —*James Brooks* (1906–1992)

EACH WORK HAS its own space, which should neither be conceived as a sort of cage nor regarded as extending to infinity. —*Mario Marini* (1901–1980)

WELL, first of all it was made by an artist and, second, that would come out as art. —*Andy Warhol* (1928–1987)

WHEN AN ARTIST explains what he is doing he usually has to do one of two things; either scrap what he has explained, or make his subsequent work fit in with the explanation. —*Alexander Calder* (1898–1976)

THE SENSES are our bridge between the incomprehensible and the comprehensible. . . . —*August Macke* (1887–1914)

MAX ERNST in *Beyond Painting,* called collage the noble conquest of the irrational and defined it as "the coupling of two realities, irreconcilable in appearance, upon a plane which apparently does not suit them." —*Harriet Janis* (1899–1963) and *Rudi Blesh* (1899–1895) on *Max Ernst* (1891–1976)

ARTISTS who approach perfection do not have many ideas. —*Odilon Redon* (1840–1916)

MYSTERY IS like a kind of atmosphere which bathes the greatest works of the masters. —*Auguste Rodin* (1840–1917)

On Creativity

AN IDEA IS SALVATION BY IMAGINATION.

—*Frank Lloyd Wright* (1869–1959)

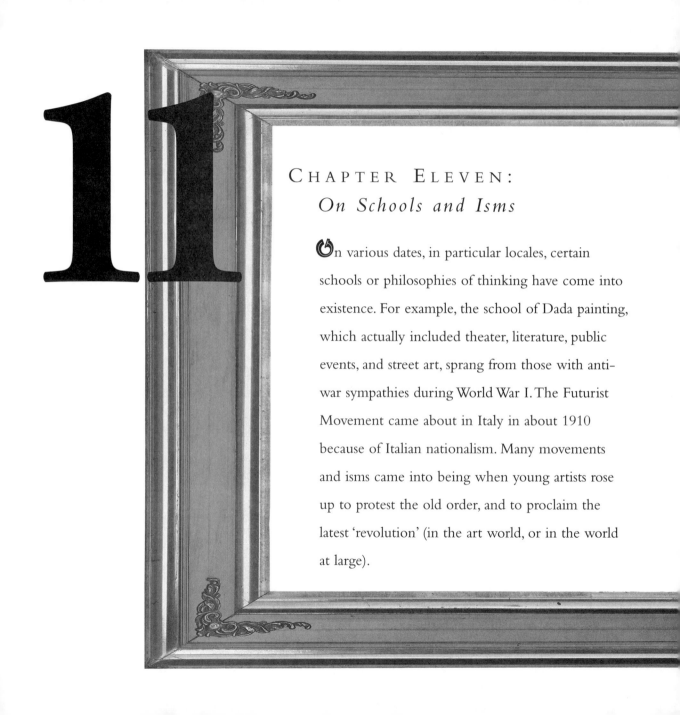

CHAPTER ELEVEN:
On Schools and Isms

On various dates, in particular locales, certain schools or philosophies of thinking have come into existence. For example, the school of Dada painting, which actually included theater, literature, public events, and street art, sprang from those with anti-war sympathies during World War I. The Futurist Movement came about in Italy in about 1910 because of Italian nationalism. Many movements and isms came into being when young artists rose up to protest the old order, and to proclaim the latest 'revolution' (in the art world, or in the world at large).

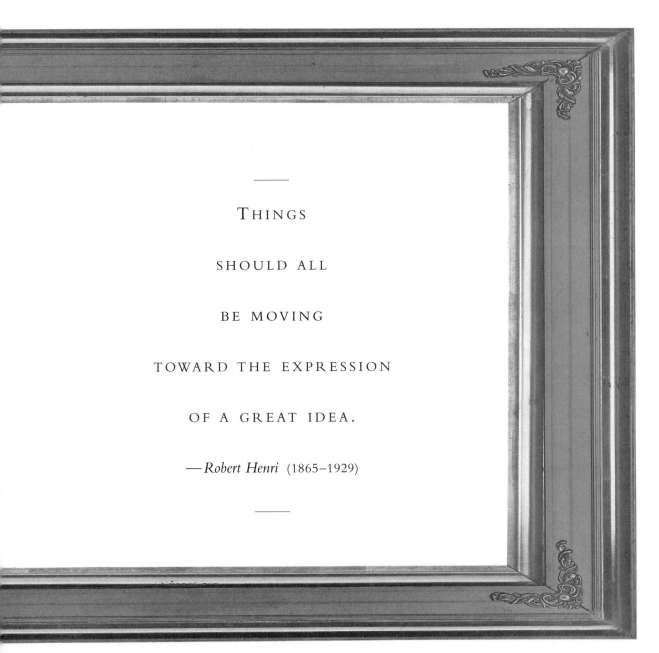

THINGS

SHOULD ALL

BE MOVING

TOWARD THE EXPRESSION

OF A GREAT IDEA.

—*Robert Henri* (1865–1929)

ABSTRACT means literally to draw from or separate. In this sense every artist is abstract . . . a realistic or non-objective approach makes no difference. The result is what counts. — *Richard Diebenkorn* (1922–1993)

THE SYNCHROMISTS had extended and intensified Cézanne's color-form theories, in which form was seen as a derivative of the organization of color planes. They had intensified these planes by abandoning completely the usual colors of nature, replacing them with highly saturated spectral colors and had extended them into an area of purely "abstract" form. — *Thomas Hart Benton* (1899–1975)

On Schools and Isms

Dada will survive only by ceasing to exist.

—*J. É. Blanche* (1861–1942)

THE WORLD will see many fashions of art and most of the world will follow the fashions and make none. These cults—these "movements" are absolutely necessary or at any rate their causes are—for somewhere in their centres are the ones who bear the Idea—are the ones who have questioned *"But what do I think"* and how shall I say it best. . . . — *Robert Henri* (1865–1929)

I WOULD RATHER see a portrait of a dog that I know, than all the allegorical paintings they can show me in the world. — *Samuel Johnson* (1709–1784)

IN 1916 at Zurich a French dictionary was opened and a finger blindly placed on a page. The fingertip landed on a word. Someone read it aloud: an onomatopoetic child's word meaning hobbyhorse. Through this tongue-in-cheek sortilege a name was found for the first art movement of international locale, one that sprang up spontaneously in

a number of cities in both hemispheres. The word of course was "dada," and it designates the strangest and for a long time least understood of all modern art movements.
— *Harriet Janis* (1899–1963) and *Rudi Blesh* (1899–1985), on the beginning of the Dada movement

DADA HAS REAPED THE HARVEST OF CONFUSION THAT IT SOWED.

— *Hans Richter* (1888–1976)

KURT SCHWITTERS operated on a creative plane so divorced from hampering practicalities that only the creative idea retained intrinsic importance. Both artist and picture were unimportant as compared with the idea creating the form. For all his dada nature, Schwitters the artist was the purest of Platonists. "The medium," Schwitters wrote, "is as unimportant as I myself. Essential is only the forming." Art at this level is comparable with pure philosophy, pure science. — *Harriet Janis* (1899–1965) and *Rudi Blesh* (1899–1985), on *Kurt Schwitters* (1887–1948)

THE PEOPLE in a Daumier or a Breughel all look as though they belonged to one family. It is this formula by which we know that a picture is the work of a certain artist or school. — *John Sloan* (1871–1951)

THE title of "realist" has been imposed upon me, as the men of 1830 had imposed upon them the title of " romantics." Titles have never given a just idea of things; were it otherwise, the work would be superfluous. Without trying to clear up the degree of correctness of a qualification which no one, one must hope, will be asked to understand exactly, I will limit myself to a few words of explanation to cut short any misunderstandings.
— *Gustave Courbet* (1819–1877)

POP'S ORIGINS may well be far less art and far more non-art, and its patron saints not Giotto and Michelangelo at all, but Henry Ford and Foster & Kleiser. Perhaps Pop is not out of Greece by Rome, but out of Detroit by Madison Avenue. If it is, so is junk sculpture and so is kinetic sculpture, and much collage from at least Schwitters on. — *Rudi Blesh* (1899–1985) and *Harriet Janus* (1899–1963)

On Schools and Isms

The golden rule is that there is no golden rule.

— *George Bernard Shaw* (1856–1950)

(ALFRED) BARR thought that American painting couldn't be abstract painting—it wasn't American. They were more favoring the Regionists, you know, and I guess they were a little bit against us: I mean, not personally, but (thought) that probably we were not on the right track. — *Willem de Kooning* (1904–1997)

I DID NOT like the *nothing,* and it is thus that I met the *empty,* the *deep empty,* the depth of the *blue.* — *Yves Klein* (1928–1962), on his art movement, *The Void*

IN NEW YORK in 1915 I bought at a hardware store a snow shovel on which I wrote *in advance of the broken arm* (title of a later artwork). — *Marcel Duchamp* (1887–1968)

I AM NOT an exponent of expressionism. I don't know exactly what that means, but I don't like the sound of it. I dislike cults and isms. I want to paint in terms of my own thinking and feeling. — *Georgia O'Keeffe* (1887–1986)

THE REALIZATION that reason and anti-reason, sense and nonsense, design and chance, consciousness and unconsciousness, belong together as necessary parts of a whole—this was the central message of Dada. —*Hans Richter* (1888–1976)

AT THE OPENING of the exhibit, when Gertrude Käsebier appeared, she said to me, "What is this Photo-Secession? Am I a Photo-Secessionist?" My answer was "Do you feel that you are?" She said, "I do." "Well," I replied, "that is all there is to it." —*Alfred Stieglitz* (1864–1946)

No high-minded painter of the last fifty years has been able to come to terms with his art without coming to terms with the problem of Cubism.

—*Darby Bannard* (1934–)

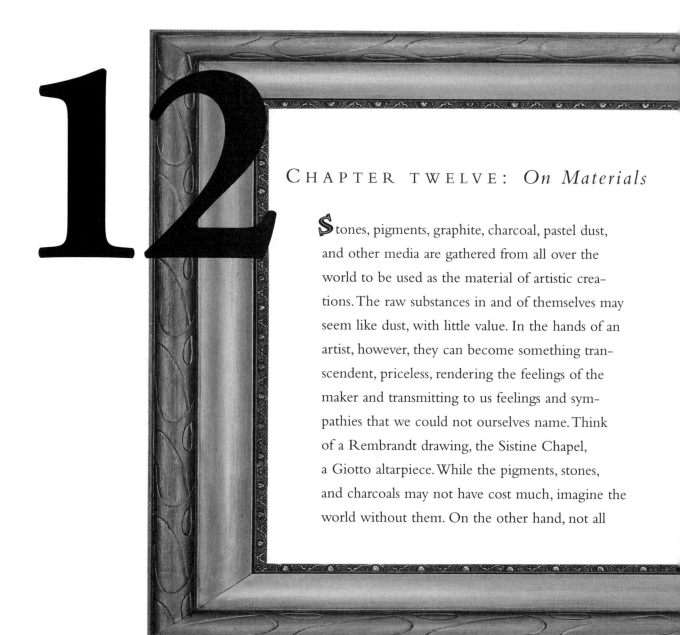

CHAPTER TWELVE: *On Materials*

Stones, pigments, graphite, charcoal, pastel dust, and other media are gathered from all over the world to be used as the material of artistic creations. The raw substances in and of themselves may seem like dust, with little value. In the hands of an artist, however, they can become something transcendent, priceless, rendering the feelings of the maker and transmitting to us feelings and sympathies that we could not ourselves name. Think of a Rembrandt drawing, the Sistine Chapel, a Giotto altarpiece. While the pigments, stones, and charcoals may not have cost much, imagine the world without them. On the other hand, not all

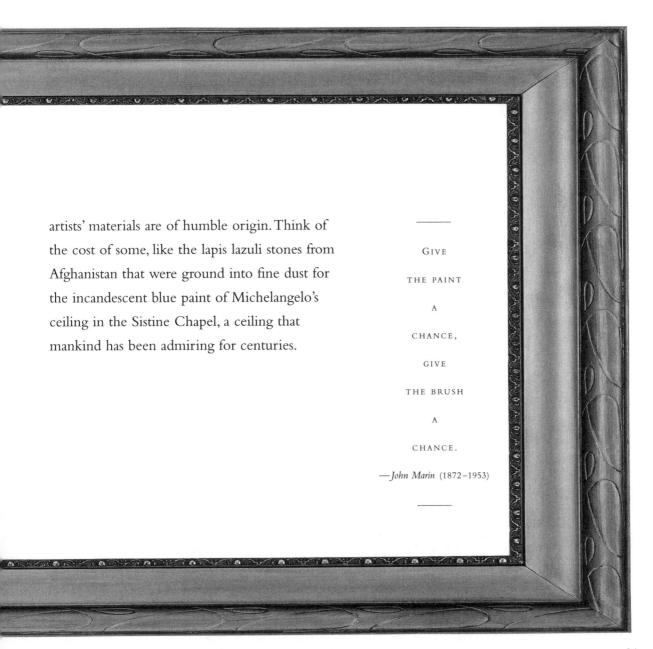

artists' materials are of humble origin. Think of the cost of some, like the lapis lazuli stones from Afghanistan that were ground into fine dust for the incandescent blue paint of Michelangelo's ceiling in the Sistine Chapel, a ceiling that mankind has been admiring for centuries.

GIVE

THE PAINT

A

CHANCE,

GIVE

THE BRUSH

A

CHANCE.

—*John Marin* (1872–1953)

IT IS . . . the custom of Venice to paint on canvas, either because it does not split and is not worm-eaten, or because pictures can be made of any size desired, or else for convenience . . . so that they can be sent anywhere with very little trouble and expense. — *Giorgio Vasari* (1511–1576)

On Materials

When the material ends, art begins.

—*Étienne Hajdu* (1907–)

UNLESS CANVASES intended for oil painting are to remain stationary, they are not covered with gesso because it would interfere with their flexibility. The gesso would crack if the canvases were rolled up. However, there is a paste, made of flour and walnut oil mixed with two and three measures of white lead, which is spread on the canvas with a knife, after the canvas has been covered from one side to the other with three or four coats of smooth size. With this paste the artist fills in all the holes that are on the canvas. When this is done, the artist applies one or two more coats of soft size followed by the composition or priming. . . . Because painting on canvas has seemed easy and convenient it has been adopted not only for small pictures that can be carried about, but also for altarpieces and other important compositions, such as are seen in the halls of the palace of San Marco at Venice and elsewhere. Consequently, where the panels are not sufficiently large, they are replaced by canvases on account of the size and convenience of the latter. — *Giorgio Vasari* (1511–1576)

A FELLOW WILL hack half a year at a block of marble to make something in stone that hardly resembles a man. The value of statuary is owing to its difficulty. You would not value the finest head cut upon a carrot. — *Samuel Johnson* (1709–1784)

WHEN we speak of the perfection of art, we must recollect what the materials are with which a painter contends with nature. For the light of the sun he has but patent yellow and white lead—for the darkest shade, umber or soot. —*John Constable* (1776–1837)

MATERIAL and its memory (in collage) have become the subject in direct statements from the real world. —*Harriet Janis* (1899–1963) and *Rudi Blesh* (1899–1985)

WHENEVER you want to do a stream, a river, or any body of water you please, either with fish or without, on wall or on panel; on a wall, take the same verdaccio which you used for shading . . . do the fish, shading with this verdaccio the shadows always on their backs; bearing in mind that fish, and in general all irrational animals, ought to have the dark part on top and the light underneath. Then when you have shaded with verdaccio, put on lights underneath, with lime white on the wall; and with white lead on panel. And make a few shadows over the fish, and all over the background, with the same verdaccio. And if you care to make any outstanding fish, lace it with a few spines of gold. Then, in secco, lay verdigris uniformly over the whole ground; and Cleophantes of Corinth was the first of the Greeks to introduce colours and Apollodorus was the first to make use of the brush. —*Giorgio Vasari* (1511–1576)

THE BRISTLE brushes are made in this style. First get bristles of a white hog, for they are better than black ones; but see that they come from a domestic hog. And make up with them a large brush into which should go a pound of these bristles; and tie it to a good-sized stick with a . . . knot. And this brush should be limbered up by whitewashing walls, and wetting down walls where you are going to plaster; and limber it up until these bristles become very supple. Then undo this brush, and make the divisions of it as you want, to make a brush of any variety. And make some into those which have the tips of all the brushes quite even—those are called "blunt" brushes; and some into pointed ones of every sort of size. Then make little sticks of the wood mentioned above and tie up each little bundle with double waxed thread. Put the tip of the little stick into it, and proceed to bind down evenly half the length of this little bundle of bristles, and farther up along the stick; and deal with them all in the same way.
—*Cennino Cennini* (c.1370–c.1440)

When I get
my hands
on painting materials
I don't give a damn
about other people's
painting:
life and me, me and life.
In art,
every generation must
start again afresh.

—*Maurice Vlaminck* (1876–1958)

YOU BEGIN with the possibilities of the material, and then you see what they can do; so the artist is almost a bystander while he's working. —*Robert Rauschenberg* (1925–)

EVERY MASTER KNOWS THAT THE MATERIAL TEACHES THE ARTIST.

—*Ilya Ehrenberg* (1891–1967)

WHAT I STRIVE most to achieve in art is to make you forget the material. The sculptor must, by means of a résumé of the impressions received, communicate whatever has struck his sensibility, so that a person beholding his work may experience in its entirety the emotion felt by the artist while he observed nature.
—*Medardo Rosso* (1858–1928)

CHAPTER THIRTEEN:
On the Working Process

I was once in an art lecture where an artist said that he worked from the upper left-hand corner of a canvas, straight through to the lower right corner, without changing anything as he worked. He had planned everything out and change was unnecessary. It is hard to imagine having such an orderly, and predetermined process; I am sure he was the exception, rather than the rule. I think artists almost always change the elements of a piece as they work, if only because some things don't work out the way

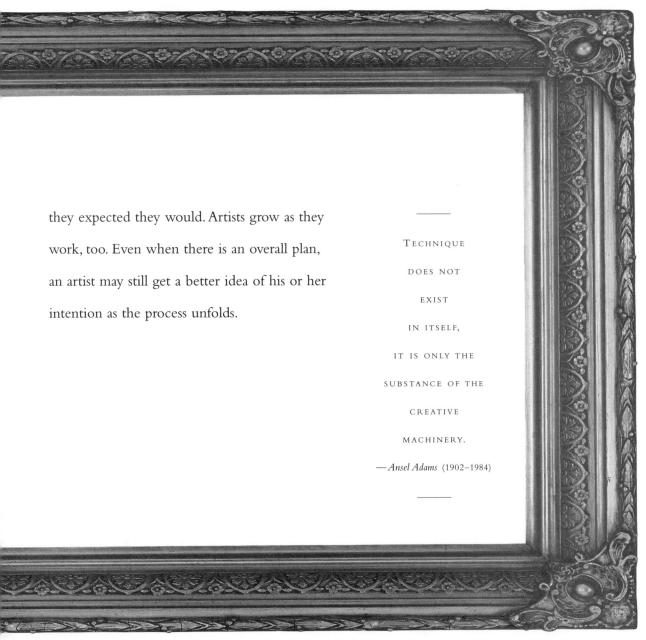

they expected they would. Artists grow as they work, too. Even when there is an overall plan, an artist may still get a better idea of his or her intention as the process unfolds.

TECHNIQUE
DOES NOT
EXIST
IN ITSELF,
IT IS ONLY THE
SUBSTANCE OF THE
CREATIVE
MACHINERY.

—*Ansel Adams* (1902–1984)

YOU CAN'T change your mind up on a scaffold without the risk of everything going awry. You must solve your problems before you get up there.
— *Thomas Hart Benton* (1899–1975)

DEVOTION to the facts will always give the pleasures of recognition; adherence to the rules of design, the pleasures of order and certainty. — *Kenneth Clark* (1903–1983)

[KNOWLEDGE OF] ANATOMY IS A TOOL LIKE GOOD BRUSHES.

—*Robert Henri* (1865–1929)

I HAVE DONE as you demanded in this painting, in every detail. The St. Michael is now perfect, with his armour painted in gold and silver as well as his clothes, for I met up with Bartolomeo Martello; he told me about the gold and everything that was needed . . . and that I should follow your wishes in every detail; and he also reprimanded me and showed how I was wrong and you were right. Now, Giovanni, I am here to act as your slave, and shall continue to do so . . . and I wrote to you that the expense would be thirty florins . . . for it is so full of ornaments . . . and so that you would be advised, I am sending you a drawing of the wooden structure, so that you can see how tall and wide it is. . . . And if I have seemed presumptuous in writing to you, please forgive me. And I shall always act according to Your Reverence's wishes.
— *Filippo Lippi* (1406–1469), to a patron

RULES serve no purpose; they can only do harm. . . . Not only must the artist's mind be clear, it must also be free. His fancy should not be hindered and weighed down by a mechanical servility to such rules. — *Federico Zuccaro* (1542–1609)

IN THE PRACTICE of art, as well as in morals, it is necessary to keep a watchful and jealous eye over ourselves; idleness, assuming the specious disguise of industry, will lull to sleep all suspicion of our want of an active exertion of strength. A provision of endless apparatus, a bustle of infinite inquiry and research, or even the mere mechanical labor of copying, may be employed, to evade and shuffle off real labor—the real labor of thinking.
— *Sir Joshua Reynolds* (1732–1792)

INDISCRIMINATE pursuit of perfection infallibly leads to mediocrity.
— *Henry Fuseli* (1741–1825)

CÉZANNE'S work demonstrates how insistently he worked toward form. Urged on by all his artistic instincts and supported by the example of the great artists whose works he had absorbed, he patiently applied himself to developing his gift for color, composition, paint handling, and the remainder of his extraordinary range of formal skills.
— *Robert Kirsch* (c. 1985)

Do whatever you do intensely.

— *Robert Henri* (1865–1929)

IT IS THE first vision that counts. The artist has only to remain true to his dream and it will possess his work in such a manner that it will resemble the work of no other man—for no two visions are alike, and those who reach the heights have all toiled up the steep mountains by a different route. To each has been revealed a different panorama.
— *Albert Pinkham Ryder* (1847–1917)

INSTANTLY paint what you see. — *Édouard Manet* (1832–1883)

How to compose groups of figures in historical pictures: When you have thoroughly learned perspective and fixed in your memory all the various parts and forms of things, you should often amuse yourself, when you take a walk for recreation, by watching and taking note of the attitudes and actions of men as they talk and dispute, or laugh or come to blows with one another—both their actions and those of the bystanders who either intervene or stand looking on at these things. — *Leonardo da Vinci* (1452–1519)

On the Working Process

The hand is the tool of tools.

—*Aristotle* (384 B.C.–322 B.C.)

TAKE NOTE THAT, before going any farther, I will give you the exact proportion of a man. Those of a woman I will disregard, for she does not have any set proportion. First, as I have said above, the face is divided into three parts, namely: the forehead, one; the nose, another; and from the nose to the chin, another. From the side of the nose through the whole length of the eye, one of these measures. From one ear to the other, a face lengthwise, one face. From the chin under the jaw to the base of the throat, one of the three measures. The throat, one measure long. From the pit of the throat to the top of the shoulder, one face; and so for the other shoulder. From the shoulder to the elbow, one face. From the elbow to the joint of the hand, one face and one of the three measures. The whole hand, lengthwise, one face. From the pit of the throat to that of the chest, or stomach, one face. From the stomach to the navel, one face. From the navel to the thigh joint, one face. From the thigh to the knee, two faces. From the heel to the sole of the foot, one of the three measures. The foot, one face long.

A man is as long as his arms crosswise. The arms, including the hands, reach to the middle of the thigh. The whole man is eight faces and two of the three measures in length. A man has one breast rib less than a woman, on the left side. A man has . . . bones in all. The handsome man must be swarthy, and the woman fair, etc. I will not tell you

about the irrational animals, because you will never discover any system of proportion in them. Copy them and draw as much as you can from nature, and you will achieve a good style in this respect. — *Cennino Cennini* (c.1370–c.1440)

THERE ARE THREE aspects to perspective. The first has to do with how the size of objects seems to diminish according to distance; the second, the manner in which colors change the farther they are from the eye; the third defines how objects ought to be finished less carefully the farther they are away. — *Leonardo da Vinci* (1452–1519)

WHEN you look in your mind you find it covered with a lot of rubbishy thoughts. You have to penetrate these and hear what your mind is telling you to do. Such work is original work. All other work made from ideas is not inspired and it is not art work. — *Agnes Martin* (1912–)

NO ONE is an artist unless he carries his picture in his head before painting it, and is sure of his method and composition. — *Claude Monet* (1840–1926)

I AM INTERESTED in the size of your intention. It is better to overstate the important than to understate it. — *Robert Henri* (1865–1929)

BE SENSITIVE TO THE QUALITIES INHERENT IN THE MEDIUM. PAINT HONESTLY AND AVOID TRICKS.

—*John Sloan* (1871–1951)

WORKING small also results in a quick turnover of ideas, and you'll avoid getting bogged down by long efforts on unrewarding pieces. Robert Motherwell said, "It's possible to paint a monumental picture that's only 10" wide, *if* one has a sense of scale, which is very different from a sense of size."
—*Anna Held Audette* (1938–), discussing scale with *Robert Motherwell* (1915–1991)

THE ARTIST must be blind to distinctions between "recognized" and "unrecognized" conventions of form, deaf to the transitory teaching demands of his particular age. He must watch only the trend of the inner need, and harken to its words alone.
— *Wassily Kandinsky* (1866–1944)

ILLUSIONS TOO, are simple facts, but they have been created by the mind, by the spirit, and they are one of the justifications of the new spatial configuration.
— *Georges Braque* (1882–1963), on collage

DO STUDIES, not pictures. Know when you are licked—start another. Be alive, stop when your interest is lost. Put off finish as it takes a lifetime—wait until later to try to finish things—make a lot of starts. It is so hard and long before a student comes to a realization that these few large simple spots in right relations are the most important things in the study of painting. They are the fundamentals of all painting.
— *Charles Hawthorne* (1872–1930)

On the Working Process

IF YOU DO NOT ACT ON A SUGGESTION AT FIRST, YOU GROW DULL TO ITS MESSAGE.

—*Robert Henri* (1865–1929)

BASICALLY, wrapping gave the essential dimensions and proportions of the object. For example, in 1985 when we finally wrapped the Pont-Neuf in Paris, the bridge became the essence of a bridge and everything around it became ethereal. All the details, the figures and elements of the original Pont-Neuf disappeared and what became visible were the principal proportions, the arches, the volume of the towers. This applies only to wrapped projects. It's important not to confuse projects like *Surrounded Islands* and certainly not *The Umbrellas* with wrapping. They have a completely different dimension. — *Christo* (1935–)

DON'T BE AFRAID to borrow. The great men, the most original, borrowed from everybody. Witness Shakespeare and Rembrandt. They borrowed from the technique of tradition and created new images by the power of their imagination and human understanding. Little men just borrow from one person. Assimilate all you can from tradition and then say things in your own way. — *John Sloan* (1871–1951)

WHEN ONE knows one's craft well, when one has learned well how to imitate nature, the chief consideration for a good painter is to *think out* the whole of his picture, to have it in his head as a whole, so to speak, so that he may then execute it with warmth and as if the entire thing were done at the same time. — *Jean-Auguste-Dominique Ingres* (1780–1867)

FIRST you shape the vision of what the projected work of art will be. The vision, I stress is no marvelous thing. . . . Many aspects of the work are still uncertain, of course; you know that. You know that if you proceed you will change things and learn things. . . . But you are wrong if you think that in the actual writing, or in the actual painting, you are filling in the vision. You cannot even bring the vision to light. You are wrong if you think that you can in any way take the vision and tame it to the page. . . . The vision is not so much destroyed, exactly, as it is, by the time you have finished, forgotten. It has been replaced by this changeling. . . . — *Annie Dillard* (1945–)

LOOK FOR ECHOES. Sometimes the same shape or direction will echo through the picture. — *Robert Henri* (1865–1929)

MY CENTER does not come from my mind—it feels in me like a plot of warm moist well tilled earth with the sun shining hot on it. . . . It seems I would rather feel starkly empty than let any thing be planted that cannot be tended to the fullest possibility of its growth. . . . I do know that the demands of my plot of earth are relentless if anything is going to grow in it—worthy of its quality. . . . If the past year or two or three has taught me anything it is that my plot of earth must be tended with absurd care—By myself first—and if second by someone else it must be with absolute trust. . . . It seems it would be very difficult for me to live if it were wrecked again just now.
— *Georgia O'Keeffe* (1887–1986)

ONE WORKS BECAUSE I suppose it is the most interesting thing one knows to do. The days one works are the best days. On the other days one is hurrying through the other things one imagines one has to do to keep one's life going . . . with a certain amount of aggravation so that you can get at the paintings again because that is the high spot—in a way it is what you do all the other things for.

The painting is like a thread that runs through all the reasons for all the other things that make one's life. — *Georgia O'Keeffe* (1887–1986)

I DO NOT repudiate any of my paintings but there is not one of them that I would not redo differently. —*Henri Matisse* (1869–1954)

On the Working Process

Work lovingly done is the secret of all order and all happiness.

—*Pierre-Auguste Renoir* (1840–1917)

No longer shall I paint interiors, and people reading, and women knitting. I shall paint living people who breathe and feel and suffer and love. — *Edvard Munch* (1863–1944)

I proceed very slowly, nature offering itself to me with great complexity, and the need for progress incessant. One has to see the model and sense very rightly; and beyond that to express oneself with distinctiveness and force. — *Paul Cézanne* (1839–1906)

Don't be so mechanical about reflections. The light on the water should come up to the edge of the boat a little stronger. Reflections in water are lower in key than the thing itself. — *Charles Hawthorne* (1872–1930)

In my productive activity, every time a type grows beyond the stage of its genesis, and I have about reached the goal, the intensity gets lost very quickly, and I have to look for new ways. It is precisely the way which is productive—this is the essential thing; becoming is more important than being. . . . — *Paul Klee* (1879–1940)

I feel that one takes advantage, in painting, of chance or accident. In other words, you direct something to happen that surprises you, and then you use it, exploit it, cancel it, wreck it, embroider upon it, whatever, but there it is, and you have the wherewithal, intelligence, and energy to recognize it and do something with it. There are many accidents that are nothing but accidents—and forget it. But there are some that were brought about only because you are the person you are. — *Helen Frankenthaler* (1928–)

Suddenly I realized that each brushstroke is a decision, and it's a decision not only aesthetically:—will this look more beautiful?—it's a decision that has to do with one's gut: it's getting too heavy, too light. It has to do with one's sense of sensuality: the surface is getting too coarse, or not fine enough. It has to do with one's sense of life: is it airy enough or is it leaden? It has to do with one's own inner sense of weights: I happen to be a heavy, awkward, clumsy man, and if something gets too airy—probably I admire it very much—it doesn't feel like my *self* to me. But in the end I realize that whatever meaning that picture has is the accumulated meaning of ten thousand brushstrokes, each one being decided as it was painted. — *Robert Motherwell* (1915–1991)

THE IMPORTANT thing is to work as much as possible. Louise Nevelson always found ways to work with her assembled sculpture. She remarked that "even if I didn't want to compose, so I painted or stacked the pieces." The wonderful thing about working is that the more you do it, the easier it is to do, and the less likely it is you'll get stuck. —*Anna Held Audette* (1938–), remembering *Louise Nevelson* (1899–1988)

DO NOT finish your work too much. An impression is not sufficiently durable for its first freshness to survive a belated search for intimate detail; in this way you let the lava grow cool. . . . —*Paul Gauguin* (1848–1903)

I HOPE always to earn my living by my art without having ever deviated by even a hair's breath from my principles, without having lied to my conscience for a single moment, without painting even as much as can be covered by a hand only to please anyone or to sell more easily. —*Gustave Courbet* (1819–1877)

PAINT WITH FREEDOM, IT GIVES YOU MORE MASTERY OF THE NATURE OF PAINT.

On the Working Process

—*Charles Hawthorne* (1872–1930)

IF one has set for himself the position that his painting shall not misconstrue his personal mode of thinking, then he must be rather alert to just what he does think. —*Ben Shahn* (1866–1969)

FIGHT WITH YOURSELF when you paint, not with the model. A student is one who struggles with himself for order. —*Robert Henri* (1865–1929)

Committing oneself to a technique causes stagnation.

—*Kimon Nicolaides* (1892–1938)

A PASSION for his art, and an eager desire to excel, will more than supply (an artist with) the place of method. By leaving a student to himself he may possibly indeed be led to undertake matters above his strength; but the trial will at least have this advantage— it will discover to himself his own deficiencies; and this discovery alone is a very considerable acquisition. One inconvenience, I acknowledge, may attend bold and arduous attempts; frequent failure may discourage; this evil, however, is not more pernicious than the slow proficiency which is the natural consequence of too easy tasks.
— *Sir Joshua Reynolds* (1723–1792)

... THERE IS another kind of high finishing, which may safely be condemned, as it seems to counteract its own purpose; that is, when the artist, to avoid that hardness which proceeds from the outline cutting against the ground, softens and blends the colors to excess; this is what the ignorant call high finishing, but which tends to destroy the brilliancy of color, and the true effect of representation; which consists very much in preserving the same proportion of sharpness and bluntness that is found in natural objects. This extreme softening, instead of producing the effect of softness, gives the appearance of ivory, or some other hard substance, highly polished. — *Sir Joshua Reynolds* (1723–1792)

ONE CAN DO such lovely things with so little. Subjects that are too beautiful end by appearing theatrical—take Switzerland, for example—Blessed are they who see beautiful things in humble places where other people see nothing! Everything is beautiful, all that matters is to be able to interpret. — *Camille Pisarro* (1830–1903)

IT HAS BEEN my uniform endeavor, since I first addressed you . . . to impress you strongly with one ruling idea. I wish you to be persuaded that success in your art depends almost entirely on your own industry; but the industry which I principally recommend is not the industry of the hands, but of the mind. —*Sir Joshua Reynolds* (1723–1792)

A PICTURE is finished when all trace of the means used to bring about the end has disappeared —*James MacNeill Whistler* (1834–1903)

WE SHALL next speak about the way to paint a dead man, that is, the face, the breast, and wherever in any part the nude may show. It is the same on panel as on wall: except that on wall it is not necessary to lay in all over with terre-verte; it is enough if it is laid in the transition between the shadows and the flesh colors. But on a panel lay it in as usual, as you were taught for a colored or live face; and shade it with the same verdaccio, as usual. And do not apply any pink at all, because a dead man has no color; but take a little light ocher, and step up three values of flesh colors with it, just with white lead and tempered as usual; lay each of these flesh colors in its place, blending them nicely into each other, both on the face and on the body. —*Cennino Cennini* (c.1370–c.1440)

THE MOST GENERAL survey shows that the foes of human happiness are pain and boredom. —*Arthur Schopenhauer* (1788–1860)

PEOPLE think one-point and two-point perspective is how the world actually looks, but of course, it isn't. It's a convention. —*Roy Lichtenstein* (1923–1997)

IF YOU WISH to embellish . . . mountains with groves of trees or with plants, first lay in the trunk of the tree with pure black, tempered, for they can hardly be done in fresco; and then make a range of leaves with dark green, but using malachite, because terre-verte is not good; and see to it that you make them quite close. Then make up a green with giallorino, so that it is a little lighter, and do a small number of leaves, starting to go back to shape up some of the ridges. Then touch in the highlights on the ridges with straight giallorino, and you will see the reliefs of the trees and of the foliage. But before this, when you have got the trees laid in, do the base and some of the branches of the trees

with black; and scatter the leaves upon them, and then the fruits; and scatter occasional flowers and little birds over the foliage. — *Cennino Cennini* (c.1370–c.1440)

RIGHT NOW a moment of time is fleeting by! Capture its reality in paint! To do that we must put all else out of our minds. We must become that moment, make ourselves a sensitive recording plate . . . give the image of what we actually see, forgetting everything that has been seen before our time.

Surely, a single bunch of carrots painted naively just as we personally see it is worth all the endless banalities of the Schools, all those dreary pictures concocted out of tobacco juice according to time-honored formulas? The day is coming when a single carrot, freshly observed, will set off a revolution. — *Paul Cézanne* (1839–1906)

CHAGALL is my favorite pupil, and what I like about him is that after listening attentively to my lessons he takes his paints and brushes and does something absolutely different from what I have told him. — *Leon Bakst* (1866–1924)

WHEN I am in my painting, I'm not aware of what I'm doing. It is only after a sort of get acquainted period that I see what I have been about. I have no fears about making changes, destroying the image, etc., because the painting has a life of its own. I try to let it come through. It is only when I lose contact with the painting that the result is a mess. Otherwise there is pure harmony, an easy give and take, and the painting comes out well. —*Jackson Pollock* (1912–1956)

On the Working Process

TAKE AN OBJECT.
DO SOMETHING TO IT.
DO SOMETHING ELSE TO IT.
DO SOMETHING ELSE TO IT.

—*Jasper Johns* (1930–)

CHAPTER FOURTEEN:
On Style and Content

An artist's style, says Robert Henri, is the way he talks in paint. Maybe you have picked up certain flourishes in your drawings that mark a work as yours as surely as your signature. I remember in a fashion illustration class, we all copied the drawings of Kenneth Paul Block, whose drawings of fashionably svelte ladies in pointy-toed shoes and at least seven feet tall, filled the *New York Times*. This style of drawing was all the rage.

Content is a slightly more serious subject. According to Ben Shahn, content has a shape. Whether that shape is discernable or only known to the artist is a secret to be explored. For a painting

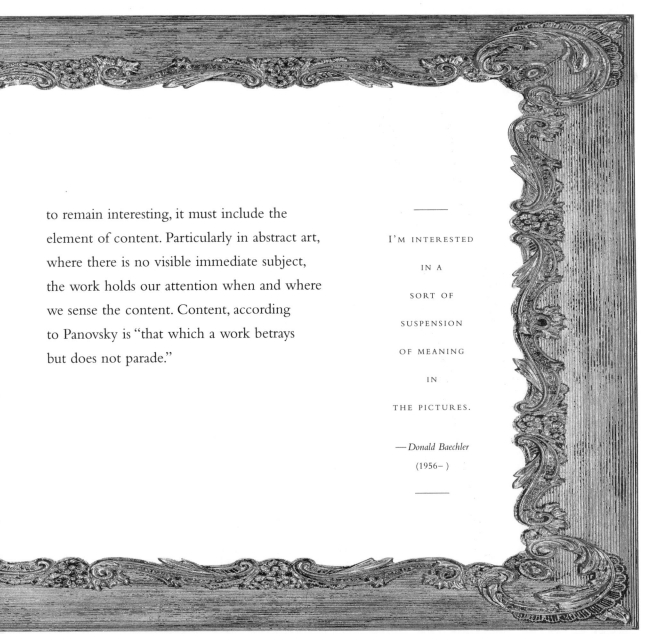

to remain interesting, it must include the
element of content. Particularly in abstract art,
where there is no visible immediate subject,
the work holds our attention when and where
we sense the content. Content, according
to Panovsky is "that which a work betrays
but does not parade."

I'M INTERESTED

IN A

SORT OF

SUSPENSION

OF MEANING

IN

THE PICTURES.

— *Donald Baechler*
(1956–)

111

CONTENT may be and often is trivial. But I do not think that any person may pronounce either upon the weight or upon the triviality of an idea before its execution into a work of art. —*Ben Shahn* (1898–1969)

PERSONAL STYLE, be it that of Michelangelo, or that of Tintoretto . . . has always been that peculiar personal rapport which has developed between an artist and his medium. —*Ben Shahn* (1898–1969)

On Style and Content

Your style is the way you talk in paint.

—*Robert Henri* (1865–1929)

THE PURPOSE OF subject matter is to veil technique. The great artist uses the cloak of resemblance to hide the means. —*John Sloan* (1871–1951)

WHAT I shall have done cannot be taken from me. And as for the ridiculous fear of making things below one's potential abilities. . . . No, there is the root of the evil. There is the hiding place of stupidity I must attack: vain mortal, you are limited by nothing, neither by memory that eludes you, nor by the forces of your body, which are feeble, nor by the fluidity of your mind, which wars against these impressions as they reach you. Always, at the back of your soul, there is something that says to you, "Mortal, drawn from eternal life for a short time, think how precious these moments are. Your life must bring you everything other mortals draw from theirs." But yet, I know what I mean. . . . I believe that everyone has really been more or less tormented by this. —*Eugène Delacroix* (1798–1863)

THE great artists do not seek their forms in the midst of the past, but take the deepest soundings they can of the genuine, profoundest of their age. —*Franz Marc* (1880–1916)

FOR A LONG time I worried—is my work pornography and if so is that bad? After quite a few years of worrying about it I came to the conclusion that I didn't know the answer because it was always in the mind of the viewer, but more importantly, it didn't matter. If it is pornography, so what? I don't have any moral compunction about pornography. Any feelings I have about it are purely stylistic and like everything else in life there's good pornography and bad pornography. I mean well done and less well done examples of the genre. I don't see why it should be excluded as a serious subject. . . . —*David Salle* (1952–)

MAKING your unknown known is the important thing—and keeping the unknown always beyond you—catching—crystalizing (sic) your simpler clearer vision of life—only to see it turn stale compared to what you vaguely feel ahead—that you must always keep working to grasp. . . . — *Georgia O'Keeffe* (1887–1986)

THE ONLY THING worth doing is what's never been done. —*David Salle* (1952–)

WHAT I DREAM of is an art of balance, of purity and serenity devoid of troubling or depressing subject-matter, an art which might be for every mental worker, be he businessman or writer, like an appeasing influence, like a mental soother, something like a good armchair in which to rest from physical fatigue. —*Henri Matisse* (1869–1954)

WHEN you have practiced drawing for a while . . . on small panels, take pains and pleasure in constantly copying the best works that you can find done by the hand of great masters. . . . And as you go on from day to day, it will be unnatural if you fail to pick up something of his style and of his spirit. For if you set out to copy after one master today and after one tomorrow, you will not acquire the style of either one or the other, and you will inevitably become fantastic, because each style will fatigue your mind. . . . If you imitate the forms of a single artist through constant practice, your intelligence would have to be crude indeed for you not to get some nourishment from them. Then you will find, if nature has granted you any imagination at all, that you will eventually acquire a style individual to yourself, and it cannot help being good; because your hand and your mind, being always accustomed to gathering flowers, would ill know how to pluck thorns.
— *Cennino Cennini* (c.1370–c.1440)

Everyone
carries his own
inch–rule
of taste,
and amuses himself
by applying it,
triumphantly,
wherever
he
travels.

—Henry Adams (1838–1918)

IT IS FITTING that a painting should exhibit gentle and agreeable attitudes, suited to the action represented. Let the movements and postures of maidens be graceful and simple, showing sweetness and quiet rather than strength—although Homer, whom Zeuxis followed approved of robust forms even in women. Let the movements of young lads be limber and joyous, with a certain display of boldness and vigor. Let mature men have steadier movements, with handsome and athletic postures. Let old men have fatigued movements and attitudes and not only support themselves on both feet but hold on to something with their hands as well. — *Leon Battista Alberti* (1404–1472)

EVERY PAGE MUST explode, whether through seriousness, profundity, turbulence, nausea, the new, the eternal, annihilating nonsense, enthusiasm for principles, or the way it is printed. Art must be unaesthetic in the extreme, useless and impossible to justify. — *Francis Picabia* (1879–1953)

CHAPTER FIFTEEN:
On Judging One's Own Work

Perhaps the most difficult thing an artist has to do is evaluate the quality of his own work. First of all, his involvement in the work—the time invested, money spent for supplies, other work put on hold (including commissions, which may have had deposits placed on them), the physical effort—obviously makes it difficult for him to be objective. The artist must also face the meaning of self-critique in terms of his future artistic journey: what does this work say, how will it determine the art he will execute in years to come? Finally, the ego of the artist comes into play. Leonardo da Vinci tells his reader that while

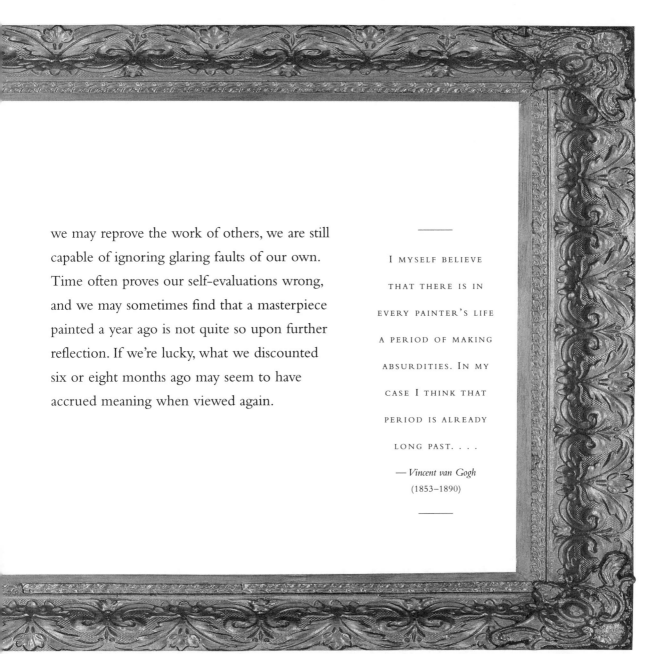

we may reprove the work of others, we are still capable of ignoring glaring faults of our own. Time often proves our self-evaluations wrong, and we may sometimes find that a masterpiece painted a year ago is not quite so upon further reflection. If we're lucky, what we discounted six or eight months ago may seem to have accrued meaning when viewed again.

I MYSELF BELIEVE THAT THERE IS IN EVERY PAINTER'S LIFE A PERIOD OF MAKING ABSURDITIES. IN MY CASE I THINK THAT PERIOD IS ALREADY LONG PAST. . . .

— *Vincent van Gogh*
(1853–1890)

THERE ARE TWO devices which can help the sculptor to judge his work: one is not to see it for a while—the other—whenever he has not the leisure for the former—is to look at his work through spectacles which will change its color and magnify or diminish it, so as to disguise it somehow to his eye, and make it look as though it were the work of another, removing by this means the delusions caused by *amour-propre* [self-love].
— *Gian Lorenzo Bernini* (1598–1680)

On Judging One's Own Work

Be sensitive to your mistakes. Observe your work. Put it on the wall for a couple of weeks. It may be that you can learn more from the study of your own work than from others.

—*John Sloan* (1872–1930)

TO DESCRIBE and explain my ideas is to lose them. — *Marino Marini* (1901–1980)

BUT, I say that when you paint you should have a flat mirror and often look at your work as reflected in it, then you will see it reversed, and it will appear to you like some other painter's work, so you will be better able to judge of its faults than in any other way. Again, it is well that you should often leave off and take a little relaxation, because, when you come back to it you are a better judge; for sitting too close at work may greatly deceive you. Again, it is good to retire to a distance because the work looks smaller and your eye takes in more of it at a glance and sees more easily the discords or disproportions in the limbs and colors of the objects. — *Leonardo da Vinci* (1452–1519)

SOMETIMES I am horribly afraid to turn round canvases which I have piled against the wall; I am constantly afraid of finding monsters where I believed there were precious gems! . . . Thus it does not astonish me that the critics in London relegate me to the lowest rank. Alas! I fear that they are only too justified! However, at times I come across works of mine which are soundly done and really in my style, and at such moments I find great solace. But no more of that. Painting, art in general, enchants me. It is my life. What else matters? When you put all your soul into a work, all that is noble in you, you cannot fail to find a kindred soul who understands you, and you do not need a host of such spirits. Is not that all an artist should wish for? — *Camille Pisarro* (1831–1903)

MAYBE four or five years ago, when I would make a figure that was so distorted it was hardly like a figure, I got a maniacal impulse to write "Figure," so I did that in a couple of paintings. I did some writing in the paintings. And then I saw the graffiti and so forth. It does give me a certain kind of whimsy, you might say, to write on an object that I'm dealing with. And I think it's this thing of multi-media, also. You know that you might get some kind of added psychological impact. So I want to go on with the graffiti paintings. I despise graffiti itself. I hate it. I think it's terrible. But it has great promise for art imaginativeness. . . — *George McNeil* (1908–1995)

One has to
guard against
a formula that is
good for everything,
that can interpret reality
in addition to the
other arts, and that
rather than creating
can only result in a style,
or a stylisation.

—*Georges Braque* (1882–1963)

ALAS, THE VERY name of *picture* produces a sadness of heart I cannot describe. Painting has been a smiling mistress to many, but she has been a cruel jilt to me; I did not abandon her, she abandoned me. I have no wish to be remembered as a painter, for I never was a painter; my idea of that profession was perhaps too exalted; I may say, is too exalted. I leave it to others more worthy to fill the niches of art. — *Samuel Morse* (1791–1872)

TWICE WHILE I was speaking at the university last night, I felt tears rise to my eyes and almost to my voice. So different from the first time I talked in public at the University of South Carolina in 1974; that echoes in my ear as honest prattle. When I speak now my experience in art wells up so articulately that I am surprised even while I am talking. I move around a podium as easily as if it were my living room and although I am keyed up I am not anxious. I feel as if I were doing what I should be doing—the feeling I have when intent in my studio. — *Ann Truitt* (1921–)

CHAPTER SIXTEEN:
On Other Artists

This chapter is made up of two different sorts of quotes: those about artists *in general,* which contain the thoughts of artists on everyone in their field (artists are always ready to criticize); and those about other artists *in particular,* in which the other artist is named. Here is revealed the envy and the admiration of one artist for another.

ARTISTS

WHO SEEK FOR

PERFECTION

IN EVERYTHING

ACHIEVE IT IN NOTHING.

—*Eugène Delacroix* (1798–1863)

HIS ROLE was heroic. His art serene and splendid. He expresses a beauty full of tenderness, and the pearly sheens of his paintings play on our senses like a rainbow. This painter is angelic. . . . Georges Braque should be called "the verifier." He has verified all the innovations of modern art, and will verify yet more. — *Guillaume Apollinaire* (1880–1918)

On Other Artists

The artist always has the masters in his eye.

—*Ralph Waldo Emerson* (1803–1882)

ORIGINALITY is a quality that cannot be imitated. The technique of the language, on the other hand, is something that belongs to all who can understand it. Reubens' technique has been in the world so long that it belongs to everybody who can understand and use it. —*John Sloan* (1871–1951)

THUS THERE WERE unequal faculties in each (type of painter), for nature gives to each intellect its own gifts. — *Leon Battista Alberti* (1404–1472)

MANET wanted one day to paint my wife and children. Renoir was there. He took a canvas and began painting them, too. After a while, Manet took me aside and whispered, "You're on very good terms with Renoir and take an interest in his future—do advise him to give up painting! You can see for yourself that it's not his *métier* at all." — *Claude Monet* (1840–1926)

THROUGH the use of perspective, many ancient painters . . . earned everlasting praise. And although there were many painters who did not employ perspective, and who were also praised, it must be said that they were praised by people who used poor judgment and who were ignorant of what could have been accomplished by means of perspective.

And since I am ambitious for the glory of art in this age, I have had the courage
and the presumption to write this small piece on perspective in painting.
—*Piero della Francesca (1416–1492)*

HE WHO resolves never to ransack any mind but his own, will soon be reduced, from
mere barrenness, to the poorest of all imitations; he will be obliged to imitate himself,
and to repeat what he has before often repeated. —*Sir Joshua Reynolds (1723–1792)*

THE Flemish and Dutch schools have their own type of merit, as I well recognize.
I can flatter myself that I appreciate that merit as much as anybody else; but,
for goodness' sake, let us have no confusion. Let us not admire Rembrandt and the
others through thick and thin; let us not compare them, either the men or their art,
to the divine Raphael and the Italian school: that would be blaspheming.
—*Jean-Auguste-Dominique Ingres (1780–1867)*

AFTER IT HAD become commonly known that whoever wanted to be portrayed by
him (Rembrandt) had to sit for him for some two or three months, there were few who
came forward. —*Filippo Baldinucci (1624–1696)*

HIS SKETCHES are so crude that his pencil strokes show more force than judgement
and seem to have been made by chance. —*Giorgio Vasari (1511–1576)*, on *Jacopo Robusti,*
known as *Tintoretto (1518–1594)*

FOR ME the great artist is a formulation of the greatest intelligence: he is the recipient
of sensations which are the most delicate and consequently the most invisible expressions
of the brain. —*Paul Gauguin (1848–1903)*

THE ARTIST SEEKS to record his awareness of order in life. One may find it in
landscapes and another in social themes. The subject may be of first importance to the
artist when he starts a picture, but it should be of least importance in the finished
product. The subject is of no aesthetic significance. —*John Sloan (1871–1951)*

AGAIN AND AGAIN experience has proved that the more deeply versed an artist is in drawing, the less he is able to paint portraits. — *Giovan Battista Armenini* (1530–1609)

AN ARTIST is an explorer. He has to begin by self-discovery and by observation of his own procedure. After that he must not feel under any constraint. But, above all, he must never be too easily satisfied with what he has done. . . . —*Henri Matisse* (1869–1954)

Tintoretto attempted to fill the line of Michel Angelo with color, without tracing its principle. . . .

—*Henry Fuseli* (1741–1825)

HERE, reality is not subordinated to painting, indeed painting seems the handmaid of reality, though we feel it tending towards a procedure which, while not at the mercy of appearances, is not yet in conflict with them. — *André Malraux* (1901–1976), on *Jan Vermeer* (1632–1675)

RAFFAEL'S drapery is the assistant of character, in Michelangelo it envelopes grandeur; it is in Reubens the ponderous robe of pomp. — *Henry Fuseli* (1741–1825)

AT THE same time that the aristocracy of England was finding expression in Sir Joshua Reynolds' portraits, the middle class was finding its voice in the art of William Hogarth. Realistic, moralistic, and anecdotal, as befitted the class he represented, Hogarth ranks among those pictorial creators who have discovered the expressive force of the brush-stroke as well as of color and its harmonies. He makes his entry into art as a reflection of Hals and Velasquez. — *René Huyghe* (1906–), on *William Hogarth* (1697–1764)

AH, MANET has come very, very close to it and Courbet—the marrying of form and colour. — *Vincent van Gogh* (1853–1890)

I AM INDEPENDENT! I can live and I love to work. Sometimes it made him [Degas] furious that he could not find a chink in my armour, and there would be months when we just could not see each other, and then something I painted would bring us together again. — *Mary Cassatt* (1844–1926)

I WOULD call that man a born artist whose soul nature has from the very beginning endowed with an ideal, and for whom this ideal replaces the truth; he believes in it without reservation, and his life's task will be to realize it completely for himself, and to set it forth for the contemplation of others. — *Hans Von Marées* (1837–1887)

NOT ONE great mind coming after them (great artists) but owes them tribute, and finds in them the prototype of his own inspiration. — *Eugène Delacroix* (1798–1863)

[WILLIAM MERRITT] CHASE used to say: "When you're looking at your canvas and worrying about it, try to think of your canvas as the reality and the model as the painted thing." — *Charles Hawthorne* (1872–1930)

WHEN Michelangelo was introduced to Titian, he said . . . that Titian's colouring and his style much pleased him, but that it was a pity that in Venice men did not learn to draw well from the beginning, and that those painters did not pursue a better method in their studies. — *Giorgio Vasari* (1511–1576)

I THINK the collectors have made an enormous contribution, not only to the market but to painters themselves. . . . These people that buy, that set standards, make everyone else itch to emulate. The itch to emulate, the desire for status, is certainly one of the main things in our society. It's not true that you get rich by buying paintings and reselling them later. Nevertheless, if you think it's true, it'll help the market; it'll start a sort of circular motion. I find that if I look at a photograph of Ethel Scull, and behind her back hangs a particular painting, I am more apt to take a look at that particular phase of that particular artist's work than I would if I hadn't seen it behind her back. So each of us goes and looks at each other's collections, and that gives us all a sense of escalation, if you will. — *Philip Johnson* (1906–)

On Other Artists

Degas will always be in bad odor for having said, "the fine arts must be discouraged."

— *Georges Roault* (1871–1958)

CÉZANNE WAS FATED, as his passion was immense, to be immensely neglected, immensely misunderstood, and now, I think, immensely overrated. Two causes I suspect have been at work in the reputation his work now enjoys: I mean causes, after all acknowledgment is made of a certain greatness in his talent. The moral weight of his single-hearted and unceasing effort, of his tragic love for his art, has made itself felt. In some mysterious way, indeed, this gigantic sincerity impresses, and holds, even those who have not the slightest knowledge of what were his qualities, of what he was driving at, of what he achieved, or of where he failed. — *Walter Richard Sickert* (1860–1942)

IN THE WORK of Seurat, you can see the dots of neutral colors carrying the form and then the dots of more intense color that make the color texture. It is a totally different principle than that of the Impressionists who used broken color to imitate visual effects. —*John Sloan* (1871–1951)

WE MUSTN'T forget to look in at Gérard's window. There's a Jongkind (painting) there. . . . Such a magnificent sky, and it's nothing but white paper! —*Pierre-Auguste Renoir* (1841–1914), on *Johan Barthold Jongkind* (1819–1891)

THE ARTIST should have a powerful will. He should be powerfully possessed by one idea. He should be intoxicated with the idea of the thing he wants to express. If his will is not strong he will see all kinds of unessential things. A picture should be the expression of the will of the painter. —*Robert Henri* (1865–1929)

NO PAINTER knew so well the extent of his own powers and his own weakness. Conscious of the power as well as the necessity of shade, he took the utmost boundaries of darkness and allowed but one-third of light, which light dazzles the eye thrown upon some favorite point, but where his judgement kept pace with his choice, surrounded with impenetrable shade. —*J. M. W. Turner* (1775–1851), on *Rembrandt* (1606–1669)

BUT THOUGH THE non-logical, instinctive, subconscious part of the mind must play its part in his work, he also has a conscious mind which is not inactive. The artist works with a concentration of his whole personality, and the conscious part of it resolves conflicts, organizes memories, and prevents him from trying to walk in two directions at the same time. —*Henry Moore* (1898–1986)

YOU CAN be a giant among artists without ever attaining any great skill. Facility is a dangerous thing. When there is too much technical ease the brain stops criticizing. Don't let the hand fall into a smart way of putting the mind to sleep. If you were so clever that you could paint a perfect eye, I would know that you would always be too clever. Some things are too well done and not done well enough. —*John Sloan* (1871–1951)

IF painters left nothing of themselves after their deaths, so that we were obliged to rank them as we do actors according to the judgment of their contemporaries, how different their reputations would be from what posterity has made them! How many forgotten names must have created a stir in their own day, thanks to the vagaries of fashion or to the bad taste of their contemporaries! But luckily, fragile though it is, painting (and failing this, engraving) does preserve the evidence for the verdict of posterity, and thus allows the reputation of an artist of real superiority to be reassessed, even though he may have been underestimated by the shallow judgment of contemporary public opinion, which is always attracted by flashiness and a veneer of truth. — *Eugène Delacroix* (1798–1863)

On Other Artists

WELL, NOW THAT HE'S FINISHED ONE BUILDING, HE'LL GO WRITE FOUR BOOKS ABOUT IT.

— *Frank Lloyd Wright* (1869–1959), on *Le Corbusier* (1887–1965)

HE . . . WHO is acquainted with the works which have pleased different ages and different countries, and has formed his opinion on them, has more materials and more means of knowing what is analogous to the mind of man, than he who is conversant only with the works of his own age or country. What has pleased and continues to please, is likely to please again; hence are derived the rules of art, and on this immovable foundation they must ever stand. — *Sir Joshua Reynolds* (1723–1792)

THE PLASTIC artist may or may not be concerned with presenting a superficial appearance of reality, but he is always concerned with the presentation—if not the representation—of the plastic values of reality. — *Hans Hofmann* (1880–1966)

ONE SHOULD NOT be too difficult. An artist should not treat himself like an enemy.
— *Eugène Delacroix* (1798–1863)

I CAN recommend nothing better . . . than that you endeavor to infuse into your works what you learn from the contemplation of the works of others. To recommend this has the appearance of needless and superfluous advice; but it has fallen within my own knowledge that artists, though they were not wanting in a sincere love for their art, though they had great pleasure in seeing good pictures, and were well skilled to distinguish what was excellent or defective in them, yet have gone on in their own manner, without any endeavor to give a little of those beauties which they admired in others to their own works. . . . — *Sir Joshua Reynolds* (1723–1792)

ALL pictures that's painted with sense and with thought
Are painted by madmen as sure as a groat;
For the greater the fool in the pencil more blest,
And when they are drunk they always paint best. — *William Blake* (1757–1827)

[FILIPPO'S WORKS WERE] acute, sharp, rich, humourous, joyful, and carefully executed. — *Cristoforo Landino* (c.1440), on *Filippo Lippi's* (1406–1469) paintings in Dante's *Divine Comedy*

I THINK it was colours and weights and pushes and pulls and how to make a surface.
— *Alex Katz* (1927–), to the question, *"What were you able to take from Matisse?"*

THE SO-CALLED conscientiousness of the majority of painters is only perfection applied to the *art of boring.*— *Eugène Delacroix* (1798–1863)

17

CHAPTER SEVENTEEN:
On Bohemian Life

In my dictionary, the second definition states that the term Bohemian (from the French) was originally another name for a gypsy, but in the nineteenth century came to mean anyone who was "living an unconventional lifestyle." Throughout history, many who have been driven to be artists have consigned themselves and their families to lives of cut corners and doing without. The artist's need to explore his imagination and his creativity rather than settling down into a secure, acceptable job often places him outside of society at large. As a result artists' families were often cut off from others, and created their own "Bohemian" communities.

For many, the Bohemian lifestyle has romantic connotations: adventure, freedom, intensity. But we should not forget that making this life choice can have painful consequences: poverty and isolation. Vincent van Gogh is a fine example of a painter who had almost no friends and was forced to use his mailman for a model.

IF A MAN
DEVOTES HIMSELF
TO ART,
MUCH EVIL
IS AVOIDED
THAT HAPPENS
IF ONE IS IDLE.

— *Albrecht Dürer*
(1471–1528)

WHY SEEK TO embarrass [the artist] with vanities foreign to his quietness? Know you not that certain sciences require the whole man, leaving no part of him at leisure for your trifles? . . . You only know this man and praise him in order to do yourselves honor, and are delighted if he be found worthy of the conversation of a pope or an emperor. And I would even venture to affirm that a man cannot attain excellence if he satisfy the ignorant and not those of his own craft, and if he be not "singular" or "distant," or whatever you like to call him. — *Leonardo da Vinci* (1452–1519)

IN CONNECTION with *McSorley's, Saturday Night* (a painting by John Sloan, of the famous bar in Greenwich Village), [Sloan] noted in a catalogue that during Prohibition the bar was never closed. The only difference was the mugs became smaller, the prices higher, and the crowd was larger. — *Van Wyck Brooks* (1886–1963)

IT SEEMS to me that today if the artist wishes to be serious . . . he must once more sink himself in solitude. There is too much talk and gossip. — *Edgar Degas* (1834–1917)

On Bohemian Life

Solitude is fine, but you need someone to tell you that solitude is fine.

— *Honoré de Balzac* (1799–1850)

. . . THIS KIND OF thinking was expressed by Fairfield Porter, who owned a house in Maine built by his father, when he said, "And so in a sense if I paint that house in Maine, I'm also painting a portrait of my father." — *Anna Held Audette* (1938–), on *Fairfield Porter* (1907–1975)

I WAS SAD to leave Europe in 1890, after my student days in Germany. While abroad, I had defended my country against all criticism. As a child, I had a glowing vision of America—of its promise. But then, once back in New York, I experienced an intense longing for Europe; for its vital tradition of music, theatre, art, craftsmanship. I was overwhelmed by a sense of emptiness and constraint, after the rich stimulus and freedom of my life abroad. I felt bewildered and lonely. How was I to use myself?
—*Alfred Stieglitz* (1864–1946)

THE ARTIST needs but a roof, a crust of bread, and his easel, and all the rest God gives him in abundance. He must live to paint and not paint to live.
—*Albert Pinkham Ryder* (1847–1917)

AS REGARDS THE supreme reasons against the admission of the female students to the study of the male nude, they cannot be mentioned to a maiden's ears.
—*anonymous* (c.1885)

ART is a jealous mistress, and if a man have a genius for painting, poetry, music, architecture, or philosophy, he makes a bad husband and an ill provider.
—*Ralph Waldo Emerson* (1803–1882)

TO GET SOMEONE to pose, you have to be very good friends and above all speak the language. —*Pierre-Auguste Renoir* (1841–1914)

THE TRUE ARTIST will let his wife starve, his children go barefoot, his mother drudge for his living at seventy, sooner than work at anything but his art.
—*George Bernard Shaw* (1856–1950)

WE MUST all teach ourselves to be fine, to be poets. Spend a lifetime in hard work with a humble mind. In his attempt to develop the beauty he sees, the artist develops himself.
—*Charles Hawthorne* (1872–1930)

THE SPIRIT, like the body, can be strengthened and developed by frequent use. . . . And for this reason, it is necessary for the artist to know the starting point for the exercise of his spirit. — *Wassily Kandinsky* (1866–1944)

On Bohemian Life

INTELLECTUAL PASSION DRIVES OUT SENSUALITY.

—*Leonardo da Vinci* (1452–1519)

PAINTERS are subject to tremblings of the joints, blackness of the teeth, discoloured complexions, melancholy, and the loss of the sense of smell. — *Bernardino Ramazzini* (c.1700)

THOUGH A living cannot be made at art, art makes living worthwhile. It makes living, living. It makes starving, living. It makes worry, it makes trouble, it makes a life that would be barren of everything—living. It brings life to life. —*John Sloan* (1872–1930)

THE MOST SENSIBLE men I know, taken as a class, are painters; that is, they are the most lively observers of what passes in the world around them, and the closest observers of what passes in their own heads. — *William Hazlitt* (1778–1830)

NEITHER is a true painter naturally pleased with the fatigue of business, and particularly of the law, but delights in the liberty which belongs to the bachelor's estate. Painting naturally withdraws from noise and tumult, and pleases itself in the enjoyment of a country retirement. — *Charles Alphonse Dufresnoy* (1611–1668)

THE BEST ART the world has ever had is but the impress left by men who have thought less of making great art than of living fully and completely with all their faculties in the enjoyment of full play. From these the result is inevitable. —*anonymous* (c.1885)

THE ARTIST is born, and art is the expression of his overflowing soul. Because his soul is rich, he cares comparatively little about the superficial necessities of the material world; he sublimates the pressure of material affairs in an artistic experience.
— *Hans Hofmann* (1880–1966)

EXCELLENT painters are not unsociable from pride, but either because they find few minds capable of the art of painting or in order not to corrupt themselves with the vain conversations of idle persons and degrade their thoughts from the intense and lofty imaginings in which they are continually rapt. — *Michelangelo Buonarroti* (1475–1564)

MOST ARTISTS have hitherto displayed something of folly and savagery, which, in addition to rendering them eccentric and fantastical, has also displayed itself in the darkness of vice and not in the splendour of those virtues render men immemorial.
— *Giorgio Vasari* (1511–1576)

BE AS SELECT in those whom you endeavor to please as in those whom you endeavor to imitate. Without the love of fame you can never do anything excellent; but by an excessive and undiminishing thirst after it you will come to have vulgar views; you will degrade your style, and your taste will be entirely corrupted. It is certain that the lowest style will be the most popular, as it falls within the compass of ignorance itself; and the vulgar will always be pleased with what is natural, in the confined and misunderstood sense of the word. — *Sir Joshua Reynolds* (1723–1792)

YOU HAVE a chance to get what you want if you go out and work for it, but you must really work, and not just talk about it. — *Georgia O'Keeffe* (1887–1986)

I HAVE written my life in small sketches, a little today, a little yesterday, as I thought of it, as I remembered all the things from childhood, on through the years, good ones, and unpleasant ones, that is how they come, that is how we have to take them. I look back on my life like a good day's work, it was done and I feel satisfied with it. I was happy and contented, I knew nothing better made the best out of what life offered. And life is what we make it, always has been, always will be. — *Anna Mary Robinson "Grandma" Moses* (1860–1961)

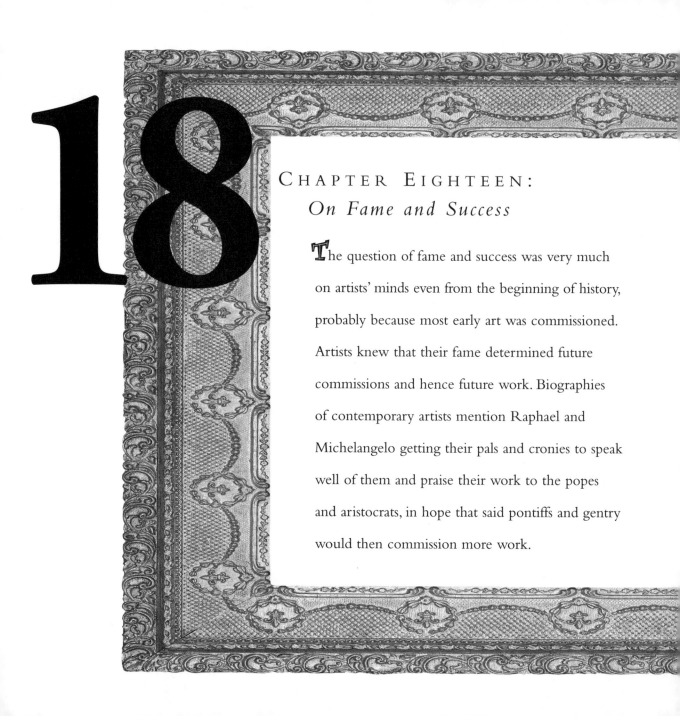

18

CHAPTER EIGHTEEN:
On Fame and Success

The question of fame and success was very much on artists' minds even from the beginning of history, probably because most early art was commissioned. Artists knew that their fame determined future commissions and hence future work. Biographies of contemporary artists mention Raphael and Michelangelo getting their pals and cronies to speak well of them and praise their work to the popes and aristocrats, in hope that said pontiffs and gentry would then commission more work.

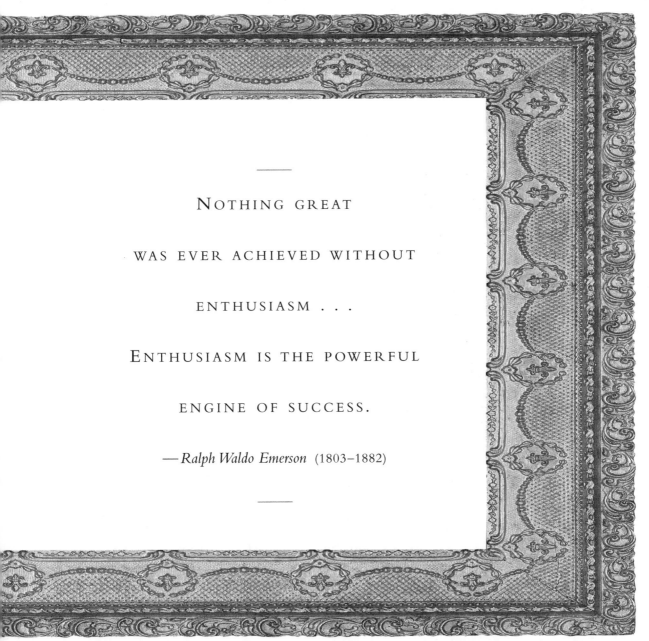

NOTHING GREAT

WAS EVER ACHIEVED WITHOUT

ENTHUSIASM . . .

ENTHUSIASM IS THE POWERFUL

ENGINE OF SUCCESS.

—*Ralph Waldo Emerson* (1803–1882)

I WISH you to be persuaded, that success in your art depends almost entirely on your own industry; but the industry which I principally recommend, is not the industry of the hands, but of the mind. — *Sir Joshua Reynolds* (1723–1792)

ACCORDING to an opinion now widely held among gentlemen, paintings are not highly valued nor achieve any reputation while the artists who did them are still alive; it is as though death's fatal scythe were essential to establish the value of the artist. — *Vincenzo Carrducci* (1576–1683)

On Fame and Success

SOME FORMS OF SUCCESS ARE INDISTINGUISHABLE FROM PANIC.

—*Edgar Degas* (1834–1917)

O PAINTER, take care lest the greed for gain prove stronger incentive than renown in art, for to gain this renown is a far greater thing than the renown of riches. — *Leonardo da Vinci* (1452–1519)

I KNOW THAT many men here in New York think women can't be artists, but we can feel and work as they can. Perhaps some day a new name will be coined for us (women artists) and so allow men to enjoy a property right to the word 'art'. — *Georgia O'Keeffe* (1887–1986)

IT IS RIGHT and proper that man should reach a pinnacle and then descend again, this is no cause for complaint. But, of course, it is a bitter experience to live through. When Michelangelo was an old man, he drew himself sitting in a child's pushcart. — *Käthe Kollwitz* (1867–1945)

IN THE SEARCH for method the artist goes still further. Art becomes so specialized as to be comprehensible only to artists, and they complain bitterly of public indifference to their work. For since the artist in such times has no need to *say* much, but only to be notorious for some small originality and consequently lauded by a small group of patrons and connoisseurs (which incidentally is also a very profitable business for him), there arise a crowd of gifted and skillful painters, so easy does the conquest of art appear. In each artistic circle are thousands of such artists, of whom the majority seek only for some new technical manner, and who produce millions of works of art without enthusiasm, with cold hearts and souls asleep. — *Wassily Kandinsky* (1866–1944)

THE consequences against (making trendy pictures) have caused great distress for students who felt increasingly wrong the more they tried to be "right." Jane Freilicher spoke pointedly to this issue when she said, "To strain after innovation, to worry about being 'on the cutting edge' (a phrase I hate), reflects concern for a place in history or for one's career rather than for the authenticity of one's painting. — *Anna Held Audette* (1938–), quoting *Jane Freilicher* (1924–)

UNDREAMED of potentialities show in the work of the workman as he becomes responsible to himself for himself. — *Frank Lloyd Wright* (1869–1959)

ART SHOULD NEVER try to be popular. — *Oscar Wilde* (1854–1900)

AS I'VE always said, the elevator is out of order, you have to take the stairs one step at a time. So when I tell you to hang in there, I'm also telling you that you'll be surprised, confused, often angry and frustrated at the number of obstacles raised against you. And, I'm also telling you that you can crawl under all the barbed wire in life and scale all the brick walls of discouragement without too many bruises and without tripping up as you run the race. You can keep going without falling down. Life is but a race. . . . The whole secret of life is to know what you want, to write it down and then commit yourself to accomplish it. — *Joe Girand* (1921–1970)

[W]HEN YOU'VE PAINTED
FOR YEARS
AND DISCOVERED
FINALLY
THAT YOU NEVER
GET ANY
NEARER TO A REAL MASTERY
OVER YOUR TRADE
A LOT OF VERY DOUBTFUL
MOMENTS COME ON.
SUCH MOMENTS
INCREASE WITH THE YEARS,
AND,
NO MATTER WHAT YOUR SUCCESS,
THEY KEEP OCCURRING.

— *Thomas Hart Benton* (1889–1975)

IF I DIDN'T start painting, I would have raised chickens.
—*Anna Mary Robinson "Grandma" Moses* (1860–1961)

THE OLDER you become in the pursuit of art, the tougher is your competition because you tend to pit yourself, not with the contemporary world, but with the past. The more you learn of the art of the past, the better it looks and, if you are intelligent, the less you seem to know yourself. — *Thomas Hart Benton* (1889–1975)

EVERYONE knows the problems of fame or imagines he knows them if he happens not to be famous (not even for Andy Warhol's twenty minutes). But it is not always sour grapes to pity the famous; not all artists dream of stardust while high on angel dust. There are serious artists highly respected, commanding even respectable prices, who are not "superstars" and are not interested in starring roles—beings who are dedicated and passionate about the quality of their work more than the quality of their lives, to whom a *succes d'estime* is more important than a *succes de scandale*. Their definition of what constitutes value is more varied and more complex. — *Lilly Wei* (c. 1985)

SUCCESS DOESN'T COME with painting one picture. It is building step by step, against all great odds. — *Georgia O'Keeffe* (1887–1986)

FAILURE IS the foundation of success; success is the lurking place of failure.
—*Lao-tzu* (550 B.C.)

CHAPTER NINETEEN: *On Critics*

If the critic wishes to act as a teacher, penning his observations and commentaries on works of art in order to enlighten, we can learn from his opinions and writings. If, however, his aim is to pursue an agenda (for example, the destruction of "degenerate" art), we only benefit if we side with him even before we have seen a new work. "Twas ever thus," and we find the situation unchanging.

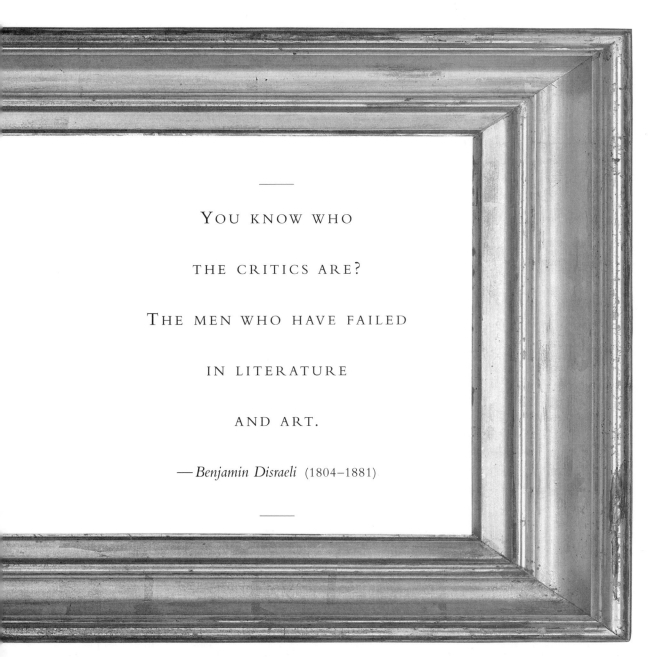

———

YOU KNOW WHO

THE CRITICS ARE?

THE MEN WHO HAVE FAILED

IN LITERATURE

AND ART.

—*Benjamin Disraeli* (1804–1881)

———

THE MERE BLUNDERING OF CLEVER PEASANTS. . . .

—*John Ruskin* (1819–1900), on the criticism of David Cox
and John Constable.

. . . IN CASE OF a complete mental breakdown, I might fall back on Art Criticism.
—*John Sloan* (1872–1930)

A CRITIC at my house to see some paintings. Greatly perturbed, he asks for my drawings. My drawings! Never! They are my letters, my secrets. — *Paul Gauguin* (1848–1903)

ONE MAY NEVER believe a theoretician . . . when he asserts that he has discovered some objective mistake in the work. — *Wassily Kandinsky* (1866–1944)

IF THAT fence is right the shadow is wrong—that ghastly thing could never make that shadow happen. — *Charles Hawthorne* (1872–1930), on a white picket fence

AS FOR MYSELF, I concede to no jury of artists the right to admit or to refuse the work of their colleagues. I want artists as well as authors to have their liberty of press, and so prevent their falling victim to the passions, and the fashion, of the moment. I recognize but one judge for the artist—the public, which can and should pass sentence upon cliques and coteries. I repeat that we must have the same rights as in literature. Would it not be absurd to make up a jury of writers, no matter how distinguished they might be, to decide which books are worth publishing? It is easy to foresee the abuses such a system would engender, with judges simply the natural and unwitting victims of their own human weakness. Many years ago I published my ideas on exhibitions free from all censorship except that required by morality. Some people objected that the number of works would be too great, and that their mediocrity would discourage the public. In the first instance, one would have to limit any single painter to one canvas; concerning the second, there is no cause for alarm. Freedom of exhibition would make the public more severe; and one can be very sure that a man who has to live by his profession would not

often submit himself to the public's sarcasm. I even believe that this system would have the tremendous advantage of getting rid of the superfluity of artists who today dispute their infrequent commissions. —*David D'Angers* (1788–1856), Paris, 1840

ONE MUST very clearly take one's position and not care what the critics say. What they say is completely unimportant. Despite all their wishes they cannot hold up the process of things. A painter is never understood, at best he is accepted.
— *Georges Braque* (1882–1963)

CRITICISM is a queer thing. If I print "She was stark naked"—and then proceeded to describe her person in detail, what critic would not howl?—who would venture to leave the book on a parlor table—but the artist does this and all ages gather and look and talk and point. —*Mark Twain* (1835–1910)

THE IDEAL art critic would not be one who would seek to discover the "mistake," "aberrations," "ignorance," "plagiarisms," and so forth, but the one who would seek to *feel* how this or that form has an inner effect, and would then impart expressively his whole experience to the public. — *Wassily Kandinsky* (1866–1944)

THE ART would lie open forever to caprice and casuality, if those who are to judge of their excellencies had no settled principles by which they are to regulate their decisions. — *Sir Joshua Reynolds* (1723–1792)

THOSE WHO HAVE undertaken to write on our art, and have represented it as a kind of *inspiration,* as a *gift* bestowed upon peculiar favorites at their birth, seem to insure a much more favorable disposition from their readers, and have a much more captivating and liberal air, than he who attempts to examine, coldly, whether there are any means by which this art may be acquired; how the mind may be strengthened and expanded, and what guides will show the way to eminence. — *Sir Joshua Reynolds* (1723–1792)

GENUINE WORKS of art carry their own aesthetic theory implicit within them and suggest the standards according to which they are to be judged.
—*Johann Wolfgang von Goethe* (1749–1832)

IT HAS BEEN the fate of arts to be enveloped in mysterious and incomprehensive language, as if it were thought necessary that even the terms should correspond to the idea entertained of the instability and uncertainty of the rules which they expressed.
— *Sir Joshua Reynolds* (1723–1792)

IN VAIN THEY (critics) snarl aloof; a noisy crowd. Like women's anger, impotent and loud. — *John Dryden* (1839–1911)

WHEN A man is painting a picture he ought not to refuse to hear any man's opinion, for we know very well that though a man may not be a painter he may have a true conception of the form of another man. . . . — *Leonardo da Vinci* (1452–1519)

THE TRUE work of a critic is not to make his hearer believe him, but agree with him.
— *John Ruskin* (1819–1900)

PAINTING: The art of protecting flat surfaces from the weather and exposing them to the critic. — *Ambrose Bierce* (1842–1914)

JOHN SLOAN (one of the "Eight" painters, a group which was formed in New York in 1908), referred to the art critic James Huneker, who had reviewed Sloan's friend, George Luks as "different from the average critic in that they usually think they are sent by God to shield mankind from what they don't care for themselves.
— *Van Wyck Brooks* (1886–1963)

AND I PRESUME, if I may be honest, that I am also interested in what anybody else has to say about my paintings and also in what they don't say because that means something to me, too. — *Georgia O'Keeffe* (1887–1986)

CRITICISM is a study by which men grow important and formidable at a very small expense. The power of invention has been conferred by Nature upon few, and the labor of learning those sciences which may by mere labor be obtained is too great to be willingly endured; but every man can exert such judgment as he has upon the works of

others; and he whom Nature has made weak, and Idleness keeps ignorant, may yet support his vanity by the name of a Critic. — *Samuel Johnson* (1709–1784)

I LIKE the kind of critics who, when they write, just put the people's names in, and you go through the columns and count how many names they drop. — *Andy Warhol* (1928–1987)

TO BE JUST, that is to say, to justify its existence, criticism should be partial, passionate, and political, that is to say, written from an exclusive point of view, but a point of view that opens up the widest horizons. — *Charles Baudelaire* (1821–1867)

I HAVE GENERALLY found that persons who had studied painting least were the best judges of it. — *William Hogarth* (1697–1764)

IN JUDGING PAINTINGS, you should consider whether the first impression pleases the eye and whether the artist has followed the rules; as for the rest, everyone makes some mistakes. — *Jacopo Robusti,* known as *Tintoretto* (1518–1594)

IF THIS is true, I shall be impertinent enough to quote Mallarmé: "A critic is someone who meddles with something that is none of his business." — *Paul Gauguin* (1848–1903)

NEVER to go overboard for an unknown artist is a sign of bad character in a critic. — *John Russell* (1919–)

ONE LOOKS AT one's picture and thinks of all sorts of ways to make that picture better. The critic comes along and knows nothing of these ways. — *John Marin* (1872–1953)

On Critics

DO NOT BE AN ART CRITIC; PAINT INSTEAD. THAT WAY SALVATION LIES.

— *Paul Cézanne* (1839–1906)

CHAPTER TWENTY: *On Genius*

The idea of geniuses in the arts is somewhat separate from our popular concept of geniuses in, say, mathematics or physics. People speak of an artistic genius as one who brilliantly colors a scene or cleverly captures a tableau. A genius artist is one who successfully fulfills his own vision and establishes the rules to his own "art world"; all of which is highly subjective. Geniuses in more objective fields must work within the rules of their established discipline, and their accomplishments are

built upon what has already been discovered and defined by others. Artists are often unschooled and are considered geniuses naturally, while a genius in math or science must be educated in his discipline before he can begin to work.

THE FIRST
AND
LAST TASK
REQUIRED OF
GENIUS
IS THE
LOVE
OF TRUTH.

—*Johann Wolfgang Von Goethe*
(1749–1832)

A GREAT PAINTER will know a great deal about how he did it, but still he will say, "How did I do it?" — *Robert Henri* (1865–1929)

Rules and models destroy genius and art.

— *William Hazlitt* (1778–1830)

WHAT WE now call genius begins, not where rules abstractly taken end, but where known vulgar and trite rules have no longer any place. It must of necessity be that even works of genius, like every other effect, as they must have their cause, must likewise have their rules; it cannot be by chance that excellences are produced with any constancy or any certainty, for this is not the nature of chance; but the rules by which men of extraordinary parts, and such are called men of genius, work, are either such as they discover by their own peculiar observations, or of such a nice gesture as not easily to admit being expressed in words; especially as artists are not very frequently skillful in that mode of communicating ideas. Unsubstantial . . . as these rules may seem, and difficult as it may be to convey them in writing, they are still seen and felt in the mind of the artist; and he works from them with as much certainty as if they were embodied . . . upon paper. It is true, these refined principles cannot always be made palpable like the more gross rules of art; yet it does not follow but that the mind may be put in such a train that it shall perceive, by a kind of scientific sense, that propriety which words . . . can very feebly suggest. — *Sir Joshua Reynolds* (1723–1792)

I CERTAINLY CONSIDER a great appreciation of painting to be the best indication of a most perfect mind, even though it happens that this art is pleasing to the uneducated as well as to the educated. — *Leon Battista Alberti* (1404–1472)

GENIUS only comes to those who know how to use their eyes and their intelligence. —*Auguste Rodin* (1840–1917)

MEN OF GENIUS sometimes accomplish most when they work the least, for they are thinking out inventions and forming in their minds the perfect idea that they subsequently express with their hands. —*Leonardo da Vinci* (1452–1519)

IN A certain way I am glad I have not learned painting. . . . I do not know myself how I paint it. I sit down with a white board before the spot that strikes me. I look at what is before my eye, and say to myself, that white board must become something; I come back dissatisfied—I put it away, and when I have rested a little, I go and look at it with a kind of fear. Then I am still dissatisfied, because I still have that splendid scene too clearly in my mind to be satisfied with what I have made of it. —*Vincent van Gogh* (1853–1890)

MEN OF GENIUS HAVE A WAY UTTERLY PECULIAR TO THEMSELVES OF SEEING THINGS.

—*Eugène Delacroix* (1798–1863)

WE ARE RICHER today in all that can be inherited, all tricks of the trade, for example, and all mechanical contrivances, but the inborn, original talent distinctive of the artist seems to grow rarer and rarer. And yet I would affirm that there is as much of it as ever, only it is a delicate plant and cannot now find the proper soil, climate and care. —*Johann Wolfgang von Goethe* (1749–1832)

It takes
a lot
of time to
be a genius,
you
have to sit around
so much
doing nothing
really doing
nothing.

— *Gertrude Stein* (1874–1946)

INVENTION is one of the great marks of genius; but if we consult experience we shall find that it is by being conversant with the inventions of others that we learn to invent, as by reading the thoughts of others we learn to think. — *Sir Joshua Reynolds* (1723–1792)

ART IS LONG, life short, judgment difficult, opportunity transient. To act is easy, to think is hard; to act according to our thought is troublesome. Every beginning is cheerful; the threshold is the place of expectation. — *Johann Wolfgang Von Goethe* (1749–1832)

I NEEDED no friends now. . . . Sundays my camera and I would take long car-rides into the country—always alone, and the nights were spent feverishly developing my plates in some makeshift darkroom . . . and then the first print I made from my first 5 × 7 negative—a snow scene—the tightening—choking sensation in my throat—the blinding tears in my eyes when I realized that a "picture" had really been conceived—and how I danced for joy into my father's office—Months of happiness followed—interest was sustained—yes—without many lapses—is with me yet. — *Edward Weston* (1886–1958)

ONE CANNOT explain the existence of genius. It is better to enjoy it.
— *E. H. Gombrich* (1909–2001)

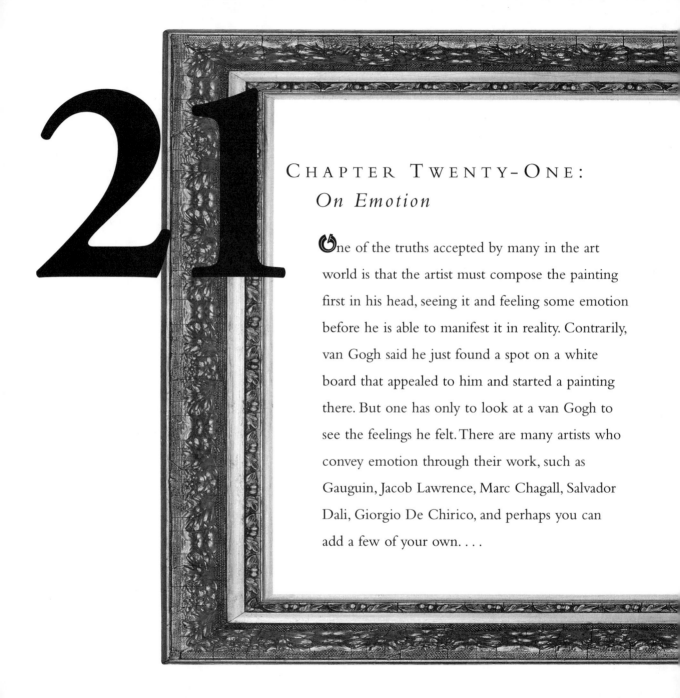

CHAPTER TWENTY-ONE:
On Emotion

One of the truths accepted by many in the art world is that the artist must compose the painting first in his head, seeing it and feeling some emotion before he is able to manifest it in reality. Contrarily, van Gogh said he just found a spot on a white board that appealed to him and started a painting there. But one has only to look at a van Gogh to see the feelings he felt. There are many artists who convey emotion through their work, such as Gauguin, Jacob Lawrence, Marc Chagall, Salvador Dali, Giorgio De Chirico, and perhaps you can add a few of your own. . . .

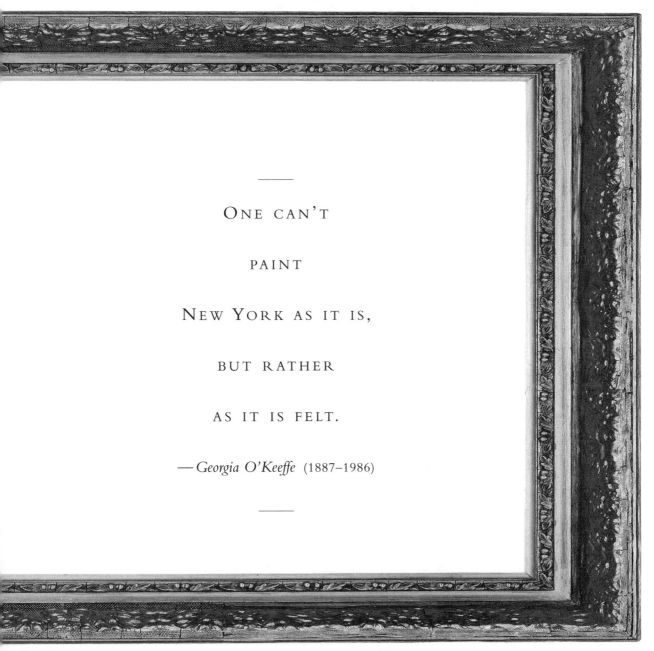

ONE CAN'T

PAINT

NEW YORK AS IT IS,

BUT RATHER

AS IT IS FELT.

— *Georgia O'Keeffe* (1887–1986)

157

I BELIEVE THAT the great painters, with their intellect as master, have attempted to force this unwilling medium of paint and canvas into a record of their emotions. I find any digression from this large aim leads me to boredom. — *Edward Hopper* (1882–1967)

AN ARTIST should strive to express his thought and not the surface of it. What avails a storm cloud accurate in form and color if the storm is not therein? — *Albert Pinkham Ryder* (1847–1917)

LAUGHTER is a reaction against rigidity. — *Hans Richter* (1888–1976)

EMOTION IS MORE outward than spirit. Spirit constructs, composes; emotion expresses mood and the like. Spirit constructs most purely, with the simplest line and the most basic color. The more basic the color, the more inward: the more pure. — *Piet Mondrian* (1872–1944)

On Emotion

PAINTING IS FOUNDED ON THE HEART CONTROLLED BY THE HEAD.

— *Paul Cézanne* (1839–1906)

ONE DOES NOT necessarily act for the best—nor even nobly, in destroying personal aspiration for the sake of others—the greatest if less apparent gain—even for those others—must come from the fulfilling of one's predilections rather than in sentimental sacrifice. Yet I realize that I face sacrifice, no matter what the decision. — *Edward Weston* (1886–1958)

People have nightmares about my paintings sometimes. It pleases me enormously.

—*Donald Baechler* (1956–)

I LIKE THE rule that corrects the emotion. —*Georges Braque* (1882–1963)

A WORK of art which did not begin in emotion is not art. Emotion is the starting point, the beginning and the end. Craftsmanship and technique are in the middle. —*Paul Cézanne* (1839–1906)

VISUAL EXPERIENCE cannot be based on feeling or perception alone. Feelings and perceptions which are not sublimated by the essence of things lose themselves in the sentimental. —*Hans Hofmann* (1880–1966)

FEELING IS ALL! —*Johann Wolfgang von Goethe* (1749–1832)

THE EYE SEEKS to refresh itself through your work; give it food for enjoyment, not dejection.... Let everything about you breathe the calm and peace of the soul.... —*Paul Gauguin* (1848–1903)

PAINTING, with all its technicalities, difficulties, and peculiar ends, is nothing but a noble and expressive language, invaluable as the vehicle of thought, but by itself nothing. —*John Ruskin* (1819–1900)

ALL HUMANITY is passion; without passion, religion, history, novels, art would be ineffectual. — *Honoré de Balzac* (1799–1850)

ART, ALTHOUGH produced by man's hands, is something not created by hands alone, but something which wells up from a deeper source out of our soul. . . . My sympathies in the literary as well as in the artistic field are drawn most strongly to those artists in whom I see most the working of the soul. — *Vincent van Gogh* (1853–1890)

On Emotion

If you mean to preserve the most perfect beauty in its most perfect state, you cannot express the passions.

—*Sir Joshua Reynolds* (1723–1792)

THE INNER ELEMENT, i.e., the emotion, must exist; otherwise the work of art is a sham. The inner element determines the form of a work of art. — *Wassily Kandinsky* (1866–1944)

PERHAPS it is the fullness of feeling with which the artist addresses himself to his theme that will determine, finally, its stature or seriousness. — *Ben Shahn* (1898–1969)

PAINTING IS FOR me but another word for feeling. —*John Constable* (1776–1837)

EVERY painter paints himself in his own works (so much is Nature accustomed to produce her own likeness). — *Charles Alfonse Dufresnoy* (1876–1938)

I CARRY THE FEELING OF BEING DISPLACED AROUND WITH ME ALL THE TIME.

—*Joan Mitchell* (1926–1992)

ALL VIOLENT FEELINGS ... produce in us a falseness in our impressions of external things, which I would generally characterize as the "Pathetic Fallacy."
—*John Ruskin* (1819–1900)

REASON IS part of feeling and feeling is part of reason. —*Hans Arp* (1887–1966)

22

CHAPTER TWENTY-TWO:
On Architecture

Architecture was perhaps the first art form, since man began arranging the environment around him. One of the first things I learned about architecture was that the ancient Greeks determine the dimensions of doorways according to each individual's height and size.

Interestingly, early architecture was not taught as it is today, but rather it was assumed that men of taste simply absorbed the knowledge necessary for constructing buildings. Thus, Michelangelo

was appointed the architect of St. Peters in Rome without any knowledge of the church's foundations or any awareness of the requirements he would need to meet in order to place a huge dome on top of it. His proposal drawings must have been very convincing!

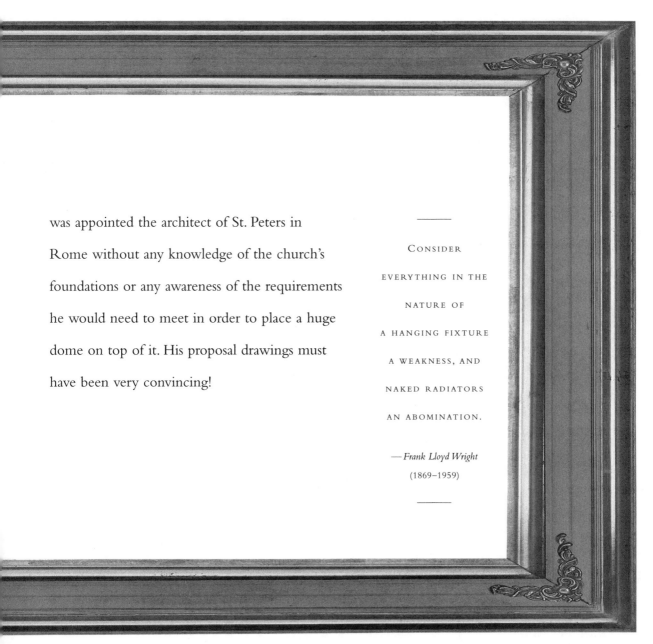

CONSIDER EVERYTHING IN THE NATURE OF A HANGING FIXTURE A WEAKNESS, AND NAKED RADIATORS AN ABOMINATION.

— *Frank Lloyd Wright*
(1869–1959)

NO PERSON who is not a great sculptor or painter can be an architect. If he is not a sculptor or painter, he can only be a *builder.* —*John Ruskin* (1819–1900)

The mother art is architecture. Without an architecture of our own we have no soul of our own civilization.

—*Frank Lloyd Wright* (1869–1959)

I WOULD like architects—not just students—to pick up a pencil and draw a plant, a leaf, the spirit of a tree, the harmony of a seashell, formations of clouds, the complex play of waves spreading out on a beach, so as to discover different expressions of an inner force. I would like their hands and minds to become passionately involved in this kind of intimate investigation. —*Charles-Édouard Jeanneret Gris,* known as *Le Corbusier* (1887–1965)

THE ROOM WITHIN is the great fact about the building.
—*Frank Lloyd Wright* (1869–1959)

THE FATE of the architect is the strangest of all. How often he expends his whole soul, his whole heart and passion, to produce buildings into which he himself may never enter.
—*Johann Wolfgang von Goethe* (1749–1832)

PHILIP JOHNSON made a famous statement about one of those magazines that photographs the extravagant homes, sumptuous apartments and unbelievable furniture of the wealthy. He said the magazines were pornography for architects. When you think about it, almost everything in American life is pornography for some special group, whether it's car buffs or house buffs or buff buffs. Everything in American life is about offering something unattainable in a commercially packaged way. That is American cultural life. . . .
— *David Salle* (1952–)

STUDY the silhouette of every object; distinctness of outline is the attribute of the hand that is not enfeebled by any hesitation of the will. — *Paul Gauguin* (1848–1903)

WE MAY LIVE without architecture, and worship without her, but we cannot remember without her. — *John Ruskin* (1819–1900)

THUS, though it is from the prejudice we have in favor of the ancients, who have taught us architecture, that we have adopted likewise their ornaments; and though we are satisfied that neither nature nor reason is the foundation of those beauties which we imagine we see in that art, yet if anyone, persuaded of this truth, should therefore invent new orders of equal beauty, which we will suppose to be possible, they would not please; nor ought he to complain, since the old has that great advantage of having custom and prejudice on its side. In this case we leave what has every prejudice in its favor, to take that which will have no advantage over what we have left, but novelty, which soon destroys itself, and at any rate is but a weak antagonist against custom.
— *Sir Joshua Reynolds* (1723–1792)

A DOCTOR CAN bury his mistakes, but an architect can only advise his clients to plant vines. — *Frank Lloyd Wright* (1869–1959)

MEN WHO LOVE buildings are their own undoers, and need no other enemies.
— *Marcus Crassus* (112 B.C.?–54 B.C.)

I have been black
and blue
in some spot,
somewhere,
almost all my life
from
too intimate contacts
with my own
furniture.

— *Frank Lloyd Wright* (1869–1959)

ARCHITECTURE completes nature. — *Giorgio De Chirico* (1888–1978)

A STRUCTURE BECOMES architecture and not sculpture when its elements no longer have their justification in nature. — *Guillaume Apollinaire* (1880–1918)

LESS IS MORE. — *Ludwig Mies van der Rohe* (1886–1969)

I WANT to speak of the difference between form and project, and of making; of the measurable and the unmeasurable aspects of our work, and of the limits of our work. Architecture nevertheless has limits. When we touch the invisible walls of its limits, then we know more about what is contained in them. — *Louis Kahn* (1901–1974)

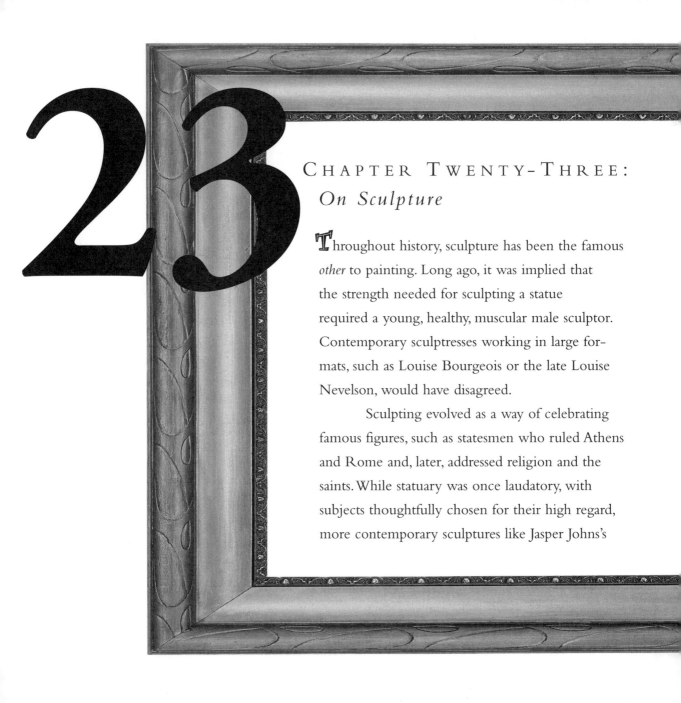

23

CHAPTER TWENTY-THREE:
On Sculpture

Throughout history, sculpture has been the famous *other* to painting. Long ago, it was implied that the strength needed for sculpting a statue required a young, healthy, muscular male sculptor. Contemporary sculptresses working in large formats, such as Louise Bourgeois or the late Louise Nevelson, would have disagreed.

Sculpting evolved as a way of celebrating famous figures, such as statesmen who ruled Athens and Rome and, later, addressed religion and the saints. While statuary was once laudatory, with subjects thoughtfully chosen for their high regard, more contemporary sculptures like Jasper Johns's

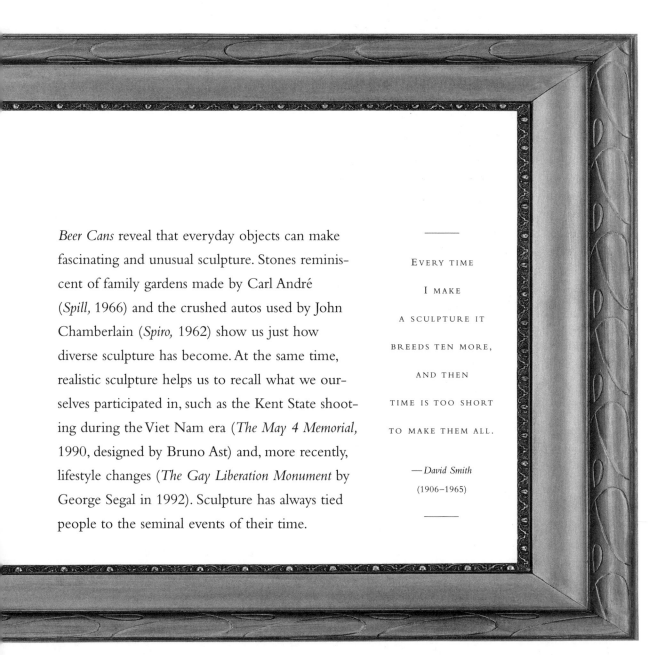

Beer Cans reveal that everyday objects can make fascinating and unusual sculpture. Stones reminiscent of family gardens made by Carl André (*Spill,* 1966) and the crushed autos used by John Chamberlain (*Spiro,* 1962) show us just how diverse sculpture has become. At the same time, realistic sculpture helps us to recall what we ourselves participated in, such as the Kent State shooting during the Viet Nam era (*The May 4 Memorial,* 1990, designed by Bruno Ast) and, more recently, lifestyle changes (*The Gay Liberation Monument* by George Segal in 1992). Sculpture has always tied people to the seminal events of their time.

EVERY TIME
I MAKE
A SCULPTURE IT
BREEDS TEN MORE,
AND THEN
TIME IS TOO SHORT
TO MAKE THEM ALL.

—*David Smith*
(1906–1965)

THE FIGURES OF the great men of those nations have come down to us in sculpture. In sculpture remain almost all the excellent specimens of ancient art. We have so far associated personal dignity to the persons thus represented. . . .
— *Sir Joshua Reynolds* (1723–1792)

On Sculpture

My drawings are the result of my sculpture.

—*Auguste Rodin* (1840–1917)

UNDOUBTEDLY his most remarkable feat has been the surrounding of open space and his use of such space as a sculptural material. — *Ben Shahn* (1898–1969), on *Henry Moore* (1898–1986)

IN SCULPTURE the first . . . principle is that of construction. Construction is the first problem that faces an artist studying his model, whether that model be a human being, animal, tree, or flower. The question arises regarding the model as a whole and regarding it in its separate parts. All form that is to be reproduced ought to be reproduced in its true dimensions, in its complete volume. — *Auguste Rodin* (1840–1917)

SCULPTURE is the mother of all arts involving drawing. If a man is an able sculptor and has a good style in this art he will easily be a good perspectivist and architect, and also a better painter than a man unconversant with sculpture. A painting is nothing better than the image of a tree, man, or other object reflected in a fountain. The difference between painting and sculpture is as great as between a shadow and the object casting it.
— *Benvenuto Cellini* (1500–1571)

IT IS WEIGHT that gives meaning to weightlessness. . . . I realized that lightness added to lightness does not add tension but diminishes it. —*Isamu Noguchi* (1904–1988)

HENRY [Geldzahler, curator at the Met] was weak about [showing] sculpture through the whole show. He simply didn't know what to do with it. He kept planting it like trees in places; you knew if you saw a room with a lot of David Smiths in it, it was an important room. Frank Stella's room had a tremendous number of Smiths in it. So did Pollack's room. If he didn't like an artist, he put a bad sculptor in the same room with him. —*Philip Leider* (c.1945)

ALL WORKS OF NATURE CREATED BY GOD IN HEAVEN AND ON EARTH ARE WORKS OF SCULPTURE.

—*Benvenuto Cellini* (1500–1571)

I SAY THAT the art of sculpture is eight times as great as any other art based on drawing, because a statue has eight views and they must all be equally good. —*Benvenuto Cellini* (1500–1571)

AS PICTURE THE colouring, so sculpture the anatomy of form. When I have seen fine statues, and afterwards enter a public assembly, I understand well what he meant who said, "When I have been reading Homer, all men look like giants." —*Ralph Waldo Emerson* (1803–1882)

AFTER PAINTING comes Sculpture, a very noble art, but one that does not in the execution require the same supreme ingenuity as the art of painting, since in two most important and difficult particulars, in foreshortening and in light and shade, for which the painter has to invent a process, sculpture is helped by nature. Moreover, Sculpture does not imitate color which the painter takes pains to attune so that the shadows accompany the lights. —*Leonardo da Vinci* (1452–1519)

THEY ARE A form of statuary which no careful father would wish his daughter, or no discriminating young man, his fiancée to see. . . . For a certain type of mind, on the other hand, it cannot but have a demoralizing tendency.
—critic on the works of *Sir Jacob Epstein* (1880–1959)

I DO NOT find any other difference between painting and sculpture than that the sculptor's work entails greater physical effort and the painter's greater mental effort.
—*Leonardo da Vinci* (1452–1519)

On Sculpture

The sculptor does not fall below the poet in realism.

—*Auguste Rodin* (1840–1917)

I HAVE to say that even the finest antique statue never strikes me as anything more than a finely ornamented piece of stone. —*Franz Pforr* (1788–1811)

I AM IN love with line. . . . Sculpture is nothing more than hundreds of different lines, profiles, silhouettes, seen from as many different angles. —*J. Chester Armstrong* (1948–)

SCULPTURE is just a language among the different languages through which the eloquence of art expresses nature. It is a heroic language in the same way that the tragic style is the heroic one among the languages of poetry. —*Antonio Canova* (1757–1822)

UPON ALL forms of sculptural ornament the effect of time is such, that if the design be poor, it will enrich it; if overcharged, simplify it; if harsh and violent, soften it; if smooth and obscure, exhibit it. —*John Ruskin* (1819–1900)

SOME SCULPTURE IS WARM, SOME FOREVER COLD. —*Robert Henri* (1865–1929)

THE BEST ARTIST has no concept which some single marble does not enclose within its mass, but only the hand which obeys the intelligence can accomplish that. . . . Taking away . . . brings out the living figure in alpine and hard stone, which . . . grows the more as the stone is chipped away. —*Michelangelo Buonnaroti* (1475–1564)

I DON'T MAKE drawings for sculpture. I don't want to conceive of something on paper, because that leads to frontality in sculpture, and I want to work directly in three dimensions, in deep space. What can be represented by perspective is not the way the eye sees things at all. Two-eye vision is a different experience from one-eye vision. —*Ibram Lassaw* (1913–)

THE FIRST hole made through a piece of stone is a revelation. A piece of sculpture can have a hole through it and not be weakened—if the hole is of a studied size, shape, and direction. —*Henry Moore* (1898–1986)

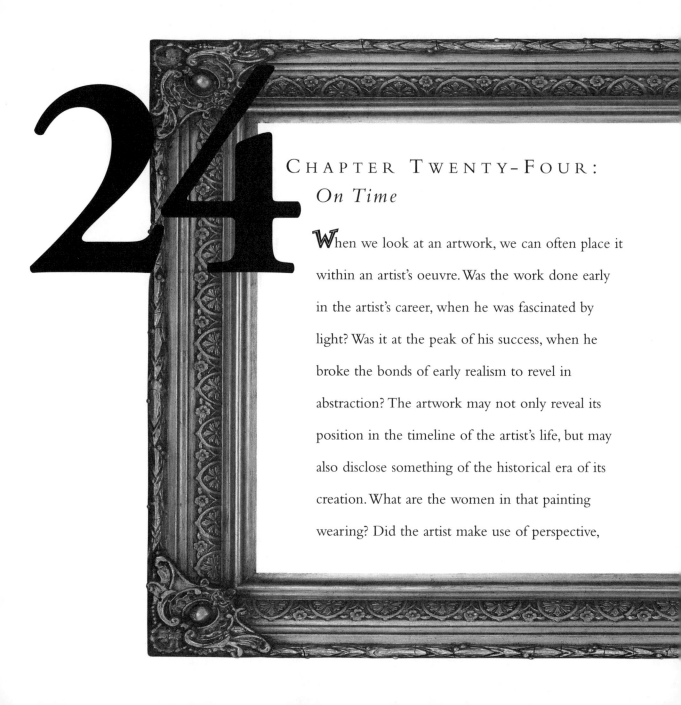

CHAPTER TWENTY-FOUR:
On Time

When we look at an artwork, we can often place it within an artist's oeuvre. Was the work done early in the artist's career, when he was fascinated by light? Was it at the peak of his success, when he broke the bonds of early realism to revel in abstraction? The artwork may not only reveal its position in the timeline of the artist's life, but may also disclose something of the historical era of its creation. What are the women in that painting wearing? Did the artist make use of perspective,

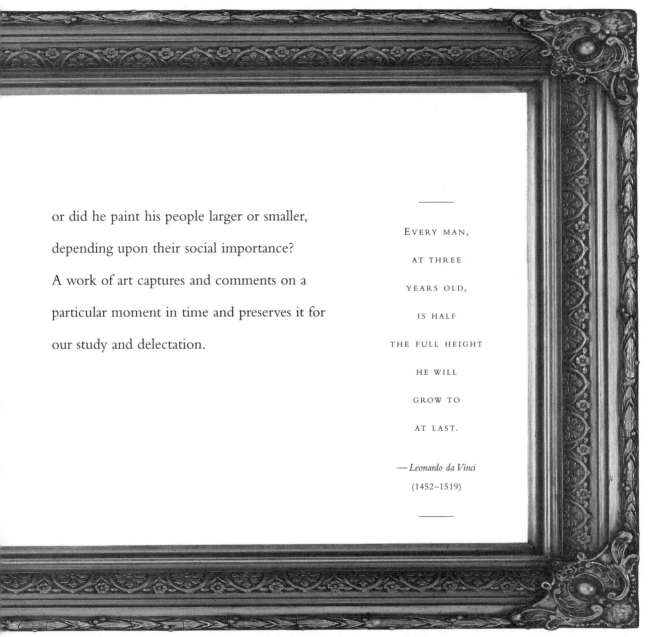

or did he paint his people larger or smaller, depending upon their social importance? A work of art captures and comments on a particular moment in time and preserves it for our study and delectation.

EVERY MAN, AT THREE YEARS OLD, IS HALF THE FULL HEIGHT HE WILL GROW TO AT LAST.

— *Leonardo da Vinci*
(1452–1519)

In great art there is no beginning and end in point of time. All time is comprehended.

—*Robert Henri* (1865–1929)

HE WHO EXHIBITS his works in public should wait many days before going to see them, until all the shafts of criticism have been shot and people have grown accustomed to the sight. —*Jacopo Robusti,* known as *Tintoretto* (1518–1594)

WHOEVER would reform a nation, supposing a bad taste to prevail in it, will not accomplish his purpose by going directly against the stream of their prejudices. Men's minds must be prepared to receive what is new to them. Reformation is a work of time. A national taste, however wrong it may be, cannot be totally changed at once; we must yield a little to the preposition which has taken hold on the mind, and we may then bring people to adopt what would offend them if endeavored to be introduced by violence. —*Sir Joshua Reynolds* (1723–1792)

IF YOUR WORK of art is good, if it is true, it will find its echo and make its place— in six months, in six years, or after you are gone. What is the difference? —*Gustave Flaubert* (1821–1880)

IF IT is to be utterly honest and direct, it should be related to the pulse of the times— the pulse of today. —*Berenice Abbott* (1898–1991)

THE NECESSITY OF being strongly of one's own time—your work to reflect intensely *le rhythm* of our time and not be retrospective, or neo-this and that—and the influences must be completely assimilated to this end—one does art but this art must be isolated from life—even though it may not be understood by the masses of one's time it can still have a quality to the greatest degree and will always be appreciated by the leading spirits of the time. —*Morgan Russell* (1886–1953)

ONE must be of one's time. —*Honoré Daumier* (1808–1879)

ONE WORKS NOT ONLY TO PRODUCE ART BUT TO GIVE VALUE TO TIME.

—*Eugène Delacroix* (1798–1863)

TIME is valuable to me. It will allow me to absorb the techniques of the mediums in which I work. In order to express in truth the basic facts of the world I behold, I hope to have digested the means of expressing it so thoroughly that the object or subject painted will become the all-important thing. —*Andrew Wyeth* (1917–)

I WOULD LIKE some day to trap a moment of life in its full beauty. That would be the ultimate painting. —*Francis Bacon* (1902–1992)

WE BELONG to our time. We share its opinions, its preferences, and its delusions. All artists bear the mark of their time, and the great artists are the ones in whom the mark lies deepest. —*Henri Matisse* (1869–1954)

TO PHOTOGRAPH New York City means to seek to catch in the sensitive and delicate photographic emulsion the spirit of the metropolis, while remaining true to its essential fact, its hurrying tempo, its congested streets, the past jostling the present. . . . The tempo of the metropolis is not of eternity, not even time, but of the vanishing instant. Especially then has such a record a peculiarly documentary, as well as artistic, significance. All work that can salvage from oblivion the memorials of the metropolis will have value.
— *Berenice Abbott* (1898–1991)

EVERYTHING has two aspects: the current aspect, which we see nearly always and which ordinary men see, and the ghostly and metaphysical aspect, which only rare individuals may see in moments of clairvoyance and metaphysical abstraction.
— *Giorgio De Chirico* (1888–1978)

NOTHING HEROIC ABOUT the changes that shock the culture but the power to deliver vision, the interplay of things and emptiness is worth talking about. Also, the element of deception and chance disposition of form and light create discontent. Perhaps there is a greater thing in the power of things to display themselves in ways we cannot recognize. That all things have life and even emptiness—I go by that. Explore that. Paint is as much a thing of life, precious and important to me. I wait upon it as a servant rather than master. Here is all I know about paint. It limits activity. It gets out of time— stops the clock. — *Milton Resnick* (1917–)

On Time

TWELVE PHOTOGRAPHS THAT MATTER IN A YEAR IS A GOOD CROP FOR ANY PHOTOGRAPHER.

— *Ansel Adams* (1902–1984)

IF today's arts love the machine, technology and organization, if they aspire to precision and reject anything vague and dreamy, this implies an instinctive repudiation of Chaos and a longing to find the form appropriate to our times. — *Oskar Schlemmer* (1888–1943)

AND WHAT DOES anyone know of my past year's work? 1,300 negatives—21,000 miles of searching. No, I have not done "faces and postures," except one dead man (wish I could have found more) and many dead animals; but I have done ruins and wreckage by the square mile and square inch, and some satires. —*Edward Weston* (1886–1958)

YOSEMITE VALLEY, to me, is always a sunrise, a glitter of green and golden wonder in a vast edifice of stone and space. . . . After the initial excitement we begin to sense the need to share the living realities of this miraculous place. We may resent the intrusion of urban superficialities. We may be filled with regret that so much has happened to despoil, but we can also respond to the challenge to re-create, to protect, to re-interpret the enduring essence of Yosemite, to re-establish it as a sanctuary from the turmoil of time. —*Ansel Adams* (1902–1984)

WELL BEGUN is half done. —*Aristotle* (384 B.C.–322 B.C.)

THAT *fin de siècle,* that windup of the nineteenth century, in which everything was angular, enervated, childishly insolent, sentimentally comical.
— *Guillaume Apollinaire* (1880–1918), describing Art Nouveau

CHAPTER TWENTY-FIVE:
On Photography

When photography was invented in 1826, its novelty created an immediate stir. While the necessary technical steps were cumbersome and lengthy, people loved the realness of horseracing, the immediacy of ballet dancing, the directness and clarity of warfare that could be captured in photographs. Among those who were fascinated were artists like Degas, who may have been the first artist to use photography in conjunction with painting. Others, such as Vlaminck, openly showed their dislike for photography ("We hate all that has to do with photography," 1910). Later, it was

accepted as an art form of its own, and artists such as Alfred Stieglitz, Ansel Adams, Edward Weston, and Berenice Abbott became known for their contributions to a new medium.

TECHNIQUE
DOES NOT EXIST
IN ITSELF,
IT IS ONLY THE
SUBSTANCE
OF THE
CREATIVE
MACHINERY.

—*Ansel Adams*
(1902–1984)

EXPRESSION without doctrine, my photographs are . . . ends in themselves, images of the endless moments of the world. — *Ansel Adams* (1902–1984)

THESE PEOPLE live again in print as intensely as when their images were captured in the old dry plates of sixty years ago. . . . I am walking in their alleys, standing in their rooms and sheds and workshops, looking in and out of their windows. And they in turn seem to be aware of me. — *Ansel Adams* (1902–1984), on a work by *Jacob Riis* (1849–1914)

IT HAS BEEN said so long about photography and television and movies. Painting has always been dead, but I was never worried about it. — *Willem de Kooning* (1904–1997)

WHAT USE IS HAVING A GREAT DEPTH OF FIELD, IF THERE IS NOT AN ADEQUATE DEPTH OF FEELING?

— *W. Eugene Smith* (1918–1978)

. . . THERE is that deeper need for self-expression. In every human being, there are capacities for creative action. . . . This need of human beings is almost as deep-seated as the need for air to breathe and food to eat. — *Berenice Abbott* (1898–1991)

IN MUSIC I still prefer the minor key, and in printing I like the light coming from the dark. I like pictures that surmount the darkness, and many of my photographs are that way. It is the way that I see photographically. For practical reasons, I think it looks better that way in print, too. — *W. Eugene Smith* (1918–1978)

IF I FEEL I have any niche at all in the photographic presentation of America, I think it would be chiefly to show the land and the sky as the settings for human activity. And it would be showing also how man could be related to this magnificent setting, and how foolish it is that we have the disorganization and misery that we have. —*Ansel Adams* (1902–1984)

IT GRADUALLY dawned on me that something must be wrong with the art of painting as practised at that time. With my camera I could procure the same results as those attained by painters—in black and white for the time being, perhaps in color later on. I could express the same moods. Artists who saw my earlier photographs began to tell me that they envied me; that they felt my photographs were superior to their paintings, but that, unfortunately, photography was not an art. I could not understand why the artists should envy me for my work, yet, in the same breath, decry it because it was machine-made—their "art" painting, because hand-made, being considered necessarily superior. Then and there I started my fight—or rather my conscious struggle for the recognition of photography as a new medium of expression, to be respected in its own right, on the same basis as any other art form. Then and there I decided to devote my life to finding out what people really mean when they say one thing and feel another: say one thing and do another. —*Alfred Stieglitz* (1864–1946)

THERE is an essential unity between photography, science's child, and science, the parent. Yet so far the task of photographing scientific subjects and endowing them with popular appeal and scientific correctness has not been mastered. The function of the artist is needed here, as well as the function of the recorder. —*Berenice Abbott* (1898–1991)

IN no other form of art is technique more closely interwoven than in photography. The photographer who thoroughly understands his medium visualizes his subject as a thing-in-itself.

He visualizes, therefore, before opening the shutter, the complete photograph. In order to do this he must be aware of every phase of technique. From the time of exposure to the mounting of the print . . . every link in the chain of production is vital in its contribution to the completed picture. —*Ansel Adams* (1902–1984)

ONE DAY during the winter season of 1902–03, there was a great snowstorm. I loved such storms. The Flat Iron Building had been erected on 23rd Street, at the junction of Fifth Avenue and Broadway. I stood spellbound as I saw the building in that storm. I had watched the structure in the course of its erection, but, somehow, it had never occurred to me to photograph it in the stages of its evolution. But that particular day, with the trees of Madison Square all covered with snow—fresh snow—I suddenly saw the building as I had never seen it before. It looked, from where I stood, as though it were moving toward me like the bow of a monster ocean-steamer—a picture of the new America that was still in the making.

. . . I can still feel the glory of those many hours and those many days when I stood on Fifth Avenue lost in wonder, looking at the Flat Iron Building.

—*Alfred Stieglitz* (1864–1946)

On Photography

My cloud photographs are *equivalents* of my most profound life experience, my basic philosophy of life.

—*Alfred Stieglitz* (1864–1946)

IT IS CLASSIC, completely satisfying—a pepper—but more than a pepper: abstract, in that it is completely outside subject matter. It has no psychological attributes, no human emotions are aroused: this new pepper takes one beyond the world we know in the

conscious mind. To be sure much of my work has this quality . . . take one into an inner reality—the absolute—with a clear understanding, a mystic revealment.
—*Edward Weston* (1886–1958)

SUCCESS in photography, portraiture especially, is dependent on being able to grasp those supreme instants which pass with the ticking of a clock, never to be duplicated— so light, balance—expression must be seen—felt as it were—in a flash, the mechanics and technique being so perfected in one as to be absolutely automatic.
—*Edward Weston* (1886–1958)

PHOTOGRAPHY IS NOT all seeing in the sense that the eye sees. . . . Our vision is in a constant state of flux, while the camera captures and fixes forever a single, isolated, condition of the moment. —*Edward Weston* (1886–1958)

IT SEEMS so utterly naive that landscape—not that of the pictorial school—is not considered of "social significance" when it has a far more important bearing on the human race of a given locale than excrescences called cities. By landscape, I mean every physical aspect of a given region—weather, soil, wildflowers, mountain peaks—and its effect on the psyche and physical appearance of the people. My landscapes of the past year are years in advance of any I have done before or of any I have seen.
—*Edward Weston* (1886–1958)

I GET A greater joy from finding things in Nature, already composed, than I do from my finest personal arrangements. After all, selection is another way of arranging: to move the camera an eighth of an inch is quite as subtle as moving likewise a pepper.
—*Edward Weston* (1886–1958)

WHEN I saw the new prints from the old negatives I was startled to see how intimately related their spirit is to my latest work. A span of fifty years. Should I exhibit in spite of my distaste for showing publicly. . . . There was Photography. I had no choice.
—*Alfred Stieglitz* (1864–1946)

MY PHOTOGRAPHS do not lend themselves to reproduction. The very qualities that give them their life would be completely lost in reproduction. The quality of *touch* in its deepest living sense is inherent in my photographs. When that sense of *touch* is lost, the heartbeat of the photograph is extinct. In the reproduction it would become extinct—dead. My interest is in the living. That is why I cannot give permission to reproduce my photographs. —*Alfred Stieglitz* (1864–1946)

AS I SEE straight photography, it means using the medium as itself, not as painting or theater. . . . All subject matter is open to interpretation, [and] requires the imaginative and intelligent objectivity of the person behind the camera. The realization comes from selection, aiming, shooting, processing with the best technic possible to project your comment better. . . . [Yet] technic for technic's sake is like art for art's sake— a phrase of artistic isolationism, a creative escapism. . . . In short, the something done by photography is *communication*. For what our age needs is a broad, human art, as wide as the world of human knowledge and action; photography cannot explore too far or probe too deeply to meet this need. —*Berenice Abbott* (1898–1991)

THE ANSWER comes always more clearly after seeing great work of the sculptor or painter, past or present, work based on conventionalized nature, superb forms, decorative motives. That the approach to photography must be through another avenue, that the camera should be used for a recording of life, for rendering the very substance and quintessence of the thing itself, whether it be polished steel or palpitating flesh. —*Edward Weston* (1886–1958)

THE CAMERA CAN only record what is before it, so I must await and be able to grasp the right moment when it is presented on my ground glass. In portraiture, figures, clouds—trying to record ever changing movement and expression, everything depends on my clear visions, my intuition at the important instant, which if lost can never be repeated. —*Edward Weston* (1886–1958)

IT'S SOMETHING
I THINK ALL PHOTOGRAPHERS
HAVE TO COME TO TERMS WITH,
WHETHER THEY
DO FASHION OR WHETHER
THEY DO DOCUMENTARY WORK.
IT'S A FORM OF VOYEURISM.
I TRY NOT TO EXPLOIT PEOPLE;
I REALLY FEEL THAT THE ACT OF TAKING
SOMEONE'S PICTURE IS
IN A SENSE EXPLOITATIVE.
NO MATTER WHAT.
BUT I THINK—
I HOPE—
THAT THE PEOPLE
I'VE DEALT WITH HAVE
WANTED THEIR STORIES TOLD.

—*Mary Ellen Mark* (c. 1997)

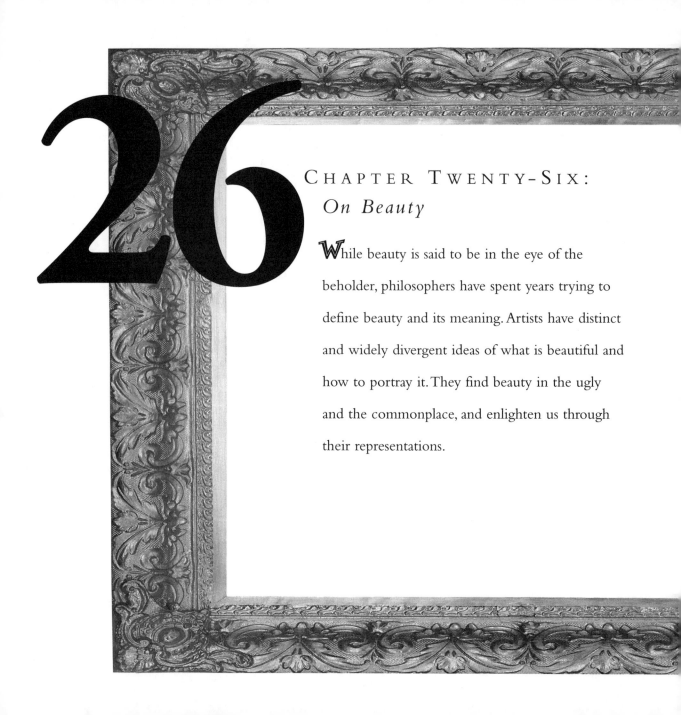

CHAPTER TWENTY-SIX:
On Beauty

While beauty is said to be in the eye of the beholder, philosophers have spent years trying to define beauty and its meaning. Artists have distinct and widely divergent ideas of what is beautiful and how to portray it. They find beauty in the ugly and the commonplace, and enlighten us through their representations.

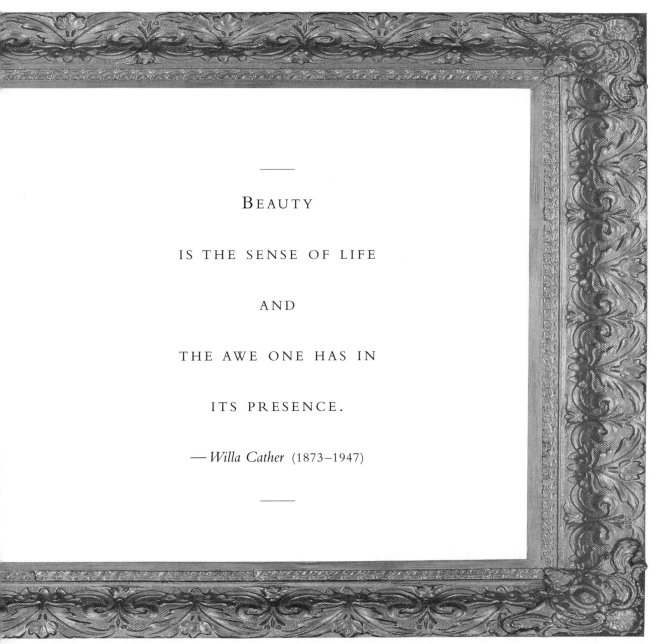

BEAUTY

IS THE SENSE OF LIFE

AND

THE AWE ONE HAS IN

ITS PRESENCE.

— *Willa Cather* (1873–1947)

YOU CAN pursue truth, you can seek the good, but you have to expose yourself to beauty. —*Mortimer Adler* (1902–2001)

THE BEAUTIFUL IS that which is desirable in *itself.* —*Aristotle* (384 B.C.–322 B.C.)

BEAUTY is the pilot of the young soul. —*Ralph Waldo Emerson* (1803–1882)

On Beauty | # Beauty is a gift of God.
—*Aristotle* (384 B.C.–322 B.C.)

I LOVE BRIDGES. I remember writing to Barney about the bridges over the Seine as dachshunds as compared to the Brooklyn Bridge. A bridge to me is beautiful. I like the idea of getting from one side to the other. —*Joan Mitchell* (1926–1992)

I COULDN'T portray a woman in all her natural loveliness. I haven't the skill. No one has. I must, therefore create a new sort of beauty, the beauty that appears to me in terms of volume of line, of mass, of weight, and through that beauty interpret my subjective impression. Nature is a mere pretext for a decorative composition, plus sentiment. It suggests emotion, and I translate that emotion into art. I want to expose the absolute, and not merely the factitious woman. —*Georges Braque* (1882–1963)

BEAUTY is indeed the sphere of unfettered contemplation and reflection.
 Beauty conducts us into the world of ideas, without however taking us from the world of sense.
 By beauty the sensuous man is brought back to matter and restored to the world of sense. —*Johann Friedrich von Schiller* (1759–1805)

IT IS WONDERFUL how any defect in a painting shows its ugliness in a mirror.
—*Leon Baptista Alberti* (1404–1472)

THIS stove is painted with a soul—there is as much beauty and religion in the painting of this black iron stove as in any . . . so-called religious paintings. That is sacred—you have put your heart in it. One of the greatest things in the world is to train ourselves to see beauty in the commonplace. Out of a consideration of ugly tones grows a real beauty—a freight car or a wash line of clothes may be as handsome as a sunset. Discover beauty where others have not found it. — *Charles Hawthorne* (1872–1930)

MAN SURRENDERS so readily to the commonplace, his mind and his senses are so easily blunted, so quickly shut to supreme beauty that we must do all we can to keep the feeling for it alive. No one can do without beauty entirely; it is only because people have never learned to enjoy what is really good that they delight in what is flat and futile so long as it is new. One ought at least to hear a little melody every day, read a fine poem, see a good picture, and, if possible, make a few sensible remarks.
— *Johann Wolfgang von Goethe* (1749–1832)

"GOOD" AND "BETTER" in respect of beauty are not easy to discern, for it would be quite possible to make two different figures, neither conforming with the other, one stouter, the other thinner, and yet we might scarce be able to judge which of the two excelled in beauty. — *Albrecht Dürer* (1471–1528)

TAKE NOTHING FOR GRANTED AS BEAUTIFUL OR UGLY.

— *Frank Lloyd Wright* (1869–1959)

I WOULD define, in brief, the Poetry of Words, as the Rhythmical Creation of Beauty. Its sole arbiter is taste. — *Edgar Allan Poe* (1809–1849)

There is nothing ugly
in art
except that which is
without character,
that is to say,
without inner
or
outer truth.

—*Auguste Rodin* (1840–1917)

THERE IS NO excellent beauty that hath not some strangeness in the proportion. A man cannot tell whether Apelles or Albrecht Dürer were the more trifler; whereof the one would make a personage by geometrical proportions the other by taking the best part out of divers faces to make one excellent.
— *Sir Francis Bacon* (1561–1626)

YOUR ABILITY to see is your tools of the trade; nothing else matters. Beautiful seeing is the desideratum. Remember, when you hear people say they can see a thing but not do it that they cannot really see it. If they did, they could do it even if they put the paint on with their fingers. — *Charles Hawthorne* (1872–1930)

WHAT beauty is I know not, though it adheres to many things. . . . As what all the world prizes as right we hold to be right, so what all the world esteems to be beautiful that will we also hold for beautiful and strive to produce. — *Albrecht Dürer* (1471–1528)

THOUGH BEAUTY is seen and confessed by all, yet from the many fruitless attempts to account for the cause of it being so, enquiries on that head have also been given up; and the subject generally thought to be a matter of too high and too delicate a nature to admit of any true or intelligible discussion. — *William Hogarth* (1697–1754)

THAT FAMOUS idea of *beauty,* which is, as everybody says, the goal of the arts. If it is their only goal, what becomes of the men like Rubens, Rembrandt, and all the northern natures generally, who prefer other qualities? — *Eugène Delacroix* (1798–1863)

BEAUTY IN ART is truth bathed in an impression obtained from nature.
— *John-Baptiste Camille Corot* (1796–1875)

BEAUTY IS EVERYWHERE, in the arrangement of your pots and pans, on the white wall of your kitchen, perhaps more than in your eighteenth-century salon or in the official museum. — *Fernand Léger* (1881–1955)

Beauty alone, fades to insipidity; and like possession cloys. —*Henry Fuseli* (1741–1825)

[MY AIM IS] . . . The revelation of the beauty of wide horizons and the tender perfection of detail. No attempt is made to portray the Range in the manner of a catalogue. A detail of a tree root, a segment of a rock, a great paean of thunder clouds—all these relate with equal intensity to the portrayal of an impressive peak or canyon. The majesty of form, the solidity of stone, the eternal qualities of the Sierra as a noble gesture of the earth, cannot be transcribed in any but the richest and the most intense expression. Nevertheless, a certain objectivity must be maintained, a certain quality of reality adhered to, for these images—integrated through the camera—represent the most enduring and massive aspects of the world, and justify more than an abstract and esoteric interpretation. I feel secure in adhering to a certain austerity throughout, in accentuating the acuteness of edge and texture, and in stylizing the severity, grandeur, and poignant minutiae of the mountains. —*Ansel Adams* (1902–1984)

BEAUTY ALONE makes all the world happy, and under its charm every creature forgets his bonds. —*Johann Freidrich von Schiller* (1759–1805)

BEAUTY, which is perhaps inseparable from art, relates not to the object but to the pictorial representation. That is why art overcomes ugliness without evading it. —*Paul Klee* (1879–1940)

DISAPPOINTED readers must, therefore, convert their dissatisfaction by transforming it into a challenge—to do for themselves what has yet to be done by anyone. To do what? To say what is common to—what universal qualities are present in—the admirable beauty of a prize-winning rose, Beethoven's Kreutzer Sonata, a triple-play in the ninth inning of a baseball game, Michelangelo's *Pieta,* a Zen garden, Milton's sonnet on his blindness, a display of fireworks, and so on. —*Mortimer Adler* (1902–2001)

BECAUSE there are these two distinct senses in which objects can be called beautiful (as admirable and as enjoyable), beauty has both an objective and a subjective dimension. The trouble is that the two dimensions do not run parallel to one another. —*Mortimer Adler* (1902–2001)

27

CHAPTER TWENTY-SEVEN:
On a Supreme Being

In the first millennium and a half, artists relied heavily on the Bible for their material. Indeed, much art was commissioned by the Church: Both Leonardo da Vinci and Michelangelo created site work for cathedrals and churches. During later epochs, more worldly subject matter, such as scenes of nature, symbolized God. In more modern times, subject matter has often been extremely secular—and mundane or nonlinear—making it more difficult to "read" in terms of the creator's beliefs. Still, when one looks at the *14 Banners* in the Houston

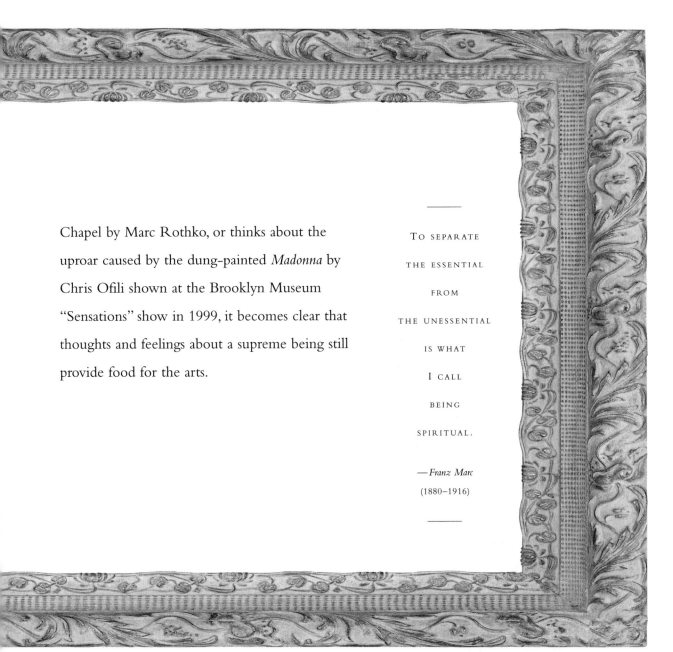

Chapel by Marc Rothko, or thinks about the uproar caused by the dung-painted *Madonna* by Chris Ofili shown at the Brooklyn Museum "Sensations" show in 1999, it becomes clear that thoughts and feelings about a supreme being still provide food for the arts.

TO SEPARATE THE ESSENTIAL FROM THE UNESSENTIAL IS WHAT I CALL BEING SPIRITUAL.

— *Franz Marc*
(1880–1916)

Spiritual energy is the primary force in art.

—*Ben Shahn* (1898–1969)

I AM A mystic. I don't go to a church or the synagogue. For me, working is praying. —*Marc Chagall* (1887–1985)

THE immortality of great art seems bound up with inevitable loss of its original surface meaning and its rebirth in the spirit of every new age. —*Anton Ehrenzweig* (1908–1966)

I PRAY every day that God make me a child, that is to say that he will let me see nature in the unprejudiced way that a child sees it. —*Camille Corot* (1796–1875)

NOW THE MATERIAL in which God worked to fashion the first man was a lump of clay. And this was not without reason; for the Devine Architect of time and of nature, being wholly perfect, wanted to show how to create by a process of removing from and adding to material that was imperfect in the same way that good sculptors and painters do when, by adding and taking away, they bring their rough models and sketches to the final perfection for which they are striving. He gave His model vivid colouring; and later the same colours, derived from quarries in the earth, were to be used to create all the things that are depicted in paintings. —*Giorgio Vasari* (1511–1576)

YES, when I work, when I am submissive and modest, I feel myself so helped by someone who makes me do things that surpass me. Still, I feel no gratitude toward *Him* because it is as if I were faced with a magician whose tricks I can't see through. I feel deprived of the profit of the experience that should have compensated my effort. I am ungrateful without remorse. —*Henri Matisse* (1869–1954)

SO FAR I have been talking about the origins of sculpture and painting, perhaps at greater length than was called for at this stage. However, the reason for my doing so has not been so much my great love of the arts as the hope that I would say something useful and helpful to our own artists. For from the smallest beginnings are attained the greatest heights, only to decline from its noble position to the most degraded status. Seeing this, artists can also realize the nature of the arts we have been discussing: these, like the other arts and like human beings themselves, are born, grow up, become old, and die. And they will be able to understand more readily the process by which art has been reborn and reached perfection in our own times. And if, which God forbid, because of indifference or evil circumstances or the ruling of Providence (which always seems to dislike the things of this world proceeding undisturbed) it ever happens at any time that the arts once again fall into the same disastrous decline, then I hope that this work of mine, such as it is, if it proves worthy of a happier fate may, because of what I have already said and what I am going to write, keeps the arts alive, or at least may inspire some of the more able among us to give them every possible encouragement. In this way, my good intentions and the work of outstanding men will, I hope, provide the arts with support and adornment of a kind which, if I may be allowed to say this outright, they have been lacking hitherto. — *Giorgio Vasari* (1511–1576)

CHARTRES IS THE STAIRWAY TO HEAVEN.

—*Morris Graves* (1910–2001)

IT IS NOT only for an exterior show or ostentation that our soul must play her part, but inwardly within ourselves, where no eyes shine but ours.
—*Michel Montaigne* (1533–1592)

THE PAINTING of Soulages is like the voice of God. — *Charles Laughton* (1899–1962), on *Pierre Soulages* (1919–)

But Nature,
which has created such
beautiful things,
is beautiful in a prior sense;
yet we, who want to have
no sense or knowledge
of spiritual things,
follow after not
recognizing that it is the
spiritual which moves us.

— *Plotinus* (205 A.D.–270 A.D.)

HAVE a religious feeling for your art. Do not suppose that anything good, or even fairly good, can be produced without nobility of soul. To become accustomed to beauty, fix your eyes on the sublime. Look neither to right nor left, much less downwards. Go forward with your head raised toward the skies, instead of bent towards the ground, like pigs routing in the mud. —*Jean Auguste Dominique Ingres* (1780–1861)

THE PRINCIPAL source of interest comes from the soul, it goes to the soul of the spectator in irresistible fashion; not that every interesting work strikes all spectators equally, because each one of them must have a soul of his own; only the person endowed with sensibility and imagination is stirred. These two faculties are indispensable to the spectator, as to the artist, though in different measure. —*Eugène Delacroix* (1798–1863)

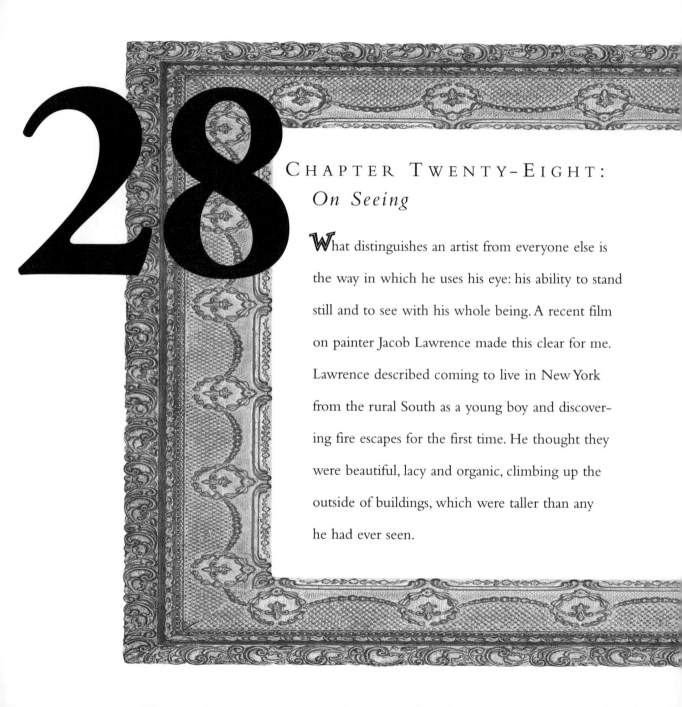

28

CHAPTER TWENTY-EIGHT:
On Seeing

What distinguishes an artist from everyone else is the way in which he uses his eye: his ability to stand still and to see with his whole being. A recent film on painter Jacob Lawrence made this clear for me. Lawrence described coming to live in New York from the rural South as a young boy and discovering fire escapes for the first time. He thought they were beautiful, lacy and organic, climbing up the outside of buildings, which were taller than any he had ever seen.

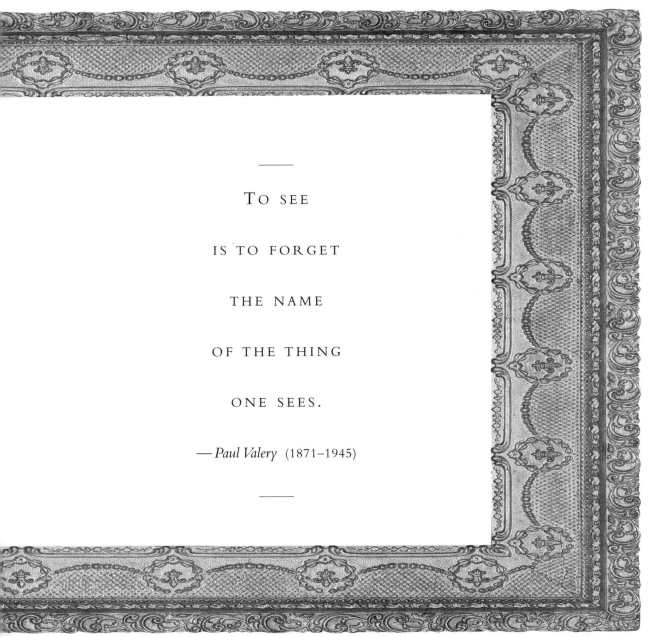

TO SEE

IS TO FORGET

THE NAME

OF THE THING

ONE SEES.

— *Paul Valery* (1871–1945)

THINK, are the energies of the model in your painting? —*Robert Henri* (1865–1929)

WHAT YOU SEE is what you see. —*Frank Stella* (1937–)

THERE ARE two ways of looking at things. One is simply looking at them, whereas the other involves considering them attentively. Merely to see is nothing else than receiving into the eye the form or likeness of the object that is looked at; but to consider a thing is more like this; it is to seek with special diligence after the means of knowing this object thoroughly. —*Nicolas Poussin* (1594–1665)

On Seeing

Five minutes' consideration of the model is more important than hours of haphazard work.

—*Robert Henri* (1865–1929)

THE MEANING of life is to see. —*Hui Neng* (700 A.D.)

YOU CAN DREAM freely when you listen to music as well as when you are looking at a painting. When you read a book, you are a slave of the author's thought. —*Paul Gauguin* (1848–1903)

I AM A CHILD WHO IS GETTING ON.

—*Marc Chagall* (1887–1985)

THIS EXHIBITION IS in fact a series of contradictions. First, the use of models, drawings, and photography to depict the phenomena of the actual work does seem to go against the grain of many of my previous commitments. To answer this . . . This exhibition was not intended as an art show per se. While I did do a couple of things (the entrance configuration and the scrim-window) to take the onus off all the documentation . . . the intention for this exhibition was to lay out an argument for the consideration of an extended frame of reference for art. This argument was intended to be articulated by all the contradictions made so apparent when the work of the past eight years . . . projects spread all over the country and projects never realized . . . are brought together cheek-by-jowl in this manner, resulting hopefully, in a set of revealing questions. —*Robert Irwin* (1928–)

THERE ARE as many images as eyes to see. . . . —*Sam Francis* (1923–1994)

29

CHAPTER TWENTY-NINE:
One Artist Talks: Picasso

If one artist could be said to exemplify the twentieth century, it is certainly Pablo Picasso. From his Cubist collages early in the century, to his depiction of the chaos of the Spanish Civil War in the 1930s (*Guernica,* 1937) and throughout the tumultuous century, Picasso was there to guide art and art lovers through ever-evolving phases in understanding themselves and their world. His *Demoiselles d'Avignon* was seminal to the Cubist Movement,

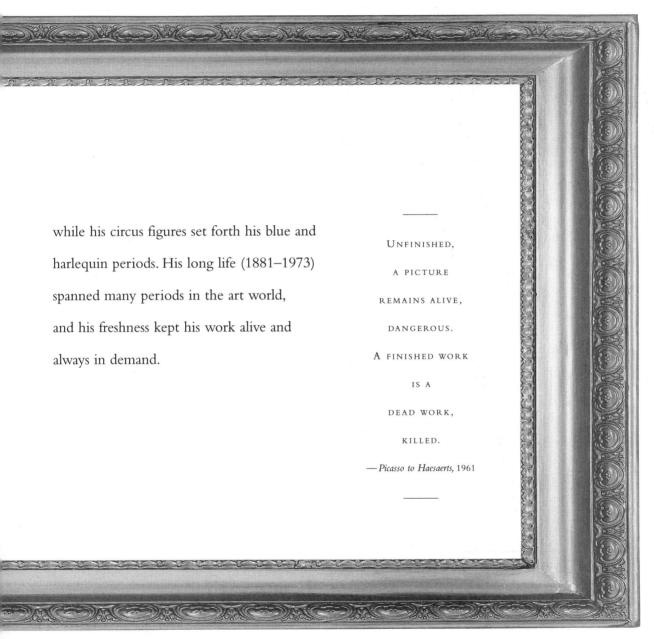

while his circus figures set forth his blue and
harlequin periods. His long life (1881–1973)
spanned many periods in the art world,
and his freshness kept his work alive and
always in demand.

UNFINISHED,
A PICTURE
REMAINS ALIVE,
DANGEROUS.
A FINISHED WORK
IS A
DEAD WORK,
KILLED.

— *Picasso to Haesaerts,* 1961

"ONE DOESN'T pay enough attention," he said to me. "If Cézanne is Cézanne, it's precisely because of that: when he is before a tree he looks attentively at what he has before his eyes; he looks at it fixedly, like a hunter lining up the animal he wants to kill. If he has a leaf, he doesn't let go. Having the leaf, he has the branch. And the tree won't escape him. Even if he only had the leaf it is already something. A picture is often nothing but that. . . . One must give it all one's attention. . . . Ah, if only everyone were capable of it!" —*Picasso* to *Sabartès,* 1954, on *Paul Cézanne*

PICASSO is right in saying that a government which would punish a painter for choosing the wrong color or the wrong line would be an impressive government. —*Cocteau,* speaking about *Picasso,* 1956

THE ARTIST GOES THROUGH STATES OF FULLNESS AND EMPTINESS, AND THAT IS ALL THERE IS TO THE MYSTERY OF ART. —1954

WHAT IS NECESSARY, is to name things. They must be called by their name. I name the eye. I name the foot. I name my dog's head on someone's knees. I name the knees. . . . To name. That's all. That's enough. —*Picasso* to *Parmelin,* 1964

TECHNIQUE? I don't have any, or rather, I have one but it wanders a great deal, according to the mood I'm in when I begin working. I apply it at will to express my idea. I think I have discovered many methods of expression, and still I believe there are a great many more to discover. —*Picasso* to *Del Pomar,* 1932

"AND THEN they asked me," he goes on, "why I didn't write. It's very easy to write when you're a writer; you have the words trained and they come to your hand like birds.

But I will really write a book," and he says it as though wanting to convince himself that he will, "a book as thick as this, and I'll offer a prize of a dozen bottles of champagne to whoever can read more than three lines of it." — *Picasso* to *Ferran,* 1926

WHEN ALBERT JUNYENT asked Picasso in an interview at Boisegeloup if a specific place was important to him, Picasso replied: "It all depends. From a personal point of view, yes. But professionally, I believe it must be very annoying to go to the other side of the world—as Matisse did, following the route of Gauguin—in order to end up with the discovery that the quality of light, and the essential elements of the landscape which the eye of the painter perceives, are not so different, after all, from those he would find on the Marne or the Ampurdan. Indeed, look at the sky today and tell me if a more intense blue ever was seen in Málaga or Alicante— and here we are in Normandy! Ah, literature!" — *Picasso* to *Junyent,* 1934

"DON'T YOU agree with me that they make too much fuss about that big word? It reminds me of a joke which my father used to tell: 'They say that the flu is going around . . . Well it must be going because everybody is catching it!' With culture it is just the reverse: if everybody is looking for it, apparently nobody is finding it. If we were cultured, we would not be conscious of lacking culture. We would regard it as something natural and would not make so much fuss about it. And if we knew the real value of this word we would be cultured enough not to give it so much importance. I feel that it is as ridiculous to want to impose 'our culture' on others as to praise fried potatoes to a guest, or to want to impose them on a neighbor, without any regard to whether or not they agree with him, or if he loathes them." — *Picasso* to *Sabartés,* 1946, on culture

ONE DAY I visited the retrospective show of the Salon. I noticed this: a good picture hung amidst bad pictures becomes a bad picture and a bad painting hung amidst good paintings manages to look good. — *Picasso* to *Tériade,* 1932

ASKED what importance he gives to likeness in portraits, Picasso answered: "None. It's not important to me to know whether a certain portrait is a good likeness or not. Years, centuries pass, and it is not important if the physiognomical traits are exactly those of the person portrayed. The artist loses himself in a futile effort if he wants to be realistic. The work can be beautiful even if it doesn't have a conventional likeness." — *Picasso* to *Del Pomar,* 1932

TALKING ABOUT GENIUS, he said: "It is personality with a penny's worth of talent. Error which, by accident, rises above the commonplace." —*Picasso* to *Sabartés,* 1946

SCULPTURE is the best comment that a painter can make on painting. —*Picasso to Guttuso,* 1964

One Artist Talks: Picasso

How often haven't I found that, wanting to use a blue, I didn't have it. So I used a red instead of the blue.

—*Picasso* to *Tériade,* 1932

"SUCCESS IS DANGEROUS. One begins to copy oneself, and to copy oneself is more dangerous than to copy others. It leads to sterility," and with a smile he added, "to make oneself hated is more difficult than to make oneself loved." —*Picasso* to *Liberman,* 1956

NOTHING can be done without solitude. I've created my own solitude which nobody suspects. It's very difficult nowadays to be alone because we all own watches. Have you ever seen a saint with a watch? Yet, I've looked everywhere for one even amidst the saints known as patrons of the watchmakers. —*Picasso* to *Tériade,* 1932

WE GIVE TO form and color all their individual significance, as far as we can see it; in our subjects, we keep the joy of discovery, the pleasure of the unexpected; our subject itself must be a source of interest. But of what use is it to say what we do when everybody can see it if he wants to? —*Picasso* to *De Zayas,* 1923

EVERYONE wants to understand art. Why not try to understand the songs of a bird? Why does one love the night, flowers, everything around one, without trying to under-

stand them? But in the case of painting people have to *understand*. If only they would realize above all that an artist works of necessity, that he himself is only a trifling bit of the world, and that no more importance should be attached to him than to plenty of other things which please us in the world, though we can't explain them. People who try to explain pictures are usually barking up the wrong tree. Gertrude Stein announced to me the other day that she had at last understood what my picture of the three musicians was meant to be. It was a still life! — *Picasso* to *Zervos*, 1935

WE ALL KNOW that Art is not truth. Art is a lie that makes us realize truth, at least the truth that is given us to understand. The artist must know the manner whereby to convince others of the truthfulness of his lies. — *Picasso* to *De Zayas*, 1923

THEY SPEAK OF naturalism in opposition of modern painting. I would like to know if anyone has ever seen a natural work of art. Nature and art, being two different things, cannot be the same thing. Through art we express our conception of what nature is not. — *Picasso* to *De Zayas*, 1923

PAINTING is a thing of intelligence. One sees it in Manet. One can see the intelligence in each of Manet's brush strokes, and the action of intelligence is made visible in the film on Matisse when one watches Matisse draw, hesitate, then begin to express his thought with a sure stroke. — *Picasso* to *Liberman*, 1956

ACADEMIC training in beauty is a sham. We have been deceived, but so well that we can scarcely get back even a shadow of the truth. The beauties of the Parthenon, Venuses, Nymphs, Narcissuses, are so many lies. Art is not the application of a canon of beauty but what the instinct and the brain can conceive beyond any canon. — *Picasso* to *Zervos*, 1935

I PAINT ONLY what I see. I've seen it, I've felt it, maybe differently from other epochs in my life, but I've never painted anything but what I've seen and felt. The way a painter paints is like his writing for graphologists. It's the whole man that is in it. The rest is literature, the business of commentators, the critics. — *Picasso* to *Jakovsky*, 1946

AND FROM the point of view of art there is no concrete or abstract forms, but only forms which are more or less convincing lies. That those lies are necessary to our mental selves is beyond any doubt, as it is through them that we form our aesthetic point of view of life. — *Picasso* to *De Zayas*, 1923

BOOKS FROM ALLWORTH PRESS

The Artist's Quest for Inspiration by Peggy Hadden (paperback, 6 × 9, 272 pages, $15.95)

The Artist's Guide to New Markets: Opportunities to Show and Sell Art Beyond Galleries by Peggy Hadden (paperback, 5½ × 8½, 252 pages, $18.95)

The Artist's Complete Health and Safety Guide, Third Edition by Monona Rossol (paperback, 6 × 9, 408 pages, $24.95)

The Business of Being an Artist, Third Edition by Daniel Grant (paperback, 6 × 9, 352 pages, $19.95)

Caring for Your Art: A Guide for Artists, Collectors, Galleries, and Art Institutions, Third Edition by Jill Snyder (paperback, 6 × 9, 192 pages, $19.95)

Artists Communities: A Directory of Residencies in the United States That Offer Time and Space for Creativity, Second Edition by the Alliance of Artists' Communities (paperback, 6¾ × 9⅜, 256 pages, $18.95)

The Fine Artist's Guide to Marketing and Self-Promotion by Julius Vitali (paperback, 6 × 9, 224 pages, $18.95)

Corporate Art Consulting by Susan Abbott (paperback, 11 × 8½, 256 pages, $34.95)

The Fine Artist's Career Guide by Daniel Grant (paperback, 6 × 9, 224 pages, $18.95)

How to Start and Succeed as an Artist by Daniel Grant (paperback, 6 × 9, 240 pages, $18.95)

The Artist's Resource Handbook, Revised Edition by Daniel Grant (paperback, 6 × 9, 248 pages, $18.95)

Legal Guide for the Visual Artist, Fourth Edition by Tad Crawford (paperback, 8½ x 11, 272 pages, $19.95)

Business and Legal Forms for Fine Artists, Revised Edition with CD-ROM by Tad Crawford (paperback, 8½ × 11, 144 pages, $19.95)

Please write to request our free catalog. To order by credit card, call 1-800-491-2808 or send a check or money order to Allworth Press, 10 East 23rd Street, Suite 510, New York, NY 10010. Include $5 for shipping and handling for the first book ordered and $1 for each additional book. Ten dollars plus $1 for each additional book if ordering from Canada. New York State residents must add sales tax.

To see our complete catalog on the World Wide Web, or to order online, you can find us at *www.allworth.com*.

DYING, DEATH, AND BEREAVEMENT

THIRD EDITION

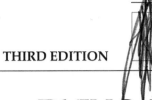

DYING, DEATH, AND BEREAVEMENT

Lewis R. Aiken
Pepperdine University

Allyn and Bacon
Boston • London • Toronto • Sydney • Tokyo • Singapore

Vice-President, Publisher: Susan Badger
Executive Editor: Laura Pearson
Editorial Assistant: Marnie S. Greenhut
Editorial-Production Administrator: Annette Joseph
Editorial-Production Coordinator: Susan Freese
Editorial-Production Service: TKM Productions
Manufacturing Buyer: Megan Cochran
Cover Administrator: Linda K. Dickinson
Cover Designer: Suzanne Harbison

Library of Congress Cataloging-in-Publication Data

Aiken, Lewis R.
 Dying, death, and bereavement / Lewis R. Aiken. -- 3rd ed.
 p. cm.
 Includes bibliographical references and index.
 ISBN 0-205-16409-9
 1. Thanatology. 2. Death--Social aspects. 3. Bereavement.
I. Title.
HQ1073.A47 1993 93-31416
306.9--dc20 CIP

Printed in the United States of America

10 9 8 7 6 5 4 3 2 1 99 98 97 96 95 94 93

A civilization that denies death ends by denying life.
—Octavio Paz

The great tragedy of life is not death, but what dies inside us while we live.
—Norman Cousins

CONTENTS

PREFACE

Thanatology, the study of death and dying, has made significant strides since the 1950s, when Herman Feifel's *Meanings of Death* introduced the field to psychologists. Before that time, death and dying were seen primarily as the concerns of poets, clergymen, and mystics. Death was viewed as a subject to be avoided as much as possible by physicians and as a somewhat taboo topic even for social scientists. Since then, the research and writings of Robert Fulton, Geoffrey Gorer, Richard Kalish, Robert Kastenbaum, Elisabeth Kübler-Ross, and Edwin Shneidman have helped to make thanatology a legitimate area of scientific discussion and research. Among the events that have prompted an increasing interest in thanatology are the growth of the elderly population, the advances in medical procedures and technology for saving lives, the decline in infant mortality, and the politicizing of abortion and euthanasia. Writings on mass deaths (*megadeath*), as in the Holocaust and Hiroshima, as well as many news stories and dramas concerned with dying and death have also contributed to an interest in this field.

During the past three decades, hundreds of articles and books dealing with the results of medical, psychological, anthropological, and sociological studies of death and dying have been published. In addition to reports of empirical investigations, the number of theoretical and other speculative writings concerned with death, dying, and bereavement has increased substantially since the 1950s. Moreover, creative works of literature and art pertaining to the topic have not diminished. Media reports and features on dying and death, including many excellent television documentaries and films, are now almost commonplace.

Courses devoted exclusively to discussions of death and dying have become increasingly popular since Robert Fulton introduced the first regular course on the subject at the University of Minnesota in 1963. Courses, workshops, and units on dying, death, and bereavement are taught in various schools and departments of colleges and universities, including psychology, sociology, social work, nursing, religion, education, physical education, medicine, counseling, and human development. Graduate schools in many American universities have followed the lead of

Brooklyn College, which in 1982 began offering a master's degree in thanatology. Outlines and descriptions of death education courses have also been published (e.g., Cherico & Margolis, 1976, 1978; Gordon & Klass, 1979; Margolis et al., 1978; Wass et al., 1990).

Dying, Death, and Bereavement is designed to fill what the author perceived to be a need for a compact but comprehensive interdisciplinary survey of research, writings, and professional practices concerned with death and dying. The book is sufficiently complete to serve as the principal text in a one-semester course on the topic but brief enough to be used as a supplementary textbook in other courses. The focus of the book is holistic or eclectic: Medical, psychological, religious, philosophical, artistic, and demographic matters concerned with dying, death, bereavement, and widowhood are all considered. Because the author is a psychologist, the psychological aspects of death and dying are emphasized. Be that as it may, a variety of viewpoints and research findings on topics subsumed under "thanatology" receive thorough consideration in individual chapters.

In addition to inevitable changes in the rates and demographics of human mortality, subsequent events and emphases make periodic revision of the book necessary. Although the second edition was the same as the first in form and, for the most part, substance, the third edition is somewhat longer and broader in content. Recent material is included on moral issues and court cases concerned with abortion and euthanasia; the widespread problems of AIDS and other deadly diseases; the tragedies occasioned by epidemics, starvation, and war; and the resumption of capital punishment in many states. Other topics that receive greater attention in this edition are the growth of health psychology and behavioral medicine and the increased social and political concerns for health care of people who are elderly.

Finally, and perhaps most important of all the topics dealt with, is the growing awareness of health and mortality on a global scale. The increased economic, social, and physical interdependency among the nations of the world has made the concerns of other countries and people our concerns. Although the Cold War and the accompanying threat of nuclear annihilation are apparently over for the time being, the problems of war and famine are of international scope and continue to demand attention. Today more than ever, it is recognized that no person is an island; everyone must accept the responsibility for being his brother's keeper.

As with the first and second editions of this book, I have tried to write the third edition in an informative, factually correct style. In addition to including a wide range of empirical findings and theoretical viewpoints, this edition has been designed with the emotional needs of students and other readers in mind. The motives for taking the kinds of courses for which this book is designed vary from person to person, not the least of which is the need to acquire some understanding of the death of a close relative or friend and to come to grips with the inevitability of one's own demise. Questions, activities, and projects are included at the end of each chapter to enhance reflection and to make the material personal and realistic.

ACKNOWLEDGMENTS

Even more than other books that I have written, this book has been a labor of love. But love is not enough, even when accompanied by factual knowledge and some ability to put one's thoughts on paper. The production of a textbook such as this one owes a great deal to the efforts of many people.

My gratitude to Debi Carter-Ford (Sinclair Community College) and Mark Shatz (Ohio University) for reviewing the manuscript of this third edition. And once again, I would like to acknowledge those individuals who reviewed previous editions: namely, for the first edition, Larry Ewing (University of Oregon), Vivien Feyer (Alameda, GA), Bert Hayslip (North Texas State University), Marguerite Kermis (Canisius College), Gary Lee (Washington State University), and Dee Shepard-Look (California State University at Northridge); and for the second edition, David E. Balk (Kansas State University), Arthur S. Evans, Jr. (Florida Atlantic University), and Robert E. Francis (North Shore Community College, Beverly, MA).

Those individuals to whom I wish to give special recognition and thanks for their contributions are the production editor, Lynda Griffiths; the copyeditor, Karen Stone; and all the students who worked and wept their way through the previous two editions of the book.

PART I

INTRODUCTION

1

MORTALITY AND THANATOLOGY

QUESTIONS ANSWERED IN THIS CHAPTER:

- *How do people feel about death?*
- *How is death defined and determined?*
- *What are the causes of death and how common is each?*
- *What is the death rate in a population and what factors are associated with it?*
- *Why has public and professional interest in death and dying increased during the past three decades?*
- *What professions are concerned with the subject of death and dying and in what activities are they engaged?*

Death eventually comes to everyone—poet and peasant, saint and sinner, the wise and the foolish. It is a fate that human beings share not only with each other but with all living things. The inevitability of death and the shortness of life have been expressed frequently in literature and art, from the time of Cicero's statement that

> *No man can be ignorant that he must die,*
> *nor be sure that he may not this very day.*[1]

to Henry Wadsworth Longfellow's

> *Art is long, and Time is fleeting,*
> *And our hearts, though stout and brave,*
> *Still, like muffled drums, are beating*
> *Funeral marches to the grave.*[2]

and Edna St. Vincent Millay's

Death devours all lovely things:
Lesbia with her sparrow
Shares the darkness,—presently
Every bed is narrow.[3]

Depressing though these sentiments may seem, they underscore the certainty of death and the importance of not wasting the time that one has. Sooner or later, each person must face his or her own vulnerability and the inevitability of death. Distraction and denial may postpone the realization and acceptance of the inevitable, but they cannot eliminate it.

DENIAL VERSUS ACCEPTANCE OF DEATH

Human beings are presumably the only living creatures who realize that they will die someday. How do they cope with this knowledge? How does it shape their attitudes, beliefs, and actions?

Attitudes toward death are not completely positive or negative. They form a continuum. At one end of the attitude-toward-death continuum is the perception of death as humanity's mortal enemy, the fearsome Grim Reaper armed with a scythe for cutting down human lives. Shaped by this perception is the idea of death as a mortal enemy that must be actively combatted with whatever heroic measures are required and available. Both medical science and religion have promoted the idea of death as an enemy, an enemy that is ultimately victorious but can be avoided for a while if one is alert, capable, and persistent. Furthermore, as seen in the biblical query "Grave where is thy victory? Death where is thy sting?" death is not permanent if one believes in a life after death.

At the other end of the attitude-toward-death continuum is the acceptance and even welcoming of death as a passage to a more blissful state of being. Such an attitude allows the dying person, who is "sustained and soothed by an unfaltering trust" to "approach thy grave like one who wraps the drapery of his couch about him and lies down to pleasant dreams." (William Cullen Bryant, *Thanatopsis*). Somewhere in the middle of the attitude-toward-death continuum, and perhaps typical of the perceptions of most people, is a feeling of mystery or bewilderment in the face of death—"the undiscovered country from whose bourne no traveler returns" (William Shakespeare, *Hamlet*). Such a realm may be considered beyond human experience, a place of uncertain character that cannot be described in words.

Familiarity with Death

To a great extent, fear and acceptance of death vary with its familiarity. Familiarity with death does not breed contempt for it, but it does promote ways of coping.

During the Middle Ages and the Renaissance, death and dying were more visible in the Western world than they are today. Publicly viewed executions,

mortal skirmishes involving ordinary people, and mass epidemics claiming the lives of thousands were commonplace occurrences before the nineteenth century. No one knew when death might come or even if it might occur before the day was over. For example, it has been estimated that the Black Plague killed approximately 25 percent of the entire population of Europe during the fourteenth century. Furthermore, sixteenth-century travelers to London might very well have seen the severed heads of the king's enemies spiked on London Bridge.

Prior to the nineteenth century, dying people frequently organized rituals in their own bedrooms. This deathbed ritual was largely replaced by a postmortem ritual during the 1800s, and by the middle of the twentieth century, even these postmortem activities had been minimized (Aries, 1974). A typical funeral in the United States in the 1990s is a rather cut-and-dried affair, often noted more for its efficiency than for its ritualism and expression of grief for the dear departed. In addition, because most people now die in institutions rather than at home or in public, personally witnessed death has become an uncommon occurrence in most Western countries.

Denial of Death

The decline of public dying and death during the twentieth century not only reflects the denial of death but also promotes it. Attempts to deny the reality of death, however, have not been completely successful. People today may not think about death very much, but they are clearly aware of it. How could it be otherwise with the constant barrage of pictures, reports, and stories of violence, disease, and deterioration vividly displayed and portrayed by newspapers, television, and the other media? Millions of deaths during this century have been caused by war, which many people in previous times viewed as a noble, glorious, and even romantic human enterprise. But two world wars, the Korean War, the Vietnam War, and various regional conflicts have dampened public enthusiasm for war and dimmed the perception of it as a heroic and glorious enterprise.

Graphic depictions of violent death on television and in motion pictures have horrified some people but anesthetized many others to the reality of dying. Death in the media and movies is usually impersonal, and if it becomes upsetting the viewer can simply turn off the set, walk out of the theater, or throw away the paper or magazine. Without dwelling on these second-hand experiences with death, or thinking about them at all, one can maintain the illusion of personal invulnerability and even exemption from death. It becomes something that happens to others but not to oneself, at least not for a very long time. It becomes a subject that can be thought about tomorrow without spoiling today. Sigmund Freud's assertion that no one can truly imagine his or her own death is not even an issue for the chronic denier of death; he or she simply never tries to imagine it.

Understanding death, and especially one's own death, is particularly difficult for young children. There is a story about a 3-year-old boy who asked his parents if he could be alone for a while with his newborn baby brother. The parents were puzzled but finally agreed. They were startled and somewhat amused to overhear

the 3-year-old, on approaching the crib, ask the baby, "What's heaven like? I don't remember; it's been so long!"

Adolescents comprehend death better than children, but to a typical teenager, it is still a distant and perhaps dreamy, romanticized event. The reality and imminence of death become clearer as one ages and experiences the demise of friends and relatives. Then it is more difficult to maintain the illusion of personal invulnerability and invincibility.

The tendency to deny or overlook death does not keep it from occurring. It has been estimated that well over 100 million deaths during the twentieth century have resulted from unnatural causes. At least 50 million deaths have occurred from violent acts and more than 60 million from starvation and deprivation in this century. Every year, roughly 50 million people throughout the world die from all causes. In the United States alone, an estimated 1 million people are in the process of dying at a given moment (Population Reference Bureau, 1989; Simpson, 1979).

DEFINITIONS AND DETERMINATION OF DEATH

Although most people tend to think of *death* as a unique event, there are many definitions of the term. According to the *Random House Dictionary of the English Language* (Flexner, 1987), *death* is "the act of dying; the end of life; the total and permanent cessation of all the vital functions of an organism." This definition is closest in meaning to *biological death*, the irreversible breakdown of respiration in an organism and the consequent loss of the ability to use oxygen. When respiration and heartbeat cease, oxygen is no longer inhaled and diffused by the lungs into the blood; when the heart fails, oxygenated blood no longer flows through the blood vessels.

When the body dies, cells in the higher brain centers, which are very susceptible to oxygen deprivation, die first. This usually occurs within 5–10 minutes after the supply of oxygen is cut off. Next to die are cells in the lower brain centers, including those in the medulla oblongata—the regulator of respiration, heartbeat, and other vital reflexes.

Thus, the death of a person does not occur all at once. Certain body structures, such as the thymus gland, deteriorate before the individual is fully mature. Old cells are constantly dying and being replaced by new cells, even before a person is born. The buildup and breakdown of body cells and structures, known as *anabolism* and *catabolism*, respectively, are complementary metabolic processes. As a person ages, the rate of breaking down begins to exceed that of building up. This point is reached earlier in some body structures than in others.

Cessation of the heartbeat is a natural result of brain death, but the brain is not always dead when the heart stops. The pumping action of a stopped heart can be restored before the vital centers of the brain are affected. Restoration of the heartbeat by electric shock (*countershock*) is a common procedure in modern hospitals. Unfortunately, if the heart has stopped for too long or for other reasons the blood supply

to the brain has been interrupted, the higher brain cells will be deprived of oxygen and their functioning disrupted. As a consequence, the sensorimotor and cognitive skills of the person may deteriorate to some extent.

The cells of certain glands and muscles die only after the medulla has stopped functioning, but skin and bone cells can live for several hours longer. The hair of a deceased person may still be growing several hours after heartbeat and respiration have stopped, and the nails on fingers and toes have often been found to continue growing even after interment. Other body processes that have been observed after the person has been pronounced clinically dead are the conversion of glycogen to glucose by the liver and the digestive actions of intestinal tissues. In fact, researchers have succeeded in keeping many body tissues alive for years after the death of the donor by keeping them in a special chemical solution.

Multiple Meanings of Death

Biological death is the most common meaning of the term *death*, but psychological death, social death, legal death, civil death, spiritual death, and certain other kinds of death have also been described. A person is said to be *psychologically dead* when his or her mind (seat of conscious experiencing and knowing) ceases to function. This could happen in a severe brain disorder or extreme cases of mental illness. A person is *socially dead* when other people act as if he or she is dead, as happened to Jean Auel's heroine Ayla in *The Clan of the Cave Bear.* An example of the distinction between biological, psychological, and social death is seen in catatonic stupor, an extreme form of withdrawal in which a person becomes immobile and unresponsive. On coming out of the stupor, the patient often reports that he or she was aware of remarks made about him or her and other events occurring in the immediate environment but simply could not react. It was as if the patient were paralyzed or restrained yet wide awake. During the stuporous state, the patient was biologically and perhaps psychologically alive but was treated by others as being not present or as dead (socially dead). Furthermore, an individual may be biologically dead and yet be talked about and reacted to as if he or she were socially alive. Many people continue to talk to (and argue with!) friends or relatives who have long been biologically dead but continue to exist in the mind of the speaker.

The idea of *legal death* refers to the judgment by a legal authority that a person is dead and therefore that his or her possessions may be distributed to the survivors or beneficiaries. In such instances, the individual may or may not be biologically dead, as when a person who is missing in action (MIA) or cannot be found for other reasons is declared legally dead. For example, many men who served in the Vietnam War and failed to return from combat or captivity within a specified period of time were declared legally dead.

Related to legal death is *civil death*, a term that is no longer used but in old English common law referred to a person who was not biologically (naturally) dead but had lost his or her civil rights. Persons who either joined a religious order or were convicted of a serious crime, declared insane, or banished from the state or nation could be declared legally dead.

Determination of Death

The definition and determination of death are not exclusively medical matters; ethical, legal, and economic considerations are also important. In certain legal cases, an exact moment of death must be established, difficult though it may be. Furthermore, legal, ethical (moral), and economic factors are involved in deciding when to "pull the plug" or stop treatment of a critically brain-damaged patient in an irreversible coma or when to attempt a costly heart transplant that may prolong life for a year or less. Physicians and medical researchers are concerned principally with the biological or medical aspects of death and dying, but they also must be sensitive to the legal, ethical, and economic ramifications of the treatments they provide.

Traditional Indicators of Death

Among the traditional clinical indicators of death are cessation of heartbeat and respiration; unresponsiveness of the eyes to light and of other sense organs to sound, touch, and pain; bluing of the extremities, particularly the mouth and lips. Signs of further progression in death include purplish-red discoloration of the skin (*livor mortis*), stiffening of the muscles (*rigor mortis*), and gradual decline in body temperature to that of the external environment (*algor mortis*).

Loss of sensorimotor functions in a dying person begins in the legs and spreads gradually to the arms. Sensitivity to pressure remains, but pain and other cutaneous sensations diminish. The decline in peripheral circulation often produces a drenching sweat, followed by a cooling of the body surface. A dying person, who may be conscious until the end, characteristically turns his or her head toward the light. Rigor mortis sets in about 2 hours after death and continues for about 30 hours.

Methods employed in previous times to determine death (no fogging of a mirror when placed near the mouth, no response to a feather placed on the nose, no constriction of the pupils to light, no reaction to a pinprick, etc.) were imperfect indicators and occasionally led to premature burial. Premature burials were more likely to occur during epidemics or wartime when, for hygienic reasons, there was a greater urgency to bury the dead and the determination of death was often a slipshod affair. As a result, many tales from the nineteenth century describe the fear and potential danger of being buried alive. A famous example is Edgar Allan Poe's fictional account of "The Premature Burial":

> *The wife of one of the most respectable citizens—a lawyer of eminence and a member of Congress—was seized with a sudden and unaccountable illness, which completely baffled the skill of her physicians. After much suffering she died, or was supposed to die. No one suspected, indeed, or had reason to suspect, that she was not actually dead. She presented all the ordinary appearances of death. The face assumed the usual pinched and sunken outline. The lips were of the usual marble pallor. The eyes were lustreless. There was no warmth. Pulsation had ceased. For three days the body was preserved unburied, during which it had acquired a stony rigidity. The funeral, in short, was hastened, on account of the rapid advance of what was supposed to be decomposition.*

The lady was deposited in her family vault, which, for three subsequent years, was undisturbed. At the expiration of this term it was opened for the reception of a sarcophagus;—but, alas! how fearful a shock awaited the husband, who personally threw open the door! As its portals swung outwardly back, some white-apparelled object fell rattling within his arms. It was the skeleton of his wife in her yet unmoulded shroud.

A careful investigation rendered it evident that she had revived within two days after her entombment; that her struggles within the coffin had caused it to fall from a ledge, or shelf to the floor, where it was so broken as to permit her escape. A lamp which had been accidentally left, full of oil, within the tomb, was found empty; it might have been exhausted, however, by evaporation. On the uttermost of the steps which led down into the dread chamber was a large fragment of the coffin, with which, it seemed, that she had endeavored to arrest attention by striking the iron door. While thus occupied, she probably swooned, or possibly died, through sheer terror; and, in falling her shroud became entangled in some iron-work which projected interiorly. Thus she remained, and thus she rotted, erect.[4]

The fear that one might accidentally be buried alive led to the practice of not burying the body of a deceased person until it began to putrefy, an indicator that was accepted during the last century as the only true test of death.

There are, of course, many cases in which a patient has been pronounced clinically dead but has "come back to life" before being buried. Furthermore, some people believe that a resurrection of the physical body is possible, even when a deceased person is not immediately restored to life. For example, occasionally there is a story in the newspaper about a deceased person whose body has been deep-frozen in liquid nitrogen at the time of death (*cryonics*) and is being kept in a special aluminum capsule. An article of faith of the American Cryonics Society is that a body preserved in this manner can be thawed and restored to life at some time in the future when a cure for the disease that caused the person's death is discovered. Whether those few bodies that are preserved in this manner can be restored to life with any semblance of the former self is debatable, but most biomedical authorities are dubious. Additional information about cryonics may be obtained from ALCOR Life Extension Foundation and the American Cryonics Society (see Appendix B).

Contemporary Indicators of Death

Although loss of heartbeat and respiration are the traditional medically accepted indicators of death, they are no longer considered sufficient. Emergency measures such as cardiopulmonary resuscitation (CPR) and countershock are frequently successful in restoring these functions, while artificial pacemakers, mechanical respirators, and heart-lung machines sustain them.

According to the laws of most states, a person is alive as long as a heartbeat and respiratory movements, no matter how they are maintained, can be detected. In states that have not passed legislation defining death, the definition is based on hospital policy. But because different hospitals may follow different procedural

BOX 1-1 • The Living Dead

The idea that people can exist in a state of suspended animation without actually being dead has fascinated popular writers and the general public for many years. Cases of catalepsy, in which partial or complete paralysis and loss of sensation occur, have been observed in certain physical and mental disorders (e.g., *catatonic schizophrenia*). Perhaps even more intriguing are so-called *zombies*, or the living dead. Originating in Africa, belief in zombies is a part of the Haitian voodoo religion. A candidate for "zombification" is reportedly administered a mixture of particular substances by a voodoo priest, or *bocor*. The candidate then apparently lapses into a state of low metabolic activity and appears to be clinically dead. Next, he or she is buried for two days or so in a shallow grave, exhumed at night, administered a hallucinogenic paste, and deprived of salt. The "soulless body" may then be sold into slavery, to work on a sugar plantation, for example.

Stories of zombies abound in Haiti, but with the possible exception of a few instances, such as that of Clairvius Narcisse, who was the subject of documentaries on BBC and ABC, most of these tales have not been verified. Some anthropologists and biochemists have conducted research on the nature of the *poud zombi*, the powder that is made by the bocors and fed to or rubbed on the skin of the person being made into a zombie. The powder may contain a mixture of extracts from the dried bodies of bufo frogs, extracts from the organs of blowfish and puffer fish, and various other substances such as a fatal cucumber, a pepper from the Orinoco, a snake from the Amazon jungle, stinging nettles, and even the fresh remains of a human cadaver! Although controversial, research conducted by the anthropologist Wade Davis (1983, 1988) has focused on the chemical tetrodotoxin, a poison that exists in small amounts in the liver and reproductive organs of puffer fish and in the fugu fish of Japan. The amount of tetrodotoxin, which blocks the sodium channels between nerve endings and can cause paralysis and even death, is critical. One in a dozen successes in producing a zombie is presumably sufficient to convince people in believing cultures that the bocors can create zombies.

definitions, it is conceivable that a resident of a particular state could be pronounced dead in one hospital and not in another.

During the past 25 years the concept of *brain death*, defined as the irreversible cessation of all functions of the entire brain and brain stem, has gained increasing credence. Brain death has now joined loss of circulation, cessation of breathing, and unresponsiveness to external stimuli as a criterion of death. Although most states have passed legislation linking legal death to brain death, the usual definition of death centers on the loss of *all* vital functions. Furthermore, the importance of indicators other than the loss of brain functioning varies from state to state.

The following four clinical indicators, known as the *Harvard criteria*, are accepted by the medical profession throughout the world in the determination of death or irreversible coma:

1. Unreceptivity or unresponsivity to touch, sound, light, and even the most painful stimuli that it is ethical to apply.

2. Absence of movements, notably those of spontaneous respiration, for at least 1 hour. Patients on respirators must not breathe by themselves for at least 3 minutes after the respirator is turned off.
3. Absence of reflexes, that is, no pupillary constriction to light; no blinking; no eye movements when ice water is poured into the ears; no muscular contractions when the biceps, triceps, or quadriceps tendons are tapped; no yawning or vocalizing.
4. A flat electroencephalogram (EEG) for at least 10 minutes (Ad Hoc Committee of the Harvard Medical School, 1968).

As pointed out by several commissions established to study and make recommendations pertaining to the determination of death, however, these four signs are not foolproof. For example, in patients who have severely overdosed on barbiturates or who are markedly hypothermic (body temperature below 90 °F), depression of both brain waves and respiration may be present. Consequently, it is recommended that the preceding four clinical indicators should be present for at least 24 hours before a final diagnosis is made (Ad Hoc Committee of the Harvard Medical School, 1968). Furthermore, it is recommended that determination of the irreversibility of death be made by two physicians. Because we are living in an era when heart, liver, and kidney transplants are commonplace, it is important that neither physician is a member of a transplant team that is considering the deceased as a potential organ donor. Although the likelihood is remote, it is possible that a physician may be so eager to obtain a viable transplant organ that the donor-patient is declared dead, or literally murdered, by oversight or even intent.

In cases of irreversible coma, the Harvard criteria are met. By equating irreversible coma with death, the application of heroic lifesaving measures may be suspended. Irreversible coma is indicated by a lack of responsiveness to external stimuli and a loss of normal reflexes that are controlled by the spinal cord and brain stem.

Certain states have adopted the concept of *brain death*—a flat EEG for at least 10 minutes—as the legal definition of death and a condition for the removal of donated organs for transplant purposes. Most states, however, still use the traditional definition of death as the cessation of all vital functions. In an attempt to provide some legal uniformity throughout the 50 states, the President's Commission for the Study of the Ethical Problems in Medical and Biomedical and Behavioral Research recommended in 1981 that the states adopt the following legal definition of death: "A person is to be considered dead if there is an irreversible cessation of circulation and breathing or irreversible cessation of all functions of the entire brain including the brain stem" (Rossiter, 1981).

Meanwhile, the problem of how to determine exactly when a patient has died or when lifesaving measures should be suspended has not been solved. The central recommendation of a 1988 report by the Hastings Center ("Guidelines on the Termination of Life-Sustaining Treatment and the Care of the Dying") was that the patient or a representative of the patient has the right to refuse or halt life-sustaining treatment (feeding tubes, blood transfusions, antibiotics, dialysis machines, ventila-

tors, etc.) that simply postpone death. Even so, the individual physician continues to bear a heavy responsibility for the final decision. To protect himself or herself, a physician should consult with the family of the dying person and obtain legal counsel before making a decision to suspend treatment.

DEMOGRAPHY, DEATH RATE, AND LIFE EXPECTANCY

One of the most important items of information on a death certificate is the cause of death. This item may be the primary cause, it may be one of many factors that contributed to the death of a person, or it may be wrong. In any event, causation is usually multiple rather than unitary. One factor that contributes to the death of many people is the gradual, intrinsic deterioration of cells and tissues with aging and trauma. Other, more extrinsic factors include severe accidents, murder, and suicide. In certain cases, the causes of death are clear, but in many instances there are several complex, interacting causes which may or may not be understood. Whether singular or plural, the causative factors in the death of a person may or may not be known. This is more likely to be true for very old people, with whom it is often difficult to identify a single, specific cause of death. Furthermore, a less stigmatizing or less basic condition, such as pneumonia rather than AIDS, may be reported as the cause of death. In any event, the causes of death vary with age, sex, nationality, socioeconomic status, and other demographic variables.

Demography

Before discussing the various causes of death in detail (specifically in Chapters 2 through 4), it will be helpful to provide some knowledge of the terminology and methods of *demography*. This science, which began with the work of John Graunt in the midseventeenth century, is concerned with examining both the structural (distributions by age, sex, marital status, etc.) and dynamic factors (births, deaths, migratory patterns, etc.) in human populations. The *mortality table* (life table), a listing of the number of deaths occurring between successive birthdays in a group of people born in the same year, was introduced by Graunt.

Other people in the eighteenth and nineteenth centuries also contributed to the science of demography. Sir Edmund Halley, a famous eighteenth-century astronomer who was immortalized when a comet was named after him, was the first person to conduct scientific analyses of life expectancy. In the nineteenth century, the Belgian scientist Adolphe Quetelet conducted statistical studies of death rates and suicides and their relationships to chronological age. A statistical concept known as the *Gompertz law,* which holds that mortality rates increase exponentially with age, was proposed by British actuary Benjamin Gompertz in 1825.[5]

The efforts of these men and other pioneers led gradually to the establishment of civil registries of births, deaths, marriages, and other demographic events. The

availability of this information, especially mortality tables, was important to the growth of life insurance companies during the nineteenth century. Today, most nations of the world have a bureau of demography or center for health statistics that is assigned the task of keeping track of the vital statistics of the population.

Civil Registries

Until the early nineteenth century, there were no central governmental registries for recording births, deaths, and marriages. Such information was usually kept by local church registries and was often highly inaccurate. The accurate, centralized registration of vital statistics began much earlier in France, Britain, and other European countries than in the United States, which was a rapidly changing nation with many sectional and religious differences. A "Death Registration Area," comprising 10 states, the District of Columbia, and a few major cities, was constituted in 1900, but it did not include the entire nation until 1933 ("Vital Statistics," 1991). During the past 60 years such registration has provided valuable information to government officials and other interested parties about population trends and has helped guide national policy on public health and other civil matters.

Crude Rate

Demographic analysis, as practiced today, is concerned with the quantitative analysis of vital statistics and census information. Birth, death, marriage, and divorce rates are determined from certificates prepared locally and submitted to state and federal governments. An important unit in demographic analysis is the *crude rate,* which is the ratio of the number of events occurring in a given year to the total population size. The crude rate of a given event is stated in terms of so many events per 1,000 or 100,000 population. Crude rates of marriages, divorces, births, and deaths are of particular interest to social scientists.

Annual death rates in the United States are not calculated on the entire population. A 10 percent systematic sample of death certificates received each month in the 50 states, the District of Columbia, and the independent registration area of New York City is selected. Then the death rates for the entire nation are estimated from this sample (National Center for Health Statistics, 1992a). Sex, age, ethnicity, and other demographic characteristics of the population are disregarded in calculating crude death rates.

The overall estimated crude death rate in the United States in 1992 was 8.5 per 1,000 population, the same as the rate for 1991 (National Center for Health Statistics, 1993). The estimated life expectancies of males and females born in 1991 were 72.2 and 79.1, respectively (National Center for Health Statistics, 1992a), figures that are projected to rise to 73.5 and 80.4 by the year 2000 and to 76.4 and 83.3 by 2050 (U.S. Senate Special Committee on Aging et al., 1991). The overall crude death rate is not the only way of describing the rate of occurrence of death in a specified population during a given year. In fact, by failing to take the age structure of a population into account, it can be misleading. Crude death rates, for example, are often higher in more highly developed countries with large numbers of elderly people.

Age-Specific and Age-Adjusted Rates

One way of taking the age distribution of the population into account in reporting mortality statistics is by determining age-specific death rates. *Age-specific death rates* are crude rates computed separately for each of several designated chronological age groups, and they depict how the death rate varies with the age of a population. The computation of *age-adjusted death rates,* which take into account the dependency of death rate on chronological age, is more complex than the computation of crude rates or age-specific rates. The National Center for Health Statistics computes age-adjusted death rates by applying the age-specific death rates for age groups to the standard (1940) population distribution by age. Age-adjusted rates are considered more useful than crude rates in analyzing the rate of change in a dynamic characteristic (such as births, deaths, marriages, and divorces) of a population from one year to the next.

Life Expectancy

Another important demographic index is *life expectancy,* the average life span in years of people born in the same calendar year. Life expectancy may be computed at birth, at age 65, or at any other age. For example, life expectancy at birth is the average number of years that a group of infants can be expected to live, assuming that they are subjected to the age-specific death rates existing in the year of their birth. This assumption is risky, but life expectancy projections are fairly accurate over a span of a few years. They become more tentative as the time period over which they are projected increases. Life expectancy may be determined for the population as a whole or separately for different demographic groups (e.g., males versus females, blacks versus whites, the poor versus the affluent).

Age and Cause of Death

Both the rate and cause of death vary with chronological age. In 1992, the death rate per 1,000 population varied from approximately 8.4 in infancy to less than .5 in childhood and early adolescence. It rose gradually from late adolescence to the beginning of middle age, subsequently accelerating to over 140 by age 85 and over (see Figure 1-1). Despite their high death rate, the *oldest old* Americans, those 85 and over, are the fastest-growing age group in the American population. While the U.S. population as a whole grew by 39 percent from 1960 to 1989, the number of Americans 85 and over increased by 233 percent. In the 85-and-over group, women outnumber men by two to one; about 39 percent of women and 21 percent of men can expect to reach their eighty-fifth birthday (U.S. Bureau of the Census, 1989).

The age distribution of deaths has changed dramatically since the founding of the United States, when most deaths occurred in children under age 15. An estimated 20 percent of children born in 1776 survived to old age, whereas 80 percent of those born 200 years later could expect to reach age 65. With improved obstetrical care and breakthroughs in combatting infectious diseases, the infant death rate per 1,000 live births in the United States has continued to decline since the midtwentieth century from 29.2 in 1950 to 26 in 1960, 20 in 1970, and 8.5 in 1992. The figure for 1992 was the lowest rate of infant mortality ever recorded in the United States. The

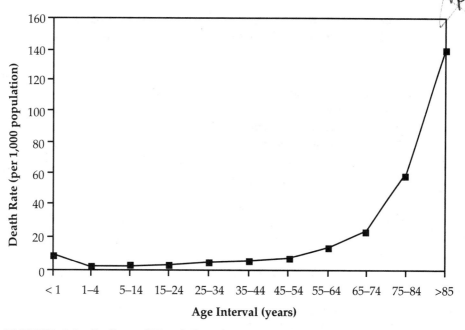

FIGURE 1-1 Estimated Death Rate by Age Interval, 1992

Source: Data from National Center for Health Statistics, 1992. *Monthly Vital Statistics Report, 41*(12). Hyattsville, MD: U.S. Department of Health and Human Services.

decline in infant mortality has been accompanied by a lowering of the death rate among women during pregnancy and childbirth. Despite the declines in mortality, life expectancy is higher and infant mortality rate lower in several European countries and Japan than in the United States.

As shown in Table 1-1, the most common cause of death among the estimated 2,189,000 people who died in the United States in 1992 was heart disease, followed in frequency by malignant neoplasms (cancer) and cerebrovascular diseases (stroke). The numbers in this table are based on a 10 percent sample of deaths; the estimated death rates are per 100,000 population.

Because of the declines in infant mortality and infectious diseases during childhood, dying in the United States is now more characteristic of the very old than the young and middle aged. The major killers of yesteryear—infectious diseases such as influenza, pneumonia, and tuberculosis—affected all age groups but especially children. These infectious disorders have given way to chronic conditions such as heart disease, cancer, and stroke as the leading causes of death (Table 1-2). Due to advances in the treatment of the last three disorders, which attack older people more often than young, smaller percentages of older people are dying of heart disease, cancer, and stroke than ever before. Nevertheless, these diseases remain the leading causes of death among the elderly. Teenagers and young adults,

TABLE 1-1 Estimated Deaths, Death Rates, and Percent of Total Deaths for 15 Leading Causes of Death in the United States in 1992

Rank	Cause of Death	Number	Death Rate[a]	Percent of Total Deaths
1	Diseases of heart	722,770	282.3	33.0
2	Malignant neoplasms	521,710	203.8	23.8
3	Cerebrovascular diseases	143,650	56.1	6.6
4	Accidents and adverse effects	85,500	33.4	3.9
5	Chronic obstructive pulmonary diseases and allied conditions	92,070	36.0	4.2
6	Pneumonia and influenza	77,450	30.3	3.5
7	Diabetes mellitus	50,750	19.8	2.3
8	Suicide	28,740	11.2	1.3
9	Human immunodeficiency virus infection	31,770	12.4	1.4
10	Homicide and legal intervention	25,930	10.1	1.2
11	Chronic liver disease and cirrhosis	24,980	9.8	1.1
12	Nephritis, nephrotic syndrome, and nephrosis	23,020	9.0	1.0
13	Septicemia	20,030	7.8	0.9
14	Atherosclerosis	16,390	6.4	0.7
15	Certain conditions originating in the perinatal period	15,630	6.1	0.7

Source: National Center for Health Statistics, 1993. *Monthly Vital Statistics Report, 41*(12). Hyattsville, MD: U.S. Department of Health and Human Services.
[a]Per 100,000 population.

on the other hand, are now more likely to die from accidents, especially accidents involving motor vehicles. Suicide and homicide, although not epidemic, are also significant causes of death in young people.

The following list summarizes the leading causes of death by age in the United States during 1991:

- Infancy (0–1 years)—certain conditions originating in the perinatal period, accidents and adverse effects, diseases of heart, pneumonia and influenza, diabetes mellitus
- Childhood (1–14 years)—accidents and adverse effects, homicide
- Adolescence and early adulthood (15–24 years)—accidents and adverse effects, homicide and legal intervention, suicide
- Adulthood (25–64 years)—cancer, heart disease, accidents and adverse effects, pulmonary diseases, pneumonia, diabetes

TABLE 1-2 Leading Causes of Death in the United States in 1900, 1940, and 1990

Rank	1900	1940	1990
1	Influenza and pneumonia	Heart diseases	Heart diseases
2	Tuberculosis	Cancer	Cancer
3	Gastroenteritis	Stroke	Stroke
4	Heart diseases	Accidents	Accidents
5	Stroke	Kidney diseases	Chronic pulmonary diseases
6	Kidney diseases	Influenza and pneumonia	Pneumonia and influenza
7	Accidents	Tuberculosis	Diabetes
8	Cancer	Diabetes	Suicide
9	Diseases of early infancy	Atherosclerosis	HIV infection
10	Diphtheria	Syphilis	Homicide

Sources: Population Reference Bureau, n.d. *Major causes of death in the United States, 1900–1975.* Washington, DC; and National Center for Health Statistics, 1992, *Monthly Vital Statistics Report, 40* (13). Hyattsville, MD: U.S. Department of Health and Human Services.

- Old age (65 years and older)—heart disease, cancer, cardiovascular disease, accidents and adverse effects, chronic obstructive pulmonary disease, pneumonia, influenza, diabetes mellitus, suicide.

Time of Death

The decline in infectious diseases in the United States had led to a steady reduction in the death rate and an increase in life expectancy. Life expectancy for an average American increased from approximately 47 years for someone born in 1900 to 75.4 years for one born in 1991. Going even further back in time, life expectancy is estimated to have been around 22 years during the time of the Roman Empire, 33 years in England during the Middle Ages, and only 36 years in the 13 colonies at the time of the American Revolution (see Figure 1-2).

The sharp rise in life expectancy during the nineteenth and twentieth centuries is attributable not only to the conquest of infectious diseases but also to significant improvements in food supply and shelter and to a less hazardous lifestyle in general. Advances in technology and improvements in production, distribution, and transportation are major reasons for the longer life expectancy and safer living

Time Period

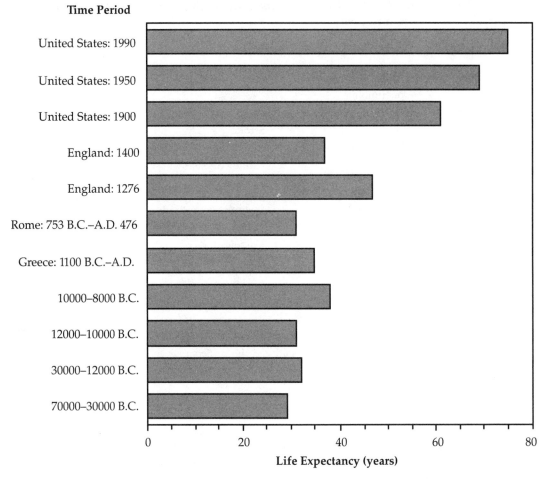

FIGURE 1-2 **Life Expectancy Throughout History**

Source: Data from Cutler, 1976.

conditions of today. Unfortunately, modern technology has liabilities as well as benefits. The effects of air, water, and ground pollution on the environment and on the health of human beings are a heavy price to pay for a more comfortable, predictable existence. It might be concluded that modern humans have traded early death from infectious diseases for later death from cancer. But it is doubtful that anyone who suffered through the epidemics of bubonic plague, cholera, influenza, poliomyelitis, and mass starvation of former times would view the exchange as an unfavorable one.

Monthly Mortality
Time, in a more restricted sense, is also related to mortality. As shown in Figure 1-3, the death rate in the United States is higher during the cooler months of winter and

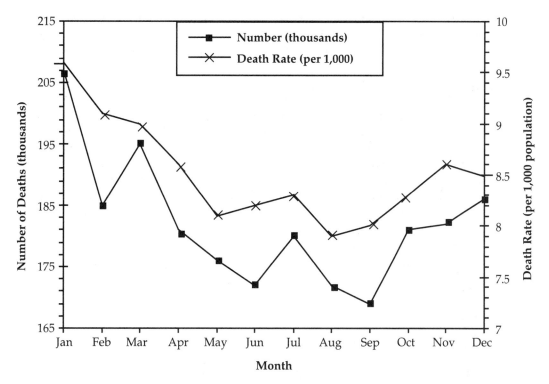

FIGURE 1-3 Number and Rate of Deaths by Month, 1992

Source: Data from National Center for Health Statistics, 1992. *Monthly Vital Statistics Report, 41* (12). Washington, DC: U.S. Department of Health and Human Services.

early spring than during the warmer months of summer and early fall. One reason for the monthly variation in death rate is the greater incidence of influenza and other cold-weather diseases during cooler periods, a change that may account in part for the mass exodus of the U.S. population to the Sunbelt states.

Ceremonial Occasions

There is some evidence that time of death is related to important events (birthday, holidays, etc.) in the dying person's life. For example, Phillips found evidence of fewer deaths than expected before three ceremonial occasions—presidential elections, the Jewish Day of Atonement, and the person's birthday. It was suggested that some people literally postpone dying until occasions of great personal significance to them are over (Phillips, 1975; Phillips & Feldman, 1973). It is noteworthy that both Thomas Jefferson and John Adams died on the Fourth of July (in the same year!)[6] and that Mark Twain died on the eve of the arrival of Halley's Comet—the date on which he had predicted he would die.

The reasons for these occurrences are far from clear, and the findings of Phillips and others have been criticized on methodological grounds (Schultz & Bazerman,

1980). Attitude or state of mind is unquestionably an important factor in the progress of an illness, but whether a dying person can delay his or her death by an act of will has not been demonstrated conclusively.

Place of Death

Life expectancy and death rate also vary with geographical location. Recent estimates of crude death rate, infant mortality rate, and life expectancy in various regions of the world are given in Table 1-3. Note that all three of these indices are related: More often than not, a high death rate is accompanied by a high rate of infant mortality and a shorter life expectancy. Higher death rates and lower life expectancies are more characteristic of less-developed nations, such as those in

TABLE 1-3 Mortality Statistics for the World Population in 1991

Region or Country	Crude Death Rate[a]	Infant Mortality Rate[b]	Life Expectancy at Birth (years)[c]
Africa	14	99	52/55
Northern Africa	8	72	59/62
Western Africa	17	111	48/50
Eastern Africa	15	110	50/53
Middle Africa	15	97	49/53
Southern Africa	8	57	60/66
Asia	9	68	63/66
Western Asia	8	63	64/68
Southern Asia	11	95	58/58
Southeast Asia	8	61	60/64
East Asia	7	32	69/73
North America	8	9	72/79
Latin America	7	54	64/70
Central America	6	50	65/71
Caribbean	8	54	67/71
South America	7	56	64/70
Europe	10	11	71/78
Northern Europe	11	9	72/79
Western Europe	10	7	73/79
Eastern Europe	11	17	67/75
Southern Europe	9	12	72/79
Former USSR	10	39	65/74
Oceania	8	33	69/75
Entire World	9	68	63/67

Source: Population Reference Bureau, Inc., April 1992. *1992 World Population Data Sheet.* Washington, DC.
[a]Per 1,000 population.
[b]Per 1,000 live births in a given year.
[c]Numbers are ratio of life expectancy for males to life expectancy for females.

Africa and Southern Asia, and less characteristic of the more highly developed, technologically based nations of Europe and North America. However, in 1990, the United States ranked eleventh in life expectancy at 75.4 years, significantly below Japan, the world leader at 78.9 years, and Iceland at 78.0 years.

Variations in death rate among different areas or sections of a particular country are perhaps less impressive that those among different countries, but they are still interesting. The death rate in the United States in 1991 ranged from a low of 4.0 in Alaska to a high of 11.9 in the District of Columbia (Table 1-4). The reasons for these differences in death rate are complex, involving interactions among age distribution, culture, climate, socioeconomic status, and other demographic and situational variables.

Place of death can be narrowed down further to exactly where people within a particular locality die. In the early years of the twentieth century, most people in the United States died at home. But the number of home deaths had fallen to 50 percent by 1949, to 40 percent by 1958, and to less than 25 percent by 1980 (Lerner, 1980; Veatch & Tai, 1980). Today, most people die in hospitals, nursing homes, or other institutions, and the percentage of institutional deaths continues to rise.

GROUP DIFFERENCES IN LIFE EXPECTANCY

Longevity and life expectancy vary with demographic variables such as sex, marital status, and ethnicity, as well as individual differences in exercise, diet, personality, and heredity.

Sex Differences

The death rate has declined and life expectancy has increased steadily for both sexes during this century, but the changes have been more pronounced for women than for men. The age-adjusted death rate per 100,000 U.S. population in 1991 was 660.1 for males and 382.1 for females. In every age category, the death rate was higher for males than for females but especially during adolescence and early and middle adulthood. Similarly, life expectancy at birth, which in 1900 was 51.1 years for white American females and 48.2 years for while American males, had increased to 72.2 for females and 66.5 for males by 1950 and to 79.7 for white females and 73.0 for white males by 1991 (National Center for Health Statistics, 1992a). The corresponding figures for all races are not available for 1900 but were 71.1 years for females and 65.6 years for males in 1950 and 79.1 years for females and 72.2 years for males in 1991.

There has been much speculation and some research on why females have a lower death rate and a longer life expectancy than males. Fewer women die in childbirth than ever before, but this fact alone cannot account for the size of the sex difference in mortality. It is also true that, compared with men, women usually have greater resistance to infectious diseases and degenerative conditions such as atherosclerosis. The major killer diseases of today—heart disease, cancer, and stroke—are

TABLE 1-4 Number of Deaths and Rate by State in 1991

State or District	Number of Deaths	Death Rate[a]
Alabama	38027	9.2
Alaska	2145	4.0
Arizona	29329	7.9
Arkansas	24230	10.0
California	218735	7.2
Colorado	22334	6.7
Connecticut	27745	8.5
Delaware	5880	8.4
District of Columbia	6961	11.9
Florida	135280	10.1
Georgia	52708	7.9
Hawaii	6715	5.9
Idaho	7789	7.5
Illinois	104389	8.9
Indiana	51780	9.1
Iowa	25906	9.1
Kansas	22511	8.8
Kentucky	35281	9.5
Louisiana	38290	8.8
Maine	10952	8.7
Maryland	37982	7.9
Massachusetts	51366	8.6
Michigan	79972	8.6
Minnesota	35270	7.9
Mississippi	25625	9.8
Missouri	53961	10.3
Montana	7071	8.8
Nebraska	14665	9.0
Nevada	9243	7.5
New Hampshire	8513	7.4
New Jersey	69983	9.0
New Mexico	11116	7.1
New York	166795	9.2
North Carolina	58909	8.7
North Dakota	5648	8.7
Ohio	99104	9.0
Oklahoma	30349	9.5
Oregon	25205	8.6
Pennsylvania	123536	10.2
Rhode Island	9294	9.2
South Carolina	29983	8.3
South Dakota	6594	9.2
Tennessee	45351	9.0
Texas	128926	7.4
Utah	9199	5.3
Vermont	4541	7.7
Virginia	49150	7.8
Washington	37682	7.6
West Virginia	19801	10.9
Wisconsin	43749	8.9
Wyoming	3167	6.8

Source: National Center for Health Statistics, 1992. *Monthly Vital Statistics Report, 40* (13). Hyattsville, MD: U.S. Department of Health and Human Services.
[a]Per 1,000 population. Note that the rates are computed for the states or district in which individuals died, which are not necessarily where their legal residences were located.

also more common in men than women. One possible explanation for these sex differences is that, because of their two X chromosomes and unlike men with their single X chromosome, women can offset a defective X chromosome and hence are less susceptible to birth defects and genetic diseases carried by a defective X chromosome.

Hormonal differences also may contribute to the greater susceptibility of males to certain physical disorders. For example, the female hormone estrogen may provide women with some protection against hardening of the arteries in old age (Retherford, 1977). Interestingly enough, women who have borne children tend to live longer than childless women. The greater longevity of childbearing women has been attributed to an increased secretion of estrogens (see Woodruff, 1977). Another sex hormone, testosterone, is secreted in far greater amounts by males than by females. By promoting blood clotting, testosterone is useful when a person is injured by an animal or human antagonist but not when it causes a blood clot in a coronary artery.

Differences in lifestyle between the sexes are also considered important. Although the difference is diminishing, women tend to smoke less than men. Women also consult physicians and follow their instructions more often, experience less exposure to industrial pollutants and hazards, handle stress more effectively, and have better social supports. As the lifestyles of women become more similar to those of men, sex differences in life expectancy should become smaller. This supposition is supported by the greater increase since 1971 in expectation of life at birth among boys than among girls ("U.S. Longevity at a Standstill," 1992). Concerning the role of smoking in life expectancy, a statistical study of residents of Erie County, Pennsylvania, found that, after eliminating those people who died because of accident, suicide, or homicide, the life expectancy figures for nonsmoking men and women were almost identical (Miller & Gerstein, 1983).

Differences in lifestyle, however, cannot explain why the sex difference in mortality occurs in infancy and even before birth. More male fetuses than female fetuses die before term, and more boys than girls die during the first year of life. Before it became possible to determine the sex of an unborn child by amniocentesis, some enterprising gamblers reportedly found it profitable to bet that the sex of an unborn child was male. This was a safe bet, considering that the odds of having a baby boy are about 105 to 100. Because boys are more susceptible to diseases of infancy than girls, this ratio declines to about 100 to 100 by the first year of life. A further drop in the ratio of males to females during adulthood and old age results in there being at least twice as many elderly women as elderly men.

Marital Status

Also of interest with respect to sex differences in mortality and longevity are the effects of marital status. In general, married people live longer than unmarried people. The difference in longevity between married and unmarried men is, however, much greater than that between married and unmarried women. Men who are

residing with their wives tend to live longer than widowers, but the difference in longevity between married women and widows is insignificant.

Several explanations for why marriage appears to protect men have been offered. For example, older married men are more likely to have adequate nutrition and much-needed emotional support than widowers and other unmarried older men. Since these factors have positive effects on physical health, married men tend to recover from illness more quickly than single men and widowers (Atchley, 1977; Gove, 1973). Another possible reason for the greater longevity of married men was offered by Gove (1973): Unmarried men usually have fewer social ties and lower social status than married men.

Compared with those of married men, the roles of married women are more confining and frustrating. On the other hand, widows, divorcees, and single women have as many interpersonal ties as married women. Unattached single women may have even higher social status since they are not subjected to the physical and psychological demands of married life. Thus, from a psychological viewpoint, women are seen as benefiting less from being married and suffering less than men from being single.

Kobrin and Hendershot (1977) tested Gove's (1973) thesis concerning the importance of social ties to longevity in a national sample of people who had died between the ages of 35 and 74. They found a complex interaction in the relationships of sex, marital status, and living arrangements to mortality rates. Among men, those who were heads of families lived longest, followed by those who were living in families but not as heads. Men who lived alone had the lowest average longevity. Among women, those who were heads of families lived longest, but in contrast to men, women who lived alone had the second-highest longevity. Lowest of all women in average longevity were those who lived in families but not as heads.

The findings of Kobrin and Hendershot (1977) are generally consistent with those of Gove: Close social ties and higher social status, which are more likely to occur within marriage than outside it, favor greater longevity. This is truer for men, however, than for women. Unmarried men usually have fewer social ties and lower social status than married men, but unmarried women usually retain their interpersonal ties and may have even higher social status than they would as dominated members of families.

Social Support

Whether or not a person is married, the results of certain studies suggest that loneliness may have as great an impact on the death rate as drinking, eating, smoking, and exercise. The findings of studies conducted in Alameda County, California, suggest that social isolation is at least as strongly related as cigarette smoking and lack of exercise to mortality (Berkman & Syme, 1979). Additional evidence for the importance of social interactions in promoting longevity was obtained in a study conducted in Tecumseh Community, Michigan (House, Robins, & Metzner, 1982). These researchers found that married men who were involved in active rather than passive leisure activities and women who attended church often

but rarely watched television had lower mortality rates than less socially active people.

The results of both the Alameda County and Tecumseh Community studies underscore the health benefits of social support and the health risks of social isolation. The precise reasons for the relationship between social support and health remain unclear, however. One possible explanation is that social support includes advice concerning good health practices: that a sick person should go to the doctor, comply with medical advice by taking appropriate medication, watch his or her diet, and engage in other healthful practices. In addition, interactions with other people can provide encouragement, give a person a greater sense of personal control, and buffer him or her against stress (Satariano & Syme, 1981). Which of these factors, or others, contribute most to health and survival is, however, not clear.

Ethnic Group Differences

Another important demographic variable related to longevity and life expectancy is ethnicity. In order of decreasing life expectancy, Asian Americans, blacks, Hispanics, and Native Americans have shorter life spans than whites in the United States (U.S. Bureau of the Census, 1989). As depicted in Figure 1-4, on the average the lives of black males born in 1991 will be an estimated 7.4 years shorter than those of white males, and the lives of black females born in that year will be an estimated 5.4 years shorter than those of white females. Among the reasons for the shorter life expectancy of blacks is inadequate health care, poorer nutrition, and poorer living conditions. In addition, hypertension is more than twice as common among black Americans as among white Americans. However, in recent years the life expectancy of black Americans has been increasing more rapidly than that of white Americans. Furthermore, the life expectancies of black men and women who reach age 65 are nearly equal to those of their white counterparts (U.S. Department of Health and Human Services, 1987; National Center for Health Statistics, 1992a). Also noteworthy is that the life expectancies of several other minority groups in the United States, Mexican Americans and Native Americans in particular, are even lower than those of blacks.

Differences between the life spans of whites and minorities living in the United States are due primarily to environmental factors. This can be seen in the relationship of improved nutrition and medical care to greater gains in life expectancy of nonwhites than of whites. Poverty, poor education, inadequate housing and unsanitary living conditions, malnutrition, lack of health care or failure to use available services, and hazardous working conditions are all more common among nonwhite than white Americans.

Socioeconomic Status

As the socioeconomic status of minorities rises, more nourishing food, better housing, improved medical care, and a higher educational level result and create a narrowing of the longevity gap. Socioeconomic status is related to life expectancy

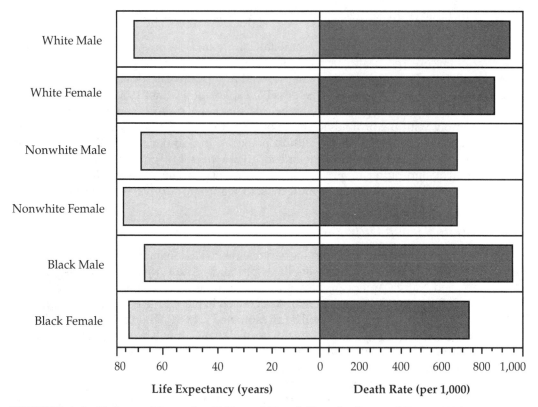

FIGURE 1-4 Estimated Length of Life and Death Rate by Sex and Race, 1991

Source: Data from National Center for Health Statistics, 1992. *Monthly Vital Statistics Report, 40* (13). Hyattsville, MD: U.S. Department of Health and Human Services.

and death rate in all ethnic groups. Sometimes the reason for the relationship is patently obvious, as when the supposedly unsinkable steamship *Titanic* struck an iceberg on the night of April 14–15, 1912. Only 705 of the 2,200 persons on board survived, and most of these were women and children. "The official casualty lists showed that only four first-class female passengers (three voluntarily chose to stay on the ship) of a total of 143 were lost. Among the second-class passengers, 15 of 93 females drowned. And among the third class, 81 of 179 female passengers went down with the ship" (Lord, 1955, p. 107). As in wartime, it was the less affluent who bore the brunt of the *Titanic* disaster.

Although mass food production, modern technology, and modern medicine have done much to reduce social class differences in mortality, such differences remain. The differences are greater when mortality rates are high, as in underdeveloped countries. With respect to age, social class differences in mortality tend to rise until the middle years, reaching a peak from ages 30–44 and declining thereafter.

Infant, child, and young adult death rates are all higher in lower-class groups. This is because communicable diseases such as influenza, pneumonia, and other infectious conditions are more common in infancy, childhood, and young adulthood and higher among poor people. For example, mothers living in poverty have smaller babies, and smaller babies are more likely to die in infancy. This is reflected in the fact that the infant mortality rate in the United States in 1990 was 814.4 for whites and 1,652.5 for blacks (National Center for Health Statistics, 1991).

Chronic degenerative disorders such as heart disease, cancer, stroke, and other so-called white-collar diseases are common among the middle class and during middle and late life. These disorders, which are less common among blue-collar workers, are not attributable to inadequate medical care or poor nutrition, but rather to an overly rich lifestyle. Blue-collar workers are more likely to escape the problems associated with poverty during early infancy, childhood, and young adulthood, in addition to degenerative diseases during middle age caused by an overly rich lifestyle. As a result, blue-collar workers in the United States appear to have it better from a health standpoint than either the poverty class or the middle class.

Another factor that may affect the health of impoverished or lower-class people in the United States is that they are treated differently by medical personnel. For example, a study conducted by the National Cancer Institute found that impoverished Americans, lacking access to qualified health care, are more likely than other Americans to die needlessly from cancer because of inadequate diagnoses (Cimons, 1989). And in a study of efforts made to resuscitate victims of cardiac arrest, it was found that the lower the apparent socioeconomic status of the victim, the less energetic were resuscitation efforts made by medical personnel (Simpson, 1979). Other factors, such as the perceived moral character and age of the victim, also appear to affect the extensiveness of resuscitation efforts.

PUBLIC AND PROFESSIONAL INTEREST IN THANATOLOGY

Research and writings on demographic variables related to death and dying are only one indicator of the death awareness movement of the past three decades. What was formerly something of a taboo topic has become the subject of extensive study and debate. Death is a now a popular topic of discussion, not only among physicians, clergy, and psychologists but among specialists in many other disciplines, professional writers, and laypersons. Spurred by documentaries and fictional accounts in the media concerned with death and dying, interest in the topic has grown substantially since the 1950s. Hundreds of articles and books dealing with the results of medical, psychological, anthropological, and sociological studies of death and dying have been published. Responding to this growing volume of literature, a number of periodicals devoted exclusively to death, dying, and bereavement, including *Omega: The Journal of Death and Dying, Advances in Thanatology,* and *Death Studies,* are now published (see Appendix A).

In addition to reports of empirical investigations, there has been an increase in theoretical and other speculative writings on matters related to death and dying. Creative works of literature and art pertaining to the topic are also numerous. The demand for academic courses and course units devoted exclusively to the topic, not only at the college level but also in elementary and secondary schools, has increased. Some universities report that courses on death and dying are almost as popular as those on human sexuality! Students who take courses on death and dying read and talk about death, listen to recordings made by dying people, view films and video recordings concerned with the topic, draw pictures or write poems illustrating their ideas about death, plan their own funerals, write their own obituaries and epitaphs, and take field trips to funeral homes, cemeteries, hospices, nursing homes, and special care units within hospitals for critically ill children and adults. These activities not only provide information but also help students become more aware and accepting of their own mortality and more sensitive to the needs of the dying.

Events Promoting an Interest in Thanatology

What factors are responsible for the growing interest in a seemingly rather depressing topic such as death? To begin, it should be pointed out that *thanatology*, the study of death and dying, is an interdisciplinary field. In addition to medicine, nursing, and the other health professions, it involves the biological sciences (biology, physiology, biochemistry), the social sciences (psychology, sociology, anthropology, political science, economics), the humanities (history, philosophy, literature, art), and even business. The contributions of each of these disciplines to an understanding of death are considered in various chapters of this book.

The impetus for the death awareness movement has come from cooperative efforts and interchanges among specialists in many disciplines. Especially noteworthy in medicine and psychology are the research and writings of Elisabeth Kübler-Ross. Kübler-Ross's 1969 book, *On Death and Dying*, which introduced her conception of psychological stages in the dying process, has been particularly influential in stimulating interest in the field. However, the fact that Kübler-Ross's work has been so popular in both professional and lay circles suggests something about the social climate in the United States during the 1960s and 1970s. This was a time of nightly newscasts depicting the gore of war and describing it in terms of "body counts" of people who were "wasted." It was a time when students were interested in subjectivism, Eastern religions, holocaust (genocide) studies, and the dangers of nuclear war. There was wider public acceptance of freedom of individual expression in behavior and alternative lifestyles than before or since. The elderly population was growing, the average age of the American population as a whole was increasing, and scientists were beginning to understand the biology of aging and dying. It was also a time when Karen Ann Quinlan and other irreversible-coma victims prompted the medical profession to reexamine its definition of death. All these events, collectively and interactively, contributed to an increased interest in death, dying, and survival.

Organizations Concerned with Death, Dying, and Survival

Many professional, governmental, and lay organizations are concerned in part or exclusively with death, dying, and their repercussions. The names and addresses of many of these organizations are listed in Appendix B. Most of the organizations publish some kind of newsletter or professional journal (see Appendix A), and many of them hold annual meetings or conventions.

Certain professional and lay organizations focus on a specific concern or interest, such as cancer, capital punishment, euthanasia, grief, hospice care, near-death experiences, pain control, suicide, or widowhood. Many national organizations have local chapters, and there are also many independent local societies. For example, locally run cryonics societies (Bay Area Cryonics Society, Cryonics Society of San Diego, ALCOR Life Extension Foundation, etc.) preserve deceased persons by freezing them to the temperature of solid carbon dioxide. It is possible, but rather unlikely, that the frozen corpses will be thawed and restored to life sometime in the future when cures for the terminal illnesses from which the persons died have been discovered.

There are also organizations concerned with the commercial and political aspects of death and dying. Innumerable associations of nursing homes, funeral homes, and other business establishments are associated with death and dying. Almost every American town has at least one funeral home, and there are over 25,000 nursing homes in the United States. As a result, national organizations of these businesses are quite effective in influencing legislation pertaining to their affairs.

Research on Death and Dying

Much of the research and training associated with death and dying is conducted at university-based centers such as the Center for Death Education and Research at the University of Minnesota. These activities are financed by private foundations and by state and federal government agencies. The research and educational activities of publicly and privately funded organizations concerned with death, dying, bereavement, and widowhood are considered in greater detail in appropriate chapters of this book. This research has been conducted by medical scientists, psychologists, sociologists, and other specialists. The medical aspects of diseases that lead to death are, of course, primarily the province of physicians and other medical specialists. However, research on the role of psychological factors in dying, how to help dying people in their efforts to cope with death, and grief therapy for the survivors require the skills of psychological scientists. Epidemiological studies of lifestyles and other social factors that contribute to disease and death, in addition to cross-cultural studies of the causes of death in different countries and cultures, require the contributions of sociologists, psychologists, and medical researchers. Other research concerned with the causes, progress, and outcomes of various disorders that lead to death may also become a team effort.

Many methods have been employed in scientific investigations of death and dying. The *experimental method*, in which certain variables are manipulated in a controlled manner to determine their effects on respondents, is used less often than observational, interviewing, correlational, and survey methodologies. Although only the experimental method can be relied upon to provide cause-effect information, the other methods are useful in suggesting causes or at least connections between variables. Both experimental and nonexperimental procedures may be used in longitudinal and cross-sectional studies. In a *longitudinal study*, a group of people is followed over a period of time to determine the effects of some manipulated or naturally occurring variable on the behavior or condition of the group members. In a *cross-sectional study*, people of different ages are compared at a certain point in time to yield information on age or cohort[7] differences in behavior and other characteristics. Combinations of the longitudinal and cross-sectional approaches, by separating the effects of time and cohort differences, can provide even more useful information than either approach alone.

A distinction is also made between prospective studies and retrospective studies. In a *prospective study*, people who are exposed to certain conditions or influences or who possess certain behaviors or characteristics at one point in time are reexamined at a later point in time to see how they have changed or developed. Thus, in a prospective study, we might identify a group of children or young adults with certain characteristics and then keep track of them during the remaining years of their lives to see when and for what reasons they died. On the other hand, in a *retrospective study*, the history of a group of people—that is, their past experiences or the conditions or influences to which they were exposed—are examined and related to their present behavior or circumstances. Thus, we might compare the past histories of a group of sexagenarians dying of cancer with a comparable healthy group of their age-mates to determine what background factors may have contributed to differences in the conditions or characteristics of the two groups.

All these approaches require some form of measurement or assessment, which may include observations, interviews, questionnaires, and tests. An acute observer or sensitive interviewer can obtain much information about a person's experiences, feelings, attitudes, and behavior related to death and dying and other matters. In addition, carefully constructed questionnaires and attitude or opinion scales can make the process of information gathering more efficient. For example, attitudes toward or fears of death have been examined not only by observing and interviewing people but also by questionnaires, rating scales, and paper-and-pencil inventories and tests.

Research on matters pertaining to death and dying has been conducted in a variety of settings, including laboratories, hospitals, nursing homes, classrooms, residences, playgrounds, and even in the streets. Although it is desirable to have as much control as possible over extraneous variables when conducting these investigations, tightly controlled research on psychosocial factors in death and dying is seldom possible. Researchers must often make their observations and measurements in naturally occurring situations such as the streets rather than in contrived

situations such as a laboratory or classroom. It is hoped that the richness of the information obtained in this way will make up for its lack of precision.

SUMMARY

Human beings realize the inevitability of death, but they often find it difficult to apply this understanding to themselves. Death has become less visible today than in former times, and this very fact supports the avoidance or denial of its inevitability. Direct experiences with death are unusual for most people, although vicarious exposure through news stories and motion pictures is common.

The term *death* has multiple meanings—biological, psychological, social, legal, and spiritual. Reference to the death of a human being, however, usually implies biological (somatic or natural) death, the irreversible breakdown of respiration and the consequent loss of the body's ability to use oxygen. The medical determination of death has become more complex in recent years and now includes not only traditional indicators (unresponsiveness to sensory stimuli, absence of respiration, absence of reflexes), but also a more recently adopted indicator—a flat EEG (a sign of brain death). The indicators must be verified by two physicians before a judgment of death is rendered. In cases of deep coma, certain signs of death are present for a time, but the patient may eventually revive. Consequently, the presence of the four indicators must be redetermined after 24 hours in order for a diagnosis of death to be made.

The computation of death rates (crude, age specific, age adjusted), life expectancy, and similar vital statistics is the business of demographers. The crude death rate in a population is the average number of deaths per 1,000 or 100,000 people during a given year. Life expectancy is the average life span in years of people who were born in the same year. The overall crude death rate for the United States in 1991 was 8.5 per 1,000 people, and the average life expectancy was 75.7 years.

Both the rate and causes of death vary with historical period and chronological age. Current death rates in the United States drop from nearly 1,000 per 100,000 in infancy to less than 100 per 100,000 in childhood and early adolescence and rise to nearly 15,000 per 100,000 in old age. Over 70 percent of the residents of the United States who died in a given year during the 1990s were over age 65. In contrast to the situation that prevailed early in this century, the infant death rate in the United States during the 1990s is very low. The major killers of yesteryear were infectious diseases such as influenza, pneumonia, and tuberculosis, which struck both the young and the old. The greatest number of deaths today are attributable to heart disease, cancer, stroke, and other chronic disorders that are more likely to afflict the elderly.

Women in the United States, both white and nonwhite, live longer on the average than men, and married people live longer than single people. The death rate is higher and life expectancy is lower among black than white Americans, but the mortality gap between whites and blacks has narrowed substantially during the

past 50 years. Differences in death rate and life expectancy among ethnic groups are related to social class. Social class differences in death rate are greater during infancy, childhood, and young adulthood than in middle and late adulthood.

Interest in death and dying has increased during the past three decades, although formerly it was a somewhat taboo topic in Western nations. Academic courses, books, media stories and dramatizations, and research investigations concerned with the topic have increased since the 1960s.

Thanatology, the study of death and dying, is an interdisciplinary field. Specialists in a variety of natural and social science disciplines, theologians, lawyers, and historians are interested in the problems of death, dying, and bereavement. The interdisciplinary focus of thanatology is reflected in the content of this book, which deals with biological, psychological, sociological, philosophical, theological, legal, and even commercial matters concerned with death and dying.

Many research and educational projects concerned with death, dying, and grief are supported by private foundations and governmental agencies. These foundations, agencies, and other organizations composed of professional people, public officials, and laypersons usually focus on one or more specific issues concerning death and dying. Among these matters are methods of treating and curing cancer, heart disorders, and other serious diseases; the pros and cons of capital punishment; legal and ethical aspects of abortion and euthanasia; the advantages of hospice care over other methods of caring for terminally ill patients; the meaning of near-death and out-of-body experiences; cryonics; the use of addictive drugs for controlling pain in terminal patients; the prevention of and intervention in suicide; and the problems of bereavement and widowhood. A variety of methods and materials are employed in research on death and dying. Nonexperimental procedures such as correlational techniques and surveys are more common than experimentation. Longitudinal and cross-sectional, prospective and retrospective research designs are all employed. Methods for assessing dependent or outcome variables in these studies include observations, interviews, questionnaires, rating scales, inventories, and tests.

QUESTIONS AND ACTIVITIES

1. Describe a time when you came close to losing your life. Did your whole life flash before you? What emotions did you experience? How did you feel afterward?

2. Have you ever experienced the death of a close friend or relative? What did the person mean to you, what reactions did you have to the death, and what do you miss most about him or her?

3. Would you like to live a long life? Do you expect to do so? What exercise, diet, or other regimens do you follow in order to increase your chances of living a long time?

4. Can you imagine your own death? What do you think it will be like? Imagine your own funeral. Who will be there? What will be said and done?

5. Describe the happiest death you can imagine, and then compare it with the saddest death you can think of. What makes a death happy or sad? Is it happy or sad to the dying person, the survivors, or both?

6. To what age would you like to live? To what age do you expect to live? How do you account for any discrepancy between these two ages?

7. What factors, both controllable and uncontrollable by you, are likely to shorten or lengthen your life compared with the average life expectancy?

8. Describe the relationships of gender, race, age, marital status, geographical area of residence, and socioeconomic status to life expectancy, death rate, and cause of death.

9. The following questionnaire is most appropriate for middle-aged or older adults. It provides an estimate of the respondent's life expectancy in years. Because it is impossible to take into account all the factors that affect a person's life span, this is admittedly a rough estimate. However, the questionnaire does include the variables that are considered most important in determining life expectancy. Complete the questionnaire yourself and compare your life expectancy with that of several other people.

 72 1. Start with 72.
 _____ 2. Subtract 3 if you are male; add 4 if you are female.
 _____ 3. Subtract 2 if you live in an urban area with a population of over 2 million.
 _____ 4. Add 2 if you live in a town under 10,000 or on a farm.
 _____ 5. Add 2 if any of your grandparents lived to age 85.
 _____ 6. Add 6 if all four of your grandparents lived to age 80.
 _____ 7. Subtract 4 if either of your parents died of a stroke or a heart attack before age 50.
 _____ 8. Subtract 3 if either of your parents or a brother or sister under 50 has (or had) a heart condition, cancer, or has had diabetes since childhood.
 _____ 9. Subtract 2 if you earn over $50,000 a year.
 _____ 10. Add 1 if you finished college. Add 2 more if you have a graduate or professional degree.
 _____ 11. Add 3 if you are 65 or over and still working.
 _____ 12. Add 5 if you live with a spouse or friend. Subtract 1 for every 10 years you have lived alone since age 25.
 _____ 13. Subtract 3 if you work behind a desk.
 _____ 14. Add 3 if your work requires regular, heavy physical labor.
 _____ 15. Add 4 if you exercise strenuously five times a week for at least half an hour. Add 2 if you exercise strenuously two or three times a week.
 _____ 16. Subtract 4 if you sleep more than 10 hours each night.
 _____ 17. Subtract 3 if you are intense, aggressive, easily angered.
 _____ 18. Add 3 if you are easygoing and relaxed.
 _____ 19. Add 1 if you are happy. Subtract 2 if you are unhappy.
 _____ 20. Subtract 1 if you have had a speeding ticket in the past year.

_____ 21. Subtract 8 if you smoke more than two packs of cigarettes a day. Subtract 6 if you smoke one to two packs a day.

_____ 22. Subtract 1 if you drink the equivalent of 1.5 ounces of liquor a day.

_____ 23. Subtract 8 if you are overweight by 50 pounds or more, 4 if you are overweight by 30–50 pounds, or 2 if you are overweight by 10–30 pounds.

_____ 24. Add 2 if you are a man over 40 and have annual medical checkups.

_____ 25. Add 2 if you are a woman and see a gynecologist once a year.

_____ 26. Add 2 if you are between 30 and 40.

_____ 27. Add 4 if you are between 50 and 70.

_____ 28. Add 5 if you are over 70.

ENDNOTES

1. Cicero, *De Finibus Bonorum et Malorum* (45 BC), VII, 28, 176.

2. Excerpt from "Tell Me Not in Mournful Numbers" by Henry Wadsworth Longfellow. From *Favorite poems of Henry Wadsworth Longfellow* (p. 302) by H. S. Canby (Introd.), 1947, Garden City, NY: Doubleday.

3. Excerpt from "Passer Mortuus Est" by Edna St. Vincent Millay. From *Collected Poems*, Harper & Row. Copyright 1921, 1948 by Edna St. Vincent Millay. Reprinted by permission of Elizabeth Barnett, Literary Executor.

4. From Quinn, A. H., and O'Neill, E. H. (1976). *The Complete Poems and Stories of Edgar Allan Poe*, Vol. 1 (p. 532). New York: Alfred A. Knopf, Inc. Reprinted by permission.

5. Actuarial data on humans, whose chances of dying double roughly every 8 years during most of adulthood, has seemed to support the Gompertz law. Recent research (see Barinaga, 1992) indicates, however, that the law does not hold for very old people, who seem to die in smaller numbers each year than predicted by the Gompertz law.

6. During the night when they both died, Adams reportedly kept asking whether Jefferson was dead yet. Even as he lay dying, Adams apparently kept competing with Jefferson; he wanted to be the one who lived longer.

7. A *cohort* consists of a group of people of the same age, social class membership, or culture, such as all people born in a particular year or in a similar cultural or social environment.

SUGGESTED READINGS

Feifel, H. (1990). Psychology and death: Meaningful rediscovery. *American Psychologist, 45,* 537–543.

Goldscheider, C. (1984). The social inequality of death. In E. S. Shneidman (Ed.) *Death: Current perspectives* (3d ed., pp. 34–39). Palo Alto, CA: Mayfield.

Kain, E. L. (1988). Trends in the demography of death. In H. Wass, F. M. Berardo, & R. A. Neimeyer (Eds.), *Dying: Facing the facts* (2d ed., pp. 79–96). New York: Hemisphere.

Risley, R. L. (1992). In defense of the Humane and Dignified Death Act. In H. Cox (Ed.), *Annual editions: Aging* (8th ed.). Guilford, CT: Dushkin.

Schultz, R., & Bazerman, M. (1980). Ceremonial occasions and mortality: A second look. *American Psychologist, 35,* 253–261.

Veatch, R. M. (1988). The definition of death: Problems for public policy. In H. Wass, F. M. Berardo, & R. A. Neimeyer (Eds.), *Dying: Facing the facts* (2d ed., pp. 29–53). New York: Hemisphere.

PART II

CAUSES OF DEATH

2

AGING AND DISEASE

QUESTIONS ANSWERED IN THIS CHAPTER:

- *What structural and functional changes occur in the human body with aging?*
- *How and why does the rate of aging vary with the individual, and what environmental and behavioral factors affect it?*
- *What processes cause aging, according to various theories?*
- *What are the most fatal diseases, what are their dynamics, and how do they vary with time and place?*
- *What lifestyle variables and psychological factors are related to fatal diseases?*
- *What factors have been responsible for epidemics and famine, both from a historical perspective and on the contemporary scene?*
- *What are the physical and psychological effects of starvation, and how are they treated?*

As any health professional should know, most of the 6,000 or so people in the United States who die on a given day are over age 65. Their deaths are not caused by old age as such; that is, no genetically programmed clock within them automatically stops because their allotted time on earth has been exhausted. Rather than dying of old age per se, approximately three fourths of those who die do so because of heart disease, cancer, or stroke—the three leading causes of death in the elderly. Others die accidentally or violently, but the great majority die of one or more illnesses.

Although death in highly industrialized countries is more common in old age, it is no stranger to youth and middle age. In the United States, approximately 28 percent of those who died in 1992 were under age 65. However, the causes of death vary dramatically from childhood through old age. Accidents are the leading cause of death among American children and young adults, cancer is the major killer of

QUESTIONS ANSWERED IN THIS CHAPTER:

- *What structural and functional changes occur in the human body with aging?*
- *How and why does the rate of aging vary with the individual, and what environmental and behavioral factors affect it?*
- *What processes cause aging, according to various theories?*
- *What are the most fatal diseases, what are their dynamics, and how do they vary with time and place?*
- *What lifestyle variables and psychological factors are related to fatal diseases?*
- *What factors have been responsible for epidemics and famine, both from a historical perspective and on the contemporary scene?*
- *What are the physical and psychological effects of starvation, and how are they treated?*

As any health professional should know, most of the 6,000 or so people in the United States who die on a given day are over age 65. Their deaths are not caused by old age as such; that is, no genetically programmed clock within them automatically stops because their allotted time on earth has been exhausted. Rather than dying of old age per se, approximately three fourths of those who die do so because of heart disease, cancer, or stroke—the three leading causes of death in the elderly. Others die accidentally or violently, but the great majority die of one or more illnesses.

Although death in highly industrialized countries is more common in old age, it is no stranger to youth and middle age. In the United States, approximately 28 percent of those who died in 1992 were under age 65. However, the causes of death vary dramatically from childhood through old age. Accidents are the leading cause of death among American children and young adults, cancer is the major killer of

1

the middle aged, and more elderly people die of heart disease than of any other condition.

This chapter focuses on aging and disease, so-called natural or intrinsic causes of death, and accidents, which are unnatural or extrinsic causes. Two other extrinsic causes of death, homicide and suicide, are considered in Chapter 3. Although the natural causes of death—aging and disease—would seem to be purely physical in nature, like accidents, homicide, and suicide they also have psychological components. There is no such thing as a "purely physical" or "purely psychological" death (Kastenbaum & Costa, 1977). The process of dying is influenced by a complex interaction of biological, psychological, and social factors. Both this chapter and the next are concerned with the influences of all three of these factors on human mortality.

AGING AND LONGEVITY

Only a handful of people live to what scientists consider the maximum life span for human beings (110–120 years). The *1991 Guinness Book of World Records* lists the greatest authenticated age as 120 years, 237 days, the age of Shigechiyo Izumi of Japan at the time of his death in 1986. The record for longevity in the United States is approximately 115 years, the age of Carrie C. White at her death in 1990. Even these very old people did not die of old age as such but rather from the deterioration of bone or other body tissues and organs occurring as a result of aging. This gradual deterioration, which is called *senescence,* is accelerated by disease processes, physical trauma, inactivity, psychological stress, and other conditions. Many people appear to die of old age, but their demise is usually the result of an interaction between the natural processes of aging, which increase vulnerability to disease and accidents, and the more direct effects of illness and/or trauma. Aging is particularly accelerated by lethal diseases such as cardiovascular disorders and cancer.

Whether a specific physical disorder is considered to be a disease or a natural consequence of aging depends in large measure on one's point of view. For example, *atherosclerosis,* a type of arteriosclerosis (hardening of the arteries) characterized by an accumulation of fatty material on the walls of arteries, causes arterial channels to become clogged and leads eventually to heart failure. Atherosclerosis may be viewed either as a disease or as a natural degenerative process associated with aging. In fact, people who live a long time typically develop a variety of chronic disorders and die of heart failure.

Despite the difficulty of separating the specific effects of aging from those of disease, gerontologists make a distinction between primary aging and secondary aging (Busse, 1969). *Primary aging* refers to a genetically regulated set of biological processes that occur over time and result in gradual deterioration of the organism. *Secondary aging,* on the other hand, consists of decrements in structure and function produced by disease, trauma, and other environmental events that are not directly related to heredity.

Age-Related Changes

Aging involves more than acquiring grey hair and wrinkles. As a person ages, decrements in body structure and function occur at many different levels. For example, heart rate, breathing rate, bone density, brain size, and kidney functioning all decrease, while blood cholesterol level increases. Age-related decrements also occur in the functioning of cells, systems, and combinations of systems. For example, the number of neurons and neural cell dendrites in the brain decreases, and the neural transmission rate slows down. The little tubules and filaments of neural tissue in the brain also become entangled, giving it a spaghetti-like appearance. There is an increase in *lipofuscin* (the tiny yellow-pigmented granules in neurons) and an accumulation of the fatty, calcified material known as plaque at neuronal synapses, and there are changes in the chemical substances (neurotransmitters) that are responsible for transmitting nerve impulses across synapses.

Hardening of the arteries (*arteriosclerosis*) in old age affects blood circulation, and changes in the structure of collagen influence the functioning of the heart, lungs, kidneys, and other visceral organs. *Collagen,* a fibrous protein material found in connective tissue, bones, and skin, becomes less elastic with age, leading to slower responsiveness and recovery of vital systems. These changes are accompanied by reductions in basal metabolic rate, mean heart rate, and kidney filtration rate. Muscular strength also declines, and all five senses become less acute.

The age-related changes in collagen promote *osteoarthritis* (inflammation of the joints) and less flexible skin. Besides having a wrinkled appearance, the skin of an aging person is rougher, dryer, more easily bruised, less hairy, and more inclined to develop pigmented areas that may be malignant. These changes, coupled with thickening of the eyelids and hollowing of the eye sockets, can greatly alter one's facial appearance. Behavior and appearance are also affected by the stiffening of hip and knee joints and compression of the spinal discs. This compression, which results from a loss of collagen between the spinal vertebrae, causes a stooped posture and makes older people look shorter.[1] Thus, aging involves a breakdown of several systems within the body, ultimately resulting in death when enough of the cells comprising these systems are altered.

Because aging produces losses in all body systems, actions that require the cooperation of several systems are most likely to be affected. For example, complex motor skills involving the coordination of sensory, neural, and motor systems manifest a greater age-related decrement than simple well-learned or automatic responses. However, older people usually do everything more slowly (or perhaps more deliberately) than when they were younger. It has been said that the most characteristic thing about being older is being slower, a process manifested in a wide range of physical and mental activities.

Individual Differences in Aging

Despite significant changes in body structure and function with aging, parallel changes in behavior do not necessarily occur. People can compensate for disabilities

by exercising good judgment about their health and capabilities and pacing themselves accordingly. Many older victims of serious disease or disability bounce back and continue functioning effectively for years after the onset of illness.

In a sense, old age and the structural and functional changes that accompany it can be viewed as simply another source of stress in a person's life—stress with which some people cope quite effectively but that devastates others. As seen in the results of an investigation conducted by Osterfeld (1968), most elderly people continue to believe in their abilities to handle the physical stresses of aging. Although the physicians consulted in this study maintained that most of the 1,900 elderly participants needed medical treatment, fewer than 20 percent of the participants themselves reported having health problems. Shanas and Maddox (1985) point out that the evaluations made by older people of their own health tend to be a better indicator than the judgments of physicians of how they feel about themselves and how well they are functioning.

For most people, the combined effects of natural aging, disease, and trauma begin to take their toll by the eighth decade of life. The ability of various body organs to compensate for losses caused by aging, disease, and stress and strain is beyond the capacity of most people. However, a fortunate few continue to feel lively and cheerful and to function well even into their ninth and tenth decades. These people do not profess to have any magic formula for survival, but they offer various explanations for their long lives. Many claim that the key to good health and longevity is moderation in all things, but somewhat peculiar explanations such as Fanny Thomas's eating applesauce three times a day and never marrying (Walford, 1983) or Eubie Blake's "good cigarettes, good whiskey, and bad women" have also been suggested. Some recipes for a long life, such as goat gland surgery, transplanted ape testicles, inhaling the breath of young girls, and imbibing various elixirs are unlikely to be effective.

Premature Aging

Although most people would like to live a long life, some people appear to age even more rapidly than normal. Children afflicted with *progeria* (also known as *Hutchinson-Gilford syndrome*), a rare disorder that mimics premature aging, may begin to look old as early as age 4 and die in their teens. One rare form of this disorder that begins in childhood is *Cockayne's syndrome.* These people show signs of premature senescence and appear to die of old age while they are still children or teenagers (see Figure 2-1). Another variety of progeria is *Werner's syndrome,* a condition of arrested growth that has its onset between the ages of 15 and 20. Werner's syndrome patients develop signs of aging such as greying and thinning hair, deteriorating skin, cataracts, tumors, and arteriosclerosis in early adulthood. All progeria-type disorders are considered to be caricatures of aging rather than true aging: Victims develop many of the external indicators but not the age pigmentation and collagen changes of true aging.

FIGURE 2-1 Development of Progeria
At 10 months (left) the child was apparently normal; at
14 1/2 years (right) a late stage of progeria is evident.

Source: From F. L. DeBusk, *Journal of Pediatrics 80:* 697, 1972. Copyright 1972 by C. V. Mosby Co., St. Louis. Used with permission.

Alzheimer's Disease

Alzheimer's disease, an organic brain disorder that claims 50,000 new victims in the United States each year (Maugh, 1991) has recently received extensive attention from researchers and the media. Postmortem microscopic examination of the brains of Alzheimer's patients reveals the presence of various structural abnormalities: dark-colored areas called senile plaques, strandlike protein filaments known as neurofibrillary tangles, and small holes (granulovacuoles) in neuronal tissue resulting from cell degeneration. More than 75 percent of the neurons in the basal forebrain may be lost. Although most victims of Alzheimer's are over age 65, changes in mental abilities and mood associated with the disease may be seen as early as the fifth or sixth decade of life.

The onset of Alzheimer's disease is insidious, and its course is progressive. The psychological changes are gradual, usually beginning with simple memory failure (e.g., difficulty remembering names). Intellectual abilities (memory, judgment, abstract thinking), personality, and behavior gradually deteriorate, becoming steadily worse over time. Mental alertness, adaptability, sociability, and tolerance for new things or changes in routine all decline. The patient may become more self-centered

in thoughts and activities, untidy, agitated, preoccupied with natural functions (eating, digestion, excretion), and in certain cases manifest paranoid symptoms. The particular symptoms and the rate at which the disorder progresses vary with the individual, but in the terminal stages all patients are reduced to a vegetative level of functioning. A person with Alzheimer's disease may live for years as a kind of walking corpse over whose demise the spouse and children are grieving but whose familiar body remains. For this reason, Alzheimer's has been labeled as "the funeral that never ends" (Aronson & Lipkowitz, 1981, p. 569). In rare instance does a remission of symptoms and a partial recovery occur, but the general picture is one of progressive deterioration.

The exact cause of Alzheimer's disease is unknown, although a variety of substances or conditions are associated with it. These include biochemical deficiencies of certain enzymes, neurotransmitters (e.g., acetylcholine), or minerals; and deposits of certain proteins (beta amyloid or A4). The fact that people with Down syndrome (formerly called Mongolian idiocy) who live on into adulthood develop Alzheimer's disease has prompted the search for a defective gene that is responsible for the condition (e.g., Schellenberg et al., 1992). A recently developed test for Alzheimer's disease involves the identification of a precursor of the amyloid beta-protein in the cerebrospinal fluid of patients (Farlow et al., 1992). For further information on Alzheimer's disease, contact the Alzheimer's Disease and Related Disorders Association (see Appendix B).

Factors Affecting Aging

It should come as no surprise that many of the same demographic variables that are associated with mortality—sex, marital status, socioeconomic status, and so on— are also related to aging. In many respects, women age less rapidly than men, and people of higher socioeconomic status age less rapidly than those of lower status. Other variables that seem to have some connection with aging are nutrition (diet), exercise, heredity, and psychological characteristics.

Nutrition

Studies of the effects of nutrition on aging and longevity are concerned with both the amount and the type of food ingested. The results of experiments on underfeeding rats and other small animals show that placing the animals on a diet in which they fast two days a week and receive a healthy diet for the remaining five days increases their longevity to some extent (Masoro, 1988; Schneider & Reed, 1985; Walford, 1983). However, it has yet to be demonstrated that caloric restriction can extend the lives of humans. In fact, the evidence seems to show that people of moderate weight live longer than those who are significantly underweight or overweight (Kaplan et al., 1987). Although it is considered wise not to overeat at any age, dramatic restriction of food intake, especially after infancy, does not appear to have a significant effect on human life span.

Conclusions about the importance of specific types of food are not entirely clear. It is true that too much salt and too many fatty or sweet foods contribute to a variety

of diseases, but nutritionists do not always agree on the best diet for promoting a long life. Results of observational studies of the Abkhasians of the Soviet Republic of Georgia and other long-lived people suggest the following dietary guidelines for improving the chances of a long life:

- Lower protein intake and more protein from vegetables (grains, legumes, cereals), and less from animal products (red meat, whole milk, eggs)
- Less fat, especially animal fat
- Fewer calories—enough to satisfy energy requirements but no more
- Skim milk instead of whole milk products
- Chicken and fish more often and red meats only three or four times a week
- Greater portions of whole grains, beans, rice, nuts, fresh fruits, and vegetables to provide essential vitamins, minerals, and fiber

Unfortunately, information concerning the relationship of nutrition to aging and longevity is based mostly on anecdotes and observations rather than scientific experiments. Walford (1983) and others maintain that taking antioxidants—substances such as vitamin E and selenium, which neutralize free radicals—can lengthen life (but see Schneider & Reed, 1985). Other research findings suggest that dietary supplements of the metal chromium can extend the life span, at least in rats (Evans, 1992). However, these findings await confirmation and may not be readily generalizable to humans.

Exercise

There is no question that regular exercise has general salutary effects, both physical and psychological. In particular, exercise reduces the incidence of cardiovascular disease and hence promotes longevity (see Paffenbarger, Hyde, Wing & Steinmetz, 1984; Paffenbarger, Hyde, Wing & Hseih, 1986; also Figure 2-2). Walking, calisthenics, swimming, and jogging in moderation increase oxygen consumption, ventilation capacity, cardiac output, blood flow, muscle tone and strength, and joint flexibility. In addition, regular exercise results in decreases in body fats and poisons, reductions in blood pressure, and slower response times of body cells and organs. By reducing nervous tension and enhancing the sense of well-being, physical exercise also improves the ability to cope with psychologically stressful situations (Brown & Siegel, 1988).

Heredity

There is humorous truth in the saying that if you want to live a long time, you should choose your own grandparents. Both casual observation and systematic investigation indicate that the rates of aging and longevity run in families (Kallmann & Jarvik, 1959). Long-living parents tend to have long-living children. Heredity is, undoubtedly, one of the most important factors in aging, but it is an after-the-fact variable from the person's own viewpoint and hence not under his or her control. Furthermore, even people whose parents' lives were shorter than average can extend their own life spans by following good health practices.

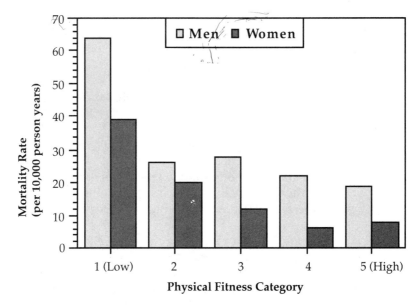

FIGURE 2-2 **Age-Specific Death Rates by Physical
Fitness Groups**

Source: Data from Blair et al., 1989.

Psychological Factors

Somewhat more directly controllable, or at least subject to personal influence, is a person's outlook or attitude toward life. The importance of psychological factors to survival is supported by the results of various investigations. For example, Granick and Patterson (1972) found that although several physiological measures did not predict survival very well in a sample of elderly patients, the degree of resourcefulness shown by the patients and the amount of social support extended to them correlated positively with how long they lived. In a later study, which tracked the longevity of 1,224 men and women through 1986, those who had been rated in the 1920s as more conscientious lived longer (Friedman et al., 1992).

Another important psychological variable is the degree of control or personal responsibility felt by the individual. Any sudden change in the lifestyle of an older person—retirement, the death of a loved one, hospitalization, being placed in an institution, being moved from one place to another—is stressful to some degree. A person can cope more effectively with the stress, however, if the change is voluntary and planned with his or her cooperation. In contrast, a significant change over which the person has no control can lead to a sense of helplessness, hopelessness, and, under certain circumstances, death (Abramson, Garber & Seligman, 1980; Seligman, 1975, 1992).

THEORIES OF AGING

In an effort to discover clues to the biology of aging, scientists who study the aging process have taken a special interest in both long- and short-lived people. Perhaps the first medical researcher to study the problem was Hippocrates, who considered a decline in body heat as the cause of aging. Other explanations of aging advanced in pretwentieth-century times were Erasmus Darwin's notion that aging is due to a loss of irritability in neural and muscular tissue and Eli Metchnikoff's concept of autointoxication (Wallace, 1977).

Breakdown Theories

One group of modern explanations of aging has been termed *breakdown theories*. According to these theories, aging is the result of wear and tear, stress, or exhaustion of body organs and cells. Body organs are thought to wear out with use and exposure to various types of environmental stress. One argument against the wear-and-tear explanation of aging is that body tissues and organs simply do not wear out through use. At least within limits, exercise, which constitutes active use of body organs, enhances physiological functioning and longevity rather than the reverse. Selye's (1976) *stress theory* that every person inherits a certain amount of adaptation energy at birth and that the rate of aging varies directly with how liberally this energy is expended can be criticized on similar grounds.

Another "breakdown" explanation of aging is the *homeostatic imbalance theory*, which attributes aging to the breakdown of homeostatic, or self-regulatory, mechanisms that control the internal environment of the body. Comfort (1964) viewed aging as the result of an accumulation of homeostatic errors or faults and a consequent loss of the ability to maintain a steady, homeostatic internal balance in the body. Support for this idea is found in the fact that as humans age, they take progressively longer to adjust after physical exertion.

Other examples of breakdown theories are immunological theory and autoimmunity theory. *Immunological theory* views aging as due to the gradual deterioration of the immune system, so that the body can no longer protect itself adequately against injury, disease, and mutant or foreign cells. The fact that hormones secreted by the thymus gland, which controls the immune system, diminish with age is consistent with an immunological theory (Zatz & Goldstein, 1985). On the other hand, *autoimmunity theory* emphasizes that the aging body becomes unable to differentiate between normal and abnormal cells. So the body creates antibodies to attack both types of cells and thereby rejects its own tissues. An example of an autoimmune disease that is characteristic of elderly people is rheumatoid arthritis.

Substance Theories

Substance theories, at the tissue level, emphasize changes in collagen and the proliferation of mutant cells. The strands of connective tissue protein (collagen)

change with age, resulting in less elasticity or resilience in visceral organs, slower healing, and other bodily changes. The number of mutant cells also increases with age, raising the likelihood of cancerous growths.

Other substance theories are cross-linkage theory, free-radical theory, and hormonal theory. *Cross-linkage* is the inadvertent coupling of large intracellular and extracellular molecules that cause connective tissue to stiffen. With age, molecules of collagen, which is the primary intercellular connective tissue, become linked or coupled. As a result, the skin becomes leathery, wrinkled, and not as pliable as it was in youth; the joints stiffen, and arteriosclerosis (hardening of the arteries) occurs. It has also been suggested that cross-linkages of DNA molecules prevent the cell from reading genetic information properly (Shock, 1977). As a consequence, enzymes that are sufficiently active to maintain the body and its functions are not produced. Some researchers maintain, however, that although cross-linkage is associated with aging, it is an effect or correlate rather than a cause of the process.

Another substance theory of aging at the cellular level points to an accumulation of chemical "garbage," such as free radicals, as the primary agent. *Free radicals* are highly unstable molecules or parts of molecules containing a free electron. They are produced by adverse reactions of body cells to radiation, air pollution, pesticides, and even some of the oxygen in the air, and they may connect to or damage normal cells or their DNA (Harman, 1981). The damaged cells or DNA are repaired more quickly in younger than in older people (Hart & Setlow, 1974; Walford, 1983).

As a person ages, waste products of body metabolism, many of which are poisonous and can interfere with normal cell functioning, build up. Cell deterioration also occurs when there are failures in the delivery of oxygen and nutrients to the cells (e.g., atherosclerosis). Within the cytoplasm of the cell are little energy "machines" known as *mitochondria*, which are composed of highly unsaturated fats combined with sugar and protein molecules. According to one theory, aging is caused by oxidation of the fat molecules in the mitochondria, which interferes with the energy-releasing function of these structures.

Hormonal Theories

Certain animals, such as Pacific red salmon, release massive amounts of hormones that cause them to die, a finding that has encouraged the development of hormonal theories of aging. One such theory is Denckla's (1974) notion that human aging is caused by the release of antithyroid hormones by the hypothalamus. These blocking hormones presumably inhibit the absorption of thyroxin, which is necessary for cell metabolism and functioning. It is also possible that another hormone, called DECO (decreased consumption of oxygen), is secreted by the pituitary gland and acts to block or keep cells from using the thyroid hormones in the blood. It has been suggested that the hypothalamus contains a kind of aging clock, which in later life alters the level of hormones and brain chemicals in such a way that body functioning is deregulated and death occurs.

Aging Clocks

Noting the great similarity in length of life among genetically related persons, many researchers are convinced that there is an aging clock—a prewired, genetically determined aging program—somewhere in the body. This aging clock presumably dictates the rate and time, barring physical mishap, at which one can expect to age and die. Some researchers believe that the aging clock is in the brain, perhaps in the hypothalamus. Others interpret the evidence as pointing to the existence of aging clocks in individual body cells.

A proponent of the individual cell aging clock theory is Leonard Hayflick (1980), whose experiments have shown that there is a built in limit to the number of times individual body cells can subdivide before dying. Tortoise cells divide 90–125 times, human cells 40–60 times, and chicken cells 15–35 times. Hayflick estimated that because of genetically based limits on cell division, the maximum life expectancy obtainable in humans is 110–120 years. If cardiovascular disorders, cancer, and all other diseases were eliminated, this limit would be reached by a sizable portion of the population.

All the preceding theories of aging have adherents, but the various positions are not mutually exclusive. This is not necessarily a shortcoming, because there is evidence of multiple sites or causes of aging. Aging can occur at the tissue level, the cellular level, or in the cell nucleus. At the tissue level, aging is related to a decrease in collagen; at the cellular level to a deterioration of mitochondria; and at the nuclear level, to mutations of DNA and the cross-linkage of molecules within the cell nucleus.

In addition to multiple sites, evidence points to at least two kinds of aging processes: (1) accidental damage to the molecules, membranes, or parts of the body; and (2) the prewired genetically programmed aging clock. Such a clock presumably consists of a series of special on-off gene switches, which, when the organism has reached maturity, turn off certain cell activities while turning on new cells that cause the destruction of the body's protein building blocks. Belief in the existence of such a genetic program has resulted in research directed at the DNA and RNA molecules responsible for cell replication. In addition, research on the role of the hypothalamus and endocrine glands—the pituitary, thymus, and thyroid glands in particular—continues.

FATAL DISEASES

As we have seen, the complex interactions among biological aging, disease processes, and environmental trauma make it difficult to isolate the effects of any single factor on the physiological decline of the human body. Furthermore, most common diseases result from a variety of influences. Because of their multifactor causation, such diseases as the common cold have proven more resistant to treatment than disorders with more specific causes. Infectious diseases with a single identifiable

BOX 2-1 • Birthday

If today is my birthday, in years I am none,
Or counting in Chinese, no older than one.
Although I'm no child, I could be sixteen
If transposing my age would put hair on my
* bean.*

Teenager I'm not, for as hard as I try
To be sharp as a lad and nearly as spry,
The creak in my knees and the crack in my
* back*
Remind me that youth is a status I lack.

If I were one third of my actual span,
I'd be once again a dashing young man,
With energy boundless and drive in my
* breast.*
Such words make me tired; I sure need a rest.

So perhaps a bit older, let's say thirty-nine.
It's a permanent age I'd like to be mine
On this anniversary of my day of birth,
Erasing all gloom and embracing all mirth!

But I fear thirty-nine is too close to forty.
And 'though it's been said that forty is sporty,
It's awfully close to that landmark of fifty,
And whatever they say, fifty's not nifty!

I guess there's no doubt that I'm three score and
* some,*
That I'm going to pot and look like a bum.
But I'm quick to remark when I meet with my
* peers,*
"What I'm lacking in beauty I make up in years."

As everyone knows, my sweet disposition
Effectively compensates for my condition.
So give me your help to conquer my fear
Of having to face one more birthday each year.

And thank you for thinking of me on this day,
When the old coot stands straight and the years
* fade away,*
When the shuffling gait gives way to the spring,
And even a fogy can have a good fling!

cause have yielded much more readily to the efforts of medical science. Examples of the latter are measles, diphtheria, poliomyelitis, and influenza—the epidemic diseases of yesteryear that have declined dramatically in frequency and fatality rate during the past century. Unfortunately, these communicable diseases have been replaced on the mortality scale by heart disease, cancer, stroke, and other chronic degenerative disorders.

Many people have several different diseases at the same time. This is particularly true for elderly people, who may have arthritis, rheumatism, heart disease, and influenza simultaneously, and eventually die of pneumonia—the so-called old man's friend. The first three of these diseases are chronic conditions of long standing, whereas the last two are acute disorders from which the afflicted individual either gets well or dies quickly.

The most common acute disorders among the elderly are respiratory ailments; accidental injury is second, and digestive disorders are third. Acute illness is less common in later life, which is dominated by chronic disorders such as arthritis, rheumatism, heart disease, and hypertension. Although acute illnesses are more common during childhood, it is hoped that the high death rates from acute infectious diseases in infants and children are things of the past. Chronic illnesses are not

as frequent in children as among older people, but, as seen by the incidence of hay fever and asthma in children, they are not immune to chronic disorders.

The number of deaths, the death rates, and the percentages of total deaths for the 15 leading causes of death in the United States in 1992 are given in Table 1-1 on page 16. It should be noted that the death rate is higher in later life (age 65 and above) for every one of the diseases listed in this table.

Demographic Variables

The incidence and type of illness vary not only with chronological age but also with sex, ethnicity, socioeconomic status, geographical region, and lifestyle. Men usually have poorer health than women, blacks have poorer health than whites, and people of lower socioeconomic status have poorer health than those higher on the socioeconomic scale. Differences in disease and longevity associated with sex, ethnicity, and socioeconomic status are often the consequences of environmental conditions such as pollution, diet, and poor sanitation rather than heredity. Thus, men are more likely than women to encounter pollution on the job, and poor people usually eat less nutritious food and have less adequate medical care than their more affluent contemporaries. Other lifestyle or pattern-of-living factors associated with poor health and a high death rate are cigarette smoking, alcohol and drug abuse, insufficient exercise, stress, and a lack of social supports. Research has revealed connections between these conditions and a host of physical disorders (see Brannon & Feist, 1992).

As discussed in Chapter 1, the death rate varies from country to country and from state to state within the United States. In addition, the incidence of death attributable to specific diseases is greater in some states than in others. This is a complex result of selective migration, environmental differences, and differences in lifestyle from one region to another. For example, death rates in California and other Western states are higher than those of most Eastern states for alcohol-caused cirrhosis of the liver and venereal disease. On the other hand, death rates for diabetes and heart disease are significantly higher in the eastern United States than elsewhere in the nation (Nelson, 1982).

Cardiovascular Diseases

Cardiovascular diseases (heart diseases, hypertension, cerebrovascular diseases, atherosclerosis, etc.) are, as a group, the leading causes of death in the entire world. During 1992, an estimated 722,770 people in the United States alone died from heart diseases, 143,650 from cerebrovascular diseases (stroke), 16,390 from atherosclerosis, 9,660 from hypertension (with or without renal disease), and 24,260 from other diseases of the arteries, arterioles, and capillaries (National Center for Health Statistics, 1993). Because the heart is the key organ in cardiovascular diseases, it is important to have some knowledge of its structure and functioning in order to understand these diseases.

The Human Heart

As shown in Figure 2-3, the human heart is divided longitudinally in half by a band of muscle called the *septum*. On either side of the septum is a lower chamber, or *ventricle*, and an upper chamber, or *atrium*. Blood returning to the heart from various parts of the body flows into the right atrium by way of two large veins, the *superior* and *inferior vena cava*. When the right atrium has filled, it contracts, and the carbon-dioxide-filled blood is pushed through the interconnecting tricuspid valve into the right ventricle. When the right ventricle is full, it contracts; the tricuspid valve closes; the semilunar valve (between the right ventricle and the pulmonary artery) opens; and the blood is pumped through the pulmonary artery into the lungs. After being oxygenated in the lungs, the blood flows through the pulmonary veins into the left atrium, which, when full, contracts and squeezes the blood through the *mitral valve* into the left ventricle. Contraction of the filled left ventricle then forces the blood through the *aortic valve* into the *aorta*, the many branches of which carry blood to all parts of the body except the lungs (DeBakey, 1990).

The relaxing and filling (*diastolic*) phase of heart action takes place on both sides of the heart simultaneously, as does the contracting and emptying (*systolic*) phase. The alternating diastolic and systolic phases are carefully timed in the normal heart to produce a periodic beating or rhythm. The number of beats per minute (pulse rate) varies with the individual and the body's needs for oxygen, but it is approximately 70 beats per minute in an average adult male.

Arteriosclerosis

Heart disease and subsequent heart failure have been known at least since the time of the Pharaohs. Heart disease can be caused by blood clots, holes in the chamber walls of the heart, or defective heart valves. A stationary blood clot (a *thrombus*) or a moving blood clot (an *embolus*) in an artery is due primarily to *arteriosclerosis*, an abnormal hardening and thickening of the arterial walls caused by deposits of fatty substances and calcium known as *plaque*. Arteriosclerosis usually affects the coronary arteries that carry blood to the heart muscle. The narrowing of arterial channels from plaque deposits increases blood pressure and the likelihood of a blood clot. By making the heart work harder, the narrowed channels can also produce heart pains known as *angina pectoris*.

Hypertension

Increased blood pressure is also the result of constriction of the small arterioles, a condition known as *hypertension*. It is called *essential hypertension* when there are no other signs of disease, and *malignant hypertension* when the disease progresses rapidly. Hypertension is sometimes associated with a cardiac problem (*hypertensive heart disease*) or with both heart and kidney problems (*hypertensive heart and renal disease*).

Other Heart Diseases

A leading cause of heart disease in children is *rheumatic fever*, a streptococcal infection. A child may be born with a defective heart (*congenital heart disease*), but

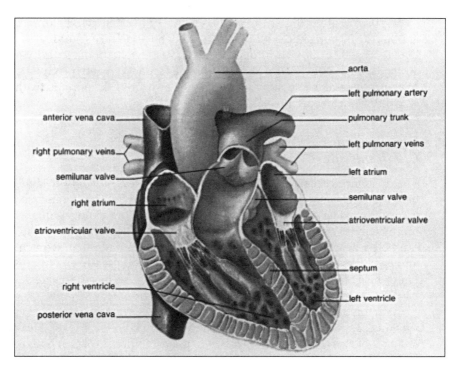

FIGURE 2-3 Structure of the Human Heart

Source: From Kent M. Van De Graaff, *Human Anatomy*, 3d ed. Copyright © 1992 Wm. C. Brown Communications, Inc., Dubuque, Iowa. All rights reserved. Reprinted by permission.

death caused by this condition and rheumatic heart disease is not common. Much more frequent, particularly in older adults, is *ischemic heart disease,* the leading cause of death in the United States. Ischemic heart disease is an anemic condition of the heart caused by an obstruction in the arteries, reducing blood flow to the heart. The usual consequence of the ischemic condition is destruction of heart muscle, or *myocardial infarction.*

Heart Attack and Stroke

In advanced cases of cardiovascular disease, the heart fails, resulting in a heart attack or stroke (*cerebrovascular accident,* or *CVA*). Whereas heart attacks are almost always caused by clots in coronary arteries, strokes result from clots or hemorrhages in cerebral (brain) arteries. In a heart attack, there is sudden dull pain and a feeling of heaviness in the chest that may move down the arms. Associated symptoms are unrelieved indigestion, pain in the jaw or shoulders, and shortness of breath. The specific symptom picture varies with the age of the victim, severe chest pains being less common in elderly patients. The symptoms of stroke, which may be even more disabling than a heart attack, are unconsciousness and partial paralysis.

Approximately 30 percent of the victims of heart attack die immediately, and another 20–30 percent die within 24 hours of an attack. The survival of the remaining 40–50 percent of victims depends to a great extent on the severity of the attack and the ability of the victim to cope with the fear and anxiety precipitated by it. The age and general health of the victim are also quite important to the speed of recovery from a heart attack.

Demographics and Lifestyle Factors in Cardiovascular Diseases

The incidence of cardiovascular diseases is related not only to age but also to heredity, sex, race, geography, nationality, and lifestyle. The significance of heredity is seen in the fact that people with a family history of cardiovascular disorders are more likely to develop a disorder in this category. Regarding sex and race, death caused by heart disease and stroke is higher among men than women and higher among blacks than whites. Hypertension (high blood pressure), a frequent companion of heart failure and cerebral hemorrhage, is also more prevalent in men and blacks than in women and whites.

Among the lifestyle factors linked to heart disorders are lack of exercise, heavy smoking, psychological stress, and high blood cholesterol level. Heavy smoking and lack of exercise have been shown to play significant roles in both heart disease and stroke. Physiological responses associated with cigarette smoking include increased heart rate and blood pressure, constriction of peripheral blood vessels, and reduced cardiac output. Even for people who smoke one pack of cigarettes or less each day, the incidence of heart attack and stroke are above average. Furthermore, among those who smoke more than one pack a day, the frequency of heart attack is double the national average and the incidence of stroke five times the average (American Heart Association, 1992).

Exercise
Moderate exercise is important for optimal physiological functioning, as indicated by a higher resting heart rate and a reduction in the number of arteries and their interconnections in bedridden patients. Exercise by itself will not prevent coronary heart disease. Nevertheless, regular exercise does improve the prognosis after a heart attack (Medical Electronics and Data, 1977).

Cultural Conditions
Lifestyle is, of course, related to culture. People in Asian and African cultures, where typical diets include higher amounts of vegetables and lower amounts of animal fat than the diets of most people in North America and Western Europe, have a lower incidence of heart disease than North Americans and Western Europeans. The situation among the Japanese, who eat large quantities of salted fish but little meat, is enlightening. The heavy vegetarian diet of the Japanese keeps their blood cholesterol, and hence the incidence of heart disease, low. A high salt intake raises their blood pressure, however, thereby increasing the likelihood of hyperten-

sion. The typical French diet, which consists of large meals accompanied by wine but few between-meal snacks, is also instructive. Despite the rich foods they eat, the incidence of cardiovascular disease among the French is substantially lower than among Americans.

Lifestyle is also related to subculture, such as the various religious subcultures in the United States. Noteworthy in this connection are the results of a study of active Mormons in California. Middle-aged high priests in the Mormon church who adhered to the habits of no tobacco, regular exercise, and a good night's sleep were found to have only 14 percent of the normal death rate from heart and blood vessel disease and 34 percent of the normal cancer death rate for their age group (Scott, 1989).

Marital Status
Another lifestyle factor related to heart disease is marital status. It has been found that the rate of death due to heart attacks is greater among single, widowed, and divorced people than among married people, regardless of age, sex, or race (Lynch, 1977). Although not absolutely guaranteed, it can be presumed that, by providing emotional support, feelings of belonging, and a sense of control over one's life, a marital relationship tends to create a healthier, more therapeutic environment. The consequence is greater recuperative power after a heart attack.

Type A Behavior
Although somewhat controversial, the results of research on the relationship of coronary heart disease to a behavioral pattern designated as *Type A* have been widely cited (Rosenman et al., 1975). Type A personalities are characterized as driven, aggressive, ambitious, competitive, preoccupied with achievement, impatient, restless in their movements, and staccatolike in their speech. The contrasting behavioral pattern is that of a *Type B* individual, who is described as more relaxed, easygoing, and patient, speaking and acting more slowly and evenly. Compared with Type Bs, Type As reportedly have a significantly higher incidence of heart attacks, even when differences in age, serum cholesterol level, smoking frequency, and blood pressure are taken into account. Also undoubtedly related to lifestyle and stress is the fact that the risk of a heart attack in the working population is significantly greater on Mondays than on other days of the week (Willich et al., 1992).

Care and Treatment of Heart-Attack Victims

Whatever its causes may be, a heart attack is an anxiety-provoking experience at any age and can have profound psychological effects on the victim. As a result, heart attack patients often require not only drugs, a special diet, and an appropriate combination of rest and exercise but psychological assistance as well. Some heart patients develop a condition known as *angor anima*, a fear of impending death, which can precipitate another attack if it is not treated. In any event, there are important physical and psychological reasons for keeping heart patients relaxed and untroubled.

During the past few decades, significant advances have been made in the treatment of heart disease and other cardiovascular disorders. Included in these advances are a variety of surgical and mechanical procedures such as coronary bypasses, heart valve replacements, arterial cleaning, the installation of electronic pacemakers and mechanical pumps, and (rarely) heart transplants. These procedures have enabled many heart-attack victims, who might once have been condemned to a life in bed, to live fairly normal, productive lives. Further information on heart disease may be obtained from the American Heart Association (see Appendix B for address and telephone number).

Cancer

The second leading cause of death in the United States, cancer, is a disease process characterized by uncontrolled cell growth resulting in a neoplasm, or tumor. The tumor is *benign* if it is restricted to a particular clump of cells, but many tumors are malignant, or *metastatic,* and spread not only to surrounding tissue but also to distant parts of the body. Every year nearly a million new cases of cancer occur in the United States; over half a million Americans died from the disease in 1992 alone (National Center for Health Statistics, 1993). Furthermore, unlike cardiovascular diseases, the death rate from malignant neoplasms (cancer) has been increasing in recent years and probably will equal that of heart disease in 25 years or so.

Cancer usually is classified by the body organ or organ system in which it arises: A *carcinoma* originates in the skin; a *sarcoma* in bone, muscle, and connective tissue; *leukemia* in the bone marrow; *lymphoma* in the lymph nodes. Not all types of cancer are equally serious. Cancer of the skin, for example, can be treated and is not fatal if it is not metastatic. As illustrated in Figure 2-4, in 1992 the highest rates of death caused by malignant neoplasms were those of the respiratory and digestive organs.

Age Differences

As with cardiovascular disorders, the incidence and type of cancer vary with age, sex, socioeconomic status, and geography. Although elderly people are more likely to die of heart disease or stroke than cancer, the death rate for all types of cancer is greater among the elderly than among the young and middle aged. It increases gradually until middle age and then accelerates rapidly in old age. The age-specific incidence of various types of cancer, however, is not the same as the death rate. Although cancer is more common after age 40, there is a sharp peak in its frequency between the ages of 5 and 10. Cancer kills more children than any other disease, but it is less likely to be fatal in childhood than in later life. Leukemia and brain tumors are more common among children; cervical, lung, and stomach cancer increase in the middle thirties; and cancers of the breast, uterus, colon, stomach, and liver occur with the greatest frequency in older adults (Krakoff, 1991).

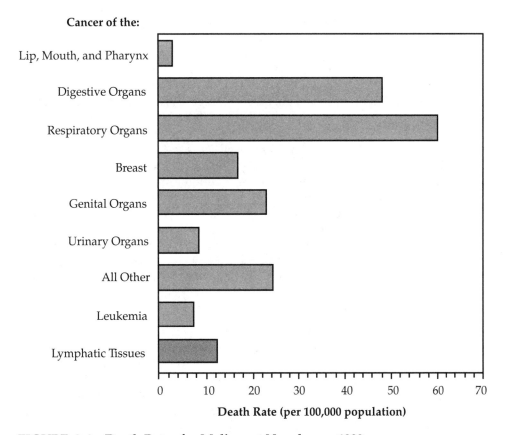

Cancer of the:

FIGURE 2-4 Death Rates for Malignant Neoplasms, 1992

Source: Data from National Center for Health Statistics, 1992, *Monthly Vital Statistics Report, 40* (13). Hyattsville, MD: U.S. Department of Health and Human Services.

Sex Differences

Age differences in the incidence of cancer are not the same for both sexes; the frequency of cancer in women is greater during their childbearing years than in men of the same age. It is the second-leading cause of death for all women and the most common cause of death for women aged 55–74 (National Center for Health Statistics, 1989). Another sex difference is in the incidence of lung cancer. Over 100,000 Americans die of lung cancer each year, most of whom are men. Due at least in part to increased smoking by women in recent years, however, the incidence of lung cancer in women has increased dramatically since 1965 and has surpassed breast cancer as the number-one killer of women. Not only the growing number of women who have lung cancer but also advances in the detection and treatment of breast cancer have contributed to this statistic.

Ethnic Differences

With the exception of breast cancer, blacks tend to get cancer at an earlier age than whites. A greater percentage of blacks than whites are also affected by and die from cancer. Concerning the relationship between ethnicity and specific types of cancer, a study of Californians found that African Americans, Caucasians, Hispanics, and Asian Indians have a higher than average risk of prostate cancer. California men of Chinese ancestry, however, are more likely to develop lung cancer, Japanese are more prone to colon cancer, Koreans to stomach cancer, and Vietnamese to lung cancer. On the other hand, breast cancer is the most common type of cancer among California women in all ethnic groups (Steinbrook, 1992). Whatever ethnic-group differences exist in the incidence of different types of cancer are undoubtedly the consequences of socioeconomic or cultural differences in lifestyle rather than race per se. For example, not only are blacks more likely than whites to live and work in physically hazardous surroundings, but they are less likely to seek medical assistance and more likely to delay seeing a physician. Even when they obtain medical help, the diagnosis and treatment of black patients are usually conducted less competently than for whites (Cimons, 1989; Kitagawa & Hauser, 1973).

Geographical Region

The frequency and type of cancer also vary with geographical region. For example, cancer of the stomach is more prevalent in Japan and certain Scandinavian countries, whereas cancer of the liver occurs more often in certain sections of Asia and Africa (Krakoff, 1991). The reasons for these geographical differences are not completely clear, but ethnicity, nutrition, and differential exposure to certain infectious conditions (e.g., liver parasites in China) are considered to be important.

Carcinogens

Many physical and chemical substances are known to be significant carcinogenic (cancer-producing) agents. Examples of carcinogens found in industrial environments or products and the types of cancer associated with them include vinyl chloride with liver cancer, industrial tars and oils with skin cancers, and aniline dyes with cancer of the bladder. Other cancer-producing substances or conditions and the associated diseases include cigarette smoking and lung cancer, excessive alcohol drinking and cancer of the larynx, overexposure to sunlight and skin cancer, nutritional deficiencies and cancer of the esophagus and liver, excessive intake of fats and breast cancer, and certain hormones and cancer of the uterus and vagina (Krakoff, 1991; Power, 1982).

Early Detection

Cancer is often referred to as the "silent killer," because it may remain undetected until well advanced. Treatment is usually more effective in the beginning stages of the disease, so early detection and diagnosis are encouraged. All adults, particularly those over age 40, should be aware of the following seven warning signs of cancer:

- A sore that does not heal
- A change in a wart or mole
- A lump or thickening in the breast or elsewhere
- Persisting hoarseness or cough
- Chronic indigestion or difficulty swallowing
- Unusual bleeding or discharge
- A change in bowel or bladder habits

People with one or more of these symptoms should consult a physician immediately.

Treatment
Depending on the specific type of cancer, treatment may include surgery, radiation therapy (external administration of X-rays, internal administration of radioactive materials), chemotherapy (nitrogen mustard, busulfan, chlorambucil, cyclophosphamide, methotrexate, and other antimetabolites; antibiotics; vinblastine and vincristine; metallic salts; cortisone and other hormones), and supportive treatments of various kinds (Krakoff, 1991).

Psychological Factors
The results of casual observation and research suggest that psychological factors, such as an attitude of passivity and hopelessness in the face of stress, influence the growth, if not the genesis, of cancer cells (Derogatis et al., 1979; Grossarth-Maticek et al., 1986; Schmale, 1971). Convinced of the importance of psychological factors in the prognosis of cancer, Carl and Stephanie Simonton (Simonton et al., 1978) have supplemented physical treatment methods (surgery, radiation, chemotherapy) with psychological techniques. Their purpose is to get patients to think positively and confidently about their ability to control the illness and to stimulate the immune system by their thoughts. Among the techniques used are relaxation to control anxiety and visual imagery, in which patients imagine that their white blood cells are attacking and destroying cancer cells. Some positive results have been reported from the use of these methods, but most physicians remain skeptical. Oncologists (physicians specializing in the treatment of cancer) tend to feel that psychological treatment, in conjunction with physicochemical treatment, is worth trying, but they warn against the danger and cruelty of raising the hopes of cancer patients too high. Further information on cancer may be obtained from the American Cancer Society, the Cancer Information Service, the Children's Oncology Camps of America, the Leukemia Society of America, and the Sky High Hope Camp (see Appendix B for addresses and telephone numbers).

Other Fatal Diseases

After heart disease, cancer, and stroke, the highest death tolls among the disorders listed in Table 1-1 are associated with chronic pulmonary diseases and pneumonia

and influenza. Next in order are diabetes, human immunodeficiency virus infection, chronic liver disease and cirrhosis, kidney disease, septicemia (blood poisoning), atherosclerosis, and certain conditions originating in the perinatal period.

Chronic Obstructive Pulmonary Diseases

Disorders classified under this label—emphysema, chronic bronchitis, asthma, and related respiratory conditions—are similar in many respects and often confused with one another. They involve interference with the normal breathing pattern, expectoration of mucus or sputum, wheezing (emphysema and asthma), and coughing (chronic bronchitis and asthma). The causes of these diseases are not well understood, but heredity plays a role in asthma and one type of emphysema. Smoking and air pollutants are important predisposing conditions in emphysema and chronic bronchitis.

Emphysema has the highest fatality rate of the three disorders, a rate that has increased fifteenfold since 1950 (Raleigh, 1991). Men over 40 years of age constitute the largest group of victims. Emphysema, which is highly disabling even when it is not fatal, involves the destruction of millions of little air sacs (alveoli) in the lungs. The patient experiences great difficulty inhaling and may develop a barrel-chested appearance.

Chronic bronchitis is a progressive inflammation of the bronchial tubes. Like emphysema, it occurs most often in men over age 40. Both emphysema and chronic bronchitis can lead to heart failure, and chronic bronchitis may also progress to emphysema or pneumonia. Furthermore, chronic bronchitis and asthma can lead to each other.

The fatality rate for asthma is substantially lower than that for emphysema, but asthma attacks may be quite alarming to observe. These attacks, in which the bronchioles construct spasmodically and the bronchial tubes swell, are precipitated by a variety of substances (certain foods, drugs, and inhalants) as well as psychological stress.

Influenza and Pneumonia

Influenza, which even during this century has been a lethal disease of epidemic proportions, is not usually considered life threatening today. But in older people who have several chronic disorders, influenza can cause death—if not directly then indirectly by making the patient less resistant to cardiac disorder or pneumonia. Inflammation of the lungs, which characterizes pneumonia, can be produced directly by a flu virus or by the uncontrolled growth of bacteria during a bout of influenza.

Diabetes

Diabetes mellitus, the symptoms of which include abnormally large amounts of sugar in the blood and urine, results from a malfunctioning pancreas. Although the symptomatic picture varies from person to person, a typical diabetic manifests persistent thirst and frequent urination combined with a loss of strength and weight. The disease also makes the patient more susceptible to infection and pro-

BOX 2-2 • Deathway

Last night I dreamed a ghost came by;
It looked at me and then
Said, "You decide how you will die,
But not precisely when."

Although it now seems strange to me,
I really felt no fear,
And spoke right up quite thoughtfully,
As I relate it here.

"I don't desire a heart attack,
Or illness of the liver.
Courage I clearly do not lack,
But 'cancer' makes me quiver.

"I really do not wish to see
Myself die from the flu,
And if pneumonia's offered me,
I shall reject it too.

"I guess I'll not get sick to death
'Cause being ill's no fun.

If something has to take my breath,
Let it be quickly done.

"I might get shot in a world war,
Or drown out on the sea,
Or fall beneath a speeding car
That's bearing down on me.

"But being killed is too unkind
To me and folks I know.
I'd better think and try to find
Another way to go.

"If I can die just as I please,
I'll die quite painlessly.
Avoiding accidents and disease,
I'll age so gradually.

"And when the knock of death at last
I hear at my life's door,
I'll say, 'Kind sir, forget the past,
And let me live some more!'"

duces varying degrees of blindness. There is no known cure for diabetes mellitus, but insulin injections and strict adherence to a prescribed diet can control it (Rizza, 1991).

Cirrhosis of the Liver
In cirrhosis of the liver, regenerative nodules (groups of hard cells) replace the normal spongy tissue of the liver, resulting in the formation of scar tissue throughout the organ. Cirrhosis can be caused by excessive alcohol consumption, dietary deficiencies, inhaling certain chemicals, and hepatitis (inflammation of the liver) (Lieber, 1991).

Diseases in Young Children

An estimated 44,730 children aged 4 years and under died in the United States in 1990, but in the developing countries of the world approximately 12.9 million children under age 5 died in that same year. Sixty-seven percent of those children died of pneumonia, diarrheal diseases, vaccine-preventable diseases, or some combination of the three—all of which are either preventable or curable (see Figure 2-5). Poverty, and what it implies in terms of lack of basic medical care, sanitation, and education, is the principal contributing factor to this grim statistic, but it is not the only one. Unlike the situation in the United States, where more young boys than young girls die, girls tend to fare far worse than boys throughout the world. In

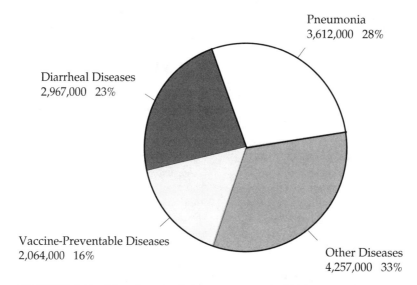

**FIGURE 2-5 Numbers and Percentages of Children Under Age 5
Dying from Diseases, 1990 (Worldwide Statistics
from Developing Countries)**

Source: Data from United Nations Children's Fund (1993). *The State of the World's Children 1993.* New York: Author.

addition to getting poorer health care as a group, girls are more poorly educated than boys (United Nations Children's Fund, 1993).

Some progress has been made in the treatment of diseases that claimed the lives of millions of the world's children in former years. One example is the 75 percent reduction in deaths due to dysentery and other intestinal ailments, thanks largely to a home remedy known as rehydration therapy. Another example is the dramatic decrease in polio, which formerly struck at the lives of a half-million children a year, but now, because of the widespread increase in immunizations, has declined to somewhat more than 100,000 cases per year. If the present trend continues, polio may be the second child killer (smallpox was the first) to be eradicated from the face of the earth (United Nations Children's Fund, 1993).

EPIDEMICS AND STARVATION

I can remember as a child having to stay indoors for two weeks because of an outbreak of poliomyelitis in our town. Although I didn't mind skipping school, being quarantined got to be a drag after a while. This was my first encounter with an epidemic, a disease that has widespread effects, afflicting and perhaps killing large numbers of people. A disease is more likely to reach epidemic proportions when it is

highly infectious, as is the case with malaria, smallpox, typhus, and a relative newcomer to the list, AIDS.

HIV Infection and AIDS

In 1987 the National Center for Health Statistics introduced a new classification in its mortality statistics: *human immunodeficiency virus infection (HIV infection)*. This disease, which was first observed in homosexuals and drug users in 1981, spread rapidly to the bisexual and heterosexual population and to women as well as men. Since then, approximately 2.5 million people throughout the world have died of AIDS and 13 million are infected with the virus that causes this diease (Stolberg, 1993).

Exposure to the HIV virus may result in *AIDS (acquired immune deficiency syndrome)* or a related syndrome. HIV infection causes the AIDS-related complex (ARC), which usually precedes the onset of AIDS. According to the National Center for Health Statistics (1992), 29,850 people in the United States died of HIV infection during 1991, an increase of 24 percent over the number of deaths caused by HIV infection in 1990. Among people who died of HIV infection in the U.S. in 1991, 61 percent were white males, 6 percent white females, 25 percent black males, and 7 percent black females. The highest numbers were in the 35–44 year age range, the next highest being the 25–34 year range.

HIV infection disables the immune system and makes the infected person more vulnerable to a host of viral, bacterial, and malignant diseases. The two most common causes of death among AIDS patients are pneumocystis carinii pneumonia and a rare type of skin cancer known as Kaposi's sarcoma. The infection spreads by exchanging body fluids during sex, by sharing needles or other drug paraphernalia, by blood transfusions, and from mother to child before delivery (Coates et al., 1987). Homosexuals, intravenous drug users, bisexual men, and hemophiliacs run the highest risk of HIV infection.

Although at present there is no cure for AIDS or a vaccine to prevent HIV viral infection, certain drugs (e.g., AZT, DDC) inhibit the spread of the virus. Efforts are being made to reduce the transmission of AIDS by educating and counseling people to avoid high-risk behaviors. Health education programs that increase knowledge of AIDS and how it spreads appear to have reduced the incidence of sexual practices associated with the disease. Emphasizing the use of condoms and other safe-sex acts (such as decreasing the number of partners) has had some effect (McKusick, Horstman, & Coates, 1985; McKusick, Wiley, Coates, Stall, Saika, Morin, Charles, Horstman, & Conant, 1985). Avoidance of needle-sharing among intravenous drug users also reduces the risk of AIDS. Unfortunately, among the high-risk groups are many people who seem to feel unconcerned or invulnerable—a belief that they will not get the disease or that at least that their sexual partners will let them know if they are infected with the virus.

The psychological effects of AIDS are not as devastating as the physical ones, but the emotional and cognitive consequences of this frightening illness are often severe. Testing positive for HIV can be a very stressful experience (Jacobsen et al.,

1990). In addition, the neurological consequences of AIDS lead to problems with balance and coordination, memory, concentration, decision making, and impulse control (Selwyn, 1986). For further information on AIDS, contact the AIDS Action Council (see Appendix B).

Other Epidemic Diseases

The history of the world has been shaped in some measure by epidemic diseases, including those that struck the armies of Hannibal and Napoleon, the Crusaders, and many other masses of people on the move (Bowman, 1990). The discovery of America by Columbus led to an exchange of infectious diseases as much as anything else, but the Native Americans clearly received the poorest part of the bargain. Millions of Native Americans died from smallpox, malaria, and certain other diseases brought to the Western hemisphere by Europeans. For example, in a 3-year span during the sixteenth century, 3.5 million Aztecs died from smallpox carried to Mexico by the Spanish army. But much smaller numbers of the conquerors succumbed to the syphilitic infection that was presumably transmitted to them by the American Indians. Another example of a disease running wild in a virgin population to which the disease is new is the tuberculosis epidemic of 1915, which killed 150,000 people in the Balkans (Felsenfeld, 1990).

Infectious diseases of epidemic proportions are associated with migration, crowding, and poverty. Although there are exceptions (e.g., poliomyelitis), epidemics have killed more people in less-developed countries than in Europe and North America. Of course, Europe has not always been exempt from epidemics. An estimated one third of the entire European population died of the bubonic plague during a 3-year period in the midfourteenth century. This second wave of the plague, which was caused by a bacillus residing in the stomachs of fleas on the fur of rats brought to the European continent from Asia, and which lasted well into the eighteenth century, was not the first or the last time that it has occurred in epidemic proportions. Although the nature of the plagues of biblical times is not entirely clear, it seems fairly certain that there was an epidemic of bubonic plague in the Mediterranean world of the sixth to eighth centuries (Carmichael, 1990). The third wave of the bubonic plague began in the 1890s, when it was spread through transoceanic shipping to Australia and the Western hemisphere. In San Francisco, the plague of 1900 was carried by ground squirrels, although Asian immigrants were blamed at first. The occurrence of the plague led to the unraveling of its causes—isolation of the plague bacillus and the discovery of its carriers. Subsequently, effective vaccines and treatments (antibiotics) were developed.

The Black Plague (Black Death) of medieval and Renaissance Europe is the wave of this disease about which so much has been written. The most famous literary treatment is Alessandro Manzoni's *I Promessi Sposi* (*The Betrothed*). The bubonic form of the plague infected the bloodstream and caused swellings of the lymph glands (buboes) and internal hemorrhages. More lethal and more communicable was the pneumonic form, which affected the respiratory system. Disturbed by the mass deaths and filled with visions of the Apocalypse, religious leaders of the

time blamed the epidemic on Jews, prostitutes, homosexuals, and what they considered other immoral or heretical individuals and influences. By the nineteenth century, this second wave of the plague had abated, but yellow flags (a sign of plague or other epidemic disease) were still flown by ships and viewed with fear.

Epidemic diseases such as bubonic and pneumonic plague continued to kill millions of people, particularly in Southeast Asia, right up through the time of the Vietnam War. Other infectious diseases, such as cholera, pneumonia, measles, whooping cough, tuberculosis, and malaria, still take their toll of human lives, particularly in the Third World countries of Africa and Asia. More exotic-sounding tropical infectious diseases such as schistosomiasis, lymphatic filariasis, river blindness, Chagas's disease, leishmaniasis, leprosy, and African sleeping sickness also infect nearly a half-billion people (Stolberg, 1993). Vaccinations and antibiotics have helped to reduce the incidence of infectious diseases, but many people in nonindustrialized nations do not receive sufficient benefits from modern medicine and health and consequently die in large numbers at an early age (Bowman, 1990).

Starvation

In 1992, the American public was startled by news reports and pictures of starving children and adults in Somalia and the efforts of relief organizations to get food to the victims and treat them. Eventually, the landing of the U.S. Marines in that country insured the uninterrupted distribution of food and the application of treatment to the afflicted children and adults. The situation in Somalia illustrated the fact that hunger is now mostly the result of manmade political factors rather than being caused by changes in the physical environment (drought, excessive rainfall and floods, unpredictable weather, etc.), plant and animal disease epidemics, or inadequate technology for producing and distributing food. In the history of the world, famine has often accompanied warfare, as when the fields of the enemy were burned and food stores destroyed.

Countries that today suffer most from starvation include those of South Asia (Bangladesh, Pakistan, Sri Lanka) and sub-Saharan Africa (Somalia, Mozambique, Zimbabwe, Malawi), although starvation also occurs in Eastern European countries such as Russia, Bulgaria, Romania, and Albania. Historically, China and India, with their large populations, have suffered greatly from famine (15–30 million people starved in China during 1958–1962!), but major strides in food production and distribution and work-for-food programs have been made in those countries in recent years (Roark, 1992). Because the uncontrolled growth of population is a major factor in starvation and famine, efforts by China and other countries to restrict population growth have also been helpful. Although death from starvation is rare in the United States, starvation is found in Appalachia and in minority groups in particular (Vorhaus, 1990).

Although a person can only last about 10–12 days without food and water, life may continue for 30–50 days without food alone. When food is first denied a person, the body feeds on its store of glycogen in the liver. As starvation continues, water is lost, and the body feeds on fat and muscle and may lose up to one third of its normal

weight. The victim looks gaunt and hollow cheeked; fluid collects in the cells, causing edema (swelling) of the abdomen; the heart shrinks; the liver is depleted; the stomach stops functioning; and the intestines break down. The victim becomes lethargic, weak, easily fatigued, and nauseated and suffers abdominal pains and cramps, headaches, and sometimes shortness of breath. Sexual activity declines. Women stop menstruating, and if they give birth, the babies are premature and underweight and seldom survive. The psychological effects of starvation include mental deterioration, confusion, depression, disorientation, irritability, and the general disintegration of personality ("The Anatomy of Starvation," 1992).

Two types of starvation have received particular attention by the news media: kwashiorkor and anorexia nervosa. *Kwashiorkor*, which is primarily the result of protein deficiency, is seen mostly among children in Africa and certain other areas of the world. The victims grow poorly, have a poor appetite, and suffer from diarrhea, atrophied muscles, swelling legs, enlarged livers, anemia, and a symptomatic skin rash. *Anorexia nervosa* is a self-imposed starvation with a psychological basis and occurs mainly in adolescent girls.

Bringing a person back from starvation is a lengthy process. He or she must begin to eat again, but not all at once and not the high-calorie rich food that generous, well-meaning American marines in Somalia were wont to offer. Doctors first administer an intravenous drip of carbohydrates. Dehydrated patients are also given tiny sips of oral rehydration solution of water, sugar, and salt. Recovering victims are fed a nutrient-intense liquid and eventually, when they can chew again, solid food ("The Anatomy of Starvation," 1992). Treatment is only part of the picture, however; prevention by means of public health measures is even more important. Many of the health problems associated with starvation and malnutrition can be prevented at a relatively low cost. For example, vitamin A deficiency, which causes blindness and early death in millions of children throughout the world, can be controlled for only 10 cents per child per year (Roark, 1992). And iodine deficiency, which causes mental retardation, can be eliminated for about $100 million. Be that as it may, good politics as much as good medicine is needed to prevent and cope with malnutrition and starvation.

SUMMARY

Senescence, the physical deterioration associated with aging, is caused by disease, physical trauma, psychological stress, and the biological aging process. Declines in body structure and functioning with aging occur at all levels—systemic, organic, and cellular. Changes in the skin and skeletal structure influence one's physical appearance, and neuromuscular changes that accompany aging reduce the speed and accuracy of responses.

Characteristics of premature aging occur in progeria and, at least in the mental sphere, in Alzheimer's disease. Even among people who age normally, there is a wide range in the rate of senescence. The effects of psychological variables may be

observed in the extent to which people can compensate for physical deterioration and continue their activities despite these changes.

Associated with aging are heredity, parental environment, nutrition, exercise, environmental pollution, and psychological stress. Various theories of aging take many of these variables into account. Wear-and-tear theories emphasize the effects of lifestyle and environment. Homeostatic imbalance theory, immunological theory, autoimmunity theory, and hormonal theory highlight changes in the body's internal environment. Theories that emphasize the breakdown of mitochondria and the role of free radicals and cross-linkages (error-catastrophe theory) concentrate on changes at the cellular level. However, most of these theories deal with the *effects* of the genetic aging process rather than the *causes* of the process itself. Research on the genetics of aging has revealed an inborn upper limit to the number of divisions of human cells, but precisely how the biological aging clock is represented in the structure of the DNA molecule is not yet known.

Scientific medicine has been more successful in combatting diseases that have a single identifiable cause (e.g., infectious diseases) than multifactor diseases produced by a combination of causes (heart disease, cancer, etc.). Cardiovascular diseases (heart disease and stroke) kill more people in the United States each year than all other diseases combined. It is clear that the lifestyle characteristic of a given cultural group, combined with hereditary predisposition, influences the prevalence of cardiovascular diseases or other disorders in the group. Many demographic variables (socioeconomic status, ethnicity, sex, etc.) associated with specific diseases that cause death are also related to background conditions such as poor nutrition, smoking, alcohol and drug abuse, lack of exercise, and psychological stress.

Among the cardiovascular diseases listed as causes of death are arteriosclerosis, hypertension, cerebrovascular disease, rheumatic fever, congenital heart disease and, most often, ischemic heart disease. Any of the disorders that result in a block (thrombosis) or break (hemorrhage) in an artery can cause heart failure. A clot in a coronary artery leads to a heart attack, and a clot or hemorrhage in a cerebral artery causes a stroke. The incidence of heart disease varies with heredity, sex, ethnicity, nationality, and lifestyle. A diet high in cholesterol contributes to a greater risk of heart disease, and a diet high in salt contributes to hypertension. Personality variables (e.g., Type A behavioral pattern) also are related to the occurrence of coronary heart disease.

Cancer—uncontrolled cell growth—is not a unitary disease, and its increased incidence is the result of conditions of living and working in modern industrial society. There are age, sex, ethnic, and geographical differences in the type and frequency of cancer. The emphasis in controlling and treating cancer has been on carcinogenic agents such as tobacco smoke, industrial wastes, ingested substances (e.g., fats), and overexposure to the sun and other sources of radiation. Psychological variables, such as loneliness and a hopeless or helpless attitude, also contribute to the incidence of cancer and shortened life span. However, the biological mechanisms by which this takes place are not understood. Some positive results have been found from applying psychological techniques to the treatment of cancer, but physicians remain skeptical.

Other significant causes of death include chronic obstructive pulmonary diseases (emphysema, chronic bronchitis, asthma, etc.), influenza and pneumonia, diabetes, cirrhosis of the liver, and acquired immune deficiency syndrome (AIDS). Because of its infectious nature and potential lethality to the general public, a great deal of research attention is being directed toward AIDS.

In the past, epidemics and starvation have taken millions of lives. Due to advances in science and technology, human beings are not so much at the mercy of changes in the physical environment and the spread of plant and animal diseases as they once were. Nevertheless, disease and famine have not been completely eradicated and continue to take their toll in deaths throughout the world every year.

QUESTIONS AND ACTIVITIES

1. What effects do psychological variables such as mental abilities and personality have on aging and disease? Are they more or less important than physical variables? How do the two sets of factors—physical and psychological—interact in the causation of disease and disability?

2. How do the types and incidence of diseases vary with chronological age? What physical and psychological variables associated with age contribute to the relationships of age to physical disorders?

3. Suppose that you were diagnosed as having an incurable illness and given only six months to live. Would you change your lifestyle? In what way? What else would you do to get ready for death?

4. Suppose that you were a member of a committee charged with deciding which patients should be provided with a new expensive medical treatment that might prolong their lives. What conditions, both personal and social, would play a role in your decision?

5. Suppose you were permitted to choose the manner in which you are going to die. What factors would play a role in that decision, and what would that decision be?

6. How do you expect to spend the rest of your life? Do you think you will end up with the same physical, intellectual, and personality characteristics as your parents? If not, how do you anticipate being different from them?

7. To what age would you like to live? To what age do you expect to live? How do you account for any discrepancy between these two ages?

8. Design a questionnaire to estimate a person's life expectancy. Among the variables that you might include in your questionnaire are:
 a. male or female
 b. ethnic group (race)
 c. education (grade or degree completed)
 d. marital status (whether married or planning to marry)
 e. place of residence (geographical area, urban/rural residence)
 f. occupation (physical and mental effort and risks involved in job; annual salary)

g. family history (how long close relatives lived; what physical disorders they now have or did have)

h. physical condition (overweight or underweight; physical disorders)

i. exercise and recreation (moderate, regular exercise and appropriate recreational activities)

j. temperament or disposition (good natured and placid or tense and nervous; handling of stress);

k. alcohol drinking (heavy drinker, moderate drinker, teetotaler)

l. smoking (whether and how much)

m. health (overall health good, fair, or poor)

n. medical care (regular medical checkups and compliance with the doctor's advice)

o. lifestyle (fast-paced or relaxed life; risk taking, etc.)

From a person's answers to these items and the weights that you assign to them, place him or her in one of the following life expectancy categories:

A: Can expect a very long life (85+ years)
B: Can expect a life of average length (70–84 years)
C: Can expect a life of somewhat less than average length (55–69 years)
D: Can expect a life of substantially less than average length (40–54 years)
E: Can expect a fairly short life (less than 40 years)

ENDNOTE

1. In a sense, all upright people are taller (longer) than they seem to be. Because of the effects of gravity they are lengthier in a prone position than in a standing position.

SUGGESTED READINGS

Benet, S. (1974). *Abkhasians: The long-living people of the Caucasus.* New York: Holt, Rinehart & Winston.

Evans, W., et al. (1991). *The ten determinants of aging you can control.* New York: Simon & Schuster.

Friedman, H. S., & Booth-Kewley, S. (1987). The "disease-prone personality": A meta-analytic view of the construct. *American Psychologist, 42,* 539–555.

LeShan, L. (1989). *Cancer as a turning point: A handbook for people with cancer, their families, and health professionals.* New York: E. P. Dutton.

Lynch, D., & Richards, E. (1986). *Exploding into life.* New York: Many Voices Press.

Marshall, V. W., & Levy, J. A. (1990). Aging and dying. In R. H. Binstock & L. K. George (Eds.), *Handbook of aging and the social sciences* (3d ed., pp. 245–260). San Diego, CA: Academic Press.

Perrow, C. (1984). *Normal accidents: Living with high risk technology.* New York: Basic Books.

Rose, M. (1991). *Evolutionary biology of aging.* New York: Oxford University Press.

3

ACCIDENTS AND SUICIDE

QUESTIONS ANSWERED IN THIS CHAPTER:

- *How serious are accidents as a cause of death, and what are the death rates for different types of accidents?*
- *How, where, when, and to whom do accidents occur?*
- *How does the suicide rate vary with time, place, and person?*
- *What explanations or interpretations have been offered for suicidal behavior?*
- *Why is suicide a serious problem among today's youth?*
- *How can suicidal behavior be predicted and prevented?*

Accidents (and other adverse effects) and suicide were the fourth- and eighth-leading causes of death, respectively, in the United States in 1991. For the 15–24-year age bracket, they were the first- and third-leading causes of death in that year. Since 1950, the accident rate in the United States has declined, but the suicide rate in the general population has remained fairly stable.

ACCIDENTS

Accidents, defined as unplanned events that result in bodily injury and/or property damage, claimed a reported 88,000 lives in 1991. This was a decrease in the number (93,000) of accidental deaths for 1990 and the lowest that it has been since 1924 (National Safety Council, 1992). However, 8,600,000 people received disabling accidental injuries, at a total estimated cost of $177.2 billion (National Safety Council, 1992). These figures are disturbing, but the accidental death rate in the United States has declined significantly during this century. The decline is due largely to the efforts of organizations, such as the National Safety Council (see Appendix B), that

emphasize the risks of driving under the influence of alcohol or drugs, not wearing seat belts, and other unsafe acts. The largest numbers and highest costs of accidents involve motor vehicles. These statistics could be reduced appreciably by the existence and aggressive enforcement of laws concerned with the use of seat belts and driving while drinking. Private organizations such as Mothers Against Drunk Driving (MADD) (see Appendix B) have made valiant efforts to reduce the incidence of accidental death associated with drinking. Despite these efforts, accidents still rank fourth as a cause of death among all age groups combined and first among adolescents and young adults.

How and Where Do Accidents Occur?

Accidents are classified according to type and class. The *type* of accident is determined by how the accident occurs or what causes it. Figure 3-1 shows how the number of deaths and the death rate varied with the type of accident in 1991. Among the accidental deaths that occurred in the United States during that year,

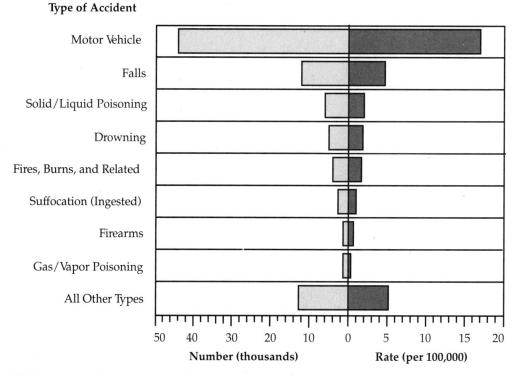

FIGURE 3-1 Number and Rate of Deaths for Different Types of Accidents, 1991

Source: Data from National Safety Council, 1992. *Accident facts, 1991 edition.* Chicago.

over 49 percent were caused by motor vehicles, nearly 14 percent by falls, and over 7 percent by poisoning. Other causes of accidental fatalities included drowning, fires, suffocation, and firearms.

The *class* of an accident is determined by where, or in what location, the accident took place. Accidents are usually grouped into four classes: motor-vehicle accidents, work-related accidents, injuries in and about the home, and public accidents (other than motor vehicles). As shown in Figure 3-2, nearly half (or 43,500) of the fatal accidents in the United States in 1991 took place in motor vehicles, over 11 percent (9900 deaths) at work, over 23 percent (20,500 deaths) in the home, and over 20 percent (18,000 deaths) in public places.

Motor vehicles have held the leading position as a cause of accidental death for over 50 years. The causes of motor-vehicle accidents are well known to traffic safety officials: improper driving in two thirds of the cases, alcohol consumption in half of the accidents, and vehicle defects in 10 percent of the cases.

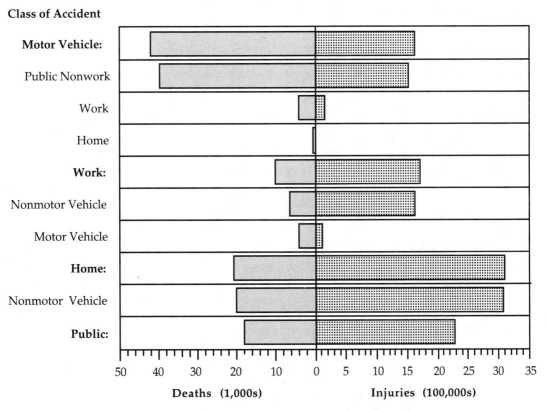

FIGURE 3-2 Deaths and Disabling Injuries Due to Classes of Accidents, 1991

Source: Data from National Safety Council, 1992. *Accident facts, 1991 edition.* Chicago.

Falls are the top-ranking cause of accidents in the home, followed by poisoning, fires, suffocation, firearms, and drowning, in that order. Within the house itself, more accidents occur in bedrooms than in any other location. The reason for the high rate of death in bedrooms is not, as some may speculate, because lovers' quarrels are more common there. Rather, it is because elderly people and infants, the two age groups with the highest nonmotor-vehicle accident rates, spend most of their time in bedrooms. The yard and kitchen also rank high as places where home accidents are likely to occur. The reasons for this should be obvious, considering the machinery, tools, and other potential hazards in these places.

Among public accidents other than those involving motor vehicles, most common are falls, followed by drownings. Falls are the second-ranked cause of death and the third-ranked cause of injury from work-related accidents. An important reason for the low incidence of job-related accidents, considering the high potential for injury and death around industrial machinery, is the great attention paid to safety rules and practices in job situations. Accident rates and fatalities are also relatively low in other organizational settings, such as schools. People are usually more observant and careful in situations where safety practices are emphasized, enforced, and rewarded.

When Do Accidents Occur?

The simplest answer to the question of when accidents are most likely to occur is "whenever prevailing conditions are unsafe." The death rate for motor-vehicle accidents tends to be higher

- at night than during the day
- from Friday through Sunday than from Monday through Thursday
- during holidays than at other times
- during the summer and fall months (July and August, in particular) than during the winter and spring months
- during times of economic expansion than during recessions

Among the conclusions that may be drawn from this list are that lower illumination and many vehicles on the road contribute significantly to vehicular accidents and fatalities. Careless driving and consumption of alcohol and drugs are also associated with motor-vehicle accidents and fatalities. The major careless driving practices that lead to fatal accidents are speeding, failing to yield the right of way, and driving on the wrong side of the road.

Unsafe conditions that lead to fatal accidents at home, in public, and at work have been studied extensively. Research in industry, for example, has shown that lighting and temperature influence accident rate on the job. Interestingly enough, the accident rate is lower among night workers than day workers. The reason why this is so appears to be because artificial illumination is better than daylight for performing job-related activities.

Who Has Accidents?

Unsafe conditions do not, by themselves, usually lead to fatal accidents. To cause accidents, unsafe conditions must be combined with unsafe acts committed by people. One variable related to unsafe acts is chronological age. Motor vehicles are the top-ranked cause of accidental death before age 74, but the peak occurs in the late teens and early twenties (see Figure 3-3). These are the ages (15–24 years) when young people are learning to drive, and lack of caution combines with lack of experience. Unlike elderly people, whose slower response times and physical disabilities contribute to the high accident rate in this age group, the high accident rate of younger drivers is reflective of inexperience, impulsivity, and a desire for peer acceptance.

Drownings are the second-leading cause of accidental death until the early forties; falls are second from ages 45 to 74; and motor-vehicle accidents are second to falls after age 74. The death rate for accidents other than those involving motor vehicles is particularly high in old age (Figure 3-3), when sensory defects and loss of motor coordination are typical, and people spend more time at home. The very old are less likely to perceive dangerous conditions, such as a small object left on the floor, an open door or other projecting object, or something burning. Even when

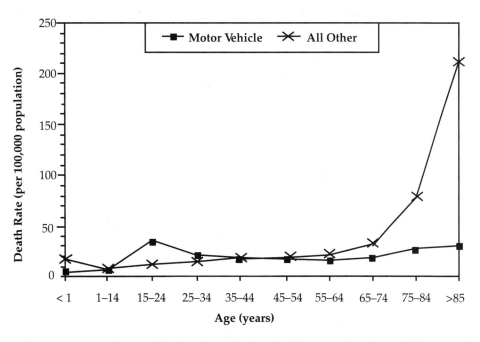

FIGURE 3-3 Age-Specific Death Rates for Accidents and Adverse Effects, 1991

Source: Data from National Center for Health Statistics, 1992, *Monthly Vital Statistics Report, 40* (13), Hyattsville, MD: U.S. Department of Health and Human Services.

elderly people sense danger, their reactions are usually slower and less precise. Like the elderly, infants have a high death rate from home accidents, but for somewhat different reasons. Infants suffer more home accidents than older children because of helplessness and lack of knowledge.

A combination of unsafe acts and greater exposure to unsafe conditions results in a greatly likelihood of accidents, including fatal accidents, among males than females. Also plausible is that individual differences in physical condition, intelligence, and personality are correlated with accident rate. There is good evidence that health and fatigue influence the accident rate, but the results of studies of the relationship of intelligence to accidents are not clear. Inexperience with a task is likely to lead to an accident, but below-average intelligence appears to be significantly related to accidents only on jobs that require frequent judgments (Schultz & Schultz, 1990).

Findings on the relationships of personality characteristics to accidents are even less conclusive than those concerning intellectual abilities. Some years ago, public attention was focused on the so-called *accident-prone personality,* who, because of some quirk of temperament or faulty habit pattern, was believed to be more likely than others to have accidents. The observation that a small number of people seem to have a large percentage of the accidents prompted an interest in accident proneness. Later research, however, revealed no valid evidence that accident proneness is a consistent characteristic of personality. This does not mean that temporary emotional states such as anger or depression cannot increase the chances of having an accident. As with any mental state that distracts the individual or causes him or her to take unwarranted risks, emotional factors can and do play a role in accidents.

Disasters

Accidents or acts of nature (or God) in which many lives (usually 25 or more) are lost are referred to as *disasters* or *catastrophes.* A number of disasters throughout history come immediately to mind, including the destruction of Pompeii and Herculaneum by the volcanic eruption in 79 AD, the deaths of an estimated 36,000 people caused by a tidal wave produced by a volcanic eruption in the East Indies in 1883, and the loss of 1157 lives in the sinking of the ship *Titanic* by an iceberg in 1912. Table 3-1 lists, by category, the greatest disasters that occurred in the United States since 1970. Many of the worst disasters, such as the 1984 calamity in the Bhopal, India, pesticide plant of Union Carbide; the 1976 earthquake in Tangshan, China; the 1985 earthquake in Mexico City; and the 1986 failure of the nuclear reactor at Chernobyl in the Soviet Union, have occurred outside the United States. The most frequent causes of disasters are nature (floods, tornadoes, blizzards), fires, and airplane crashes; train and ship wrecks and other collisions and structural failures also take many lives. Disasters involving airplanes, trains, and buses are usually more publicized than automobile accidents, but the death rate per million passenger miles is substantially higher in automobiles and motorcycles than in other methods of transportation.

TABLE 3-1 Largest U.S. Disasters (1970–1990) and Major Disasters of 1991

Largest U.S. Disasters, 1970–1990

Year	Date	Type and Location	No. of Deaths
		Air Transportation	
1979	May 25	Crash of scheduled plane near O'Hare Airport, Chicago, Ill.	273
1987	August 16	Crash of scheduled plane in Detroit, Mich.	156
1982	July 9	Crash of scheduled plane in Kenner, La.	154
1978	September 25	Two-plane collision over San Diego, Calif.	144
1985	August 2	Crash of scheduled plane in Ft. Worth/Dallas, Texas, Airport	135
1975	June 24	Crash of scheduled jetliner in New York, N.Y.	113
1989	July 19	Crash of scheduled plane in Sioux City, Iowa	112
1971	September 4	Crash of scheduled jetliner into mountainside near Juneau, Alaska	111
1972	December 29	Crash of scheduled plane near Miami, Fla.	101
1974	December 1	Crash of scheduled jetliner near Upperville, Va.	92
1973	July 31	Crash of scheduled plane in Boston, Mass.	89
1986	August 31	Two-plane collision over Los Angeles, Calif.	82
1982	January 13	Crash of scheduled plane in Washington, D.C.	78
1970	November 14	Crash of chartered jetliner in Huntington, W.Va.	75
1990	January 25	Crash of scheduled plane in Cove Neck, N.Y.	73
		Weather	
1974	April 3	Tornadoes in South and Midwest	307
1972	June 9	Flash Flood in Rapid City, S. Dak.	237
1976	July 31	Flash flood in Big Thompson River Canyon, Colo.	145
1972	June 19–28	Hurricane and floods near Eastern seaboard	122
1971	February 21	Tornadoes in Mississippi and Louisiana	117
1978	Jan. 25–27	Blizzard in Midwest	80
1977	July 20	Floods in Johnstown, Pa.	76
1985	May 31	Storm and tornadoes in Pennsylvania and Ohio	74
1985	Nov. 4–5	Floods in W.Va., Va., Pa., and East Coast	65
1984	Mar. 28–29	Storm and tornadoes in N.C., S.C., and East Coast	62
1977	Jan. 27–Feb. 1	Blizzard in Ill., Ind., Mich., Ohio, and Buffalo, N.Y.	51
1973	May 26–29	Tornadoes and floods in South and Midwest	50
1978	Feb. 5–7	Severe snowstorm in Northeast	50
		Work	
1972	May 2	Mine fire in Kellogg, Idaho	91
1978	April 27	Scaffolding in cooling tower collapsed in Willow Island, W.Va.	51
1970	December 30	Coal mine explosion in Wooton, Ky.	38
1977	December 22	Grain elevator explosion in Westwego, La.	35
1979	November 1	Collision of tanker and freighter off coast of Galveston, Texas	32
1987	April 24	Collapse of apartment building under construction in Bridgeport, Conn.	28
1982	March 19	Military plane exploded and crashed near Chicago, Ill.	27
1984	December 21	Mine fire in Orangeville, Utah	27
1976	March 9–11	Coal mine explosions in Whitesburg, Ky.	26
1975	January 31	Collision of two tankers in Delaware River, Pa.	25
1971	February 3	Explosion and fire at munitions plant in Woodbine, Ga.	25

Continued

TABLE 3-1 *Continued*

Largest U.S. Disasters, 1970–1990

Year	Date	Type and Location	No. of Deaths
		Other Disasters	
1977	May 28	Night club fire in Southgate, Ky.	164
1972	February 26	Dam collapse in Buffalo Creek, W.Va.	118
1981	July 17	Collapse of aerial walkways in Kansas City, Mo., hotel	113
1980	November 21	Hotel fire in Las Vegas, Nevada	84
1976	October 20	Collision of ferry and tanker in Mississippi River, La.	78
1971	February 9	Earthquake in Los Angeles, Calif.	64
1989	October 17	Earthquake in San Francisco, Calif., and surrounding areas	61
1980	May 18	Volcanic eruption of Mount St. Helens, Wash.	61
1972	October 30	Collision of commuter train in Chicago, Ill.	44
1973	February 10	Explosion of storage tank in Staten Island, N.Y.	40
1977	November 6	Dam collapsed in Toccoa, Ga.	39

Source: National Safety Council, *Accident Facts,* 1971–1991 editions. Itasca, IL.

Major Disasters, 1991

Below are the four major U.S. disasters taking 25 or more lives during 1991.

Type and Location	No. of Deaths	Date of Disaster
Collision of two aircraft on ground in Los Angeles, Calif.	34	February 1, 1991
Crash of scheduled aircraft in Colorado Springs, Colo.	25	March 4, 1991
Fire at food processing plant in Hamlet, N.C.	25	September 3, 1991
Brush fire in Oakland, Calif.	25	October 21, 1991

Source: National Transportation Safety Board, North Carolina State Library, Oakland County Clerk's Office.

Any kind of accident produces a certain amount of psychological stress in anyone, but the stress becomes particularly acute when many people are killed, as in a disaster. Varying to some extent with the individual, the immediate reactions to disaster include fear, sadness, and rage, which may lead to a denial that the disastrous event even occurred. The individual's sense of control over his or her life and many of the things that make it real and predictable are threatened by a disaster. In most cases, the individual faces up to the tragedy and begins to regain control over life. Carson and Butcher (1992) describe a so-called *disaster syndrome* consisting of three stages. The victim first goes through a stage of shock, in which he or she is stunned, dazed, apathetic, and experiences a loss of control. Following the shock is a suggestible stage, consisting of passivity, suggestibility, and a willingness to take directions from other people. Last is the recovery stage, which begins with

tension, apprehension, and generalized anxiety but leads gradually to the regaining of equilibrium on the part of the survivor. At this stage the survivors typically feel a need to talk about the disaster or catastrophe. The three stages of the disaster syndrome are apparent in the following description.

> *On July 25, 1956, at 11:05 P.M., the Swedish liner* Stockholm *smashed into the starboard side of the Italian liner* Andrea Doria *a few miles off Nantucket Island. . . . During the phase of initial shock the survivors acted as if they had been sedated . . . as though nature provided a sedation mechanism which went into operation automatically. (During the phase of suggestibility) the survivors presented themselves for the most part as an amorphous mass of people tending to act passively and compliantly. They displayed psychomotor retardation, flattening of affect, somnolence, and in some instances, amnesia for data of personal identification. They were nonchalant and easily suggestible. (During the stage of recovery, after the initial shock had worn off and the survivors had received aid) they showed . . . an apparently compulsive need to tell the story again and again, with identical detail and emphasis. (Friedman & Linn, 1957, p. 426)*

Unfortunately, feelings of anxiety, nightmares, and flashbacks associated with a disaster or other stressful experience may occur for months or even years after the event. These and other symptoms (feelings of estrangement, recurring dreams and nightmares, a tendency to be easily startled, problems with social relationships, substance abuse) are characteristics of *posttraumatic stress disorder* (PTSD). PTSD is not limited to accidents and cataclysms; it has been studied most intensively in fighting men and victims of war and terrorism, as well as other disasters caused by unnatural events. Finally, as with any severely traumatic experience, witnessing a disaster can lead to long-term mental disorder in a highly susceptible person.

SUICIDE

Over the years, I have occasionally asked large groups of high school and college students whether they have ever thought seriously of committing suicide. When permitted to answer anonymously, over half the students in several groups have answered in the affirmative. At first it seems surprising that so many healthy, attractive young people in the spring of their lives with presumably so much to live for have entertained thoughts of self-destruction. It becomes less surprising when one realizes that pain and suffering are no respecters of youth, health, beauty, ability, or affluence. Even the most physically and socially favored individuals can hurt and sometimes desire to end their sufferings by ending their lives. The rate of attempted suicide among high-school students is around 8–9 percent, a figure that has shown a greater increase than for any other age group during the past few years (Fremouw et al., 1990). It is estimated that every 9 minutes an American teenager attempts to kill himself or herself, and one in ten succeeds (Coleman, 1987). A

portion of the increase in suicides among teenagers and young adults may be associated with drug abuse (Fowler et al., 1986; Rich et al., 1986).

Until the last 25 years or so, suicide was somewhat of a taboo topic that many people thought about but few discussed. This has changed markedly in recent years, and *suicidology*, the study of suicide, has become a popular topic. Research on the demographics and dynamics of suicide has accompanied the growth of suicide-prevention centers, prescriptions for committing suicide, and university courses and course units on the topic. Although the greater openness with which suicide is now discussed has led to some rather bizarre notions, the situation is healthier than it once was.

Statistics and Demographics of Suicide

There were 30,200 reported suicides in the United States in 1991, an average of one every 17 minutes. Suicides accounted for 1.4 percent of all deaths in this country during that year (National Center for Health Statistics, 1992a). If one considers the large number of suicides that are hushed up or disguised as accidents, as many as 200,000 Americans try to kill themselves in a given year, and over 5 million attempt suicide at some time during their lives (Carson & Butcher, 1992)

A listing of the methods used to commit suicide is given in Table 3-2. Firearms is the most common method of suicide in both sexes; hanging, suffocation, and strangulation also rank high for both men and women, but poisoning and jumping from high places are significantly more common among women (Bell, 1991). Other, less common methods include cutting or stabbing oneself, drowning, and even

TABLE 3-2 Methods Used to Commit Suicide in the United States in 1989

Method	Number of Suicides	Percentage of Total
Poisoning by solid and liquid	3,215	10.6
Poisoning by gases and vapors	2,228	7.4
Motor-vehicle exhaust gases	1,814	6.0
Other and unspecified gases and vapors	414	1.4
Hanging, strangulation, and suffocation	4,484	14.8
Drowning	405	1.3
Firearms	18,178	60.1
Handgun	3,120	10.3
Shotgun	2,310	7.6
Hunting rifle	941	3.1
Other and unspecified firearms	11,807	39.1
Cutting and piercing instruments	418	1.4
Jumping from high places	712	2.4
Other, unspecified suicide and late effects	592	2.0
All suicide deaths	30,232	100.0

Source: National Safety Council, *Accident facts,* 1992 edition. Itasca, IL.

(rarely) ramming one's head, aspirating paper or food, or tearing blood vessels with the fingers (Watkins et al., 1969).

Geographical Differences

Despite the seemingly large number of suicides that take place annually in the country, the U.S. suicide rate (11.9 per 100,000 in 1991) is by no means the highest in the world. Hungary has the world's highest annual suicide rate, 44.9 per 100,000. The rates for Czechoslovakia, Finland, Austria, Sweden, Denmark, and Germany, all around 20, are also higher than that of United States. The suicide rate in Canada is roughly the same as that of the United States, but those of England, Greece, Israel, the Netherlands, and Norway are lower. Even lower rates (fewer than 9 per 100,000) occur in predominantly Roman Catholic countries such as Ireland, Italy, Mexico, Spain, and Portugal (World Health Organization, 1982). The lowest rates of all (near 0) occur in Iceland, the Faeroe Islands, and among the aborigines of western Australia (World Health Organization, 1982). Not only the rate but also the method of committing suicide vary with nationality. Undoubtedly because of their easy availability, firearms are the most popular method in the United States. On the other hand, inhaling domestic gas is the most common method of committing suicide in the United Kingdom.

Of all geographical regions in the United States, the Mountain states have the highest suicide rate. Among the Mountain states, Nevada is highest (26 per 100,000) and New Mexico second highest. The lowest regional suicide rate in the continental United States is in the Middle Atlantic states, but Hawaii has the lowest rate (7.9 per 100,000) of any state. The suicide rate for the District of Columbia, which has the highest homicide rate, is even lower. Attempted suicide is a felony in nine states (Alabama, Kentucky, New Jersey, North Carolina, North Dakota, South Carolina, South Dakota, Oklahoma, and Washington) (Curran, 1987).

Age Differences

Figure 3-4 shows that the suicide rate in the United States as a whole is lowest in early childhood. This low rate is due, at least in part, to the practice of the National Center for Health Statistics of not reporting deaths of children under age 8 as suicides. In any event, the suicide rate increases to about 15 per 100,000 in the late twenties to early forties. It remains fairly constant during middle age, but rises again after age 65.

The high incidence of suicide among the elderly is seen in statistics from both the nineteenth and twentieth centuries. Also noteworthy in interpreting age-related statistics on suicide is that older adults are more successful than younger adults in their suicide attempts. The presumed reasons are that older people who commit suicide are more determined to die, and their power to recover from physical injury is weaker. A suicide pact is usually viewed as a phenomenon of romantic youth, but double suicide also occurs among elderly people. Newspapers occasionally carry stories of older married couples, who, because they have been the repeated victims of crime or suffer from severe neglect or chronic illness, become despondent and decide to end their lives together.

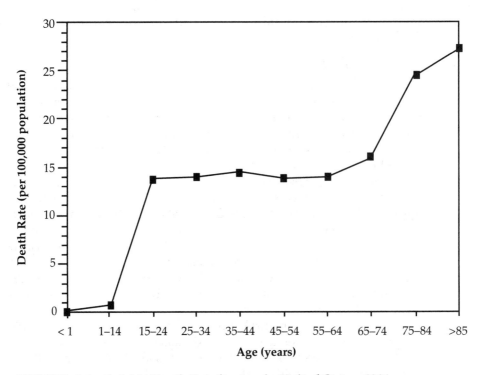

FIGURE 3-4 Suicide Death Rate by Age in United States, 1991

Source: Data from National Center for Health Statistics, 1992. *Monthly Vital Statistics Report, 40* (13). Hyattsville, MD: U.S. Department of Health and Human Services.

Although the suicide rate is lower among teenagers than among the elderly, for at least three decades it has been increasing among 15–19-year-old males. The increase has been particularly pronounced among white males, with black males second, white females third, and black females fourth (National Center for Health Statistics, 1989). Adolescent females attempt suicide more often than adolescent males, but, because they employ less lethal methods, they are successful less often. Whereas teenage males are likely to use gunshots and hanging, teenage females tend to ingest substances, thereby leaving more time for emergency treatment (Garland & Zigler, 1993).

Cluster suicide, in which several suicides take place in the same group or community, also occurs. An example of cluster suicide is the case of seven high school students in Omaha who attempted suicide in rapid succession; three were successful (*Time,* February 24, 1986) (also see Box 3-1). Cluster suicide on a large scale has also occurred, as at Masada in Judea in 73 AD and Jonestown, Guyana, in 1978. Both the Masada and Jonestown tragedies were actually murder/suicides in which many people killed each other, at Jonestown by drinking soft drinks laced with cyanide.

BOX 3-1 • Wind River's Lost Generation

They looked like kids on a high school field trip, clad in Levi's and Springsteen sweatshirts, lining up by the hundreds at the entrance to a teepee. These students, though, were Indians, and the healing ritual to which they were invited was solemnly dedicated to saving their lives.

Inside the tepee, redolent of burning herbs, tribal elders daubed the students with scarlet paint to cleanse them of evil spirits. This was "big medicine," last invoked during the killing flu epidemic of 1918 and now revived to banish the modern-day evil that has lately infected Wind River.

The nine recent suicides admit to no pattern, except that all the victims were young men and all died by hanging. They ranged in age from 14 to 25. Friends and relatives saw no warning signs among most of the victims, and no explanation could be found in the two notes left behind: one youth simply willed his stereo to his brother.

The rash of suicides began Aug. 12, when a 19-year-old Indian, in jail for public drunkenness, hanged himself with socks taken from a sleeping cellmate. A 16-year-old pallbearer at his funeral became the second victim, using a pair of sweatpants to hang himself from a tree. In turn one of the youth's mourners became the third victim. Says Fremont County Coroner Larry Lee: "It seems to be a copycat, domino kind of thing."

Lee, however, has found no evidence of a suicide pact. He believes that alcohol or drugs were factors in fewer than half the cases.

"Many parents of these kids are friends of mine, and we can't explain it," he says. "These kids haven't even lived yet, and they're killing themselves."

Some tribespeople view the suicide epidemic as a reason to re-examine the reservation's social and economic ills. About 70 percent of the Wind River work force is unemployed, and jobs for the young are especially scarce. At the same time, the reservation's oil and gas wealth provides royalty payments of up to $300 a month per person, thus fostering a debilitating welfare culture. Howard Smith, fiscal officer for the Arapaho tribe, which shares the 2 million-acre reservation with the Shoshones, says, "Too many of our young people have time on their hands, so they drink and watch TV and get depressed."

Set apart from American society, yet unable to escape its corrosive influence on tribal life, young Indians often face suicidal despair. "Our Creator can be cruel when he wants to open our eyes," says Wes Martel of the Shoshone Business Council. "Our tribes have great elders, but we have not used them to provide for our children's spiritual needs." To help the young recover some of their cultural identity, elders of Wind River are introducing students to tribal tradition that may ease their plight. In the past few days, teachers and clinic workers have reported that the wave of suicide attempts has subsided. Perhaps the healing ritual has survived the decades of neglect.

Source: Time, October 21, 1985, p. 40. Copyright 1985 Time Inc. Reproduced by permission.

Religious and Cultural Differences

Despite occasional attitudes of tolerance and even admiration when committed in a heroic context, suicide was opposed in ancient Greece, Rome, and other early Western nations. Judaism did not sanction suicide but was less opposed to it than to murder. Although the Bible commands that "Thou shalt not kill," the five recorded incidents of suicide in the Bible (Samson, Saul, Abimilech, and Achitophel in the

Old Testament and Judas Iscariot in the New Testament) are described without comment. For example, the Bible simply states that Saul "took a sword, and fell upon it," and Achitophel "put his household in order, and hanged himself." The Koran, on the other hand, strongly forbids suicide; it was and still is most severely condemned in Islamic countries.

Suicide is a mortal sin in Catholic theology. Unlike murderers, suicides cannot confess and receive absolution for their sins. The rules against suicide that became the basis for Catholic doctrine were established by St. Augustine, who was concerned over excessive martyrdom through suicide, and reinforced by Thomas Aquinas during the Middle Ages. Aquinas characterized suicide as a mortal sin that usurps God's power over life and death. The Christian church in the Middle Ages viewed the taking of one's own life as a violation of the commandment "Thou shalt not kill" and as destroying something (a human life) created by God. As a result, the penalties for suicide were severe, including denial of Christian burial, degradation of the corpse, confiscation of the deceased's possessions, and censure of the survivors. However, Catholicism has changed during the present century, and the Roman Catholic Church now permits the Mass of Christian Burial and burial in consecrated ground for suicide victims. Among religious groups today, the suicide rates for Jews and Protestants are higher than for Roman Catholics and Moslems (Dublin, 1963; Farberow, 1975).

Far Eastern cultures in which Hinduism, Buddhism, and related religions predominate have traditionally been tolerant of suicide. Both Hinduism and Buddhism condone suicide under certain circumstances, as when it serves religion or country. *Suttee,* an ancient Hindu custom in which the living wife of a deceased man was voluntarily (or involuntarily) cremated on her deceased husband's funeral pyre, was practice in northern India until it was outlawed by the British in the nineteenth century (see Figure 3-5). It was also customary among the Vikings and other early northwestern European groups for the wife or concubine of a slain warrior to commit suicide or be killed so she might be available to serve the deceased in the afterlife.

Suppuku, or *hara-kiri,* a ritual in which a disgraced samurai disemboweled himself with a knife before having his head chopped off by an assistant, was considered an honorable way to die in medieval Japan. A more modern form of ritual suicide was committed by an estimated 1,000 Japanese kamikaze pilots during World War II. So eager were many young Japanese men to sacrifice themselves for emperor and country that their superior officers had to restrain them and discourage the practice. Even today, the Japanese, whose language contains 58 different phrases pertaining to suicide, remain sympathetic toward hara-kiri as an honorable way to die under certain circumstances (Jameson, 1981). Since World War II, however, changes in the social and political structure of Japan have led to the virtual disappearance of ceremonial hara-kiri.

Sex Differences
More women than men, perhaps nine times as many, in the United States attempt suicide, but men succeed three to four times as often before old age and ten times as

**FIGURE 3-5 A Hindu Widow Leaps onto the Funeral Pyre of Her Husband.
This sacrificial rite, known as *suttee* and once regarded as a virtuous obligation, has long been forbidden by law in India.
(Bettmann Archive)**

often after age 85 (Shneidman, 1987). The National Traumatic Occupational Fatality (NTOF) data collected by the National Institute for Occupational Safety and Health show that in 90 percent of the cases of suicides at work during 1980–1985, the victims were men. One reason why men are more successful than women in committing suicide is that men are likely to employ more lethal methods. Men tend to use guns, which are more often fatal, whereas suicidal women are more apt than men to take an overdose of a drug (unpublished data provided by the National Center for Health Statistics).

Sex differences in suicide among the elderly are influenced by the differing roles that men and women are expected to play in our culture and the resulting changes in those roles with aging. The assertive, achievement-oriented role of a typical man is not so adaptable to the changes in later life as the more passive, nurturant role assumed by a typical woman. So the greater change in behavior and self-esteem required of an older man may create more stress and resulting depression when he cannot find satisfaction in his new role or situation. It is noteworthy

Race and Sex

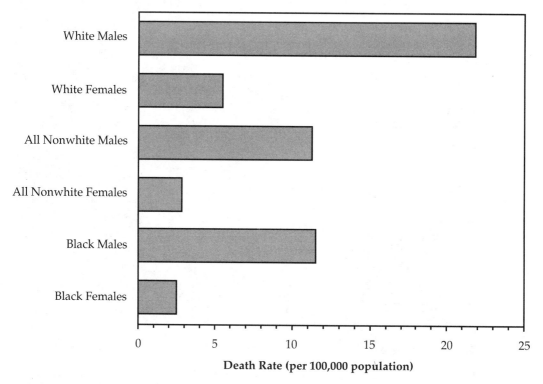

FIGURE 3-6 Suicide Death Rates by Race and Sex, 1988

Source: Data from National Center for Health Statistics, 1991. *Vital statistics of the United States,* 1988. Hyattsville, MD: U.S. Department of Health and Human Services.

that men who have fairly good incomes from Social Security, pensions, and other sources are less likely than their poorer age-mates to take their own lives (Marshall, 1978).

Ethnic Differences

The increase in the total suicide rate during old age is primarily a reflection of the very high rate for white males; the rate for both white and nonwhite females declines after age 50. In the United States, the suicide rate is higher among Caucasians and Asians than among African Americans. However, the suicide rate for African Americans, especially males, has increased steadily since World War II. Their rising suicide rate in the past 40 years may be attributable to their vertical social mobility, the consequent role changes, and the associated high degree of psychological stress. Social changes occurring during the 1950s and later decades created high expectations in ethnic groups that had for generations resigned them-

selves to low social status. When people do not know what they are missing or when opportunities for acquiring material welfare do not exist, people usually adjust and resign themselves to their low estate. However, frustration inevitably follows when hopes and expectations are raised and not fulfilled fairly soon. Such frustration then leads to anger and depression, and, in certain instances, to violence against society and oneself (Simpson, 1979).

Cultural conflict, as seen among certain Native American and Eskimo groups, is a significant cause of frustration that may lead to suicide. For example, the high rate of suicide among Eskimo teenagers in Alaska may be the consequence of finding oneself caught between the ancestral culture and the white man's world (Parkin, 1974).

Social Class and Occupational Differences
Within the United States, the suicide rate is higher for city dwellers than for country dwellers and higher for people of lower socioeconomic status and those who are downwardly mobile. According to data collected by the National Institute for Occupational Safety and Health, the suicide rate for the years 1980–1985 was highest in the military, followed by farmers and other agricultural workers (Conroy, 1989). Within occupational groups, the rate of suicide was highest for public administration, agriculture, forestry, and fishing. Suicide shows no regard for social class; it is high among physicians (particularly psychiatrists), dentists, and lawyers, but low among teachers and clergy (Wekstein, 1979). Understandably, the rate of suicide is also a function of availability of the means for committing it. Physicians can easily obtain lethal drugs and instruments; soldiers and police officers, who also have a high suicide rate, have easy access to firearms. Furthermore, the fact that all three of these occupations can be quite stressful undoubtedly contributes to the high suicide rate (Cavan, 1991).

Other Correlates of Suicide

Suicide rate is also related to mental and physical health, family history, and marital status. As would be expected, the suicide rate is highest for people who have serious problems—the chronically ill or violent, alcoholics, drug addicts, and the mentally ill. Suicide also runs in families, not necessarily through the genetic transmission of a potential for self-destructive behavior but because the suicide of a relative may serve as an example of a way to solve one's personal problems. The suicide rate is also high among the childless and those from broken homes. With respect to marital status, the rate of suicide is highest for divorced persons, next highest for the widowed, then for singles, and lowest for married people (Ezell et al., 1987).

Although the suicide rate is slightly higher on Mondays and the first part of the month (specifically the fifth day), day and season are not closely related to suicide (McCleary et al., 1991). The rate is higher during periods of economic recession, depression, and social unrest but declines during wartime and times of natural disasters (e.g., earthquakes) (Carson & Butcher, 1992). Contrary to popular belief, with the possible exception of New Year's Eve and New Year's Day, suicides are not

as common on major holidays as at other times of the year (Phillips & Wills, 1987; McCleary et al., 1991). The suicide rate also decreases during times of war mobilization (Marshall, 1981) and during presidential elections (Boor, 1981).

There is an imitative or modeling aspect to suicide, the rate tending to increase after the suicide of a famous person such as Marilyn Monroe or Freddie Prinze. Imitative suicide is, of course, not a phenomenon that has been limited to the twentieth century alone. During the romantic era of the nineteenth century, suicide reached epidemic proportions in Europe (Kull, 1990) following the publication of Wolfgang Goethe's *The Sorrows of Young Werther*. Other famous suicides in literature include Antony and Cleopatra, Romeo and Juliet, Madame Bovary, and Richard Cory (Box 3-2). Statistics also show that the number of suicides increases significantly after a TV suicide, so even fictional suicides can trigger imitative deaths (Phillips, 1979; Phillips & Carstensen, 1986). The effects of newspaper stories of suicide are emphasized by Phillips (Krier, 1987, p. VI-6).

> *One of the main things that influence the short-term fluctuation of suicide is the presence of a suicide story in the newspaper. A suicide story is followed by a much larger jump in suicides than any seasonal factor. You find significant increases in suicides after suicide stories. . . . The more publicity given the suicide story, the greater increase in the number of suicides, and it occurs mainly in the geographic area where the publicity occurs.*

Suicide and Law

Many of the penalties for suicide in canon (ecclesiastical) law were codified into civil law. Under early English law, suicide was a felony punishable by driving a stake through the heart of the victim and burying the body at a crossroads ("Suicide," 1983).

BOX 3-2 • Richard Cory

by Edwin Arlington Robinson (1869–1935)

Whenever Richard Cory went down town,
We people on the pavement looked at him:
He was a gentleman from sole to crown,
Clean favored, and imperially slim.

And he was always quietly arrayed.
And he was always human when he talked;
But still he fluttered pulses when he said,
"Good morning," and he glittered when he
* walked.*

And he was rich—yes, richer than a king—
And admirably schooled in every grace:
In fine, we thought that he was everything
To make us wish that we were in his place.

So on we worked, and waited for the light,
And went without the meat, and cursed the
* bread;*
And Richard Cory, one calm summer night,
Went home and put a bullet through his head.

Antisuicide laws continued to be on the law books of Western countries until the late eighteenth century, when they began to be repealed. France was the first (1789) and England the last (1961) European nation to repeal antisuicide legislation. In both the United Kingdom and most of the United States, suicide is no longer illegal, but aiding and abetting it is a felony in 20 states. In addition, both those who attempt suicide and the relatives of those who succeed may still be socially censured.

Durkheim's Analysis

Hara-kiri, suttee, and other ritualistic or conventional forms of suicides were labeled *altruistic suicides* by the sociologist Emile Durkheim (1897). A person who is strongly integrated overtly into society, has an exaggerated concern for it, and is willing to die for the group is more likely to become an altruistic suicide. Durkheim also described three other types of suicide—anomic, egoistic, and fatalistic. *Anomic suicide* is a personal response to a loss of social equilibrium. The social norms are no longer effective for such an individual, and he or she feels betrayed by the institutions of society. For example, a sudden loss of a job or one's personal fortune (as in a stock market crash) can precipitate anomic suicide.

The third type of suicide in Durkheim's analysis is *egoistic suicide,* a selfish act committed by an individual who, through failure to become socially integrated, lacks adequate social supports to help weather a personal crisis. Such people may have peculiar talents or exist in circumstances that place them in a special category (e.g., a celebrity or star) but are not connected to society in conventional ways.

A final type of suicide described by Durkheim is *fatalistic suicide,* in which the victim has been overcontrolled (held to strict rules) or oppressed by others. Acting out of a sense of despair over a lack of opportunity to satisfy or fulfill individual needs and potentials, the person decides to end it all.

Rather than viewing it as a medical problem, Durkheim saw suicide as caused by the failure of people to become adjusted to or integrated into society and to absorb its values and norms. As a result, he maintained, people with strong group ties are less likely to commit suicide. They are more sensitive to the standards and expectations of the group, including opposition to group dissolution and suicide, and more susceptible to the enforcement of those standards. It follows that an important deterrent to suicide by distressed or depressed people is involvement and identification with others—a conclusion supported by research (Slater & Depue, 1981).

As pointed out earlier in the chapter, married people, who presumably have stronger familial or social ties than divorced, widowed, or single people, are less likely to attempt suicide. In addition, people whose relationships with others are stable and satisfying are less likely to kill themselves than isolates, loners, or those whose social relationships are unrewarding (Farberow, 1974; Ezell et al., 1987). Findings such as these would appear to lend substance to Durkheim's analysis, but the current scientific viewpoint on suicide is more holistic: It includes not only sociological factors but also biological and psychological ones.

Psychological Aspects of Suicide

As suggested by the large number of people who admit having contemplated suicide at one time or another, no traits of personality consistently differentiate between suicidal and nonsuicidal people. All kinds of people kill themselves, for a variety of reasons, and many make several attempts. Among the reasons are rejection by or the death of a loved one; loneliness; feelings of guilt; failure to attain a desired professional or social position, or the loss of same; chronically poor health and physical pain; a desire for revenge; and even altruism. Among young people, loss of self-esteem, failure to live up to parental expectations, and problems with interpersonal relationships are common causes. Associated emotional reactions include depression, guilt, anger, hopelessness, and despair. Depression is the most common emotion in suicide, and mental disorders in which depression is a primary symptom carry the highest risk of suicide. This risk increases when drinking and drugs accompany the state of depression.

Most people who are contemplating suicide communicate their intentions, directly or indirectly, to at least one other person (Farberow & Litman, 1970; Rudestam, 1971). These cries for help range from subtle hints that one may not be around very long all the way through clear-cut threats to kill oneself. Although people are usually ambivalent about taking their own lives, suicide threats should never be taken lightly. A survivor who is oblivious to such cues often finds that the suicide of a friend or relative has placed a permanent "psychological skeleton in the survivor's emotional closet" (Shneidman, 1969, p. 12).

Psychoanalytic Perspective

Because so many personal and situational variables contribute to a decision to take one's own life, no single theory of personality or behavior can explain all suicides. The classical psychoanalytic interpretation views the act of suicide as an internalization of anger that the person is unable to express externally. Freudians believe that the destructive instinct, *Thanatos,* is always present in an individual and gains the upper hand in suicide. Freud viewed suicide as an act in which the anger or guilt felt toward another person was turned inward and redirected toward the "introject" or internalized image of that person. In addition, a person who attempts suicide has not lived up to his or her ego ideal, and the pressure of the superego becomes intolerable, driving the person toward self-destruction.

Humanistic and Behavioristic Perspectives

The humanistic perspective views a good life as one that is meaningful and self-actualizing. Consequently, suicide represents a waste or defeat. By destroying themselves—slowly or quickly, directly or indirectly—people fail to fulfill their potentialities, and so their lives become meaningless. According to the behavioristic analysis of suicide, a person attempts to self-destruct only when there is a real or imagined loss of reinforcers (health and vitality, love, success, material benefits, etc.). By committing suicide, the person fancies that he or she will move from a position of no reinforcement to a position in which pity, attention, revenge, and

other possible consequences of death provide reinforcement (unfortunately, in absentia) (Bootzin & Acocella, 1980).

Cognitive Perspective

Shneidman and Farberow (1970) interpret suicide as an action that results from particular modes of thinking. *Catalogical thinking* is described as despairing and destructive; the individual feels helpless, fearful, and pessimistic about becoming involved in personal relationships. In *logical thinking,* on the other hand, the person's thought processes are rational. An example of this is an elderly person who, after enduring long years of physical suffering or loss, decides to gain release by departing from this life. *Contaminated thinking,* as represented by hara-kiri, perceives suicide as a way of saving face or as a transition to a better life. For these people, death is a religiocultural ritual with a deep personal significance. In a fourth type of suicidal thinking, *paleological thinking,* the person responds with the act of suicide to accusatory delusions or hallucinations that involve shame and promise redemption only through death.

More on Suicide in the Young

> *Dear Mom, Dad, and everyone else,*
>
> *I'm sorry for what I've done, but I loved you all and I always will, for eternity. Please, please, please don't blame it on yourselves. It was all my fault and not yours or anyone else's. If I didn't do this now, I would have done it later anyway. We all die someday. I just died sooner.*
>
> *Love,*
>
> *John*
>
> (Berman, 1986, p. 151)

Although suicide is more common among the old than the young, among American teenagers it is the third-leading cause of death, just behind accidents and homicide. During the 1970s and 1980s, the suicide rate increased alarmingly among adolescents and young adults, sometimes following an epidemic pattern (Brody, 1987; Hendin, 1985; Peck et al., 1985).

Many of today's youth appear confused and frightened about the future. Feelings of anonymity and alienation, insecurity, and pressure to grow up too soon or to become popular and successful overnight are widely expressed by teenagers and young adults. Children may reach a point at which they feel that nothing is fun anymore, that they are loved by no one and must reciprocate by loving no one and nothing. The failure to live up to parental expectations and the resulting loss of feelings of belonging and self-esteem act as predisposing conditions for anger and depression. Then the danger signals of potential suicide begin to appear.

Various physical and behavioral changes may precede suicide attempts in children and youth. Among the physical precursors of suicide are digestive upsets, headaches, insomnia, loss of appetite, and a decline in appearance. Behavioral warning signs include a decline in school performance, irritability, mishaps of various kinds, unhappiness, loss of interest in things, a slowing down of movements, and increased use of alcohol and drugs. Cognitive changes such as increasingly rigid and negative thoughts, as well as preoccupation with suicide, are also commonplace.

Young boys with high suicide potential are more apt to have temper tantrums, engage in violent actions, and run away from home; young girls are more likely to become deeply depressed and develop psychosomatic symptoms, including headaches, nervous quirks, and excessive weight gains. In addition to a decline in academic achievement, older youths may exhibit depression, deterioration in personal care and hygiene, withdrawal and isolation, and self-criticism indicative of low self-esteem (Carson & Butcher, 1992). The person may increase his or her consumption of alcohol or drugs, talk about methods of committing suicide, and even threaten to kill himself or herself. Such behavior is most likely to occur during a crisis or transition period in a young person's life—the breakup of a romance, parental divorce or death, academic failure, or when the person is forced to rely on his or her own resources for the first time.

Identification of Suicide Potential

It is not unusual for people to think about suicide, but very few make real plans to end their lives, and even fewer collect the pills or other materials to do it. Nevertheless, even an occasional suicidal thought should be taken seriously, and anyone who is obsessed with thoughts of suicide requires immediate help.

People who are thinking about suicide usually fail to realize that they need help and therefore do not seek it. Interested family members, friends, and associates must be aware of and alert for the danger signs of potentially suicidal behavior. Because prediction facilitates prevention, much attention is given by suicidologists to symptoms of suicide potential. These symptoms include suicide threats, statements revealing a desire to die, previous suicide attempts, sudden changes in behavior (withdrawal, apathy, moodiness), depression (crying, sleeplessness, loss of appetite, hopelessness) (Beck et al., 1989), and final arrangements (such as giving away personal possessions) (Suicide Prevention and Crisis Center of San Mateo County, California, no date).

Research results indicate that it may be possible to predict suicidal behavior by physiological or biochemical tests. For example, a study conducted in Sweden found that, among patients hospitalized for suicide attempts, those with low levels of serotonin in their blood were ten times more likely than those with high serotonin levels to have died from suicide within a year (Goleman, 1985). The results of other studies have found relationships between violent behavior and other metabolic, biochemical, or neurophysiological dysfunctions. However, the responsibility for determining whether a person is contemplating suicide usually rests with his or her

informal contacts. Shneidman (1980b) advises that to prevent suicides, one must be particularly alert for cues such as heightened anxiety, expressions of hopelessness, a seeming tendency to act against one's own best interests, and a narrowing of focus (tunnel vision). Threats to commit suicide, even when made in a joking manner, as well as actual suicide attempts, should be taken seriously. A sizable percentage of people who threaten to take their own lives actually attempt it, and many of those who try and fail try again and again. I remember a mental patient who was so desperate to end his life that he swallowed his wire-rimmed spectacles. Luckily, they were extracted from his chest and he went on living.

Hotline volunteers at the Los Angeles Suicide Prevention Center are given a "lethality checklist" to help identify callers with a high potential for suicide. "Yes" answers to the following questions characterize a high-risk case:

1. Does the person communicate an intent to commit suicide?
2. Is the person highly specific about the details of the suicide plan? (e.g., "I know how many pills it will take for my body weight; my will is folded under the telephone; I will end it at sunset looking out my window; I will be wearing. . .")
3. Does the person have no family or other social support system?
4. Is the person facing a concrete life stress?
5. Is the individual suffering from a serious illness?
6. Has the person suffered from symptoms such as insomnia, depression, or alcoholism?
7. Is the individual a male?
8. Does the person have a chronic, debilitating illness?

Suicide Prevention

The prevention of suicide is important not only to the victim but also to the survivors. Perhaps not the most important reason, but a serious one, is that insurance companies usually are not required to pay death benefits to the survivors of suicide victims. Nearly a million people in the United States are influenced each year by someone else's suicide, not just economically but also psychologically. The grief, guilt, blame, and feelings of helplessness experienced by these survivors are incalculable.

Whenever a person, either directly or indirectly, threatens suicide, the listener should be accepting, caring, and supportive. However, if a suicide attempt is judged imminent, then the person should be encouraged to call a crisis intervention center or accompany the listener to a hospital. If these efforts fail, the listener should call a rescue unit (911) or the police.

The need for a professional approach to suicide prevention has led to the establishment in many countries of clinics devoted to this task. One of the first formal organizations to help prevent suicide was the Samaritans, founded by an Anglican minister, Chad Varah, in 1953 in London, England. Samaritans' volunteers, known as "befrienders," are available to listen and help, with no strings

attached, not even expressions of gratitude. The organization has chapters through-
out the British Commonwealth and in other parts of the world (Wekstein, 1979).

The first suicide prevention clinic in the United States opened in Los Angeles a
few years after the founding of the Samaritans. At present there are over 300 such
clinics nationwide. These clinics, which are oriented mainly toward crisis interven-
tion, provide psychological first aid and support to thousands of lonely, desperate
people every year. Clinic staff members try to help suicidal people cope with
immediate crises in their lives. They are not always successful in preventing suicide,
but the reward of having saved a few lives is worth the effort.

Long-term programs for treating suicidal persons emphasize helping them
realize the possibilities that remain open and giving them hope and the courage to
make their lives more meaningful and worthwhile. Counselors of suicidal persons
employ the following procedures:

1. Urge the person to speak frankly, no matter how negative his or her statements
 may seem.
2. Listen carefully and show genuine interest, concern, and caring.
3. Assess the person's internal and external strengths and resources.
4. Assist the person in clarifying his or her problem(s) and formulating a plan of
 action.
5. Arrange for psychiatric hospitalization when the situation is highly lethal, even
 if legal commitment becomes necessary (Altrocchi, 1980).

Various techniques for modifying behaviors and thoughts may be effective
with suicidal people. These include self-monitoring, differential reinforcement,
social support, and cognitive restructuring. *Self-monitoring* consists of attending to
and thus becoming more aware of one's thoughts and behaviors and how they are
interpreted by other people. The very process of attending to what one is thinking
and doing can help to change negative thoughts and behaviors. *Differential reinforce-
ment* consists of rewarding positive or constructive thoughts and behaviors and not
rewarding negative or destructive thoughts and behaviors. *Social support* for posi-
tive, nondestructive ideas and actions is, of course, itself a kind of differential
reinforcement. All three of these behavior modification techniques are employed in
cognitive restructuring, which consists of: (1) identifying persisting thoughts that
lead to depression; (2) training the person to realize that these kinds of thoughts are
distortions of reality; and (3) showing the person how to eliminate such thoughts by
"thought-stopping" maneuvers and by dealing with the negative thoughts ratio-
nally (Beck et al., 1979).

Biological treatments aimed at dealing with depression and hence reducing the
risk of suicide include the use of electroshock therapy and antidepressant drugs
such as the tricyclics and MAO (monoamine oxidase) inhibitors. A combination of
biological and psychological treatments may be employed and is often the best
strategy (Beck et al., 1985).

Psychotherapeutic procedures, when applied by trained, empathic counselors
and therapists, are effective in treating a large percentage of suicidal persons.

Unfortunately, these procedures do not always work, and a suicidal person may ultimately decide that the only reasonable solution to an intolerable situation is to take his or her own life. Psychiatrist Thomas Szasz (1986) maintains that suicide is a "fundamental right" of *adults*, and if the person does not want help and actively rejects it "then the mental health professional's duty ought to be to leave him or her alone (or, perhaps, try to persuade him or her to accept help)" (p. 809). Additional information on the prevention and treatment of suicide may be obtained from the American Association of Suicidology and the International Association for Suicide Prevention (see Appendix B for addresses and telephone numbers).

EUTHANASIA

Many people question whether a person who has decided to take his or her own life, after examining the various alternatives in detail, should be permitted to do so and even helped to make it less painful. *Euthanasia* (easy death) is the act of painlessly putting to death an individual who is suffering from an unbearably painful incurable disease or condition. *Passive euthanasia* is simply letting a terminally ill person die without applying lifesaving measures to keep him or her alive. *Active euthanasia*, on the other hand, entails using active measures to end a suffering person's life.

Throughout human history, active euthanasia has sporadically been practiced on certain groups of people (infants, the elderly, the chronically ill, the physically or mentally deformed, and even certain unpopular or "social unendurable" ethnic or religious groups). Mercy killing of infants, for example, was common in ancient Greece and certain other Middle Eastern countries. Historically, Christianity, Islam, and Judaism have opposed euthanasia, but a number of eminent philosophers, scientists, and other famous people have supported the practice in moderation. For example, Plato, Aristotle, David Hume, and Immanuel Kant all endorsed euthanasia under certain circumstances. In our own time, euthanasia has sometimes been associated with *genocide,* as in the extermination of millions of European Jews by the Nazis during World War II. Genocide is not only active, however, but also involuntary: It is done without the consent of the victims.

Active euthanasia is a criminal offense in the United States and Great Britain. Organizations such as the Society for the Right to Die (formerly Euthanasia Society of America) and the Voluntary Euthanasia Legalization Society of Great Britain have lobbied for legislation that would legalize active euthanasia with the consent of the person whose life is at issue (*voluntary euthanasia*). These organizations have gained many supporters, but no matter how humane their reasons may be, aiding and abetting suicide, which is how U.S. law interprets voluntary active euthanasia, remains a crime in the United States. Passive euthanasia, on the other hand, is not illegal under certain circumstances. This topic is discussed in more detail in Chapter 7. Other information on euthanasia may be obtained from the Center for the Rights of the Terminally Ill, Choice in Dying, Inc., the Hemlock Society, the International Anti-Euthanasia Task Force, and the Society for the Right to Die (see Appendix B for addresses and telephone numbers).

SUMMARY

Accidents, the fourth-leading cause of death in the United States, killed an estimated 88,000 people in this country in 1991. However, the rate of both fatal and nonfatal accidents has declined significantly in recent years. The main causes of fatal accidents in 1991 were, in order and grouped according to type, motor vehicles, falls, poisoning by solids and liquids, drowning, fires or burns, suffocation, firearms, and poisoning by gases and vapors. Grouped according to class, the four main causes of accidental death were motor vehicles, injuries in and about the home, public accidents, and job-related accidents.

Fatal motor-vehicle accidents are more likely to occur at night, on weekends and holidays, in the summer and fall, and during periods of economic upswing. Although elderly people have more accidents than other age groups, young people in the 15–24 year age range lead the list of motor-vehicle fatalities. Accidents and accident fatalities are more common among males than females and among people in poor physical condition (caused by illness, fatigue, alcohol, or drugs) than among the physically healthy and alert. Intelligence and personality variables are not highly related to accidents, but temporary emotional states can affect the occurrence and severity of accidents.

The annual suicide rate in the United States of 12–13 per 100,000 inhabitants is about average for the world. The world rate varies from 0 for Iceland and western Australia to over 26 for Hungary and Denmark. The suicide rate increases with chronological age and is higher in males than females, higher in Caucasians and Asians than blacks, higher in Jews and Protestants than Catholics, higher in city dwellers than rural dwellers, higher in lower-class than upper-class people, and higher in divorced than married people. It is also higher during times of economic recession than during economic upswings, and higher after the suicide of a famous person, real or fictional.

Suicide is opposed in most Western and Middle Eastern countries, especially predominantly Catholic or Islamic countries. It is viewed with less disfavor in the Far East, where conventional suicides such as suttee in India and hara-kiri in Japan were practiced for generations. The act of suicide is no longer a criminal offense in most Western countries, but it is generally disapproved by society. Helping a person commit suicide is illegal, but some nonconformists (e.g., Derek Humphry, Dr. Jack Kevorkian) are testing the laws.

A major sociological theory of suicide is Durkheim's classification of suicides into four types—altruistic, anomic, egoistic, and fatalistic. Psychological theories of suicide include the psychoanalytic notions of Thanatos and self-directed aggression, the behavioristic view of suicide as an attempt to attain positive reinforcement, and the cognitive conception of catalogical, logical, contaminated, and paleological thinking.

An increase in the incidence of suicide among teenagers and young adults has been attributed to their feelings of anonymity, alienation, and uncertainty. Young people who are contemplating suicide, and suicidal individuals in general, usually

show changes in behavior and other indications of their intentions. Suicidologists and suicide prevention clinics are making efforts to predict and prevent suicide in all age groups.

Interest has been growing in voluntary euthanasia and the right of an individual to end his or her own life. Active euthanasia is illegal, whether voluntary or not, but passive euthanasia is legal under certain circumstances.

QUESTIONS AND ACTIVITIES

1. Have you ever been in a motor vehicle accident? If so, was anyone injured? Some people who are in automobile accidents are unable to remember what happened just before the accident (*retrograde amnesia*) or just after the accident (*anterograde amnesia*). Have you or anyone whom you know had such an experience? If so, describe it and try to explain why it occurred.

2. Do you think that some people are more prone to accidents than others? What individual characteristics, both physical (size, motor dexterity, sex, etc.) and mental (intelligence, aggressiveness, carelessness, etc.) seem to play a role in accidents?

3. Do you believe that many accidents, such as being hit by an automobile or shot while playing with a gun, stem from suicidal impulses? How could it be proven that an "accidental" death was really a suicide, and why would one want to prove it?

4. Differentiate among the psychoanalytic, humanistic, behavioristic, and cognitive (modes of thinking) perspectives on suicide. Try your hand at combining these various perspectives into a general theory of suicidal behavior.

5. Have you ever known anyone who committed suicide, or at least made a bona fide attempt to do so? What do you believe were the reasons or motives for the person's act? Was there anything unique or different about the person as far as you could tell? Was he or she depressed or angry?

6. Arrange to visit a suicide prevention center or community hotline (or helpline) and interview the staff about their activities, training, goals, and the sources of gratification to be found in their kind of work.

7. Complete the following questionnaire and administer it to several other people. Compare your responses with theirs.

Attitudes Toward Suicide

Directions: Indicate your degree of agreement or disagreement with each of the following statements by writing SA (Strongly Agree), A (agree), U (undecided), D (disagree), or SD (strongly disagree) in the marginal dash.

_____ a. Only people with certain types of personalities are capable of suicide.

_____ b. Almost anyone is capable of suicide in the right circumstances.

_____ c. People should be permitted to commit suicide if they really want to.

_____ d. Suicide is a crime against humanity.

_____ e. People who are very ill and have nothing to live for should be helped to commit suicide if they request it.

_____ f. There should be no legal penalty for attempting to commit suicide.

_____ g. You should do everything that you possibly can to keep a person from committing suicide.

_____ h. Suicide is a crime against nature and a sin against God's law.

_____ i. People should be permitted to do whatever they wish with their own bodies—even commit suicide.

_____ j. The family and society deserve protection against suicidal behavior.

_____ k. People who attempt suicide should be sentenced in a court of law and punished.

_____ l. People who attempt suicide usually don't want to die; they just want attention.

_____ m. Suicide is a cry for help rather than a genuine attempt to die.

_____ n. Through their own actions, some people seem to be expressing a desire to die.

_____ o. Most people who attempt suicide really want to die.

_____ p. People who try to commit suicide are mentally ill.

_____ q. People who commit suicide are cowardly and inconsiderate of others.

_____ r. In certain cases, suicide can be a beautiful, moving experience.

_____ s. Suicide may be a rational response to an unbearably painful situation.

_____ t. People who help others commit suicide should be punished to the limit of the law.

SUGGESTED READINGS

Alvarez, A. (1974). *The savage god.* New York: Bantam.

Berman, A. L. (1986). Helping suicidal adolescents: Needs and responses. In C. A. Corr & J. N. McNeil (Eds.), *Adolescence and death* (pp. 151–166). New York: Springer.

Coleman, L. (1987). *Suicide.* New York: Scribner's.

Curran, D. K. (1987). *Adolescent suicidal behavior.* Washington, DC: Hemisphere.

Moreland, J. P., & Geisler, N. L. (1990). Suicide. In J. P. Moreland & N. L. Geisler, *The life and death debate: Moral issues of our time* (pp. 83–102). Westport, CT: Praeger.

Perrow, C. (1984). *Normal accidents: Living with high risk technology.* New York: Basic Books.

Plath, S. (1971). *The bell jar.* New York: Harper & Row.

Shneidman, E. (1985). *Definition of suicide.* New York: Wiley.

4

MURDER AND WAR

QUESTIONS ANSWERED IN THIS CHAPTER:

- *How common is murder, and how is it different from other types of homicide?*
- *How, by whom, why, where, and when are murders committed?*
- *What roles do biological, psychological, and cultural factors play in murder?*
- *What are the characteristics of mass murderers, serial murderers, and political murderers?*
- *What are the causes and characteristics of genocide?*
- *What are the causes and characteristics of terrorism?*
- *What are the causes and consequences of war?*
- *Can wars be prevented? If so, how?*

Homicide was the eighth-leading cause of death in the United States population as a whole and the second-leading cause of death in the 15–24-year age group in 1991. An estimated 27,440 deaths in this country were attributed to homicide and legal intervention during that year. Unlike the suicide rate, which has remained fairly stable, the rate of homicide and legal intervention has almost doubled since 1950 (National Center for Health Statistics, 1992a). As shown in Figure 4-1, a graph of the homicide rate by age has two peaks, one in infancy and a higher peak between the ages of 15 and 24. After age 25, the homicide rate declines fairly steadily until it levels off in old age (age 65 and over).

According to the National Institute of Mental Health, the average American has seen approximately 18,000 murders on television by the time he or she is 16 years old. Although the mass media give more attention to murder than to suicide, concern over both of these causes of death is sufficient to stimulate a constant flow of newspaper and magazine articles, television programs, motion pictures, and

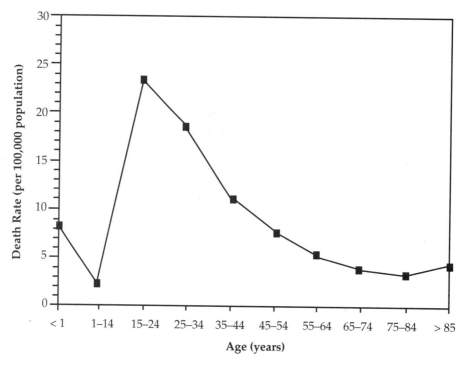

FIGURE 4-1 Homicide Death Rate by Age in United States, 1991

Source: Data from National Center for Health Statistics, 1992. *Monthly Vital Statistics Report, 40* (13). Hyattsville, MD: U.S. Department of Health and Human Services.
Note: Death rates are per 100,000 population in age interval.

professional research reports and books. Discovering the reasons for the high rates of self-inflicted or other-inflicted death is not simple; many questions remain unanswered. Furthermore, it is not always easy to differentiate between murder and suicide. In cases of victim-precipitated homicide, for example, what looks like murder on the surface may actually be a subtle form of self-destruction. Murder and suicide also can be masked as accidental death, as when a person "accidentally" falls (or is pushed) in front of an automobile. In any event, the speculations, theories, and research findings on murder and suicide are interesting, informative, and perhaps even a bit fascinating.

HOMICIDE AND MURDER

The terms *murder* and *homicide* are often used interchangeably, but the latter term has a broader meaning. *Homicide*, the killing of one human being by another, includes a variety of criminal and noncriminal acts. A criminal charge of homicide is

established by proof that a person died (even when no body has been found) and that the death was caused by a criminal act (even when no weapon is found). Furthermore, it must be shown that the victim died within a year and a day after the criminal act was committed. The information is obtained by various means, including an autopsy of the body and a police investigation to obtain the facts about the killing and pertinent evidence. The results are then evaluated by the district attorney's office and the court system and a decision is made either to bring the case to trial or to dismiss the defendant.

A critical matter in deciding whether to prosecute the alleged killer(s) in a homicide case is whether the act was justifiable, excusable, or felonious. A homicidal act may be *justifiable,* as when killing in self-defense or to protect other people. Homicide is justifiable when a felon is killed by a law enforcement officer in the line of duty or by a private citizen while a felony is being committed. In 1991, there were 693 justifiable homicides in the United States, 366 involving law enforcement officers and 327 by private citizens.

A homicidal act is *excusable,* as in accidents or other misfortunes, when it involves neither negligence nor unlawful intent. It is *felonious* when negligence, unlawful intent, or both were present during the homicidal act. Felonious homicide, in turn, is classified as *manslaughter* when it involves negligence but not malice or as *murder* when there is an intent to kill. Manslaughter itself may be either *voluntary,* when committed during the heat of passion, or *involuntary,* when the killing takes place during a misdemeanor (e.g., reckless driving). Although viewed legally as a lesser crime than murder, manslaughter is a serious criminal offense, and, depending on the circumstances and the jurisdiction, it is punishable by 1–15 years in prison.

The most serious type of homicide is *murder,* in which the killer intended to kill the victim (malice aforethought). A deliberate and premeditated (cold-blooded or planned) killing is classified as *first-degree murder* (murder one), and a deliberate but not premeditated killing is classified as *second-degree murder* (murder two). Exceptions to this rule are when a killing takes place during the course of a robbery, rape, or kidnapping, or when a high government official or a police officer is killed intentionally in the line of duty. Such killings are classified as first-degree murder. The distinction between first- and second-degree murder is particularly important during sentencing of the guilty person: The former crime is punishable by life imprisonment or death, whereas the latter crime carries a sentence of 5 years to life with the possibility of parole. However, a person who has been tried for murder and found to have committed the crime is not necessarily sentenced. He or she may be judged not guilty of murder by reason of insanity and given an open-ended commitment to a mental institution rather than a fixed prison sentence.

The United States has one of the highest murder rates in the world, a rate that has doubled since 1965. Gunshot deaths alone have doubled since 1938, although they have dropped somewhat during the past decade. There were 23,438 reported murders in 1990 and 24,703 in 1991, an increase of 5.4 percent (U.S. Department of Justice, FBI, 1992). How, why, when, and where were all these people killed, and who were the killers and their victims?

How Are Murders Committed?

People kill each other with guns, knives, ice picks, clubs, poisons, fire, gas, their bare hands, by drowning, and in a variety of other ways. Table 4-1 shows that, due largely to their general availability, handguns are the most popular murder weapon in the United States. Next in popularity to handguns as murder weapons are cutting or stabbing instruments. Smaller but substantial numbers of people are killed by rifles, shotguns, clubs, poisons, and, when the murderers are strong enough, by beating, choking, or throwing the victim across a room or out a window.

Since 1900, over 1 million U.S civilians have been killed by guns. This figure is greater than the total number of military personnel killed in all wars in which this country has fought. Understandably, the number and rate of people killed with guns are highest in those geographical areas with the largest per capita ownership of guns.

Because guns are so much more likely to be lethal than other weapons and are employed so often in criminal activities, why hasn't greater legal force been exerted to control the sale and use of these weapons? The answer to this question has two parts: (1) Strict gun control is probably impossible to enforce, and (2) Americans who own guns form a powerful lobby (the National Rifle Association) against gun control. Imagine the difficulties of disarming a population of over a quarter-billion

TABLE 4-1 Weapons Used in Murders in the United States in 1991

Weapon Used	Number of Murders	Percent of Total
Total firearms	14,265	66.3
Handguns	11,411	53.1
Rifles	741	3.4
Shotguns	1,113	5.2
Other guns	30	.1
Firearms—not stated	970	4.5
Cutting or stabbing instruments	3,405	15.8
Blunt objects (club, hammer, etc.)	1,082	5.0
Personal weapons (hands, fists, feet, etc.)	1,193	5.5
Poison	12	.1
Explosives	16	.1
Fire	194	.9
Narcotics	22	.1
Drowning	39	.2
Strangulation	326	1.5
Asphyxiation	113	.5
Other weapons or weapons not stated	838	3.9
Total	21,505	100.0

Source: U.S. Department of Justice, 1992. *Uniform crime reports: Crime in the United States, 1991*, p. 17. Washington, DC: U.S. Government Printing Office.

people in which every other household owns a gun and millions more are sold every year. Even the relatively tame Federal Gun Control Act of 1968, which prohibits mail-order and over-the-counter sales of guns and ammunition to certain groups of people (out-of-state residents, convicted felons, juveniles, mental defectives, mental hospital patients, drug addicts) has proven difficult to enforce. The proposed "Brady bill" would require a waiting period before anyone is permitted to purchase a hand gun.

Besides the Federal Gun Control Act, all states have laws that limit the sale and use of guns. New York and Massachusetts, for example, limit gun possession to adults with no criminal record who can show a legitimate need for a gun. A recent California law completely bans military-style assault weapons. However, many states deny guns only to mental patients and paroled felons. None of these laws is very effective in limiting the acquisition and use of guns. Additionally, the National Rifle Association and certain other influential organizations have mounted stiff opposition to laws that would prohibit the manufacture or importation of guns and their purchase by ordinary citizens.

Murderers and Victims

The total number of murder victims in the United States in 1991 consisted of 78 percent male, 47 percent white, 50 percent black, and 37 percent under age 25 (Figure 4-2). Most of those arrested were below average in socioeconomic status and had not finished high school (U.S. Department of Justice, 1992).

In 1991, nine of every ten female murder victims were killed by males, whereas only 13 of every 100 male murder victims were killed by females.

Ninety-three of every 100 black murder victims were killed by other blacks, and 85 of every 100 white victims were killed by other whites. In 48 percent of the cases the murderer and victim were either related to or acquainted with each other (U.S. Department of Justice, FBI, 1992).

Despite the fact that blacks constitute only 12 percent of the U.S. population, in roughly half of the murders committed in this country, black people kill black people. This fact, combined with the youthfulness of most offenders and their victims, results in homicide being the leading cause of death in young black men. As a consequence, young black men are on the list of the ten most endangered species.[1]

Why, Where, and When Are Murders Committed?

Most murders are not carefully planned, complex crimes of the sort described by Agatha Christie or solved by Sherlock Holmes. Murder is usually an impulsive, spur-of-the-moment event stemming from an argument or another felony (see Figure 4-3). A typical murder involves two young working-class males under the influence of alcohol or drugs who begin arguing about something and, to prove their toughness, resort to physical violence.

In most murders, both the killer and the victim had been drinking (Lunde, 1976). The larger the volume of alcohol consumed, the greater the likelihood of a

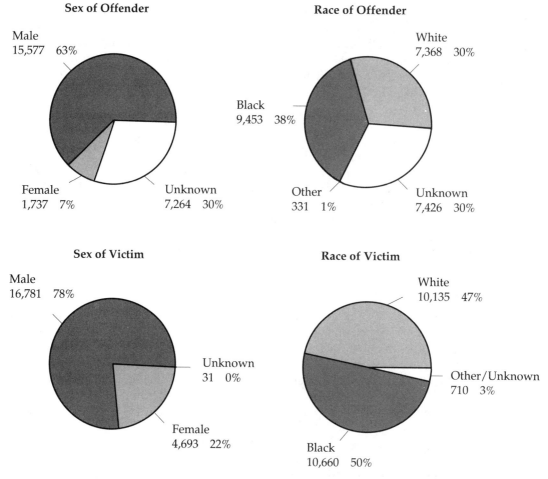

FIGURE 4-2 Sex and Race of Murder Offenders and Victims, 1991

Source: Data from U.S. Department of Justice, Federal Bureau of Investigation, 1992. *Uniform Crime Reports, Crime in the United States, 1991.* Washington, DC: U.S. Government Printing Office.

violent crime. Drinking, of course, contributes to accidental death. Other drugs, such as amphetamines, also may lead to accidents and outbursts of violence.

The most common location for murder is in the home, and a bedroom in particular. More women than men are murdered in bedrooms, and more men are murdered in kitchens. The kitchen is the second most deadly room in the home, and the living room is third. Outside the home, murders occur most often in the streets, followed by bars and other commercial establishments.

Murder rates are higher in large cities than in suburbs or rural areas. The murder rate for metropolitan areas in the U.S. in 1991 was 11 per 100,000 inhabitants, compared with 6 per 100,000 for rural counties and 5 per 100,000 for cities

Circumstance

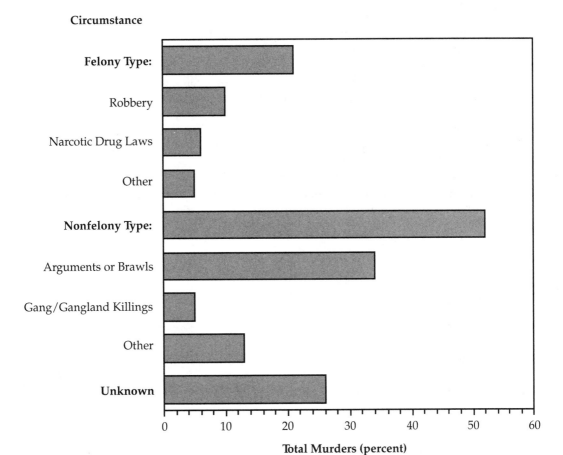

FIGURE 4-3 Percentages of Murders in Various Circumstances, 1991

Source: Data from U.S. Department of Justice, Federal Bureau of Investigation, 1992. *Uniform Crime Reports, Crime in the United States, 1991.* Washington, DC: U.S. Government Printing Office.

outside metropolitan areas (U.S. Department of Justice, FBI, 1992). Within large cities are a few sections with exceptionally high murder rates, usually areas of high population density, high unemployment, substandard housing, poor health-care services, and a generally low educational level among residents.

The Southern United States, the most populous region, accounted for 43 percent of the murders committed in this country in 1991. The Western states accounted for 21 percent, the Midwestern states 19 percent, and the Northeastern states 17 percent of the murders (U.S. Department of Justice, 1992). Interestingly, the national murder rate tends to increase with a decrease in geographical latitude, and to some extent this phenomenon is also apparent on the international scene. Countries such as Columbia, Mexico, Guatemala, and Nicaragua, which are closer to the equator,

have even higher murder rates than the United States. On the other hand, the rates are much lower in most European countries and Japan.

Murder rates show both temporal and spatial variations. For example, murders are more common on weekends, holidays, vacations, and during times of economic prosperity. The significant relationship between alcohol consumption and murder rate may be due in part to an increase in both murder and the consumption of alcoholic beverages during times of economic prosperity (Lunde, 1976). Concerning murder by month, in 1991, more murders were committed during August and December, when large numbers of people are on vacation and large sums of money are visible (see Figure 4-4).

Understandably, murder for personal profit is more common during times of economic recession and in poorer countries. Also of interest is that both murders and suicides have tended to decline during presidential elections (Boor, 1981) and when the country was mobilizing for war (Marshall, 1981). On the other hand, the

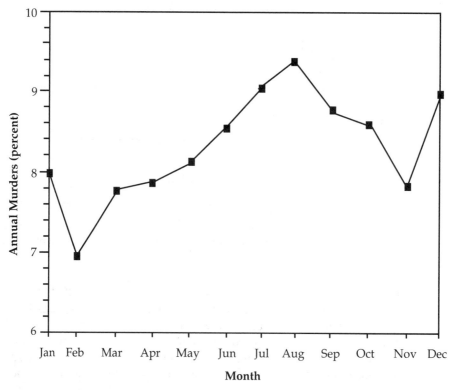

FIGURE 4-4 Percent of Annual Murders by Month, 1991

Source: Data from U.S. Department of Justice, Federal Bureau of Investigation, 1992. *Uniform Crime Reports, Crime in the United States, 1991.* Washington, DC: U.S. Government Printing Office.

homicide rate in the United States doubled during the Vietnam War (Archer & Garner, 1976).

Although no relationship has been found between murder rate and weather conditions, nighttime murders are more common during a full moon. A 1956–1970 study in Florida found, however, that more murders occurred during the dark phase of the lunar cycle (see Lunde, 1976). It has been speculated that this phenomenon is attributable to the gravitational pull of the moon on the brain. Considering the very small effect of the moon's gravity on the human body, this conclusion seems a bit far fetched. Similar kinds of explanations have been proposed for the slight correlation between the murder rate and magnetic fluctuations of the earth.

We live in a violent society, one conditioned to violence not only through a history of settling disputes by individual and collective battle but by films and stories that are full of aggression, injury, and death. Violence on television and in the movies can habituate people to violent acts and stimulate them to commit those acts themselves. According to statistics compiled by Phillips (1983), from 1973 to 1978, homicides in the United States increased by an average of 12.46 percent after heavyweight championship prize fights. Apparently, viewing prize fights on television stimulates fatal aggressive behavior, which may lead to death. In any event, it is advisable not to argue with a young whiskey-drinking, gun-totin' acquaintance at home or in a bar on a Saturday night in August or December when the moon is full and a lot of cash is flashed!

Cultural Differences in Murder

The relationships of murder to geography, nationality, ethnicity, sex, religion, and many other demographic variables can be interpreted to a large extent in terms of cultural differences. For example, the dominant culture of the Southern United States has been characterized historically by firearms, duels, militia, military training, military titles (e.g., Colonel), and vigilante groups such as the Ku Klux Klan (Franklin, 1956). The maintenance of extreme social class differences in this geographical region required the use of violent punishment to control troublemakers and rebels against the system. This latter-day feudal system persisted even after the Civil War, when the South continued to resist industrialization, defended local ownership and control, and reacted suspiciously to strangers. The affinity for guns, manifested by both Southern whites and blacks, correlated with the murder rate. Given the central role of guns and militarism in Southern history, it is not surprising that the incidence of murder is higher in states that were settled primarily by Southerners in the westward expansion of the nation (e.g., Louisiana and Texas) than in states settled predominantly by Northerners (e.g., Wisconsin and Minnesota) (Lunde, 1976). Three of the four states with the highest homicide rates in the nation—Louisiana, Texas, and Georgia—are in the South. On the other hand, the city with the highest rate in the nation (New York City) is in the North. New York City has twice as many homicides in a given year as the entire country of Japan ("Homicide Rates Hit Record High," 1990).

The use of violence and firearms to settle disputes occurs in many subcultural groups, especially those in the lower socioeconomic strata. Members of the subculture of violence that characterizes certain sections of large U.S. cities are likely to subscribe to the macho ethic that one should carry a weapon and be ready to use it when one's status is questioned or threatened. Such a person may become sensitized to any real or imagined insult and be prepared to attack on a moment's notice. Furthermore, those who do not conform to this ethic of machismo are usually ostracized or victimized.

Violence and murder have been condoned in certain countries and certain historical periods. The murder rate in Mexico, a country in which the dominant majority subscribes to the machismo ethic, is three times that of the United States. By way of contrast, the murder rate in Canada, a nation that absorbed the British emphasis on order and self-control, is only one fifth that of the United States.[2]

Mexico and other Latin American countries with high murder rates (Nicaragua, Colombia, Guatemala, etc.) also have quite low suicide rates, a fact that may be interpreted in terms of the effects of religion on behavior. Although the Bible commands that "Thou shalt not kill," the Koran is less vehemently opposed to murder. The teachings of the Bible, the Koran, and other religious books have obviously been interpreted somewhat differently by different cultural groups. Homicide is not necessarily a mortal sin in Roman Catholic theology, but Judaism is strongly opposed to murder.

Consistent with religious differences in attitudes toward homicide and suicide are the observations that the murder rate is high and the suicide rate low among Moslems and Catholics, whereas the reverse is true among Jews. Protestant theology is less opposed to suicide than Catholicism and less opposed to homicide than Judaism. Predictably, the rates of murder and suicide in Protestant groups fall between those for Catholics and Jews (Ezell et al., 1987; Lunde, 1976).

The seeming tendency for homicide and suicide rates to vary in opposite directions over time and across cultural groups has intrigued many social scientists (e.g., Binstock, 1974; Havighurst, 1969). In an early study, Porterfield (1949) found that cities with high suicide rates had low murder rates, and cities with high murder rates had low suicide rates. Following up on Porterfield's research, Henry and Short (1954) pointed out that suicide decreases and homicide increases during economically prosperous times, but the opposite is true during economically depressed periods. In addition, suicide is more common than murder among higher social classes, but murder is more common than suicide in lower social classes. It is tempting to conclude, with Henry and Short, that a sociological law underlies these findings: There appears to be a relatively fixed level of violent energy in any given culture or society. The expression of this energy depends on the relative strength of restraints imposed on individual behavior by social forces outside the person (external restraints) and restraints imposed from within the person himself or herself (internal restraints). The extent to which violent energy is expressed in homicidal or suicidal behavior depends not only on the relative strengths of these external and internal restraints but also on the degree to which homicide and

suicide are culturally prohibited. When homicide is more strongly prohibited than suicide, the murder rate will be low and the suicide rate high. When suicide is more strongly prohibited, the murder rate will be high and the suicide rate low. Furthermore, if there are strong external restraints on group members and suicide is strongly forbidden, then the murder rate will be higher than the suicide rate; this is true in the lower social classes. If internal restraints on group members are strong and murder is more severely censured than suicide, as in the upper social classes, the suicide rate will be higher than the murder rate. Unfortunately, the results of subsequent studies fail to support Henry and Stout's thesis. Both the murder and suicide rates have risen in recent years, and both are now higher in lower than in upper social classes (Lunde, 1976).

Murder, suicide, and other violent behaviors are usually interpreted as culturally conditioned reactions to specific situations, but modern-day cultures are not static. A culture may change rapidly, being influenced by information and techniques communicated by interactions with people from other cultures. Children in many different cultures now see murders in domestic situations, in the streets, and in combat situations almost every day on television, in films, and in other media. Socially condoned violence in the Middle East results in the social acceptability of violence as a means of handling disputes elsewhere in the world. People become conditioned to guns as symbols of violence and react violently to them (Berkowitz, 1968). They learn to murder by mail, with explosives, with military-style assault weapons, and with other instruments provided by modern technology. Specialized techniques of killing are not restricted to a certain culture; they are there for all unhappy, frustrated people to see and use.

Psychosocial Considerations in Murder

Criminology, the study of criminal behavior, traditionally was the province of sociologists, whose primary explanation of the cause of criminal behavior was the *principle of differential association.* A modified version of this principle states that "Overt criminal behavior has as its necessary and sufficient conditions a set of criminal motivations, attitudes, and techniques, the learning of which takes place when there is exposure to criminal norms more than exposure to corresponding anticriminal norms during symbolic interaction in primary groups" (DeFleur & Quinney, 1966, p. 7). According to this principle, a necessary and sufficient condition for murder is prolonged exposure to a subculture of violence and violent role models without compensating exposure to nonviolent situations and models. The principle does not take biological variables into account, but it does consider the learning process. The study of learning is a primary concern of psychologists, who consider learning to be crucial in the development of criminal behavior in general and homicidal behavior in particular.

Many anthropologists and biologists have been interested in the possible influences of such biological variables as body build (somatotype), hormones, brain waves, and abnormal chromosomes or genes in the determination of criminal

behavior. The nineteenth-century notion of the bad seed continues to influence speculations about the causes of murder and other crimes (see Yochelson & Samenow, 1976). Although not denying the importance of environment, supporters of a genetic basis for criminality maintain that a predisposition to such behavior, manifested in temperamental characteristics such as impulsiveness or low frustration tolerance, is inherited. In recent years, for example, the XYY, or so-called supermale, chromosomal pattern has received much attention as a possible biological basis for aggressiveness and impulsive murder, but research has failed to confirm the hypothesized relationship between the XYY pattern and violence. Other theorists believe that, although criminal behavior is not strictly determined by heredity, one may inherit a characteristic, such as an athletic (mesomorphic) body build that makes violent activity more likely or rewarding (Glueck & Glueck, 1956).

Unfortunately, no single theory of criminal behavior in general or of homicidal behavior in particular can account for the variety of crimes and their antecedents. Not all murderers have biological abnormalities, not all come from deprived backgrounds or have criminal associates, and not all have low IQs or the same personality traits. Even Guttmacher's (1960) classification of murderers into four groups—normal, sociopathic, alcoholic, and avenging—fails to do justice to the range of characteristics and motives found in people who kill.

There is some evidence that the greater the impulsiveness and violence of a murderer, the more likely he or she is to be rather shy, inhibited, and, for a male, more feminine in interest pattern (Lee et al., 1977). The overcontrol normally exhibited by such people breaks down when the core of the person's identity is threatened and he or she is no longer able to deny intense feelings of anger. In contrast to the overcontrolled, impulsive murderer is the more common undercontrolled, macho individual who acts out his aggressions with little restraint. Such a person may kill you for stepping on his shoes, staring at him, or looking at his girlfriend. If you have something that he wants, he may kill you for it without a second thought. As one juvenile offender confessed in describing why he killed the driver of a car and pushed the body out before driving away: "I needed the car, but I didn't need the person." Even more bizarre is to be selected randomly for killing as a way of proving your assailant's masculinity. In any case, the violent act of murder releases feelings of frustration and tension and sometimes fear in the murderer. The killer may view both the victim and himself with a sense of impersonality or detachment. The victim becomes a dehumanized object, to be exploited and destroyed. The detached self of the killer looks on as he uses the lethal weapon, after which a release of emotion occurs.

Another link between murder and suicide has been noted by many authorities. According to Halleck (1971), both of these violent acts may represent efforts to cope with feelings of helplessness, hopelessness, hostility, and depression. Halleck reports that murder can be an act of self-preservation: Murderers kill other people to keep from killing themselves. Of course, this self-protective gesture fails when a murder is committed and the murderer then commits suicide.

Murder, Insanity, and Serial Killing

Any discussion of the psychological aspects of murder requires some consideration of the popular assumption that many murderers are insane. Most law-abiding citizens probably find it impossible to identify with or understand a person who commits a particularly violent murder in which the victim is ravished or mutilated. Therefore, it is natural to conclude that anyone who would commit such a crime must be deranged. This point of view is perhaps more common in countries such as England, where the murder rate is substantially lower than in the United States and one fourth of the apprehended murderers are declared legally insane. Although social supports for murder and efficient means of committing it are less common in England, the rate of mental illness is just as high as it is in the United States. In addition, murder is more often followed by suicide in England than in the United States, presumably because of the stronger social sanctions against taking a life and the resulting fear and guilt experienced by the killer.

Mentally ill people are often feared, but most of them are less likely to commit murder than so-called normal people. Those few mentally ill people who kill usually provoke dramatic, frightening stories in the media that stimulate public fear of drooling mad dogs on the loose or horrible, subhuman monsters roaming the streets. This fear becomes particularly intense when a mass murderer or serial killer such as the Boston Strangler, the Son of Sam, or the Hillside Strangler is depicted as prowling by night and stalking unsuspecting innocent victims. Stories of Ted Bundy, who bludgeoned college coeds from coast to coast in the 1970s, John Gacy, who murdered over 30 young boys in Chicago, and Juan Corona, who killed 25 migrant workers in California over a period of years, sell newspapers but also prey on the public's feelings of helplessness and fear of the unknown. Still, many people experience a morbid fascination with the actions and personalities of mass murderers, such as the fictional Hannibal (the Cannibal) Lecter of "Silence of the Lambs" fame.

Not all mass murderers are serial killers who pursue their lethal activities over a span of months or years. The killings of a mass murderer may be committed in a very short period of time, as when Patrick Purdy shot a group of children in a Stockton, California, schoolyard or James Huberty shot 21 patrons in a San Diego fast-food restaurant before committing suicide.

Hundreds of scholarly and speculative articles have been written on mass murderers and serial killers, including reports of childhood experiences and family background, neurological disorders, artificial food coloring, and the sexual nature of the acts (see Box 4-1). Some serial killers, such as David Berkowitz (the Son of Sam), are diagnosed as paranoid schizophrenics, whereas others, such as Jack the Ripper, are described as sexual sadists. Paranoid mass murderers usually have a history of psychiatric treatment, but sexual sadists, who derive sexual pleasure from killing, abusing, and mutilating their victims, usually do not. Not all mass murderers are paranoids or sexual sadists, and, unlike the typical impulsive killer, most have no police record and are quite intelligent. These characteristics make mass

BOX 4-1 • **Profile of the Serial Killer**

The offender, Peter Kursten, was 47 years old at the time of his apprehension in Dusseldorf, Germany, for a series of lust murders. He was a skilled laborer, well-groomed, modest, and had done nothing that annoyed his fellow workers.

Peter came from a disturbed family background, his father having been an alcoholic who had been sent to prison for having intercourse with Peter's older sister. Peter's own earliest sexual experiences were with animals. When he was about 13 years old, he attempted to have intercourse with a sheep, but the animal would not hold still, and he stabbed her with a knife. At that moment he had an ejaculation.

After this experience, Peter found the sight of gushing blood sexually exciting, and he turned from animals to human females. Often he first choked his victim, but if he did not achieve an orgasm, he then stabbed her. Initially he used scissors and a dagger, but later he took to using a hammer or an axe. After he achieved ejaculation, he lost interest in his victim, except for taking measures to cover up his crime.

The offender's sexual crimes extended over a period of some 30 years and involved over 40 victims. Finally apprehended . . . he expressed a sense of injustice at not being like other people who were raised in normal families.

Source: From Carson & Butcher, 1992; adapted from Berg, 1954.

murderers difficult to apprehend. Many appear to have a Dr. Jekyll-Mr. Hyde personality, seeming to be ordinary, law-abiding citizens to their neighbors and coworkers. In actuality, the mass murderer may be experiencing severe feelings of inadequacy and status frustration, secretly acting out his problems on persons who contribute to these feelings or who represent or threaten his status (Leyton, 1986).

Murder in the Home

As noted previously, more murders occur in the home than in any other location. This is a place where parents kill their children, husbands kill their wives, and wives kill their husbands. Coupled with the demands they place on immature parents, the fragility of young children makes them prime targets for the hostility of overwrought fathers and mothers. It is often the case that parents who abuse and murder their children were abused themselves during childhood. Such parents are usually unrealistic in their expectations of children, demanding things that the children cannot always do. In most cases, parents who commit infanticide do not intend to kill their children, but the stress and frustration of coping with them become too great and the parents vent their rage in child abuse and murder. As in other murders, the child victim is perceived as a demanding, dehumanized thing that is interfering with the parent's emotional gratification (Kastenbaum & Aisenberg, 1976).

The motives of people who kill their spouses vary with the sex of the killer. Wives are more likely to kill their husbands because of bruised bodies, whereas

husbands are more likely to kill their wives because of bruised egos. A wife will usually attempt to kill her husband only as a last resort, after she has been verbally and physically brutalized for a prolonged period of time. On the other hand, a husband who murders his wife usually does so as an impulsive response to a walkout, a demand, or a threat of separation. These behaviors represent rejection, abandonment, or desertion to the husband or lover (Barnard et al., 1981).

The killing of a spouse in the home is sometimes victim precipitated, in the sense that the victim either knowingly or unknowingly contributes to his or her own death (Lester, 1973). Victim precipitated homicide is more common in lower socio-economic classes and when the victim and offender have similar characteristics. Homicide victims may contribute to their own deaths in a variety of ways and circumstances—by habitually exposing themselves to danger, by badgering, insulting, or arguing with a drunken person or one who for other reasons is out of control (e.g., "You haven't got the guts to kill me!" or "Go ahead and kill me; I don't care"), by being indiscriminately seductive, and even by striking the first blow. In such instances it seems as if the victim harbored a secret suicidal desire and encouraged violence as an indirect form of self-destruction. A similar psychological process occurs in people who commit "senseless" murders in order to receive the death penalty. In these cases, the murderer consciously or unconsciously believes that it is more socially or morally acceptable to be killed by another person or agency than to kill yourself (Abrahamsen, 1973; Wolfgang, 1969).

Apprehending Murderers

Although not as high as it once was, the rate of arrest, or *clearance rate,* is higher for homicide than for any other crime. For example, in 1991, law enforcement agencies nationwide registered a murder clearance rate of 67 percent (U.S. Department of Justice, FBI, 1992). In approximately two thirds of the cases, the killer, who usually goes to great pains to escape or avoid detection, is in police custody within 24 hours after committing the crime. For whatever reason—fear, tension, a feeling of helplessness—murderers often act in such a way as to ensure their own detection and capture. The desire to be caught, as dramatically portrayed in Fyodor Dostoyevski's *Crime and Punishment,* is most apparent in impulsive murders committed by quiet, nonviolent people who have no prior arrests. However, if a suspect is not caught within 48 hours after the crime, the odds against detection and capture increase markedly.

The arrest of a homicide suspect does not, of course, ensure a conviction. Only about 6 out of 10 people charged with murder or voluntary manslaughter in the United States are convicted and sentenced. The severity of the sentence depends on a variety of mitigating circumstances—for example, whether the defendant expresses remorse over the crime. The death penalty is used infrequently, and even a person who is sentenced to life imprisonment is usually eligible for parole in 7 years. On the average, people convicted of first-degree murder in the United States spend 10 1/2 years in prison; those convicted of second-degree murder are in prison for approximately 5 years, and those convicted of manslaughter for about 3 1/2 years.

Less than 2 percent of convicted murderers kill again, a recidivism rate that is lower than for any other crime. Still, many people feel that stiffer prison sentences and a more liberal application of the death penalty are necessary to curb the rise in murder and other violent crimes in this country. This issue, and in particular the national debate over capital punishment, is considered in more detail in Chapter 7.

Collective Crime and Genocide

A special type of mass murder known as *collective crime* occurred in the killings committed by the Manson family or the U.S. soldiers led by Lt. William Calley in Vietnam. On March 16, 1968, 455 men, women, and children in the village of My Lai, South Vietnam, were massacred by American soldiers. When such killings, which are sanctioned by a particular social group, occur on a sufficiently large scale and are directed at a specific social, national, or ethnic group, they are known as *genocide*. In genocide, an attempt is made to exterminate an entire ethnic, national, or religious group, as in the systematic extermination of 800,000 Armenians by the Ottoman Turks during World War I, the shooting and gassing of 6 million Jews and an additional 5 million political opponents by the Nazis during World War II, and the execution and starvation of 2 million Cambodians by the Khmer Rouge in the mid-1970s. More recent examples are the killing of tens of thousands of Kurds in northern Iraq and the slaughter of Bosnian Moslems by Serbs in Yugoslavia. Genocide, which often occurs during times of economic recession, political upheaval, and social disorder, is a form of displaced aggression against a less powerful group who is blamed for the prevailing troubles.

The victims of genocide are almost always viewed as subhuman or nonhuman objects by their executioners, an attitude that presumably makes the slaughter seem justified and easier to carry out. Thus, the Nazi regime characterized the Jews, Slavs, and other non-Nordic groups as "Untermenschen" and depicted them as packs of rats that should be eradicated. New heights (or depths) or eradication were achieved in the so-called final solution of gassing and cremating 2 million Jews and political prisoners in the slaughterhouses of Auschwitz and other concentration camps during the early 1940s. Although the strong were spared for a while as slave laborers, the old, the young, the sick, and women with children were led to special chambers, ostensibly to be deloused and showered, but actually to be gassed and then disposed of. Efforts to systematically exterminate the Jewish population, who were believed by the Nazi leaders to be the source of Germany's problems, were carried out in all of the countries occupied by the Germans during World War II. Some Jews were saved by the indigenous population of those countries, the most notable example being the successful transfer of the entire Danish Jewish community to Sweden in private boats. With the exception of several cities in Poland (Warsaw, Bialystok, Vilnius), there was surprisingly little organized resistance to the efforts of the Nazis to round up the Jews. The great majority of the inhabitants of the occupied countries apparently did not believe that the Jews were being killed en masse, a belief that some people still hold today. This act of genocide against the

Jews, which has come to be known as the *Holocaust*, is commemorated today throughout the world in books, works of art, and a special day (April 19 or 20).

Political Assassination

Genocide, the systematic effort to eliminate an ethnic or nationality group, is sometimes called *political murder*. On a much more limited scale is the assassination of a political leader such as the president or the pope. The assassination of political leaders has been a common practice, and even a profession of some, for many centuries. For example, of the 107 emperors of the Byzantine Empire between 395 and 1453 AD, 23 were assassinated, 18 were mutilated and dethroned, 12 died in prison, 8 were killed in war, and only 34 died of natural causes (Bell, 1979). In our own country, attempts have been made to cause bodily harm to one fourth of all American presidents, and four of them have been assassinated while in office.

Although a popular view of political assassins is that they are deranged or crazy, many assassins act from rational motives. According to Clarke (1982), there are at least four types of political assassins. Type I is extreme but rational, selfless, principled, and without perversity; Type II kills for revenge or to gain acceptance or recognition from a significant other; Type III is a psychopath who views life as meaningless and purposeless and the destruction of society (including himself) as desirable for its own sake; and Type IV is a real crazy. Not all the 17 political assassins considered by Clarke fell into one of these four categories, but the great majority (15) did. Finally, whatever his or her personality characteristics may be, a political assassin's task is easier when guns and explosives are easily available. Most assassins and would-be assassins have military training in the use of lethal weapons, which improves the odds of success.

Terrorism

Related to assassination, and usually political in its aims, is *terrorism*, the use of threats and violence to intimidate or coerce. Although murder is a common result of terrorist activity, the primary purpose of terrorism is not to kill or injure people but rather to frighten, anger, or otherwise emotionally arouse them into committing irrational acts. Since the 1960s, terrorist activity has been a frequent source of news, but terrorism is by no means a new phenomenon. Three prominent terrorist groups in previous times were the Jewish Zealots of Roman Judea, the Moslem Assassins of the Ottoman Empire, and the Indian Thugs. The Jewish Zealots were perhaps the most successful of terrorists groups in the ancient world, in that their activities led to a popular uprising. However, those activities also led eventually to the mass suicides at Masada in 73 AD, the destruction of the Second Temple, the deaths of half the Jewish population, and the scattering of the Jews outside Palestine (the *Diaspora*) (Shurkin, 1988). It is noteworthy that terrorism against the British perpetrated by certain Jewish groups was an important factor in the founding of the new state of Israel some 19 centuries later.

WAR

Another type of political murder, but one that is considered legal and even heroic, is *war*—a condition of hostile conflict between opposing forces. These two or more forces are typically nations whose rulers or representatives perceive that the vital interests of their nations can only be fulfilled through armed intervention. Most wars are *limited*, in which case the daily lives of most of the civilian population of the combatant nations are not affected. *Total war*, on the other hand, involves both the military and the civilian population. Fighting is not limited to military personnel; all of the resources, people, and weapons of the country are used and subject to attack. Of course, the enemy in war may be internal rather than another country or external source. In rebellions, insurrections, revolutions, and civil wars, internal rebel forces attempt to overthrow the existing government.

Historical Perspective

In the Book of Revelations, war is symbolized as one of the four horsemen of the Apocalypse. The first horse, pestilence, is white; the second horse, war, is red; the third horse, famine, is black; and the fourth horse, death, is pale (see Box 4-2 and Figure 6-2). The actions of these horsemen and other catastrophes lead to the massive destruction of the human race. In the end, only 144,000 souls are left.

To many students and teachers, it seems as if the history of the world consists of one war after another. Certainly, armed conflicts involving large numbers of people have occurred since the beginnings of recorded history. Some of the most famous wars in ancient times—the Trojan War, the Peloponnesian War, and Caesar's Gallic

BOX 4-2 • The Four Horsemen of the Apocalypse

I watched as the Lamb opened the first of the seven seals. Then I heard one of the four living creatures say in a voice like thunder, "Come!" I looked, and there before me was a white horse! Its rider held a bow, and he was given a crown, and he rode out as a conqueror bent on conquest.

When the Lamb opened the second seal, I heard the second living creature say, "Come!" Then another horse came out, a fiery red one. Its rider was given power to take peace from the earth and to make men slay each other. To him was given a large sword.

When the Lamb opened the third seal, I heard the third living creature say, "Come!" I looked, and there before me was a black horse! Its rider was holding a pair of scales in his hand. Then I heard what sounded like a voice among the four living creatures, saying. "A quart of wheat for a day's wages, and three quarts of barley for a day's wages, and do not damage the oil and the wine!"

When the Lamb opened the fourth seal, I heard the voice of the fourth living creature say, "Come!" I looked and there before me was a pale horse! Its rider was named Death, and Hades was following close behind him. They were given power over a fourth of the earth to kill by sword, famine and plague, and by the wild beasts of the earth.

Source: Holy Bible: New International Version (Revelations 6:1–8).

Wars—became the stuff of legends and literature. The romance and heroism as well as the destruction and horror of war have been represented in many famous works of art and literature. Examples of famous novels or plays about war are Homer's *Iliad*, the Hindu *Mahabarata*, Leo Tolstoy's *War and Peace*, and Margaret Mitchell's *Gone With the Wind*.

The successes of the victors in wars are usually as much a matter of weaponry as bravery and leadership. For example, in ancient times, iron weapons enabled the Hittites to defeat the Egyptians and the Greeks to defeat the Persians. Superior armaments, as seen in automatic weapons, ironclad ships, airplanes, and nuclear weapons, have continued to ensure victory in more recent wars. A dramatic example of the effectiveness of superior firepower in the hands of a much smaller force was the slaughter in 1893 of 3000 attacking Zulu tribesmen by 50 British security guards equipped with only four machine guns (Kearl, 1989). Technological advances are, however, not the only factor leading to a change in the nature of war. Prior to the Napoleonic Wars, battles were fought mostly by professional soldiers and on a limited basis. Napoleon's Grande Armee of a half-million men, most of whom were conscripts rather than volunteers, changed all that. Now, instead of a few hundred or thousand casualties, hundreds of thousands of men died in battle. Over a million Russians were killed at the Battle of Tannenberg and another million men at the Battle of the Somme during World War I. Soldiers were cut down by big guns and automatic firepower like wheat before a thresher. Rats grew as large as dogs from gorging themselves on human flesh. A few decades later, saturation bombing in World War II killed thousands of military personnel and civilians in England, Germany, Japan, Korea, and Vietnam. Even more combatants have died of infectious diseases or were permanently disabled by physical and psychological trauma.

The destructiveness of war throughout human history is seen clearly in the record of military casualties in wars involving the United States (see Figure 4-5). The war that claimed the most American lives was not World War I or II but rather the Civil War. In battles at Manassas, Antietam, Gettysburg, and other locations during that war, more American soldiers were killed (over 600,000) than in all wars fought by this country in the twentieth century. Two of the most recent wars involving the United States, the Korean War and the Vietnam War, claimed 54,000 and 58,000 American lives, respectively. However devastating these numbers may seem, they do not compare with the estimate of 7.5 million Russian troops who perished in World War II. Since World War II, approximately 20 million people have died in more than 100 conflicts.[3] Relatively few American were killed in the Persian Gulf War, but an estimated 40,000–100,000 Iraqi troops died.

Causes of War

Is war rational or irrational? Is it the result of logical decision making or the impetuous act of frustrated, angry people? Traditionally, in story, song, and propaganda, the emphasis has been on war as a glorious, honorable, chivalrous enterprise. This was perhaps true to some extent of smaller wars during ancient and

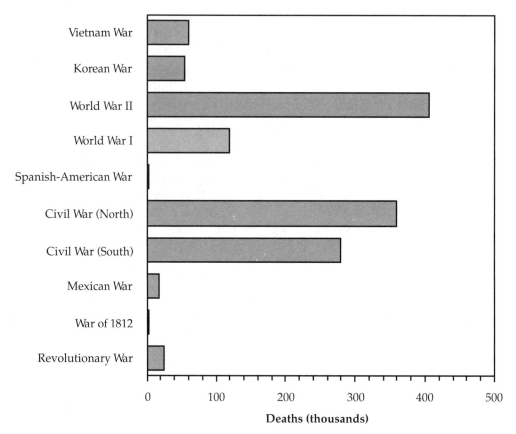

FIGURE 4-5 Military Deaths in Wars Involving the United States

Source: Data from *World Book Encyclopedia* (Vol. 21), 1990, p. 25.

medieval times, but even then the supposed nobility of war was nine-tenths fictional. Men may have thought that they were fighting for God, honor, country, and ladies fair, but the actual causes of combat were much less idealistic.

Although tribes and nations have fought since time immemorial for territory, wealth, security, and power, as well as against deprivation, injustice, and suffering, many wars have been waged for religious reasons. Christians versus Moslems, Catholics versus Protestants, Hindus versus Sikhs, and other religious conflicts led to a long history of warfare before the seventeenth century. Although the motives of religious zealots may have been pure, their techniques were not. For example, many honorable European knights slaughtered hundreds of innocent women and children as well as armed men as they poured into Jerusalem and other Moslem strongholds during the Crusades. Even today religious differences continue to be a source of discord, but since the seventeenth century war has been waged less for religious reasons than for more materialistic motives.

According to Carl von Clausewitz (1982), war is a rational instrument of foreign policy, "an act of violence intended to compel our opponent to fulfill our will." The writings of von Clausewitz and other military theorists served as a justification for German militarism in the late nineteenth and the twentieth centuries. But is war really a rational act, or is it the result of more emotional, irrational motives? This was the question discussed in the famous correspondence between Albert Einstein and Sigmund Freud during the 1930s. Einstein, Freud, and the social psychologist William McDougall all believed that human beings are born with an instinct for destructiveness and aggression, which Freud (1933) referred to as a "death instinct" (*Thanatos*). The conflict between Eros (the life instinct) and Thanatos is always won in the end by the latter. Rather than attempting to deny or suppress this instinct, Freud advocating diverting it into other activities, such as sports and creative productivity. The famous biologist Konrad Lorenz also emphasized the inherent nature of aggression in humans. To Lorenz (1966), aggression is a spontaneous activity within ourselves and not simply a reaction to an external stimulus.

Behavioral psychologists and other social scientists have tended to disagree with the concept of a destructive or aggressive instinct that causes armed conflict. To the early behaviorists, aggression was the result of frustration—any interference with goal-directed activity. The hypothesis that frustration necessarily leads to an increment in aggression is, however, now recognized as not entirely correct. Rather than resulting in aggression, frustration may lead to escape behavior, regression, or other attempts to reduce the frustration. After reviewing the literature on aggression as an instinct and as learned behavior, Berkowitz (1990) concluded that "the negative affect generated by an aversive occurrence produces a number of behavioral inclinations—to fight and to flee—as well as several relatively primitive feelings, including anger and fear. A wide variety of conditions (including genetic influences, prior learning, and the perceived consequences of a particular action) determine the relative strengths of these different tendencies and feelings" (p. 35). In somewhat oversimplified fashion, it may be said that humans possess the neural circuitry for aggressive, warlike behavior, but if and how such behavior is expressed depends on whether the proper switch is thrown (i.e., whether an appropriate instigating stimulus is present) as well as the individual's perception of how the environment will react to aggressive or attack behavior. But even if this formulation is correct, it is an inadequate explanation of why nations go to war. As Berkowitz (1990) admits, the national decision to declare war is almost always made on a rational, although not necessarily "intelligent," basis.

Waging War

Training civilians to become combat soldiers is not an easy task. An important part of the training is discipline—learning to do what one is told without question, even when it goes against one's upbringing and natural impulses. Turning civilians into soldiers also involves a liberal amount of propaganda and hate training, in which the enemy is dehumanized and the cause of one's country is depicted as just and even sanctioned by God. The enemy may be depicted as subhuman or barbaric, a

torturer or rapist, a desecrator of all that is sacred, or even as death itself. To explain and condition the civilian population to war and the proper attitude toward the enemy, propaganda campaigns, such as those designed by the Creel Committee of the United States during World War I and the staff of Josef Goebbels in Germany during World War II, are put into effect. Films such as "Triumph of the Will" in Germany and "Why We Fight" in the United States helped during World War II to create an attitude of one's country as noble and virtuous and the enemy as barbaric and evil. It sometimes happens, however, that the negative qualities attributed to the enemy are projections of the very same qualities that we deny in ourselves (DeSpelder & Strickland, 1992).

Discipline and dehumanization of the enemy enable soldiers to kill without question, although the process is not easy or immediate. Fear is a constant companion of most combatants, but morale and group cohesiveness—relying on one's comrades and reluctance to let them down—helps the soldier to face the fear. And then, the game of war can be adventurous and exciting—at least while it is still seen as a potentially winnable competition. Soldiers on the battlefield often report experiencing a vibrant feeling of being alive, of living in the present from heartbeat to heartbeat. Past and future time collapse into the present, and one lives only for the moment.

Waiting for battle rather than the actual encounter with the enemy is often the worst part of combat. An illustration of the agony of waiting and the "aliveness" of actual combat was provided by Lt. J. H. Allen after his first action in World War I:

> *I felt an overwhelming elation. It was not so much that one had left the firing line as that one had been in it. I often think of H. Benson's story of the man who was to be tortured and the agony of his dread. When he was put on the wheel they saw he smiled. His suffering was less than his suspense. Full of wretchedness and suspense as the last few days have been, I have enjoyed them. They have been intensely interesting. They have been wonderfully inspiring. (Holmes, 1985, p. 148)*

Still, there is nothing wonderful or inspiring about the suddenness with which a person can be changed from a breathing, living human being to an inert corpse in combat.

> *I was looking straight at him as the bullet struck him and was profoundly affected by the remembrance of his face, though at the time I hardly thought of it. He was alive, and then he was dead, and there was nothing human left in him. He fell with a neat round hole in his forehead and the back of his head blown off. (Holmes, 1985, p. 176)*

After viewing such scenes, it is no wonder that many soldiers, as in Stephen Crane's *Red Badge of Courage*, make an unordered retreat. In fact, the natural tendency not to advance in the face of enemy fire is so strong that officers in some armies have ordered their own retreating troops to be fired upon. Retreat has also been discouraged by executing selected members of squads that failed to advance against the

enemy. Unable to retreat or unwilling to let one's buddies down, many combat-hardened veterans slip into an unreal, dreamlike state, as if they were robots going through their paces; not only the enemy but also they themselves become depersonalized and frozen in time. These feelings of depersonalization are reinforced by the use of colloquial euphemisms for death such as "eliminated," "neutralized," "taken out," "wasted," "whacked," and "zapped."

Although intentionally firing at one's own troops is discouraged in most armies, accidents and so-called friendly fire kill many soldiers. Such was the case with American casualties in the Vietnam War and the Persian Gulf War. Heroism and chivalry have little place in the modern theater of war. Few soldiers express an eagerness to fall on hand grenades to save the lives of their buddies or to "reup" or "ship over" in a dangerous combat zone.

Effects of War and Imprisonment

It was called *shell shock* in World War I, *combat fatigue* in World War II, and *posttraumatic stress disorder* during the Vietnam War and subsequently. By whatever name, the psychological effects of war can be persistent and devastating. Of more than 10 million American men accepted for military service in World War II, the greatest number of medical discharges were for neuropsychiatric reasons (Bloch, 1969). The situation had improved somewhat by the Vietnam War, in that soldiers were not required to serve as long on the front line. Nevertheless, it is estimated that as many as 50 percent of the 800,000 Americans who served in Vietnam continued to suffer from the experience long after the war (Shehan, 1987) despite being rotated every 12–13 months. The Americans who fought there were the youngest soldiers in our history and, unlike the situation during World War II and the Korean War, they did not remain in the same unit for the duration of the war. The Vietnam War was also a different kind of conflict than preceding wars. It was a guerrilla war, in which booby traps were employed and the killing of women and children occurred more frequently than in previous wars. Another difference is that, although the United States was not defeated militarily by Vietnam, we did not win the war. Unlike the returning veterans of other twentieth-century wars in which America was involved, there was no glory and there were no parades for Vietnam veterans. Many American citizens had been opposed to the war and showed their opposition in the treatment of the Vietnam veterans. Lack of civilian support and epithets such as "baby killers" convinced many of these returning servicemen that they had sacrificed and fought for nothing.

The situation was even worse for American soldiers who were taken prisoner by the Viet Cong or North Vietnamese. Like the survivors of Nazi concentration camps in an earlier generation, they were malnourished, treated like animals, and induced to perform acts that seemed unpatriotic or immoral. In addition to physical disorders such as diarrhea, serious infections, and malnutrition, prisoners suffered from anxiety, insomnia, headaches, irritability, depression, nightmares, and other psychological symptoms. Even those who cooperated with their captors were not immune to maltreatment (see Box 4-3). Many of the psychological symptoms,

BOX 4-3 • A Vietnam War Prisoner

When, in early 1973, medical army officer Major F. Harold Kushner returned from five and a half years as a prisoner of war in South Vietnam, he told me a stark and chilling tale. His story represents one of the few cases on record in which a trained medical observer witnessed from start to finish what I can only call death from helplessness.

Major Kushner was shot down in a helicopter in North Vietnam in November 1967. He was captured, seriously wounded, by the Viet Cong. He spent the next three years in a hell called First Camp. Through the camp passed 27 Americans: 5 were released by the Viet Cong, 10 died in the camp, and 12 survived to be released from Hanoi in 1973. The camp's conditions beggar description. At any time there were about 11 men who lived in a bamboo hut, sleeping on one crowded bamboo bed about 16 feet across. The basic diet was three small cups of red, rotten vermin-infested rice a day. Within the first year the average prisoner lost 40 to 50 percent of his body weight, and acquired running sores and atrophied muscles. There were two prominent killers: malnutrition and helplessness. When Kushner was first captured, he was asked to make antiwar statements. He said that he would rather die, and his captor responded with words Kushner remembered every day of his captivity: "Dying is easy; it's living that's hard." The will to live and the catastrophic consequences of the loss of hope, are the theme of Kushner's story. . . .

When Major Kushner arrived at First Camp in January 1968, Robert had already been captive for two years. He was a rugged and intelligent corporal from a crack marine unit, austere, stoic, and oblivious to pain and suffering. He was 24 years old and had been trained as a parachutist and a scuba diver. Like the rest of the men, he was down to a weight of ninety pounds and was forced to make long, shoeless treks daily with ninety pounds of manioc root on his back. He never griped. "Grit your teeth and tighten your belt," he used to repeat. Despite malnutrition and a terrible skin disease, he remained in very good physical and mental health. The cause of his relatively fine shape was clear to Kushner. Robert was convinced that he would soon be released. The Viet Cong has made it a practice to release, as examples, a few men who had cooperated with them and adopted the correct attitudes. Robert had done so, and the camp commander had indicated that he was next in line for release, to come in six months.

As expected, six months later, the event occurred that had preceded these token releases in the past. A very high-ranking Viet Cong cadre appeared to give the prisoners a political course; it was understood that the outstanding pupil would be released. Robert was chosen as leader of the thought-reform group. He made the statements required and was told to expect release within the month.

The month came and went, and he began to sense a change in the guards' attitude toward him. Finally it dawned on him that he had been deceived—that he had already served his captors' purpose, and he wasn't going to be released. He stopped working and showed signs of severe depression: he refused food and lay on his bed in a fetal position, sucking his thumb. His fellow prisoners tried to bring him around. They hugged him, babied him, and, when this didn't work, tried to bring him out of his stupor with their fists. He defecated and urinated in the bed. After a few weeks, it was apparent to Kushner that Robert was moribund: although otherwise his gross physical shape was still better than most of the others, he was dusky and cyanotic. In the early hours of a November morning he lay dying in Kushner's arms. For the first time in days his eyes focused and he spoke: "Doc, Post Office Box 161, Texarkana, Texas. Mom, Dad, I love you very much. Barbara, I forgive you." Within seconds he was dead.

Robert's was typical of a number of such deaths that Major Kushner saw. What killed him? Kushner could not perform an autopsy, since the Viet Cong allowed him no surgical tools. To Kushner's eyes the immediate cause was "gross electrolyte imbalance." But given Robert's relatively good physical state, psy-chological precursors rather than physiological state seem a more specifiable cause of death. Hope of release sustained Robert. When he gave up hope, when he believed that all his efforts had failed and would continue to fail, he died.

Source: From *Helplessness: On Development, Depression and Death* by Martin E. P. Seligman. Copyright © 1975 and 1992 by Martin E. P. Seligman. Reprinted by permission of W. H. Freeman.

referred to collectively as posttraumatic stress disorder (PTSD), which also included flashbacks to frightening experiences during the war and captivity, persisted even after release from imprisonment.

Survivors of prisoner-of-war and concentration camps generally manifest a variety of debilitating conditions. Among these are lowered resistance to disease and frustration, greater dependence on alcohol and drugs, and general emotional instability (Hunter, 1978; Strange & Brown, 1970; Wilbur, 1973). The longer they were imprisoned and the harsher the treatment they received, the greater the likelihood that they would develop psychiatric problems (Hunter, 1978; O'Connell, 1976). Depression, marital problems, and divorce were significantly more common among Vietnam veterans than among their age-mates who did not go to war (Hunter, 1981).

It was some time after the withdrawal of the last American troops from Vietnam before it became possible to begin the soul searching as to why we fought the war in the first place and how poorly the veterans had been treated by their country. Motion pictures such as "Apocalypse Now," "Platoon," and "Full Metal Jacket" dramatically depict what combat in Vietnam was like and how the soldiers who fought in that war felt and acted. Wider recognition of the psychological effects of the war on those who fought and those who stayed at home and wondered why has come slowly, but it has come. An important event in the process of catharsis with respect to the war was the $7 million Vietnam War Monument, consecrated on November 11, 1982. When one first views the Wall, it doesn't seem like much, but further reflection creates a profound effect. As described by one Vietnam veteran:

> As I walked closer, down the long slope toward the bottom of the apex, the polished black granite arms tapered off on either side. I was about ten feet from the Wall when the impact of the thing hit me. From ten feet higher than my head, stretching out of sight on either side, were the names of 57,939 people. The dead and the missing from Vietnam. I was slammed with the enormity of it all, the weight of those people who were not here, who had died because they had been asked, or sent, to do a job their nation wanted done. Emotions washed across me, and my eyes filled with tears. I moved away and sat alone on the grass.

Later, I watched a couple, obviously tourists, start at one end and walk toward the apex, chatting and looking around. About three-quarters of the way down, I saw it hit them, too. They suddenly knew what it was and what it meant. In the last analysis, this is what Vietnam was all about, 57,939 people listed on the Wall and millions of veterans who, in their minds somewhere, sat on the grass abandoned and alone, betrayed by the nation they'd fought for.

If the Wall could do that, I thought, it's doing all that could be asked of it (cited in Cook & Oltjenbruns, 1989, pp. 300–301).

Controlling and Reducing the Threat of War

Despite the recognition given to so-called rules for conducting warfare, armed conflicts between civilized nations have usually led to the violation of these rules and barbarism on both sides. The mistreatment of prisoners of war during the nineteenth century led to the Geneva Convention, a series of international meetings beginning in 1864. This convention led to the establishment of rules for the humane treatment of prisoners of war and of the sick, the wounded, and the dead in battle. Other international efforts concerned with the regulation and reduction of wars among nations led to the Hague Peace Conference in 1899 and a second conference in 1907. A result of the first Hague conference was the establishment of a Permanent Court of Arbitration to settle disputes among nations. The second Hague conference defined rules for the treatment of prisoners of war, the conduct of maritime war, and the position of neutral nations during wartime. Another effort to reduce the threat and abuses of war was made in the Treaty of Versailles, which established a League of Nations to promote world peace and international cooperation. This organization was dissolved in 1946 and replaced by the United Nations.

Unfortunately, none of the above attempts to minimize the horrors of war and insure peace was completely successful. Despite the continuing demonstration that military buildup tends to increase rather than decrease the threat of war, since World War II over $17 trillion has been spent on weaponry. The threat of nuclear war has been made very real by the capacity of missiles carrying nuclear warheads to hit within a few hundred feet of a target 6000 miles away within 30 minutes of launch. International conferences concerned with the need to restrain national self-interest, reduce armaments, achieve a better balance of power between competing nations, and to ensure collective action against aggression have not been without success. Still, the Cold War between the Soviet Union and the United States, the persisting conflict between Israel and its Islamic neighbors, wars in Korea, Vietnam, and Afghanistan, and other disagreements among nations throughout the world have been used to justify the necessity for a strong military and a large stockpile of arms. The end of the Cold War has made the likelihood of a nuclear holocaust less imminent, but dozens of "hot spots" still exist throughout the world. At any moment war may break out in one or more of these places, leading to a regional conflict and perhaps even triggering a worldwide conflagration. The United States is now recognized as the sole remaining superpower, but it should not act alone as the world's policeman. Collective, cooperative action among nations is required to

achieve world peace. In all likelihood, even maximum cooperation among nations and swift action against aggression will not guarantee permanent peace. However, for the present there is no viable alternative if we wish to minimize the threat of wholesale destruction to our planet and its people.

SUMMARY

Suicide and homicide were the eighth- and tenth-leading causes of death in the United States in 1991. Homicide is more common than suicide in young adulthood, whereas suicide is more common in middle and late life. Rates of death from both causes have increased during the past 25 years, the homicide rate twice as rapidly as the suicide rate.

The law distinguishes among justifiable, excusable, and felonious homicide, between voluntary and involuntary manslaughter, and between first- and second-degree murder. Manslaughter involves criminal negligence but not malice. Second-degree murder involves malice but not premeditation. First-degree murder is both malicious and premeditated.

Firearms are the most popular murder weapon in the United States, accounting for nearly two thirds of all murders in 1991. Compared with other countries that have stricter gun-control laws, firearms are not difficult to obtain in the United States. Cutting and stabbing instruments are the second most popular weapons, accounting for 16 percent of U.S. murders in 1991.

Over four fifths of the apprehended murderers and three fourths of the murder victims in the United States in 1991 were male. Two fifths of all apprehended murderers and slightly less than half of their victims were white, while over half the murderers and their victims were black. In terms of both victims and offenders, murder is more common in lower socioeconomic than upper socioeconomic groups. It is the leading cause of death in young black men.

Alcohol and arguments are associated with murder, which in most cases is a result of impulsive rather than premeditated violence. Homes are the most popular places for murder, followed by streets and bars. The murder rate is higher in cities than in small towns and rural areas and higher in the Southern and Western states than in the North Central and Northeastern states. The murder rate is also higher in countries closer to the equator. The frequency of murder is usually greater during August and December and during holidays and vacations. Among the major religious groups in the United States, the murder rate is highest among Roman Catholics, intermediate among Protestants, and lowest among Jews.

The principle of differential association attempts to explain criminal behavior, including homicide, as a natural result of living in a subculture of violence and around violent role models. Biologically based explanations of violent behavior point to the inheritance of aggression and other temperamental and structural characteristics that predispose human beings to violence. Psychological theorists emphasize specific personality traits and learning processes in their analyses of violent behavior.

Most murderers are not legally insane; the murder rate is lower than average among the mentally ill. Mass murders and serial killings are rare, and no single personality profile is associated with mass or serial killers. Collective crime, genocide, and war are types of mass murder sanctioned by a particular social group. Such murders are usually politically motivated, as are many assassinations of public figures. Political assassins, however, vary greatly in their motives and personalities.

Women who murder their husbands or lovers most often do so because of bruised bodies, whereas men who murder their wives or lovers do so because of bruised egos. Parents also abuse and murder their own children; the usual cause is frustration, combined with emotional immaturity or psychosis. In these cases, as in almost all murders, the offender perceives the victim as a dehumanized, impersonal object to be damaged or destroyed.

The clearance rate, which is the percentage of perpetrators of crimes who are apprehended, is still higher for homicide than for any other crime. However, the clearance rate for homicide has declined to less than 70 percent in recent years. People who are charged with murder, however, are not necessarily tried, convicted, and sentenced. Murderers who are paroled from prison rarely kill again; the recidivism rate is around 2 percent.

War, the second horseman of the Apocalypse, has been called the scourge of humanity. The flower of a nation's youth has been slaughtered in wars throughout human history, and particularly in the world wars of the twentieth century. Wars are waged for many reasons—religious and secular, materialistic and psychological. Rather than being precipitated by an inborn aggressive instinct, however, wars are usually the consequences of rational, although not necessarily intelligent, decisions by powerful people.

Efforts to eliminate war by stockpiling weapons and maintaining large standing armed forces have not been very successful. When the arms and armies exist, they are likely to be employed sooner or later. Among the reasons for going to war are national security and pride, the need for territory and resources, and the desire to impose one's beliefs or way of life on others.

The Hague Conferences, the League of Nations, and the United Nations represent international efforts to control the manner in which war is waged and, hopefully, to ensure more enduring peace among nations. Unfortunately, the existence of nuclear arsenals, the arms race, the Cold War, and persisting external and internal conflicts throughout the world have made these efforts only partially successful.

QUESTIONS AND ACTIVITIES

1. It has been said that almost anyone will commit homicide if pushed to an extreme, whereas many believe that some people just don't have it in them to kill another human

being. It has also been said that the first murder is the hardest to commit. What do you believe? Justify your answers.

2. An interesting, if potentially disturbing, experience is a trip to a maximum security prison, and particularly the death row and execution chamber of the prison. If you have a chance and feel that you are up to the experience, take the trip and the prison tour. Perhaps your instructor can arrange it. If this is not possible, perhaps students in the class who have visited a prison can describe their experiences and reactions to the class as a whole.

3. Arrange to view the film "Scared Straight" and its sequel. Do you believe that the experiences of the juveniles depicted in the film(s) could discourage them from a life of violent crime?

4. Complete the following questionnaire and administer it to several other people. Compare your answers with theirs.

Attitudes Toward Homicide

Directions: Indicate your degree of agreement or disagreement with each of the following statements by writing SA (strongly agree), A (agree), U (undecided), D (disagree), or SD (strongly disagree) in the marginal dash.

_____ a. Only people with certain types of personalities are capable of murder.

_____ b. Almost anyone can commit murder in the right circumstances.

_____ c. A person has to be under extreme stress to kill someone.

_____ d. I could never kill another human being, regardless of the provocation.

_____ e. I believe that homicide is justifiable in certain situations.

_____ f. Taking a human life, for whatever reason, is a mortal sin.

_____ g. Some people are so bad that they deserved to be killed.

_____ h. I could kill a person who threatened my home or family.

5. Have you ever visited the Vietnam War Monument in Washington, DC? If not, by all means visit the memorial if you have an opportunity. Over 58,000 Americans died in the Vietnam War, and the memorial is a stark reminder of the slaughter and horror of that war and all wars. It is a much less romanticized memorial than some of the monuments that appear to glorify armed conflict.

6. Under what conditions would you expect the frequencies of homicide and suicide in a culture to be positively related, and under what conditions would you expect them to be negatively related?

7. It sometimes seems astounding that highly educated, cultured people would go to war and kill each other. Then why does it happen? What are the contributing factors?

8. Administer the following "Scale of Attitude Toward War" to ten women students and ten men students. Using the key given below the scale, compute each student's score. Then find the mean score for men and the mean score for women. Is there any difference between the two means? Why or why not?

Directions: Put a check mark on the line in front of the number if you agree with the statement; otherwise leave it blank.

_____ 1. Under some conditions, war is necessary to maintain justice.

_____ 2. The benefits of war rarely pay for its losses, even for the victor.

_____ 3. War brings out the best qualities in people.

_____ 4. There is no conceivable justification for war.

_____ 5. War has some benefits, but it's a big price to pay for them.

_____ 6. War is often the only means of preserving national honor.

_____ 7. War is a ghastly mess.

_____ 8. I never think about war and it doesn't interest me.

_____ 9. War is a futile struggle resulting in self-destruction.

_____ 10. The desirable results of war have not received the attention they deserve.

_____ 11. Pacifists have the right attitude, but some pacifists go too far.

_____ 12. The evils of war are greater than any possible benefits.

_____ 13. Although war is terrible, it has some value.

_____ 14. International disputes should be settled without war.

_____ 15. War is glorious.

_____ 16. Defensive war is justified but other wars are not.

_____ 17. War breeds disrespect for human life.

_____ 18. There can be no progress without war.

_____ 19. It is good judgment to sacrifice certain rights in order to prevent war.

_____ 20. War is the only way to right tremendous wrongs.

Scoring: Add the following points for the statements checked, then divide the sum by the number of statements checked. The resulting mean is the examinee's score on the scale.

Statement	Points	Statement	Points	Statement	Points
1	7.5	8	5.5	15	11.0
2	3.5	9	1.4	16	6.5
3	9.7	10	8.3	17	2.4
4	.2	11	4.7	18	10.1
5	6.9	12	2.1	19	3.2
6	8.7	13	6.8	20	9.2
7	.8	14	3.7		

Source: From *Scale of Attitude Toward War,* by Ruth C. Peterson, The University of Chicago Press. Copyright 1931. Reprinted by permission of The University of Chicago Press.

ENDNOTES

1. An organization known as Parents of Murdered Children, Inc. (see Appendix B for address and telephone number) is making an effort to reduce the number of murders in childhood and adolescence.

2. Indicative of the differences in political philosophy of Canada and the United States, and consequently in the behavior of the citizens of these two neighboring countries, are the rights enunciated in the Declaration of Independence and the British North America Act. For the United States, those rights include "life, liberty, and the pursuit of happiness." For Canada, they are "peace, order, and good government."

3. World Campaign for the Protection of Victims of War, International Red Cross and Red Crescent Movement.

SUGGESTED READINGS

Berkowitz, L. (1990). Biological roots: Are humans inherently violent? In B. Glad (Ed.), *Psychological dimensions of war* (pp. 24–40). Newbury Park, CA: Sage Publications.

Brende, J. O., & Parson, E. R. (1985). *Vietnam veterans: The road to recovery.* New York: Plenum Press.

Browne, A. (1987). *When battered women kill.* New York: Free Press.

Clarke, J. W. (1982). *American assassins: The darker side of politics.* Princeton, NJ: Princeton University Press.

Lunde, D. T. (1976). *Murder and madness.* San Francisco: San Francisco Book Co.

Moreland, J. P., & Geisler, N. L. (1990). *The life and death debate: Moral issues of our time* (pp. 124–141). Westport, CT: Praeger.

Roberts, L. (1988, July 8). Vietnam's psychological toll. *Science, 241,* 159–161.

Schmidt, J. D. (1986). Murder of a child. In T. Rando (Ed.), *Parental loss of a child* (pp. 213–220). Champaign, IL: Research Press.

Staub, E. (1989). *The roots of evil: The origins of genocide and other group violence.* New York: Cambridge University Press.

Strean, H. S., & Freeman, L. (1991). *Our wish to kill: The murder in all our hearts.* New York: St. Martin's Press.

CULTURAL BELIEFS AND PRACTICES

5

FUNERARY RITUALS AND RELIGION

QUESTIONS ANSWERED IN THIS CHAPTER:

- *What are the origins and characteristics of death rituals and beliefs?*
- *What purposes are served by funerary rites and customs?*
- *What factors have played a role in methods of treating and disposing of corpses and in selecting and designing graves?*
- *What have been the major differences in Eastern and Western attitudes and customs concerning death?*
- *What are the relationships between myth and religion, and what purposes do these cultural belief systems serve?*
- *What are the differences between Eastern and Western religions in their conceptions of life after death, and how did these differences arise?*
- *What are the similarities and differences among the major religions of the world in eschatological beliefs (final battle between good and evil, appearance of savior figure, last judgment, etc.)?*

The topic of death and dying is not something that has been of interest only to writers and scholars in the late twentieth century. From the beginnings of civilization, people have been faced with death and the questions of why it occurs, what it means, and how to cope with it. Primitive people encountered death almost daily, and the members of early cultures and societies were undoubtedly keenly aware that it was their fate to die someday. Because one's life expectancy at birth was less than 30 years in ancient times, that day was not long in coming.

Death is a personal event experienced by the individual, but it is also a social event. People did not have to wait for John Donne's seventeenth-century verses to realize that "no man is an island" and that "each man's death diminishes me." As is true today, the death of a member of an ancient social group disrupted the harmony of the group, forcing readjustments in roles and feelings. Rather than having a

uniformly negative effect on other members of a tribe or clan, in most cases death served to increase group cohesiveness, adaptability, and growth. The death of a relative or friend, however, was an emotional experience for a person and was accompanied by a sense of loss. Not only did it remind other members of the group of their own mortality, but collective ignorance about the causes and meanings of life and death led to a fear of dying and of the dead. This fear, known in its extreme form as *thanaphobia*, contributed to the invention of a variety of methods for dealing with death and efforts by the living to gain some control over it.

The great diversity of cultural rituals and customs concerning death originated from both a psychological need to cope with the fear of death and a practical need to dispose of the deceased and his or her belongings. According to cultural anthropologists, such rituals may either relieve or intensify anxieties about death. Anxiety concerning immortality and the afterlife may be decreased, but the loss itself, the need for social readjustment, and the possible existence of spirits and ghosts may precipitate additional anxieties in the living (Lessa, 1976).

Although the beginnings of death customs and rituals were associated with magic, myth, and religion, to some extent they have become self-perpetuating and continue to exist even in the absence of strong religious beliefs. Just as Moslems make pilgrimages to Mecca, Christians and Jews journey to the Holy Land, and Hindus make the trek to the Ganges River, nonreligious people may attach great importance to traveling long distances to visit the graves of their heroes and idols. Even when they involve no true religious sentiment, such rituals serve to strengthen the feeling of belonging or togetherness with other adherents and devotees.

Research on the ways in which human beings have dealt with death requires the efforts of archaeologists, linguists, theologians, psychologists, cultural anthropologists, and historians. Information concerning death customs and rites has been obtained from relics and documents discovered in archaeological excavations of ancient graves, tombs, churches, and other structures, from manuscripts and records preserved by monasteries and in other antique collections, and by anthropological studies of primitive cultures that continue to exist in out-of-the-way places of the world today. Findings thus far have revealed a kaleidoscope of practices and beliefs concerning death. Each culture has, to use Kastenbaum's (1991) term, its own *death system*—a network of beliefs and practices with which a society attempts to cope with death and come to terms with it. Many of the elements of any death system are oriented toward the seemingly universal and timeless belief that the dead do not cease to exist but rather continue to function in some kind of afterlife. Different death systems have different conceptions of the nature of the afterlife and the persistence of human personality or individuality in that afterlife.

FUNERARY RITES AND CUSTOMS

Strictly speaking, humans are not the only creatures that bury their dead. For example, elephants have been seen burying dead elephants and other animals with mud, leaves, and earth (Douglas-Hamilton & Douglas-Hamilton, 1975). Large

quantities of food, flowers, and fruit are sometimes included in these elephant graves. Burying behavior has also been observed in other animals, and it is possible that early humans watched and copied the burying behaviors of animals (Siegel, 1980).

Be that as it may, no animal buries its dead with as much deliberation, detail, and fanfare as Homo sapiens. In a typical modern funeral, for example, the grave is prepared carefully and the corpse is treated and neatly groomed. One or more services or events at which the behavior of participants and spectators is prescribed are then performed. As we shall see, the funeral rituals of high-ranking people were particularly elaborate and painstakingly planned in ancient times.

Purposes of Funerary Customs

Social customs associated with burial and mourning of the dead serve a variety of purposes:

- Disposing of the physical body
- Publicly recognizing that a life has been lived
- Paying tribute to the deceased
- Facilitating the expression of grief and providing support to the bereaved
- Experiencing a rite of passage for both the deceased and the bereaved from one status to another
- Assisting the deceased in afterlife activities
- Providing an opportunity to reestablish contact with friends and relatives
- Reaffirming or rearranging the surviving social group that may have been disrupted by the death of the deceased

Concerning the transition of the deceased from one state to another, many societies believe that the soul of the deceased must be assisted or allowed to pass from the land of the living to its final resting place in the land of the dead. Archaeological evidence suggests that these purposes have applied in both ancient and modern times. For example, the presence of food, tools, and ornaments in the graves of Neanderthal men who lived over 50,000 years ago suggests a belief in an afterlife. Another archaeological finding that points to a belief in an afterlife is the discovery in some of the earliest graves of skeletons bound by their hands and feet into a fetal position, an orientation presumed to be most appropriate for rebirth.

Observations of funeral customs among primitive peoples living today, coupled with archaeological evidence, lead to the conclusion that burial rites have existed since Lower Paleolithic times (circa 500,000–250,000 BC) (Middleton, 1991). Rather than hygienic considerations, about which early humans presumably knew nothing, these burial ceremonies were apparently motivated by fear of the supernatural. They were used as a means of placating the ghost of the deceased by facilitating the journey to the spirit world and the new existence of the deceased in that world. Funerary rites also served in later times to honor the dead and to find favor with the gods. As time passed, the rites and customs became more elaborate,

and in certain cases were set down in writing, as in the Egyptian and Tibetan versions of the *Book of the Dead*. These books provide detailed descriptions of the death systems of the respective cultures, including instructions for treatment of the deceased in accordance with specific views of the afterlife.

Funerary rites and customs served not only religious purposes; they also became occasions for artistic, engineering, and even scientific achievements. The monumental (literally!) creations of the pyramid and tomb builders of Egypt, Greece, and other ancient cultures undoubtedly contributed to the feeling that people are not utterly helpless in the face of death. These edifices served not only as repositories for people of high status but also to remind the living of the lives and accomplishments of those who died. The construction and decoration of these structures also provided occasions for cooperative social action, thus reaffirming the vitality and permanence of the community.

Corpse Disposal

Human beings, both ancient and modern, have shown an almost obsessive concern with proper disposal of the dead—a process that has often involved elaborate rituals and multiple steps. There are sound hygienic reasons for this concern, but they were not the principal aims of corpse disposal in prehistoric and early historic times. People in many cultures have believed that the soul cannot find its final resting place until the physical body is properly cared for. Consequently, survivors were anxious to dispose of the corpse as quickly as possible in order to circumvent the activities of ghosts and help the dead find peace.

Interment (Inhumation)
Burial of a corpse in a covered or enclosed pit, a cave, or other structure, in which it eventually decomposes, has probably been the most common method of disposing of the dead (Middleton, 1991). It is also the most ancient method, dating back to the Paleolithic era. Burial was presumably prompted by the belief that a body planted in the soil will rise again like a plant rises from a seed (Fulton, 1991). Among certain peoples, such as the ancient Egyptians and the Peruvian Indians of a later date, the body was treated with preservatives before interment, a process known as *mummification*. Similarly, in the modern world, the corpse is often chemically treated or embalmed before interment to preserve it for a time. During the American Civil War, embalming was reintroduced and improved as a method for temporarily preserving a dead soldier's body so it could be returned to his home. However, embalming was not practiced routinely until the late nineteenth or early twentieth century.[1]

In preparation for burial, people in former times might dress the corpse, wrap it in a cloth or animal hide, paint or decorate it in other ways, and bury it with some of the deceased's possessions or other *grave goods*. Another practice was to bury the body and wait until the flesh had decomposed. The bones were then exhumed, cleaned, and buried a second time in a receptacle or place for the bones of the dead known as an *ossuary*.

A special type of interment occurring in Northern and Western Europe during the pre-Christian era was ship burial. Ship burial was based on the belief that the deceased must make a sea journey to the land of the dead. The deceased was buried in a boat, which might then be burned; finally an earthen mound was raised over the ashes or unburned boat.

Open-Air Disposal

Not all cultures buried the dead. In some cases the corpse was simply left to rot on the ground, in a tree, or on a specially constructed scaffold (see Figure 5-1). Such open-air disposal was practiced by certain Australian aborigines, North American Indian tribes, and many Polynesian societies. Even today, the Parsee people of northern India practice the ancient Zoroastrian rite of placing their dead on scaffolds known as high *dakhmas* ("towers of silence"); the bones are eventually picked clean by vultures. It is a tenet of Zoroastrianism, an early religion brought to India from Persia, that other methods of corpse disposal defile the basic elements of nature (earth, air, fire, and water).

Water Burial

Certain Pacific Island and early Northeastern European cultures apparently did not share the Zoroastrians' concern that dead bodies would contaminate the water. To these seafaring folk, water burial seemed a natural way to dispose of a corpse, and

FIGURE 5-1 **Scaffold Burial of the Dakota Indians of North America (The New York Public Library)**

their custom was to place the body in water until the flesh was gone. Water burial also occurs in modern times whenever a person dies at sea and the body cannot be preserved until land is reached. Also of interest with respect to burial and water was the custom during the early days along the Atlantic Coast of the United States to locate burial grounds for African Americans near the ocean. It was believed that by so doing, the deceased would be carried back to Africa, "back home to heaven," by the ocean. Indicative of their belief that the world of the dead was a watery world, an upside-down world under the living world, were grave decorations that included dishes, plates, cups, saucers, and other items associated with water (Hillinger, 1989).

Consuming the Corpse

Instead of being picked clean by animals, the corpse may be consumed by other humans (*mortuary cannibalism*) or by fire (*cremation*). In *endocannibalism*, the deceased is consumed by members of his or her family. Archaeological evidence of mortuary cannibalism was found in the remains of Peking man of some half-million years ago and in Neanderthal man of roughly 100,000 years ago. In more recent times, certain Australian aborigine tribes and the Luiseño Indians of southern California practiced mortuary cannibalism. They believed that consuming a portion of a dead body endowed the consumer with the virtues (and vices) of the deceased, thus uniting the dead with the living. This magical feature of mortuary cannibalism has been incorporated into various religions. For example, the Christian sacrament of communion (Eucharist) and the associated ritual of changing bread and wine into the body and blood of Christ (*transubstantiation*) may have a symbolic connection to mortuary cannibalism (Lessa, 1976).

Cremation

For thousands of years, burning the corpse has been a common procedure for disposing of it. It was the primary method of corpse disposal during the Bronze Age, especially among the Hindus, Buddhists, and Romans. The Roman practice of *os resectum*, in which a severed finger joint was buried after cremation of the body, was probably a symbolic representation of the earlier custom of interring the whole body ("Death Rites and Customs," 1983).

The ancient Hebrews considered burial to be the only proper method of corpse disposal, a practice that influenced early Christian doctrine. The rise of Christianity, which, together with Judaism and Islam, opposed cremation, put a stop to the practice in Western Europe for a time. Traditionally, Roman Catholics, like Orthodox Jews and some Protestant groups, believed that the body is the temple of the soul and therefore should not be destroyed by fire. Until the Second Vatican Council (1962–1963), canon law of the Roman Catholic Church forbade cremation as a form of disposing of the dead. However, cremation is now condoned by the Roman Catholic Church, and priests can take part in services for cremated persons. Reform Judaism also permits cremation and entombment, although burial is the preferred method. Moslems continue to oppose cremation because Islamic doctrine holds that the dead, like the living, can feel pain (Bardis, 1981).

In a typical cremation, a gas or electric crematory is heated to 2,000–2,500° Fahrenheit; then the coffined body is placed inside the crematory and reduced to 5 pounds or so of ash (actually, calcified material) in approximately 80 minutes. The "ashes" (*cremains*) are then disposed of in various ways, for example, by scattering them on a holy river (in the manner of the Hindus) or some other natural formation (mountains, desert, etc.), storing them in a special vault, or keeping them in an attractive urn.

Cremation has grown in popularity during recent years, especially in predominantly Protestant countries. For example, from 1975 to 1991 the percentage of cremations to deaths rose from 7 percent to 18.5 percent in the United States and from 12.4 percent to 34.25 percent in Canada (Cremation Association of North America, 1992). The practice has several advantages over other methods of corpse disposal, including economy, space conservation, public health considerations, and emotional comfort to people who are horrified by slow decay. In some instances, however, there are legal complications and religious opposition. Murder is more easily concealed by cremation than by burial, so the cause and circumstances of death must be carefully determined before a corpse is cremated.

Grave Sites and Structures

In very ancient times people frequently were buried where they fell or, if that was inconvenient, in some randomly selected spot. Stone Age humans had special burial sites, mounds, or pits that were associated with magical and religious rites and beliefs. Fear of spirits and ghosts often led to efforts to keep these burial places secret. Then, as now, a person's status or wealth influenced the location of his or her burial place. The selection of a site also varied with religious beliefs.

The first known use of coffins and the construction of stone tombs took place in the Near East, in particular Egypt and Sumer, during the third millennium BC. As time passed, more elaborate stone coffins (*sarcophagi*) were constructed. These sarcophagi had various shapes—oval, curved, houselike, humanlike—and were decorated with symbols and pictures of gods to protect the deceased. During Egypt's first dynasty (circa 3000 BC), the earlier burials in graves and caves gave way, at least for royalty and priests, to tombs of massive size. The walls of these tombs were decorated with writings and pictures of various kinds, depicting the life and beliefs of the deceased (Seele, 1987).

Pyramids

The ancient Egyptians became most famous for those wonders of the ancient world, the pyramids. The oldest known structure of this kind, the Step Pyramid, was built around 2650 BC.[2] The most widely known, however, are the three pyramids of Giza, which were constructed 150 years later. These three structures and the surrounding pyramids and the Sphinx comprise a *necropolis,* or City of the Dead; other necropolises are at Memphis and Thebes.

Each pyramid was designed to be the tomb of a pharaoh or other royal personage. In addition to housing the mummy of the deceased, it contained precious

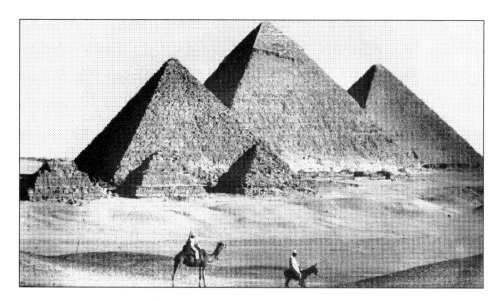

FIGURE 5-2 Pyramids (Bettmann Archive)

objects, foodstuffs, and other materials to ease the deceased's life in the next world. The pyramidal shape was based on the belief that it would be easier for the *Ka*, or soul, of the dead person to climb up to join the gods in the sky (Lesko, 1991). An inspection of the interior of a pyramid reveals a complex maze of many passageways and blind alleys designed to confuse grave robbers. Nevertheless, the robbers (and subsequently, professional Egyptologists!) eventually succeeded in relieving all the known pyramids and other Egyptian tombs of their treasures.

Greek Tombs

Decorative sarcophagi and tombs were also constructed by other ancient groups of people. Most early Greek corpses were placed in simple sepulchers (tombs) cut out of rock or in graves similar to those in use today. As seen in the Tomb of Mausolus at Halicarnassus in Caria, during the classical Greek period the tombs of royalty or heroes were often quite impressive and artistic. The art of *sepulchral iconography* rose to a high peak in such monuments. In addition to bearing a brief inscription, a sepulchral iconograph depicts the deceased performing some action or deed for the last time and the grief of the survivors. The ancient Greeks believed, as did other people during those early historical times, that such sepulchers possessed magical powers and hence should be treated as shrines.

Roman Tombs

The Etruscans, whom the Romans displaced as rulers of the Italian peninsula, were constructing stone tombs and terra cotta sarcophagi around 600 BC. The Romans were also great builders of tombs. Because burial in the city was forbidden, tombs

lined the Appian Way and other roads leading into and out of Rome. The ruins of many of these early tombs, including those of Gaius Cestius, Caecilia Metella, Hadrian, and the tombs at Pompeii, are popular tourist attractions.

The early Roman Christians had no elaborate tombs, but they had the catacombs, a system of underground passageways on the outskirts of the city that were used for burial purposes. According to Roman law, such burial places were sacred sanctuaries, and so the early Christians could take refuge in the catacombs without being pursued inside by the authorities.

Jewish, Christian, and Moslem Tombs

Like the Greeks, Jews who lived during the time of Christ usually cut tombs out of rock. This practice was followed in constructing early Christian tombs, which were fairly simple structures. Christianity subsequently made up for the simplicity of these funerary monuments, and many of the Christian tombs of later centuries were quite rich and elaborate. None, however, can match the Taj Mahal. This famous Islamic tomb was built in Agra, India, between 1630 and 1642 by Shah Jahan for his favorite wife (Figure 5-3).

Contemporary Tombs

Almost every modern nation has one or more famous tombs that attract thousands of visitors annually. In the United States are the Tomb of the Unknown Soldier, Grant's Tomb, and the Tomb of George and Martha Washington. The most famous sarcophagi in the world are those of George Washington (United States), Napoleon Bonaparte (France), the Duke of Wellington (Great Britain), and Vladimir Lenin (Russia).

Treatment of the Corpse

Several ancient methods of treating corpses (cremation, eating, etc.) have been discussed. The corpse may also be dismembered and each of the resulting parts buried at a different location. Such was the fate of the remains of William the Conqueror. The body of this first Norman king of England was buried at Saint-Etienne, the heart in Rouen Cathedral, and the entrails in the Church of Chalus. More typical was the practice of burying the head of a feared or disliked person in one place and the body in another, so they could not be rejoined and work further mischief on the living.

It was typical to groom and adorn the corpse before disposing of it. The corpse was usually cleaned, anointed, and covered with some colored substance. The custom among certain primitive European peoples was to cover or bury the corpse in ocher (iron pigment), perhaps because of the belief that the red color would revitalize the dead. In addition, the various body openings were often plugged and the eyes closed. Early Christians perfumed the body, after which it was either covered with a shroud or left naked. Depending on the social status and wealth of the deceased, ornaments, as well as a more expensive covering such as linen, might

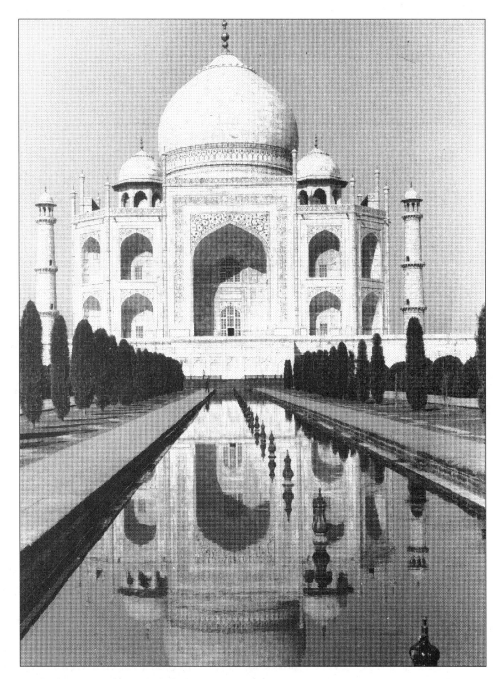

FIGURE 5-3 **The Taj Mahal**
**This white marble mausoleum was built during 1628–1658 at
Agra, India, by the Mogul emperor Shah Jahan for his favorite
wife. (Bettman Archive)**

be placed on the body. The Chinese pared the nails of the corpse, shaved its head, and dressed it according to rank ("Death Rites and Customs," 1987).

Mummification

As in life, wealth had its privileges in death. For example, in ancient China, dead men of higher social status were buried in better suits (with several spares!) than those of lower social rank. But no cultural group expended more of its material and human resources on deceased persons of high rank than the early Egyptians. The elaborate treatment accorded a dead pharaoh and the expense of his funeral preparations have seldom been duplicated. Other nations have constructed magnificent tombs for their leaders, but none like the pyramids. Other cultures have embalmed their royalty, but none as expertly nor on such a scale as the early Egyptians.

According to early Egyptian beliefs, preservation of the body was necessary so that the soul of the deceased, which took 3,000 years to make a round-trip journey across the heavens, would have a place to stay on its return to earth. The preservation process involved the use of extensive wrappings, gums, and oils in an attempt to exclude all the air and moisture from the body; the resin-soaked bandages were applied so as to reproduce the features, especially the face and genital organs, of the deceased. Before wrapping the body, however, the intestines, liver, stomach, eyes, and brain had to be extracted (Bardis, 1981, p. 20):

> *First, a metal hook was used to remove the brain. This process was completed by means of encephalic drainage (dissolving the remainder with drugs). Then, with an Ethiopian stone, the side was cut and the viscera were removed (evisceration). After filling the abdomen with palm oil, spices, and aromatic powders, the body was sewn up. Thus, mainly the less corruptible skin, cartilages, and bones remained. These were dehydrated by immersion of the corpse in salt of natron for 70 days. Hundreds of yards of fine gauze and bandages, protective amulets, stone eyes, and more aromatic substances completed mummification. At each stage, which symbolized a step in the death and resurrection of Osiris, the priests recited passages from the sacred texts—for instance: "You will live again, you will live again forever! Behold, you are young again forever!"*

Not included in this description is the rite of opening the mouth of the mummy to restore its ability to breathe, see, and take nourishment. After being wrapped, the mummy was elaborately encased and deposited in the tomb. Painstaking procedures, such as constructing a false tomb above the actual tomb, were often employed to hide the mummy and thus protect it from grave robbers.

Just as high social status had its advantages in death and life, low social status had its disadvantages in both states. In every culture, there have been groups of people who were not accorded special death rites or ceremonies and were disposed of with indignity. Among these individuals were infants, slaves, criminals, suicide victims, heretics, and victims of violent death or illness.

BOX 5-1 • The Mummy's Return

Summum, a Salt Lake City Company, has revived the ancient Egyptian practice of preserving bodies for posterity. For a minimum of $32,000, Summum will turn you into a museum-quality corpse.

The method . . . borrows heavily from ancient Egypt—except the part about removing the brain through the nostrils. "We tried that, but it's pretty hard," says [John A.] Chew [a mortuary professor in Boca Raton, Florida]. Instead, Summum "injects a chemical preservative into the cranial vault," which converts the brain into an "almost plastic-like" lump.

Other internal organs are steeped in Summum's secret sauce, then inserted back in the body. Then the corpse is painted with polyurethane (Egyptians used hot tar), wintergreen, and wine, and wrapped in a cocoon of cloth and fiberglass gauze.

The procedure takes up to 70 days, during which a team of Chinese artisans works on the sarcophagus. Customers have a choice of styles: Art Deco, traditional Egyptian or custom made. The price tag for the latter—which can include decorative gold inlay and eye sockets drilled out for sapphires—runs upwards of a half-million dollars.

Among the designs on order: an Oscar statue with the face of the deceased, a woman in a wedding dress, and, for an attorney who lives in Salt Lake City, a three-piece suit. Other customers have asked to be immortalized holding soccer balls, wrenches, autographed baseball bats, microphones and the Beatles' White Album.

Once the sarcophagus is ready, the body is slipped inside, argon is pumped in to replace the oxygen, and the seal is welded shut. Argon, an inert gas, helps prevent the mummy from decomposing.

So what are the advantages of being petrified for posterity? Ancient Egyptians did it because they believed their souls would someday return to their bodies.

Modern mummies seem motivated more by vanity: "When you're buried in a cemetery, you're covered with dirt and forgotten. With mummification, you're remembered."

Source: "Return of the Mummy," by Roy Rivenburg. *Los Angeles Times,* January 27, 1993, pp. E-1, E-6. Copyright 1993, Los Angeles Times. Reprinted by permission.

Ancient Greek and Moslem Practices

Unlike the Egyptians, the Greeks of Homer's time (ninth century BC) never embalmed corpses. Rather, the corpse was washed and perfumed and, in the case of a hero, cremated together with several servants. Whether or not the deceased was a hero, a coin (*obolus*) was placed in the mouth of the corpse to pay Charon, ferryman on the river Styx to Hades. Moslems, who have traditionally opposed both embalming and cremation, pour a mixture of sugar and water into the mouth of the deceased. Then the mouth is tied shut, the two great toes are tied together, and the body is cleaned and perfumed before burial (Bardis, 1981). Preparation of the body in orthodox Judaism requires that it be washed by a burial society in a special purification process (*tahorah*). The cleansed body is dressed in a plain linen shroud and, for a man, with his prayer shawl. Then the body is placed in a plain wooden casket and, if at all possible, buried before sunset on the day of death.

Posture and Orientation of the Corpse

Traditionally, graves have been dug rather deep, usually 6 feet or so, to prevent seepage, odors, and exhumation of the dead by animals or other grave robbers. In Western cultures, the pit is dug wide enough for the body to lie horizontally, although certain cultures have interred the body in a sitting position or even upright. Some Australian aborigine tribesmen bury their dead in a vertical position with a space above the head; dead Japanese may be seated in tublike coffins and buried.

During primitive times, the corpse usually was buried in a fetal position. Jonas (1976) maintained that Cro-Magnons were buried in this position because of the belief that it would facilitate rebirth. However, the fetal posture of the skeletal remains of many ancient people is probably due to tying the arms and knees of the corpse to the chest. The purpose of binding the corpse in this fashion was presumably to keep the soul from walking and hence disturbing the living. In later times, the body was buried in a horizontal position.

Concerning the directional orientation of the corpse, in horizontal burials the face was usually turned toward the west, perhaps emphasizing the setting (i.e., death) of the sun. In ancient Egypt from 2500 BC onward, however, the body was placed with its head to the north and its face to the east. This easterly orientation of the face was presumably chosen to indicate rebirth of the sun (Lessa, 1976). Early Christian burial was with the feet to the east, so that the last trumpet, which would presumably be sounded from that direction, could best be heard and responded to more quickly.

The custom of directing the feet eastward continues in modern England, although some Christians are buried with their feet pointed toward Jerusalem. An associated belief is that, with their feet pointed toward the Holy City, the dead will more readily rise up and meet Christ there on Judgment Day. Other religions dictate other body orientations. Moslems are buried lying on the right side, head toward the north, feet toward the south, and the face turned toward Mecca. Buddhists are buried on their backs with the head facing north, which is believed to have been the Buddha's dying position ("Dead, Disposal of the," 1976).

Grave Goods

The presence of various kinds of valuables and other goods found in prehistoric graves suggests a belief in an afterlife. For example, the grave of a Neanderthal man who lived about 70,000 years ago in what is now southwestern France also contained a leg of bison with the flesh still attached. The implication of this finding seems to be that the leg was buried to provide meat for the deceased in the next life. The goods accompanying the dead in later graves included not only food and drink but ornaments, weapons, flowers, and implements of various kinds. Occasionally the objects were quite large, such as those discovered in the Sumerian city of Ur in what is now Iraq. Excavators of one of the 5,000-year-old graves in this city found

not only the skeleton of a king, but also a chariot, the remains of a donkey to pull the chariot, various weapons, tools, valuables, and 65 members of the royal court! Apparently the ladies, soldiers, and grooms who made up this cortege had taken a lethal drug, marched to their assigned positions, and then died (Woolley, 1965).

The killing of wives and servants to accompany the deceased also occurred among the Scythians, a nomadic people who lived in Southern and Eastern Europe from 600 BC to 100 AD. This ancient rite was practiced among the Vikings of Northern Europe and, even more recently, in the suttee custom (northern India) of cremating alive the wife of the deceased (Figure 3-5). The early Egyptians followed a similar practice, but *paddle dolls* later replaced people in Egyptian tombs. Paddle dolls, shaped from thin strips of board into small canoe paddles, were placed in the tombs to act as servants and companions to the deceased in the spirit world. The tombs also contained jewels, household furnishings, and food. The food was presumably replenished periodically by attending priests.

The burial of goods in graves continued during the time of ancient Greece and Rome and down through the Middle Ages. In addition to boat fare for Charon, a dead Greek was provided with honey cakes for Cerberus, the three-headed dog that guarded the entrance to Hades. Even today, modern African societies and other cultural groups place grave goods alongside the dead body. The practice in many of these contemporary societies, however, does not imply a belief in an afterlife, but rather it is a custom signifying termination of the social position occupied by the deceased.

Prefunerary Rites

Today's emphasis on dying and death as essentially private affairs to be kept from public view and on rationality and efficiency in disposing of the dead contrasts sharply with the social nature and extensive preparation for death that occurred in previous times. Woodcuts of death scenes in medieval Europe depict crowded rooms, with friends, servants, clergy, and even animals attending the dying person.

Throughout history, many cultures have placed much emphasis on proper preparation of both the dying person and his or her associates for the death. As described in the *Tibetan Book of the Dead (Bardo Thedol)*, Buddhist teaching provides details on how a dying person should concentrate on the experience in order to have a good reincarnation or to become free of the birth-death cycle. A similar purpose was served by the *Ars Moriendi (The Art of Dying)*, a book written in the latter part of the Middle Ages. It contained advice for both the dying person and his or her relatives, religious sayings, prayers, and answers to questions about salvation.

Traditional Jewish teachings encouraged the dying person to put his or her spiritual life in order by confessing and repenting. By expressing personal fears in open communication with loved ones, the dying person obtained both social and spiritual support. In addition, the survivors received instructions from the rabbi on how the dying person should be treated and how his or her affairs should be handled.

Dying persons of the Roman Catholic faith traditionally received the sacrament of *extreme unction* (now called *anointing of the sick*). In this ritual, which was performed as much in the hope of curing the sick or injured person as to prepare his or her soul for the next world, the dying person's eyes, nose, mouth, ears, hands, and feet were anointed with sacred olive oil while prayers were said for his or her health. In addition to receiving the sacrament, it was very important to confess one's sins to a priest. It was believed that if the last rites were not performed, the unconfessed or otherwise unprepared soul would be seized by demons as soon as the last breath occurred. On the other hand, a properly prepared soul would be taken immediately by the angels.

In medieval and Renaissance Europe, a continuous vigil known as a *deathwatch* was usually maintained beside the bed of a dying person, and a death knell (bell) sometimes sounded as soon as the person died. In some societies, the deathwatch continued even after the person had expired, perhaps in the hope (or fear) that the deceased might return to life. The modern-day Irish wake harks back to the earlier custom of filling the house of the dead with entertainment to "rouse the ghost." Similarly, a time-honored practice among southern African Americans is to stay awake all night beside the body, praying, singing spirituals, and recalling pleasant memories of the deceased. Friends and relatives bring cooked hams, fried chicken, salads, and home-made pies for the all-night vigil (Hillinger, 1989).

Other prefunerary practices in medieval Europe, some of which have persisted into modern times, include opening all doors and windows and hanging wreaths on the doors of the deceased's home, turning mirrors toward the wall, covering anything made of glass with a black cloth, stopping all clocks in the home of the deceased, removing tiles from the roof, and either emptying all water receptacles or filling them for use by the deceased. The exact origins of such customs are not known but presumably had to do with superstitious beliefs concerning the activities of spirits and protection against their influence. As archaic and quaint as these practices may seem, they provided people with ways of coping with their fears of death. They also brought the survivors closer together, creating a sense of community that is often lacking in the prefunerary practices of today.

Funeral Transports and Processions

In addition to methods of disposing of the body, funeral rites and customs include special ways of transporting the corpse to the grave, the apparel and treatment of the mourners, and their behavior in the funeral procession and afterward. Great care may be taken to make certain that the spirit of the deceased does not return to haunt the living. For example, the corpse may be blindfolded, taken from the house by a special door that is later sealed, and carried to the grave by an indirect route; thorns may then be strewn along the pathway from the grave back to the house or town. Loud sounds and bad odors or, in exceptional circumstances, dismemberment of the corpse, have also been used to ensure the nonreturn of the deceased's spirit. Finally, in some instances it was considered taboo to speak the name of the deceased for fear that it might arouse his or her ghost from sleep (Lessa, 1976).[3]

FIGURE 5-4 **Death Mask of Napoleon Bonaparte
(Bettmann Archive)**

American funeral customs date back several thousand years to early Judeo-Christian beliefs, which themselves were influenced by earlier practices and beliefs. The custom of walking in a funeral procession was introduced in Britain at the time of the Roman invasion of 43 AD, but it did not originate with the Romans. A highlight of a Roman funeral procession was the parade of the death masks of the deceased's ancestors (Figure 5-4). Today people of many different religions—Hinduism, Judaism, Christianity, Islam—march in procession to the place of burial or, for Hindus, to the place of cremation. The Romans were also responsible for introducing into Britain the funerary practices of wearing black and raising a mound over the grave (Fulton, 1992; Hambly, 1974). Mourners in other cultures

might wear black or white, but their garments usually were colorless. Also of interest is that the older practice among Roman Catholic priests of wearing only black to funerals and using black candles gave way to white vestments and white candles after the Second Vatican Council (1962–1963) ("Death Rites and Customs," 1983).

The funerals of pharaohs in ancient Egypt also included a journey by the deceased, first to the Nile River and then across the river in a boat. A gathering of people on the west bank of the Nile voted to decide whether the dead pharaoh had been a good or bad king. The outcome of the vote determined if the body was buried in a tomb or merely dumped into the river (Hardt, 1979).

Lamentations and Other Mourning Behaviors

The behavior of survivors during and after funerals has often been quite dramatic and disturbing. They may cover their faces with mud (ancient Egypt), tear their clothing (Jews, Moslems),[4] let their hair become unkempt (Moslems), turn their clothing inside out and walk backward (Australian aborigines), and even mutilate themselves (various cultures). Mourners may wear special clothing and adorn themselves with ashes, black armbands, and other death symbols; they may observe food taboos and physically seclude themselves. Physical isolation of a widow or widower is regarded as a sign of the marginal status of the survivor, who is considered contaminated, unclean, perhaps even dangerous, and hence taboo. Also included in the rites are attempts to determine the cause of the death—whether it was due to the actions of God, the wrath of ancestors, the envy or spite of others (magic, witchcraft), or to scientific or medical factors.

Characteristic of mourners in many cultures are wailing, shrieking, and other wild actions. Since ancient times, societies have also hired professional mourners— usually women who are highly gifted in simulating hysterics—to walk and otherwise perform in funeral processions. Kamerman (1988, p. 85) notes that

> The actor Rudolph Valentino's death in 1926 resulted in riots around the funeral home in New York. For publicity, actresses were hired to wail outside the funeral home, which precipitated the riot. Those inside feared that the casket, the body, the flowers, and the home itself might be ripped apart by the crowd anxious to carry off some shred to preserve the memory for their fallen idol.

Besides the hysterical wailing of professional mourners, lamentations may be expressed in dirges (funeral songs and songs commemorating the dead), dances, art, and writings. The ancient Greeks and Romans also honored the dead with funeral games and banquets. The end of mourning, which might last as long as a year, included purification of the mourners and sharing of a sacrificial meal by the deceased's relatives (Middleton, 1991). Jewish custom prescribed a meal of recuperation for mourners, a practice also followed by certain Christian denominations.

Pre- and postfunerary rituals were not always sad affairs. Chinese and Irish cultures, to name just two, emphasized the more optimistic aspects of death, cel-

ebrating it on occasion with festivity and revelry. To add to the festivities, animal and even human sacrifice was a funerary practice in certain ancient cultures. It was the custom among blacks in the Southern United States to meet on a Sunday after the burial for a memorial service. During the service, families and friends arranged themselves in a circle, shouted praises to the Lord, clapped their hands, sang spiritual songs, and performed a special "ring shout" dance in which no person crossed his or her feet. Not crossing the feet while dancing was considered a sacred practice rather than a secular one (Hillinger, 1989).

RELIGIOUS BELIEFS

Although they lived in a world where death was ever present and realized that all living things die, primitive humans still were not prepared to accept death as the end of personal existence. Being close to nature and therefore aware of seasonal cycles in which death in winter is followed by rebirth in spring undoubtedly influenced their interpretation of death as a transition from one stage of life to another (Cavendish, 1977). Thus, death was perceived as a kind of rite of passage from this world to the next one. Many early customs and myths characterize life and death as a cyclical process similar to the growth, death, and revival of plants.

Myths and Beliefs Concerning Death

Every culture has had *myths,* stories concerned with the creation of things (e.g., the world, human beings, gods) or with the explanation of events such as sickness and death. To people of another culture, such myths may be viewed as interesting but fanciful folk tales and legends. To members of the culture in which they originated, however, the myths may be sacred. As a result, myths are a significant part of the spiritual life of many societies and a forerunner of institutionalized religion. Most myths concern the actions of supernatural or divine beings, who possess human characteristics but superhuman powers. These beings may look human, at least in part or in idealized form, and they interact (both socially and sexually) with real people. The actions of these godlike creatures often go back to primordial time, as in myths concerned with the creation of the world from a primal substance (Babylonian and Hebrew myths) or from a giant egg (Chinese and Hindu myths). Supernatural beings are believed to be responsible not only for creation but also for death; people die because of the actions of mythical beings (Long, 1990).

Unlike the scientific view of death as a natural event that signals the end of an individual's existence, and like the mythologies that preceded them, most religions have depicted death as an unnatural occurrence resulting from the actions of supernatural beings. Also unlike the scientific viewpoint, religions do not consider death as final or complete; the body is destroyed but the soul continues to exist after death.

Concern with death and life after death has varied extensively with culture and religion. For example, the early Sumerians (circa 5000 BC) were more interested in

BOX 5-2 • The Forbidden Fruit

Disobedience to divine commandments results in the death of the offenders and their descendants. This is the theme of the forbidden fruit, which is common in both Africa and the South Sea Islands. The theme explains the origin of death and not the origin of sin as in the Book of Genesis. The Wachagga, who live in the Kilimanjaro region, believe that death occurs from eating a certain tree's fruit that their supreme god has forbidden.

A Hawaiian legend relates how Kumuhomua, the first man, lived with his wife, Lalohomua, in the land of Kane, until she met the Great Seabird. She was induced to eat the sacred apples of Kane, after which she and her husband were carried away by the Great Seabird into the jungle. There they were lost, and death became the penalty for both Kumuhomua and his wife for not obeying God's command.

The same idea is found among the pygmies. Death came to early people in the form of a cataclysm that obliterated the ancestral paradise at the source of the Nile. The following is one of the many versions. God, who made the first man and woman, allowed them to live forever as long as they would not pick the fruit of the tahu tree. When the woman became big with child, she decided that she must eat that fruit and no other. Her husband warned her that God had forbidden them to eat the fruit, but the woman argued, cried, and screamed. In desperation, in order to quiet his wife, the husband picked the fruit, and they ate it together and hid its peel under the leaves. God sent a wind to blow the leaves away and saw the peel. He became angry and punished both by condemning them to hard work, illness, and ultimate death. He punished the woman even more for initiating the problem and gave her the pain of childbirth.

In Australia, some tribes have a slight variation on the forbidden fruit theme. Death is blamed on women who have gone to a forbidden hollow tree containing a bee's nest, searching for honey. A huge bat, the spirit of death, was released from the tree, and the bat roamed the world, providing death to all it could touch with its wings.

Source: Corcos, A. & Krupka, L. (1984). How death came to mankind: Myths and legends. In R. A. Kalish (Ed.), *The final transition* (pp. 165–166). Farmingdale, NY: Baywood Publishing Company. Reprinted by permission.

life than in life after death. They believed that since the gods had assigned death to man when he was created, they would not help him in death. As we have seen, the ancient Egyptians gave much more attention to death than the Sumerians. The Egyptians enjoyed life, but sadness and tears accompanied the death of a loved or revered person. They thought of death constantly, and although they had no god of death as such, two Egyptian goddesses (Sekmet and Bastet) were associated with death. The ancient Greeks, on the other hand, placed the responsibility for death squarely on the shoulders of a single male deity—Thanatos (Bardis, 1981).

Like the ancient Egyptians, the early Chinese enjoyed life, but at the same time, they were concerned about dying. Historically, the Chinese valued longevity, and the death of an elderly person was as much an occasion for rejoicing as for mourning. Consistent with their reverence for long life was the belief that the death of a young person is a sign of an evil spirit at work, and hence a threat to other people.

They also believed that, at death, the body-soul system is dispersed and the dead person becomes a sacred ancestor.

Islam is fatalistic about death: The time of a person's death is believed to be fixed in advance. Mohammed taught that because a person's death is predetermined, it should be accepted joyfully and without fear. Of particular interest are those who die in defense of Islam, as in a *jihad* (holy war); they are assured of a place in heaven. This credo is similar to the early Greek and Viking beliefs that warriors who die bravely in battle go to a special place (Elysian Fields, Valhalla). Moslems also believe that death is caused by a supernatural being—the Angel of Death—who steals the soul of the deceased (Adams, 1992; Bardis, 1981). In an Islamic funeral procession, the coffin of the deceased precedes the mourners, since the Angel of Death is believed to be at the front of the line. Islam has many other beliefs and teachings in common with those of other cultures and religions, Judaism and Christianity in particular. In addition to being monotheists, Moslems view the Koran not as nullifying the Bible but rather as correcting the version of the scriptures followed by Jews and Christians. Abraham was the patriarch who, through his sons Isaac and Ishmail, is said to have given rise to both the Jewish and the Arab peoples. Furthermore, many of the Old Testament prophets, and even Jesus Christ, are recognized by Islam as holy men. However, Muhammed is the principal prophet of Islam.

The Judeo-Christian view of death and afterlife developed over many centuries. The Old and New Testaments of the Bible do not have very much to say about death, but the attitude toward death expressed in the books of Job, Proverbs, Psalms, and Ecclesiastes is one of fatalistic resignation. Job 7:9–10 expressed the pessimistic attitude that

> *As a cloud vanishes and is gone, so he who goes down to the grave does not return.*
> *He will never come to his house again; his place will know him no more.*[5]

In early Judaism, as among the ancient Greeks, the emphasis was more on the perpetuation of the community or social group than on the eternal existence of the individual. Because Abraham did what the Lord asked him, the Lord promised:

> *I will surely bless you and make your descendants as numerous as the stars in the sky and as the sand on the seashore. Your descendants will take possession of the cities of their enemies, and through your offspring all nations on earth will be blessed, because you have obeyed me. (Genesis 22:17–18)*

The perpetuation of Abraham's seed, not personal immortality, was what God promised. Thus, Judaism became a religion of faith, faith in God's promise to preserve the Jewish people as a nation and enable them to fulfill their common destiny. Similarly, among the early Greeks, it was the *polis* or city state that would survive, not the individual member of that state.

From the time of Job to that of Ezekiel and Daniel, the resigned attitude toward death gradually changed to one of hope that the dead are merely sleeping and will awaken one day. The Lord now promises that

> *I am going to open your graves and bring you up from them; I will bring you back to the land of Israel. (Ezekiel 38:1–2)*

Whether the awakening of the dead will result in everlasting life or everlasting disgrace will vary with the individual. Thus, in Daniel 12:5, it is promised that

> *Multitudes who sleep in the dust of the earth will awake: some to everlasting life, others to shame and everlasting contempt.*

Despite these Old Testament promises of revitalization of the dead, it remained for Christianity to express the idea of personal resurrection to its greatest degree. There is no specific passage in the first three Gospels of the New Testament (the "synoptic Gospels") in which Jesus discusses the subject of death. Rather, it is in the writings of Paul of Tarsus that death is described as man's last and greatest enemy, an enemy whose power results from man's sinfulness:

> *Listen, I tell you a mystery: We will not all sleep, but we will all be changed—in a flash, in the twinkling of an eye, at the last trumpet. For the trumpet will sound, the dead will be raised imperishable, and we will be changed. For the perishable must clothe itself with the imperishable, and the mortal with immortality. When the perishable has been clothed with the imperishable, and the mortal with immortality, then the saying that is written will come true: "Death has been swallowed up in victory." "Where, O death, is your victory? Where, O death, is your sting?" (1 Corinthians 15:51–55)*

Paul taught that, except for the intervention of Jesus Christ, who died on the cross to atone for man's sins, death would mean obliteration. By the resurrection of Christ, Paul maintained, man has attained victory over death. In Paul's words:

> *Just as Christ was raised from the dead through the glory of the Father, we too may live a new life. (Romans 6:4)*

Several centuries later, St. Augustine, in *The City of God*, interpreted Paul's writings on the subject as meaning that death is a punishment for sin and that only divine grace can free man from the fear of death. In Augustine's view, humans were created by God in His image. When Adam sinned, however, all humanity fell from grace, and hence everyone is born in sin and spiritually flawed. A consequence of that sin is death—an experience that every person must undergo in order to restore his or her previous state of perfection.

Immortality and the Soul

As witnessed in the elaborate process of mummification and the writings in the *Egyptian Book of the Dead*, the ancient Egyptians believed in a life after death. This belief is seen in the myth of Osiris, the god of the underworld, who was reassembled and came back to life after being cut into 14 pieces. Henceforth, immortality was assured by the intervention of Osiris. The ancient Greek and Roman myths also describe a life after death, and even earlier peoples (e.g., Neanderthals) apparently believed in rebirth after death. Such a belief is, in fact, much older than the idea of personal extinction. The latter notion, that individual identity ceases to exist at death, appeared first in early Buddhism (sixth century BC) and two centuries later in the writings of the Greek philosopher Epicurus (341–270 BC):

> *Become accustomed to the belief that death is nothing to us. For all good and evil consists in sensation, but death is deprivation of sensation. And therefore a right understanding that death is nothing to us makes the mortality of life enjoyable, not because it adds to an infinite span of time, but because it takes away the craving for immortality. For there is nothing terrible in life for the man who has truly comprehended that there is nothing terrible in not living. (Epicurus,* Letter to Menoeceus*)*

The idea of personal extinction maintains that after death a person no longer exists as a distinct personality but becomes, as before birth, one with nature and the cosmos.

The Soul

All religions teach that something of the individual survives death, but they differ in their beliefs of what it is that survives. As revealed in attempts to ensure immortality for the pharaohs by preserving their bodies, the early Egyptians did not clearly distinguish the spirit or soul from the physical structure of a person. Although the Egyptians had a word, *Ka*, roughly equivalent to the English *soul*, the Ka lived in the person's mummy after death. In contrast, the dualistic notion of a discardable physical body and an inner, immortal soul, which was proposed in the ancient Greek philosophy of Orphism, greatly influenced Greek thought and religious beliefs. The Orphists taught that the immortal soul retains the personality of the deceased.

The Pentateuch, or first five books of the Old Testament, contains no specific discussion of personal immortality or the idea of a soul. Genesis 3:19 states that

> *By the sweat of your brow you will eat your food until you return to the ground, since from it you were taken; for dust you are and to dust you will return.*

The book of Genesis may be interpreted as implying that either (1) man's mortality was part of God's original plan of creation, or (2) man was originally created as immortal, but God took away the immortality as punishment for man's disobedi-

ence. Thus, the ancient Hebrew belief was that people are mortal and whatever immortality they may attain is collective rather than personal. God did not promise Abraham personal immortality but rather perpetuation of his line through a multitude of descendants. Thus, in ancient Judaism there is no such thing as a personal afterlife. The individual's life acquires meaning only by its contribution to the mission of the People of the Covenant (Gatch, 1980).

Social or national immortality was the dominant theme among the Jews well into the time of Christ. During the second century BC, due presumably to the influence of Zoroastrianism, belief in immortality of the individual soul gained strength among the Pharisaic Jews. After the destruction of the temple at Jerusalem in 70 AD, the idea of resurrection of the dead became a part of orthodox Jewish faith. As indicated by Gatch (1969, p. 78):

> *The notion of resurrection and of the restoration of an elect people continued to be prominent. But the idea of a disembodied afterlife for the soul was also current and led to the conception of some sort of afterlife between the separation and the reunion of soul and body. From a picture of death as the inauguration of a sleep which would last until the divinely instituted resurrection, there emerged a picture of death as the beginning of quiescence for the body and of a continued life for the soul, the nature of which remained more or less undefined.*

Like the Old Testament, the synoptic Gospels of the New Testament contain no specific reference to a soul or nonphysical aspect that survives death. Again, it is in the writings of Paul, who was presumably influenced by Greek thinking on the matter, that the idea of a soul is enunciated. Expanding on the concept, Paul and other early Christian thinkers saw damnation and salvation of the soul as determined by the actions of a person during his or her lifetime. However, even a sinner can be saved by the unmerited favor and love bestowed by God on His human creations (God's *grace*).

Reincarnation

The single physical lifetime of Christian doctrine contrasts with the multiple lifetimes of Eastern religions. In many religions, Hinduism and Buddhism in particular, life and death are likened to points on a constantly moving wheel. Each person has a succession of lives, being reborn or reincarnated after death into a life form determined by the person's character and actions during the previous lifetime (*karma*). According to the doctrine of *reincarnation*, souls (*jivas*) pass through (*samsara*) a succession of human and animal forms. Each successive life form is determined by a person's thoughts and actions and the lessons he or she learned in the previous life. For example, behaving like an animal and failing to learn to be obedient may lead to reincarnation as a dog.

Both Hinduism and Buddhism teach that only when the soul is purified and the individual finds identity and unity with the cosmos (*nirvana*, Enlightenment; *Brahman*, the Universal Power) can it break the continuous cycle of life, death, and

rebirth (Bouquet, 1991). Then and only then, all ignorance and craving disappear and the individual flame goes out as the spirit merges with the cosmos.

Although it was more time consuming to travel between the Far East and the Middle East during ancient times, there was still some communication between Asian and Mediterranean cultures. Therefore it is not surprising to find the influence of the Eastern idea of reincarnation, or transmigration of souls, in Plato's writings. As we have seen, the doctrine of immortality and rebirth of the soul espoused by Plato had a profound influence on Paul and Christian theology.

Resurrection

The concept of reincarnation in Hinduism and Buddhism is not a resuscitation of the dead in the same form but rather a metamorphosis or change. However, the belief in physical *resurrection*, or the return of the dead to life in bodily form, existed in part among the ancient Egyptians. The process of mummification and associated rites were supposed to enable the deceased to live forever in his or her well-equipped tomb. The Zoroastrians of ancient Persia also believed in resurrection of the dead, a belief communicated to and absorbed by Pharisaic Judaism and subsequently by Christianity and Islam (Toynbee, 1980). It was Paul's message that the resurrection of Jesus Christ in both body and spirit contains the promise of personal resurrection of body and soul to all who believe in Him and have attained salvation. In John 12:25–26, Jesus says to Martha:

> I am the resurrection and the life. He who believes in me will live, even though he dies; and whoever lives and believes in me will never die.

The Land of the Dead

Many myths and religious stories describe the soul after death as traveling to a land of the dead. This realm may be in the sky, deep within the ground, on top or inside a high mountain, in the ocean, or in some unspecified place. Belief in the first two locations prevailed in ancient Egypt. The sun god Ra lived in the heavens, and the god Osiris ruled in an underworld entered by way of the grave. At night, the soul (Ka) either followed Ra on his journey across the sky or, according to the dominant viewpoint, remained in Osiris's underground fields. At dawn, Ka returned to its mummy and spent the day in the tomb.

Wherever the underworld or land of the dead might be, the trip involved obstacles and dangers—rivers to be crossed by bridge or barge, monstrous animals to be faced, and personal humiliation or pain to be endured. The gradual unfrocking of the goddess Ishtar of Babylonian mythology as she descended to the land of the dead and the labors of Hercules in Hades are cases in point (Bardis, 1981). Having entered the underworld, it was no easy matter to leave. This is illustrated by the myth of Orpheus's pursuit of his dead wife Eurydice into the land of the dead. By charming Hades, Orpheus obtained permission to lead Eurydice away providing she did not look back until they returned to earth. Unfortunately, like Lot's wife of Biblical fame, Eurydice looked back at the last moment and thereby was lost to Orpheus forever.

On arriving at the land of the dead, the ancient traveling spirit was likely to find it a dreary abode of shadows where the spirit residents would prefer not to remain. As Homer has Achilles say to Odysseus in the *Odyssey*,

Speak not smoothly of death, I beseech you, O famous Odysseus. Better by far to remain on earth the thrall of another . . . rather than reign sole king in the realm of bodyless phantoms.

Detailed descriptions of this realm were offered by the ancient Greeks and in the fourteenth-century epic poem the *Divine Comedy*, by Dante Aligheri. The god Hades (Pluto) and his queen Persephone (Proserpina) ruled the Greek land of the dead, a dreadful place that had to be approached by a river (the Styx or Acheron). The fee paid to the boatman Charon for ferrying a soul across the river was an obolus (coin) carried in the mouth of the deceased. The deceased also brought along some honey cakes to bribe the ferocious three-headed dog (Cerberus) that guarded the entrance to the underworld.

After passing through the gates of Hades and being judged, the soul was assigned to one of three sections—Tartarus (the worst section), the Plains of Asphodel (an intermediate section) or the Elysian Fields (the best section). The Elysian Fields, or Isles of the Blessed, were the abode of heroes and others favored by the gods. Despite his assignment to the Elysian Fields, as noted in the previous quotation from the *Odyssey*, the Greek hero Achilles found it unpleasant compared with life among the living. Nevertheless, his dissatisfaction must have been mild compared with that of Sisyphus, who, as punishment for fooling the god Hades, was condemned forever to Tartarus. There, according to legend, Sisyphus is spending eternity rolling a huge stone to the top of a high hill, at which point the stone rolls back down the hill and Sisyphus must start all over ("Death Rites and Customs," 1983).

Somewhat similar to the model of Greek mythology, the great religions of the world describe the land of the dead as consisting of two, three, or even more sections. Comparable to the Greek land of the dead are the Mesopotamian *Land of No Return*, the Hebrew *She'ol*, and the Scandinavian *Hel*. The sorrows and tortures endured by souls consigned to Tartarus are shared by those forced to abide in the Moslem and Christian hells. According to the Koran, there are seven layers of heaven and seven layers of hell (*alnar*); each layer merits lesser rewards or greater punishments than the one above it (Long, 1987). The sufferings of the damned in the Christian inferno or hell are vividly and fearfully described in *The Inferno*, the first part of Dante's *Divine Comedy*.

Paradise and Purgatory

In contrast to the sufferings of the souls of sinners are the delight and peace experienced by those who have attained salvation and gone to paradise or heaven. Both Christian and Islamic texts described heaven as a gardenlike paradise where the spirits of the blessed or righteous go after death. It is the abode of God (Allah) and the angels and permeated by the divine spirit.

Early Protestant theologians (Martin Luther, John Calvin) maintained that the dead, depending on how they are judged, are consigned to either heaven or hell. However, both Catholic and Moslem theologies provide for a third region (*purgatory*) for souls not deserving of heaven or hell. In purgatory, the souls of those who confessed their sins before dying are purified of venial sins or undergo temporal punishment for mortal sins that have been forgiven. Roman Catholicism also provides for a region on the border of hell or heaven known as *limbo*, a place inhabited by unbaptized infants or righteous people who died before the coming of Christ.

The existence of an intermediate zone between heaven and hell did not originate with Christianity or Islam. Dante's Purgatorio is reminiscent of the Plains of Asphodel of Greek mythology and the ten hells of Chinese Buddhism. However, Christianity and Islam connected the notion of purgatory to that of the last judgment. Whereas those who had committed unremitted mortal sins went directly to hell, persons judged guilty of venial (pardonable) sins or those whose mortal sins had been remitted could atone and suffer temporal punishment in purgatory while awaiting final judgment.

Testing and Judgment

Both Eastern and Western religions view life as a time of testing for the individual: A person's actions in this life influence what becomes of him or her in the next life. For example, the Egyptian papyrus of Hunifer pictures the Hall of Judgment and the Great Balance for weighing the soul against the feather of truth. Below the scales, awaiting the unjust, is the Devourer of Souls; awaiting the just is Horus, who is prepared to lead them to Osiris and a pleasant afterlife.

The standards by which a person's life is evaluated have varied with the religion and cultural context. Christianity and Islam have tended to demand a more ascetic or austere life than Hinduism and Buddhism, which stress the importance of contemplation and mysticism. As in Christianity, asceticism in Islam varies with time and sect. Islamic teaching holds that since life on earth is the seedbed of an eternal future, a person should try hard to be good and helpful to others and trust in the justice and mercy of Allah to decide his or her fate (Adams, 1983). Still, earthly punishments, such as stoning for adultery and execution for heresy, tend to make Islam seem like a rather hard religion.

Except for the existence of purgatory, the outcome of the "life test" is final in Christianity. In Eastern thought, however, a failed life test can be taken again in a subsequent reincarnation. Thus, the outcome of the test might be described as "pass/fail" or "all or none" in Christianity, compared with the "pass/try again" (until you get it right) philosophy of Hinduism (Pardi, 1977). Zoroastrianism also subscribes to a pass/fail system, but the test is less difficult than that of Christianity. The prophet Zoroaster taught that a moral life is sufficient to attain life after death and that it is not necessary to be an ascetic who subjects himself to torments of the flesh, such as self-flagellation.

Asceticism or Damnation

Eastern religions do not necessarily deny the importance of asceticism and individual suffering. Certain Buddhist sects, for example, are quite strict in their belief that bodily deprivations and pain are important to moral uprightness. The emphasis in Christianity on asceticism also varied with the particular sect and time period. Asceticism reached a high point during the late Middle Ages, when life was characterized as a "place of trials" that one must endure and a "vale of tears" through which one must pass stoically in order to attain a heavenly reward. The consequences of failure to follow the teachings and ascetic example of Christ, whatever the personal cost, were vividly described as endless torment and mortification in hell. There, one would suffer not only severe physical punishment but would be forced to listen to his or her evil deeds recounted gleefully and perpetually by a horde of demons. Because damnation was likely if one were deprived of the last rites of the Church, a sudden death was to be avoided at all costs and was constantly feared during the Middle Ages (Aries, 1974).

Predestination and Assurance

The notion that Christianity represents a pass/fail system is not entirely accurate, at least if one assumes that the examinee's voluntary actions ensure his or her fate. Although medieval theology emphasized the importance of good works in attaining salvation, the Calvinist doctrine of predestination holds that it is predetermined whether a given person will end up in heaven or hell. But one's future fate is unknown, and there is nothing that can be done about it. According to the *doctrine of assurance,* a person can never be certain of being chosen for salvation, but can only hope that God's grace will save him or her. In actuality, Protestants of various denominations came to believe that avoiding temptation, being pious, participating in the punishment of sinners and the destruction of evil, and even working hard (the Protestant ethic) could improve one's chances of going to heaven rather than hell (Anthony, 1977; Weber, 1958).

Battle of Good and Evil

Many ancient myths influenced the development of the world's great religions. One of these myths is that a last great battle will be fought between good and evil before the world ends (God vs. Satan, Ahura Mazda vs. Ahriman, etc.). Revelation 16 states that this final battle will occur at a place in central Palestine known as Armageddon. Once the battle begins, a savior figure will arise to save the day for the forces of good. Then, as described in Zoroastrian, Hebrew, Christian, and Moslem myths, the living and the dead will be judged and sent to heaven or hell.

Last Judgment

Belief in a judgment after death, the outcome of which will determine where the soul goes, existed among the Egyptians, Persians, Greeks, Hebrews, and many other ancient peoples. The Egyptian judge was Osiris, god of the underworld; the

Zoroastrian judge was Ahura Mazda, the god of light. The three judges of Greek mythology were Minos, Aeacus, and Rhadamanthys, divine residents of Hades. The biblical Old Testament proclaims a day of coming of the Lord, at which time the Israelites will be called to task for their sins, and Israel and the other nations of the world will be judged. But this day will not necessarily be a pleasant one (Amos 5:18–20):

> *Why do you long for the day of the Lord?*
> *That day will be darkness, not light.*
> *It will be as though a man fled from a lion*
> *only to meet a bear,*
> *as though he entered his house*
> *and rested his hand on the wall*
> *only to have a snake bite him.*
> *Will not the day of the Lord be darkness,*
> *not light—*
> *pitch-dark, without a ray of brightness?*

Early Christian theology described judgment in two stages—an initial judgment immediately after the death of the person and a final judgment after the second coming of Christ. At the time of the last judgment, when the world has ended, souls will be reunited with their bodies and a final decision will be made to send the individual to heaven or hell. Similar to the Christian belief is the Moslem credo that on the last (judgment) day of the world, everyone will be presented with a record of his or her earthly deeds. If this Book of Deeds is placed in the individual's right hand, he or she has been pronounced "good" and will go to heaven. If the record book is placed in the left hand, the person has been deemed "bad" and will be sent to hell (Adams, 1992).

SUMMARY

Historically, death has been both a personal and a social event. Death produces existential anxiety and fear of the supernatural but also leads to group reorganization and increased cohesiveness. The death system of a society consists of a composite of rituals and beliefs by which the society attempts to cope with death.

Human beings are not the only creatures to bury their dead, but they certainly do so more painstakingly than other animals. Funeral customs or rites, which go back at least to the Stone Age, serve four purposes: disposal of the corpse, helping the soul find rest and peace, honoring or paying tribute to the deceased, and reaffirming or reorganizing the social group. The primary methods of corpse disposal are inhumation (burial in the ground or in a cave) and cremation. However, open-air disposal, water burial, and eating by other humans or animals have also served as means of taking care of dead bodies.

The practice of using coffins and tombs dates back to the third millennium BC. The most elaborate stone coffins and tombs from ancient times are the sarcophagi and pyramids of Egypt. Many of these structures, including the sarcophagi and tombs designed by the Greeks, Romans, Christians, and Moslems, were elaborately and beautifully decorated. The ancient Egyptians also practiced mummification of the corpses of royalty and priests, as did the ancient Peruvians.

The position in which the body is placed in the grave has varied with religious beliefs and social customs. It has also been the practice since Neanderthal times to bury various objects (food, weapons, ornaments, other people, etc.), referred to collectively as grave goods, with the corpse.

In addition to religious sacraments, prefunerary rites have included a variety of superstitious rituals to pacify or confuse the ghost of the deceased person. Funerary rites, such as transporting the corpse and marching in procession to a holy place or burial site, are found in many different cultures. These rituals have also included lamentations, religious services, and, in some instances, festivities (games, banquets, etc.).

As suggested by the presence of grave goods and other indicators, primitive man apparently believed in a life after death. The later development of myths is based on this early belief, in addition to other beliefs about the creation of the world, natural phenomena, and death. Cultural myths, which are concerned with the activities of superhumans or gods, were the antecedents of formal systems of religious beliefs. Like myths, religions offer explanations of natural phenomena, including the origin and fate of the universe, and human beings in particular, as well as guidelines for human conduct.

Although the Sumerians, Egyptians, Greeks, and other ancient people had many myths and associated religious beliefs, the principal religions have been Hinduism, Buddhism, Judaism, Christianity, and Islam. The teachings of these religions developed and changed over the centuries, influencing each other and hence having many elements in common. One shared belief is that human beings have immortal souls. Hindus and Buddhists, however, subscribe to the doctrine of reincarnation, whereas Jews, Christians, and Moslems believe in resurrection.

The location and character of the land of the dead vary with the particular mythological or religious system. Best known in Western cultures are the underworld of ancient Greek mythology and the heaven (paradise)/purgatory/hell (inferno) complex of medieval Christianity. In Greek mythology, Chinese Buddhism, Islam, and certain other mythologies and religions, the land of the dead consists of several sections or zones reserved for souls of different character.

Both Eastern and Western religions teach that life is a time of trial and testing: An individual's actions in life affect his or her next condition or destination. Hinduism and Buddhism teach that it is a person's karma to be reincarnated after death as an animal or another human, depending on the person's deeds in the previous incarnation. The cycle continues until the individual finds identity and unity with the cosmos. Christianity and Islam, on the other hand, hold that the soul goes to heaven, hell, or some intermediate zone, depending on the record of sins. Protestant

(especially Calvinistic) theology maintains that whether or not a person attains salvation and goes to heaven depends on God's grace rather than the person's temporal actions, although many Christians believe that their chances of going to heaven are improved by good works on earth.

The *eschatology*, or doctrine of last things, in many religions maintains that the world will end with a final battle between good and evil. The battle will be won for good when a savior figures appears to lead the forces of good to victory. After the battle is won, a last judgment of souls—both living and dead—will be made to consign the individual to heaven or hell.

QUESTIONS AND ACTIVITIES

1. An *epitaph* is a commemorative inscription on a tomb or mortuary monument concerning the person buried at that site. During former times, and even more recently, it was the practice for some people to write their own epitaphs, either in prose or poetry form. Some epitaphs or writings on tombstones have been humorous, such as "I told you I was sick," "Now do you believe me?" and "I'd rather be here than in Chicago." Others have expressed feelings of love of family or religious thoughts. Still others have expressed a love of life or the sea and a conception of death as a journey or a return, as seen in the following epitaph by Robert Louis Stevenson (1850–1894):

 Under the wide and starry sky
 Dig the grave and let me lie.
 Glad did I live and gladly die,
 And I laid me down with a will.

 This be the verse you grave for me:
 Here he lies where he longed to be:
 Home is the sailor, home from sea,
 And the hunter home from the hill.

 Most of us are not as poetic as Stevenson, but try your hand at writing your own epitaph, either in poetry or prose form. What features of your past life or expectations for a future life do you choose to include in the epitaph? Should it be a short statement of what you were, what you accomplished in life, or what you hope for in an afterlife? What attitude toward your demise should be incorporated in your epitaph—resignation? Hope? Should you concentrate only on your own self and feelings or also try to take into account the thoughts and feelings that other people who read your epitaph after you have gone may have about you?

2. By consulting encyclopedias and other sources, investigate the similarities and differences in the conceptions of death in Hinayana (Theravada), Mahayana, Tantrayana, and Zen Buddhism. How does Buddhism differ from Hinduism in its conception of death and afterlife?

3. Refer to the topic of "death" in the concordances (alphabetical indexes) of various versions on the Bible (e.g., *The Jerusalem Bible, King James Version of the Bible, New International Version of the Holy Bible, Catholic Bible*). Note the similarities and differences in references to this topic in the various books.

4. Ask several students of nationalities or religions other than yours about the funeral customs in their own countries and religions, and compare them with the funeral customs of your country and religion. How are the customs and rituals different, and how are they the same? What purposes do the customs and rituals serve, and how have these changed over the years?

5. Under what circumstances are religious beliefs and customs a comfort to a dying person? To the loved ones or survivors? Under what circumstances are such beliefs and customs a cause of discomfort or fear to such people?

6. Contrast the Christian, Jewish, and Islamic positions on heaven and hell, the last judgment, and immortality. Besides reading about the differences in various books, ask several Christian, Jewish, and Islamic students about their beliefs concerning these topics.

7. Answer the following questions about your own death:

 a. What kind of funeral will you have?
 b. Who will attend your funeral?
 c. How will your body be disposed of?
 d. Where will your remains be placed?
 e. Who will your survivors be?
 f. What do you think people will say about you when you are dead?
 g. What do you think will happen to your spirit after you have died?

8. Administer the following questionnaire to a variety of students of both sexes and several religions. Compare the answers of (1) females and males, (2) Catholics, Jews, Protestants, members of other religions, and those who have no religious preference:

 a. Do you often think about your own death?
 b. Do you think that your behavior would change in any way if you were absolutely certain that there is no life after death?
 c. Do you have a strong desire to live again after you have died?
 d. Does the question of life after death worry you?
 e. Do you feel that religious practices (i.e., intercession by means of prayer or gifts to the church) by the living can help those who are already dead?
 f. Do you anticipate being reunited with your loved ones in an afterlife?

9. A story is told about a man's wife and mother-in-law who traveled from Philadelphia to Denver, where the mother-in-law died of some ailment or other. The distraught wife telephoned her husband for funeral directions: "Should we embalm, cremate, or bury her?" asked the wife. After some deliberation, the husband replied, "Just to make certain, you'd better have her embalmed, cremated, and buried." According to another story, a young man accompanied his mother to Egypt, where she died. The young man decided to ship his mother's body back to their home in London. After returning to London and opening the casket, he discovered the body of a Russian general who had also died in Egypt at about the same time. A day after informing the Russian embassy about the mixup, the young man received the following telegram from Moscow: "Buried your mother yesterday with full military honors. Do what you like with the general." Do you think that either one of these stories is amusing? Why or why not? Does appreciation of such "mortuary humor" reveal anything about the personality of an individual?

ENDNOTES

1. Although perhaps not as effective as modern techniques, embalming was also practiced in ancient times. For example, as stated in Genesis 50:2: "Then Joseph directed the physicians in his service to embalm his father Israel. So the physicians embalmed him, taking a full forty days, for that was the time required for embalming." The Greek historian Herodotus also wrote of embalming taking place in 484 BC.

2. Contemporary with, and in some instances predating, the Egyptian pyramids were the Sumerian *ziggurats,* temples built in a pyramidal shape as a series of terraces. Despite the notion that the existence of pyramidlike structures in Central America is indirect evidence that Egyptian reed boats must have reached that area in ancient times, not only were the "pyramids" of Central America constructed some 2000 years after the last Egyptian pyramid was completed, but, unlike their predecessors, they are capped with temples.

3. While most cultures have devised ways to discourage the activities of ghosts, on November 1 and 2, the custom in traditional Mexican families is to welcome the spirits of dead loved ones into their homes. Candles are burned in the cemetery, flower petals are sprinkled in a path to the home, and the family stays awake all night waiting for the dead to return. A special altar is built in the home for the "faithful dead" and adorned with the traditional elements of water, sugar cane, incense, salt, chocolate and a special sweet "bread of the dead" (Darling, 1992).

4. Among many modern Jewish funerals, the ritual of rending or tearing one's clothing has been replaced by ripping a black ribbon and attaching it to the clothing.

5. All of the biblical quotations included in the remainder of this chapter are according to the *New International Version of the Holy Bible.*

SUGGESTED READINGS

Aries, P. (1985). *Images of man and death.* (J. Lloyd, Trans.). Cambridge, MA: Harvard University Press.

Badham, P., & Badham, L. (Eds.). (1986). *Death and immortality in the religions of the world.* New York: Paragon House.

Barber, P. (1988). *Vampires, burial, and death: Folklore and reality.* New Haven, CT: Yale University Press.

Finucane, R. C. (1984). *Appearances of the dead: A cultural history of ghosts.* Buffalo, NY: Prometheus Books.

Harris, M. J. (1985). *Raised immortal: Resurrection and immortality in the New Testament.* Grand Rapids, MI: Eerdmans.

Kalish, R. A. (1980). *Death and dying: Views from many cultures.* Farmingdale, NY: Baywood.

Leca, A. P. (1981). *The Egyptian way of death* (pp. 273–290). (L. Asmal, Trans.). Garden City, NY: Doubleday.

Long, J. B. (1975). The death that ends death in Hinduism and Buddhism. In E. Kübler-Ross (Ed.), *Death: The final stage of growth* (pp. 52–72). Englewood Cliffs, NJ: Prentice Hall.

Spencer, A. J. (1982). *Death in ancient Egypt.* New York: Penguin Books.

Toynbee, A. (1984). Various ways in which human beings have sought to reconcile themselves to the fact of death. In E. S. Shneidman (Ed.), *Death: Current perspectives* (3d ed., pp. 73–97). Palo Alto, CA: Mayfield.

6

THE ARTS AND PHILOSOPHY

QUESTIONS ANSWERED IN THIS CHAPTER:

- *What role does the awareness of death play in artistic accomplishments?*
- *What death themes are expressed in the nonverbal and verbal arts, and how has the emphasis on different themes varied with the historical period?*
- *How is the figure of death represented in the nonverbal arts and literature? Why?*
- *What differences between realism and romanticism have been expressed in the verbal and nonverbal arts since ancient times?*
- *What are some of the ways in which the topic of immortality is treated in literature, and how has the treatment varied with the specific culture and historical period?*
- *What are the similarities and differences in attitudes toward death and belief in immortality expressed by the great philosophers?*
- *In what ways have Eastern religious writings influenced the thinking of Western philosophers on the topics of death and immortality?*

Human beings are restless, striving organisms whose activities over the past 5,000 years have altered the shape of this planet. Evidence of these changes, this manipulation of the environment, can be seen almost everywhere. Many factors—economic, political, social, personal—have motivated these human efforts and creations. The awareness of personal impermanence and the associated fear of death are not the least of these. Perhaps for this reason, inventiveness and creativity seem to flourish during war, political upheavals, and other periods of insecurity or strife for a nation.

The realization that their days are numbered and that death may be lurking just around the corner has challenged people since antiquity to make the most of their lives and leave their marks upon the world. The awareness and fear of death also prompted attempts to understand the human condition and to find some meaning in existence. As discussed in Chapter 5, the uniquely human struggle to find purpose and meaning in life contributed to the great religions of the world. Like the arts and philosophy, these theological systems are the products of human discovery and creativity.

Sigmund Freud, the founder of psychoanalysis, believed that many achievements of human culture stem from the operation of the psychological defense mechanism of *sublimation,* the channeling of (sexual) energy into socially acceptable forms. Included among these achievements are the arts, the sciences, philosophy, religion, and even civilization itself. Freud emphasized the central role of sexual energy, *libido,* in all higher-order activities. Interpreted in its broadest sense, *sexual* means *life* or *creative* energy.

As recognized by Freud and other influential thinkers, the creative impulse (*Eros*) is the opposite of the death instinct (*Thanatos*). Death means destruction, and, unless one is convinced of a life after death, the death of an individual implies personal extinction. In any case, creative artists and philosophers have been and still are concerned with death. They have theorized about death; constructed funerary monuments; painted, sculpted, and etched death scenes; composed elegies, requiems, and tales about death; and staged dramas concerned with death and dying. It is interesting to speculate whether many famous artists, composers, and writers would have attained their high levels of creativity and productivity without an awareness of their own mortality (Goodman, 1981). Knowing that their time was limited perhaps served as a stimulus to action, an impetus toward greater exploration and achievement. Thus, it can be argued that an awareness of death prompted them to make something special of their lives, to convert their potentialities into actualities. As a consequence, they were able to reach the end of life with fewer regrets about what they had failed to accomplish. To the creative person, even greater than the fear of death is the fear of living an incomplete life. Such a life seems too short or rapid to do the things the person is capable of doing. This feeling is not unique to artists and philosophers, but rather something they have in common with all people who strive toward self-actualization.

DEATH IN THE NONVERBAL ARTS

The depiction of death in the nonverbal arts (the visual arts and music) is at least as ancient as the Stone Age drawings on cave walls. The themes of death and life after death, for both religious and commemorative purposes, have been represented in painting, sculpture, architecture, and music for thousands of years. Artists have designed memorial monuments, gravestones, coffins, and even cemeteries and death announcements (see Jones, 1967). Mythological beings and their activities

provided the stimuli and content for much of the world's art, inspiring masterpieces in painting, sculpture, music, and poetry. Many works of art also stemmed from religious motives and therefore contain religious themes. In addition, they express the living person's fear of death, the democracy of death, and other secular and moralistic themes. These works range from the sublime to the ridiculous and from the inspirational to the obnoxious, depending on the tastes of the viewer or listener. They also reveal something about the artist and his or her time, especially the fears of annihilation and punishment, the hopes for an afterlife, and the desire to understand and represent the human condition.

Funerary Monuments

Tombs, sarcophagi, and the associated art of sepulchral iconography were discussed briefly in Chapter 5. From the time of ancient Egypt and Greece, down through the Middle Ages, and into the modern era, many of the sculptured scenes on tombs and caskets have been essentially commemorative. They were designed to keep alive the memory of the dead in the minds of the living. In other cases, funerary monuments were constructed to serve magical or religious purposes.

One common scene that appears on funerary monuments, both ancient and medieval, depicts the deceased performing some activity. The deceased is usually represented as in life, healthy and dressed according to his or her social standing. In the *memento mori* ("Remember, you must die") tombs of the late Middle Ages (thirteenth to fifteenth centuries), an effigy of a naked, decaying corpse or skeleton is shown below the figure of the deceased as he or she appeared in life. The purpose of this double image was to illustrate the corruption of death and its egalitarian nature ("Death," 1983).

Among other mementos of the dead are death masks (Figure 5-4), which are plaster casts of molds taken from dead faces. Since ancient times, such masks have served as aids to portrait sculptors and models for sculptors of tomb effigies. Death masks were also used for effigies at royal funerals and kept as mementos of the dead. Some of the best examples of death masks are those of Edward VII, Isaac Newton, Ludwig von Beethoven, Oliver Cromwell, and Napoleon Bonaparte ("Death Masks," 1987).

Themes of Death

Memento mori tombs are only one indicator of the preoccupation or obsession with death that characterized the late Middle Ages. This preoccupation is not surprising, considering that the period from the thirteenth through the fifteenth century in Europe was a time of almost continuous conflict, starvation, and disease—a time in which death and destruction were common sights. It has been estimated, for example, that during a 5-year period during the midfourteenth century, the population of Europe declined by at least 25 percent because of the ravages of the Black Death (bubonic plague). The plague arrived in Europe at a port on the Black Sea in

1347 and continued to ravage the continent periodically until the latter part of the eighteenth century.

Death was everywhere in medieval Europe. Since it was nearly impossible to live the ascetic life that they were taught would merit a heavenly reward, people were threatened with an afterlife in hell that was even worse than the one they were experiencing on earth. Themes and scenes of the Last Judgment and the tortures inflicted on sinners in hell were common in painting and sculpture, especially during the early part of the period. Such scenes exerted a powerful effect on the public fear of eternal damnation and undoubtedly assisted the Church's efforts to dominate human thoughts and actions. Nevertheless, after a thousand years of almost uncontested control over the religious beliefs of Western society, the hold of the Roman Catholic Church in Europe began to weaken during this period.

The Triumph of Death

In addition to the memento mori tombs, the late Middle Ages were a time when the *triumph of death*, the *danse macabre* (dance of death), and the *Ars Moriendi (Art of Dying)* were featured in all the arts. The first of these features is represented in Francesco Traini's 1350 fresco, "The Triumph of Death" (Figure 6-1). The painting shows three young knights on horseback who encounter three coffins containing corpses at progressive stages of decay. A similar theme is depicted in a painting of a beautiful young girl staring at her skeletal reflection in a mirror. These paintings and similar works of art (e.g., "The Tomb of Cardinal Lagrange" in the Musee Calvet, Avignon) dealt with the vanity theme, a theme inspired not only by the bubonic plague epidemic but also by the Hundred Years' War. This intermittent war, in which England lost all its French possessions except Calais, lasted from 1337 to 1453 and resulted in the slaughter of thousands of soldiers and civilians.

The Dance of Death

The *danse macabre*, or dance of death, refers to an allegorical dance in which a group of dead figures leads a procession of living persons, arranged according to their social position in life, to their graves. Many of the followers are high-status members of the nobility or clergy as well as children, clerks, and hermits, demonstrating the democracy of death (Figure 6-2). The message is that no matter how attractive one may be or how high his or her station in life, that person will soon be a rotting corpse. By illustrating the democracy of death—that the proud and humble, rich and poor, good and bad, are all equal in death—the vanity theme of medieval art was interpreted in somewhat secular fashion as implying that one's situation or conduct has no bearing on his or her fate in the afterlife.

The dance of death was first illustrated in a series of early fifteenth-century paintings in France. German versions of the theme, popular only north of the Alps, are seen in sixteenth-century woodcuts and paintings (e.g., Hans Holbein's "Die Totentanz"). Sixteen-century poems (e.g., "La Danz General de la Muerte") and music ("Totentanz") also represent the idea. More recent depictions of the dance of death are Juan Posada's *calaveras*, the Mexican Dance of Death of skeletons engaged in everyday human activities and illustrating the follies of human existence. Another example is Ingmar Bergman's film, "The Seventh Seal."

FIGURE 6-1 **Traini, Francesco, "Triumph of Death." Pisa, Camposanto.
Alinari/Art Resource, NY.**

Ars Moriendi and Carpe Diem

The *Ars Moriendi* is a written treatise, apparently prepared by German monks, that provides details on how to die in a dignified, holy manner. The scenes of devils, fornication, murder, and robbery with which the treatise was illustrated, however, both whetted and satisfied the appetites of people of the time for ghoulish, macabre art. Despite the visibility of death almost everywhere, the artists of the time dwelled on the themes of violence and mortuary putrescence. Popular paintings focused on the "maggotry" of death—the mutilation of corpses, worms crawling through decaying bodies, and ugly bulbous toads squatting on glassy human eyeballs. It was a time of artistic preoccupation with death that has never been equaled. As such, it stands in stark contrast to the beautification, romanticism, and denial of death that characterized later times.

Preoccupation with death during the late Middle Ages was not limited to famous works of art. Death also became a popular art theme depicted on jewelry and in woodcuts, statues, poems, and dramas. In ancient Egypt and Rome, silver

FIGURE 6-2 **"Dance Macabre." Fresco, Church of St. Robert. Death with Youth, Doctor of the Sorbonne, Troubadour, Benedictine, Serf. Photographie Giraudon/Art Resource, NY.**

skeletons and miniature coffins were sometimes given to the guests at feasts to remind them of their mortality and to encourage them to have a good time while they still could (*carpe diem,* or "seize the day"). But such party antics did not reflect the feelings of the mass of people during ancient times and hence were not indicative of a general cult of the dead of the sort that existed in Europe during the Middle Ages (Boase, 1972; Tuchman, 1978).

Similar memento mori and playing-with-death antics are found in certain modern cultures (Box 6-1). In a historical sense, such bravado in the face of death has often been the stuff of which heroes are made. In many cultures, daring or challenging death is socially admired, macho behavior, at least up to a point. However, taking extreme risks (laughing in the face of death, spitting in the eye of the devil) may also be viewed as extremely foolish or irrational.

The Middle Ages were not the only historical period in which death influenced art. Representations of death in the visual arts and poetry were common in early Greece (Vermeule, 1979), and, as in the Middle Ages, these representations were not

BOX 6-1 • The Mexican Way of Death

Poet Octavio Paz writes that Mexicans are seduced by death. They defy it, mock it, play with it, and in some stories they even make love to the figure of death. Not that Mexicans, he adds, are unafraid of death, but they must try to touch it, for in that touch life is given its truest meaning. It's the ultimate act of selfhood, an attempt to transcend life and the solitude of human existence.

To most Americans this may sound cultish, morbid. Here in North America we prefer to elevate life and serenely usher death into tiny boxes that are carried to precisely cut rectangles in the ground. Nothing messy, no residues of what death really is—a few bones, stillness, perhaps an afterlife, perhaps oblivion. Grief should be shortlived, get on with life. Tough it out. I once heard an Englishman say, "dwelling on it only retards health and progress."

These two ways of coping with death—one sprung from Indian-Catholic roots, the other from an Anglo-Protestant past—admittedly are extreme, as I've described them. Most urban dwellers, whoever they are, probably approach death in similar urban ways—with funeral parlors, graveside prayers, consolations. We do what the system allows.

Still, there's one time of the year when the difference between north and south surfaces. In the United States it's Halloween, in Mexico the Dia de los Muertos, or Day of the Dead (actually two days, November 1 and 2).

In this century, Halloween marks but almost never celebrates the eve before All Souls Day, since remembering the dead doesn't seem to mesh well with a night of pumpkin lanterns and giggly, costumed children. The Day of the Dead, on the other hand, is just as festive yet quite different in purpose and expression. Even if Mexicans and by extension Chicanos, don't openly celebrate this holiday, the everpresent display of barrio skulls and skeletons in the form of masks, candies, bread, cookies, and papier mache figures underscores a typically Mexican closeness or familiarity with death. Behind the parades, the laughter, church Masses, and a profusion of cemetery flowers lurks the very real grimace—some say entreaty—of one's own death, not just that of those already buried.

I'll explain. About five years ago my six-year-old son was killed in a stupid freak accident. He was hit by a car that jumped the sidewalk and swept him under its tires, lacerating his liver. A few hours later he died.

The following week Benito, a Mexican friend of mine in Aguascahentes, Mexico, sent my family some toy plaster skulls. He hadn't known of my youngest son's death. The gifts, all with our names boldly written across each bony forehead, were a mischievous—you might say affectionate—reminder of our mutual humanity, our own common mortality. Benito meant nothing morbid. I told myself, it's a Mexican custom. The toys were simply folk products of a city known throughout Mexico for its enthusiastic celebration of the Day of the Dead. He even sent them in March in a show of his year-round playfulness. Aguascahentes, by the way, was the home of Jose Guadalupe Posada, a turn-of-the-century caricaturist whose skulls and skeletons (calaveras) later influenced the paintings of such muralists as Diego Rivera and David Alfaro Siqueiros.

At the time, I shrugged off the grim coincidence of Benito's gifts and my son's death. Yet, strangely, we kept those skulls around the house and in view. They weren't obvious, but they were there. My other son and I even fiddled with the string that pulled the flapping jaw up and down. We never talked about it, but I'm sure my wife—from a Jewish family but quite familiar with everything Mexican—understood what was really at play with these reminders that Benito had innocently sent us. Looking back, I see them now as embodiments of a presence that came crashing into our lives, stealing our will to live in the present yet shor-

Continued

BOX 6-1 *continued*

ing us up for the future. Paradoxically, Benito's lighthearted gesture—along with the embrace of almost everyone else we knew—helped us through the worst of times.

No, I don't celebrate the Day of the Dead in the Mexican way. A second generation Chicano, I was raised literally and figuratively between Glendale's predominantly Anglo Forest Lawn and East Los Angeles' mostly Mexican (at least in recent years) Evergreen Cemetery. Thus, I had two choices for coping with death, and I chose neither. Instead, like so many urban Chicanos, I've worked out a blend of two traditions, two emotions. My behavior isn't entirely Mexican, yet I haven't completely entered the controlled mechanistic world of Anglo answers to grief, fear, and the unknown.

An Aztec poem says the following:

Must I go like the flowers that die?
Won't anything be left of my name,
Nothing of my life here on Earth?
At least flowers
At least songs.

It's an ambivalent view of death, one certainly not endorsed by the friars who converted the Aztecs, at least nominally, to a belief in immortality. But this very ambivalence is what most often is misunderstood by those outside the Mexican culture, and it is what Octavio Paz and others try to explain. We may believe in an afterlife, we may even be good Catholics, yet an uneasiness toward death persists. So why not celebrate it, play with it, mock it, challenge it? Outsiders may call it fatalism, bravado. But for Mexicans and many Chicanos this careless defiance, when carried to an extreme, is a matter of affirmation, even ecstasy.

An Anglo friend of mine recently witnessed a scene that shocked and puzzled him. In a California bar patronized mostly by Mexi-

can farm workers, a group of men were gathered around a table covered with broken glass. Two of the men, one at a time, were competing in a bloody contest to see which man could smash down more empty bottles than the other. The bottles were gripped by the throat, pointed upward and brought down hard, resulting in quite a few glass-skewered palms and fingers. The men, of course, had drunk much and my Anglo friend was told that this was the kind of contest that frequently took place in some parts of Mexico. These men were just having a go at it here.

I explained to my head-shaking friend what I knew and felt of Mexican death, of defiance, of a damn-it-all approach to life, of moments of truth and selfhood. All academic, he couldn't quite grasp its meaning—perhaps something to do with sacrifice—any more than many of us can fathom what occurs in the minds of gang members when bullets and knives shatter a closed-in desperation.

Myself, I prefer a milder approach to death. It's part practical American, part Mexican grandmother, my own. She was realistic and, it seemed to me, amused to the end. About 80 years old and dying, she could clown about her wasted appearance, her toothless mouth, her skeletal hands. Not long before she died she motioned for me to come close to her bed. At the time, I was young, impatient. Life was all. Shakily, she touched my hand, winked one glaucous eye and said: "Asi como me ves, te veras"—as you see me now, so you will see yourself.

Even today, years later, her words won't leave me. They are stronger, far more insistent than Benito's toy skulls. In this sense I am familiar with death. At times, I joke about it, and luckily I have not yet needed to defy death. There is no desperation in my voice, so I can now whisper—but warily—that I don't intend to be seduced.

Source: "The Mexican Way of Death: Celebrate It, Play with It, Challenge It" by Ron Arias, November 2, 1981, *Los Angeles Times*, p. II–7. Reprinted by permission of Ron Arias.

merely symbolic. Early Greek art depicts the dead undergoing horrifying physical tortures in the underworld, the rape and slaughter of humans and deities, and the mutilation of heroes in battle. Nevertheless, the general atmosphere in early Greek art is heroic rather than necrophilic. The theme of human fortitude and competence in the face of mortality, which was characteristic of early Greek art, became fashionable again during the Renaissance period (sixteenth and seventeenth centuries). New geographical and scientific discoveries led people to believe that they could prevail against nature, an optimism reflected in all art forms.

The theme of death appears extensively in the nonverbal arts, albeit often in romanticized form, down through the nineteenth century. Unlike their counterparts in previous centuries, twentieth-century painters have dealt with the subject of death rather sparingly. This is a reversal of the popularity of the theme during the Middle Ages, which has in common with the twentieth century the slaughter of millions of people. Even when twentieth-century painters deal with the subject of death, unlike the reality of the nineteenth century, it is typically indirect or symbolic (Gottlieb, 1959). An exception is the art of the Norwegian painter and graphic artist Edvard Munch. Munch's mother and sister died of tuberculosis and another sister became mentally ill. Throughout his life, Munch was preoccupied with the specter of death and terminal illness. It was a principal theme of his work, best illustrated in the paintings "The Sick Child," "The Death Chamber," "By the Death Bed," and "The Dead Mother."

Representations of Death and Immortality

From the Bronze Age to the Atomic Age, death has been personified and symbolized artistically in a variety of ways. The most widely known personifications are the Angel of Death, the Rider on a Pale Horse, the Grim Reaper, and the Twin Brother of Sleep. Death may be a skeleton, a mummy, a shrunken body, or an old man or woman. It may be naked, covered with a white or black shroud, or dressed in some other distinctive attire. It may be standing menacingly, riding a horse, or lying in a coffin, often grinning or leering. It may be carrying a scythe, a sword, a dart, bow and arrows, or some other weapon to deliver the mortal stroke that severs a human life.

Death has also been represented symbolically, usually by obvious symbols such as coffins, cemeteries, amputated limbs, deathbeds, skulls, and bones. One of the earliest representations, which was found in a Neolithic settlement located in modern Turkey, shows gigantic black, vulture-like birds attacking headless human corpses (Cavendish, 1970). Other easily understood symbols for death are an inverted torch and a clock set at the hour of death, 12 P.M.–1 A.M. The association of death with time also occurs in Holbein's painting "Totentanz," in which death is depicted as a skeletal figure with an hourglass. In another painting, Albrecht Dürer's "The Knight, Death, and the Devil," the figure of Father Time carries a scythe. Other common symbols of death are environmental scenes such as winter landscapes, ruins, leafless trees, trees struck by lightning, dead birds, and vultures (Gottlieb, 1959). Today's motion pictures frequently contain grey skies, rain, and

thunder in graveyard or burial scenes to make them appear more ominous or frightening.

Birds and certain insects (butterflies, beetles) have been employed since ancient Egyptian and Greek times to represent the soul and immortality. To the ancient Egyptians the butterfly and beetle (scarab) symbolized the soul (Ka) and immortality (resurrection). Birds were often used to represent the soul, the soul bird being a common artistic symbol from early Greek art. Reptiles that shed their skins, and thereby are assumed to be immortal, are symbols of immortality in certain primitive cultures. The Judeo-Christian tradition, of course, views snakes as symbolic of evil rather than immortality. Another lower animal, the fish, was a symbol of Christianity. Presumably the symbol was derived from the Greek letters for Christ, which somewhat resemble a fish; it is also associated with Christ's injunction that the apostles be "fishers of men." The cross, however, is the most time-honored symbol of the Christian religion and resurrection, just as the crescent moon is a symbol for Islam.

As represented in the visual arts, the figure of death is usually masculine. Some famous works of art and the death symbols incorporated in them are Francesco Traini's "Triumph of Death" (corpses); Hans Baldung Grien's "Three Ages of Woman and Death" (skeletal figure with hourglass); Albrecht Dürer's "Apocalypse" (Figure 6-3) and "Knight, Death, and the Devil" (rider on a pale horse); Marc Chagall's "Gate to the Cemetery" (cemetery); Albert Ryder's "Death Bird" (dead bird); Pablo Picasso's "Vanities with Skulls" (human skulls) and "Woman Kissing a Crow" (crow); and Salvador Dali's "Persistence of Memory" (broken watches) (Gottlieb, 1959).

Music

Music has a peculiar ability to strike the emotional chords connected to death and dying and to make life and death seem meaningful. Classical music has incorporated the vanity theme, the dance of death (e.g., Liszt's "Totentanz" and Saint-Saens's "Danse Macabre"), and other symbols of mortality. Grand opera and ballet are also replete with deadly themes of murder, suicide, and other forms of death.

As with funerary monuments, the role of music in death has been closely associated with religion throughout human history. The masses of Johann Sebastian Bach, several of George Frideric Handel's oratorios, requiem masses or masses for the dead (such as those by Berlioz, Mozart, and Verdi), the hymns of Charles Wesley, and many other musical compositions are sacred in nature. Thousands of chants, dirges, elegies, and songs were composed to express sorrow, longing, and love for the dead. The "Dies Irae" ("Day of Wrath") section of the requiem mass has become a symbol for death. Funeral music is common throughout the world, assuming different forms in different cultures. For example, many American Gospel songs (e.g., "If I Could Hear My Mother Pray Again," "Precious Memories," "Oh, Mary Don't You Weep," "When the Saints Go Marching In") contain themes of death such as loss, mourning, and afterlife. Many country/western and folk songs ("The Wreck of the Old 97," "John Henry," "Where Have All the Flowers Gone") are

FIGURE 6-3 **The Four Horsemen of the Apocalypse: Pestilence, War, Famine, and Death**
From "Apocalypse," by Albrecht Dürer, 1498 (Bettmann Archive)

based on death caused by illness, accident, murder, or suicide. These themes also permeate rock music, as in Elton John's "Candle in the Wind" and James Taylor's "Fire and Rain."

DEATH IN THE VERBAL ARTS

Beginning with the oldest known poem, the *Epic of Gilgamesh*, death has been an enduring topic in literature throughout human history. Transcending both time and place, poems, stories, essays, and other written compositions on death and dying

are exceeded in popularity only by works concerned with romance and love. The themes of love and death are universal; they appeal to the emotions of readers of all ages and in various circumstances. Both themes transport the reader through the entire gamut of human emotions, from ecstasy to despair. They have also inspired the noblest and vilest of human actions, ranging from heroism to cowardice, from generosity to greed, and from altruism to narcissism. In many enduring favorites, such as the story of Romeo and Juliet, the themes of love and death are blended into a single romantic tale.

Mythological Origins

Mythology has served as a source of inspiration for much of the world's great art and literature. The *Epic of Gilgamesh*, which has been preserved since ancient Babylonian times (circa 2000 BC) but was rewritten during the first millennium BC, deals with the activities of mythological beings, both human and divine. The hero of the epic, Gilgamesh, is initially an oppressive Sumerian king. The gods create a wild man, Enkidu, to challenge Gilgamesh in battle, but the two men become friends and share many adventures. After Enkidu dies, Gilgamesh, obsessed by the death of his friend, begins searching for the secrets of knowledge and immortality. Gilgamesh is successful in obtaining a branch of the tree of knowledge and another branch from the tree of immortality. Unfortunately, he drops the second branch while crossing a river, and a water snake eats it. In another version of the story, Gilgamesh leaves his clothes and the immortality plant on the shore of a lake and goes swimming. While he is swimming, a snake, smelling the plant, comes out of a hole and eats it. Both versions of the story end with humankind gaining knowledge but losing immortality. Similarities between this story and the biblical tale of Adam and Eve in the Garden of Eden are obvious. Furthermore, there is a great flood in the *Epic of Gilgamesh*, like the one experienced by the biblical Noah (Kramer, 1989; Weir, 1980).

Many cultural groups have believed that people were meant to be immortal and that death is an unnatural intruder. Although several cultures have incorporated the forbidden-fruit theme in their explanations of how death came to humanity, several other themes are also common. According to one type of myth, death arrived as the result of a mistake—a garbled or wrongly delivered message, a punishment for human disobedience, ingratitude, or just plain stupidity. An illustration from Africa is the myth that God sent the chameleon to tell humans that they were immortal, but the chameleon dawdled along the way and the lizard—the messenger of death—arrived first (Cavendish, 1970). Another mythical explanation views death as the outcome of a debate or contest between divine beings or the first humans. The moon theme and the banana as the image of immortality are prevalent in the Pacific Islands. Other explanations include the overpopulation theme, the equitable-distribution-of-property theme, and the theme of anger, jealousy, or other strong emotions expressed by gods and men (Corcos & Krupka, 1984).

The molting animal theme maintains that humans once had the power to shed their skins (*ecdysis*) and thereby rejuvenate themselves, but for some reason the gods decided to take away this power. Variations of this theme occur in several Pacific

Island cultures. Primitive people, who undoubtedly observed snakes shedding their skins and seemingly rejuvenating themselves in this manner, presumably came to the conclusion that people originally had the same ability. One myth that includes both the mistake and skin-shedding themes comes from Africa. According to this myth, God sent a serpent to deliver the message to human beings that all they had to do to be young again was to shed their skins. The serpent repeated the message to a bird, but the bird failed to deliver the correct message. In similar myths, insects or other animals are told to inform people of their immortality, but the messengers go astray or the messages are garbled in some way. In another skin-changing story, a child sees its mother changing her skin. According to a different version, the mother either dies immediately or climbs back into her old skin when the child cries, thus losing the opportunity for immortality.

As seen in the Old Testament story of Adam and Eve, death may be viewed as a punishment for human transgression. Many cultures have myths of this type, in which women most often figure as the transgressors or culprits. According to an Australian aborigine myth, a tribe was forbidden by God to steal honey from a beehive located in a certain tree. The men obeyed God, but the women approached the tree and one hit it with an ax; out flew the bat of death!

A woman is also the culprit in a Blackfoot Indian myth of death as the result of an argument and a trick, a myth that also contains the overpopulation theme. According to this story, there was a debate between the first old man and the first old woman. The man wanted people to live forever, but the woman argued that this would result in more people than the world could hold. They agreed to settle their dispute by a game of chance. If a piece of buffalo meat thrown into the water floated, then humans would be immortal. However, the old woman used her magical powers to change the meat into a stone, which, of course, sank. This outcome of the game condemned humanity to mortality (Cavendish, 1970).

Tales such as these formed the bases of oral stories, and ultimately literature, in ancient cultures. Explanatory myths concerned with the origin of death and the destination of the dead, for example, were the sources of much ancient Greek poetry and art (Vermeule, 1979). As seen in the poetry and sculpture of Greece during the Bronze Age, memories and tales of dead ancestors and heroes had a significant influence on early Greek civilization. It would be incorrect to characterize these effects as a cult of the dead, but the dead were revered and featured extensively in stories and poems. The resulting classical literature not only reflected death but also helped determine Greek interest in it. For example, the scenes of the underworld (land of the dead) and its tortures described in Homer's *Odyssey* undoubtedly had a profound effect on the attitudes and behavior of the ancient Greeks.

Personifications of Death in Literature

Death in ancient Egypt was occasionally represented as a jackal-headed god named Anubis. Homer used another animal—the mythological winged Harpy—to depict death in the *Iliad*. The jackal and other animals with pointed ears, horns, long

snouts, and splayed tails also represented evil, and death sometimes combined with evil in the same form.

A connection between death and the Devil is seen in the mythological descent of Christ into hell; death is often depicted as a skeletal figure prostrate beneath the victorious Christ (Cavendish, 1970). The literature of certain cultures describes death as a monster with multiple heads and hands, a villain who uses a built-in flamethrower or other weapon to attack humans. Ancient Mesopotamians called this monstrous death god Uggae, perhaps an appropriate name! As in the nonverbal arts, personifications of death in the ancient literature of both the Occident and the Orient include a humanlike entity dressed in black or red and carrying a scythe, spear, rope, timepiece, and so on. Later Greek mythology depicted death as a winged youth with a sword, and the literature of the Vedic period of Hinduism (1500–450 BC) describes death as Yama, the first man. A Hindu poem of a somewhat later period, the *Mahabharata*, characterizes death as a beautiful, dark-eyed woman, Mara (or Mrtya). According to the poem, Mara came from within Brahma, creator of the world, who ordered her to kill all the world's creatures. Because the god Shiva interceded, the deaths were not permanent; the slain individuals were reincarnated as other forms of life. Another deathlike figure in Hindu literature is the goddess Kali, the consort of Shiva, a black person with three eyes and four arms who gorges herself on the blood of her victims.

Ancient Persian literature associates death with time, so the god of time, Zurvan, is also the god of death. Islam, the major religion of modern Persia (i.e., Iran) and the entire Arab world, holds that an artist who paints or forms something lifelike is trespassing on the divine right of Allah (Ettinghausen, 1983). Therefore, although the Koran refers to an Angel of Death, Islam strictly forbids depicting death as a person in painting or sculpture.

In Hebrew literature, death is an angel known as Sammael (the drug of God). In the New Testament, death is described as the "last enemy that shall be destroyed" (1 Corinthians: 15) and as riding on one of the baleful horses (Revelations: 6).

Death has been personified in modern Western drama and literature as a pale-faced man in a long, black cloak (Ingmar Bergman's "The Seventh Seal"), a hunter who stalks human beings (Carlos Casteneda's *Journey to Ixtlan*), and as a blundering fool dressed in a black-hooded cape and skin-tight black clothes who is challenged by his victim to a game of gin rummy (Woody Allen's "Death Knocks") (Weir, 1980).

The Inevitability and Universality of Death

Many death themes and scenes have appeared in literature, including the inevitability of death, the universality of death, the fear and love of death, murder and suicide, romanticized death, deathbed scenes, bereavement, and immortality. Interestingly enough, people in many primitive cultures appear to be unaware of the naturalness and inevitability of death. Living in a culture in which people usually die of accidents or diseases rather than old age, it is understandable how death could come to be viewed as an unnatural consequence of something gone wrong.

Even in more developed cultures, there is a pronounced tendency to act as if death were not inevitable—at least not for "me"—until something happens to disturb one's feeling of invulnerability.

Although writers have been tempted by the human tendency to deny the inevitability of death, many playwrights, poets, and novelists have succeeded in directing the reader's attention to the fact that death comes to everyone (see Stewart, 1984; Weir, 1980). Realization of the certainty of death is seen in Jean-Paul Sartre's *The Wall* and *The Victors,* and the famous verse from Thomas Gray's "Elegy Written in a Country Churchyard":

> *The boast of heraldry, the pomp of power,*
> > *And all that beauty, all that wealth e'er gave,*
> *Awaits alike the inevitable hour.*
> > *The paths of glory lead but to the grave.*

Acceptance of death's inevitability can be a disturbing or at least sobering experience and a source of great anxiety, but it can also be a source of strength and motivation to make the most of time.

Realism and Romanticism

Historically, the fear induced by the realization of death has been handled in various ways, for example, by reveling in or laughing at death, by romanticizing it, and by denying or suppressing thoughts of it. None of these responses is completely successful, but each has been emphasized in the art and literature of different periods. As in the nonverbal arts, emphasis on the physical aspects of death—blood, decaying fish, worms, and other "realistic" images—was a preoccupation in the literature of the Middle Ages. The memento mori, the dance of death, and interest in the maggotry of death can be interpreted as a kind of anxiety extinction process: By absorbing oneself in the paraphernalia of death, one gradually becomes less terrified of it. Such wallowing in death is exemplified by illustrations from the *Ars Moriendi* treatise of the late Middle Ages—emotional deathbed scenes, grave diggers uprooting bones, and vicious black devils fighting with angels over the naked corpse or soul of the deceased. Other literary indicators of this cult of the dead are scenes in plays and mysteries in which, for example, Christ's body is viciously hacked by Roman soldiers, a mother roasts and eats her own child, or a woman's belly is sliced open so an emperor can see the place where children are conceived. Besides the maggotry and decomposition of death, an erotic-morbid theme in which the ecstasy of orgasm combines with the agony of death occurs in some of the poetry of the time (Tuchman, 1978).

Tuchman (1978) argues that anxiety over the expected end of the world contributed to the cult of the dead during the Middle Ages. A belief in the approach of Judgment Day was prompted not only by the massive number of deaths caused by war, disease, and famine during the fourteenth and fifteenth centuries but also by a widespread feeling that sin was becoming rampant and the human soul was aging.

The maggotry of death, of course, was not unknown in other historical periods. This maggotry theme was still very much in evidence in the nineteenth century, as seen in Edgar Allan Poe's poem "The Conqueror Worm":

> *It writhes!—it writhes!—with mortal pangs*
> *The mimes become its food,*
> *And the seraphs sob at vermin fangs*
> *In human gore imbued.*

For the most part, however, eighteenth- and nineteenth-century literature expressed a hatred for the ugly, violent death and a preference for the beautiful, tame death. The great romances of the Middle Ages (*Chanson de Roland, Le Morte d'Arthur, Tristran and Iseult*) emphasized the acceptance of death and the proper way to die. But the romantic poets of the eighteenth and nineteenth centuries pictured death as a bittersweet or even an attractive destiny, and occasionally expressed a desire for it (Simpson, 1977). The romantic view of death seen in poems by William Wordsworth, Stéphane Mallarmé, Lord Byron, Percy Bysshe Shelley, and the younger Johann Wolfgang von Goethe is also a kind of denial of mortality: The poet will be reunited with his lady love in the hereafter.

Denial of death was difficult to maintain in real life. The poet Goethe, for example, was quite anxious about death, and he avoided deathbeds, funerals, and any contact with death whenever possible (Simpson, 1977). Fear of death during the eighteenth and nineteenth centuries was also associated with the fear of premature burial, as seen in many stories of the time. Aries (1981) describes the "shelters of doubtful life," or funeral parlors, in nineteenth-century Germany. Bells were attached to the extremities of the deceased, who was kept for several days until there was no possibility of reanimation. A similar practice is described in Crichton's (1975) story *The Great Train Robbery*. Coffins were equipped with bells on the outside and pull-chains on the inside; the chain could be pulled and the bell rung by the supposedly deceased person if he or she revived in the coffin.

Death scenes have figured prominently in both ancient and modern literature (e.g., *Epic of Gilgamesh*, Erich Segal's *Love Story*) and in many different cultures (e.g., *Dream of the Red Chamber* in Chinese literature). Especially popular in literature during the Romantic era of the eighteenth century were scenes of the death of a beautiful young woman, a child, a wife, or other loved one, and the resulting grief that stressed the sweet sadness and poetic nature of the attractive death. The film critic Roger Ebert has labeled the beautiful death as the "Ali McGraw Disease" (from the film adaptation of *Love Story*), in which the heroine becomes progressively more beautiful while dying, until, at the moment of death, she is absolutely breathtaking.

Deathbed scenes, elegies, and the topic of death went out of fashion in Anglo-American culture during the twentieth century. Whereas sex was an unmentionable topic in polite Victorian society (later nineteenth century), when a request for a chicken "leg" or "breast" was considered embarrassing, death scenes were popular set pieces. In contrast, sex has become a more popular subject in the twentieth

century, and death themes have been muted in art, literature, and drama. The ugly facts of death were disguised and cosmetized during the early part of this century: People "passed on" rather than died and were "laid to rest" in lovely gardens rather than being buried (Gorer, 1980).

Despite the tendency to deny or at least avoid the subject of death in the twentieth century, it has proven impossible in a time of millions of victims of war and genocide. Whatever theme of romanticism remained in poetry written during the early part of World War I, for example, was extinguished by the reality of wholesale human slaughter in the trenches of France. The time-honored belief that it is gallant and noble to die for one's country and the associated chivalrous images of warrior knights battling for honor, country, and ladies fair gave way to the anger, bitterness, and sorrow of soldier-poets such as Robert Graves and Wilfred Owen:

> *If you could hear, at every jolt, the blood*
> *Come gurgling from the froth-corrupted lungs*
> *Bitter as the cud*
> *Of vile, incurable sores on innocent tongues—*
> *My friend, you would not tell with such high zest*
> *To children ardent for some desperate glory,*
> *The old lie:* Dulce et decorum est
> Pro patria mori.[1]

The realism in literature stimulated by the events of World War I persisted in twentieth-century poetry with modifications. Many poets, especially those of the Confessional School (Robert Lowell, Sylvia Plath, Anne Sexton), revealed a fascination with death and especially suicide. Much of their poetry is autobiographical and self-centered, occasionally bordering on the pathological. Theirs is a subjective art form that describes universal truths in terms of the poet's own experiences and expresses little social conscience or concern for other people. This is especially true of the poems of Plath and Sexton, both of whom committed suicide (Simpson, 1977).

Immortality

Some people end their lives voluntarily, but a much larger number desire to live forever. Both the religious and secular literature of Eastern and Western cultures have developed the theme of immortality. As mentioned previously, the earliest written story concerned with immortality was the *Epic of Gilgamesh*. The associated doctrine of the soul (Ka) also appeared in writing in the Egyptian Book of the Dead at about the same time (circa 2000–1800 BC). However, Plato's philosophical writings on the soul (*psyche*) exerted a greater influence on Western religion and literature. The dualistic position proposed in Plato's dialogues describes the body as material and ending at death, but the soul as immaterial and everlasting. Although Epicurus and certain other philosophers and writers in ancient Greece and Rome questioned Plato's dualistic doctrine, it has remained an important distinction in Western philosophy, science, and everyday discourse. However, the notion that the

biblical Paul taught a Platonist dualism between body and soul is incorrect. In 1 Corinthians: 14, the resurrection of *the body* is stressed—a changed body, but a body nonetheless. Many Christians subsequently subscribed to Plato's body-versus-soul distinction, but in so doing they were more Platonic than Christian.

The Jewish tradition regarding immortality, as expressed in the second book of Samuel in the Old Testament, is different from that of the Greeks. To the ancient Jews, who perceived death as a "draining away of the body's aliveness," the afterlife kingdom of She'ol was only a land of shadows. But the dominant Jewish viewpoint on immortality changed over the centuries. During the first century AD, after the destruction of the temple of Jerusalem, the orthodox belief shifted from one of collective, or social, immortality to that of personal immortality.

Hindus and Buddhists have no single sacred text such as the Bible that explains the nature of their beliefs in reincarnation. Ancient Hindu scriptures are contained in the *Vedas*, at least one part of which—the *Upanishads* (Mascaro, 1965)—has influenced the thinking of many Western philosophers and writers. The Hindu idea of reincarnation is best explained in the sacred writings known as the *Puranas*. Two other sacred writings in Hinduism, the *Ramayana* and the *Mahabharata*, are long epics containing mythical stories and philosophical principles. Unlike Christianity and Hinduism, one theory in Buddhism is the "nonsoul doctrine" that at death both the mind and the body disintegrate. Only a "stream of life" or character disposition, not a permanent soul, remains to be reborn in another living being. The stream of life continues until *nirvana*, a state of eternal bliss and oneness with the cosmos, is attained (Weir, 1980). One Buddhist treatise, the Tibetan *Book of the Dead (Bar Thedol)*, provides minute details on the state of consciousness that exists between death and reincarnation.

In the West, epic stories such as Homer's *Odyssey*, Virgil's *Aeneid*, and Dante's *Divine Comedy* expressed and helped determine conceptions of immortality and the afterlife. On the more modern scene, a belief in immortality is expressed in Johann Wolfgang von Goethe's *Faust*, Alfred Lord Tennyson's "Crossing the Bar," Robert Browning's "Prospice," Miguel de Unamuno's fiction, Federico Garcia Lorca's dramas, and many other poems, stories, and plays. Perceptions of life after death are provided in D. H. Lawrence's "Ship of Death," Thornton Wilder's "Our Town," and Amos Tutuola's "The Palm-Wine Drunkard" (see Weir, 1980, Chapter 10 for further details and illustrative selections).

Many Western poets have revealed a conflict over the notion of personal immortality in their works. Although they are not completely confident of a life after death, hope remains, particularly among those who have been deeply frustrated in their own lives. Certain poets stress the attainment of biological immortality through one's descendants. Others, in a manner reminiscent of early Judaism, write of social immortality through the enduring influence of one's work or the memory of one's life and personality in the minds of the living. Still others appear to be content with a more nature-centered conception of immortality through the survival of the basic elements comprising the body (Simpson, 1977).

DEATH IN PHILOSOPHY

Philosophy, which literally means "love of wisdom," originally encompassed all fields of human intellectual endeavor. *Natural philosophy* included the natural sciences, *mental philosophy* dealt with psychological topics, and *moral philosophy* was concerned with ethics and religion. During the Renaissance and the Industrial Revolution, many specialized areas of knowledge separated from the parent discipline of philosophy and formed their own fields of study (physics, biology, psychology, etc.). However, the academic discipline of philosophy remains interested in questions about the nature of reality (*metaphysics*), the basis of human knowledge (*epistemology*), the principles of right and wrong conduct (*ethics*), the laws of valid inference (*logic*), and the nature of beauty and aesthetic judgments (*aesthetics*).

Philosophy is similar to literature because it is a creative field, and the results of philosophical analysis are usually recorded in written form. Furthermore, many creative writers are, like philosophers, careful observers and thinkers who desire to understand and explain some phenomenon of nature or human action. Literary writers, however, focus more than philosophers on entertaining or at least interesting their readers in what they have to say. In addition, poets, novelists, and other creative writers are usually less concerned than philosophers with the logic and reality of their works. Creative writers concentrate as much on the form as on the substance of a written composition.

Philosophical Interest in Death

Whereas literary writers in all countries and cultural periods have shown continuing interest in death and afterlife, philosophers have often appeared uninterested in these topics. There was no lack of interest in death among the philosophers of ancient Greece and Rome, but philosophical writings concerned with these matters declined after the fall of the Roman Empire. It may be argued that European philosophers of the Middle Ages assumed that questions concerning mortality and immortality had been answered by Christianity and consequently were the province of religion rather than philosophy (see Bardis, 1981; Choron, 1963). Of course, this argument assumes that Christian thinkers such as Augustine, Thomas Aquinas, Ignatius Loyola, John Calvin, and Hugo Grotius were only "theologians" and not "philosophers." Such an assumption perhaps betrays a secularistic bias that only persons who articulate secularly rooted systems of belief are true philosophers.

Be that as it may, even during the Renaissance period, when the power of the Church began to wane, philosophers continued to devote little formal thought to death. Certain famous philosophical thinkers, such as Benedict de Spinoza, included almost nothing on the topic in their formal writings. Spinoza disposed of the subject of death in one sentence: "A free man thinks of nothing less than of death, and his wisdom is not a meditation upon death but upon life" (Elwes, 1951, p. 203). Not until the nineteenth century was death once again viewed as a suitable subject

for philosophical analysis. Arthur Schopenhauer was the first famous philosopher in modern times to pay serious attention to death in his writings. These writings provided a background for the thoughts and writings of late nineteenth- and early twentieth-century existentialists (Bardis, 1981).

Professional philosophers, or anyone interested in philosophy, might wish to ponder the following questions about death:

1. How does the fear of death originate? Should it be conquered and, if so, how?
2. Does death imply permanent extinction, or does something of the individual survive in an afterlife? If something does survive, what is it and what is the nature of the afterlife?
3. Does God exist? If so, how do human beings become aware of God, and why should He care about humanity?
4. How should one live life, knowing that death is certain to occur sooner or later?
5. Under what circumstances, if any, is taking one's own life or the life of another person justifiable and acceptable?

Some of these questions are metaphysical, some are epistemological, and still others are moral in nature. Consequently, the search for answers involves several philosophical (and nonphilosophical) fields.

Although philosophers as a whole have not shown an overwhelming interest in death, many have expressed something of their attitudes toward the topic in their writings. Table 6-1 provides very brief descriptions of the attitudes toward death espoused by the most famous philosophers. Table 6-2 summarizes the attitudes of selected philosophers toward suicide, a topic that one philosopher/novelist, Albert Camus, described as "the one truly serious philosophical problem."

Greek and Roman Philosophers

Philosophers in ancient Greece who had something to say about death included Pythagoras, Socrates, Plato, Aristotle, Epicurus, and Zeno. Plato (427–347 BC), who believed in a life after death and lived to the ripe old age of 80, expressed his optimistic attitude in the *Phaedo*:

> *He who has lived as a true philosopher has reason to be of good cheer when he is about to die, and . . . after death he may hope to receive the greatest good in the other world. . . . For I deem that the true discipline of philosophy . . . is ever pursuing death and dying; and if this is true, why, having had the desire of death all his life long, should he repine at the arrival of that which he has been always pursing and desiring?*

Despite an interest in death, the ancient Greek artists, poets, and philosophers believed in enjoying life while it lasted, although not necessarily in a blatant, exhibitionistic manner. This was specifically the philosophy of Epicurus (342?–270 BC), who held that "the external world is a series of fortuitous combinations of

TABLE 6-1 Philosophers' Attitudes Toward Death

Socrates (469–399 BC): Death may be better than life, and the true philosopher is cheerful in the face of it.

Plato (427–347 BC): Death is the release of the soul from the body.

Aristotle (384–322 BC): A brave man is one who is fearless in the face of a noble death.

Epicurus (341–270 BC): Death is personal extinction but it should not be feared.

Zeno of Cyprus (335–263 BC): We should never oppose unavoidable evils, including death.

Lucius A. Seneca (4 BC–65 AD): The best way to diminish the fear of death is by thinking about it constantly.

Leonardo da Vinci (1452–1519): Just as a happy day ends in a happy sleep, so a happy life ends in a happy death.

Michel de Montaigne (1533–1592): One learns how to die properly by living properly.

Benedict de Spinoza (1632–1677): A free man meditates on life rather than death.

George W. F. Hegel (1770–1831): Death is the reconciliation of the spirit with itself, a reuniting of the individual with cosmic matter.

Arthur Schopenhauer (1788–1860): Death is the true aim of life and the muse of philosophy.

Ludwig A. Feuerbach (1804–1872): Life must be lived fully in spite of death.

Bertrand A. Russell (1872–1970): When I die, I shall rot and nothing of my ego will survive.

Martin Heidegger (1889–1976): A person's life becomes more purposeful when he faces his own death.

Jean-Paul Sartre (1905–1980): Constant awareness of death intensifies the sense of life.

Source: From *Death and Western Thought* by J. Choron (I. Barea, trans.), 1963, New York: Macmillan; and *History of Thanatology* by P. D. Bardis, 1981, Washington, DC: University Press of America.

atoms and that the highest good is pleasure, interpreted as freedom from disturbance or pain" (Flexner, 1987). Epicurus was the first Western philosopher to conclude that death means personal extinction (see Table 6-1). Unlike his more famous predecessors Socrates, Plato, and Aristotle, Epicurus did not believe in a soul—a position also adopted over two centuries later by the Roman philosopher-poet Titus Lucretius Carus (Toynbee, 1980).

Both the Epicurean and Stoic philosophers were interested in how the fear of death can be overcome. Epicurus proclaimed that this "most terrifying of all ills is nothing to us, since as long as we exist, death is not with us, but when death comes, then we do not exist" (Oates, 1940, p. 31). He taught that freedom from the fear of death can be attained by seeking moderate pleasures, especially the pleasures of friendship, and avoiding pain. However, the philosophy of hedonism, "eat, drink, and be merry, for tomorrow we die," was not precisely what Epicurus had in mind and is wrongly attributed to him. The Epicureans, like the Stoics, preached and practiced moderation in all things and did not approve of the notion that one should have fun at all costs (Pardi, 1977). Certainly the drabness with which the afterlife was depicted by the ancient Greeks and Romans made hedonism and the idea of *carpe diem* ("seize the day") attractive, but this notion is not attributable to Epicurus.

TABLE 6-2 Philosophers' Attitudes Toward Suicide

According to Jacques Choron (1984, p. 342), "Philosophers have been instrumental in bringing about the permissive and tolerant view of suicide that generally prevails today. Thanks to them, no one seriously challenges the individual's right to dispose of his life as he sees fit, society does not enforce the penalties which may still be on the books, and even religious sanctions are often waived under some pretext or other." As seen in the following statements, philosophers have differed in their attitudes toward suicide; some have been opposed and others sympathetic. A number of famous philosophers have also ended their own lives, albeit under external compulsion in certain cases (e.g., Socrates, Lucretius, Zeno, Seneca).

Plato—Committing suicide contradicts God's will and, in so doing, forfeits one's chance for a pleasant afterlife. Thus suicide should be punished by the state.

Aristotle—To die to escape from poverty or love or anything painful is not the mark of a brave man but rather of a coward.

Epicurus—Opposed to suicide, even in misfortune, he maintained that "we must heal by the grateful recollection of what has been and by the recognition that it is impossible to make undone what has been done."

Lucretius—Those who find no flavor in life should not hesitate to take leave of it.

Zeno—The question of suicide is not one of moral right or wrong, but of a rational decision as to what is preferable in a given situation, life or death.

Epictetus—Suicide for trifling reasons is inadmissible. "Men as you are, wait upon God. When He gives the signal and releases you from your service, then you shall depart to Him."

Montaigne—Unbearable pain and a worse death seem to be the most excusable incentives for suicide.

Descartes—We should not really fear death, but also we should never seek it.

Spinoza—"No one, I say, from the necessity of his own nature, or otherwise than under compulsion from external causes, shrinks from food or kills himself. . . . That a man, from the necessity of his own nature, should endeavor to become non-existent is as impossible as that something should be made out of nothing."

Hume—No one throws away his life as long as it is worth keeping, but "prudence and courage should engage us to rid ourselves at once of existence when it becomes a burden."

Kant—As a natural being, as an "animal creature," man's first duty is self-preservation, and suicide therefore is a vice.

Schopenhauer—Although vigorously defending the right of every individual to a voluntary death, Schopenhauer maintained that suicide is opposed to the achievement of the highest moral goal, in that it substitutes an imaginary deliverance from this vale of tears for the real one.

Nietzche—"The thought of suicide is a strong consolation; it helps to get over many a bad night."

Camus—Although life has no meaning, suicide is not justified.

Source: The statements in this table were abstracted from *Philosophers on Suicide* by J. Choron in E. S. Shneidman (Ed.), *Death: Current Perspectives* (1984, pp. 341–361). Palo Alto, CA: Mayfield.

Zeno of Citius (c340–c265 BC), the first Stoic philosopher, believed that the principles of logical thought reflected the existence of a cosmic reason in nature. Zeno maintained that "people should be free from passion, unmoved by joy or grief, and submit without complaint to unavoidable necessity" (Flexner, 1987). He advocated a life based on reason and self-control in the face of death, a life of calm, austere fortitude. A later Stoic, the Roman statesman and writer Lucius Seneca (c4 BC–65 AD), maintained that only by thinking about death constantly can one be prepared for it. Somewhat fatalistic in outlook, Seneca and Marcus Aurelius, who was emperor of Rome from 161–180 AD, believed that preparation for death was the only proper goal of philosophy. The Stoics did not place much faith in an afterlife but rather emphasized the importance of living a satisfying life with no regrets, a life that would not bring shame upon one's family (Bardis, 1981; Choron, 1972). Understanding how nature works and that human beings are a part of nature presumably facilitates a stoical attitude toward death. Such a view is similar to the Taoist principle in Buddhism, which states that human beings can find happiness and completeness in life only when they discover "the Way" (*Tao*) of nature and surrender to it (Pardi, 1977).

Philosophers of the Enlightenment

As indicated previously, little philosophical writing on death appeared from the decline of the Roman Empire until the nineteenth century. One can find statements about death in the writings of the French essayist Michel de Montaigne (1533–1592), the Dutch philosopher Benedict de Spinoza (1632–1677), the French philosopher and mathematician René Descartes (1596–1650), the German philosopher, writer, and mathematician Gottfried Wilhelm von Leibnitz (1646–1716), the German philosopher Immanuel Kant (1724–1804), and the German philosopher Georg Wilhelm Friedrich Hegel (1770–1831). During the seventeenth century, the French philosopher and mathematician Blaise Pascal (1623–1662) proposed his famous wager concerning the existence of God. According to Pascal, if you bet that God exists and He does not exist, then you have lost nothing. But if you bet that God does not exist and He does exist, you have lost everything. So, given no choice but to bet, the wiser strategy is to bet that God exists and behave accordingly.[2]

Philosophers during the Age of Enlightenment were certainly concerned with immortality, especially during the eighteenth century (Choron, 1963). However, even the great eighteenth-century philosophers Immanuel Kant and Georg Hegel had little to say about death. The precedent set by Spinoza during the seventeenth century was that there are much more interesting philosophical questions, and these do not invade the domain of the theologians or step on the toes of ecclesiastics.

Schopenhauer

Arthur Schopenhauer (1788–1860) was a German philosopher who taught that "only the cessation of desire can solve the problems arising from the universal

impulse of the will to live" (Flexner, 1987). He made the awareness of death, which he called "the muse of philosophy," a central part of his philosophical system. Schopenhauer was a pessimistic atheist who viewed life as dominated by pain. In a fashion reminiscent of the Stoics, he maintained that an awareness of death facilitates indifference to this pain. Unfortunately, one cannot be indifferent to death itself, which every animal fears "instinctively." Although Schopenhauer characterized life as a struggle for existence—a struggle that eventually must be lost—and did not believe in personal immortality, he maintained that the idea or "will" of the species survives death. Thus, Schopenhauer taught that the species is indestructible and there is an immortality of nature. This conclusion, of course, is reminiscent of early Judaism and the philosophy of Buddhism, which influenced Schopenhauer's thinking (Choron, 1963).

Schopenhauer was succeeded by other philosophers, some who agreed with his viewpoint and some who disagreed. The German philosopher Friedrich Wilhelm Nietzsche (1844–1900), who maintained that the will to power is the primary motivating force of the individual and society, attacked the idea that death is the muse of philosophy. Many of the philosophers and philosopher-scientists who came after Schopenhauer and were interested in the problem of death were agnostics or even atheists. Nietzsche was an admirer of Zoroastrianism, whereas Sigmund Freud, Bertrand Russell, and Jean-Paul Sartre were acknowledged atheists (Bardis, 1981).

Existentialism

Rooted in the nineteenth-century writings of Søren Kierkegaard and Friedrich Nietzsche, *existentialism* answers the age-old question of "What or who am I?" with "You are what you do." To Kierkegaard, the meaning of existence is to be found in the actions of people as participants rather than spectators in the game of life. People cannot sit idly by and simply watch the passing parade if they wish to find meaning in their lives. They must get into the game and take chances.

The primary maxim of existentialism, "existence is prior to essence," implies that the theories and methods designed by empiricists to help understand the substance, or "objectiveness," of human beings and other phenomena are inadequate to the task. Science, with all its techniques and laws, will never succeed in telling us who we are and what our lives mean. Meaning must be discovered by *being-in-the-world (Dasein)*, by engaging in our own search and finding our own meanings through what we do and how we live.

Social upheavals and human tragedies during the nineteenth and twentieth centuries gave a particular impetus to existential thought. The decline of religious faith and the pursuit of materialism, new styles of working and living resulting from mechanization and mass production, world wars, genocide, and other sudden changes and disasters led to widespread doubt concerning the optimistic belief that "God's in His heaven and all's right with the world."

Existentialism was the first philosophical school to make a detailed study of death and its meaning to the individual. Martin Heidegger, Jean-Paul Sartre, Albert

Camus, and other existentialists stressed that an awareness of mortality makes people anxious and concerned about whether their lives have any significance. From the existentialist viewpoint, genuine human happiness is impossible to attain, but the meaning of an individual's life develops from an awareness of its inevitable ending. While admitting that death is absurd—a kind of cosmic joke on reasoning humanity—existentialism maintains that people do not fear death so much as a meaningless, valueless life. By exercising the freedom to choose and create one's own life, the person loses much of the fear of death and comes to see his or her life as productive and meaningful. Everyone is alone, life lacks any real sustained meaning, and death is inevitable. Nevertheless, each of us has the freedom to make of life what he or she will. The realization that life may end at any moment frees the individual to interpret personal experiences and act on them as he or she wishes. But freedom of choice does not guarantee that the choices or decisions will be wise ones. A person who acts freely must assume the responsibility for those actions and their consequences. Accepting this challenge and the associated risks requires courage, the courage *to be* and to live an authentic life.

Sartre did not believe that there is a providential order in nature or personal immortality. Like Schopenhauer, however, he accepted the notion of social immortality and that the life of each person can contribute to that immortality. And how does the individual come to make such a contribution? Sartre's answer is that, faced with the inevitability of a personal ending, the individual tries to live a life that will have some social significance (Bardis, 1981).

Thus, this chapter has come full circle on the subject of creativity and death. We began with Goodman's (1981) conclusion from interviewing almost 700 prominent artists and scientists. Goodman found that the fear of living an incomplete life, a life in which one has not had the opportunity to experience or accomplish all that he or she wishes to, is greater than the fear of death. If life must be experienced and acted upon to the limit of one's potential in order to be most meaningful, then the parallel between Goodman's research and existentialism is apparent. Prominent artists, scientists, and philosophers, however, are not ordinary people. Perhaps this select group cannot speak for the feelings and attitudes of the average person. As we shall see in Chapter 9, there is more to attitude toward death than is dreamt of in a great man's philosophy.

SUMMARY

Research findings suggest that the awareness of personal mortality has prompted the efforts of creative people to achieve something of lasting value. They fear not so much the idea of death but rather that they may die without having fulfilled their potentialities.

The dual themes of death and immortality are expressed in all art forms. Tombs, sarcophagi, and other funerary art forms have served magical, religious, and memorial functions. Particularly noteworthy in the sepulchral iconography of medieval times are memento mori tombs that depict the deceased as both living and

dead. These images were designed to reveal the corruption of death and to suggest its egalitarian nature (the great leveler). Other artistic themes that illustrate the preoccupation with death during the late Middle Ages are the triumph of death, the danse macabre, and the *Ars Moriendi.*

Death has been personified and symbolized in art in a multitude of ways since the Bronze Age. Common personifications are the Angel of Death, the Rider on a Pale Horse, and the Grim Reaper. Common symbols of death are cemeteries, skulls, clocks, and dead birds.

The origins of much of the nonverbal art and literature concerned with death are found in mythology. One of the earliest mythical stories was the *Epic of Gilgamesh,* an ancient tale of a Sumerian king and his search for immortality. Many myths in primitive cultures attempt to explain how humans came to be mortal—as the result of a mistake, as a punishment inflicted on humans by deities, or as the outcome of a great debate.

Representations of death in Western literature include grotesque animals and monsters and a humanlike individual dressed in black and carrying a scythe, another weapon, or a timepiece and perhaps riding a pale horse. Similar personifications are contained in the literature of the Middle and Far East.

Death has been a popular topic in literature, particularly themes of the inevitability and universality of death, the beautiful and romantic death, deathbed scenes, grief, immortality, and unnatural death (murder, suicide, death in combat). The obsession with death that characterized the arts during the Middle Ages is seen in a preoccupation with the maggotry of death in painting, poetry, and drama. A romantic view of death characterized much of the literature of the eighteenth and nineteenth centuries, giving way initially to a denial of death and then to greater realism during the twentieth century.

Ancient Greek and Roman philosophers (Plato, Epicurus, Seneca) were quite interested in the topics of death and immortality, but philosophical interest waned during the Middle Ages. Not until the nineteenth century was death once again considered a topic worthy of philosophical analysis. Arthur Schopenhauer was the first modern philosopher to pay serious attention to the topic, a precedent that greatly influenced the philosophical school of existentialism during the late nineteenth and early twentieth centuries. Heidegger, Sartre, Camus, and other existentialists agreed with Schopenhauer that death is the muse of philosophy. Expanding on this theme, the existentialists argued that the awareness of death gives meaning to life. The realization that eventually they must die motivates people to strive to live meaningful, self-actualizing lives.

QUESTIONS AND ACTIVITIES

1. Discuss attitudes toward death during the Middle Ages in Europe, citing evidence from the literature and art of that time to support your assertions.

2. Contrast the attitudes toward death of the Epicureans, the Stoics, and the Existentialists.

3. What novels or other fictional accounts of dying, death, and bereavement have you read? Describe any features that these works have in common. Were these accounts romantic, realistic, or a combination of the two?

4. What can painting, sculpture, music, and other nonverbal arts tell us about death that is not expressible in poetry or other written works of art?

5. What do *carpe diem, memento mori, the triumph of death,* and the *danse macabre* all have in common? What evidence can you cite to show that these themes are more or less prevalent today than they were during the Middle Ages?

6. What purpose was served in medieval art by emphasizing the maggotry of death and the vanity theme? In what way were these themes a reflection or product of the times?

7. Describe as many ways as you can of how death is personified in classical literature and the contemporary media. Which of these personifications is the most popular? Which are the most obvious or open, and which are more abstract or abstruse?

8. List the titles and describe popular songs that you have heard and films that you have seen with a central theme of death. What features or characteristics of death and dying are emphasized in these "works of art?" What have you learned from listening to the songs and viewing the films?

9. Certain works of art in early Greece and medieval or early Renaissance Europe combined the themes of love and death in the same work. In several paintings, eroticism and mortality are combined. Can you find examples of the mixture of sex and death in contemporary popular music, films, or television programs (e.g., MTV)? What is the purpose of this mixture? What is the artist or creator of the work trying to represent or communicate? Is the desired effect merely one of arousal or shock, or is there a real message in the medium?

10. The Middle Ages were, of course, not the only historical period of popular interest in the maggotry of death, violent death, and horror. Since the early days of Hollywood, there has been a huge market for horror films featuring ghosts, mummies, vampires, and other creatures that prey upon the living. Contemporary examples include the stories of Stephen King, the "Nightmare on Elm Street" movies, and the annual resurrection of the Dracula legend on film. How many horror films have you seen, and what psychological purposes do such films serve?

ENDNOTES

1. Reprinted from *The Collected Poems of Wilfred Owen.* Copyright 1946 © 1963 by Chatto & Windus, Ltd. Reprinted by permission of New Directions and the Owen estate.

2. Pascal's "wager" was formulated in the context of his interest in the mathematics of games of chance, an interest stimulated by a correspondence with the French nobleman Chevalier du Mere. One wonders how God might view such a wager, or whether He would approve of Einstein's famous dictum that "God doesn't shoot craps." Other mathematicians and logicians have offered so-called formal proofs of the existence of God and immortality. One interesting exercise claims to show how God could have created the universe from nothing. Let ∞ = God, 0 = nothingness, and 1 =

the universe. Since anything divided by 0 equals infinity, $1/0 = \infty$. Cross-multiplying yields $\infty \times 0 = 1$, proving that God (∞) could have created the universe (1) from nothing (0). Like Pascal's wager, there is a problem with this proof. Do you know what it is?

SUGGESTED READINGS

Bertman, S. L. (1991). *Facing death: Images, insights, and interventions*. Washington, DC: Hemisphere Publishing Corporation.

Boase, T. S. R. (1972). *Death in the Middle Ages: Mortality, judgment, and remembrance*. New York: McGraw-Hill.

Choron, J. (1984). Philosophers on suicide. In E. S. Shneidman (Ed.) *Death: Current perspectives* (3d ed., pp. 341–361). Palo Alto, CA: Mayfield.

Goodman, L. M. (1981). *Death and the creative life*. New York: Springer.

Gottlieb, C. (1959). Modern art and death. In H. Feifel (Ed.), *The meaning of death* (pp. 157–188). New York: McGraw-Hill.

Hoffman, F. J. (1959). Mortality and modern literature. In H. Feifel (Ed.), *The meaning of death* (pp. 133–156). New York: McGraw-Hill.

Kearl, M. C. (1989). Death in popular culture. In M. C. Kearl, *Endings: A sociology of death and dying* (pp. 379–405). New York: Oxford.

Silver, D. (Ed.). (1983). Themes of death and mourning in art and literature. *Psychoanalytic Inquiry, 3* (2).

Simpson, M. A. (1977). Death and modern poetry. In H. Feifel (Ed.), *New meanings of death* (pp. 313–333). New York: McGraw-Hill.

Vermeule, E. (1979). *Aspects of death in early Greek art and poetry*. Berkeley: University of California Press.

Weir, R. F. (Ed.). (1980). *Death in literature*. New York: Columbia University Press.

7

LEGAL PRACTICES AND ISSUES

Death is unique. It is unlike aught else in its certainty and its incidents. A corpse in some respects is the strangest thing on earth. A man but yesterday breathed and thought and walked among us has passed away. Something has gone. The body is left still and cold, and is all that is visible to mortal eye of the man we knew. Around it cling love and memory. Beyond it may reach hope. It must be laid away. And the law—that rule of action which touches all human things—must touch also this thing of death. It is not surprising that the law relating to this mystery of what death leaves behind cannot be precisely brought within the letter of all the rules regarding corn, lumber, and pig iron. And yet the body must be buried or disposed of. If buried, it must be carried to the place of burial. And the law, in its all-sufficiency, must furnish some rule, by legislative enactment or analogy, or based

on some sound legal principle, by which to determine between the living questions
of the disposition of the dead and the rights surrounding their bodies.[1]

The survival of individuals and groups demands that certain basic needs be satisfied. For thousands of years, human beings have known that both competition and cooperation play a role in need satisfaction, but these complementary processes are much more effective for society as a whole when they take place in an orderly fashion. The existence of order implies rules and sanctions, which when formalized and codified are called *laws*.

Although human beings are proud of their individuality and freedom, much of their behavior is governed by customs, mores, and laws. There are laws concerning almost every aspect of interactions among people, whether they be living, dying, or dead. *Dead* generally means biologically dead, but the laws of Western society also distinguish biological death from civil death and presumptive death. *Civil death* is a term in English common law that was formerly used to designate the legal status of a person who had lost his or her civil rights. *Presumptive death*, on the other hand, refers to a situation in which a person has, for some reason, been physically absent from his or her place of residence and out of contact with family and acquaintances for several years (usually seven). The legal determination of death in such cases is made by a court of inquiry, after which the property and familial rights and duties of the missing individual become those of a dead person. For example, a soldier who has been missing for seven years is presumed dead. Consequently, the survivors of this presumptively dead individual are entitled to the same legal rights (of inheritance, remarriage, etc.) as they would be if direct proof of the soldier's death were available.

First and foremost, the law is charged with protecting people from untimely death. When direct evidence that a person has died exists, the major legal issues are:

- Determining when death occurred and what caused it
- Disposing of the corpse in a decent manner
- Taking or shortening human life for medical or legal reasons
- Disposing of the decedent's property according to his or her wishes

The first three matters are concerns of both medicine and law, whereas the fourth is primarily of legal interest. These matters are not necessarily independent; the manner in which a decedent's property is disposed of, for example, may be affected by how and when the death occurred.

CAUSE OF DEATH AND DISPOSAL OF THE CORPSE

The exact moment of death must be known in a number of legal situations, such as in civil and criminal liability lawsuits, in processing insurance claims and determining survivors' benefits, and in matters of inheritance. When two people have died, it may be necessary to determine which one died first. Furthermore, when bodily

organs are donated, to make certain that a viable organ is obtained, it is important to know when the donor actually died.

It would seem to be a straightforward task to determine when a person is dead, except that death can be defined in so many ways, and different parts of the body die at different times. Among the physiological indicators of death are a drop in body temperature (*algor mortis*), stiffening and rigidity of the muscles (*rigor mortis*), and the presence of a waxy substance (*adipocere*) in the blood produced by the decomposition of animal tissues. Unfortunately, these indicators are rather crude and furnish only an approximate time of death.

Ambiguity in the definition of death and the consequent uncertainty of establishing a precise moment of death have led many states to adopt the provisions of the Uniform Determination of Death Act. As stated in this act, "An individual who has sustained either (1) irreversible cessation of circulatory and respiratory functions, or (2) irreversible cessation of all functions of the entire brain, including the brain stem, is dead. A determination of death is to be made in accordance with acceptable medical standards." (Uniform Determination of Death Act, 1986). The act, now adopted by over half the states, has clarified the definition of death to some extent but has not eliminated conflicting interpretations and lawsuits.

The Death Certificate

Not only must a time of death be specified, but a cause must also be identified. Both time and cause of death are recorded on a *death certificate,* a medicolegal document that must be completed and signed by a physician before the death can be registered. Death certificates vary in format from state to state but usually follow the U.S. Standard Certificate of Death (Figure 7-1). Death certificates constitute legal proof of death in a host of situations concerned with burial, insurance and pension payments, inheritance claims, and prosecution of homicides. Several copies of a death certificate should be obtained by the survivors or executor of the deceased's estate for filing insurance claims and other legal procedures. Death certificates are also useful in research on genealogy and to obtain knowledge about the incidence of diseases and other fatal conditions.

A copy of the death certificate is filed with the local and state vital statistics branches of the Department of Health and Human Services. After it has been filed, the death certificate constitutes official registration of the death and is a necessary preliminary to disposal of the corpse.

The first four sections of a certificate of death are for recording descriptive information on the decedent (name, sex, date of death, race, etc.), the names of the deceased's parents, how and where the remains were disposed of, and medical certification of death. The last section of the death certificate is for filling in the cause of death. Among the causes that may be indicated are accident, suicide, homicide, undetermined, or pending investigation. A natural death is assumed if none of these terms is entered on the form. This classification system has been criticized as too simplistic (Shneidman, 1980a), but it is fairly standard in the United States and

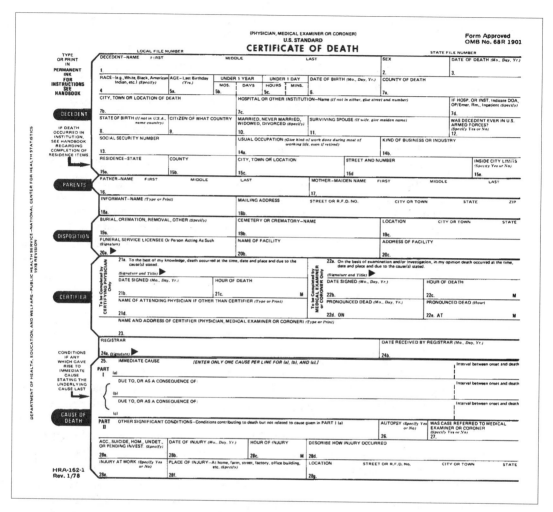

FIGURE 7-1 U.S. Standard Death Certificate

Source: U.S. Department of Health and Human Services, Public Health Service.

Europe. Thanks to the efforts of the World Health Organization, a uniform death certificate has been adopted by various nations throughout the world.

Legal problems concerning death are most likely to arise when the identified cause is accident, suicide, or homicide. When the death was caused by accident or homicide, for example, the survivors may have a legal claim against the person or persons responsible for the mishap or crime. These rights stem from Lord Campbell's Acts (1846) in British law, which legally entitled the surviving kin to monetary benefits from the guilty party equal to those they would have received if

the decedent had lived. Certain insurance clauses and benefits are also activated in the event of accidental death (e.g., double indemnity provisions, workers' compensation death benefits). In the case of any voluntary and unlawful taking of life, the guilty party is not entitled to benefits that he or she might otherwise have received at the death of the victim. When death is self-inflicted, life insurance policies are generally declared void and accidental death benefits are likewise barred (Schroeder, 1989).

Coroners and Autopsies

Three other items of interest on the certificate of death are the coroner's certification, an indication of whether an autopsy was performed, and information on how, where, and by whom the corpse was disposed.

In medieval England, *coroners* (from "crowners," appointed by the Crown) were agents commissioned by the king to determine the cause of death and, in murder cases, to collect revenues from forfeiture of the property of the murderer. In the United States, coroners now are usually elected officials who, depending on the locality, may or may not be medical doctors. Functions similar to those of a coroner are performed by a *medical examiner,* who is a physician usually trained and certified in forensic pathology and appointed to the job by a government official or commission.

The task of a coroner or medical examiner is to examine deaths resulting from unclear causes, in which cases the cause of death is either unknown or unnatural (accidental, suicide, or homicide). The coroner or medical examiner may conclude that doubt as to the cause of death is great enough to make a postmortem examination (an autopsy) necessary. An *autopsy* involves inspection and dissection of the corpse, including removal and examination of the internal organs. Following completion of the autopsy, organs that require no further examination are returned to the body cavity and all incisions are closed. Traditionally, permission of the next of kin was needed to perform an autopsy. One reason for requiring permission is that sometimes there is a conflict between an autopsy and religious beliefs concerning mutilation of the body. For example, Jews believe in immediate burial, but it may be necessary to delay the burial for some time when an autopsy is performed. Certain religious groups also view a dead body as the temple of the soul, and therefore believe that it should not be mutilated by an autopsy. Be that as it may, a coroner or medical examiner can order an autopsy whenever it appears that the deceased was in good health before dying, or in other instances in which the death has not been explained satisfactorily.

The results of an autopsy, conducted by a pathologist, are recorded on appropriate legal documents. In certain cases, this may be followed by a legal inquest in which witnesses are heard and other evidence pertaining to the cause of death is presented. An *inquest* is a preliminary investigation rather than a trial, although in some localities, coroners are authorized to issue arrest warrants based on the results of an inquest. The typical outcome of an inquest is issuance of a death certificate or other official report concerning the cause of death and related information.

Corpse Disposal and Disinterment

Historically, the burial of corpses was controlled by the Church, and not until the seventeenth century did the legal concept of a right to a decent burial develop (Schroeder, 1989). Although no one actually owns a dead human body, the law now requires the next of kin or executor/executrix of the decedent's estate to make arrangements for disposal of the body. Since the corpse is not property in the legal sense, any directions that the deceased may have made concerning funeral arrangements and method of disposing of his or her body (burial, cremation, etc.) may be taken into account but are not legally binding. Not only do members of the family have a *right* to bury the deceased; they are legally *required* to do so as quickly and appropriately as possible. In the usual situation, the next of kin or personal representative obtains a burial permit when the death is registered (see Figure 7-2) and then engages a funeral director or mortician to take care of the details of the funeral and disposal of the body. Burial costs are charged to the estate, except when the deceased is destitute or the relatives have authorized use of the body for scientific or educational purposes.

A dead body may be embalmed, cremated, or treated in other ways (e.g., frozen). The laws relating to disposal vary from state to state. In 80 percent of the cases, the body is embalmed, a procedure that dates back to at least 4 BC. *Embalming* was first used in France and England in the 1600s and in the United States during the Civil War. It entails removal of the blood and injection of a special preservative mixture into the arteries. This procedure retards putrefaction of the body for only a few days and is not usually necessary. However, it may be legally required whenever the body is to be transported for a long distance before being buried.

Because cremation may conceal a crime, a more detailed legal inquiry usually precedes issuance of a permit to cremate than a permit to bury. There are also laws pertaining to exhumation or disinterment of a buried body. In general, it is a misdemeanor to mistreat or disinter a corpse, but disinterment can be legally authorized to obtain evidence for prosecuting civil or criminal cases.

Organ Donation

Laws governing anatomical donations vary from state to state, but by the early 1970s all states had enacted some form of the Uniform Anatomical Gift Act. This act provides guidelines concerning who can donate, to whom the donation can be made, and what can be donated. In general, a donor must be at least 18 years old. Although the survivors may act to donate if the deceased owner of the organ has not, the latter's request supersedes all others. Even when the donor has authorized it, physicians usually refuse organ donations when surviving family members object. The donor may also revoke the gift, or it may be refused by the intended recipients.

Rather than donating the entire body for educational or research purposes, typically a dying person or the relatives of the deceased will donate one or more organs to help a living person. Many different organs (eye, heart, kidney, liver, pancreas, pituitary gland, lung) and tissues (bone, bone marrow, skin, tendon,

APPLICATION AND PERMIT FOR DISPOSITION OF HUMAN REMAINS

USE BLACK INK ONLY—MAKE NO ERASURES, WHITEOUTS OR OTHER ALTERATIONS

1A. NAME OF DECEDENT—FIRST (GIVEN)	1B. MIDDLE	LAST (FAMILY)	2. DATE OF BIRTH MONTH, DAY, YEAR	3. DATE OF DEATH MONTH, DAY, YEAR	4 SEX

5A. CITY OF DEATH	5B. COUNTY OF DEATH—OUTSIDE CALIF., ENTER STATE	6. NAME, RELATIONSHIP, FULL MAILING ADDRESS AND ZIP CODE OF INFORMANT

7A. TYPED NAME AND ADDRESS OF CALIFORNIA—FUNERAL DIRECTOR OR PERSON ACTING AS SUCH	7B. CALIF. LICENSE NUMBER —IF APPLICABLE

ACKNOWLEDGMENT OF APPLICANT	I hereby acknowledge as applicant that the proposed disposition stated herein is one of the dispositions authorized by Section 103776 of the Health and Safety Code, and was authorized pursuant to Section 7100 of the Health and Safety Code.	8A. SIGNATURE OF APPLICANT—Person taking permit	8B. DATE SIGNED

PERMIT AUTHORIZATION OF LOCAL REGISTRAR ANY CHANGE IN DISPOSITION REQUIRES A NEW PERMIT TO SHOW FINAL DISPOSITION.	THIS PERMIT IS ISSUED IN ACCORDANCE WITH PROVISIONS OF THE CALIFORNIA HEALTH AND SAFETY CODE AND IS THE AUTHORITY FOR THE DISPOSITION SPECIFIED IN THIS PERMIT. NOTE: THIS PERMIT GIVES NO RIGHT OF DISPOSAL OUTSIDE OF CALIFORNIA.	9A. AMOUNT OF FEE PAID	9B. DATE PERMIT ISSUED	9C. SIGNATURE OF LOCAL REGISTRAR ISSUING PERMIT
	9D. ADDRESS OF REGISTRAR OF DISTRICT OF DEATH— IF DEATH OCCURRED IN CALIFORNIA		9E. ADDRESS OF REGISTRAR OF DISTRICT OF DISPOSITION— IF DISPOSITION IS TO OCCUR IN ANOTHER DISTRICT IN CALIFORNIA	

10. AUTHORIZED DISPOSITION(S) CHECK APPLICABLE ITEMS

		FOR CORONER'S USE ONLY
☐ A. BURIAL (INCLUDES ENTOMBMENT)	☐ E. TEMPORARY ENVAULTMENT	☐ I. DISPOSITION PENDING—REMAINS LOCATED AT (Name and Address)
☐ B. CREMATION	☐ F. DISINTERMENT	
☐ C. DISPOSITION OF CREMATED REMAINS OTHER THAN IN A CEMETERY	☐ G. SHIP IN TO CALIFORNIA	
☐ D. SCIENTIFIC USE	☐ H. TRANSIT TO OUTSIDE OF CALIFORNIA	

COMPLETE ALL APPLICABLE ITEMS

BURIAL	11A. NAME AND ADDRESS OF CALIFORNIA CEMETERY	11B. DATE BURIED	11C. SIGNATURE OF PERSON IN CHARGE OF BURIAL
CREMATION	12A. NAME AND ADDRESS OF CALIFORNIA CREMATORY	12B. DATE CREMATED	12C. SIGNATURE OF PERSON IN CHARGE OF CREMATION
SCIENTIFIC USE	13A. NAME AND ADDRESS OF CALIFORNIA FACILITY RECEIVING REMAINS	13B. DATE RECEIVED	13C. SIGNATURE OF PERSON IN CHARGE OF FACILITY
TRANSIT	14A. NAME AND ADDRESS IN RECEIVING STATE OR COUNTRY WHERE REMAINS OR CREMATED REMAINS ARE TO BE SHIPPED	14B. DATE SHIPPED	14C. ADDRESS AND SIGNATURE OF PERSON IN CHARGE OF PLACING WITH THE CARRIER
SCATTERING AT SEA OR DISPOSITION OTHER THAN IN A CEMETERY	15A. ADDRESS, NEAREST POINT ON SHORELINE, OR OTHER DESCRIPTION SUFFICIENT TO IDENTIFY FINAL PLACE AND CA DISTRICT OF DISPOSITION	15B. DATE OF DISPOSITION	15C. SIGNATURE OF PERSON IN CHARGE OF DISPOSITION / 15D. LICENSE NUMBER OF CREMATED REMAINS DISPOSER —IF APPLICABLE

COPY 1 OF THE PERMIT ACCOMPANIES THE REMAINS TO THE STATED PLACE OF DISPOSITION. THE PERSON IN CHARGE OF DISPOSITION IS RESPONSIBLE FOR COMPLETING AND FORWARDING THE PERMIT WITHIN 10 DAYS OF DISPOSITION TO THE REGISTRAR OF THE DISTRICT IN WHICH DISPOSITION OCCURRED OR THE DISTRICT NEAREST THE POINT WHERE THE CREMATED REMAINS WERE SCATTERED AT SEA. THE LOCAL REGISTRAR MAY DESTROY ANY ORIGINAL OR DUPLICATE PERMIT AFTER ONE YEAR FROM ISSUE DATE.

COPY 1 STATE OF CALIFORNIA, DEPARTMENT OF HEALTH SERVICES, OFFICE OF STATE REGISTRAR VS 9 (REV. 6/91)

SPECIAL INSTRUCTIONS REGARDING CREMATION

THE FOLLOWING STATUTORY PROVISIONS ARE APPLICABLE TO THE DISPOSITION OF CREMATED HUMAN REMAINS OTHER THAN IN A CEMETERY AND BURIAL AT SEA AFTER CREMATION AS PROVIDED IN HEALTH AND SAFETY CODE SECTIONS 7054.6, 7054.7, 7117, 10376 AND 10376.5.

NO PERSON SHALL DISPOSE OF OR OFFER TO DISPOSE OF ANY CREMATED HUMAN REMAINS UNLESS REGISTERED AS A CREMATED REMAINS DISPOSER BY THE STATE CEMETERY BOARD. THIS ARTICLE SHALL NOT APPLY TO ANY PERSON, PARTNERSHIP, OR CORPORATION HOLDING A CERTIFICATE OF AUTHORITY AS A CEMETERY, CREMATORY LICENSE, CEMETERY BROKER'S LICENSE, CEMETERY SALESMAN'S LICENSE, OR FUNERAL DIRECTOR'S LICENSE, NOR SHALL THIS ARTICLE APPLY TO ANY PERSON HAVING THE RIGHT TO CONTROL THE DISPOSITION OF THE CREMATED REMAINS OF ANY PERSON OR THAT PERSON'S DESIGNEE IF THE PERSON DOES NOT DISPOSE OF OR OFFER TO DISPOSE OF MORE THAN 10 CREMATED HUMAN REMAINS WITHIN ANY CALENDAR YEAR. (BUSINESS AND PROFESSIONS CODE SECTION 9740.)

CREMATED REMAINS SHALL NOT BE SCATTERED OVER INLAND WATERS OR OVER LAND UNLESS IN A DEDICATED CEMETERY IN A GARDEN AREA USED EXCLUSIVELY FOR SUCH PURPOSES.

FIGURE 7-2 **Application and Permit for Disposition of Human Remains**

Source: State of California, Department of Health Services, Office of State Registrar.

blood vessels) may be transplanted. Some donated organs, such as corneas, pituitary glands, and skin, can be stored in organ banks until needed. Also in great demand are vital organs (e.g., hearts, kidneys, livers), which must be transplanted immediately to avoid tissue damage. A national computerized system has been in operation for several years to facilitate the process of matching organs with persons. However, problems in coordinating information concerning the availability of organs continue to exist.

Forms for making organ donations are found on documents such as driver's licenses and senior citizen cards, or as separate documents (see Figure 7-3). To make an organ donation legal, two witnesses must be present and the donor adjudged competent at the time the form is completed. Despite the fact that the majority of Americans favor organ donations at death, only a small proportion actually complete an organ donation form. One medicolegal concern with respect to organ donation is that overeagerness on the part of an attending physician to obtain a transplant organ as quickly as possible could lead to a premature decision to terminate life support for a patient. Consequently, the restriction that no member of a transplant team should be involved in the terminal care or death determination of a patient-donor is a reasonable precaution.

ABORTION AND EUTHANASIA

A decision by a lawfully constituted authority that a death is natural makes it legally, if not always personally, acceptable. Unnatural death due to accident, homicide, or suicide may also be legally sanctioned under certain conditions that vary with time, place, and circumstances. Like every aspect of human culture, laws are a function of the changing needs and tolerance of society. Laws and law enforcement pertaining to unnatural death caused by abortion, euthanasia (mercy killing), or capital punishment, for example, have not always been consistent or just. Nevertheless, there are indications of greater tolerance and fairness in contemporary attitudes and legislation applying to these issues. Fair or not, laws pertaining to these matters, as well as the interpretation and enforcement of these laws, continue to be reexamined and debated in the legal community and among the public at large.

Abortion

The most general definition of *abortion* is any procedure that results in the death of an unborn child. An abortion may be *spontaneous*, in which case it is referred to as a *miscarriage*, or it may be *induced* by some external agent. Abortions can be induced by either chemical or surgical means. Medical procedures employed through the first trimester (first 12 weeks of pregnancy) consist of either scraping the fetus from the uterus (dilatation and curettage) or aspirating the fetus from the uterus by means of a special suction pump (vacuum aspiration). After the first trimester, aborting the fetus becomes increasingly more hazardous to the health of the mother.

TO MY FAMILY AND PHYSICIAN

It is my wish that upon my death, my body, or any part of it, be used for the benefit of mankind.

I, therefore, execute the following Deed of Gift, under the Anatomical Gift Act, and I request that in the making of any decision relating to my death, my intentions as expressed herein shall govern.

I am of sound mind and 18 years or more of age. I hereby make this anatomical gift to take effect upon my death. The marks in the appropriate places and words filled into the blanks below indicate my desires.

I give: my body _____; any needed organs or parts _____; the following organs or parts

I give these to the following person or institution: the physician in attendance at my death

_____; the hospital in which I die _____; the following named physician, hospital, storage bank

or other medical institution _____

the following individual for treatment _____

for any purpose authorized by law _____; transplantation _____;

therapy _____; research _____; medical education _____.

Dated _____ _____
 signature of donor

Signed by Donor in presence of _____
following who sign as witnesses address of donor

_____ _____
 witness witness

UNIFORM DONOR CARD

_____ _____
Name of Donor Date of Birth

In the hope that I may help others, I hereby make this anatomical gift, if medically acceptable, to take effect upon my death. The words and marks below indicate my desires. I give:
(a) ___ any needed organs or parts (b) ___ only the following organs or Specify: _____

_____ _____
Signature of Donor Date & Place Signed

_____ _____
Witness Witness

This is a legal document under the Uniform Anatomical Gift Act.

FIGURE 7-3 Uniform Donor Forms

Source: Understanding Death and Dying (3d ed., p. 416), by S. G. Wilcox and M. Sutton, 1985, Palo Alto, CA: Mayfield. Reprinted by permission.

The maternal mortality rate for aborting the fetus during the first trimester is even lower than for childbirth, but the rate increases dramatically for later abortions, especially for hysterotomy.

After the first trimester, the usual abortion technique consists of injecting a hormonelike substance (prostaglandin) or a saline solution into the amniotic fluid surrounding the fetus. When all other methods have failed, a hysterotomy is performed. This procedure is essentially a caesarean section and may result in the fetus being born alive (Cavanaugh, 1991).

The controversy over induced abortion revolves around the issue of taking a human life. Although it was opposed by Hippocrates, Plato and Aristotle viewed it as a useful method of population control. Taking its position from the Sixth Commandment ("Thou shalt not kill"), organized Christianity historically has opposed induced abortion. Similar opposition has been expressed by Buddhism, Hinduism, and Judaism. British common law and the laws of many other countries also consider abortion to be a crime when induced after the onset of "quickening" (fourth to fifth month of pregnancy), because the fetus is legally regarded as a person after it has begun to move (Williams, 1989). In U.S. law, a third-trimester fetus is considered a citizen, and a death certificate must be filed when it dies.

Protestant and Jewish positions on abortion have become less conservative during the twentieth century. If the procedure is needed for saving the life or preserving the health of the mother, it is now generally acceptable to those religions. The Roman Catholic Church, however, continues to oppose abortion, arguing from a sixteenth-century doctrine that "ensoulment" occurs at the moment of conception. Roman Catholic doctrine maintains that abortion is unjustified even if the life of the mother is threatened.

Public opposition to abortion is not restricted to the religious community; many professional and lay groups are also opposed to it. The major point in opposition to abortion is that an unborn child is actually a human being and, hence, abortion is tantamount to murder. Antiabortionists ("prolifers") believe that this is certainly true of the fetus (third month to term) and, according to some opponents of abortion, even of the embryo and the fertilized egg.

Organized opposition to induced abortion is not as strong in other countries as in the United States. For example, abortions by qualified physicians are performed with virtually no restrictions in Eastern Europe, Russia, Japan, and China. Interestingly enough, abortion is also legal in heavily Roman Catholic Italy. In the United States, it is legal in many states to abort for reasons of health of the mother or fetus, or when pregnancy is caused by rape or incest. Most of the 1.5 million or more abortions that take place in this country every year are, however, prompted by reasons other than health or unlawful sexual intercourse.

Pressure on state and federal legislators to liberalize abortion laws continues, especially by women's rights groups ("pro-choicers"). One argument of these groups is that the fetus is part of a woman's body, and she has a right to control her own body. Pro-choicers also argue that making abortion illegal will lead to unsafe practices and have a disproportionate effect on poor people who cannot afford to travel to places where abortion is legal. Pro-lifers argue that abortion is murder, a

violation of the fetus's right to life, and that it may even lead to the acceptance of infanticide and a disregard for human life in general—a so-called "slippery slope to Auschwitz" (Schur, 1991).

Most of the current controversy over abortion is the result of the 1973 decision by the U.S. Supreme Court in the case of *Roe* v. *Wade.* In that decision, the Court ruled that: (1) states cannot prohibit abortion during the first three months of pregnancy, but beyond that period they may regulate abortion in ways that reasonably relate to maternal health; and (2) states may prohibit abortion in the final 10 weeks of pregnancy except when the mother's life is at stake. In justifying that decision, the Court stipulated that an unborn child is not a person within the meaning and protection of the term *person* in the Fourteenth Amendment of the U.S. Constitution. Furthermore, a woman's right to privacy implies that a decision whether to have an abortion during the first three months of pregnancy should be left to the woman and her doctor. During that same year, in the case of *Doe* v. *Bolton* (1973), the Court removed the earlier requirement that abortions can be performed only in hospital settings.

The pro-choice interpretation of a pregnant woman's right to have an abortion that characterized Supreme Court decisions in the 1970s was reversed by the more conservative Court of the late 1980s. In 1989, the Court upheld a Missouri law banning abortions in public hospitals and forbidding public employees to assist in abortions except when the woman's life is in danger. The Court also ruled that the state of Missouri may require physicians to test women who are at least 20 weeks pregnant to determine if their fetuses are viable, and to prevent abortions if they are. Although the Missouri law does not forbid abortions in private medical facilities (where the vast majority take place), the Supreme Court ruling was viewed as a step in a series of efforts by the Court to limit access to abortion and thus slowly rescind the decision of *Roe* v. *Wade.*

During the past few years, the abortion issue has polarized activists in the United States into prolife (antiabortion) and prochoice (proabortion) groups. Both groups have been stridently vocal and at times quite aggressive. They have undoubtedly influenced U.S. public opinion and politics on the issue. The results of national polls show that the public is deeply divided on the complex abortion issue, which shows no immediate signs of being resolved. With regard to the feelings of women who have had abortions, in national polls, some have said that the loss and resulting grief had profoundly affected their lives, whereas others were grateful that abortion was available (Tumulty, 1989).

Euthanasia and Natural Death Act

Euthanasia ("good death"), the practice of putting to death people who suffer severe, unremitting pain, disease, or handicaps, was discussed briefly in Chapter 3. As indicated there, the distinction between *active* and *passive* euthanasia, which is not always clear, pertains to whether positive action is taken to hasten a person's death or whether extraordinary, lifesaving measures are simply withheld from a dying

person. Euthanasia is *voluntary* if the person whose life is in question voluntarily decides to die; it is *involuntary* if death occurs against the person's will.

Despite the support of many people, the history of euthanasia has been at least as stormy as that of abortion. The debate has not centered on the voluntary-involuntary distinction, since it is generally conceded that *involuntary euthanasia* is merely a euphemism for murder. Rather, the most frequently debated issue is whether active and passive euthanasia are morally and legally justifiable. Laws in the United States, Canada, and most European countries define *active euthanasia*—taking active measures to shorten the life of a person whether or not that person approves—to be a crime. Shortening one's own life is defined as *suicide*, and shortening the life of another person is *murder*. Euthanasia is not strictly legal in Israel and Japan, but the laws concerning doctor-assisted death are more liberal in these countries than in North America and Europe. Active euthanasia that permits a physician to end the life of a consenting terminally ill patient is legally countenanced in the penal code of only one country—Uruguay, where no criminal charges are brought against a mercy killer.

Although it is not technically legal, physicians in the Netherlands can perform mercy killing through lethal injection if a strict procedure established by the Dutch medical profession is followed. The conditions of this procedure are that (1) the person must express an enduring, freely decided wish to die; (2) the person must be in unbearable physical or emotional pain that shows no signs of abating; (3) the person must not be mentally disturbed; (4) the person's death must not cause harm to others; (5) anyone who assists in the death must be a qualified health professional, and the lethal drug must be administered by a medical doctor; (6) the helper should consult with colleagues before assisting in the death; (7) the death must be fully documented and the documents made available to appropriate legal authorities. Following these steps, physician-assisted suicide has become fairly common in Holland. More than 6,000 people, including many AIDS victims, commit suicide with medical help each year in that country (Diekstra, 1987).

Certain organizations, such as Exit in Great Britain and the Society for the Right to Die in the United States, were established to lobby for changes in laws pertaining to euthanasia, so far without notable success. Noteworthy in the United States for encouraging euthanasia is Derek Humphry's National Hemlock Society and his how-to death manual, *Final Exit* (Humphry, 1991). Also of interest are the efforts of Dr. Jack Kevorkian, unaffectionately referred to by opponents as "Dr. Death," who also has achieved some notoriety for assisting at least 17 terminally ill patients to die more easily. Many of these individuals reportedly contacted Dr. Kevorkian for assistance because of their need to be a part of something more important than their own invisible lives (Warrick, 1993). The media attention and certainty of success assured by enlisting the services of Dr. Kevorkian were very seductive to many of these people.

At present, in none of the 50 states can terminally ill patients legally have help in dying, although the enactment of such legislation has come close in some states. Unsuccessful efforts to legalize euthanasia in the United States go back to the 1930s, when the legislatures in Nebraska and New York turned down such proposals. In

**BOX 7-1 • Comments on Kevorkian and
Treatment of the Dying**

According to Professor George Annas of
Boston University's School of Medicine:

*A significant percent of the American public
sees Kevorkian as a reasonable alternative to mod-
ern medicine. He's a total indictment of the way we
treat dying patients in hospitals and at home. We
don't treat them well, and they know it.*

*First we don't tell them they are dying. We do
tell them their diagnosis and all the alternative
treatments available. But we don't tell them their
prognosis. We tell them, "You have cancer, and
you can have surgery, radiation, chemotherapy, or
all three together, or even any two." We don't tell
them that no matter what we do, it's almost certain
they are going to die soon.*

*Up to 90 percent of patients die in too much
pain. Some doctors actually argue that their pa-
tients are going to get addicted. But they can't
have thought about it for more than two minutes to
say something like that. The vast majority simply
don't know how to treat pain, and they don't think
it's important. They want to cure the person.
Death is still seen as the enemy. And that's what
Kevorkian throws in their face. What he says is,
"Some people want death, and I am going to give it
to them."...*

*We more or less abandon dying patients.
When there is nothing more medicine can offer, we
turn them over to the nursing staff and we don't
see them anymore.*

Source: From Gibbs, N. (1993, May 31). Rx for death. *Time,* p. 36. Copyright 1993 Time Inc. Reprinted by
permission.

1986, the Council on Ethical and Judicial Affairs of the American Medical Associa-
tion affirmed that it is not unethical for physicians to discontinue life support
systems for patients in irreversible coma even if death is not imminent (Malcolm,
1986). And in 1989, a distinguished group of medical ethicists concluded that it is
"not immoral for a physician to assist in the rational suicide of a terminally ill
person" (Wanzer et al., 1989). For personal, ethical, or religious reasons, or fear of
malpractice suits, most physicians have been reluctant to help terminally ill patients
to die. However, a survey by the American Medical Association found that nearly
80 percent of the 1,000 responding physicians favored withdrawing life support
systems from hopelessly ill or irreversibly comatose patients if the patients or their
families request it (*American Medical News,* June 3, 1988). Likewise, in national
surveys, approximately four fifths of the respondents indicate that terminally ill
patients should be able to tell their doctors to let them die. As seen in the fate of
California's recent (1992) Proposition 161, a majority of voters continue to reject the
legalization of passive euthanasia. A similar proposal was rejected by voters in the
state of Washington.

Religious Opposition

One reason why citizens may report feeling one way but vote another on euthanasia
is religious opposition. Christianity, Judaism, and Islam have traditionally been
opposed to suicide and euthanasia, the objections being directed more toward

active than passive euthanasia. Roman Catholic opposition to euthanasia stems not only from the Sixth Commandment but also from St. Augustine's maxim that the Scriptures do not authorize the destruction of innocent human life. But as seen in the *Ars Moriendi* treatise and the "double-effect" principle of the Middle Ages, Roman Catholic theologians have tended to be more interested in saving souls than in preserving lives. According to the *double-effect principle*, an action that has the primary effect of relieving human suffering may be justifiable even when it shortens human life (Wasmuth, 1991). Thus, the fact that administration of narcotics to relieve pain in terminally ill patients can lead to respiratory depression and thereby hasten death is not inconsistent with this principle.

Modern Catholic theologians have also addressed the matter of passive euthanasia (e.g., when should a respirator be turned off, or when should lifesaving medical measures cease?). Dealing with the question of whether a respirator should be turned off if the patient is in an irreversible coma, Pope Pius XII concluded in a 1957 statement that there is no moral obligation to keep the respirator turned on in such instances.[2] A case in point was that of Karen Ann Quinlan, an irreversible-coma patient during the late 1970s and early 1980s whose Roman Catholic parents, presumably after consulting with Church authorities, decided to have their daughter's respirator turned off. Even when the respirator was turned off, she continued to live and breathe for some months. Karen Ann Quinlan's parents had decided against the removal of the feeding tube, however, which would have led to a much quicker termination of her life.

Another famous case concerning the right-to-die question was that of Nancy Cruzan, a 32-year-old Missouri woman. After nearly suffocating in an automobile accident, she was, like approximately 10,000 other Americans, in a so-called persistent vegetative state—a permanent unconsciousness in which she was able to breathe on her own but had to be fed through a feeding tube. In similar cases in several other states, the courts had ruled that life support measures could legally be terminated. These rulings were consistent with the 1986 statement by the American Medical Association that it is not unethical to discontinue all means of life prolonging medical treatment for patients in irreversible comas, including artificial feedings. However, the Missouri court held that "the burden of continuing the provision of food and water" was "emotionally substantial for Nancy Cruzan's loved ones," but not for her. In the face of "the uncertainty of Nancy's wishes and her own right to life," the court concluded that "We chose to err on the side of life, respecting the rights of incompetent persons who may wish to live despite a severely diminished quality of life" (Steinbrook, 1989). Nancy Cruzan's parents appealed this decision to the U.S. Supreme Court, but the Court ruled that the parents of a comatose woman do not have an automatic right under the U.S. Constitution to insist that hospital workers stop feeding her (Savage, 1990). Nancy Cruzan eventually died, but only after a long and bitter legal battle.

Living Will

In the cases of Karen Ann Quinlan, Nancy Cruzan, and other patients in comas, it is rarely clear what the wishes of the patient regarding termination of treatment

would be if the patient were conscious. Realizing that terminally ill patients may prefer to be permitted to die rather than linger on in a painful or vegetative state and remain a financial, physical, and emotional burden on their families and friends, an organization known as Choice in Dying (formerly Concern for Dying and Society for the Right to Die) made available a form known as a Living Will. A Living Will can be filled in, while the patient is still able to think clearly, to express the desire that extraordinary medical techniques not be used to keep him or her alive when the medical situation becomes final and hopeless (see Figure 7-4). Laws in 38 states and the District of Columbia accept living wills as representing the patient's wishes ("Specific Instructions Needed in Living Wills," 1989). Furthermore, the U.S. Congress has passed a Patient Self-Determination Act that requires hospitals to inform patients of their right to control treatment by means of living wills and powers of attorney.

Natural Death Act

Physicians' concerns over medical malpractice suits, coupled with the efforts of those who support passive euthanasia, have resulted in so-called natural death legislation in many states. The first of these, California's Natural Death Act, permits a patient who has been diagnosed by two physicians as terminally and incurably ill or injured to sign a directive stating that life sustaining procedures not be used to prolong his or her life when death is imminent. This law does not provide for or permit active steps to end life, but only to terminate treatment that is prolonging the dying process.

Patients who sign such a directive must be emotionally and mentally competent to make the decision, which is effective for 5 years and may be revoked at any time. The directive must be executed within 14 days after the patient has been diagnosed as having a terminal condition; otherwise it is only advisory and need not be complied with by the attending physician. As with any legal procedure, the patient's signature must be witnessed by two other people.

Natural death legislation has not been without problems and criticisms. Nowhere in the California statute, for example, is the word *imminent* defined. Furthermore, a terminal patient in a comatose state obviously cannot make or sign such a declaration. Relying on guidelines provided in 1968 by the Harvard Medical School Ad Hoc Committee, California law permits physicians (at least two) to declare a patient dead when there is an absence of brain waves for 24 hours; there must also be no spontaneous breathing and no response to external stimulation. Once the patient has been declared dead, the physicians can "pull the plug" on life sustaining machinery. Because the law is not clear in all situations, most physicians lean toward the conservative side and consult with the patient's family and legal counsel before making a final decision.

Another problem has arisen in attempting to implement the California Natural Death Act and similar laws in other states: Many doctors are ethically or religiously opposed to any form of euthanasia. Physicians may also view the demand for death with dignity as romantic nonsense contrary to their own experiences with dying patients. In the eyes of these doctors, terminally ill patients are usually frightened,

ADVANCE DIRECTIVE
Living Will and Health Care Proxy

Death is a part of life. It is a reality like birth, growth and aging. I am using this advance directive to convey my wishes about medical care to my doctors and other people looking after me at the end of my life. It is called an advance directive because it gives instructions in advance about what I want to happen to me in the future. It expresses my wishes about medical treatment that might keep me alive. I want this to be legally binding.

If I cannot make or communicate decisions about my medical care, those around me should rely on this document for instructions about measures that could keep me alive.

I do not want medical treatment (including feeding and water by tube) that will keep me alive if:
- I am unconscious and there is no reasonable prospect that I will ever be conscious again (even if I am not going to die soon in my medical condition), <u>or</u>
- I am near death from an illness or injury with no reasonable prospect of recovery.

I do want medicine and other care to make me more comfortable and to take care of pain and suffering. I want this even if the pain medicine makes me die sooner.

I want to give some extra instructions: *[Here list any special instructions, e.g., some people fear being kept alive after a debilitating stroke. If you have wishes about this, or any other conditions, please write them here.]*

The legal language in the box that follows is as health care proxy.
It gives another person the power to make medical decisions for me.

I name _____, who lives at _____,

phone number _____, to make medical decisions for me if I cannot make them myself. This person is called a health care "surrogate," "agent," "proxy," or "attorney in fact." This power of attorney shall become effective when I become incapable of making or communicating decisions about my medical care. This means that this document stays legal when and if I lose the power to speak for myself, for instance, if I am in a coma or have Alzheimer's disease.

My health care proxy has power to tell others what my advance directive means. This person also has power to make decisions for me, based either on what I would have wanted, or, if this is not known, on what he or she thinks is best for me.

If my first choice health care proxy cannot or decides not to act for me, I name _____,

address _____, phone number _____, as my second choice.

(over, please)

LWGEN

FIGURE 7-4 Living Will

I have discussed my wishes with my health care proxy, and with my second choice if I have chosen to appoint a second person. My proxy(ies) has(have) agreed to act for me.

I have thought about this advance directive carefully. I know what it means and want to sign it. I have chosen two witnesses, neither of whom is a member of my family, nor will inherit from me when I die. My witnesses are not the same people as those I named as my health care proxies. I understand that this form should be notarized if I use the box to name (a) health care proxy(ies).

Signature _____

Date _____

Address _____

Witness' signature _____

Witness' printed name _____

Address _____

Witness' signature _____

Witness' printed name _____

Address _____

Notary [to be used if proxy is appointed] _____

Drafted and Distributed by Choice In Dying, Inc.—the National Council for the right to Die, Choice In Dying is a National not-for-profit organization which works for the rights of patients at the end of life. In addition to this generic advance directive, Choice In Dying distributes advance directives that conform to each state's specific legal requirements and maintains a national Living Will Registry for completed documents.

CHOICE IN DYING INC.—
the national council for the right to die
(formerly Concern for Dying/Society for the Right to Die)
200 Varick Street, New York, NY 10014 (212) 366-5540

5/92

Source: Reprinted by permission of Choice in Dying (formerly Concern for Dying/Society for the Right to Die), 200 Varick Street, New York, NY 10014-4810, 212/366-5540.

suffering people who do not really want to die. In a moment of despair, a patient may state a desire to die and may even sign a legal form requesting that extraordinary life sustaining procedures not be used. But the patient often changes his or her mind when something hopeful or pleasurable occurs.

CAPITAL PUNISHMENT

Another controversial legal issue concerned with actively taking a person's life is capital punishment. The death penalty has been applied to hundreds of different crimes since ancient times. Hammurabi's Code decreed death for selling beer, and a similar fate awaited a Roman wife who stole the keys to her husband's wine cellar. The ancient Egyptians executed people for idolatry; the ancient Persians executed people who accidentally sat on the king's throne, and the ancient Greeks executed those who committed a sacrilege (Caldwell, 1991). During the Middle Ages, capital punishment was widely employed for crimes against the church and state. Even as late as 1819, 223 different capital crimes were listed under British law (Radzinowicz, 1948). The 13 capital crimes in Massachusetts in 1636 indicate the influences of sex and religion on legal punishment: adultery, assault in sudden anger, blasphemy, buggery, idolatry, manstealing, murder, perjury in a capital trial, rape, rebellion, sodomy, statutory rape, and witchcraft (Haskins, 1956). The American colonies had no uniform system of criminal justice, and whether or not an offense was deemed a capital crime depended to a great extent on the locality in which it occurred.

Number of Executions

Although the total number of crimes warranting the death penalty has declined since colonial times, people in the United States have been executed during the twentieth century for armed robbery, arson, kidnapping, murder, rape, treason, and military desertion. Unlike the public executions of earlier centuries, which were supposed to serve as examples to would-be criminals, the great majority of executions in this country since 1900 have not been public spectacles. Most of these executions were for murder, with the crime of rape being second.

The number of executions for capital crimes has varied widely from state to state. Approximately 86 percent of the executions from 1976 to January 1993 were in the South, over 28 percent occurring in Texas alone (National Coalition to Abolish the Death Penalty, 1992).

Figure 7-5 is a graph of the number of executions each year from 1930 to 1993. From 1930 to 1968, an average of more than 100 people were executed in the United States each year. Because of U.S. Supreme Court rulings, executions were suspended from 1968 through 1976, but 191 people were executed between 1976 and 1993. An additional 160 executions have been carried out under military authority since 1930. As shown in Figure 7-6, 54 percent of those executed from 1976–1992 were white, 39 percent were black, and 5 percent were Hispanic; one Native American was executed. However, 84 percent of the victims were white, 13 percent

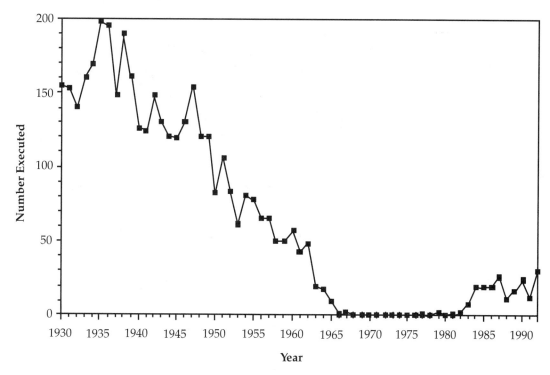

FIGURE 7-5 Number of Persons Executed in the United States, 1930–January 1993

Source: From data provided by U.S. Department of Justice, Bureau of Justice Statistics.

were black, and the remainder were Hispanic or Asian. Capital defendants who kill white victims are more likely to receive the death penalty than those who kill black victims, a fact cited in support of the allegation that capital punishment is racist.

Methods of Execution

Historically, people convicted of capital crimes have been beheaded, boiled in oil, burned, crucified, crushed, disemboweled, drowned, electrocuted, flayed alive, forcibly overfed, gassed, hanged, impaled, injected with chemicals, poisoned, shot, smothered, stoned, strangled, thrown to wild beasts, torn apart, or subjected to other forms of overkill. Two intricate examples of cruel and unusual punishment are those prescribed in ancient Persia and Rome. In the ancient Persian method of "the boats," the condemned person was placed in a boat and another boat was fitted over it. The prisoner, whose head, hands, and feet protruded from the boats, was then force-fed with milk and honey and smeared with the mixture. Following this treatment he was left exposed to the sun and eventually eaten by insects and vermin (Caldwell, 1991). In ancient Rome, persons found guilty of the crime of parricide (kin killing) were bound and sealed in a sack with a dog and a chicken. The sack was

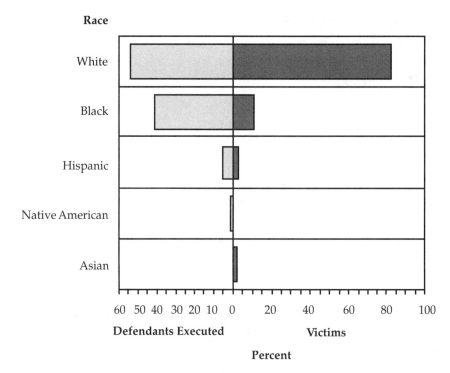

**FIGURE 7-6 Races of Defendants Executed and Victims, 1976–
January 1993**

Source: From data provided by National Coalition to Abolish the Death Penalty.

then tossed into the water, and the person drowned if he or she was not first
scratched to death by the animals (Rosenblatt, 1982). A dog also figured in a 1906
execution in Switzerland. The animal, along with several people, was executed for
its participation in a robbery and murder (Gambino, 1978).

Hanging was the most common method of execution in England during colo-
nial times, with the ax being reserved for treason, burning at the stake for witchcraft,
and disemboweling and quartering for counterfeiting. As illustrated by the follow-
ing legal sentences, the first of which was imposed on an Englishman in the
thirteenth century and the second on several Englishmen in the nineteenth century,
methods of execution could be quite cruel and unusual.

*Hugh (Hugh Dispenser the Younger) . . . you are found as a thief, and therefore
shall be hanged; and are found as a traitor, and therefore shall be drawn and
quartered; and for that you have been outlawed by the King, and . . . returned to the
court without warrant, you shall be beheaded and for that you are abetted and
procured discord between the King and Queen, and others of the realm, you shall be*

embowelled, and your bowels burnt. Withdraw traitor, tyrant and so go take your judgment, attainted wicked traitor. (Jankofsky, 1979)

That each of you, be taken to the place from whence you came, and from thence be drawn on a hurdle to the place of execution, where you shall be hanged by the neck, not till you are dead; that you be severally taken down, while yet alive, your bowels be taken out and burnt before your faces—that your heads be then cut off, and your bodies cut into four quarters, to be at the King's disposal. And God have mercy on your souls. (Scott, 1950, p. 179)

Five different methods of execution are now lawful in the United States, depending on the particular state: lethal injection (22 states), electrocution (12 states), lethal gas (7 states), hanging (3 states), firing squad (2 states). Electrocution and lethal gas have been the most common methods since 1930, accounting for 75 percent of the executions (see Figure 7-7). Some states authorize one of two different methods of execution, such as lethal injection or electrocution (U.S. Department of Justice, 1992). Federal executions are carried out according to the method of the state in which they are performed.

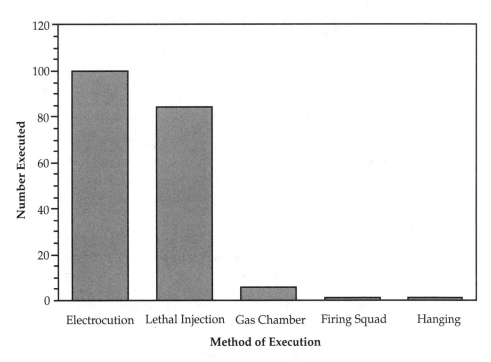

FIGURE 7-7 Executions by Method Used in United States, 1976–January 1993

Source: From data provided by National Coalition to Abolish the Death Penalty.

Court Decisions

A landmark U.S. Supreme Court decision on capital punishment was handed down in 1972 in the case of *Furman* v. *Georgia.* By a vote of five to four, the court judged Georgia's death penalty law, as it was administered in the mid-1960s, to be unconstitutional, according to the Eighth Amendment prohibiting cruel and unusual punishment. The effective result of this decision and subsequent Supreme Court decisions pertaining to capital punishment was to strike down existing capital punishment statutes. Laws that made capital punishment mandatory for certain crimes, and that eliminated the discretion of the judge and jury in setting penalties, were declared unconstitutional (*Roberts* v. *Louisiana, Woodson* v. *North Carolina,* 1976). Laws making rape a capital crime (*Coker* v. *Georgia,* 1977) and laws specifying a limited number of mitigating circumstances in deciding punishment (*Lockett* v. *Ohio,* 1978) were also invalidated. Other laws declared unconstitutional were those excluding prospective jurors who admit that the possibility of capital punishment would make their decision difficult (*Adams* v. *Texas,* 1980). Several studies have shown that so-called death-qualified juries, composed of jurors who are not opposed to the death penalty, tend to be conviction prone (Gross, 1984).

On the side of capital punishment, three separate Supreme Court decisions rendered in 1976 (*Gregg* v. *Georgia, Jurek* v. *Texas, Profitt* v. *Florida*) upheld state laws providing for guided discretion in setting capital punishment sentences. Thus, the Court concluded that when applied thoughtfully, carefully, and under the right circumstances, capital punishment is not unconstitutional. As a result of these decisions, by 1992, a total of 38 jurisdictions had revised capital punishment statutes on their books, but 15 jurisdictions were still without capital punishment statutes (U.S. Department of Justice, 1992).

Although the minimum age for capital punishment in 17 states is under 18 years, relatively few juveniles have been executed. However, in 1989, the U.S. Supreme Court ruled that the constitutional ban on cruel and unusual punishment does not forbid the execution of youths who commit crimes at 16 or 17 years of age, nor does it automatically prohibit death sentences for mentally retarded defendants ("Bad News for Death Row," 1989).

Death Row

The number of prisoners awaiting execution has increased sharply since 1973, while the states awaited Supreme Court decisions on capital punishment and drafted new legislation to conform to those decisions (see Figure 7-8). At the beginning of 1993, there were 2,676 prisoners on death row in the United States. Approximately 98 percent of these inmates were men and 51 percent were white (see Figure 7-9). A typical death-row inmate is a white or black man in his late twenties or early thirties with less than a high school education. In over 40 percent of the cases, he is imprisoned in one of four states—Texas, California, Florida, or Illinois (NAACP Legal Defense and Educational Fund, 1992).

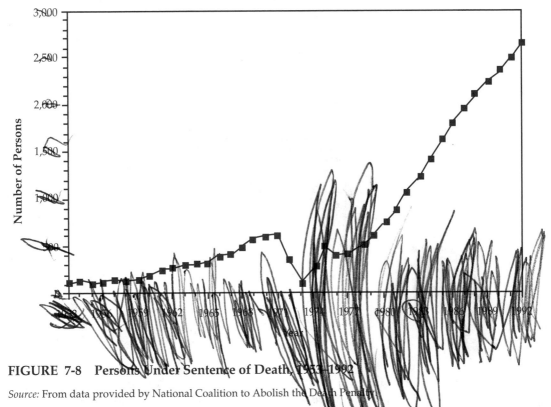

FIGURE 7-8 Persons Under Sentence of Death, 1953–1992

Source: From data provided by National Coalition to Abolish the Death Penalty.

Life during the several years that a typical prisoner resides on death row has been characterized as legalized torture. Several men executed since 1976 chose not to appeal the death sentence and many more chose suicide rather than being forced to remain in the oppressive atmosphere of death row. As one prisoner stated, "A maggot eats and defecates. That's all we do: eat and defecate. Nothing else. They don't allow us to do nothing else" (Johnson, 1982).

There is at least one other thing that death row inmates do besides eating, sleeping, and performing other natural functions: They spend much of their time thinking. And what do they think about? From an analysis of letters and other documents written by inmates awaiting execution, Shneidman (1980b) concluded that they think intensively about themselves and what it will be like when they are dead. Knowing that one is about to die results in focusing on the self, to such an extent that the person literally begins to mourn or grieve for himself. Shneidman's sample of written documents is probably not representative of death-row inmates in general, but many of the letters demonstrate a nobility of sentiment and concern about other people in the face of death. Thus, the execution notes analyzed by Shneidman reveal an increased compassion for loved ones and a feeling of inner

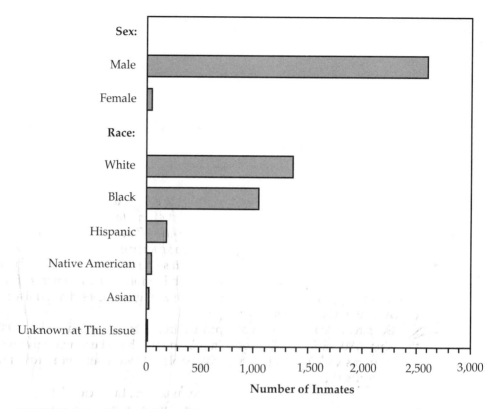

FIGURE 7-9 Sex and Race of Inmates on Death Row, United States, in January 1993

Source: From data provided by the NAACP Legal Defense and Educational Fund, Inc.

peace as the end of life approaches. Many death-row inmates also develop strong religious convictions and beliefs in reincarnation or other forms of afterlife.

Pros and Cons of Capital Punishment

The United States is one of the few Western nations that has not abolished the death penalty, although for over 200 years many prominent citizens have opposed it. One of those citizens was Benjamin Rush, a doctor in the Revolutionary War, the father of American psychiatry, and the father of the U.S. movement to abolish capital punishment (Post, 1944). Other industrialized nations that make regular use of capital punishment are Russia, South Africa, and Japan, but it has been abolished in Canada and most Latin American countries.

Only a small percentage of death-row inmates have been executed in recent years, but public sentiment in favor of the death penalty remains high. For example, 75 percent of those questioned in a 1989 poll indicated approval of capital punish-

ment ("Bad News for Death Row," 1989). Why is there such overwhelming support for what some would call "legalized murder?" According to Sellin (1980, p. 6), there are at least three community services that the death penalty might be expected to perform:

1. Satisfaction of the demand for retribution by making the criminal pay with his or her life
2. Discouraging others from committing capital crimes, that is, general deterrence
3. Removal of the danger that the criminal's survival would pose to society, that is, prevention and protection

In general, opponents of capital punishment argue that extensive research has provided no conclusive evidence in support of capital punishment for retribution, general deterrence, or prevention and protection. There is certainly no evidence that murderers, who typically act impulsively, are deterred by the legal consequences of their actions. Rather than the threat of punishment, it is the swiftness with which punishment is applied that deters criminal behavior. And due process of law, which typically takes years in the U.S. judicial system, guarantees that punishment for a capital crime will not be swift.

Despite the concern with due process in capital cases, Margolick (1985) found that since 1900 at least 350 people in this country have been wrongly convicted of crimes punishable by death. Of these people, 139 were sentenced to death and 23 were executed.

Regarding protection against further murders, the recidivism rate for murder parolees is extremely low. Regarding retribution, it may be considered sufficient that capital punishment serves as an expression of community outrage and the moral right of society to retribution. This position stems from Hammurabi's Code or *talion law* (the principle of "an eye for an eye and a tooth for a tooth") and the Mosaic Law, but it is at odds with the position of many religious groups (National Interreligious Task Force on Criminal Justice, n.d.). Nevertheless, Christians who favor capital punishment point out that the scriptural prohibition against killing should be interpreted as applying only to the actions of persons acting solely on their own. Even Christ, it is maintained, accepted his execution because it was ordered by legally constituted authority.

Whether or not a society feels that capital punishment is justifiable on the grounds of social retribution, it would seem necessary for the sentence to be imposed fairly, without regard to race, sex, socioeconomic status, or special influence. But law enforcement pertaining to capital punishment has never been very consistent or fair. For example, only about half of the willful homicides lead to murder charges, and only about half of those charged with murder are prosecuted for capital murder (Sellin, 1980). It is usually impossible to determine all the factors that led to a capital murder charge and to the imposition of a capital sentence, but the fact that justice has been applied unequally justifies the question of whether capital punishment is administered fairly. After examining the roles of sex and other factors in sentencing for capital cases, it can be concluded that not only has the

death penalty failed as an agent of retribution but that the selective application of capital punishment has grossly distorted justice.

Another argument made by proponents of capital punishment is an economic one: It is cheaper to execute a person than to keep him or her in an institution for a long period of time. Opponents of the death penalty maintain, however, that enforcement of capital punishment is becoming more and more expensive and that simple incarceration for life or a long period of time provides a convicted person with the opportunity for self-support and some form of restitution to the relatives of the victim (Caldwell, 1991).

Perhaps the most pernicious effect of capital punishment is that it makes people believe they have done something constructive about crime, whereas in reality they are probably only making matters worse. All too often capital punishment has merely brutalized a society, and the sanctioning of official killing as a response to a private killing has only added a second defilement to the first (Camus, 1955).

WILLS, TAXES, AND LIFE INSURANCE

Another matter pertaining to death and dying that is of concern to the legal profession is the disposition of estates. Not everyone who dies leaves behind an appreciable amount of property. Many people die poor, and a few even manage to "take it with them." For example, there are no wealthy people in a certain Arizona Indian culture, because a dead person's possessions are buried with the corpse (Shaffer & Rodes, 1977). Since the dead take their possessions with them into the next world rather than leaving them to the living, the survivors are materially poor and remain that way except for what they can earn or what they are given by others.

Burying a dead person's possessions with the corpse is not unique to these Indians. As noted in Chapter 5, it has been practiced since Stone Age times and reached its height in the opulent grave goods of the Egyptian pharaohs' tombs. However, even the dead pharaohs did not take everything with them; some of the royal treasury was left for future pharaohs.

Wills in the Middle Ages

Throughout history, the usual practice of disposing of one's property at death has been to leave it to family, friends, and institutions. As far back as ancient Rome, the manner in which a decedent's property was to be distributed was frequently recorded in a legal document known as a *will*. In medieval Europe, under the direction of the Church, the preparation of a will prior to death became an obligatory sacrament, even for the poor. Like the confession of sins, the disposal of one's worldly property served as a form of redemption, as long as it was given to pious causes. A person who did not make a will could be excommunicated, and those who died intestate (without a will) were presumably not buried in sacred ground (Aries, 1981).

Despite the shortness of life and the weak condition of entrepreneurship during the Middle Ages, many people managed to accumulate property and other holdings. They were proud of their possessions, but they also had strong beliefs in an afterlife. And there arose the conflict—a conflict of love of life and material things versus the paralyzing fear of eternal damnation and hell. The resolution of this conflict in many cases was to give all one's worldly goods, or at least a substantial portion of them, to the poor, to hospitals, and to churches and religious orders. In response to this generosity, which often left the benefactor's family almost penniless, the Church issued a kind of passport to heaven to the benefactor, agreeing to have masses, services, and prayers said in perpetuity for his or her soul. As for the living, having little or no legacy made it even more difficult to accumulate the fortunes required for successful capitalistic enterprises.

By the middle of the eighteenth century, charitable contributions and the endowment of masses were no longer the principal reasons for the last will and testament. What had been a philanthropic religious document during the Middle Ages now focused on family management (Aries, 1981). Ambivalence between love of life and desire for salvation was still expressed in the wills of the Renaissance and Enlightenment, often in poetic or at least literary form. But the hold of the Church on the human mind and spirit had weakened, and the influences of more practical economic and legal factors begin to manifest themselves.

Modern Wills

Although two thirds of all Americans die without having made a will, drawing up wills is a big business in the modern world. Most states have a common procedure for implanting a written attested will, but there is actually no standard legal form on which it must be drawn up and no universally required procedure for making a will. In fact, certain states accept an unwitnessed will prepared in the testator's[3] (legator's) own handwriting (a *holographic will*) or even an oral will (a *nuncupative will*). A nuncupative will, however, is legal only under limited circumstances, as when a person is in fear of imminent death from an injury sustained on the same day or by a soldier or sailor engaged in military service.

Another special type of will is a *mutual will,* which contains reciprocal provisions as when, for instance, a husband and wife decide to leave everything to each other without restrictions. Also used in some circumstances is a *conditional will,* the provisions of which are put into effect only when certain events occur. For example, the will may state that certain monies or property are to be held in trust until specific conditions described in the will are satisfied.

Among the legal requirements for making a will in most states are that the testator or legator (the person making the bequest) be at least 18 years old and of sound mind, that a sufficient number of witnesses (usually two or three) be present, and that the document be executed in proper form. Included in the will are the testator's name, address, and age, followed by a statement of his or her capacity to make a will (*testamentary capacity*)[4] and voluntariness of the action. Next is a listing

BOX 7-2 • A Holographic (Homemade) Will

The following is a will written by Herman Oberweiss, as offered for probate at the June 1934 term, County Court of Anderson County, Texas.

I am writing of my will mineself that des lawyer want he should have too much money he asked to many answers about the family. First think i want i dont want my brother Oscar to get a dam thing what i got he is a mumser and he done me out of four dollars fourteen years since.

I want it that Hilda my sister she get the north sixtie akers of at where i am homing it now i bet she dont get that loafer husband of hers to brake twenty akers next plowing. She cant have it if she lets Oscar live on it i want i should have it back if she does.

Tell mama that six hundred dollars she been looking for twenty years is berried from the bakhouse behind about ten feet down. She better let little Frederick do the digging and count it when he comes up.

Pastor Ticknitis can have three hundred dollars if he kiss the book he wont preach no more dumhead talks about politics. He should a roof put on the meeting house with and the elders should the bills look at.

Mama should the rest get but i want it that Adolph should tell her what not she should do so no more slick irishers sell her vaken cleaner they noise like hell and a broom dont cost so much.

I want it that mine brother Adolph be my executer and i want it that the judge should please make Adolph plenty bond put up and watch him like hell. Adolph is a good bisness man but only a dumpph would trust him with a busted pfennig.

I want dam sure the schlaimial Oscar dont nothing get. Tell Adolph he can have a hundret dollars if he prove judge Oscar dont nothing get that dam sure fix Oscar.

(Signed) Herman Oberweiss

Source: William J. Prosser, *Judicial Humorist: A Collection of Judicial Opinions & Other Frivolities.* Fred B. Rothman & Company, 1989. Reprinted by permission.

of the disposition of specific items in the estate and the names of the heirs (distributees, legatees) (see Box 7-3). The will may also include the line of succession to be followed or alternate beneficiaries in the event that the primary beneficiary dies before the estate is probated. The name of the appointed executor of the will or estate should also be given, followed by the dated signature of the testator and the signatures and addresses of the witnesses. A will may be altered, added to by means of a codicil, or destroyed by the testator at any time. Thus, a will is considered "ambulatory" in that it may be altered or revoked as long as the testator is of sound mind and intends to revoke it.

Laws concerning inheritances and wills vary from country to country and state to state within the United States. Most states, however, require that either a will be filed or the nonexistence of a will be disclosed to a probate court within 10 days after death. Certain procedural matters pertaining to the legality of a will are usually resolved fairly easily. If a person names an executor of the estate, that executor serves under the jurisdiction of a local probate court. But if no executor is named by the testator or if a person dies *intestate* (no valid will having been found), the court appoints an administrator to handle the distribution of the decedent's property. Probate courts also become involved in disputations about whether a will is valid or

BOX 7-3 • Some Illustrative Bequests

The following illustrative bequests were taken from *To Will or Not to Will*, by Joseph E. Bright, published by W. S. Hein & Associates, Buffalo, New York.

A captain of finance wrote:

To my wife, I leave her lover, and the knowledge that I wasn't the fool she thought I was.

To my son, I leave the pleasure of earning a living. For twenty-five years he thought the pleasure was mine. He was mistaken.

To my daughter, I leave $100,000. She will need it.

The only good piece of business her husband ever did was to marry her.

To my valet, I leave the clothes he has been stealing from me regularly for ten years, also the fur coat he wore last winter while I was in Palm Beach.

To my chauffeur, I leave my cars. He almost ruined them, and I want him to have the satisfaction of finishing the job.

To my partner, I leave the suggestion that he take some other clever man in with him at once if he expects to do any business.

which of several wills takes precedence (usually the most recent). If no legal heirs can be found, the estate *escheats,* or passes to the state in which it is probated.

One of the most common disputes regarding bequests and wills has to do with the question of legal heirs or beneficiaries. British law historically subscribed to the rule of primogeniture, in which the male was preferred over the female line and the eldest over the youngest in the distribution of real property. A decedent's property, however, went to the next of kin. Furthermore, illegitimate children had no rights of inheritance under English common law (Arenson, 1991). Such distinctions have largely disappeared in modern inheritance laws, and, depending on the particular state, anyone—relative or not—can be a legal heir to an estate. On the other hand, under the legal provisions of states with community property laws, each spouse has an equal interest in certain property and therefore cannot be disinherited. At the death of the testator, the surviving spouse is entitled to half the community property. In many other states, however, the spouse who earned the funds used to acquire the property owns the property outright and need not leave any of it to the surviving spouse. Regardless of the wishes of the testator, most states do not permit the surviving spouse to be left destitute, and will award at least a portion of the estate to that person.

Whether or not preferential treatment is given to the surviving spouse, a testator may legally elect to leave nothing to the surviving children. Traditionally, a person's natural heirs have been his or her blood kin, and adopted or foster children may receive nothing at the death of their foster parents. In recent years, however, there has been a liberalization of children's rights of inheritance. For example, California has liberalized its rules to allow foster children to inherit under certain circumstances.

When a widow or widower dies, the bulk of the estate goes to the children or, if there are none, to other immediate relatives. The estate is typically distributed among the heirs in a pattern of *serial reciprocity,* in which the largest share of the

estate goes to the adult child who has rendered the greatest service to the deceased over the years; the adult child who has rendered the second-most service receives the next largest share, and so on. The principle that bequests should be proportional to the amount of assistance provided to the parent is usually acceptable to the heirs, but sometimes arguments occur over precisely how much assistance was rendered by whom (Sussman, 1985).

Avoiding Probate

Probate is a judicial process, handled by a special court (*probate court*) for administering the estate of a deceased person. Following a public announcement to the effect that the will of the decedent is being probated, all claims against the estate must be settled and the property distributed by the executor of the estate according to the decedent's wishes. The probate process can be time consuming and expensive when there are disputes concerning the disposition of the estate.

One of the first questions asked of an estate planning attorney is how to avoid probate. Increasingly, wealth is being passed through annuitization (insurance, retirement plans, employee stock plans, annuities, etc.), which is outside the normal probate estate. In addition, legislatures are now allowing bank accounts held pursuant to survivorship rights to be treated like joint tenancy in real estate so they are not subject to probate. Probate may also be avoided by transferring most of one's property to others (beneficiaries) while one is still alive or by transferring it into a form of coownership (joint tenancy) with right of survivorship.

Trusts and Life Insurance

One of the most common methods of managing property during the later years with a view to continuing support of the survivors once the owner (trustor or settlor) has died is to establish a trust. The trustor retains control over the property during his or her lifetime, but on the death of the trustor the trust property is distributed to the designated beneficiaries without being probated.

The purchase of life insurance as a way of protecting dependents from paupery in the event of the death of the insured did not become popular in the United States until the midnineteenth century. Today, however, it is a multibillion-dollar business. There are many types of life insurance, including term life insurance, universal life insurance, and variable life insurance. Premiums are lowest for a term policy, which is in effect for a fixed number of years (5, 10, etc.) with the premiums increasing as one ages. Group policies, in which the amount of the premiums depends on being a member of a particular employment or other group, are typically less expensive than individual policies. Unlike term insurance, universal and variable life policies include investment opportunities. Universal life is most flexible, not only for its investment possibilities but also because the premiums may be increased or decreased depending on the coverage on one's life. Variable life also includes opportunities for purchasing stocks, money market shares, and other investments, but the amounts of the premiums and life coverage do not change.

It is important to study the terms and conditions of an insurance policy carefully before taking out a policy on one's life. For example, the accidental death benefit will depend on whether the contract contains a double-indemnity clause; if so, then twice the face value of the policy is paid in the event of accidental death. If death occurs in an employment context, the beneficiaries are also entitled to workers' compensation death benefits. When death is caused by suicide, accidental death benefits are void. And when death is due to homicide, the murderer loses all rights to the decedent's property to which he or she might otherwise have been entitled. Even when the death is accidental, if it is proven to be the result of negligence by another person, that person may be held accountable for damages to which the deceased would have been entitled if he or she had lived.

Death Taxes

Traditionally, a legal system of inheritance has had three purposes: (1) to maintain order in dividing the decedent's property; (2) to support the decedent's dependents; (3) to inhibit the growth of private wealth and raise revenues for the government. It is the third purpose that has prompted the levying of *death taxes*. These kinds of taxes existed even in ancient Egypt, Greece, and Rome and continued to be levied during the Middle Ages (Mercer, 1991).

There are two kinds of death taxes—estate and inheritance taxes. *Estate taxes* are levied on property left at death and are paid from the estate before the remaining assets are distributed to the heirs. *Inheritance taxes* are levied on the heirs, the tax being a percentage of the value of the property inherited by the heir. The United States has both state and federal death taxes, Pennsylvania having been the first state (1826) to impose death taxes. Today all states except Nevada have estate and/or inheritance taxes, ranging from 2 to 23 percent of the taxable property. Recently, however, several states have moved away from inheritance taxes, effectively abolishing them in some instances.

The U.S. government levied its first death tax in 1797, a 0.5 percent stamp tax on the transmission of estates. The current federal system of estate taxation began in 1916; the rates were raised in 1924, lowered in 1926, raised again in 1932 and 1941, and "reformed" in 1976. Death taxes are higher in Great Britain, where they have served to break up large landed estates (Sennholz, 1976).

Despite their apparent magnitude, only a small percentage of the total tax collected by the U.S. government comes from estate taxes. The availability of many tax shelters, such as trusts and foundations, results in the payment of relatively low estate taxes by affluent people. As of 1987, only estates greater than $600,000, after various deductions, are taxed.

One way to avoid large federal and state taxes is to set up a trust spanning one or more generations. For example, if a husband's property is placed in trust, his wife can avoid inheritance taxes by living only on the income from the estate after his death. When she dies, the estate either remains in trust or passes to the surviving children. In the former case, the children also avoid taxation; in the latter case, the

estate is now taxed. The appreciated property remaining in the estate is free of capital gains, and the estate tax is probably less than it would have been previously.

Gift Taxes

In addition to death taxes, gifts made by a person before death may be taxed (gift taxes). Gifts of unlimited amounts may be given to charity without paying gift taxes, and other gifts of certain amounts during a specified time period are also not taxed. Thus, a person may distribute $10,000 per donee per year to as many people as he or she likes without paying any taxes on the gifts; the donee pays no income tax on the gift. This gift splitting allows a husband and wife to transfer $20,000 per year. The largest tax savings on gifts, however, come from property, cash, or stock given to private foundations. Nonvoting stock given to a charitable foundation is not taxed, but the gift enables the benefactor to retain control of the company by means of his or her voting stock. It is understandable why numerous private educational, medical, and charitable institutions owe their very existence to the dislike of the wealthy for taxes.

The Tax Reform Act of 1976 and the Economic Recovery Tax Act of 1981 instituted a fairly uniform tax on lifetime and death transfers, so the tax advantages of transferring property before death are now minimal. However, since estate or gift taxes are assessed on the value of assets at the time of transfer, lifetime transfer may be advantageous when property is expected to increase in value (Scheible, 1988).

There are so many opportunities and intricacies in death tax law that finding ways to avoid these taxes has become a full-time occupation for some accountants and attorneys. Considering the complexities of federal and state laws pertaining to inheritances and gifts, it is advisable for anyone planning a bequest to consult an attorney. Estate planning, of which the will is only a part, is itself only one aspect of planning for death. In addition to preparing a will and understanding death taxes, it is wise for both benefactors and beneficiaries to become familiar with the language of laws pertaining to insurance policies, joint bank accounts, safe-deposit boxes, Social Security benefits, veterans' benefits, and civil service benefits.

SUMMARY

The major legal issues pertaining to death are determining when death occurred and what caused it, taking or shortening human life for medical or legal reasons, and disposing of the decedent's property. The various legal procedures associated with death and dying are designed to protect people from untimely death and improper burial and to make certain that estates are disposed of according to the decedent's wishes.

The concept of brain death is now accepted in many states, but the definition of *death* as the cessation of all vital functions is still applied in others. All states require a death certificate that contains identifying data and information on the time and cause of death; the death must be registered and a burial permit issued after the

death certificate is completed. Special legal problems occur when a death is not natural, that is, when it is due to accident, homicide, suicide, or an undetermined cause. In such cases, the coroner or medical examiner may decide to conduct an autopsy to isolate the cause of death.

An estimated 1.6 million abortions are performed annually in the United States. When performed after the twelfth week of pregnancy, abortion becomes increasingly hazardous to the health of the mother. Opposition by the Roman Catholic Church and other organizations has made induced abortion illegal in most Western countries, but there are virtually no restrictions on performing abortions in Eastern European countries, Russia, Japan, or China. In the United States, abortion has been the subject of intense debate between prolife and prochoice groups over the past two decades.

Euthanasia, or mercy killing, may be voluntary or involuntary and active or passive. The debate over euthanasia has centered on voluntary euthanasia (with the person's consent) of the active or passive sort. Despite strong religious opposition, public approval of euthanasia—especially passive euthanasia—has increased during recent years. The Roman Catholic Church now accepts passive euthanasia as morally defensible in certain instances, for example, turning off the respirator in a case of irreversible coma. Some states have passed natural death acts pertaining to medical responsibilities and procedures with regard to terminal patients, but the wording of these laws is not always legally or medically clear.

Over 4,000 people were executed in the United States between 1930 and 1992, the great majority for murder or rape. They were electrocuted, gassed, hanged, shot, or, more recently, injected with a lethal substance. There were no executions in this country from 1968 to 1976, but there were 191 executions from 1977 to January 1993. In early 1993 there were approximately 2,700 persons on the death rows of this nation, living in an environment described by some as legalized torture.

The United States is one of the few Western nations that have not abolished the death penalty, although much care is now exercised to make certain that prisoners' legal rights are not violated. Proponents of capital punishment argue that it serves its purposes of retribution, general deterrence, and prevention. The results of research on the effects of capital punishment, however, do not support this assertion.

The last will and testament has changed from a primarily religious document in the Middle Ages to a legal document for family and estate management. Wills are usually written and then witnessed by two persons, but oral and unwitnessed wills are legal under certain conditions. Questions concerning the authenticity or conditions of a will must be resolved in a probate court.

There are two kinds of death taxes, estate and inheritance, either or both of which may be assessed by state (except Nevada) and federal governments. Setting up a trust and/or giving property to a foundation are ways of avoiding large estate taxes. A person can avoid death taxes on a certain amount of money while still alive by giving the money to a number of individuals, although gift taxes are assessed when the amount becomes large. Preparing a will and being knowledgeable about death taxes are essential to estate planning, but planning for death should obviously go beyond estate planning.

QUESTIONS AND ACTIVITIES

1. Suppose that a close relative or friend of yours was dying from a painful, incurable illness and asked you to help him or her die. What would you say or do? Under what conditions, if any, would you be willing to help the person die? If you denied the request, what arguments would you make to encourage the person to give up the self-destructive thoughts and go on living?

2. Design a questionnaire or rating scale to measure student attitudes toward abortion and euthanasia. Administer your questionnaire to a dozen students and summarize the results.

3. Administer the following questionnaire to six men and six women students. Analyze the differences in the responses of the two sexes.

Attitudes Toward Capital Punishment

Directions: Indicate your degree of agreement or disagreement with each of the following statements by writing SA (strongly agree), A (agree), U (undecided), D (disagree), or SD (strongly disagree) in the marginal dash.

_____ a. I am in favor of capital punishment for the crime of murder.

_____ b. I am in favor of capital punishment for the crime of rape.

_____ c. I am in favor of capital punishment for the crime of arson.

_____ d. I am in favor of capital punishment for the crime of armed robbery.

_____ e. I am in favor of capital punishment for terrorism.

_____ f. Killing another person while driving under the influence of alcohol is deserving of capital punishment.

_____ g. Committing a murder for $100,000 is deserving of capital punishment.

_____ h. A killer who is guided by a radical ideology, such as the Zebra killers in the San Francisco Bay Area, deserves capital punishment.

_____ i. A person who commits murder when he is 15 years old or younger deserves capital punishment.

_____ j. A person who obeys the voice of God commanding him to kill his neighbor deserves capital punishment.

4. Take and defend a position on capital punishment. Cite specific research findings and logical arguments to support your position.

5. What is the legal status of (a) abortion, (b) euthanasia, and (c) capital punishment in the United States at the current time? Cite specific legislation to support your assertions in each case.

6. Not only epitaphs, but also wills have stimulated the poetic muse in some people. Consider the following poetic will:

I cherish life and have such fun
That I would hate to leave.
But death must come to everyone,
And all loved ones must grieve.

So now before my time is through,
I make this last bequest.
I hope that it will comfort you
When I have gone to rest.

The total of my property
To my dear spouse should go.
Whatever else belongs to me,
I will as said below.

I leave my love to all the earth,
My body to the sod,
And finally, of greatest worth,
I give my soul to God.

Try writing your own will in poetry, either rhymed or free verse. Before you begin the actual writing of the will, make an outline of what you wish to include in the will. After you have completed your will, date it, sign it, and have it signed by two witnesses.

7. What are some reasons for making a will, what procedures should be followed, and what should be included in it? How can a will be broken, under what conditions is a will considered invalid, and how is a will probated?

8. Arrange to visit an estate attorney's office and discuss his or her professional activities and experiences. What sort of training does an estate attorney need and what does he or she need to know? What rewards and other sources of satisfaction are to be found in this type of work?

ENDNOTES

1. *Louisville & N. R. Co. v. Wilson,* 123 Ga. 62, 51 S.E. 24 (1905).

2. Address of Pope Pius XII to an International Congress of Anesthesiologists, Nov. 24, 1957. AASXXXXXIX (1957). (Translation from the original French, *The Pope Speaks,* Spring 1958, Vol. IV, No. 4, pp. 393–398.)

3. Throughout this section, the masculine noun forms *testator, legator,* and *executor* are used to refer to both men and women. The comparable female nouns are *testatrix, legatrix,* and *executrix.*

4. *Testamentary capacity* is possessed by a testator who knows (1) the nature of his or her property ("bounty"), (2) that he or she is making a will, and (3) who his or her natural beneficiaries are. A testator's testamentary capacity is not the same as the competency to handle his or her life and property. A person's competency, if questioned by relatives or heirs, must be determined by a legal hearing separate from that required to establish testamentary capacity.

SUGGESTED READINGS

Annas, G. J. (1991). *The rights of patients: The basic ACLU guide to patient rights* (2d ed.). Clifton, NJ: Humana Press.

Bouma, H., Diekema, D., Langerak, E., Rottman, T., & Verhey, A. (1989). *Christian faith, health, and medical practice.* Grand Rapids, MI: Eerdmans.

Humphry, D. (1981). *Let me die before I wake:*

Hemlock's book of self-deliverance for the dying. Los Angeles: The Hemlock Society.

Moreland, J. P., & Geisler, N. L. (1990). *The life and death debate: Moral issues of our time.* Westport, CT: Praeger.

Nathanson, S. (1987). *An eye for an eye? The morality of punishing by death.* Totowa, NJ: Rowman Littlefield.

Scheible, S. S. (188). Death and the law. In H. Wass, F. M. Berardo, & R. A. Neimeyer (Eds.), *Dying: Facing the facts* (2d ed., pp. 301–319). Washington, DC: Hemisphere Publishing Co.

Sutkowski, E. F. (1986). *Estate planning: A basic guide.* Chicago: American Bar Association.

Zucker, A. (1988). The right to die. Ethical and medical issues. In H. Wass, F. M. Berardo, & R. A. Neimeyer (Eds.), *Dying: Facing the facts* (2d ed., pp. 323–344). Washington, DC: Hemisphere Publishing Co.

PART IV

HUMAN DEVELOPMENT AND DEATH

8

CHILDHOOD AND DEATH

Childhood is supposed to be a happy time, a time when one's thoughts and feelings are focused on living, learning, and having fun. Therefore, *children and death* may appear to be an unkind, or at least an unfortunate, combination of words. Death is seen as a more appropriate companion of old age than of childhood. Certainly children in industrialized societies today seem to be less familiar with death than sex—the opposite of what was true for children of yesteryear. Another way of expressing this phenomenon is that today's children know more about their beginning than their end.

Why are children of today less acquainted with death than those of earlier generations? One reason is a lack of exposure to death at an early age. Today it is not unusual for people to reach their late teens or even twenties without directly experiencing the death of a single friend or family member. In fact, it has been estimated that during the first half of life, the average American attends only one funeral every 15 years (Whitley, 1983). For most people, death is an unwelcome stranger who finds them emotionally and intellectually unprepared for the meeting.

Death was no more welcome in previous times than it is now, but it was no stranger. Yesterday's children lived with death, and it was an exception for a child to reach adolescence without having witnessed the death of a sibling, a grandparent, or another close relative or friend. Death was a part of children's lives, and, as seen in the needlepoint samplers that young girls in early nineteenth-century Rhode Island made of a woman grieving over a crypt, a part of their education.

At the beginning of the twentieth century, death was almost as common in infancy as in old age. Childhood diseases such as measles, mumps, and chicken pox, which are now viewed as little more than passing inconveniences, were epidemic killers of children in the past. In addition, many children who escaped death from some contagious disease in infancy or early childhood became orphans when one or both of their parents succumbed. Because children's lives were so fragile, parents and other members of the family did not permit themselves to become too attached to a young relative; by today's standards their reactions to the death of yet another child might seem unfeeling (Wilcox & Sutton, 1985). The fact that families tended to be larger, often having a dozen children or more, not only served to protect the family from being demolished but also tended to soften the blow when a member died.

There is another reason why today's children are less familiar with death than those in previous generations: Dying has become less public. In former times, people died at home, surrounded by young and old family members and friends; now, they are more likely to expire in antiseptic, electronically equipped hospitals or nursing homes. Consequently, children are spared the unpleasantness and, unfortunately, the growth experience of observing the death of a grandparent or other relative. The relative simply "passes away" or "goes to heaven" without saying goodbye to the child. Even dead animals are something to be disposed of quickly, by a rendering plant or pet cemetery, before children see them and ask embarrassing questions.

The isolation and rapid disposal of the dead has been interpreted by thanatologists as indicative of a denial of death that was ushered in with the twentieth century (Aries, 1962). Death became what sex was in Victorian times—an unavoidable process but unsuitable for public viewing or discussion. In a turnabout from the Victorian era, modern children are permitted to ask questions about where they came from but not where they are going.

There are many signs that death has become rather distant from everyday life. Even the funeral has changed from a home-based event in which the deceased was laid out in the living room for all to see to a professionally orchestrated affair designed to maximize the efficiency of corpse disposal and minimize the public

display of grief. Also unlike previous times, particular efforts are now made to isolate children from the dying process and exclude them from participating in funerary rites. Children are typically viewed as fragile, impressionable little creatures who cannot cope with death and might very well be traumatized by it. Even discussing death with children, a process that makes adults uncomfortable and anxious, is taboo in many families.

The concept of childhood as a special stage in human development is actually a fairly recent occurrence in Western history. Until the eighteenth century, young people who were not yet fully grown were usually dressed very much the same as adults. They also participated in most of the same activities as adults, and shared many of the responsibilities of their full-grown elders. This was more likely to be true of the poor than the more affluent. In any event, the concept of *child* was much less age related than it is today. No matter what his or her chronological age, anyone who, because of limited ability or misfortune, was dependent on other people was labeled a *child* (Aries, 1962). One explanation of why children were treated more like adults in earlier times is that people in general were less educated, and children were more likely to contribute to the welfare of the family than they are today. Consequently, differences between adults and children in knowledge, ability, and behavior were less extreme in those days (Wass & Stillion, 1988).

Whatever the reasons for historical variations in the treatment of children may be, there are indications that, after almost a century of denying death and attempting to isolate young people from it, a different viewpoint is beginning to emerge. Research on topics such as the development of ideas and feelings about death, the effects of terminal illness in children on both the child and the family, and the effects on children of the loss of a parent is providing information and guidelines for death education and counseling. One result of these efforts has been the introduction of death and dying units and courses, not only at the college level but throughout the elementary and high-school grades. Much of the material used in these courses is also of value to parents who want to provide more meaningful answers to children's questions about death and dying and to prepare them for the death of a family member, a friend, or even a pet.

DEVELOPMENTAL CHANGES IN CONCEPTIONS AND FEARS OF DEATH

Despite the beliefs of many adults that children who think about death are abnormal in some way, death is a part of human development and a subject of interest to normal children. Parents cannot shield their children from death forever; it will be encountered in nature, in the media, and in conversations with other children and adults. What parents can do is deal with death and the child's questions about it in a natural manner that is suitable to the child's level of cognitive and emotional development.

Stages of Development

Jean Piaget's theory of stages in cognitive development has provided a starting point for much psychological research on children during the past half century, including children's conceptions of death. More than 40 years ago, Maria Nagy (1948) conducted a study of 378 Hungarian children, ages 3–10, that has become a classic in the psychology of death. All the children were questioned on their ideas about death, and those aged 6–10 also made drawings to represent those ideas. Following Piaget's theory of cognitive development, Nagy found evidence for three stages in the growth of children's conceptions of death. Nagy allowed for some overlap among the three stages and slight variations in the ages of onset of the stages, but she claimed that the order of the states and their age ranges are universal and invariant.

Most of the children in Nagy's first stage (ages 3–5) did not distinguish death from separation. People who died were believed to be asleep or on a journey from which they would awaken or return in time. To the preschoolers studied by Nagy, death was not a final or permanent condition; a dead person might come back to life at any moment. The person who was dead was seen as being less "alive" than a living person, but the deceased could still breathe, eat, and drink in the coffin or wherever he or she was.

The following excerpts are illustrative of the thinking of preschoolers:

"Dead people don't get hungry—well, maybe just a little!" *(Kastenbaum, 1985, p. 629)*

From a child's conversation with her 84-year-old great-grandmother) "You are old. That means you will die. I am young, so I won't die, you know. . . . But that's all right. Grandmother, just make sure you wear your white dress. Then, after you die, you can marry Nomo [great-grandfather] again and have babies." (Kastenbaum, 1977, p. 280)

Children in the second of Nagy's stages (ages 5–9) saw death as related to age (as did the child in the second quotation above); it is something that happens to old people. At this second stage, in which children are capable of concrete operational thinking and understanding the concept of conservation, death is seen as irreversible but not inevitable or universal.

Only bad people or those who have accidents die, and death can be outwitted if you are good, cautious, and fast. Therefore, one must be careful not to eat or drink too much, catch a disease, or get hurt. Children in this second developmental stage tend to accept the mortality of strangers before recognizing that the members of their family and even they themselves are also mortal. In Nagy's study, these children personified death as an angel, a bogy man (monster), or the death man. They also had difficulty understanding the difference between life and death. They were apt to view moving things as alive, whether or not those things moved by themselves, and nonmoving things as dead.

By stage three (ages 10 and above), the children studied by Nagy had developed a more realistic, adultlike view of death. Note that this stage overlaps Piaget's stage of formal operations, implying the ability to think abstractly. To these children, death was the real, inevitable, and irreversible destruction of body life—a fate that is yours even if you're careful. The conversation in Box 8-1 reveals the more mature level of questioning and thinking about death in a stage-three child. A 10-year-old girl and her father are discussing the death and cremation of their pet dog, which took place while the child and her brother were away at camp.

Effects of Culture and Experience

As with the Piagetian stages of cognitive development, not all children of a given chronological age fit into the stage posited by Nagy's schema. Culture, social class, and other experiences have significant influences on the development of death concepts. For example, a study of the death concepts of 6–16-year-old American children failed to find the extensive personification of death reported by Nagy. Instead, the children in this investigation were inclined to use specificity of detail as a means of mastery and control over death (Koocher, 1974). The results of another study indicate that children in the United States also understand the organic basis of death at an earlier age than Nagy's subjects (Childers & Wimmer, 1971; Melear, 1973).

Nagy's conclusion that an appreciation of the finality and universality of death is related to chronological age is supported by subsequent investigations (e.g., White et al., 1978). As they grow older, school-age children come to understand the concepts of irreversibility, the cessation of biological functions, and the universality of death. Still, there are large individual differences in the chronological ages at which children comprehend these concepts, and the ways in which they conceptualize death are more closely related to cognitive maturity than to chronological age (Speece & Brent, 1984; Koocher, 1973).

Nationality differences are obviously not the only cultural factor that can affect ideas about death. Social-class differences within the same country are also influential. Lower-class American children are more likely to associate death with violence, whereas middle-class American children tend to associate it with old age and disease (McIntyre et al., 1972; Tallmer et al., 1974). In addition to cultural differences, specific experiences in the family, such as the death of a pet, affect a child's knowledge and feelings about death and dying. From her work with terminally ill children, Bluebond-Langner (1978) found that all views of death can be expressed at any stage of development. The particular view expressed by a child of a given age depends on the psychosocial stimulation and concerns that the child is experiencing at the time, not the child's chronological age or intelligence. In particular, children who have lost family members or have had direct experiences with death tend to have a more mature understanding of the concept than children who have not had such experiences.

**BOX 8-1 • Conversation About Death Between a
Father and His 10-Year-Old Daughter**

*Daughter: Daddy, Ken [her brother] and I were
talking—why did you and Mommy spread
Jumblie's ashes without us?*

*Father: Well, you and Ken were at camp, so
Mommy and I thought we should go ahead and do
it.*

Daughter: What were the ashes in?

Father: They were in a jar.

Daughter: All of them?

Father: Yes, all of them.

Daughter: How big was the jar?

*Father: It was round like a bottle and about 6 or 8
inches high.*

Daughter: But where was Jumblie?

*Father: The ashes were all that was left of Jumblie
after he was cremated.*

Daughter: But what about his bones?

Father: They were all burned down to ashes.

*Daughter: But what about the rest of him? What
about his ears?*

Father: Everything was burned to ashes.

*Daughter: Daddy are you and Mommy going to
have your ashes spread out on the dunes when you
die?*

*Father: I think so—that's our plan now. What do
you think of that plan?*

Daughter: I don't know. Who will spread them?

Father: Well, it depends on who dies first—who-

*ever dies first, the other will spread them, and
maybe you and Ken.*

Daughter: But what if you die together?

*Father: Then I guess you and Ken will spread
them. But that isn't very likely. Anyhow, we don't
plan to die for a while.*

*Daughter: Daddy, do you believe that when you
die you are reborn again?*

*Father: No, dear, I don't. I believe that when you
die, that's the end.*

Daughter: I don't think Mommy believes that.

Father: Well, maybe not. But that's what I believe.

Daughter: Then how could it be the end. *You
must feel something.*

Father: No, not after you're dead.

Daughter: But what happens to you?

*Father: Well, when you die, there is only your
body left—not really you—and you can't feel any-
thing at all anymore.*

Daughter: Does it hurt?

Father: Not after you're dead.

Daughter: But you can still dream, *can't you?*

*Father: No, not after you're dead. You can't
dream either. You just don't have any feeling at all.
That must be pretty hard to understand, isn't it.*

Daughter: Yeah, it is.

*Father: Well, even adults like us have a hard time
understanding it.*

Source: From *The broken connection: On death and the continuity of life,* by Robert Jay Lifton, 1979, New York: International Creative Management. Copyright 1979 by Robert Jay Lifton. Reprinted by permission.

Death Concepts in Infancy and Childhood

One of Nagy's conclusions that has been extensively criticized is that infants and toddlers have no conception of death. The observations of several investigators (Anthony, 1972; Fraiberg, 1977; Maurer, 1966; Pattison, 1977) suggest that rudimen-

tary conceptions of death begin to form as early as the first year of life. It is proposed that an infant's awareness of dichotomous states such as here-gone (as in the game peek-a-boo or in separation from the mother), sleeping-waking, and other alternating internal states become the basis for object constancy and a *me/not me* distinction. An infant's experiments with states of being and nonbeing, as in peek-a-boo, are believed to provide a conceptual foundation for later thinking about death. Separation anxiety in an infant, which is frequently replaced by mutilation anxiety in school-age children, is closely related to death anxiety in young children (Wass & Stillion, 1988).

Anthony (1972) maintained that observations of the growth and deterioration of things, the one-directional nature of time, and the many linguistic references to death also play a role in the young child's understanding of death. Thus, psychologists have concluded that the child perceives and understands more about death than he or she is capable of expressing to researchers such as Maria Nagy.

Children's Games and Sayings About Death

Traditionally, death has been a common theme in the play and fantasies of children. Peek-a-boo, which is derived from an old English word meaning "dead or alive," is only one of many games that have presumably assisted young children throughout history to develop the concept of being versus nonbeing. Other popular children's games that may help instill this concept are hide-and-go-seek, I spy, and ring-around-a-rosy. The chant "Ashes, ashes, all fall down" in an older version of ring-around-a-rosy reportedly came from the reactions of children during the Middle Ages to the Black Plague. The children's prayer,

> *Now I lay me down to sleep*
> *I pray the Lord my soul to keep.*
> *If I should die before I wake,*
> *I pray the Lord my soul to take.*

is also a holdover from a time when many children died at night and parents were often fearful that a young son or daughter would not be alive in the morning. Unfortunately, this prayer may now serve no better purpose than to frighten young children needlessly. With this in mind, one objector (Pardi, 1977, p. 119) recommended changing the last two lines of the prayer to:

> *Thy love guard me through the night,*
> *And wake me with the morning light.*

Children's stories in the eighteenth and nineteenth centuries were replete with warnings of hell and damnation and with frightening little verses of the following sort taken from the *Oxford nursery rhyme book* (Opie & Opie, 1960, p. 20):

> *Baby, baby, if he hears you,*
> *As he gallops past the house,*
> *Limb from limb at once he'll tear you,*
> *Just as pussy tears a mouse.*
> *And he'll beat you, beat you, beat you,*
> *And he'll beat you all to pap,*
> *And he'll eat you, eat you, eat you,*
> *Every morsel, snap, snap, snap.*[1]

Certain other sayings (and jokes) quoted by children may actually help them to cope with the idea of death. The common threat of the elementary child that "I'll kill ya" is a case in point, having the effect of putting the child rather than death in control. Unfortunately, the entertainment media, with their seeming dedication to themes of violence, often serve to anesthetize the child with respect to death while stimulating cruelty and criminal behavior.

Death Concepts in Adolescence

The death concepts of children vary with both cognitive development and life experiences, which change from childhood to adolescence. Maria Nagy did not carry her research beyond 10-year-olds, but other investigators have questioned older children, adolescents, and adults concerning their ideas and feelings about death. Like younger children, adolescents are likely to view death as something that happens to old people. It is a distant, abstract event, although sometimes tinged with romance and indescribable peace and beauty. They may characterize it as darkness, light, a transition state, or nothingness (Wenestam & Wass, 1987). Adolescents come to accept death as something that happens eventually to everyone, but, with respect to themselves, it tends to be associated with fate or violent circumstances (Ambron & Brodzinsky, 1979).

Preadolescents and younger children have fairly simple beliefs about life, death, and the hereafter. Those with a religious background are more likely to think about heaven, hell, and the afterlife, but religious doubts are also more common at this age (Hogan, 1970). Adolescents, however, do not necessarily accept the finality of death. In fact, the 7–9-year olds questioned in one study accepted the finality of death more readily than the adolescents (McIntyre et al., 1972). Like their older contemporaries, adolescents may come to believe in reincarnation, the transmigration of souls, or some kind of spiritual survival on earth in another location (Wenestam & Wass, 1987).

Children's Fears of Death

Cursory observations of the behavior of a typical young child show that separation from the mother or other nurturing person causes the child to respond in a fearful manner. Many authorities believe that the fear produced by such separations lays the groundwork for later fears of death (Imara, 1989). A very young child probably

does not remember being separated from its mother, but frequent or prolonged separations at a critical stage of development can lead to a high level of anxiety, depression, and emotional overactivity in the child (Fraiberg, 1977).

Most normal children, depending on their stage of development, are afraid of some things (e.g., being sucked in by a vacuum cleaner or bathtub drain), but they are not generally fearful nor are they intensely afraid of a specific object or situation. For example, children do not normally develop a pathological fear of death (*thanaphobia*); they do not dwell on the topic, but they can handle it. On the other hand, many emotionally disturbed children are abnormally afraid of death, among other things. Many of the fears of these children are related to the more general fear of separation.

Fears of dying and death are usually associated with other problems in the child's life. These problems naturally are influenced by the child's experiences, particularly those occurring in the home situation. Physical separation from the parents through death or divorce, or emotional separation through lack of understanding and outright rejection of the child, are important home-related factors in emotional disturbances in childhood. One symptom of severe emotional disturbance in children is death anxiety. Unlike the leveling off of death anxiety that occurs in emotionally healthy children as they become older, death anxiety in emotionally disturbed children tends to increase steadily with age (Von Hug, 1965). Level of death anxiety is also related to the self-perceptions of children; that is, children with better self-concepts tend to be less anxious about dying than those with poorer self-concepts (Wass & Scott, 1978).

Parents are important in many other ways in shaping a child's attitudes and feelings about death. By means of the identification process, fearful parents tend to produce fearful children—just as suicidal parents are more likely to produce suicidal children (see Templer et al., 1971). On the other hand, the children of adults who discuss the topic of death in a calm, accepting manner tend to be less afraid of it. The following conversation illustrates a rational parental approach to a young child's concerns about death (Rust, n.d.):

Child (4 1/2 years old): *Mummy, what means a dead mother?*

Mother: *A woman who has died and does not walk or talk anymore.*

Child: *But what will the children do?*

Mother: *Well, if a mother should die, the father would take care of them and maybe an aunt.*

Child: *Will you be a dead mother some day?*

Mother: *Why yes, though I don't expect to be for a long time.*

Child: *A very long time?*

Mother: *Yes.*

Child: *But I don't want you to die; I want you here like this.*

Mother: *Well, you will probably be quite grown-up before that happens.*

Child: *A long time?*

Mother: *Yes.*

Child: *But what means dead, mummy?*

Mother: *Well, your heart stops beating and you lie still without breathing.*

Child: *And what do you do with the talking part—you know, the inside talk?*

Mother: *I'm not sure, but some people think you live in another world and, of course, some don't.*

Child: *I guess we do (excitedly). Yes! And then you die in a long, long time—a very long time, and then I die and we both hug each other and then you won't have any wrinkles....*

It is recommended that adults should be natural but thoughtful in answering a child's questions about death, trying to see beneath the surface of the questions and responding in words the child understands. However, it is not advisable to lie to the child by professing beliefs one really doesn't have (Gordon & Klass, 1979). Using euphemisms, such as "gone away" or "gone to sleep," rather than "dead" to explain what happened to a relative is also confusing to young children. Saying that grandmother is "in heaven with the angels," where she is "watching over you" is especially inappropriate if the parent does not believe in these things. Furthermore, as Stein (1974) points out, the child might not like to have grandmother watching all the time, observing not just the good things but also the bad things that the child does.

Adolescents' Fears of Death

Like their younger counterparts, psychologically healthy adolescents are able to cope with death more effectively than adolescents who have emotional problems. Maurer (1964) found that adolescents who were low academic achievers, for example, had stronger fears of death than those who were higher achievers; the former also showed greater separation anxiety and a greater tendency to believe in ghosts. Poor academic achievers also usually have lower intellectual ability than high achievers, so the lower achievement and greater fearfulness of the poor achievers in Maurer's (1964) study may have both been due to lower ability. Support for this interpretation is provided by the results of a study by Chalmers and Reichen (1954). These investigators found that intellectually subnormal high-school girls were more likely to show fears of death in their expressed thoughts and feelings than girls of higher ability. A significant negative relationship between mental ability and fear of death is also suggested by Wass and Scott's (1978) findings in a study of preadolescents (ages 11–12). Children with college-educated fathers manifested less fear of death, although they theorized about death and verbalized

thoughts concerning it more than children whose fathers had only a high-school education.

Children whose parents have prepared them for the changes and challenges of adolescence can cope more effectively with the problems of identity and status that characterize this period of development. Needing to maintain the illusion of invulnerability, adolescents usually reject thoughts of death (Kastenbaum, 1959). Denial of one's death, except as an abstract event in the distant future, is a mental mechanism employed by both children and adolescents to defend themselves against the fear of death. Unfortunately, such denial may result in an attitude of invincibility and a tendency to take unnecessary chances by driving recklessly, experimenting with drugs, and engaging in other adventurous but dangerous behavior.

The rapid physical and psychological changes during adolescence also tend to increase anxiety levels. Adolescent girls who have not been informed about the physical changes of puberty, for example, may imagine that they are dying when they first begin to menstruate. And media talk about nuclear war and other cataclysmic events may lead adolescents to believe that they will never grow up, never get jobs, and never marry or have children (Caldicott, 1982). So, says the adolescent, why not live it up while I still can, regardless of the consequences, for tomorrow I may be dead?

DEATH OF A CHILD

It has been estimated that during colonial times one third of all children born in New England died before they had reached their tenth birthday (Stannard, 1977). Even in the latter part of the twentieth century, as pointed out by Blauner (1966),

> *among the Sakai of the Malay Peninsula, approximately 50 percent of the babies born die before the age of three; among the Kwinai tribe of Australia, 40–50 percent die before the age of 10. Fifty-nine percent of the male deaths in Nigeria among the "indigenous" blacks were children who had not reached their fifth birthday. Thirty-five percent of an Indian male cohort born in the 1940s died before the age of 10.*

The situation is substantially better in more developed countries. In 1900, an average of 162 out of 1,000 U.S. infants died—a rate that had dropped to 30 in 1,000 by 1950 and to 9 in 1,000 by 1991. Today, less than 2 percent of the total number of deaths in the United States occur in infancy, and only 2.3 percent of all deaths occur before age 15 (National Center for Health Statistics, 1993). For this reason, today's children have been labeled the first "death-free" generation in history. Although this characterization is not quite accurate even when applied to the more developed nations of North America and Europe, it is certainly incorrect when extended to children in other parts of the world. In many African countries, in particular, the infant mortality rate is ten times what it is in the United States, Canada, and Northern and Western Europe (see Figure 8-1).

Region

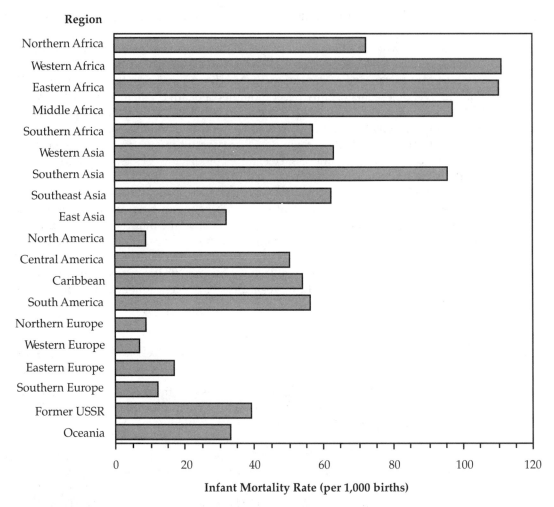

FIGURE 8-1 Infant Mortality Rates Throughout the World

Source: Data from Population Reference Bureau, Inc., April 1992. *1992 World Population Data Sheet* (prepared by Carl Haub and Machiko Yanagishita, demographers). Washington, DC.

Mortality rates for young Americans have declined dramatically during this century, but even in highly industrialized nations such as the United States thousands of children still die every year. During 1992, an estimated 34,500 infants, 7,040 children in the 1–4-year range, and 8,410 children in the 5–14-year range died in this country (National Center for Health Statistics, 1993). However, the infant mortality rate of 842.2 per 100,000 live births in 1992, compared with 892.8 in 1991, was the lowest rate ever recorded in the United States. The major causes of infant deaths are listed in Table 8-1. As shown in this table, nearly half of the infant deaths were attributable to three causes: congenital anomalies, sudden infant death syndrome, and disorders relating to short gestation and unspecified low birth weight. Of

TABLE 8-1 Major Causes of Infant Mortality in the United States in 1991

Cause of Death	Death Rate[a]
Congenital anomalies	186.0
Sudden infant death syndrome	126.6
Disorders relating to short gestation and unspecified low birth weight	110.2
Respiratory distress syndrome	56.3
Intrauterine hypoxia and birth asphyxia	17.9
Pneumonia and influenza	14.9
Certain gastrointestinal diseases	7.8
Birth trauma	3.9
Other conditions originating in the prenatal period	213.5
All other causes	155.2
All causes, under 28 days	554.2
All causes, 28 days–11 months	338.6
All causes, under 1 year	892.8

Source: National Center for Health Statistics, 1992. *Monthly Vital Statistics Report, 40* (3). Hyattsville, MD: U.S. Department of Health and Human Services.
[a]Per 100,000 births.

course, many children die before or at birth. In 1988, an estimated 1,581,000 fetal deaths in the United States were caused by induced abortions and another 840,000 were due to other causes (National Center for Health Statistics, 1992b).

Congenital anomalies in internal body organs and tissues, the leading cause of death in infancy, are often treatable. The cost of infant care in an intensive care unit is quite high, averaging about $50,000 and ranging upward to $500,000 for the total period of treatment. Because a large percentage of the infants treated in these facilities survive, the high cost is usually considered justified. But whether to continue the intensive care or to give up is not always an easy decision for parents. Not only is the cost a strain on the typical family budget, but the child (and the family) may be forced to endure a severe physical handicap for life.

Sudden Infant Death Syndrome

Sudden infant death syndrome (SIDS), also known as *crib death,* has received a great deal of public attention during the past few years. This interest has been prompted not only by the frequency of SIDS, but also because the causes of the condition are unclear. For some reason, the sleeping infant simply stops breathing. Such sudden deaths in infants have often been thought to be caused by the sleeping mothers lying on the infant, an early example of which is found in Kings 3:19: "During the night this woman's son died because she lay on him." However, this is not a valid explanation for SIDS.

SIDS is rare during the first month after birth, increases gradually to a peak at about 10 weeks, and then declines until it becomes rare again after 6–8 months (Hines, 1980). It is more common during the winter and spring, among poor, black,

teenage mothers, and mothers who smoke and use alcohol and drugs (Cope, 1980). A variety of theories, including heart defect, viral infection, and elevated levels of the thyroid hormone T-3 have been proposed as an explanation for SIDS. Problems with respiration, heart functioning, and sleep have all been explored as possible causes, but so far without notable success.

A susceptibility to SIDS is often detectable from observing the sleeping, crying, sucking, breathing, swallowing and cuddliness of the infant. Infants who are prone to SIDS tend to be below-average in alertness, as measured by an Apgar test administered a few minutes after birth. Newborns whose Apgar scores indicate that they are at risk for SIDS can be connected to an apnea monitor, which sounds an alarm when their breathing stops. Further information on SIDS can be obtained by writing or telephoning the American Sudden Infant Death Syndrome Institute, the National Sudden Infant Death Syndrome Foundation, or the SIDS Alliance (see Appendix B).

Occasionally associated with death in the fetus or newborn is death in the mother due to complications during pregnancy, childbirth, or the postchildbirth period (the *puerperium*). Like infant mortality, the maternal mortality rate has declined steadily during the current century.

Mortality in Children and Adolescents

As shown in Figure 8-2, the rate of death for U.S. children under 1 year of age is related to sex; the rate for boy babies (893.9 per 100,000 in 1992) is higher than that for girl babies (789.3). Infant mortality is also related to ethnicity, a demographic variable associated with health and prenatal care. The 1992 death rate for black children under 1 year of age was over twice that for white children in the same age category: 1,622.4 for blacks and 685.8 for whites. Maternal mortality rate is also higher for blacks than for whites (National Center for Health Statistics, 1992a).

Statistics on the leading causes of death in U.S. children during 1991 are listed in Figure 8-3. Many of the fatal disorders are chronic conditions, involving a long period of home care and hospitalization before the child dies. Such disorders, referred to as *terminal* or *catastrophic* illnesses, usually demand a great deal of physical and emotional investment—not only by the patient but by the entire family. There are extraordinary medical measures, such as liver and bone marrow transplants, that can be taken to arrest or retard certain conditions, but costs often run into hundreds of thousands of dollars. Because insurance companies often refuse to pay for experimental treatments, whether a child with a catastrophic illness lives or dies frequently depends on the affluence of the family or the generosity of the public.

> *Rick and Pat Escalambre know that all too well. Everyone who meets their three-year-old Rachel agrees that she is an adorable child. While her cancer was in remission, she giggled, she smiled, she danced for strangers. She jabbered on about Donald Duck. Dark-eyed and button-nosed, she stole hearts with the finesse of a jewel thief. The only reminder of her life-threatening illness was the soft covering of*

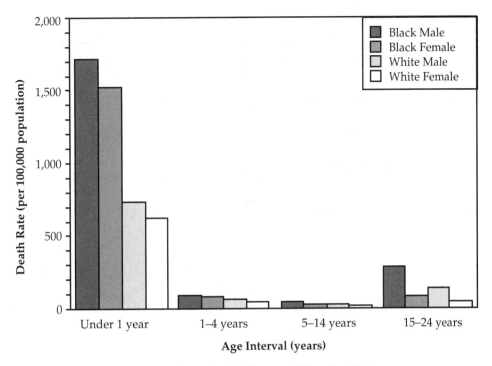

FIGURE 8-2 Death Rates for U.S. Children and Youths, 1992

Source: Data from National Center for Health Statistics, 1992. *Monthly Vital Statistics Report, 41* (12). Hyattsville, MD: U.S. Department of Health and Human Services.

down on her head, the aftermath of chemotherapy that caused the loss of her long dark hair.

"You were told she was sick, and you knew it, but she is very bright and personable and gregarious," said Jennifer Foote, a reporter for the San Francisco Examiner, which published more than 30 articles about Rachel and helped raise $250,000 for a bone marrow transplant.

"So you had this winning kid juxtaposed with this terminal illness, and it creates this real desperation to want to defeat the illness and save the winning kid."[2]

BOX 8-2

Dear little child, who never grew
Beyond the age of five,
I wish I could have died for you
And you were still alive.

I loved you so and loved each day
When you and I were near.

I never thought that I would stay
And you would not be here.

But I survive and dream about
The times that used to be.
How hard it is to live without
Your sharing life with me!

Cause of Death

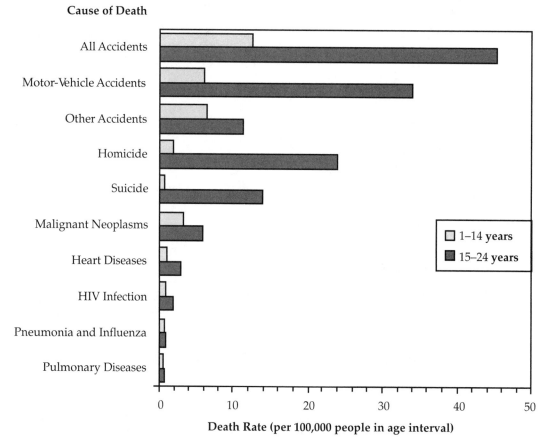

Death Rate (per 100,000 people in age interval)

FIGURE 8-3 Rates for Leading Causes of Death in U.S. Children and Youths, 1991

Source: Data from National Center for Health Statistics, 1992. *Monthly Vital Statistics Report, 40* (13). Hyattsville, MD: U.S. Department of Health and Human Services.

The three leading causes of death in adolescence are accidents, homicide, and suicide, although cancer and cardiovascular diseases also claim their share of victims in this age category. The loss of an adolescent son or daughter, bright with promise and full of great expectations, can be heartbreaking for a parent. The loss of a friend or sibling in adolescence can also place a heavy burden on a person and act as a damper on enthusiasm and hope.

Feelings of Dying Children

Based on Nagy's (1948) research with normal children, the assumption was made at one time that the majority of dying children, and especially those below the age of 4–

5 years, have no real understanding of impending death. It was obvious that terminally ill children were made anxious, depressed, and even angry by the pain and treatment connected with illness and by the social separation of hospitalization, but so were children whose illnesses were not terminal (Yudkin, 1967). However, the results of later studies revealed that fatally ill children are made even more anxious than other sick children by hospitalization and the treatments associated with it (Spinetta et al., 1973; Waechter, 1971).

In Waechter's (1971) investigation, dying and nondying hospitalized children between the ages of 6 and 10 years were administered an anxiety inventory and asked to make up stories about pictures shown to them. Fatally ill children scored significantly higher on the anxiety inventory and told more stories associated with dying than nonfatally ill children. Many of these stories expressed concerns about mutilation or loss of body functioning. Further observations (Waechter, 1984) confirmed the finding that dying children have higher levels of anxiety—about death, mutilation, separation, and loneliness—than healthy or chronically ill children whose death is not imminent. Spinetta and his coresearchers (1973) also found that children with leukemia were more anxious than other chronically ill children about being injured or the inability to function normally, even when both groups had received the same number and duration of medical treatments.

The nature of the anxiety or fear experienced by a terminally ill child varies with the chronological (and mental) age of the child. Spinetta (1974) found that what dying preschool (3–5 years) children feared most about death was separation from their parents, grandparents, and playmates. Children of this age are primarily afraid of being left all alone or abandoned, and are comforted by frequent attention and reassurance that mommy and daddy will never leave them. In contrast, the 5–9-year-olds in Spinetta's (1974) study were more afraid of death as the end of life and of body mutilation.

One of the most important investigations concerned with the feelings of terminally ill children was conducted by Myra Bluebond-Langner (1977, 1978). From her observations of fatally ill 4–5-year-olds, Bluebond-Langner concluded that such children often have a keen understanding of the threat to their lives caused by illness. Close personal encounters with death and dying are significant in determining the feelings and understanding of terminally ill children, in particular their observations of and experiences with other dying children. In addition, not only the 4–5-year-old children but even those as young as 18 months can understand that they are dying and that the process cannot be reversed.

This understanding does not come all at once, but progresses through a series of stages. At each successive stage, the child acquires a little more information about the illness and its prognosis and alters his or her self-concept in accordance with that information. In the first stage, after the initial diagnosis is made, the child is concerned about the seriousness of the illness and with feeling so sick; the self-concept is one of *seriously ill*. In the second stage, after experiencing his or her first remission of symptoms, the self-concept is changed to *seriously ill but will get better*. In the third stage, after the first relapse or return of symptoms the child begins to feel that he or she will always be ill but continues to hope for improvement; the self-

concept is modified to *always ill, but will get better*. In the fourth stage, the illness has continued and the child wonders if he or she will ever improve; the self-concept changes to *always ill, and will never get better*.

In the fifth and final stage, the child comes to realize, perhaps after observing the death of another child, that he or she is also going to die; then the self-concept changes to *dying*. Each time that the child is readmitted to the hospital, he or she seems to become more aware of the imminence of personal demise and quite likely has progressed from one stage to the next. As the child's understanding of the illness progresses from the first to the fifth stage, references to a personal future decline appreciably and the child behaves as though pleasant experiences must now happen quickly if they are going to happen at all.

As the above scenario suggests, terminally ill children are under a great deal of stress, not only from painful medical procedures and a growing realization that they are dying but also because of separation from the mother or mother figure and exposure to the deaths of other children with similar diagnoses. The major source of stress varies with the age of the child, focusing more on separation from the mother in children under 5 years of age, on discomfort and possibly disfiguring effects of the illness or medical procedures in 5–9-year-olds, and by exposure to the deaths of other children in those over 9 years of age (DeSpelder & Strickland, 1992). Whatever the age of the child, he or she will attempt to cope with the anxiety produced by the stress of disease and death by employing various defense mechanisms. These mechanisms include denial, rationalization, regression, sublimation, and any other techniques that are effective in restructuring a stressful situation into manageable dimensions (Juenker, 1977).

Family Reactions to the Death of a Child

The death of a child can be emotionally devastating to a family. This is especially true when the death is unexpected, as in an accident, a suicide, or a sudden fatal illness. Even in the case of an infant who is aborted, stillborn, or dies shortly after birth, the mother's emotional attachment to the child has already started forming (Grobstein, 1978). The loss is usually even more difficult to bear when the child has developed to the point at which he or she can interact socially with the parents. Then the parents may feel that they have failed to fulfill their parental obligations and thereby, directly or indirectly, caused the death of the child. The accompanying feelings of guilt may interfere with the parents' ability to grieve properly and work through the loss of the child (Miles & Demi, 1983–1984).

Coupled with the guilt and depression experienced by bereaved parents are feelings of impotence, frustration, and anger that this should happen and at being unable to do anything to help the fatally ill or dead child. The anger may be directed toward anyone who seems to bear a responsibility for the tragedy—the hospital staff, the parents themselves, and even God. These feelings are so intense in many cases that the parents never fully recover; the emotional problems associated with the death may still be present a decade or more after the death of the child. When

one or both of the parents are unable to work through their grief, family life becomes disrupted. Alcoholism, sexual dysfunctions, sleep and eating disturbances, and other symptoms of emotional disorder are commonplace, indicating a need for psychological counseling or psychotherapy. If untreated, these bereavement reactions often lead to separation and divorce (Simpson, 1979).

Not only the parents but all members of the family are affected by the fatal illness and death of a child. Grandparents grieve in a threefold sense—for the grandchild, for their son or daughter, and for themselves (Hamilton, 1978). Furthermore, the parents are frequently so preoccupied with their own thoughts and feelings and with attending to the dying or dead child that they neglect their other children. The siblings of dying and deceased children often feel anxious, deprived, confused, and socially isolated. The physical and behavioral changes that occur in a dying child as the illness progresses can also be frightening to a young brother or sister. And when the child dies, the surviving children are not only sad, as everyone else in the family is, but they may also feel guilty for having mistreated the dead sibling or having wished he or she were dead. They may also show regressive behavior and develop an unreasonable fear of doctors, hospitals, and their own death. If ignored by the parents, these feelings can persist and influence the surviving child's future emotional behavior and mental stability.

A number of writers (Green & Solnit, 1964; Pollock, 1978; Rosenzweig & Bray, 1943) have described the psychological vulnerability of surviving children and their greater-than-average tendency to have emotional problems that persist into adulthood. Fairly high percentages of adjustment problems (problems with school, fears of death, etc.) have been found in the sibling survivors of children who died of cancer. The surviving children frequently behave defensively with respect to the death, refusing to even talk about it or listen to the parents talk about the dead child (Cook, 1983).

On the other hand, the attitudes of children with terminally ill or dead siblings are often healthier than those of their parents. Childhood is a time of flexibility, a time when losses and frustrations are usually adjusted to rather quickly. What seems like a traumatic experience to an adult is typically not as disturbing to a growing child, who is full of energy and keen on living and learning. However, children do need reassurance and a sense of being included, both during the fatal illness and after the death of a brother or sister. They should be made to feel that they are important and needed at all stages of the illness. They can be permitted to visit the hospital, provided with details on their brother's or sister's illness, and encouraged to express their feelings and thoughts—especially any feelings of guilt—about the dying child (Wass & Stillion, 1988). After the death, the surviving siblings should not be excluded from the funerary rituals or postmortem discussions. Those in middle childhood (6–10 years) can certainly understand the significance of death and loss and the meaning of a funeral, so adults should take time to explain to them, at their own level, the cause of the death and what it means. Consider the following conversation between a small girl and her mother after the child's recently deceased brother had been cremated.

"I will keep your ashes, Mom (after you die), but who will keep mine?"
"Your kids will, if you have kids. Or your best friend."
"Who will keep the ashes of the last person in the world?"
"God will," I say.[3]

Even children as young as age 5 or 6 can cope with a funeral and, to some extent, understand its significance. Therefore, they should be encouraged, but not forced, to participate. In any event, the key to how a surviving sibling deals with the death is almost always in the hands of the parents and other significant adults. Clearly, then, it is important for these individuals to work through their own problems associated with the death as soon as possible (Wass & Stillion, 1988).

Working with Terminally Ill Children and Their Parents

Physicians, nurses, and other health workers usually recognize the importance of being fairly open and truthful in responding to dying children. They also recognize the cruelty of repeatedly encouraging the child to minimize the seriousness of the illness or of pretending that a severe loss is not being endured. On the other hand, complete candor and a failure to offer some hope is inadvisable and unrealistic. Hope should always be expressed explicitly as long as there is any basis at all in reality for it. After all, over one third of American children who are stricken with leukemia each year survive more than 5 years, and many are able to live normal lives.

Health workers and counselors are advised to listen to terminally ill children and remain open to their questions. These questions are usually not highly technical queries about disease or afterlife but rather questions indicating a need for reassurance, companionship, and assistance. Green (1966) noted that three questions are of greatest concern to terminally ill children in the 6–12 year age range: Am I safe? Will there be a trusted person to keep me from feeling helpless, alone, and to help me overcome pain? Will you make me feel all right? Other, perhaps more negative and defensive, questions asked by dying children are: Why is this happening to me rather than to you or someone else? How could you let this happen to me? Did I do something bad or terrible to make this happen to me? It takes patience and experience to respond to these questions in a manner appropriate for a particular child, but love and understanding, combined with adequate training and a high tolerance for frustration, can help.

Hospitals are not the only community agencies that are concerned with fatally ill children. Various organizations provide books, toys, and other materials for young catastrophically ill patients. Every year, the Sunshine Foundation, based in Philadelphia, sends a number of dying or chronically ill children and their families on expense-paid trips to athletic events, amusement parks, and other places of interest. Similarly, the Make-a-Wish Foundation grants special requests from children with terminal or life-threatening illnesses. Information on various services that

are available to sick children and their parents, such as the Brass Ring Society, the Starlight Foundation, the Make-a-Wish Foundation, and the Ronald McDonald House, can be obtained by writing to addresses listed in Appendix B.

One of the most important contributions of health workers in treatment programs for terminally ill children is making suggestions and giving advice to parents. Parents are a significant part of the total treatment program for dying children, and calm acceptance on their part leads to a better prognosis for the child (Morrissey, 1963). Health workers should begin by recognizing the cognitive, emotional, and social needs of the parents. On the cognitive side, parents require clear explanations of the child's diagnosis (nature and type of disease), the type of therapy or treatment to be undertaken, and the prognosis (probable outcomes). On the emotional side, health workers, who often feel frustrated and distressed because their primary goal is to save lives, must also be aware of the depth of shock and despair felt by parents of dying children. Feeling guilty because they have failed in the basic parental task of protecting their children and keeping them healthy, parents are under even greater strain than the attending physicians and nurses.

Parents of terminally ill children typically progress through three stages when dealing with their emotional reactions (Natterson & Knudson, 1960):

1. Shock and denial, frequently accompanied by anger, weeping, and overprotection of the child.
2. Acceptance of the child's illness, and a willingness to search for ways to save the child.
3. Defensively sublimating their feelings by directing energy toward sick children other than their own.

Health workers must be prepared to discuss and help relieve any guilt felt by the parents and to emphasize any possible hope.

On the social side, health workers should be ready to assist parents with any problems in telling other people about the illness and in maintaining continuity in rearing a sick child. Effective parent counselors will also want to assess the capacity of the family for coping with the child's illness and to encourage building on the family's strengths. A final parent conference after the death of the child is recommended to provide an opportunity for the expression of postmortem feelings and to achieve closure (Wass & Stillion, 1988).

Futterman and Hoffman (1983) concluded that parents who are able to deal successfully with the impending death of a child usually progress through a series of five emotional stages, collectively described as *anticipatory mourning*. The anticipatory mourning taking place in these stages may shorten and soften postbereavement mourning to some extent. The stages are:

1. Acknowledging that the child's death is inevitable.
2. Grieving in response to this knowledge.
3. Becoming reconciled to the child's death by finding meaning in it and in the child's life.

4. Becoming somewhat emotionally detached from the child.
5. Memorializing the child by forming a lasting mental image of him or her.

DEATH OF A PARENT

It is the natural order of things for parents to precede their children in death, and this usually occurs after the children are grown. However, it is estimated that 5 percent of American children experience the death of at least one parent by age 15 (Kliman, 1979). Young children are usually quite resilient when faced with upsetting situations, but the death of a parent can be an overwhelming tragedy for a child. In fact, children under age 8, perhaps in part because they have a poorer understanding of death, tend to have greater difficulty adjusting than older children (Kastenbaum, 1986, p. 151). The death of a sibling, another relative, a friend, or even a pet is disturbing enough, but this usually does not compare with the child's emotional reactions to the death of a close parental figure.

Children's Grieving

The normal grief responses of children who have lost parents are similar to those seen in anyone who has suffered a severe loss, but children do not grieve exactly like adults. Children are less likely to accept a death, and they tend to grieve intermittently for several years. In fact, genuine mourning of a deceased parent may not set in until adolescence (Krupnick & Solomon, 1987).

A young grieving child typically refuses to believe that the parent is actually dead, protests vigorously, and tries to find a way to get the parent back (Bowlby, 1974). Defense mechanisms such as denial or inhibition of grief and identification with or idealization of the deceased are also employed by bereaved children. Girls, who are more vulnerable than boys to the loss of a parent, are more likely to idealize a dead father (Arthur & Kemme, 1964). When defense mechanisms are unsuccessful, the child's behavior becomes disorganized, and genuine grief sets in. Eventually the child accepts the reality of the loss and begins to reorganize his or her life. Even with strong social support, working through the loss of a parent is rarely easy. And as with adults, the degree of vulnerability of a child to the death of a parent depends on whether the relationship was dependent or ambivalent (Raphael, 1983).

A review of the clinical and research literature indicates that the following factors are closely related to psychological problems in children after the death of a parent or sibling (Krupnick, 1984, pp. 126–127):

- Loss occurs at an age below 5 years or during early adolescence
- Loss of mother for girls below age 11 and loss of father for adolescent boys
- Psychological difficulties in the child preceding the death (the more severe the preexisting pathology, the greater the postbereavement risk)
- Conflictual relationship with the deceased preceding the death

- Psychologically vulnerable surviving parent who is excessively dependent on the child
- Lack of adequate family or community support or parent who cannot make use of available support system
- Unstable, inconsistent environment, including multiple shifts in caretakers and disruption of familiar routines (transfer to an institutional setting would be an extreme example)
- Experience of parental remarriage if there is a negative relationship between the child and the parent replacement figure
- Lack of prior knowledge about death, unanticipated death
- Experience of parent or sibling suicide or homicide

Persisting Psychological Reactions

Loss of a parent has been found to be related to delinquency, problems in school, and depression. The persistence of psychological problems associated with the loss of a parent is shown in studies of normal preadolescent Israeli children who lost a father during wartime. Three years later, these children continued to have symptoms such as soiling, social isolation, and learning difficulties (Elizur & Kaffman, 1982; Kaffman & Elizur, 1979). Other studies have shown that years after losing a parent, a child may suddenly become depressed when confronted by a situation that reminds him or her of the parent (Kastenbaum, 1986).

Children who lose one or both parents through death tend to have more physical and psychological problems as adults than children whose families remain intact (Bendiksen & Fulton, 1975). Adults who in childhood lost a parent are more likely to have psychiatric problems, including depression and suicidal behavior (Beck et al., 1963; Brown, 1961; Crook & Eliot, 1980), schizophrenia (Blum & Rosenzweig, 1944), antisocial behavior (Barry, 1939), and physical disorders such as cardiovascular disease (Lynch, 1977). After summarizing research on the link between adult depression and childhood bereavement, Lloyd (1980) concluded: "Parental bereavement during childhood increases the risk of depression in adulthood by a factor of about 2 or 3" (p. 534). Sometimes the depression becomes particularly acute on the anniversary of the parent's death, a so-called *anniversary reaction*.

Coping with the Death of a Parent

The process of coping with the death of a parent is less intense when the bereaved child has alternative sources of emotional support and understanding. In fact, grieving can be eased even before the death by offering the child a role in caring for the sick parent. No matter how minor the role may seem, it can give the child a feeling of contributing to the well-being of the parent. One child may be comfortable in the role of practical nurse to the parent, whereas another child would rather talk to the parent or simply listen to music with him or her (Pier, 1982).

DEATH EDUCATION

Like sex, death is a part of life about which children and adults need to know. Nevertheless, as with sex education, introduction of the topic of death into schools and colleges has sometimes been met with cries of alarm about the potentially damaging effects of readings, discussions, and other activities concerning this topic. Some people have voiced concerns that discussions of death and dying will make children and youth anxious, depressed, and callous, in addition to increasing suicide and homicide rates and decreasing religious faith. The fact that such fears are unwarranted is seen in the results of studies of changes occurring in children and adults who have been exposed to educational experiences and courses concerned with thanatology. Rather than creating emotional havoc, a typical product of a discussion or course on death and dying is a moderate improvement in participants' attitudes and knowledge about this subject (see Leviton, 1977).

Units, courses, and entire curricula on death and dying have been designed for schools, colleges, senior citizens' organizations, and many special-interest groups. The goals of these educational efforts are both theoretical and practical. Because people frequently lack accurate information on death and dying, one important goal is to increase students' knowledge about death, as well as the professions and organizations (medical, governmental, funeral, etc.) most concerned with it. Another goal is to help students learn to cope, in an emotional sense, with the death of loved ones and associates. Beyond these two very concrete goals is the more abstract goal of helping students understand the social and ethical issues pertaining to death, and particularly the value judgments involved in discussions of these issues (Gordon & Klass, 1979).

Death Education in College and Adulthood

Because formal education in death and dying was first offered at the college level, a brief look at the activities of higher education programs is perhaps in order before discussing death education for children. Leviton (1977) describes a number of these programs and the organizations that helped structure the curricula. The addresses of several such organizations, including the Center for Death Education and Research, the Grief Education Institute, and the International Institute for the Study of Death, are listed in Appendix B. These organizations are hopeful that carefully designed courses and curricula will also contribute to the development of empathy and concern for one's fellow human beings. A successful course on death and dying should make students not only more knowledgeable but also more sensitive to the feelings and needs of dying people.

In addition to readings, lectures by the course instructor, and class discussions, several special activities have become a part of college and adult education courses on death and dying. These activities include such things as:

- Describing one's reasons for taking the course and what is expected from it
- Live talks, tape recordings, and films, particularly films featuring dying people
- A visit to at least one death-related institution, for example, a cemetery, a funeral home, or a crematorium
- Drawing pictures or writing poems and stories describing one's personal feelings and ideas about death
- Writing one's own epitaph and obituary
- Role-playing scenes of dying, death, and related matters

All adults do not require a formal course in death and dying in order to become informed about the topic. Many of the books listed in the Suggested Readings list at the end of this chapter and in Table 8-2 provide useful information for both adults and children. However, parents and teachers need to make certain that they themselves are sufficiently informed before attempting to explain death to children. Adults also need to get in touch with their own feelings about death, because emotional reactions are even more easily communicated than misinformation.

Educating Children About Death

Much of the death-oriented teaching of young children is impromptu and informal, depending on what is taking place at the time and the questions asked by the child. Parents and teachers usually talk about death only when the child wants to or when the death of a pet or person indicates that a "teachable moment" has come (Leviton & Forman, 1974). The nature of the response to a child's query about death depends not only on the specific question asked or the particular situation but also on the maturity level of the child. Preschoolers, for example, require less elaborate explanations than older children. Therefore, death can be explained in simple physical and biological terms to children in this age group without becoming too detailed or abstract. In fact, what preschoolers need, more than highly accurate explanations about death, is reassurance that they are loved and will not be abandoned. Older children, on the other hand, should be encouraged to go beyond simple notions and think a bit more abstractly about the meaning of life and death (Stein, 1974).

Regardless of the child's age, adults should be honest, sensitive, and sympathetic, encouraging children to express their own feelings and ideas. Children need to be told when family members or other individuals whom they know are dying, and they should be permitted to stay with the rest of the family at this time. School-age children should be encouraged, but not forced, to attend the funerals of family members and friends, and, if they decide to attend, should be told exactly what to expect. However, viewing a corpse, observing the casket being lowered into the grave, and leaving a close friend or relative in the cemetery may be quite upsetting to preschoolers. So, special care should be exercised in determining whether young children can handle the funeral experience. Finally, when children question them

TABLE 8-2 • Books on Death and Dying Recommended for Children and Adolescents

Preschool and Primary Grades (Ages 3–8)

Berger, T. (1971). *I have feelings*. New York: Human Sciences Press.
Bonnet, S. (1974). *About death*. New York: Stein, Walker.
Brown, M. W. (1965). *The dead bird*. Glenview, IL: Scott Foresman.
De Paola, T. (1973). *Nana upstairs and Nana downstairs*. New York: Putnam's.
Hogan, B. (1983). *My grandmother died*. Illustrations by Nancy Munger. Nashville: Abingdon.
Fassler, J. (1971). *My grandpa died today*. New York: Behavioral Publications.
Kantrowitz, M. (1973). *When Violet died*. New York: Parents Magazine Press.
Miles, M. (1976). *Annie and the old one*. Boston: Little, Brown.
Rogers, F. (1988). *When a pet dies*. New York: G. P. Putnam's Sons.
Shector, B. (1973). *Across the meadow*. New York: Doubleday.
Stein, S. (1974). *About dying*. New York: Walker.
Stull, E. (1964). *My turtle died today*. New York: Holt, Rinehart & Winston.
Tressalt, A. (1971). *The dead tree*. New York: Parents Magazine Press.
Viorst, J. (1971). *The tenth good thing about Barney*. New York: Atheneum.
Warburg, S. (1969). *Growing time*. Boston: Houghton Mifflin.
Zolotow, C. (1974). *My grandson Lew*. New York: Harper & Row.

Elementary Grades (Ages 8–12)

Carlson, N. (1970). *The half sisters*. New York: Harper & Row.
Corley, E. (1973). *Tell me about death, tell me about funerals*. Santa Clara, CA: Grammatical Sciences.
Erdman, L. (1973). *A bluebird will do*. New York: Dodd, Mead.
Farley, C. (1975). *The garden is doing fine*. New York: Atheneum.
Harris, A. (1965). *Why did he die?* Minneapolis: Lerner Publications.
Hunter, M. (1974). *A sound of chariots*. New York: Harper & Row.
Lancaster, M. (1985). *Hang tough*. New York: Paulist Press.
LeShan, E. (1976). *Learning to say goodbye: When a parent dies*. New York: Macmillan.
Lorenzo, C. L. (1974). *Mama's ghosts*. New York: Harper & Row.
McLendon, G. H. (1982). *My brother Joey died*. Photographs by H. Kelman. New York: Simon & Schuster.
Orgel, D. (1970). *The mulberry music*. New York: Harper & Row.
Smith, D. B. (1973). *A taste of blackberries*. New York: Crowell.
Watts, R. (1975). *Straight talk about death with young people*. Philadelphia: Westminster.
White, E. B. (1952). *Charlotte's web*. New York: Harper & Row.

Junior and Senior High School (Ages 12 and up)

Agee, J. (1959). *A death in the family*. New York: Avon.
Bach, A. (1980). *Waiting for Johnny Miracle*. New York: Harper & Row.
Bach, R. (1970). *Jonathan Livingston Seagull*. New York: Macmillan.
DeVries, P. (1961). *Blood of the lamb*. Boston: Little, Brown.
Greene, C. C. (1979). *Beat the turtle drum*. New York: Dell.
Hunter, M. (1972). *A sound of chariots*. New York: Harper & Row.
Kerr, M. E. (1986). *Night kites*. New York: Harper & Row.
Klein, N. (1974). *Sunshine*. New York: Avon.
Lee, V. (1972). *The magic moth*. Boston: Houghton Mifflin.
L'Engle, M. (1980). *The summer of the great-grandmother*. New York: Seabury.
L'Engle, M. (1980). *A ring of endless light*. New York: Farrar, Straus & Giroux.
LeShan, E. (1976). *Learning to say goodbye: When a parent dies*. New York: Macmillan.
Mazer, N. F. (1987). *After the rain*. New York: William Morrow.
Myers, W. D. (1988). *Fallen angels*. New York: Scholastic.
Olander, J., & Greenberg, M. H. (1978). *Time of passage*. New York: Taplinger.

about life after death, adults should express their own beliefs but admit that they do not know all the answers.

A Comprehensive School Curriculum

The degree of formality of death education in elementary and secondary schools varies with the school and the teachers, but a number of curricular plans have been proposed. A comprehensive curriculum designed by Gordon and Klass (1979) is outlined in Table 8-3. Spanning the entire grade range from preschool through senior high, this curriculum is based on four goals. The first goal, which is concerned with the question of what happens when people die, is attained when students become informed about facts that are not generally known in the culture. The second goal is concerned with how to cope with the reality of death in a healthy way. It is reached when students have learned to deal effectively with the idea of personal death and the deaths of people who are significant to them. The third goal is concerned with the practical matter of making students informed consumers of medical and funeral services. The fourth and final goal, which is the most abstract of all, is to help students formulate socioethical issues related to death and to define value judgments raised by these issues.

Each of the four goals of the Gordon/Klass curriculum is broken down into several subgoals or objectives that understandably become more complex and abstract at higher grade levels. Special methods and materials are employed in attaining each objective. For example, poems, stories, and films are often useful in attaining the affective objectives listed under Goal II. Assignments similar to several of those listed previously for college and adult education courses can also be made in teaching children about death. For example, a trip to a mortuary, a hospice, or a hospital ward for terminally ill patients can contribute significantly to children's lessons on death and dying. Despite the concerns expressed by certain adults, children rarely find such experiences frightening or distasteful. In fact, when prepared and accompanied by a sensitive, knowledgeable adult, young visitors almost always find these trips interesting and informative.

SUMMARY

Because death has become less common, less public, and a topic that is not discussed as much in the presence of children as it once was, today's children are less familiar with death and dying than those in previous times were. However, there are indications that the denial of death that was characteristic of Western culture during the first half of this century is changing to a greater openness and an interest in educational experiences concerning the subject.

The findings of Nagy's classic research investigation on children's conceptions of death were interpreted as pointing to the existence of three stages: a first stage between the ages of 3–5 years, in which children do not distinguish between death and separation; a second stage between 5–9 years, in which death is conceived of as

**TABLE 8-3 Goals and Grade-Level Objectives of Death
Education Curriculum**

I. Goal
To inform the student of facts not currently widespread in the culture.

 A. Objectives in Preschool and Grade 1
 Explore the life cycle of plants and animals in order to introduce students to birth,
 life, and death as part of the same cycle.
 Find out what happens to dead people and pets, and explore the cemetery.
 Identify various stages in the life cycle, with special attention to the characteristics
 of old age.

 B. Objectives in Grades 2–3
 Include human death within the biological life cycle.
 Find out what causes death.

 C. Objectives in Grades 4–5
 Introduce students to factual information about the demography of death.
 Introduce students to the facts about institutions that are concerned with death.

 D. Objectives in Grades 6–7
 Acquaint students with the legal and scientific definitions of death.
 Study various methods of body disposal.

 E. Objectives in Grades 8–9
 Study beliefs and customs about death in various cultures in order to acquaint
 students with a broad range of viewpoints and practices concerning death.
 Understand the dynamics of aging and death and the social institutions that deal
 with them.
 Explore attitudes and stereotypes about aging in the United States.
 Understand the hospice movement.

 F. Objectives in Grades 10–11
 Acquaint students with current legal and medical definitions of death, and intro-
 duce the problematic character of those definitions.
 Acquaint students with the legalities and problems of body and organ donation.

 G. Objectives in Grade 12
 Survey theories about suicide and its occurrence in our culture.

II. Goal
To help the student effectively deal with the idea of personal death and the deaths of
 significant others.

 A. Objectives in Preschool and Grade 1
 Talk about the feelings students have when they experience loss.

 B. Objectives in Grades 2–3
 Explore students' feelings when someone dies.
 Explore students' ideas of death as expressed in the culture.

 C. Objectives in Grades 4–5
 Help children reflect upon their past ideas of death, and consolidate these views.
 (Students are in a transitional period to more mature concepts of death, and
 this topic will help them formulate new ideas and acceptance of death as a final
 reality.)

Children begin to accept the reality and finality of their own deaths.

D. Objectives in Grades 6–7
 Help students develop a philosophy of life and death.
 Students learn the appropriate social behavior at the time of death and mourning.
 Maturing students identify feelings they and others have in anticipating death
 and feelings they might have at the time of death.

E. Objectives in Grades 8–9
 Explore students' own feelings about the aged and getting old.

F. Objectives in Grades 10–11
 Make students aware of their responses to loss and ways of coping with loss.
 Have students explore decisions about death and dying as these decisions could
 affect them and their families.

G. Objectives in Grade 12
 Have students explore their own feelings about suicide.
 Acquaint students with experiences connected with the crises of death and dying
 that may not fit into commonly accepted reality.

III. Goal
 To make the student an informed consumer of medical and funeral services.

 A. Objectives in Grades 2–3
 Introduce funeral procedures and the funeral establishment.

 B. Objectives in Grades 6–7
 Help students clarify their value systems on the issue of body disposal.

 C. Objectives in Grades 8–9
 Discover the medical context of dying, and introduce students to the technology,
 professional duties, and attitudes surrounding death.

 D. Objectives in Grades 10–11
 Acquaint students with the financial aspects of medical care for terminal illness
 and life-threatening situations.

 E. Objectives in Grade 12
 Acquaint students with insurance and wills.

IV. Goal
 To help the student formulate socioethical issues related to death and define value
 judgments raised by these issues.

 A. Objectives in Grades 4–5
 Explore society's values on issues related to death and dying as presented in
 media ordinarily seen by young children.

 B. Objectives in Grades 8–9
 Introduce students to basic ethical and social policy issues connected with dying.

 C. Objectives in Grades 10–11
 Acquaint students with the legal and moral issues reflected in the problems of the
 prolongation of life and the termination of life.

Source: Adapted from *They Need to Know,* by Audrey K. Gordon and Dennis Klass, 1979, Englewood
Cliffs, NJ: Prentice Hall. Adapted by permission of the authors.

irreversible but avoidable; and a third stage at 10 years and over, in which children understand death as real, inevitable, and irreversible. Nagy has been criticized for failing to consider the effects of culture and experience on the child's conceptions of death and for her assumption that very young children have little or no understanding of mortality. Studies conducted in the United States, for example, have not found the frequent personifications of death reported by Nagy's second-stage children. Furthermore, lower-class American children are more likely to associate death with violence; middle-class children are more likely to associate it with old age and illness. From her research on terminally ill children, Bluebond-Langner concluded that, rather than being restricted to a specific chronological age range, all views of death are present at every stage of child development.

Extreme fears of death in children are not normal and are usually indicative of other emotional problems. A child who is intensely afraid of death or dying is, in most cases, actually afraid of being separated from a parent or other nurturing person. Like all fears, fear of death can also be learned from parents and others who are afraid. Whatever their origin, a child's fears and questions about death should be responded to by adults in a natural but thoughtful manner. The respondent should neither lie nor deny, but rather answer in a way that the child is capable of understanding.

Death in infancy has declined dramatically during this century, but it is still more common than in early or later childhood. The three leading causes of infant death are congenital anomalies, sudden infant death syndrome, and disorders relating to short gestation and unspecified low birth weight. The three leading causes of death in children aged 1–14 years are accidents and adverse effects, malignant neoplasms, and homicide. The three leading causes in the 15–24-year age range are accidents, homicide, and suicide.

Terminally ill children are usually more afraid, depressed, and angry than other hospitalized children, and in most cases, they realize that they are dying. The fears concerning death expressed by dying children vary with their chronological age. Young children are more afraid of separation, whereas those in middle childhood are more concerned with body mutilation and end of life. Bluebond-Langner's formulation of five stages in the changing attitudes and self-concepts of terminally ill children points to a fairly high level of awareness on the part of such children.

The death of a child can be an overwhelming tragedy for the parents and other members of the family. Anxiety, depression, guilt, and anger are common parental and sibling reactions that can lead to more serious emotional problems and family disruption when unresolved. The siblings of deceased children usually adjust more readily than the adult members of the family, especially when the parents do not neglect them while caring for the dying child.

Health workers are advised to be open and truthful with dying children, not giving them false encouragement but communicating a realistic degree of hope. The dying child's questions about his or her condition and future should be answered sensitively and at a level appropriate to the child's ability to understand. Realizing that the parents must also be helped, for the sake of both the dying child and the parents themselves, health workers are advised to recognize and deal with the

cognitive, emotional, and social needs of the parents as they relate to the dying child. Parents pass through a number of stages before accepting the fact that their child is dying or has died. Anticipatory mourning begins even before the child's death, and it is a positive sign that the parent is working on his or her emotional problems related to the impending death.

Sometimes parents die before their children have grown up. A very small percentage of newborns never know their mother and form no direct emotional attachment to her. The loss of a parent to whom the child has become emotionally attached, however, can produce an extreme psychological reaction. If not dealt with properly, this reaction can create an emotional disorder that persists into adulthood.

The realization that death is a part of life for which children and adults require preparation has led to increased attention to this topic in schools and colleges. Lessons, courses, and entire curricula on death and dying have been designed for a variety of formal and informal groups, ranging from preschoolers to senior citizens. The goals of these efforts are both practical and theoretical, cognitive and affective. The overall aim is to enable participants to cope more effectively with their own deaths and the deaths of significant others. The participants in sessions or courses on death and dying are provided with information by means of conventional instructional approaches (lectures, discussions, readings, writing assignments) as well as experiences such as trips to hospitals, mortuaries, cemeteries, and other death-related places. A comprehensive curriculum for the school grades, encompassing a wide range of materials and experiences, has been designed by Gordon and Klass.

QUESTIONS AND ACTIVITIES

1. Why are today's children less familiar with death than children in previous generations were, and what effect does the lack of familiarity have on their attitudes toward death and dying?

2. What counseling techniques are employed by health personnel who work with dying children and their parents?

3. Was the subject of death talked about very much in your family? Who talked to you about death, and what did they say?

4. What are your earliest memories of death? Did this involve a dead animal, a dead relative, or another person? What were your feelings at the time, and what did people say to you about it?

5. How old were you when you first attended a funeral? Who was the deceased, and were you emotionally close to her or him? Were you told or forced to attend the funeral, or did you do so voluntarily?

6. What are some of the terms or expressions that people use to make death and dying seem less distressing? Examples are "passed away," "put to sleep," "gone to heaven,"

and so on. List some others. Is it helpful to use such euphemisms or circumlocutions in trying to explain death to children? Why or why not?

7. A great deal of research on the causes of sudden infant death syndrome (SIDS) has been conducted during the past few years. Consult the *Reader's Guide*, the index of a big-city newspaper, or other sources on the subject of the causes and cures for SIDS. Write a brief paper on your findings.

8. Consider the following case presented by Wilcox and Sutton (1985, pp. 313–314):

> *The parents of a seven year-old leukemic boy are meeting with a health care team consisting of the child's physician, nurse, and social worker. The child has reentered the hospital in the terminal phase of his painful illness; he has previously experienced three spontaneous remissions and returned home, only to fall dangerously ill and return to the hospital each time. A fourth remission is not expected. The group must decide whether to begin the child on an expensive new experimental treatment. Although the treatment is not expected to be able to control the disease for the child, it might keep him alive for up to six months longer, and its use in this case would add to medical knowledge and possibly improve the survival rate of other sick children. However, the parents and the two younger brothers of the child have prepared themselves for his death at each return to the hospital. The emotional strain of the dramatic recoveries is reflected in the worsening relationship between the parents and in behavior problems in the children. The father is working a second job to help pay the medical bills. The mother alternates between wanting to keep her child alive at all costs and wanting to release him from pain. The doctor is committed to saving and prolonging life if at all possible, especially in the case of a child. The nurse has cared for the child during each hospitalization and considers herself to have the primary responsibility for caring for the child. The social worker has given the parents financial counseling and has tried to give them psychological support during the long illness.*[4]

As a class project, select a representative group of six students to discuss this case and make a decision about whether to prolong the boy's life. Treat the project like a jury trial, electing a foreman and taking a series of secret ballots between discussion periods. A typed copy of the case should be given to each group member, and the foreman should read it aloud before proceeding with the discussion. The group members should be told that their task is to reach a group decision on whether to prolong the boy's life. Discussion should then begin, and after a few minutes a ballot should be taken. The foreman should announce the results of each balloting before proceeding with the next round of discussion. When all group members have agreed on a decision, or at least agreed not to actively oppose it, each member should explain to the class his or her personal decision, what factors played a role in it, whether the case information was sufficient, and how he or she felt about the discussion and the group decision. Were all group members in accord with and satisfied with the decision? Did they feel that they had enough information to make a decision? Was the exercise interesting and educational or just disturbing and frustrating?

9. After obtaining the permission of their parents or teachers, administer the following questionnaire to five 5-year-old boys, five 5-year-old girls, five 10-year-old boys, and

five 10-year-old girls. Questions 1–5 are concerned with the cessation of life, questions 6–7 with the irreversibility of death, questions 9–12 with the universality of death, and questions 12–13 with biological causality of death. Questions 1–11 should be answered "yes" or "no," whereas questions 12–13 are open ended. Compare the answers of the 5-year-olds with those of the 10-year-olds and the boys with the girls. Interpret all differences.

Some Questions on Death

Yes No 1. Can a dead person move?

Yes No 2. Can a dead person get hungry?

Yes No 3. Can a dead person think?

Yes No 4. Can a dead person dream?

Yes No 5. Do dead people know they are dead?

Yes No 6. Can a dead person become a live person again?

Yes No 7. Is there anything that could make a dead animal come back to life?

Yes No 8. Does everyone die sometime?

Yes No 9. Will your parents die someday?

Yes No 10. Will your friends die someday?

Yes No 11. Will you die someday?

 12. What makes a person die?

 13. Why do animals die?

10. Arrange, either through your instructor or on your own, to visit the terminal or oncology ward of a children's hospital or hospital wing. Talk with the staff on the ward and a sample of the children. What impressions did you obtain of the attitudes of the staff and children? What special techniques, both physical and psychological, are used by the staff in treating these children?

ENDNOTES

1. From P. Opie and I. Opie (Eds.), *Oxford nursery rhyme book* (Oxford: Oxford University Press, 1960), p. 20.

2. From the *Los Angeles Times*, July 17, 1983, p. 1B. Reprinted by courtesy of the Associated Press.

3. Excerpt from "When Wendy's brother died," by Marty Keyser, *Reader's Digest*, July, 1977.

4. From S. Wilcox and M. Sutton, *Understanding death and dying* (3rd ed.) (Palo Alto, CA: Mayfield). Reprinted by permission.

SUGGESTED READINGS

Bluebond-Langner, M. (1978). *The private worlds of dying children*. Princeton, NJ: Princeton University Press.

Buckingham, R. W. (1989). *Care of the dying child: A practical guide for those who help others*. New York: Continuum.

Gordon, A. K. (1986). The tattered cloak of immortality. In C. A. Corr & J. N. McNeil (Eds.), *Adolescence and death* (pp. 16–31). New York: Springer.

Gravell, K., & Haskins, C. (1989). *Teenagers face to face with bereavement*. Englewood Cliffs, NJ: Julian Messner.

Johnson, S. E. (1987). *After a child dies: Counseling bereaved families*. New York: Springer Verlag.

Kastenbaum, R. (1986). Death in the world of adolescence. In C. A. Corr & J. N. McNeil (Eds.), *Adolescence and death* (pp. 4–15). New York: Springer.

Klass, D. (1988). *Parental grief: Solace and resolution*. New York: Springer.

Krupnick, J. L., & Solomon, F. (1987). Death of a parent or sibling during childhood. In J. Bloom-Feshbach, S. Bloom-Feshbach & Associates (Eds.), *The psychology of separation and loss* (pp. 345–371). San Francisco: Jossey-Bass.

Lonetto, R. (1981). *Children's conceptions of death*. New York: Springer.

Rosenthal, N. R. (1986). Death education: Developing a course of study for adolescents. In C. A. Corr & J. N. McNeil (Eds.), *Adolescence and death* (pp. 202–214). New York: Springer.

Schowalter, J. E., Buschman, P., Patterson, P. R., Kutscher, A. H., Tallmer, M., & Stevenson, R. G. (1987). *Children and death*. New York: Praeger.

Smilansky, S. (1987). *On death: Helping children understand and cope*. New York: Peter Lang.

9

ADULTHOOD AND DEATH

QUESTIONS ANSWERED IN THIS CHAPTER:

- *How can fears and attitudes toward death and dying be determined?*
- *In what ways are fears and attitudes toward death associated with chronological age, culture, and history?*
- *What are near-death experiences, and how have they been interpreted?*
- *What is a terminal drop, and how can it be explained?*
- *What roles do feelings of helplessness and hopelessness play in dying, and how can they be counteracted?*
- *What is Kübler-Ross's stage theory of dying, and why has it been criticized?*
- *What are some alternative descriptions and explanations of the psychological processes involved in dying?*

Children and young adults do not usually spend much time thinking about death. When one is young, energetic, and full of hopes and expectations, life is just beginning, and death, if it is considered at all, is perceived as lying in the distant, uncertain future. Rather than being concerned about growing old and dying, young people are usually in a hurry to grow up so they can start living their own lives and acquiring all the benefits that adulthood seems to promise.

There is no specific age at which people begin thinking more about death and dying. Certainly there is no scarcity of death scenes in the media to stimulate children's feelings and knowledge about death. Although today's children rarely see an actual dead body, it is noteworthy that by the time they are 18 years old, Americans have witnessed approximately 18,000 television deaths, most of them homicides (Oskamp, 1984). Despite this saturation with death scenes, children and young adults do not typically dwell on death.

Perhaps because they are not particularly aware of their own aging processes, young adults do not think very much about death. A young man who has a serious

accident or a young pregnant woman may experience some death anxiety, but frequent thoughts of death do not intrude upon the consciousness of most people until middle age. Tradition has it that a turning point in the concern about death and dying is age 30 for women and age 40 for men. Whatever the critical age may be, there comes a time in the life of an individual when he or she is apt to measure life in terms of the number of years left rather than the years already spent. At this time, the reality of temporal limits on personal existence becomes of greater concern to the individual than it has previously. If that time comes sooner than expected, say in young adulthood, the person may be

> *filled with rage and anger for the interruption of her life at the moment of its fulfillment. . . . There is frustration, rage, and a sense of unfairness and of being cheated. . . . The patient holds onto life more tenaciously than at any other age. The losses are now especially acute, as the patient will never see the promise for self and significant others (especially children) fulfilled (Rando, 1984, p. 246).*

Sometime during the fifth decade of life, signs that the *catabolic* (breaking down) processes of the body are outstripping the *anabolic* (building up) processes become all too clear. Physical deterioration caused by aging begins to show in one's appearance and abilities. The deaths of relatives and friends who are in the middle or late years of life remind a person that the chances of dying increase every year after age 45 or so. This trend is demonstrated by the age-specific death rates in Figure 9-1. Not only does the likelihood of dying increase, but it does so at an accelerated rate after young adulthood. This is the time when more and more of one's relatives and friends, and even strangers in one's own age group, are dying. Physical changes occurring in oneself at this time of life reveal as untrue the unexpressed but half-believed romantic assumption that "other people may die, but I am invulnerable and hence immortal." Death is recognized as something that eventually happens to everyone, including oneself.

The review, reevaluation, and realization of midlife may precipitate what Levinson (1978) has labeled a midlife crisis, a crisis that can lead to new efforts or resignation. It is a time when one thinks less about how long he or she has lived and more about how much time is left in which to attain the goals or realize the dreams of early adulthood. In any event, midlife is a time to shed one's irrational notions about life. Among those notions are the illusions that I will be safe forever, death cannot happen to me or my loved ones, and it is impossible to live without a partner in the world (Gould, 1980).

FEARS OF DEATH

Cross-sectional surveys of adults are fairly consistent in showing that fear of death is more common and more intense during middle age than in later life (Bengston et al., 1977; Gesser et al., 1987–1988; Kalish & Reynolds, 1981). This fear, which has been identified as part of the midlife crisis, is precipitated by the individual's

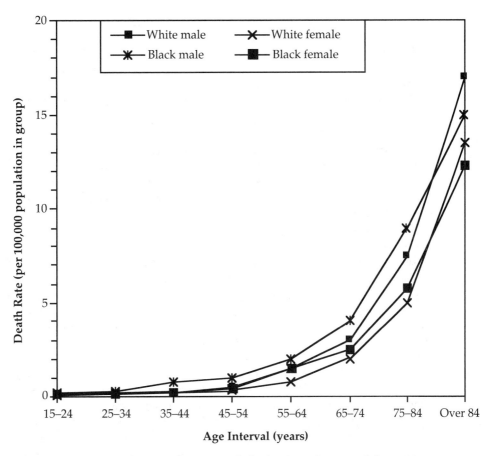

FIGURE 9-1 Death Rates for U.S. Adults by Age, Race, and Sex, 1992

Source: Data from National Center for Health Statistics, 1992. *Monthly Vital Statistics Report 40* (13). Hyattsville, MD: U.S. Department of Health and Human Services.

BOX 9-1 • When I Have Fears That I May Cease to Be

*When I have fears that I may cease to be
Before my pen has glean'd my teeming brain,
Before high-piled books, in charact'ry
Hold like rich garners the full-ripen'd grain;
When I behold, upon the night's starr'd face,
Huge cloudy symbols of a high romance,
And think that I may never live to trace
Their shadows, with the magic hand of chance;*

*And when I feel, fair creature of an hour!
That I shall never look upon thee more,
Never have relish in the faery power
Of unreflecting love!—then on the shore
Of the wide world I stand alone, and think
Till love and fame to nothingness do sink.*

—John Keats

awareness of his or her declining health and appearance, coupled with unfulfilled dreams and unattained goals. An event that can enhance this fear is the death of one's parents. When mother and father have died, the buffer between oneself and death seems to be gone, and one is next in line. Fears of death can be particularly intense in middle-age people who are living enjoyable, personally meaningful lives and become seriously ill. An inventory of one's assets and liabilities, combined with a reasonable assessment of the time remaining in life, frequently acts as a stimulus to anxiety, sometimes hastening the very event that the individual dreads most.

Levinson (1978) refers to the period between ages 60 and 65 as the *late adult transition,* a time when the person realizes that he or she can no longer occupy center stage. The heavy responsibilities of middle adulthood must be reduced as the aging individual learns to function in a changed relationship between himself and society. In the end, what matters most is "one's view from the bridge"—the final sense of what life is all about and what it means. Such a perception typically takes place as a result of what Butler (1971) termed a *life review,* a process of looking back over one's life and sorting the good from the bad.

As an individual grows older and the physical deterioration of the body becomes more and more apparent, annoying, and debilitating, the psychological distance from death diminishes. With each passing year, people perceive themselves as getting closer and closer to the end of life. In this shifting time perspective, the personal past—the time of one's major successes and failures—is seen as being relatively long and the personal future as relatively short. People begin to talk more and more about bygone days and "how it used to be"—a tendency that may cause their younger associates to remark that their elders are "living in the past."

Compared with the middle aged, the elderly are more likely to see themselves as having had their day and to view death in old age as only fair. Experiencing the decline in their own bodies and being reminded of death as their age-peers and even younger people die, elderly people realize that their time is shorter than in earlier years. Being thus forced to confront the reality of death, they are better able to cope with fears of it (Kalish, 1985b). They do not plan as far ahead and tend to be more inner directed or private in their activities than their younger contemporaries. The deaths of friends and relatives, a lack of satisfying social roles, health and financial problems, and increased dependence on others all contribute to feelings of having outlived one's usefulness and resignation to one's fate. Whatever the reasons may be, elderly people are usually not as afraid of dying as younger and middle-age people (Neimeyer, 1988; Wass, 1979). The fears that they have are those of isolation and loneliness rather than the pain and the sadness at leaving loved ones. Dying persons, both young and old, have feelings of regret over lost opportunities. Although the majority of older people do not express great fears of death, many do. Butler and Lewis (1982) found, for example, that although 55 percent of the elderly people whom they surveyed had realistically resolved their fears of death, 30 percent were overtly afraid of it, and the remaining 15 percent used defensive denial to cope with those fears.

Fears of death and dying may be quite strong in elderly people who are in poor physical or mental health or who have a disabled spouse, dependent children, or

important goals that they still expect to attain. By and large, however, the elderly are more likely to fear the process of dying rather than the state of death itself. Even terminally ill older people tend to be less afraid than their younger counterparts. Although terminal illness usually increases fears of dying in the young (Feifel & Jones, 1968), it appears to have no such effect on the majority of elderly individuals (Kastenbaum, 1969). When asked how they would want to spend the time until they died if they had a terminal disease and six months to live, significantly more elderly than young or middle-age adults stated that they would spend the time reading, contemplating, praying, or focusing on their inner lives (Kalish & Reynolds, 1981) (see Figure 9-2).

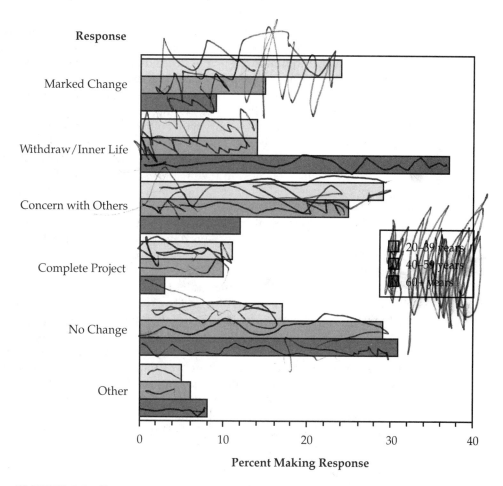

FIGURE 9-2 Responses to Question of How One Would Spend Time If Terminally Ill

Source: Data from Kalish, R. A., & Reynolds, D. K., *Death and ethnicity: A psychocultural study* (1981). Farmingdale, NY: Baywood.

Kalish (1985b) maintains that the "blurring of ego boundaries," or diffusion of the sense of self, in the elderly may serve as a mechanism for transcending pain, and hence contribute to the lower incidence of death fears in this age group. Also associated with the blurring of ego boundaries are "altered mind states" resulting from psychedelic drugs and psychological techniques, which have been found to reduce fears of death and dying (Kalish, 1985b; Peck, 1968).

Causes and Correlates of Death Fears

Why are people afraid of death? Is it the process of dying and the associated pain and suffering that evoke anxiety? Is it a fear of dying before accomplishing one's goals, or a fear of not knowing what will happen after death (the "great unknown")? Is it what the existentialists refer to as the state of nonbeing, nothingness, or extinction—the loss of identity—that is feared? There are no simple answers to these questions. In addition to the fear of death there are fears *about* death, but it is the former that undermines our emotional and mental life.

People are afraid of death for different reasons. Furthermore, the intensity and direction of the fear vary with the person and external circumstances. Fears and attitudes toward death and dying vary with culture, chronological age, sex, educational level. For example, Myers, Wass, and Murphy (1980) found that in a sample of elderly people whom they studied, black males were most afraid of death, followed by black females, white females, and white males, in that order. Familial and other social supports, personal mishaps, the sense of purpose or meaning in an individual's life, and other conditions and situations also influence fears of death. Like all affective responses, attitudes and fears concerning death are shaped by the sociocultural context in which a person develops, and particularly in the family situation (Huyck & Hoyer, 1982).

Not all people admit to being afraid of death and dying, and some even express a wish to die. Pain, loneliness, shame, guilt, depression, and the feeling that there is nothing worthwhile to live for may all lead to a desire for death. Only a minority of elderly people report being afraid or terrified by death (Kalish & Reynolds, 1981; Reker et al., 1987; Leming, 1980) (see Figure 9-3). But even though they express less fear of death, older people are certainly very aware of it. As one grows older, awareness of death increases, an awareness that is prompted by the deaths of friends, relatives, and associates on an almost daily basis. Compared with younger and middle-age people, more elderly people report thinking and dreaming about death (Kalish & Reynolds, 1981). They think about it and discuss it with others, but these thoughts and discussions are rarely expressions of strong fears of death.

Assessment of Fears and Attitudes Toward Death

Whatever the origins of death fears and attitudes may be, as with other affective and cognitive characteristics, efforts have been made to measure them. A variety of methods have been applied to the measurement of attitudes toward death, including behavioral observations, interviews, projective techniques, physiological re-

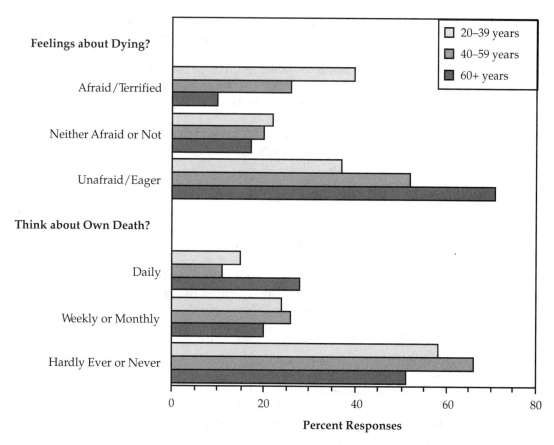

FIGURE 9-3 Age Changes in Feelings and Thoughts About Death

Source: Data from Kalish, R. A., & Reynolds, D. K., *Death and ethnicity: A psychocultural study* (1981). Farmingdale, NY: Baywood.

sponses, and questionnaires. One popular method of assessing attitudes is a simple opinion poll. For example, Shneidman (1973) asked the question "What does death mean to you?" of a large national sample of people. The most common responses and the percentages of respondents who gave each response were:

- The end; the final process of life (35 percent)
- The beginning of a life after death; a transition; a new beginning (13 percent)
- A joining of the spirit with a universal cosmic consciousness (12 percent)
- A kind of endless sleep; rest and peace (9 percent)
- Termination of this life but with survival of the spirit (17 percent)
- Don't know, or other answers (14 percent)

These answers do not measure the intensity of death fears, but they do reveal something of what death means to people.

Somewhat more precise than a simple yes-no tabulation of responses, at least from a measurement standpoint, is to ask people to rank a series of statements in order of their perceived importance. This procedure was followed by Diggory and Rothman (1961) in a study of the rankings given by 550 people to seven statements concerning death. The three statements that received the highest rankings, in order of their importance to the respondents, were:

1. My death would cause grief to my friends and relatives.
2. All my plans and projects would come to an end.
3. The process of dying might be painful.

Other studies (e.g., Kalish & Reynolds, 1981; Kastenbaum & Aisenberg, 1976) have also found that the death of a family member or relative is one of the most stressful events in a person's life.

More psychometrically sophisticated efforts to assess the intensity of death fears are seen in the administration of death anxiety scales, such as those constructed by Boyar (1964), Collett and Lester (1969), Hoelter (1979), Krieger, Epting, and Leitner (1974), and Templer (1970). The most frequently administered of these scales is Templer's Death Anxiety Scale (see Figure 9-4). The test-retest reliability of

Directions: Mark "T" if the statement is true of you; mark "F" if it is false.

1. I am very much afraid to die.
2. The thought of death seldom enters my mind.
3. It doesn't make me nervous when people talk about death.
4. I dread to think about having to have an operation.
5. I am not at all afraid to die.
6. I am not particularly afraid of getting cancer.
7. The thought of death never bothers me.
8. I am often distressed by the way time flies so very rapidly.
9. I fear dying a painful death.
10. The subject of life after death troubles me greatly.
11. I am really scared of having a heart attack.
12. I often think about how short life really is.
13. I shudder when I hear people talking about a World War III.
14. The sight of a dead body is horrifying to me.
15. I feel that the future holds nothing for me to fear.

FIGURE 9-4 Death Anxiety Scale

Source: Journal of General Psychology, 82, pp. 1167, 1972. Reprinted with permission of the Helen Dwight Reid Educational Foundation. Published by Heldref Publications, 1319 Eighteenth St., NW, Washington, DC 20036-1802. Copyright © 1972. *Note:* See exercise 1, Questions and Activities, this chapter, for scoring information.

this instrument over short time periods is moderately high, but its internal consistency reliability is uncertain. A revision of Templer's scale, in which the true-false format was changed to seven-point agreement scales, failed to improve its psychometric characteristics appreciably (McMordie, 1978).

Somewhat more carefully constructed than the Templer scale is the Threat Index (Krieger et al., 1974). This instrument was designed to assess the respondent's interpretation of the concepts of "death" and "self" on opposite poles of a sample of bipolar adjective constructs (sick vs. healthy, static vs. changing, etc.). Also noteworthy is the multidimensional Collett-Lester Fear of Death Scale (Collett & Lester, 1969). Designed to assess four conceptually distinct dimensions of death fears—death of self (DS), dying of self (DyS), death of others (DO), and dying of others (DyO)—the Collett-Lester inventory employs a Likert-type response format in which respondents indicate their agreement or disagreement with each of 36 statements on a six-point scale.

Another multidimensional inventory that is administered even less frequently than the Collett-Lester instrument is the Hoelter Multidimensional Fear of Death Scale (Hoelter, 1979). The 48 Likert-type statements on this instrument are grouped into eight subscales of six items each. The factors assessed by the eight subscales are fear of dying, fear of the dead, fear of being destroyed, fear for significant others, fear of the unknown, fear of conscious death, fear for body after death, and fear of premature death. Little research data has been collected on the Collett-Lester and Hoelter instruments, but available psychometric findings indicate that the reliabilities of the subscales are relatively low (Neimeyer, 1988).

Extreme Fear of Death

As with any phobia, an extreme fear of death (*thanaphobia*) may have a generalized quality in which the person is afraid of the idea of death or dying rather than a specific condition or situation associated with it. In such cases, reminding the person that he or she is going to die, as in the memento mori ("Remember, you must die") of bygone years, can trigger a panic reaction or anxiety attack. On further analysis, the fear usually turns out to be not so much a fear of death itself but rather a fear of what death represents or connotes—personal extinction, separation from loved ones and things, the great unknown, the supernatural, uncertainty of going to heaven or hell, or disfigurement and destruction of the body. On the other hand, rather than being a generalized fear of everything associated with death, the person may be afraid of the process of dying because of the pain associated with it. The fear of death may also be related to specific situations or objects, such as funerals, churches or anything religious, spirits or anything supernatural, stories or dramas in which someone dies, illness, injuries, hospitals, operations, or disabled, disfigured, or handicapped persons.

An extreme fear of death does not usually exist alone as a symptom, but is part of a general pattern of disordered behavior and cognition. In such cases, focusing on treatment of the fear exclusively may be insufficient. The patient's problems and life should be explored more fully and a variety of techniques employed. In many cases, however, it is sufficient, or at least efficient, to deal with the specific fear by itself.

Taking a personal history can reveal the predisposing and precipitating antecedents of the fear and the consequences or results of the thoughts and behaviors associated with it. A program for treating the fear may then be designed, which may include techniques such as systematic desensitization, self-monitoring, and modeling. Systematic desensitization, combined with progressive relaxation and counterconditioning, has proven effective in the treatment of many phobias. First, the patient is taught how to relax the muscles of the body progressively whenever he or she wishes to. Then a series of stimuli, graded according to their fear-provoking capacity, are presented. Initially, these stimuli are symbolic (e.g., "Imagine a situation . . ."), but eventually they may be made real (e.g., actual exposure to the fear object or situation). The patient is exposed to the hierarchically arranged stimuli or situations in order from least feared to most feared. When the patient has learned to tolerate the first feared stimulus, the next one in the hierarchy is presented, and so on until desensitization to all stimuli in the hierarchy has occurred. Although the patient and the therapist usually cooperate in designing a desensitization hierarchy based on the particular patient's experiences, one possible hierarchy for the systematic desensitization of an extreme fear of death is:

1. Reading a book in which someone dies
2. Looking at a painting of a deathbed or other dying scene
3. Viewing a film in which people die
4. Walking through a cemetery and looking at the tombstones
5. Writing a will and making other plans for my death
6. Attending the funeral of someone whom I know well
7. Imagining my funeral and wondering what will happen to me when I'm dead
8. Getting sick and not being able to get well
9. Discovering that I have a potentially fatal illness
10. Being admitted to the critical ward of a hospital
11. Being told that I have only a short time to live
12. Hearing that I am expected to die in the next day or so

In the therapeutic technique of *self-monitoring*, patients are instructed to carry materials such as a note pad, a diary, a wrist counter, and a timer with them at all times to keep a record of occurrences of their fear experiences and the time, place, and circumstances in which those experiences occurred. The recorded information is then reported and discussed with the psychotherapist. Interestingly enough, the very process of self-monitoring—observing and tabulating occurrences of specific fears and thoughts—can result in a decrease in their occurrence. *Modeling* the behavior of another person has also been shown to be an effective approach to overcoming phobias. In modeling, the patient watches another person interacting with the feared object or performing the feared act without showing any fear. The model may be on film, or it may be a real live model. The patient may also be encouraged to rehearse the feared behavior in a role-playing situation before actually engaging in it.

DEATH ATTITUDES IN HISTORICAL AND CONTEMPORARY PERSPECTIVE

Differences in attitudes toward death and dying are obviously not unique to the current scene but have varied throughout human history. Despite the difficulties of attempting to reconstruct the past to obtain insight into the origins of death rites and customs, the painstaking research of Philippe Aries (1981) has yielded many interesting findings. Employing a variety of historiographic methods, Aries set out to test the hypothesis of a relationship between attitude toward death and awareness of self or sense of individuality. Beginning his studies with documents and artifacts from the European Middle Ages of a thousand years ago, Aries traced the evolution of attitudes toward death and their relationships to self-awareness up to the twentieth century. The following discussion is a synopsis of his conclusions.

Aries's Eras in Attitudes Toward Death

During the *tame death* era of the Middle Ages, death was accepted and expected as a terrible but necessary human misfortune. In this group-centered, less individualistic period dominated by the Church, the dead were thought merely to be sleeping until the Second Coming of Christ. Death itself was not feared so much as the method and timing of death. Of greatest concern was a sudden death, without warning or during sleep, because it provided no opportunity for confession and absolution. Except in the case of upper-class persons, even funerary practices were a testimonial to the unimportance of the individual. Most people were buried in common pits, their bones being removed and placed in special receptacles, *ossuaries,* after the flesh had decayed. The ossuaries were tended by church workers and could be seen from the villages, where the descendants of the dead lived.

The late Middle Ages (through the fifteenth century) were, according to Aries, a time of the *death of the self,* a period when individuality was minimized even more than previously. People were believed to be judged at the moment of death, and hence that moment became especially feared. Cries of "Confess me! Confess me!" were heard on many battlefields strewn with dying men. Deathbed confessions abounded, for without a last confession it was believed that at the moment of death the immortal soul of the person would be seized by a devil instead of an angel.

The death-of-the-self attitude was succeeded by the *remote death* attitude of the seventeenth and eighteenth centuries. Death was now perceived as a sorrowful but remote event. Mortality was accepted, but thoughts of personal death still made people anxious. It was a time of romantic or macabre eroticism in which death was intermingled with sex in art and literature.

According to Aries, the prevailing attitude toward death had changed again by the beginning of the nineteenth century. The attitude toward death as ugly, including the belief in hell, began to diminish. During this period, which Aries maintained was dominated by a *death of the other* attitude, death was considered to be a beautiful event leading to a happy reunion in paradise. Religious beliefs prevailing at the time

held that the personal self survives death and roams the earth with other disembod-
ied spirits.

Aries is most critical of the next era, the *denial of death* era that began in the late
nineteenth century. This was the start of what he calls *the lie* and a time when death
became less visible. Dying people were hidden away in hospitals, children were
"spared" the unpleasantness of viewing and knowing about death and dying, the
deceased was efficiently prepared and interred by a team of professionals, and
public mourning was essentially eliminated. Death was likely to be seen as either an
accident or a medical failure, and, in contrast to the belief of the Middle Ages, the
best way to die was during sleep.

There are indications that the denial and externalization of death, which have
been so characteristic of twentieth-century Western society, have eroded somewhat
in the past few decades. Adults and children are learning once again that death is a
part of what it means to be human, and that it is inhuman for people to die all alone,
connected to tubes and life sustaining machines, without being given a chance to
make their peace and say their goodbyes.

Contemporary National and Racial Differences in Attitudes

Although customs and attitudes associated with death have varied extensively with
time and place, there are many cross-cultural similarities in practices and beliefs.
Most cultures do not consider death to be the end of existence. Rather, it is believed
that something of individual consciousness survives death and goes to a heavenly
or hellish afterlife (Grof & Halifax, 1977). As among the Murngin tribe of Australia
and the Gond people of India, the cause of death is often viewed as accidental or
external (due to magic or demons). A similar belief that death, illness, and other
misfortunes are nonrandom occurrences precipitated by forces external to the
individual is found among many native African groups.

The Murngins respond with anger and fear to the death of a member of their
tribe. In contrast, the Tlingit people of Alaska, who view death as a natural phenom-
enon, accept it calmly and even joyfully. Similarly, the Basques of northern Spain
hold that death is the crowning point of life, to be anticipated and celebrated by
complex mourning rites. The East African Masai are also apparently unafraid of
death, but, unlike the Basques, they minimize the importance of death and practice
quite simple burial customs.

Cultural differences in attitudes and beliefs concerning death are widespread
within the United States. For example, Kalish and Reynolds (1981) found many
differences among the responses of their samples of blacks, whites, Japanese Ameri-
cans, and Mexican Americans to questions about death and dying. Larger percent-
ages of blacks and whites indicated that patients should be told when they are
dying. Mexican Americans were less likely than the other three groups to believe
that (1) they would let people die if they wanted to, (2) they should be informed
when they are mortally ill, and (3) they would try very hard to control their
emotions in public if someone close died. A greater percentage of whites than the

other ethnic groups indicated that slow death is more tragic than sudden death and death in childhood is most tragic of all. Whites also reported having had less contact with the dead and dying and were more likely to avoid funerals. Greater percentages of both African Americans and Mexican Americans (1) saw the death of a woman as more tragic than the death of a man, (2) admitted having experienced or felt the presence of someone who had died, and (3) wanted to live past age 90. Many of the differences in the responses of the four ethnic groups declined with age, and there were noteworthy similarities. For example, large percentages of all four groups viewed the private expression of grief as more appropriate than public display.

Other Factors Related to Fears and Attitudes Toward Death

Chronological age, ethnicity, and culture are obviously not the only factors related to attitudes and fears toward death. One important variable that helps control the fear of death is living (and dying) in familiar and stable surroundings (Lieberman & Coplan, 1969). The feelings of social support and belongingness resulting from being a part of the same group and locality both before and after death serve to reduce and calm one's fears.

Although the majority of older people die in hospitals and nursing homes, most prefer to die in the familiar surroundings of their homes (Kalish, 1985a). Attitudes toward death are also related to sex, education, occupation, personality, religious beliefs, social acceptance, and other demographic and personal characteristics.

Sex

Women score higher on scales of death anxiety than men (Lonetto et al., 1980; Pollack, 1979). For example, in a study by Wass and Sisler (1978), noninstitutionalized elderly women expressed more fears of death than men. However, sex differences in anxiety and attitudes toward death may be due to the fact that, rather than having more intense feelings, women are simply more open in expressing their attitudes and emotions. In addition, the perceptions that women have of death are different from those of men. Back (1971) found that, in comparison with elderly men, elderly women tend to be more accepting and benevolent in their attitudes toward death. Women tend to liken death to a compassionate mother or an understanding doctor rather than an opponent. Men, on the other hand, tend to view death as an evil antagonist, a grinning butcher, or a hangman with bloody hands who must be combatted.

Education

Concerning the relationships between education and fears of death, Riley (1968) found a significant negative correlation between educational level and fear of death. Compared with more highly educated people, those with less education expressed more negative views concerning death. This result was confirmed by Keith (1979), who found that the less educated are more likely to view death negatively, as

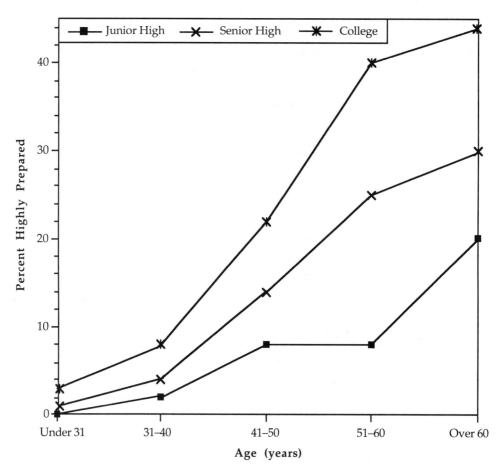

FIGURE 9-5 Age Differences in Reports of a High Degree of Preparation for Death

Source: Data from Riley & Foner, 1968.

coming too soon, and as being associated with suffering. People with less education are also less likely to talk about death or to make any plans for it, as in preparing a will or discussing funeral arrangements (see Figure 9-5).

Occupation

Several studies of the relationships of occupation to fears and attitudes toward death have been conducted. One study found that physicians and medical students have greater death anxiety than most professional persons (Feifel et al., 1967). This finding, however, was not confirmed by Neimeyer, Bagley, and Moore (1986). Neimeyer (1988) makes a distinction between "death exposure" occupations and "death risk" occupations, concluding that death anxiety is likely to be high in the latter but not necessarily in the former.

Personal Adjustment

People who are emotionally and financially stable and have attained most of their life goals are typically more accepting of death than those who have not been so successful. Those who have many unresolved frustrations or are extremely self-centered are more likely to view death in a negative way or, alternatively, as an escape from an unrewarding life (Hinton, 1972). Furthermore, the presence of neurotic symptoms such as anxiety and depression is more common among the highly death anxious (Conte et al., 1982; Gilliland & Templer, 1985; Howells & Field, 1982). Treating people who are both depressed and death anxious tends to reduce their death anxiety as their depression is alleviated (Templer et al., 1974).

Defensiveness and Denial

Another personality variable that is related to death anxiety is denial or repression. The results of studies by Tobacyk and Eckstein (1980) and Kane and Hogan (1985) indicate that low death anxiety is associated with a defensive personality that avoids rather than confronts threatening situations. Nevertheless, a certain amount of denial is not necessarily pathological or even maladaptive if it helps the person to cope with potential threats to existence and to keep hope alive. As implied in the following quotation, denial of death is as natural for humans as eating and sleeping

> *Man contains within himself a most profound contradiction. At the conscious, intellectual level he is absolutely convinced that he must die, this belief being reinforced and sustained by contacts with those around him who share it, as well as by the knowledge of the deaths of others. He can be more certain of his death than of his name. His unconscious is "immortal," however, denying the reality of his death and not allowing him to imagine himself dead. There is absolutely no way to eradicate the emotional feeling of immortality, so that the individual's emotions deny his death quite as steadfastly as his intellect affirms it. (Dumont & Foss, 1972, pp. 104–105)*

Religious Beliefs

Research studies have also noted a relationship between death anxiety and religious beliefs. Rigdon and Epting (1985) found that college students who were less afraid and less threatened by death were more likely to attend church, read religious books, and believe in an afterlife. The results of previous studies support the conclusion that people who believe in some form of God and have truly integrated religion into their lives are usually better able to face death without overwhelming fears than are those who are uncertain about religion (Kübler-Ross, 1974; Nelson & Nelson, 1973). Feifel and Nagy (1981) found that fear of death was inversely related to religiosity, whether religiosity was defined as self-reported religiousness, intrinsic religiousness, belief in God, importance of religion in everyday life, or belief in life after death.

People with intense religious beliefs in God and an afterlife presumably find more meaning in life and relief from fear of death than those who are uncertain and practice religion only for "status" or "safety" reasons (Cassem, 1988). Simply pro-

fessing a belief in God and an afterlife and attending church regularly are not likely to protect people from fears of death and dying. Furthermore, affirmed atheists, who disbelieve intensely, also profess few fears of death. Like the philosopher-mathematician Bertrand Russell, they have resigned themselves to the fact that "When I die I shall rot, and nothing of my ego will survive." The greatest apprehension concerning death is found among people in the middle range between strong believers and strong nonbelievers in religion, those sporadically religious people who are inconsistent or uncertain in their beliefs (Aday, 1984–1985; McMordie, 1981). Apparently, it is ambivalence or uncertainty of belief rather than a lack of religious belief that leads to unresolved fear of death.

AFTERLIFE AND NEAR-DEATH EXPERIENCES

The event of death can obviously be viewed in a number of ways—as the final insult to humanity, as the last developmental task, or as a rite of passage to another plane of existence. However it is perceived, the fact remains that death comes to all and should be thought about and dealt with by everyone. Whether these thoughts produce motivational paralysis on the one hand or a beneficial or destructive change in personality on the other depends on the individual's past experiences and present social supports. The effects of increased awareness of death also depend on one's philosophy of life, a philosophy shaped by the multiplicity of social interactions taking place from childhood to senescence. A part of that continually developing philosophy is concerned with a sense of purpose in life, a purpose that serves as a mainstay in coping with the problems and emotions precipitated by the inevitability of life's ending.

Since time immemorial, the great majority of humankind has found meaning and purpose in life through religious beliefs. A strong belief in conventional religious principles is, however, not essential to a calm acceptance of death. Although strong religious beliefs are frequently a comfort to dying people, other philosophical tenets may serve just as well. Erikson (1976) maintained, for example, that an identification with the human race rather than religious orthodoxy is the best defense against death anxiety.

Belief in an Afterlife

Characteristics of religion that provide comfort to dying people vary widely with time and culture, but all religions try to provide a purpose and meaning for human existence. Although most religious people believe in some form of personal afterlife, such a belief is not essential to facing death calmly (Kalish & Reynolds, 1981). In fact, elderly people are usually more concerned about death per se and their own demise that they are with life after death (Hurlock, 1980). It is understandable, however, that feelings of personal transcendence and belief in an afterlife often provide comfort and reassurance to dying people. Such beliefs may be interpreted as wish-

ful thinking or defensive denial, and those mechanisms are present in many cases. The threat of total extinction and nothingness is a fearsome prospect, and it is natural for the human ego to defend itself against that threat.

Conceptions of immortality and afterlife, heaven, and hell form a part of most religions. Christians are frequently unclear about the nature of the life to come, but a large percentage believe that something of human personality survives the death of the body. Hindus, Buddhists, and members of certain other religious groups believe in reincarnation or metempsychosis, in which something of the spirit of the deceased passes into another living body. Buddhists, however, do not accept the notion that what passes from one life to the next is an unchanging self or permanent soul. In both Hinduism and Buddhism, the particular form in which the deceased is reincarnated is determined by his or her *karma,* or actions in previous lives. The individual's last thought before dying is particularly important in determining the character of the next incarnation.

The United States prides itself on being a religious nation, and belief in a hereafter is held quite strongly by many Americans. In a Gallup poll conducted in the United States during the early 1980s, 67 percent of those who were questioned stated that they believe in life after death. However, the percentage who professed such a belief varied significantly with geographical region, size of community, ethnicity, religion, and other demographic variables. Greater percentages of Southerners and Midwesterners than Easterners and Westerners, and a greater percentage of small-city than large-city dwellers, reported believing in an afterlife. Greater percentages of whites than blacks and of Protestants than Catholics also stated that they believed in an afterlife. Of all those who were polled, only 20 percent felt that life after death would ever be scientifically proved.

Near-Death Experiences

Despite mythological and mystical accounts of individuals who returned to life after having died, little if any scientific evidence of an afterlife has been obtained. Interview data from patients who were "dead" for a few minutes have been obtained by physicians and others since Plato's time, but interpretations of this anecdotal information have varied. The first systematic investigation of these so-called *near-death experiences* (NDEs) was conducted at the turn of the century by Albert Heim, a Swiss geologist. Heim interviewed 30 skiers and mountain climbers who had accidents resulting in paranormal experiences. Three quarters of a century later, Kletti and Noyes (1981) interpreted these experiences as defensive depersonalization: by getting outside oneself, as it were, the person defends himself against the reality of death.

Since Heim's time, a wealth of anecdotal information has been obtained from people who almost died and were actually pronounced medically dead in some instances (cessation of heartbeat, not brain death). Based on a number of these reports, Noyes (1972) identified three experiential phases occurring at the moment of death—resistance, life review, and transcendence. During the first phase, *resistance,* the dying person is initially aware of extreme danger, which leads to fear and

struggling; sensations are enhanced and accelerated, and time seems to expand. During the second phase, *life review*, there is a pleasant out-of-body sensation of observing one's own physical being from somewhere outside; past experiences also pass rapidly before the individual. During the third phase, *transcendence*, there is a sense of awareness of the cosmos, of being one with other people and nature—a feeling of contentment and even ecstasy in which one is outside space and time.

Reports of such out-of-body experiences are not uncommon. For example, 15 percent of a national sample of adults polled by Gallup and Proctor (1982) reported having been on the verge of death or having had a close call that involved an unusual experience at the time. Particularly influential in stimulating both popular and scientific interest in life after death have been the research and writings of Raymond Moody (1976). Moody's research methodology consisted of interviewing people who have been resuscitated after having been pronounced clinically dead. Although the 150 or so people whom Moody interviewed had difficulty describing their experiences, some common features emerged. Most people referred to a feeling of peace and quiet, a sense of floating out of and above one's own body, traveling through a dark tunnel and toward a distant white light. On approaching the light the person had a powerful sense of love and an impression of being interrogated about his or her life and the degree of satisfaction with it. At this time a colorful, panoramic review of one's life was experienced, a review that was totally accepted by a "being of light." Many people who reported having these experiences confessed that they were reluctant to return to their physical bodies, but the need to complete unfinished tasks made them do so (see Box 9-2).

A number of other investigators have employed Moody's methodology (e.g., Garfield, 1979; Noyes, 1982–1983; Ring, 1980, 1982). From a study of 102 people who had experienced NDEs, Ring (1980) analyzed interviews of 49 people who, according to Moody's definition, were "core experiencers" of NDEs. Ring concluded that the experiences of these individuals occurred in five stages: (1) peace and a sense of well-being, (2) leaving the body behind, (3) entering the darkness, (4) seeing the light, and (5) entering the light. The third and fourth stages were accompanied by a life review, encounters with a "presence" and loved ones, and a final decision to return to life.

According to Sabom (1983), the experiences of Moody's and Ring's patients are not rare; millions of people of all ages, cultures, religions, and educational levels have had NDEs. The question is not whether the experiences are real but rather how to explain or interpret them. Siegel (1980) admitted that Moody's findings can be interpreted as demonstrating that people survive death, but he prefers a more parsimonious explanation. Noting the similarity of these afterlife visions to hallucinations produced by drugs such as keatmine, which is related to PCP ("angel dust"), Siegel (1980) interpreted NDEs as dissociative hallucinations caused by abnormal brain activity. Related physiological explanations for NDEs have been offered by Blacher (1979) (a "fantasy of death" or hallucinations accompanying oxygen deprivation), Comer, Madow, and Dixon (1967) (sensory deprivation), and Carr (1981) (a surge of endorphins triggered shortly before death).

BOX 9-2 • A Near-Death and Out-of-Body Experience

A man is dying and, as he reaches the point of greatest physical distress, he hears himself pronounced dead by his doctor. He begins to hear an uncomfortable noise, a loud ringing or buzzing, and at the same time feels himself moving very rapidly through a long dark tunnel. After this he suddenly finds himself outside of his own physical body, but still in the immediate physical environment, and he sees his own body from a distance, as though he is a spectator. He watches the resuscitation attempt from his unusual vantage point and is in a state of emotional upheaval.

After a while, he collects himself and becomes more accustomed to his body with very different powers from the physical body he has left behind. Soon other things begin to happen. Others come to meet and to help him. He glimpses the spirits of relatives and friends who have already died, and a loving, warm spirit of a kind he has never encountered before—a being of light—appears before him. This being asks him a question, nonverbally,

to make him evaluate his life and helps him along by showing him a panoramic, instantaneous playback of the major events of his life. At some point he finds himself approaching some sort of barrier or border, apparently representing the limit between earthly life and the next life. Yet, he finds that he must go back to earth, that the time for his death has not yet come. At this point he resists, for by now he is taken up with his experiences in the afterlife and does not want to return. He is overwhelmed by intense feelings of joy, love, and peace. Despite his attitude, though, he somehow reunites with his physical body and lives.

Later he tries to tell others, but he has trouble doing so. In the first place, he can find no human words adequate to describe these unearthly episodes. He also finds that others scoff, so he stops telling other people. Still, the experience affects his life profoundly, especially his views about death and its relationship to life.

Source: Raymond A. Moody, Jr. 1975. *Life After Life: The Investigation of a Phenomenon—Survival of Bodily Death.* Boston: G. K. Hall, pp. 16–18. Reprinted by permission of the publisher. All rights reserved.

Other explanations of NDEs have been proposed by Simpson (1979) and Thomas (1975). In describing what he labels "the Lazarus syndrome," Simpson interprets near-death experiences as delirium states, romantic wish fulfillment, or psychological attempts to survive death. Consistent with Siegel's (1980) viewpoint, Thomas (1975) suggests that these experiences are caused by the release of beta-endorphin, an opiate produced by the body at the time of death. After pointing to the similarity of NDEs to psychedelic drug experiences, Kastenbaum (1981) concluded that people who have NDEs are still alive and that these experiences have nothing to do with death. In short, he maintains, "There appears little reason to accept the current spate of NDEs as demonstrating anything about the death state per se, or about the possibility of survival" (Kastenbaum, 1981, p. 294). These sentiments are echoed by Kung (1984, p. 20), a renowned theologian:

What then do these experiences of dying imply for life after death? To put it briefly, nothing! For I regard it as a duty of theological truthfulness to answer clearly that

experiences of this kind prove nothing about a possible life after death: it is a question here of the last five minutes before death and not of an eternal life after death.

Whatever one's personal belief may be, many researchers have concluded that NDEs cannot be adequately explained at this time. Like religious portrayals of the hereafter, interpretations of near-death experiences as revealing something of the nature of afterlife are a matter of faith rather than science. It appears reasonable that the pleasant experiences of NDEs would tend to reduce fears of death and intensify belief in an afterlife (Sabom & Kreutziger, 1982) and serve as a consolation to those who are mourning a loved one or anticipating death themselves. One can interpret NDE research as demonstrating that the moment of death need not be feared; the pain goes away and the feeling can be calm and peaceful. Unfortunately, it is apparently not always so. Although reported visits to the "other side" are usually pleasant, they can be terrifying as well. One physician (Rawlings, 1978) reported that half of the 30 resuscitated patients whom he interviewed had unpleasant visions of hell when they were near death. Furthermore, a danger of publicizing a romantic, pleasant view of death is that such reports may encourage suicide in people who are already oriented in that direction (Kamerman, 1988).[1]

TIMING AND CONTROL OF DEATH

The rate of decline in functioning from health to death can be fast or slow, with many starts and stops. The *dying trajectory*, as it has been labeled, depends on the nature of the disorder, the patient's age and lifestyle, the medical treatment received, and various psychological factors. The effects of a specific disorder are seen in the "staircase" trajectory of multiple sclerosis, in which there are rapid declines followed by periods of remission (Glaser & Strauss, 1968). A long dying trajectory, although it gives the dying person a better chance to put his or her affairs in order and is perhaps less stressful to the survivors than a short dying trajectory, is not always desired by the dying person. Given a choice, many people would rather die quickly and avoid much pain and psychological stress for themselves and, presumably, their loved ones (Feifel, 1959).

Whether the dying trajectory is long or short, and especially when it is short, people of all ages are expected to deal with impending death in a reasonable way. What is socially accepted as reasonable, however, varies with the age of the person. It is generally expected that young people will resist death actively and even antagonistically and attempt to take care of uncompleted tasks. Elderly dying people, on the other hand, are expected to be more passive than younger adults and to express less anger and frustration when death is imminent (Sudnow, 1967).

Terminal Drop

Although people are seldom permitted to choose how quickly or slowly they die, there are usually signals of impending death. For example, certain researchers have

found evidence of a *terminal drop*—a decline in mental functioning (IQ, memory, cognitive organization), sensorimotor abilities such as reaction time, and personality characteristics such as assertiveness during the last few months or years of life. Prompting the initial research on the terminal drop was the claim made by a nurse in a home for the aged that she could predict which patients were going to die soon merely by observing that they "seem to act differently" (Lieberman, 1965).

Subsequent research findings revealed declines in various areas of cognitive ability and sensorimotor functioning in patients who died within a year after being tested (Granick & Patterson, 1972; Lieberman & Coplan, 1969; Reimanis & Green, 1971; Riegel & Riegel, 1972). Studies of deceased men who had participated in the Duke University longitudinal studies of aging found no terminal drop on tests of physical functioning, but scores on intelligence tests tended to drop sharply a few months or years before death (Palmore, 1982; Palmore & Cleveland, 1976; Siegler et al., 1982). The terminal drop was more likely to occur on nonspeeded tests such as vocabulary than on perceptual or problem-solving tests with short time limits. On the other hand, patients who did not show declines in intellectual functioning and behavior did not die until a significantly longer period after being tested.

To the extent that it is a genuine phenomenon and not merely an artifact of inadequate research methodology (Palmore & Cleveland, 1976), a terminal drop in cognitive functioning is probably caused by cerebrovascular and other physiological changes during the terminal phase of life. Lieberman (1965) also noted that people who are approaching death become more preoccupied with themselves, not because of any inherent conceit or egocentricity but rather as a desperate effort to keep from falling apart psychologically. Realizing that they are no longer able to organize and integrate complex sensory inputs efficiently and that they cannot cope with environmental demands adequately, they may experience feelings of chaos and impending doom and be less willing or able to exert themselves to perform up to their potential on psychological tests.

Personal Control of Death

Not all dying people manifest the sharp decline in mental functioning and behavior described by Lieberman (1965). But whatever the explanation may be, many individuals realize when they are about to die (Kalish & Reynolds, 1981). This realization affects different people in different ways. Some who no longer wish to live may give up without a struggle and die rather quickly. Having lost the will to survive, they embrace death as a solution to their personal problems. For example, Kastenbaum (1971) found that over one fourth of a group of terminally ill patients whom he interviewed wished to die soon.

Another group of severely ill people, those who find themselves unable to cope with the pain and frustration of prolonged illness but are also afraid of death, continually vacillate between a desire to live and a wish to die. The conflict between living and dying is aggravated when the person has one or more dependents but is afraid of becoming a burden to them.

Whether they desire to die sooner or later, it is generally acknowledged that people can, through their own attitudes and efforts, either hasten or delay their own

death. Having accepted the fact that they are going to die, they may even decide on a particular time for the event to occur. Evidence for this point was obtained by Kastenbaum and Aisenberg (1976), who found that cancer patients who had strong motivation to survive—as indicated by resentment against the illness and positive attitudes toward treatment—survived longer than patients whose will to live was weaker. Also associated with longer survival times is the maintenance of cooperative, happy social relationships, as opposed to the depressive reactions and destructive social relations that are associated with shorter survival times (Weisman & Worden, 1975).

Both John Adams and Thomas Jefferson died on July 4 of the same year (1826), and Mark Twain died on the eve of the second arrival of Halley's comet (1910)—the date on which he had predicted that he would die. Similar phenomena have been observed with less eminent persons (Fischer & Dlin, 1972). A priest who worked with Indians in the interior of Alaska observed that they could, to some extent, control the time, place, and manner in which they died. The priest was called to pray for Indians who believed, usually because of some "sign" in nature, that they were dying. They asked the priest to bring to them individuals to whom they had something to say, concerning such matters as an old score to be righted or a debt to be forgiven. Having made their peace with others, the majority reportedly died soon after receiving the last sacrament (Trelease, 1975).

More systematically obtained data also point to a relationship between time of death and important events (birthday, holidays, etc.) in a dying person's life. Research by D. P. Phillips and his coworkers (Phillips, 1975; Phillips & Feldman, 1973) found evidence of fewer deaths than expected before three ceremonial occasions—presidential elections, the Jewish high holy days, and the person's birthday. These findings suggest that people may possess an ability to postpone dying until after occasions of great personal significance to them. The reasons for these findings are not clear, however, and have been criticized on methodological grounds (Schultz & Bazerman, 1980).

In a more recent study of a large sample of Chinese women living in California, it was found that mortality dipped by 35 percent in the week before the Harvest Moon Festival and peaked by the same amount in the week after. The largest dip-peak pattern was seen in cerebrovascular diseases, followed by diseases of the heart and malignant neoplasms. The researchers concluded that the dip-peak pattern, which was not observed in various control groups, occurred because death can be postponed until after the occurrence of an occasion that is significant to the dying person (Phillips & Smith, 1990).

Helplessness, Hopelessness, and Choice

Deaths resulting from extreme stress and fear, as in voodoo, are referred to as *sympathetic deaths*. Believers in the power of voodoo curses that are placed on them can be literally "scared to death." The breaking of taboos has also apparently contributed to the deaths of violators who were convinced that spirits were going to kill them for their transgressions. Barker (1968) reported the following anecdote:

In New Zealand, a Maori woman ate some fruit which she subsequently learned had come from a tabooed place. She explained that the sanctity of her chief had been profaned thereby and that his spirit would kill her. She apparently died within twenty-four hours (p. 19).

Tales of being "scared to death" are not limited to people in less-developed cultures. Kalat (1984) presents a horrific account:

A story is told of a fraternity that decided to initiate a new pledge in what they considered a particularly imaginative way. They bound his arms and legs, blind-folded him, and tied him to a railroad track. Unbeknown to the poor pledge, they tied him to a track that was never used, but which was adjacent to one that was used. Along came a train. Although the young man was in no physical danger, he had every reason to believe he was, and he died (pp. 23–25).

In contrast to such sympathetic deaths is the plight of nursing-home patients and other ill or otherwise desperate people who give up and sometimes die *parasympathetic deaths*. The parasympathetic nervous system becomes excessively active, resulting in an extreme reduction in heart action and a fatal lowering of blood pressure (Seligman, 1975, 1992). In actuality, voodoo death and perhaps many other cases of sudden death in a frightening situation may be caused by excessive parasympathetic activity, either as a rebound effect from excessive sympathetic activity or as a response to a frightening but hopeless situation (Houston et al., 1989).

Parasympathetic death is believed to be the result, in many instances, of feeling helpless and hopeless. Death attributable to loss of hope and simply giving up has been observed in convicts, prisoners of war, and other institutionalized persons (see Box 9-3). For example, being forced to move from a more familiar environment to a less familiar one, such as a different hospital ward or institution, is commonly associated with increased rates of illness and mortality in elderly people (see Box 9-3).

Engel (1971) compiled reports of 70 cases of sudden death that were not medically expected and concluded that the common elements in all cases were feelings of hopelessness and helplessness. The individuals apparently resigned themselves to being unable to cope with whatever physical and psychological stress they were experiencing and simply gave up and died; to die was apparently the only choice they thought they had.

The results of Ferrare's (1962) study of nursing home applicants also underscore the importance of individual choice. Fifty-five women applicants to a nursing home were interviewed and classified as seeing themselves as either (1) having no choice but to enter the nursing home or (2) having other alternatives. Although no medical differences between the two groups of women were observed on admission to the home, 8 of the 17 women in the "no-choice" group died within 4 weeks and another 8 died within 10 weeks. But only 1 of the 38 women in the "choice" group died during the initial period.

BOX 9-3 • A Case of Parasympathetic Death?

A female patient who had remained in a mute state for nearly 10 years was shifted to a different floor of her building along with her floor mates, while her unit was being redecorated. The third floor of this psychiatric unit where the patient in question had been living was known among the patients as the chronic, hopeless floor. In contrast, the first floor was most commonly occupied by patients who held privileges, including the freedom to come and go on the hospital grounds and to the surrounding streets. In short, the first floor was an exit ward from which patients could anticipate discharge fairly rapidly. All patients who were temporarily moved from the third floor were given medical examinations prior to the move, and the patient in question was judged to be in excellent medical health though still mute and withdrawn. Shortly after moving to the first floor, this chronic psychiatric patient surprised the ward staff by becoming socially responsive such that within a two-week period she ceased being mute and was actually becoming gregarious. As fate would have it, the redecoration of the third-floor unit was soon completed and all previous residents were returned to it. Within a week after she had been returned to the "hopeless" unit, this patient, who like the legendary Snow White had been aroused from a living torpor, collapsed and died. The subsequent autopsy revealed no pathology of note, and it was whimsically suggested at the time that the patient had died of despair.

Source: H. M. Lefcourt (1973). The function of illusions of control and freedom. *American Psychologist, 28,* 422.

The findings of a later investigation by Langer and Rodin (1976) support and extend Ferrare's (1962) results on the importance of having choices or control over one's life. Nursing home patients between the ages of 65 and 90 were divided into three groups. One group was told by the home administrator that they still had a great deal of control over their own lives and should therefore decide how to spend their time. For example, they were encouraged to decide whether or not they wanted to see a movie that was being shown, and they were made responsible for taking care of a plant. A second (comparison) group of patients was assured that the nursing home staff was concerned with their well-being, but they were not encouraged to assume greater control over their own lives. They were told that the staff would inform them when they were to see the movie, and although they were also given a plant, they were told that the nurses would take care of it. A third (control) group of patients was given no special treatment. Subsequent ratings of the happiness, alertness, and activity of the residents were obtained from the nurses and the residents themselves. The results revealed significant increases in the happiness, alertness, and activity of the group that was urged to assume greater control over their lives, whereas the ratings of the comparison group on these variables declined. Follow-up data obtained 18 months later (Rodin & Langer, 1977) revealed even more impressive results. Not only did the patients in the first (experimental) group continue to be more vigorous, sociable, and self-initiating than those in the comparison and control groups, but the death rate in the first group was only half that of the other two groups.

The results of studies such as these support the recommendation that patients and other institutionalized persons be permitted as much control as possible over their own lives, for example, in planning their own meals, selecting their own clothes, deciding how to decorate their rooms, choosing whether or not to attend meetings and recreational activities, and the like. Unfortunately, these choices, often with good intentions, are sometimes taken away by institutional personnel and family members.

PSYCHOLOGICAL STAGES IN DYING

In her writings, talks, and workshops, Elisabeth Kübler-Ross has probably done more than any other person during the past 25 years to stimulate both popular and professional interest in death and dying. Her theory of five stages in the process of dying (Kübler-Ross, 1969) has been of particular interest. These stages, which dying people presumably go through, were formulated from an analysis of interviews with over 200 dying patients. Kübler-Ross argues that it is important for health workers and the families of dying people to be observant and aware of these progressive stages, because the psychological needs of patients and the appropriate responses to them vary somewhat from stage to stage. Throughout all five stages, however, efforts must be made to encourage the patient not to lose hope or to become pessimistically resigned to dying. Kübler-Ross advocates supporting the patient's feelings of hope with constant reassurance that everything medically and humanly possible is being done to help.

Kübler-Ross's Five Stages

Denial
The first stage, denial, is a common reaction to being told that one is dying. As noted previously in this chapter, denial is an important self-protective mechanism. It enables a person to keep from being overwhelmed or rendered helpless by the frightening and depressing events of life and to direct his or her attention to more rewarding experiences. Certainly, a seriously ill person will do well to question a terminal prognosis and seek additional medical opinions concerning the prognosis. But denial becomes unrealistic when the patient invests precious time, money, and emotions in quacks and faith healers.

Denial of death manifests itself in many ways. For example, patients who have been told clearly and explicitly that they have a heart disorder, cancer, or some other serious illness may deny having been told anything (Aitken-Swan & Easson, 1959; Bennett, 1976). Such "oversights" demonstrate how denial operates in selective attention, perception, and memory. Defensive, unconscious denial also helps a person to minimize the importance of bad news without dogmatically refusing to believe it.

Denial of death is not limited to dying patients. It is at least as common among medical personnel, who are trained to save lives and to whom the loss of a patient

represents failure. The family and friends of dying persons may also deny the inevitable, and all too often they perform a disservice to patients in doing so.

Anger

Continual deterioration of the patient's health and sense of well-being makes it more and more difficult to suppress the fact that time is growing short. As the dying process continues, denial gradually fades into partial acceptance of death. But partial acceptance creates feelings of anger at the unfairness of having to die without being given a chance to do all that one wants to do, especially when so many less significant or less valuable people will continue to live. The feelings of anger experienced by the dying person are frequently nondiscriminating, being directed at family, friends, the hospital staff, and God. The direct target of the patient's anger, however, is the unfairness of death rather than other people. It is important for those who have regular contacts with dying people to be prepared for these attacks of anger and to recognize that much of the hostility represents defensive displacement of emotion from the real target to a convenient scapegoat. To facilitate the expression of anger ("emotional venting") in a safe atmosphere, Kübler-Ross recommends the use of "screaming rooms" for both patients and staff.

Bargaining

In the normal course of events, the patient's anger fades and is replaced by a desperate attempt to buy time, for example, by striking a bargain with fate, God, the attending physicians, or with anyone or anything that offers hope for recovery or at least a postponement of death. Although it is not obvious in all patients, the stage of bargaining is a healthier, more controlled reaction than denial or anger. In any event, patients in the bargaining stage make many promises—to take their medicine without fussing, to attend church regularly, to be kinder to others, and so on. Praying for forgiveness, embracing new religious beliefs, and engaging in rituals or magical acts to ward off death are also common.

Depression

The fourth stage is depression, a stage in which the partial acceptance of the second stage gives way to a fuller realization of impending death. Denial, anger, and bargaining have all failed to stave off the demon, so the patient becomes dejected in the face of everything that has been suffered and will be relinquished in dying. Kübler-Ross considers depression, like the previous three stages, to be a normal and necessary step toward the final peace that comes with complete acceptance of death. She advises loved ones and medical personnel to let the patient feel depressed for a while, to share the patient's sadness, and then to offer reassurance and cheer when appropriate.

Acceptance

The last stage in the dying process, that of acceptance, is characterized by "quiet expectation" and is the healthiest way of facing death. The weakened, tired patient now fully accepts death's inevitability and its blessings in terms of release from pain

and anxiety. The patient may reminisce about life, finally coming to terms with it and acknowledging that the experience has been meaningful and valuable. This is a time of disengagement from everyone except a few family members and friends and the hospital staff. In these social interactions, old hurts become erased and last goodbyes are said. This calm acceptance of death has been immortalized in many poems, stories, and other works of art, including William Cullen Bryant's "Thanatopsis," Alfred Lord Tennyson's "Crossing the Bar," and Robert Louis Stevenson's "Requiem." More recently, as he lay dying of cancer, the noted journalist Stewart Alsop wrote: "A dying man needs to die as a sleepy man needs to sleep, and there comes a time when it is wrong, as well as useless, to resist" (Alsop, 1973, p. 299).

Criticisms of Kübler-Ross's Theory

Kübler-Ross's observations and investigations of dying are important contributions to thanatology, but her stage theory of the dying process has been questioned by a number of her professional colleagues. In all fairness, she has cautioned that the five stages should not be interpreted as a fixed, unvarying sequence or inevitable progression, but rather as a model for understanding how dying persons feel and think. In general, dying people move from a stage of initial shock to one of acceptance, but some die still angry at everyone and everything, and others die depressed. Nevertheless, the orderly listing or sequencing of these stages has encouraged application of the theory as an exact description of how dying people should behave and the precise order of occurrence of their reactions. Medical personnel can memorize the names and characteristics of the five stages fairly easily, and the pat descriptions make them appear more definite than they were perhaps intended to be. Nurses and doctors have been known to chide terminally ill patients for not completing particular stages in the proper sequence and "on time." As a consequence, dying patients are made to feel guilty for failing to accomplish the various tasks associated with specific stages "in order" and "on time." On the other hand, patients may also inform physicians and nurses of the stages they are in and therefore what to expect of them.

Despite criticisms of her stage theory and her dabbling in the occult and the connection between death and sex, Kübler-Ross is right in certain respects. Although there is considerable movement back and forth between denial and acceptance, denial is more common during the early part and acceptance more common during the later part of the dying trajectory (Kalish, 1985a). A similar sequence of behaviors can occur in response to any major loss, whether it be the death of a close relative, a divorce, or even the loss of a prized possession. Stage theory is also appealing from a training point of view: Medical personnel are busy people and therefore receptive to learnable and easily applicable suggestions for dealing with terminal patients, their relatives, and their close friends. As a result of the training, health personnel may also become more accepting of the full range of emotions expressed by dying people, emotions that otherwise might have been deemed inappropriate.

Other Descriptions of the Dying Process

Alternative ways of viewing the dying process have been proposed by a number of researchers, including Weisman and Kastenbaum (1968), Shneidman (1976, 1987), and Pattison (1977). Weisman and Kastenbaum (1968) observed two broad patterns of response in the dying persons whom they studied. One group consisted of two subgroups: (1) those who seemed unaware of the fact that they were dying, and (2) those who simply accepted it. Both of these subgroups became less and less active as the time of death approached. A second group remained active in hospital life until the very day on which they died.

Referring to the dying person's task as "death work," Shneidman (1976) maintains that the person first deals with impending death at a psychological level and prepares to meet the end. Next, the person readies himself or herself for death in a way that assists loved ones to prepare for their role of survivors. Shneidman recognizes, however, that there is a great deal of individuality in how people face death. As with any life crisis, the manner in which a person approaches death is a reflection of his or her total personality. Consequently, reactions to impending death reveal something about the personality and the kind of life that a person has lived. One person may view death as a punishment for wrongdoing, another is afraid of the separation entailed by death, and still another perceives death as an opportunity to be reunited with departed loved ones.

Various emotions and concerns are expressed by dying people—fear of the unknown, loneliness and sorrow, pain and suffering, loss of body, loss of self-control, and loss of identity. Pattison (1977) proposed a three-phase descriptive model, including those reactions and other psychological responses of persons during the *living-dying interval*—the interval between the initial death crisis and the actual time of death. During the *acute phase*, which corresponds to Kübler-Ross's denial, anger, and bargaining stages, anxiety and fear are at a peak. The high level of anxiety experienced during this first phase is reduced by defense mechanisms and other cognitive and affective resources of the person. During the second stage, the *chronic living-dying phase*, anxiety is reduced and questions about the unknown are asked: What will happen to my body, my "self," and my family and friends while I am dying and afterward? Considering my present situation, what realistic future plans can I make? It is also during the chronic living-dying phase that the person begins to accept death gracefully. During the third and final stage, or *terminal phase*, the person still wants to live but now accepts the fact that death is not going to go away. Functioning at a low energy level and desiring mainly comfort and caring, the person begins a final social and emotional withdrawal from life.

SUMMARY

Fears and attitudes toward death and dying have been assessed by means of polls, rankings, questionnaires, and inventories. Psychometric inventories, such as the Death Anxiety Scale, typically have modest reliabilities and validities.

Fears and attitudes toward death are correlated with a wide range of variables, including chronological age, cultural and social status, education, occupation, sex, personal experiences, personality, and religious or philosophical beliefs. Different cultures view death and dying and associated practices or rituals from different perspectives. Many of these cultural variations are, understandably, related to religious beliefs, socioeconomic status, ethnicity, and education.

Philippe Aries's historical research on the evolution of attitudes toward death since the Middle Ages points to relationships between attitude toward death and awareness of the self. Aries characterizes the dominant changes in attitude from the early Middle Ages to the present as a transition from the *tame death* to the *death of the self* to the *remote death* and, finally, to the *denial of death* in the twentieth century.

Elderly people think and talk more about death than young and middle-age adults, but fears of death are usually more intense during middle age. Even in old age, there are significant individual differences in fears and attitudes toward death. Older women are more likely to view death in a benevolent way, whereas older men tend to perceive it as an enemy. Furthermore, more positive attitudes toward death and dying are found in emotionally adjusted and financially stable people than among the maladjusted and the poor.

Deeply religious people and affirmed atheists tend to be less afraid of death than those who are uncertain about their beliefs. By providing a meaning for human existence and hope for an afterlife, religion can give comfort to the dying. The results of studies of people who have had near-death and out-of-body experiences have been interpreted either as actual visits to "the other side" or as hallucinatory phenomena with a biochemical or psychophysical basis. Such experiences are almost always reported as pleasant and therefore may provide hope and comfort to terminally ill patients and their survivors.

People have different dying trajectories, depending on the specific illness, the treatment program, and the age and lifestyle of the individual. Time of death, which may be signaled by a decline in mental abilities and changes in personality (*terminal drop*) can apparently be controlled to some extent by the dying person's attitude and desires. The results of observational and correlational studies indicate that feelings of helplessness and hopelessness can contribute to a short dying trajectory, whereas permitting patients to make choices and exert other controls over their lives can delay death.

Elisabeth Kübler-Ross described five psychological stages through which patients presumably pass in the process of dying—denial, anger, bargaining, depression, and acceptance. This formulation has been criticized as implying a unidirectional, unvarying sequence that is seldom observed in dying patients. Rather than progressing irreversibly from denial to acceptance, the patient is more likely to fluctuate between two or more emotional states. Alternative descriptions of the dying process have been proposed by Weisman and Kastenbaum, Shneidman, and Pattison. Kübler-Ross's theory, however, has found greater favor among doctors and nurses, who consider it a useful guide in the treatment of dying patients.

QUESTIONS AND ACTIVITIES

1. Make a dozen copies of the Death Anxiety Scale in Figure 9-4, and administer them to a dozen classmates or other individuals. The scoring key for the scale is: 1-T, 2-F, 3-F, 4-T, 5-F, 6-F, 7-F, 8-T, 9-T, 10-T, 11-T, 12-T, 13-T, 14-T, 15-F. For each of the preceding answers, score 1 point. The respondent's total score, which will be between 0 and 15, is the number of statements that he or she answered in the same direction as the key. Score the scale for each person and compare the scores of men and women. A score of 10 or above, which is higher than that obtained by 16 percent of a sample of college students, may be considered "high." What was the highest score obtained by your respondents? The lowest score? On the average, did men score lower or higher than women? Did older people score higher or lower than younger people? Why or why not?

2. Try the following exercise with yourself or a friend who did not make an extremely high score on the Death Anxiety Scale. *Do not try this exercise if the person is very fearful about death.* Construct a hierarchy of death-related events or scenes varying from most to least fearful. Now sit in an easy chair or lie down and try to relax as much as possible. Take several deep breaths, exhale slowly and relax your muscles one by one. Next try to picture the least fearful death-related event or scene on your hierarchy. Think about it as long as you can while continuing to relax and without becoming too fearful. Repeat this process with the next least fearful event on your hierarchy. Try one event per day until you are able to think about all the events on the hierarchy without become anxious or upset. Summarize the experience in a brief report.

3. Ask several friends or acquaintances if they will help you with a little course assignment that will take only about 10 minutes. Tell each person that you are going to read a list of words out loud, and that after each word is read the person should respond with the first word that comes to mind. Using a watch, a pencil, and a piece of note paper, record the response time, in seconds, and the association given to each word. Summarize the results in terms of the number of responses of a particular kind given to each stimulus word, average response times, and insights provided into the fears and attitudes of the respondents toward death. The words are: burial, disease, hell, cemetery, dying, kill, coffin, embalming, murder, cremation, funeral, soul, death, heaven, suicide. Use a different arrangement of the words for each respondent.

4. Why should moderately religious people be more afraid of death and dying than very religious people or nonreligious people? Under what circumstances might religion make a person less afraid of death, and when might it make a person more afraid of death?

5. How can a person control the time of his or her death? What psychophysiological mechanisms might come into play to influence the degree of control?

6. Do you know of anyone who became so depressed or in such despair that he or she simply seemed to just give up and die? How could this happen?

7. Ask a few people who have had close calls or near-death experiences in accidents about the thoughts and feelings they remember having at the time. Did their whole lives flash

before them? Did they have out-of-body experiences? Do they remember what happened just before the near-death experience, or is it a total blank?

8. Explain and criticize Elisabeth Kübler-Ross's conception of five stages in the dying process. Does it do more harm than good to teach these stages to nurses and other health professionals who work with dying patients?

9. Do you believe in a life after death? If so, where do you think you will be after you die, and what will your feelings and experiences be like?

10. Have you ever played with a ouija board or participated in a seance? If so, describe your experiences. If not, ask several classmates about their experiences with ouija boards, seances, the occult, and spirits. How valid are these reports?

ENDNOTE

1. An organization that collects and disseminates information on near-death and after-death experiences is the Survival Research Foundation, P.O. Box 8565, Pembroke Pines, FL 33084. 305/435-2730.

SUGGESTED READINGS

Aries, P. (1975). Death inside out. (B. Murchland, Trans.). In P. Steinfels & R. M. Veatch (Eds.), *Death inside out: The Hastings Center report* (pp. 9–24). New York: Harper & Row.

Becker, E. (1973). *The denial of death.* New York: Free Press.

Glaser, B., & Strauss, A. L. (1968). *A time for dying.* Chicago: Aldine.

Grosso, M. (1982). Toward an explanation of near-death phenomena. In C. R. Lundahl (Ed.), *A collection of near-death readings* (pp. 205–230). Chicago: Nelson-Hall.

Kübler-Ross, E. (Ed.). (1975). *Death: The final stage of growth.* Englewood Cliffs, NJ: Prentice Hall.

Moody, R. (1988). *The light beyond.* New York: Bantam.

Neimeyer, R. A. (1988). Death anxiety. In H. Wass, F. M. Berardo, & R. A. Neimeyer (Eds.), *Dying: Facing the facts* (2d ed.) (pp. 97–136).

Washington, DC: Hemisphere Publishing Corporation.

Pattison, E. M. (1977). Attitudes toward death. In E. M. Pattison (Ed.), *The experience of dying.* Englewood Cliffs, NJ: Prentice Hall.

Phillips, D. P., & Smith, D. G. (1990). Postponement of death until symbolically meaningful occasions. *Journal of the American Medical Association, 263* (14), 1947–1951.

Pollak, J. M. (1979–80). Correlates of death anxiety: A review of empirical studies. *Omega, Journal of Death and Dying, 10,* pp. 97–122.

Ring, K. (1980). *Life at death: A scientific investigation of the near-death experience.* New York: Coward, McCann & Geoghegan.

Seligman, M. (1992). *Helplessness* (2d ed.). San Francisco: Freeman.

Siegel, R. K. (1980). The psychology of life after death. *American Psychologist, 35,* pp. 911–931.

P A R T V

DYING AND SURVIVING

10

TREATMENT OF THE DYING AND THE DEAD

QUESTIONS ANSWERED IN THIS CHAPTER:

- *What are the arguments for and against dying at home rather than in a health-care institution?*
- *What attitudes have hospital staff members traditionally shown toward dying patients?*
- *In what ways are individual differences related to efforts to sustain life and/or resuscitate?*
- *How do medical definitions differ from legal definitions of death?*
- *What are the goals of hospice treatment and the procedures used to attain these goals?*
- *What is a conspiracy of silence and how should it be handled?*
- *What techniques are recommended for counseling dying persons?*
- *How do modern funerals differ from traditional funerals?*
- *What problems are being experienced by the funeral industry, and what are the causes of these problems?*

Whether death is perceived as a tragedy or a normal event depends not only on how it occurs but also on the dying person's age and relationships with the survivors. The death of a young person and any sudden, unexpected death may be perceived as more tragic than death in old age or death at the end of a long illness. In fact, when a person has suffered extensively, death is often seen as a relief or blessing rather than a tragedy.

In another sense, death is always something of a tragedy to the survivors, especially when the deceased was deeply loved, highly esteemed, or valued in other ways. The tragedy of death is compounded when a person dies all alone in the

impersonal, unloving atmosphere that characterizes some general hospitals, nursing homes, and even private residences.

Unlike previous times, when most dying was done at home, over two thirds of all deaths today take place outside the home (Kamerman, 1988). They occur in large, unfamiliar intensive-care units or wards of hospitals, where the emphasis is on preserving life rather than on quality of life, or in long-term care institutions. Given a choice, however, most people, particularly young adults and the elderly, prefer to die at home (Garrett, 1978). Home provides a familiar atmosphere of intimacy and loving care, a place where the dying person is more likely to face the inevitability of death without feeling abandoned and humiliated by his or her declining physical condition and dependence on others.

For humanitarian and medical reasons, home care is not always advisable. Although most family members would rather have their loved ones die at home, attending to a dying relative can place severe physical and emotional strains on a family (Cartwright et al., 1973). A decision not to die at home may also be made when family relations are unstable or unhappy or when older patients are concerned about upsetting young children in the home. Furthermore, private homes are usually poorly equipped to handle medical emergencies and other special procedures that may be required to sustain life and make dying patients more comfortable.

DYING IN INSTITUTIONS

A classic study of dying in institutions was conducted by Glaser and Strauss (1968). These researchers made intensive observations of dying patients and the way they were treated by doctors, nurses, and other personnel in six San Francisco-area medical facilities. They observed that, when confronted with a seriously ill or injured person, physicians in these facilities focused on the questions of certainty ("Will this patient die?") and time ("When?"). With regard to the "when" question, Glaser and Strauss noted various "dying trajectories" among patients. In the *lingering trajectory,* patients died over a long period of time, seeming to "drift out of the world, sometimes almost like imperceptibly melting snowflakes." Treatment of such patients emphasized "comfort, care, and custodial routine, complemented by a sentimental order emphasizing patience and inevitability" (Glaser & Strauss, 1968, p. 64). Patients who died quickly were characterized as following a *quick-dying trajectory,* which may or may not have been expected by the staff. Patients with an "expected quick death" were often seen in emergency rooms and intensive-care units of hospitals. On the other hand, the medical staff might expect the patient to die, but not as quickly as it occurred ("unexpected quick dying, but expected to die"). Finally, the staff might not have expected a patient to die, but death occurred suddenly ("unexpected quick dying, not expected to die") (Strauss & Glaser, 1970). Whether the patient is expected to die or not, and particularly if not, an unexpected quick-dying trajectory results in a crisis atmosphere in the hospital or long-term

care institution. The crisis atmosphere created by quick dying is especially disruptive on obstetrical wards or other wards where death is uncommon (Mauksch, 1975).

In general, nursing homes are better equipped than hospitals to handle patients who have lingering dying trajectories. Hospital personnel, whose training and attitudes are oriented toward recovery and cures rather than dying, have less difficulty dealing with quick-dying trajectories than with lingering dying trajectories.

Training and Attitudes of Medical Personnel

Despite the availability of lifesaving equipment and medical expertise, a typical hospital or nursing home is not, from a psychosocial perspective, the best of all possible places in which to die. Busy physicians and nurses, who are preoccupied with administrative and technical duties, have little time to try to understand and deal with the emotional and social needs of dying patients. The hospital staff can be seen moving swiftly and efficiently in and out of intensive-care rooms or terminal wards, checking their watches, administering medicines, and connecting, disconnecting, and tuning machines. If they do stop to chat with patients, it is usually only for brief moments before they are off to more pressing duties.

Doctors and nurses are trained to save lives, so it is not surprising if they become frustrated when, in spite of their best efforts, their patients die. For example, in discussing the findings of a study of dying patients in a teaching hospital, Mumma and Benoliel (1984–1985) state: "Despite the fact that the majority of patients had been designated 'no code' (no resuscitation attempts to be made) and had conditions labeled by their physicians as either grim or terminal, the treatment orientation was overwhelmingly toward the cure end of the comfort-cure continuum" (p. 285).

Sometimes, efforts by medical personnel to avoid failure assume the form of defensive anger at dying patients, in which they are treated differently from other patients. "Good" patients are those who make the staff look good; they do what they are expected to and do not cause a lot of trouble. "Bad" patients, on the other hand, are those who cause trouble by not getting well or by dying at the wrong time.

Staying away from a dying patient as much as possible is one method of coping employed by some hospital staff members. Research has shown that staff contact with a patient declines abruptly when the illness is diagnosed as terminal (Gordon & Klass, 1979). As one hospital staff member confessed, "When you've exhausted everything you can do for a patient medically, it becomes difficult to walk into the room every day and talk to the patient" (Barrow & Smith, 1983, p. 364).

To cope with their feelings of frustration, helplessness, and embarrassment, some doctors and nurses also tend to stereotype terminally ill patients as already dead or at least as different from the living. Depersonalization, which is reflected in the tendency to refer to patients by a specific disease and room number rather than a personal name, is most marked when the patient is most helpless. The hospital staff may become abrupt and tense with dying patients and confess that they don't

want them to die on their shift (Kübler-Ross, 1975). Sudnow (1967) studied a hospital in which it was common for aides or orderlies to prop up or ignore patients who died on their shift, leaving it for orderlies on the next shift to "discover" the body and hence be responsible for wrapping it. Mauksch (1975) quotes one head nurse who tearfully referred to a patient as particularly "cooperative" because she had died at three o'clock so neither shift would be responsible for the consequences.

To be fair, the preceding paragraph is itself probably an example of stereotyping or at least biased reporting. There is indeed a tendency for medical professionals to become detached specialists and spectators, who protect themselves by objectifying and combatting death rather than dealing with personal feelings. However, many doctors and nurses genuinely care for their dying patients and miss them when they are gone. These medical professionals have learned to be comfortable with dying patients and to accept death as a natural event rather than a frightening consequence of a medical mistake. By adopting this attitude, they are in a better position to help patients come to terms with the inevitable.

Recognizing the need for psychological as well as technical training of hospital personnel, medical educators are now more likely to include the topic of the psychology of death and dying in their teaching. For example, the number of full-term courses on death and dying offered by medical schools in the United States has increased substantially in recent years. In addition to complete courses, medical and nursing students are being trained by means of occasional lectures and short courses to deal with dying and death. Such training is designed to assist medical personnel in establishing greater rapport with terminally ill patients and their families and thus help them to view death less fearfully and make the passage from life to death more dignified for all concerned. One training procedure that has been used to increase the sensitivity of medical and nursing students to the role of psychological factors in dying is a *psychological autopsy*. This is an in-depth postmortem analysis of the psychosocial aspects of the patient's death and how they may have contributed to or eased the dying process (Weisman & Kastenbaum, 1968).

Sustaining Life and Resuscitating

For understandable reasons, the quality of medical care and efforts to arrest the decline in a patient's condition often diminish when the patient is diagnosed as incurable or terminal. This is particularly likely in the case of elderly patients or those who are perceived as being less valuable to society (Troll, 1982). For example, research findings indicate that both doctors and nurses in nursing homes often let terminally ill patients simply die, without making any special efforts to prolong their lives (Brown & Thompson, 1979).

A medical decision (*coding*) specifying the extent of efforts at resuscitation when the heart and lungs stop functioning is frequently made beforehand and entered in a patient's chart. *Code blue* is a directive for all-out efforts, including heroic or extraordinary measures as well as cardiopulmonary resuscitation (CPR). A *no code* directive indicates that neither CPR nor medical heroics are to be applied with the

patient. Finally, a *slow code* directive, which is often not even entered in a patient's chart, instructs nurses to initiate only CPR.[1]

Although the extent to which this coding system is followed varies with the medical facility and personnel involved, most physicians probably do as much as or more than can reasonably be expected to sustain the lives of patients. Sometimes doctors seem insensitive to dying patients and their rights to live as long as they can, but probably more common is the doctor who is unwilling to recognize when further efforts on behalf of a dying patient not only will fail but also will cause even more suffering to the patient and his or her loved ones. Erring on the side of taking extraordinary (heroic) lifesaving measures to extend life is, of course, made more likely in the face of expensive malpractice suits and other legal measures against medical personnel.

Much has been written about the rights of dying patients to decide when expensive and uncomfortable medical procedures should be terminated and the patient permitted to die a "natural" death. However, physicians and nurses are well acquainted with the ambivalent feelings of terminally ill patients toward living and dying. A dying person should certainly be permitted to have a voice in deciding whether to die at home and whether to prolong life by artificial means. But other voices, including those of family members and the attending medical staff, also have a right to be heard before a final decision is made.

In addition to ambivalence within patients, there are individual differences among patients in their expressed desires to have doctors make heroic efforts to keep them alive. When elderly people in a veterans' home were asked their preferences as to what medical efforts should be employed to sustain their lives if they were terminally ill, under great physical stress, and bearing heavy medical expenses, the responses were mixed. Almost 50 percent of the respondents said they would want the attending physician to keep them alive, but another 25 percent stated that they would wish death to be speeded up under such circumstances. The remaining 25 percent did not want either heroic measures or efforts to hasten death to be used (Preston & Williams, 1971).

Defining Death

Many writers of horror stories have capitalized on the fact that the traditional indicators of death—no heartbeat, pulse, respiration, or reflexes—are not always conclusive. The fact that these accounts are not entirely fictional is seen in cases of catalepsy and other conditions in which people (and animals) only appear to be dead (*thanatomimesis*). None of the traditional vital signs are present in these persons, yet they make an unexplainable recovery after a period of time. The following excerpt from Kastenbaum and Aisenberg (1972, pp. 138–139) graphically describes an Italian soldier who presumably had died from an attack of asthma.

> *A doctor, glancing at the body, fancied he detected signs of life in it. A lighted taper was applied to the nose of the carabineer—a mirror was applied to his mouth; but all*

BOX 10-1 • The Dying Person's Bill of Rights

I have the right to be treated as a living human being until I die.

I have the right to maintain a sense of hopefulness, however changing its focus may be.

I have the right to be cared for by those who can maintain a sense of hopefulness, however changing this might be.

I have the right to express my feelings and emotions about my approaching death in my own way.

I have the right to participate in decisions concerning my care.

I have the right to expect continuing medical and nursing attention even though "cure" goals must be changed to "comfort" goals.

I have the right not to die alone.

I have the right to be free from pain.

I have the right to have my questions answered honestly.

I have the right not to be deceived.

I have the right to have help from and for my family in accepting my death.

I have the right to die in peace and dignity.

I have the right to retain my individuality and not be judged for my decisions which may be contrary to the beliefs of others.

I have the right to expect that the sanctity of the human body will be respected after my death.

I have the right to be cared for by caring, sensitive, and knowledgeable people who will attempt to understand my needs and will be able to gain some satisfaction in helping me face my death.

Source: Karen C. Sorenson and Joan Luckmann, *Medical-Surgical Nursing: A Psychophysiologic Approach* (3d ed.). Philadelphia: W. B. Saunders, 1979. Reprinted by permission.

> *without success. The body was pinched and beaten, the taper was applied again, and so often and so obstinately that the nose was burned, and the patient, quivering in all his frame, drew short spasmodic breaths—sure proof, even to a nonprofessional witness, that the soldier was not altogether dead. The doctor applied other remedies, and in a short time the corpse was declared to be a living man.*

This kind of situation, which took place in the 1880s, was not particularly unusual in the nineteenth century. Such reports led to a distrust of the traditional vital signs of death and to the practice of leaving corpses above ground for several days before burial. Although rare, similar cases of apparent death occur even today:

> *A 40-year-old woman, pronounced dead by emergency medical technicians, lay on the floor of her apartment for nearly three hours on Monday night until an investigator from the city Medical Examiner's office heard a gurgling sound and realized that she was alive (James, 1993).*

The lack of a completely objective, uniform legal definition of death, as well as ambiguities concerning the responsibilities of attending physicians toward dying patients and their families, has resulted in many malpractice suits and a number of manslaughter and murder charges against doctors in recent years. Thus far, no physician in the United States has been convicted of killing a patient in order to end

that person's suffering. However, in the absence of legal and medical consensus on what constitutes death, the threat of legal action by the families of persons who die in hospitals is a continuing possibility.

According to the laws of most states, a person is alive as long as a heartbeat and respiratory movements, no matter how they are maintained, can be detected. Certain states have adopted the concept of brain death (flat EEG for at least 10 minutes) as the legal definition of death and a condition for the removal of donated organs for transplant purposes. Most states, however, still use the traditional definition of death as the cessation of all vital functions. In states that have not passed legislation defining death, the definition is based on hospital policy. The problem of how to determine exactly when a patient has died and when all heroic measures should be terminated has not been solved. To protect themselves, most physicians are advised to consult with the family of the dying person and obtain legal counsel before deciding to terminate the use of life sustaining equipment. Even so, the individual physician continues to bear a heavy responsibility for the final decision.

Controlling Pain

Another responsibility of physicians is concerned with the extent to which drugs such as heroin, morphine, and marijuana should be used to make terminally ill cancer patients physically and emotionally comfortable. The need for pain control in dying patients has been demonstrated by the results of various studies (e.g., Rees, 1972; Simpson, 1976). A consensus of findings from various studies revealed that approximately one half of the patients with terminal illnesses had unrelieved pain and another one fourth had severe or very severe pain. It might be argued that greater use of heroin by these patients would result in more drug addiction. However, this hardly seems of foremost concern with terminally ill patients who are allergic to or have developed tolerances for high doses of morphine and other addictive drugs and who may very well die in agony without heroin (Quattlebaum, 1980).

The use of heroin and other analgesics makes it possible for the majority of terminally ill patients to die without pain. A combination of drugs, the disease process itself, and psychological withdrawal usually results in the patient being drowsy rather than terrified at the moment of death. The release of beta-endorphins at the time of death is also thought to play a role in making the moment less stressful (Thomas, 1975). In any event, only about 6 percent of patients are conscious just before they die (Hinton, 1972). For the great majority, death appears to be a peaceful, painless experience.

HOSPICE TREATMENT OF THE TERMINALLY ILL

The interest that terminally ill people take in life depends greatly on the care and human concern that other people show toward them. Dying people can be stimulated to live more fully until the end if they feel that genuinely concerned individuals are doing everything humanly possible to help them. Permitting and

encouraging the terminally ill to exercise some control over their own activities and to participate in treatment decisions leads them to take a greater interest in their surroundings and make the most of the remaining time (Rosel, 1978). Although most doctors and nurses would probably agree with this statement, the relatively impersonal, technology-based modern hospital with its busy atmosphere that is oriented primarily toward curing illness and prolonging life does not always permit application of these humanitarian principles (Holden, 1980). Many people who die in hospitals and other health-care institutions end their days feeling abandoned, alienated, and embittered.

History of the Hospice Movement

In the late 1960s, a medical staff member in a busy London hospital developed the idea of an environment for dying people that would be psychologically superior to terminal hospital wards or nursing homes. This idea, which came to be known as the *hospice concept,* stemmed from a friendship between nurse Cicely Saunders and a Polish refugee. The first hospice, St. Christopher's Hospice in London, was started in 1967 to provide an atmosphere that would foster positive attitudes toward death in terminally ill cancer patients by helping them die with comfort and dignity (Saunders, 1980). Following its initiation in England, the hospice movement spread to the United States in the mid-1970s and subsequently throughout the world. The first U.S. hospices, including the pioneering efforts at St. Luke's Hospice in New York and the New Haven Hospice in Connecticut begun in 1974, were modeled after St. Christopher's Hospice. By the end of 1979 there were 263 programs in the United States, a number that had increased to 1659 by end the of 1989 (see Figure 10-1). These programs are designed to provide an alternative for terminally ill persons and their families, not only an alternative between impersonal hospital care and personalized home care but also an alternative to euthanasia.

Although active euthanasia has frequently been proposed as a means of avoiding death in a dehumanized hospital environment, Saunders has been an outspoken opponent of attempts to legalize euthanasia. To her and other hospice advocates, the pain experienced by dying people—not only physical but also psychological and spiritual pain—does not require a speeding up of death but can be controlled in a specially designed environment. Thus, the goal of hospice treatment is similar to that expressed in Saunders's original concept of the term—an easy or painless death, but not one that is hastened by an external agent. The guiding philosophy is that patients should be enabled to carry on an alert, pain-free life and manage other symptoms so their final days are spent with dignity and quality at home or in a homelike setting (National Hospice Organization, n.d.). This philosophy is expressed in the statement of purpose of the National Hospice Organization (1988):

> *The purpose of hospice is to provide support and care for people in the final phase of a terminal disease so that they can live as fully and comfortably as possible. Hospice affirms life and regards dying as a normal process. Hospice neither hastens nor postpones death. Hospice believes that through personalized services and a caring*

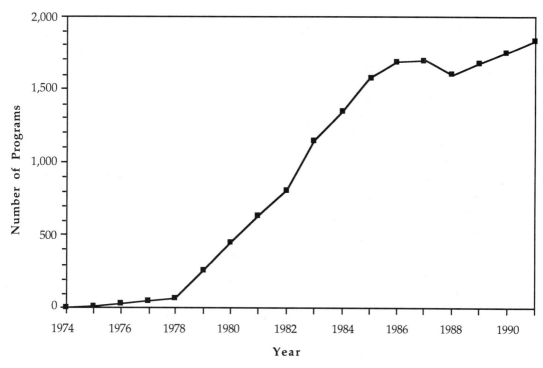

FIGURE 10-1 Growth of Hospices in the United States

Source: Data provided by the National Hospice Association from *1990 National Hospice Census.*
Note: The definition of *hospice* was changed in 1988.

*community patients and families can attain the necessary preparation for a death
that is satisfactory to them.*

Features and Procedures

The major features of hospice care, as enunciated by Saunders (1980), are:

1. Control of the patient's pain and discomfort
2. Discussions of death and dying between patients and medical staff
3. Death with dignity and a sense of self-worth rather than feelings of isolation or aloneness

As implied by this list, hospice care is centered on meeting not only the physical
needs but also the social, emotional, and spiritual needs of terminally ill patients.
The focus of this kind of treatment is on coping with pain and depression, which are
common companions of fatal illness, without making extraordinary efforts to pro-
long life. Hospice differs from other types of health care in that the treatment is

palliative rather than curative, the person rather than the disease is treated, quality rather than length of life is emphasized, the entire family and not just the patient is the "unit of care," and round-the-clock help and support to the patient and family are offered (National Hospice Organization, n.d.).

A special pain-relieving concoction, known as *Brompton mix*, which is a mixture of morphine, cocaine, ethyl alcohol, and a sweetener, has been used in hospice treatment to provide maximum relief from pain with minimal sedative effects. Morphine by itself is also employed with similar effects. Regular periodic doses of the pain killer are used initially, but by keeping a "comfort chart," patients can learn to manage their own medication.

Clearly, hospice treatment pays a great deal of attention to pain control. Efforts are made, however, not to sedate patients so much that communication is hindered. Oversedation would interfere with the important goal of bringing patients and family members together. By providing a warm, homey atmosphere in which pain is controlled, patients can remain alert, active, and productive until they die. Meanwhile, death can be discussed openly, without unnecessary fear and without the feeling that it is the end of everything. In this way, dying becomes more meaningful and acceptable to the patient.

> *One woman . . . was in great misery because she wanted to live to see a grandchild about to be born, but knew it was impossible. The controlling of her pain, however, made it possible for her to recover enough strength to knit a gift for the child she would never see, thus helping brighten her last days. Another hospice patient had been lying all of the time in a fetal position with a hot water bottle clutched to his chest, staring into space, moaning in his private hell which he said was compounded by pain that was like fire . . . but when the hospice team showed him they could control his pain he became a different person, able to live rather than vegetate during his last days. (Rossman, 1977, p. 126)*

The Hospice Team

Home care of the dying is an important part of most hospice treatment programs. With good home care, patients can remain in their own homes as long as they desire—even dying there if they wish. A typical treatment program allows the patient to be cared for at home until transfer to a medical facility is deemed advisable. In both the home and medical settings, an interdisciplinary, nurse-coordinated team of health professionals and volunteers is available to provide medical care on a 24-hour-a-day, seven-day-a-week basis for the patient and counseling for both the patient and the family. The professional members of the team are physicians, nurses, a social worker, and a chaplain. In addition, a psychologist and other health professionals are on call as needed. All members of the team treat the terminally ill as valuable persons whose significance is in no way diminished because they are dying.

Hospice treatment emphasizes the significance of every moment of life and the importance of using one's remaining time wisely. In the most desirable situation,

the terminally ill patient is surrounded by family and friends and, in the home, by volunteers who perform both patient-support and family-support duties of various kinds. These home volunteers, whose training, after an initial orientation program, is principally on the job, are important members of a hospice team. They perform such activities as reading to patients, staying with them while family members are out, making patients comfortable, providing transportation, and assisting families to understand and cope with other problems created by the dying process. The importance of these volunteer services underscores the need for carefully designed training and orientation programs that will sensitize the volunteers to the rewarding but demanding nature of hospice work.

Family members are important, integral participants in any hospice treatment plan, not only in the home but also after the patient has been moved to a medical facility. Provisions can be made for overnight accommodations for family members in the medical facility in order to provide every opportunity for patients and their families to work through problems and provide mutual support. The hospice team also assists the family in understanding the dying person's feelings, needs, and behavior, and in dealing with difficulties related to the patient's death.

Patient Admission Criteria

Only patients who are dying from cancer or other terminal illnesses are accepted for hospice treatment. Other criteria for admission include a prognosis of death in weeks or months, not years, and an agreement on the part of the referring physician to continue his or her association with the patient and cooperate in the treatment. The patient must live within a reasonable distance of the hospice, and a primary caregiver (spouse, relative, trusted friend) must agree to take continuing responsibility for the care of the patient. These criteria vary somewhat with the particular setting, but they have been adopted by most hospices. Once a patient has been accepted for hospice care, a treatment program centered on the features described above, but also designed to meet the patient's individual needs, is put into action.

Models and Problems

The term *hospice* originated in the Middle Ages to refer to a place where pilgrims were fed and sheltered on their way to the Holy Land. In its modern definition, *hospice* refers to a philosophy of care for the terminally ill rather than a specific location or building. One model of a hospice, however, is that of a house where people go for visits and counseling. A second model is hospice care in a segregated or separate ward or palliative care unit of a hospital, a unit where patients are cared for by a roving hospice team. A third model, which is more in line with the primary thrust of the hospice movement toward home care, is home-care service only. The original British model is that of a freestanding unit with beds for inpatient care as well as service for home care. This model, the one publicized most extensively in the media, is not as popular in North America as in the United Kingdom.

The existence of various hospice models, ranging from freestanding buildings to hospitals and home care, has led to a certain amount of confusion about what the *hospice* idea really means. In some instances, the term has been used so loosely that it is difficult to differentiate between what is called a hospice and a back ward or terminal-care unit of a general hospital. Such confusion has led to problems of identity and quality control for the hospice movement.

Although hospice care in the United States is covered under most private insurance plans, federal grants, charitable foundations, and private donors have provided the major financial backing for the establishment of most hospices. Since 1983, hospice care in Medicare-certified programs has been insured under Medicare, and even Medicaid in some states. The benefits covered under Medicare include nursing and physician services; drugs, including outpatient drugs for pain relief and symptom management; physical, occupational, and speech-language therapy; home health aid and homemaker services; medical supplies and appliances; short-term inpatient care; medical social services; spiritual, dietary, and other counseling; continuous care during crisis periods; trained volunteers; and bereavement services (National Hospice Organization, n.d.).

Hospice expenses are rarely met by private and federal insurance programs, so a great deal of the cost must be borne by grants and community support. Unfortunately, the use of public and private funds for the development and implementation of hospice care programs has not always been carefully regulated. Profiteering, quackery, and other forms of exploitation are, as they have been in the case of nursing homes, always a danger in the uncontrolled expansion of health-care facilities and procedures. It would be tragic indeed if, because of overzealous development, unethical practices, and gross mismanagement, hospices came to be viewed as warehouses of death run by self-serving profiteers and incompetent health care workers.

Associated with the problem of quality control is the attitude toward hospice shown by the medical and nursing profession. Doctors and nurses, who have traditionally been trained only in curative therapy and rehabilitation, are not always prepared to accept the hospice approach to helping patients deal with dying and death. Health-care professionals may view the hospice concept as an overly romantic notion of death and dying. Supporters of the hospice movement have argued, however, that health care professionals have a responsibility for dealing with society's denial and fears of death and other negative attitudes that are perpetuated when death is hidden away in the back wards of hospitals. To its advocates, the hospice approach provides one way of bringing death back into the community, so to speak, and putting the entire health-care system on the right track.

Despite some problems of quality control, hospice care has been shown by research to cost less than conventional hospital treatment of the terminally ill, mainly because of fewer days spent in the hospital and the use of a smaller number of expensive diagnostic and treatment procedures. Not only is hospice care more affordable, but there is a marked reduction in severe pain and a general attainment of the other goals of hospice programs (Greer et al., 1984).

COMMUNICATING WITH AND COUNSELING THE DYING

There is no time now for the game
Of mutual pretense.
To act as if I'm still the same
Quite simply makes no sense.

Observe me here, the worn remains
Of what I used to be.
This weary mass of aches and pains
Is plain for all to see.

But still it loves and wants to share
Its feelings with its friends.
So listen now and show some care
Before my sweet life ends.

Most people can accept death in the abstract, but the actual fact of dying usually makes them anxious and uncomfortable. This is especially true when the dying person is a relative or close friend. Having had no training and usually little experience with dying people, the average person does not know how to relate to a terminally ill patient at anything other than a superficial level. After reassuring the patient and trying to cheer him or her up, the conversation usually turns to more pleasant, but psychologically less meaningful, topics.

Even medical personnel tend to shun discussing death with patients whenever they can, and to avoid patients whose death is imminent. Believing that a terminally ill patient will be unable to cope with the knowledge that he or she is dying and that such knowledge may even accelerate the disease process, physicians have traditionally favored not sharing this knowledge with the patient (Butler, 1975; Powers, 1977). Of course, not all medical staff members employ the same approach in responding to a patient's desire to discuss death and dying. Kastenbaum and Aisenberg (1976) found that, although the typical response of medical staff members was evasion, five strategies might be applied in such situations: (1) reassurance ("You're doing so well"); (2) denial ("Oh, you'll live to be a hundred"); (3) changing the subject ("Let's talk about something more cheerful"); (4) fatalism ("Well, we all have to die sometime"); (5) discussion ("What happened to make you feel that way?").

Conspiracy of Silence

Surveys have revealed that, despite the fact that a large majority of patients would like to be told if they are going to die in the near future, physicians and nurses are frequently reluctant or uncomfortable in breaking the news to them. Hogshead (1978) recommends that, when telling a patient that his or her condition is terminal,

physicians should: (1) keep the information simple; (2) try to understand what the diagnosis means to the patient; (3) not reveal all the information at once, but not say anything that is not true; (4) wait for patients' questions and answer them honestly; (5) not argue with patients who attempt to deny the information; (6) ask the patient to repeat what has been said, but not destroy all hope.

Even when patients realize that they are dying and want to discuss it with someone, the physical orientation of physicians usually does not prepare them for dealing with the emotional needs of dying patients. Carrying out one's medical duties in a technically proficient but fairly impersonal manner is seen as safer than becoming emotionally involved with patients and trying to answer their questions about death. Another factor that may lead some physicians to intellectualize and withdraw emotionally from dying patients just when empathy and understanding is most needed is the avoidance of confronting their own above-average fears of death (Feifel et al., 1967). This is perhaps less true of more experienced physicians. Research studies have shown that physicians and other health-care personnel who encounter death frequently are more comfortable in discussing it with patients than those who have had little experience with death (Dickinson & Pearson, 1979; Rea et al., 1975).

Sometimes it seems as if family, friends, and medical personnel are collaborating in a *conspiracy of silence*—a conspiracy that the patient may also tacitly comprehend and agree to. Unfortunately, this silence, which is ostensibly for the good of the patient, often leaves him or her to face death psychologically alone—a frightened, dehumanized body attached to a mass of sterilized tubes and machinery. A classic description of a conspiracy of silence was given by Leo Tolstoy (1886, pp. 137–138) in "The Death of Ivan Ilych":

> *What tormented Ivan Ilych most was the deception, the lie, which for some reason they all accepted, that he was not dying but was simply ill, and that he only need keep quiet and undergo a treatment and then something very good would result. He, however, knew that do what they would nothing would come of it, only still more agonizing suffering and death. This deception tortured him—their not wishing to admit what they all knew and what he knew, but wanting to lie to him concerning his terrible condition, and wishing and forcing him to participate in that lie. Those lies—lies enacted over him on the eve of his death and destined to degrade this awful, solemn act to the level of their visitings, their curtains, their sturgeon for dinner—were a terrible agony for Ivan Ilych. And strangely enough, many times when they were going through their antics over him he had been within a hair-breadth of calling out to them: "Stop lying! You know and I know that I am dying. Then at least stop lying about it!" But he had never had the spirit to do it. The awful, terrible act of his dying was, he could see, reduced by those about him to the level of a casual, unpleasant, and almost indecorous incident (as if someone entered a drawing-room diffusing an unpleasant odor) and this was done by that very decorum which he had served all his life long. He saw that no one felt for him, because no one even wished to grasp his position. Only Gerasim recognized it and pitied him. And so Ivan Ilych felt at ease only with him.*

Open Communication

It is unfortunate when relatives and medical professionals find it difficult to discuss death with dying persons, because many patients are eager to share their thoughts with others. Medical judgment clearly is an important factor in determining whether to tell a patient when death is imminent; not all patients can or want to deal with this kind of information. Such denial, however, is less likely to be true of elderly people, who see death as inevitable in any case and are more likely to have made preparations for it. In fact, most dying people—young and old—are usually grateful for being told the truth and welcome an opportunity to discuss it with an understanding and sympathetic person (Glaser & Strauss, 1965; Puner, 1974).

Today, physicians and nurses are more willing than they once were to tell dying patients the truth. Thirty years ago, Feifel (1963) reported that 60–90 percent of the physicians whom he interviewed did not approve of telling a patient when an illness was terminal. More recently, however, telling the patient in a gentle but honest manner that his or her condition is terminal has come to be favored by most physicians as long as it is considered to be in the patient's best interest (Schulz, 1978). The "closed awareness" context of yesterday has given way in most instances to a more open awareness or "full disclosure."

Health-care professionals who work intensively with the dying, as in hospices, almost always advocate an open, honest approach to the dying patient (Saunders, 1980). Knowing the truth provides terminally ill patients with the time and, it is hoped, the incentive to review their lives and prepare for death. Rather than being devastated by the knowledge of a terminal diagnosis, they are more likely to be strengthened by it (Weisman, 1972).

Even when they are not told directly by a family member, a friend, a doctor or a nurse, a large majority of terminally ill patients realize that they are going to die in the very near future. They sense it in the changes in their bodies and the attitudes of other people. Consequently, an honest report on the part of others frequently comes as no surprise but simply confirms what the patient suspected all along (Kübler-Ross, 1969). Being told, whether outright or by intimation, however, opens the door for the ventilation of feelings and constructive discussion. Thus, a consequence of openness toward death is meaningful communication with others. It also provides patients with an opportunity to take care of financial matters, items pertaining to bequests, and other business, family, or spiritual matters.

Communication and compassion go hand in hand. Dying people need to be aware of their impending death, but this knowledge can be dealt with more effectively in the presence of loving care and companionship. Open communication does not imply preoccupation with death talk, but rather openness to discussing the patient's worries and concerns. Fears can be expressed, confessions made, and emotional support and forgiveness found only with someone who cares. The need of a dying person for a warm, supportive, caring listener, however, cannot be met by just anyone. As Kübler-Ross (1969) pointed out, to listen to a dying person in a warm, supportive manner requires acceptance of one's own mortality and a comfortable feeling in the presence of death. Such companionship is usually provided

by a relative or perhaps a caring health professional. Talking with relatives, friends clergy, social workers, and medical personnel can help dying patients work through their anxieties, worries, depressions, and other emotions.

Discussions with other dying patients, as in *peer counseling,* are also helpful. One of the first peer counseling programs to be founded, the Shanti Project in northern California, arranges for peer counseling sessions in which one cancer patient helps another, and those who have experienced grief counseling help those who are undergoing a similar experience. Nationwide support groups such as Make Today Count and the Forum for Death Education and Counseling (see Appendix B), as well as local support groups, have also been established to meet the psychological needs of dying patients and their families. Although it may strike some people as a kind of macabre commercialism, at least one business organization, "Threshold" of Los Angeles, provides trained companions to help ease lonely, dying people out of this world. Regardless of how it is obtained, honest communication is essential in assisting dying people to cope with their physical, emotional, and spiritual suffering.

Professional Counseling Procedures

As noted above, counseling terminally ill patients and their families does not always require the services of a professional counselor or psychotherapist. Paraprofessional counselors with minimal training but an empathic, nonjudgmental attitude who are patient and willing to listen often do just as good a job as someone with a degree in clinical psychology or a residency in psychiatry. Counseling or psychotherapy with dying patients involves no fixed prescription and is not limited to practitioners who possess specific professional credentials. However, professional counselors and psychotherapists are available to work with terminally ill persons whose dying trajectories permit more prolonged psychological treatment. Whatever else the counselor may be, he or she should be a compassionate person who can share a feeling of mutual trust with the patient and assist him or her in coping with fears of the unknown.

In helping dying people concentrate on taking one day at a time and living each day as joyfully and peacefully as possible, professional counselors and psychotherapists employ a variety of techniques. These techniques include uncritical acceptance, attentive listening, reflection of feelings, life review, group-oriented therapy, and even consciousness-altering drugs (Kalish, 1977). The specific objectives of counseling with the dying vary with both the patient and the situation, but some overall goals are to help patients overcome feelings of sadness and despair, to resolve interpersonal (especially intrafamilial) conflicts, and to obtain insight into the meaning and value of their lives.

Counselors must be careful not to force their own values, religious or secular, on dying patients. Rather, they should attempt to understand and share the hopes, fears, and other feelings of dying persons and to assist them in finding their own

ways of meeting death. The dying patient should set the pace, but an effective counselor is alert to symbolic and indirect communications and does everything possible to facilitate competent and effective behavior on the part of the patient.

One phenomenon that frequently occurs when a patient becomes aware that he or she is dying is a *life review*. According to Butler (1971), mentally reviewing one's life is a universal process ranging in duration from a split-second overview to a lengthy reminiscence. Whenever a life review occurs, in later life (which is more likely) or earlier, it provides an opportunity to relive old pleasures and sufferings and to work through persisting problems. Consequently, reviewing one's life can be a healing process, and is recommended by Butler and Lewis (1982) and others as a counseling technique for use with dying patients. Surveying, observing, and reflecting on one's past experiences leads to insight and understanding, a sense of continuity, a strengthening of one's identity, and a feeling of inner peace.

A major principle of hospice care and other psychosocially oriented programs of treatment for the dying is that patients and their families benefit from discussions with doctors and nurses. Aronson (1959) maintained that a major question in interactions between medical personnel and terminal patients is how patients can be helped to be respected human beings with some sense of dignity despite their condition and prognosis. Retaining one's individuality and identity becomes difficult when the severe pain and feelings of despair experienced by a patient lead to regressive, childlike behavior. Aronson (1959) cautioned doctors not to tell the patient anything that might induce psychopathological behavior, not to let hope die before the body is dead, and not to minimize the gravity of the situation.

For those physicians and nurses who are comfortable with Kübler-Ross's five-stage conception of the dying process, Herr and Weakland (1979) offer a number of counseling suggestions. To begin, counselors of the dying must realize that counseling goals are limited and that the least they can do is refrain from making a painful and difficult situation worse. In general, it is recommended that counselors be gently available, quiet, and compassionately realistic. Being *gently available* means that the counselor does not force himself or herself on the patient or push the patient to talk. The counselor is attentive, however, and aware of subtle cues that the patient may be ready to talk about death (e.g., a sudden interest on the part of the patient in disposing of his or her property, giving up valued activities, arranging for the welfare of people and pets). Being *quiet* does not imply complete silence on the part of the counselor but rather controlling his or her own anxieties while watching and listening to the patient. *Compassionate realism* means refraining from unrealistic optimism about the patient's condition on the one hand and unwarranted pessimism on the other.

Concerning specific aspects of counselor behavior based on Kübler-Ross's (1975) five-stage model, in responding to a patient who is *denying* the reality of the situation, the counselor should realize that confronting the patient with the truth or arguing about it is futile. Rather, the counselor should be quietly available, neither confronting the patient with the terminal prognosis nor supporting unrealistic plans for the future.

BOX 10-2

One little word that would not let me go,
One senseless hope that helped me bear the
* pain,*
One transitory dream that let me know
My fleeting life had not been lived in vain.

My life was cut off from humanity,
A barren, selfish soul enclosed within.
I made my god invincibility,
And lived for nothing else except to win.

But then a time came when my fortress broke
Like some great dam that kept me from the
* Nile.*
I could not see the truth that others spoke,
And I was helpless for a little while.

Then in the dusk before my life was spent,
I sensed that there was someone at my side,
And so I came to know what others meant
By love, which found me just before I died.

Anger is one of the most difficult emotions for the counselor to contend with, because the patient's anger is often indiscriminate. Everyone, including the counselor, is subject to attack. As with denial on the part of the patient, confronting anger is useless. About all that the counselor can do when the patient is angry is to accept the anger but not necessarily agree with it in terms of particulars.

Bargaining behavior is usually easier to deal with than denial or anger. But even so, the hope expressed by the patient in bargaining should be tempered with caution on the part of the counselor. *Depression* is contagious and difficult to deal with, but when it is expressed, the counselor should continue to be available and not make the patient feel abandoned. Finally, if and when the patient has come to *accept* his or her impending death, the counselor can help with any practical matters or tasks that require attention. Family and friends can be brought in to say their last goodbyes, and under certain circumstances, the counselor may even say the goodbyes for the patient.

MODERN FUNERAL PRACTICES

Funerary rituals were discussed at some length in Chapter 4, but that discussion was from an historical rather than a contemporary perspective. Historically, the purposes of funeral rites were to honor the dead, supply them with the necessities for the next world, and gain favor with the gods. The first of these aims, honoring the dead, still forms part of the funeral rituals of today, but the emphasis has shifted somewhat from the deceased to the survivors. Thus, a primary function of the modern funeral is to provide a mechanism for those who were close to and/or admired the deceased to work through their own feelings connected with the death. Honoring the deceased and grieving for her or him at the funeral and during the subsequent period of mourning serve both to affirm the deceased's value and provide an opportunity to attain emotional closure with respect to the life and death of the departed individual.

Funerary Rituals

The time between the death of a person and consignment of the body to its final resting place traditionally has been divided into three intervals or activities: wake, funeral service, and committal. Mourners are no longer summoned to the wake by bidders or to the funeral service by bell ringers, as they were in earlier times. Rather, a notice is usually placed in the obituary column of a newspaper, and relatives and close friends are informed by telephone or telegram or in person.

During the wake, the groomed and often embalmed corpse is on display in a funeral home, a church, or (rarely) a private home. A variety of social activities, depending on the customs of the social group of which the deceased was a member, may take place during the wake. In general, family, friends, and others who knew or admired the deceased come to express their feelings and comfort the bereaved. The principal activity of the wake, however, is to visit the deceased and view the remains. Working people other than members of the immediate family are usually not excused from work to attend the funeral. Consequently, they are more likely to attend the wake, which is held in the evening, than the funeral, which takes place during the day. Most funerals are attended only by family members and close friends.

Unless the deceased was terribly disfigured by accident or disease, the body is usually on display during the wake and, depending on the wishes of the family, during the funeral. Modern funeral directors maintain that having the casket open during the wake and the funeral allows viewers a "memory picture" of the deceased. According to funeral directors, this picture should be positive and lifelike, thus justifying the cost of embalming and cosmetically preparing the corpse. Beautification of the corpse to make it seem almost alive, however, appears to impress some groups (e.g., Protestants) more than others (e.g., Catholics) (Khleif, 1976).

A wake (or visitation) does not have to be held, especially when the casket, for whatever reason, is kept closed. Wakes are reportedly favored more by persons of low or middle socioeconomic status than those of high status, and by blacks more than whites (Salomone, 1968). Also of interest is Fulton's (1971) finding that widows and widowers who chose a conventional funeral, in which the body was exposed to public view, had fewer difficulties in adjusting to the death and had more positive memories of the deceased than those who opted for a closed casket or immediate disposal of the remains.

The nature and location of the funeral service itself vary with the cultural and religious background of the participants. Catholics are reportedly more favorably disposed toward funerals, followed by Protestants, Jews, nonaffiliated respondents, and Unitarians. Catholics are more likely to hold the funeral service in a church, whereas Protestants are just as likely to use a funeral home as a church (Khleif, 1976). Wherever it is held, the funeral service still provides an opportunity for a group of people to acknowledge the value of the deceased and to affirm their social and religious ties. The trend during this century, however, has been to tone down the more emotion-arousing features of the funeral service and to deritualize the mourning process. Another modern trend has been away from large church funerals and toward simpler funerals or memorial services.

BOX 10-3 • Much Ado About Death

Since life in Southern California is so unreal, or at least perceived to be, it follows that the one reality we have to cling to is death.

Californians we are and Californians we will be, right until the time a local member of the Flying Funeral Directors of America drops our ashes from his plane (not catching the propeller backwash, we hope) and into the Pacific, or until we rest in peace beneath the latest innovation, the talking tombstone.

O death, where is thy sting? Not here, not where funeral processions use the freeways to hasten the deceased to his destination, where a certain cemetery is one of the top tourist attractions, where a do-it-yourself coffin entrepreneur sent a set of his blueprints to one man who had been contemplating having himself strapped to a surfboard and launched at sea.

Remember that although it happened in Texas, it was one of our own, Beverly Hills millionairess Sandra Ilene West, who scribbled a handwritten will that resulted later in having herself buried in her black nightgown while at the wheel of her baby blue Ferrari, "with the seat slanted comfortably."

As is true with everything in Lotusland, don't question our life style and don't question our death style.

Even for elephants, the riddle of where they go when they die was answered two years ago when Dr. Jack Adams of Cal State Dominguez Hills buried a pachyderm on the grounds, possibly the only campus with such a distinction. Ashes to ashes, tusk to tusk.

As for us humans still here, because the colleges generally accept only the living (ostensibly), our only recourse in the long run is the numerous memorial parks, the most celebrated of which is Forest Lawn.

The late Humbert Eaton of Beverly Hills, after gaining control of the cemetery, embarked upon a series of innovations that made it a subject of worldwide comment, especially from Evelyn Waugh. Today not only are there burials at Forest Lawn's four locations, but many weddings, and even christenings. Babies, brides, corpses. Center attractions at different events.

And where else but in this area could one bid for the privilege of spending eternity in the crypt next to Marilyn Monroe?

When the Hollywood women who happened to own that empty slot at Westwood Memorial Park offered it for sale, it went quickly, although for what the seller said was less than the asking price of $25,000.

This location, of course, is where thrice weekly, six fresh red roses are placed in the holder of the beauty queen's crypt, courtesy of former husband Joe DiMaggio. A standing order for a Hollywood florist since her death in 1962.

In Delano, from 5 P.M. to 7 P.M. daily, music of the Swing Era has been played for decades over radio station KCHJ. The disc jockey, however, has been dead since 1968. His widow, Jean Johnes, has seen fit to continue broadcasting tapes of the program all these years, making only one change. He used to close each show by saying goodnight to his mother, but she also is dead, so the ending was cut.

Let us not forget the enterprising San Diegan who for a while was turning a nice profit with his company called "Play Dead." He rented coffins to the living. One customer was an 80-year-old woman who wanted to stage a funeral so she could enjoy it this time around.

An Azusa man found an old coffin in a scrap yard, added two wheels, hooked it to his motorcycle, and registered it as a trailer with the Department of Motor Vehicles.

Death in California. It becomes Can You Top This? Although, of course, it is off the coast of Oregon where a former Coast Guard lighthouse was recently bought for conversion to an oceanic mausoleum.

But that, as all Easterners will assume, may be attributed to a quirk of geography. There simply were no lighthouses in the current Southland multiple listing.

Regardless, we do our share. A firm here called Personal Words puts together eulogies for delivery at funeral services. Jules (Ghouls) Mattland not only labors over the phrases, but, if asked, will choreograph the event. For a man who loved dogs, Mattland had two of the dearly departed's Great Danes sit on either side of the casket.

At the mortuary science department of Cypress College, students are taught to make wax replica death masks, in the event family requests it.

Then there is the brisk business in guides to the graves of movie stars, such as Michael's Memory Map, an alternative to visiting the homes of the worshiped. Or you may choose to tour Angeles Abbey Memorial Park in Compton, where the fifth row in one of the mausoleums has side-by-side crypts with the names Lucky and Strike.

And the beat goes on. Two years ago, at a motel in North Hollywood, there was an auction—of a 2,700-year-old mummy. He fetched $32,000. Which brings to mind the Long Beach amusement park, which for years had on display what they thought was a wax dummy, until his arm fell off and he was found to be a real mummy of an Oklahoma badman shot by a posse in 1911.

Earlier this year the first Reincarnation Ball was held at the Shrine Auditorium, for those who felt they had lived a previous life. The early arrivals got a free psychic reading.

Just what the effect of all this will be on the result of the nation remains to be seen. Or rather the remains must be seen.

Or at least dealt with in a California manner.

Source: "Much Ado About Death, or Crying in the American Bier," by Dave Larsen. Copyright 1982, *Los Angeles Times.* Reprinted by permission.

The deemphasis on funerary rituals in recent years has been interpreted by Aries (1981) as a manifestation of the denial of death that has come to characterize Western culture during the twentieth century, a deemphasis seen more in England than in the United States and Canada. In all three of these English-speaking, primarily Protestant countries, neither the funeral service nor the procession from the place where the service is held to the final resting place is as dramatic or flamboyant as it once was. As described in Box 10-3, however, there are exceptions. Like the kings of old, some individuals still finish their lives in lavish, spectacular style.

In most cases, the final resting place is a private cemetery maintained by a religious order, another nonprofit organization, or a commercial enterprise. If the body has been cremated, the remains are sometimes sprinkled on top of a mountain or in an ocean or other large body of water or saved in an urn or vase. Multistoried walls divided by vaults or niches (*columbaria*) are quite popular in certain areas of the world in which land is scarce. Each niche bears a commemorative plaque containing a picture and the name of the deceased, in addition to the date of death. *Athenaeums,* which look like air-conditioned houses and are built near cemeteries, are becoming popular in Europe as places to house the remains of the dead.

Approximately four fifths of the corpses in the United States are disposed of by burial and the remaining one fifth by cremation. Cremation is most popular in the Pacific and Mountain regions and least popular in the South. It is also very popular in Canada, particularly Western Canada, but most popular of all in Japan and

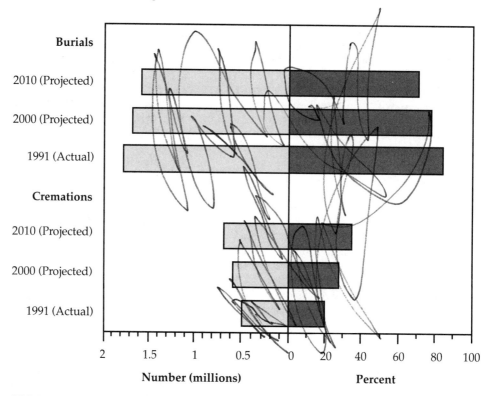

**FIGURE 10-2 Actual and Projected Burials and Cremations in the
United States**

Source: Data provided by Cremation Association of North America, *1992 Projections to the Year 2010.*
Presented at the 74th Annual Convention, San Francisco, California, August 12–15, 1992.

certain other Asian countries. As depicted in Figure 10-2, cremation is becoming
more popular and burial less popular in the United States. It is estimated that by the
year 2010, 32.41 percent of the corpses in the United States and 60.87 percent of those
in Canada will be cremated (Cremation Association of North America, 1992).
Among the purported advantages of cremation are sanitation, space economy,
emotional comfort to the family, avoidance of decay, and reduced cost. Another
advantage is convenience, in that an urn can be transported more easily than a
casket:

> *Les Boatwright's death won't keep him from going to the Super Bowl today. He'll be
> there in a small brass urn. Boatwright, 75, died of a heart attack Monday, clutching
> two Super Bowl tickets as he prepared to place a bet with his bookie, said
> Boatwright's widow, Midge.*
>
> *His two sons will take the urn carrying the ashes of the San Jose, California,
> resident to the Big Game between the San Francisco 49ers and the Cincinnati
> Bengals, Mrs. Boatwright said. "I told the boys, 'Do it for your daddy,'" she said.*

Boatwright's 33-year-old son, Todd, flew to south Florida with his father's ashes early yesterday. His brother Marc, 37, arrived earlier (Associated Press, from the Arizona Daily Star, Tucson, January 22, 1980, page E3).

The Funeral Business

Prior to the nineteenth century, there were no undertakers, morticians, or funeral directors. Families, with the assistance of friends and other members of the community and church, were responsible for disposing of their own dead. In less affluent families, the corpse was laid out on the kitchen or dining room table, where it was washed, clothed, and otherwise prepared for burial while a surviving male or local carpenter constructed a coffin and others dug the grave. The cost of an elaborate funeral, even in the Middle Ages, could be quite high and potentially ruinous to the survivors. However, the existence of mutual-aid societies and burial groups helped keep costs under control for those who were willing to settle for less extravagant ways of disposing of the dead.

Undertaking first became a skilled occupation in the early nineteenth century. The first undertakers were craftsmen or carriage hirers who obtained transportation and coffins (Aries, 1981). The titles *mortician* and *funeral director* came into use later in the century, underscoring the growing commercialization of funerary activities. These activities are now handled quite professionally by a team of specialists, including not only funeral directors and embalmers, but also doctors, lawyers, ministers, florists, grave diggers, and many others. Although the preprofessional education of most funeral directors, morticians, and embalmers is little more than high-school level, a license to practice in these fields requires the completion of certain professional training courses, an apprenticeship, and passing a state examination.

Depending on its nature, elegance, and location, a funeral in the United States can cost quite a bit of money. The funeral business in this country is comprised of 700 or more firms that dispose of 2 million corpses a year at the cost of more than $6 billion. The average price of a funeral and burial is approximately $5000, the total cost depending on the specific items and services requested. However, many memorial societies have arranged funerals costing $1,000 or less. A major item in the cost of a funeral is the casket, averaging $1,800, with prices ranging from $300 to top-of-the-line caskets costing $10,000 or more. The cheapest casket is made of particle board, and the most expensive of ornate bronze on the outside, a velvet liner on the inside, and an adjustable inner-spring mattress that can be tilted to make the corpse more visible when on display. Caskets in an intermediate price range are made of steel or copper. A cloth-covered wooden casket for use in cremation, including the cost of cremation, costs around $800. Other expenses include

- Cemetery plot: $480
- Cemetery vault: $430
- Cemetery marker: $430
- Endowment care: $200
- Opening of the grave: $125
- Closing of the grave: $125
- Marker set fee: $75
- Funeral: $1395

Additional charges may be incurred for transporting the body to or from another funeral home and to a gravesite, for acknowledgment cards, memorial folders, or prayer cards, for a register book, for flowers, and for using other facilities. If a religious service is held, the minister must also be paid and perhaps given a gratuity. A substantial saving is possible when these items are ordered on a preneed basis, that is, some months or years before death.

Religious and cultural customs dictate to some extent what items are included in a funeral and what they cost. For example, Orthodox Jewish custom requires that hand-tooled wood and no metal be used in making the casket and that the corpse not be embalmed. Funeral cost differentials are also related to sex, age, and social status. Women tend to spend more than men on funerals, older adults spend more than younger adults, and lower- and middle-class people spend relatively more than upper-class people (Pine & Phillips, 1970).

Legal Regulation of the Funeral Industry

In the 1960s, exposés written by Jessica Mitford (1963), Ruth M. Harmer (1963), and other influential individuals led to public concern about the funeral industry in the United States. Allegations of exorbitant prices and high-pressure salesmanship inflicted on confused, grief-stricken consumers by self-styled "grief therapist" morticians proved all too accurate in some cases. As critically expressed by Mitford (1963, p. 15):

> O Death, where is thy sting? O grave, where is thy victory? Where indeed. Many a badly stung survivor, faced with the aftermath of some relative's funeral, has ruefully concluded that the victory has been won hands down by a funeral establishment—in a disastrously unequal battle.

Subsequently, the U.S. Federal Trade Commission (FTC) took up the cause of bereaved consumers in a series of recommendations concerning the choices and prices offered by funeral homes. Under these regulations, instead of selling a preselected package to consumers, funeral directors are required to provide itemized lists of goods and services and their prices. Prices must be given over the telephone on request, and misrepresentation of state laws governing embalming and cremation is prohibited. Funeral providers may not make claims that expensive products are necessary for cremation, that embalming is required by law when it is not, and that particular items have greater preservative effects than they do. They must reveal the individual costs of flowers, death notices in newspapers, provision of hearses and limousines, pallbearers, guest registers, and other services (Funeral Industry Practice, 1985). These regulations, which went into effect in 1984, were objected to by the funeral industry as being biased against the traditional American funeral. The provision that an item-by-item list of funeral costs be provided has been particularly irksome to many funeral directors and is still under review.

Although the FTC regulations have helped, the responsibility for policing the funeral industry continues to fall to some extent on private consumer organizations. One important service that such organizations and other interested parties perform

is to make the public aware of exactly what the laws of various states require and do not require in connection with funerals. For example, *no* state requires an outer burial container, a casket for cremation, or routine embalming (except in specific circumstances such as the presence of certain diseases, a lengthy preburial interval, or transportation of the corpse for a long distance). Furthermore, the funeral laws in a large majority of states prohibit misrepresentation of prices and services and misrepresentation of cemetery and legal requirements connected with burial. On the other hand, very few states require funeral establishments to make available to consumers a preselected, itemized price list, price information over the telephone, a separate casket price, or an outer burial container price list. Nor do most states require explicit permission to embalm, truthful disclosures of service charges for cash advances, or that a majority of the members on the state funeral board be individuals who are not connected with the funeral industry.

Changing Attitudes and Practices

Due to a number of factors, including exposés of the funeral industry, inflation and economic hard times, and changes in public attitudes toward death, the traditional funeral business in the United States has declined during the past 25 years. The decline has been especially marked in metropolitan areas on the East and West Coasts, where cremation is also more popular. For example, compared with a national figure of approximately 18.5 percent of cremations to deaths in 1991, 41 percent of those who died in the Pacific states were cremated (Cremation Association of North America, 1992). The national cremation rate is expected to exceed 32 percent by 2010, which will still place it significantly below the rates for Canada, England, and Japan. The popularity of cremation as a means of corpse disposal is being affected by six trends: (1) society is becoming middle-aged; (2) the educational level is rising; (3) the earnings gap is widening; (4) the origins of immigrants are changing; (5) regional differences are diminishing; (6) cremation is becoming more acceptable as a normal method of corpse disposal (Cremation Association of North America, 1992). In addition, the Catholic church, which for centuries strongly opposed cremation, removed its objection to the practice in the 1970s.

The increasing popularity of cremation, however, is only one factor in the decline of the funeral business in the United States. Many authorities believe that the main reason for the decline is a change in public attitudes toward death and funerals. Public discussions of death and light treatments of the topic by the media have helped Americans become more comfortable with death. Simultaneously, the population has become more mobile and experimenting, and as a result, traditional family and religious ties have weakened. The greater openness about death and the loosening of cultural constraints have contributed to a fundamental change in attitudes and a consequent trend toward simpler, more economical funerals.

In the forefront of the movement toward simpler funerals are not only intellectuals and social reformers but also religious authorities. Sharing the mistrust of superstition and irrational sentimentality that characterize lavish funerals, these individuals agree in pointing out that a memorial service is not only simpler and more economical but also quite dignified and meaningful to the survivors.

SUMMARY

Most of the dying today is done in health-care institutions rather than at home. The consequences of this shift in the place of death have been mixed. Hospitals are better equipped to meet medical emergencies, and the treatment of dying patients is technically proficient. Compared to private homes, however, hospitals and other health-care establishments are rather impersonal places where the psychological needs of patients are not always attended to. Medical personnel, who are trained primarily to cure illness and rehabilitate, often have difficulties in relating to dying patients.

Efforts made to sustain life and resuscitate persons who have stopped breathing tend to be less vigorous in the case of terminal patients, the elderly, and persons of lower socioeconomic status. These efforts also vary with the definition of death, both legal and medical. There is no uniform definition of death to which all states subscribe, but common definitions include cessation of circulation, breathing, and brain functions.

Effective control of pain—physical, psychological, and spiritual—in terminally ill patients is a primary goal of hospice care. Other important goals are personal, caring contact between dying patients, their families, and health personnel, and facing death with dignity. Hospice treatment, inaugurated by Cicely Saunders during the late 1960s, uses no heroic measures to keep dying patients alive, but rather concentrates on making dying as pleasant as possible. The traditional hospice model views treatment of the terminally ill as an individualized, team-oriented effort involving patient, medical staff, volunteers, and family members, in which the patient is maintained in the home environment as long as possible. However, various models of hospice care have been developed in recent years. This has led to some confusion about what hospice really is. The hospice movement has also been criticized as being overly romantic in its attitude toward death and as an inefficient type of health care. In general, however, the hospice concept has prompted a more humane approach to terminal care.

Health personnel have traditionally favored not telling patients when death was imminent, but medicine has changed in recent years and so have the attitudes of doctors and nurses toward death and dying. The conspiracy of silence, in which death was not discussed with dying patients, has become less common. Open communication between patients, medical staff members, and families is now more the rule than the exception. Dying patients are usually strengthened rather than devastated by honesty regarding their condition. When combined with companionship and caring, open communication can be therapeutic.

Counseling terminally ill patients is an activity performed by many professionals—doctors, nurses, psychologists, psychiatrists, ministers, and social workers, as well as family members, friends, and other nonprofessionals. A variety of counseling methods may be employed, the most basic of which are attentive listening and uncritical acceptance. It is recommended that counselors be gently available, quiet, and compassionately realistic. A life review of the patient's past can also be valuable. Certain counseling procedures are based on theories of personality and behavior, such as Kübler-Ross's stage theory of the dying process.

The traditional emphasis on the funeral as a rite for honoring the dead has changed somewhat in the modern era to a concern with the feelings of survivors. The three phases of the traditional funeral—wake, service, and committal—have been simplified and made less emotional. The elaborateness of funerals today, however, varies greatly with the sociocultural background, sex, age, and place of residence of the participants.

Exposés of the funeral industry, inflation and other economic difficulties, and changes in society's attitudes toward death have led to problems in the funeral industry. Until the mid-1980s, however, efforts by the federal government to require openness in advertising and selling on the part of the funeral industry were not very successful. In any event, it is expected that the changing attitudes and funeral practices in our society, including the trend toward simpler and less costly funerals, will encourage greater sensitivity to consumer needs by the funeral industry.

QUESTIONS AND ACTIVITIES

1. What is a conspiracy of silence, and how should it be handled?

2. Have you ever been present when someone died? If so, describe the circumstances of the death (who died, where the death took place, what the cause of death was, how others reacted to the death) and your reactions to the death.

3. Describe the funerals and memorial services that you have attended. Who were the deceased persons, and how did the people in attendance react? Was there a great deal of emotion and excitement, or was the funeral a sedate, quiet affair?

4. The following exercise can assist people of any age to realize that they may be settling for a safe but zombielike existence and stimulate them into taking the remainder of their lives more seriously.

 Seat a group of five or so people in a circle in a quiet room and ask them to imagine that it is 10 years later and that they are seated in this same room. After they have succeeded in projecting themselves 10 years into the future, ask them to imagine that they have not achieved the goals or developed personally in the ways that they hoped to 10 years before. Suggest to them that they have not been able to face up to their fears or take advantage of their experiences and opportunities but rather have chosen to remain as they were rather than risk failure. Next ask them to talk about their lives as if they were going to die soon.

 What did you and the other participants learn from this experience? Did it make you more aware of the age-old advice to "seize the day" and "make the most of your opportunities"? What else did you learn? How would you use this exercise in counseling people with terminal illnesses?

5. What are the philosophy and goals of hospice treatment? What techniques and procedures are employed to attain those goals? Why does the term *hospice* refer to a concept rather than a specific place or setting?

6. Schedule a visit to a hospice organization or a hospice ward of a hospital. Interview the director or head nurse about the goals of the organization or ward and how its services actually work in practice.

7. Ask your course instructor to arrange a trip to a funeral home, including a guided tour of the facilities and a description of services by the social director or funeral director. In particular, ask to see the casket room, the embalming room, the crematorium, and the chapel. After the trip, discuss your impressions and what you learned from the tour with your instructor and other members of the class. Was the experience pleasant or unpleasant? Informative or uninformative?

8. During the 1960s and 1970s, the funeral industry in the United States was the target of a great deal of criticism by certain writers and members of the general public. Among other things, the industry was criticized for deceiving the public as to prices of funeral services and which services were necessary, taking advantage of bereaved persons when they were most vulnerable, overemphasizing the professional qualifications of funeral directors, embalmers, and other members of the funeral home (mortuary) staff, and confusing the roles of salesman and professional. Interview several people who have had experiences with mortuaries or funeral homes, and ask them whether they felt pressured to purchase certain caskets, gravesites, and other goods and services offered by funeral establishments. Then interview a funeral home director to get his or her opinions on the 1984 FTC rulings and the reputation of funeral homes.

ENDNOTE

1. Other terms or acronyms that may be used by medical personnel to refer to the treatment or condition of patients are CMO (comfort measures only), Code 90 (patient utterly without hope), and DNR (do not resuscitate). Police also have their own jargon, including: DAS (dead at scene), DRT (dead right there), and, of course, the ever-popular DOA (dead on arrival).

SUGGESTED READINGS

Beisser, A. (1990). *A graceful passage: Notes on the freedom to live or die.* New York: Doubleday.

Benoliel, J. Q. (1988). Institutional dying: A convergence of cultural values, technology, and social organization. In H. Wass, F. M. Berardo, & R. A. Neimeyer (Eds.), *Dying: Facing the facts* (2d ed., pp. 159–180). Washington, DC: Hemisphere Publishing.

Davidson, G. W. (1988). Hospice care for the dying. In H. Wass, F. M. Berardo, and R. A. Neimeyer (Eds.), *Dying: Facing the facts* (2d ed., pp. 185–200). Washington, DC: Hemisphere Publishing.

Garfield, C. A. (1977). Impact of death on the health-care professional. In H. Feifel (Ed.), *New meanings of death* (pp. 144–151). New York: McGraw-Hill.

Kelly, O. E. (1977). Make today count. In H. Feifel (Ed.), *New meanings of death* (pp. 181–193). New York: McGraw-Hill.

Kushner, H. (1981). *When bad things happen to good people.* New York: Schocken.

Mor, V. (1987). *Hospice care systems: Structure, process, costs and outcome.* New York: Springer.

Morgan, E. (1988). *Dealing creatively with death: A manual of death education and simple burial.* Burnsville, NC: Celo Press.

Raether, H. C. (1988). *The funeral director's practice management handbook.* Englewood Cliffs, NJ: Prentice Hall.

Tolstoy, L. (1960). The death of Ivan Ilych. In L. Tolstoy, *Death of Ivan Ilych and other stories.* New York: New American Library. (Original work published in 1886.)

Waugh, E. (1977). *The loved one* (Rev. ed.). Boston: Little, Brown.

11

BEREAVEMENT AND WIDOWHOOD

QUESTIONS ANSWERED IN THIS CHAPTER:

- *How are the concepts of bereavement, mourning, and grief related, and how are they different?*
- *What psychological and physical changes are associated with grief?*
- *What are the various stage theories of grief, and how accurately do they describe the grieving process?*
- *How do emotions and behaviors associated with grieving vary from person to person?*
- *Under what circumstances is grief considered to be pathological?*
- *What conclusions can be drawn from the results of research relating mortality to bereavement?*
- *What techniques or procedures are employed in counseling and psychotherapy with the bereaved?*
- *How are family and social relationships affected by widowhood?*
- *What problems are encountered by widowed persons, and how can they be solved?*

Not all who survive the death of a relative or friend have been equally involved in the care of that person before and after death. The wife, husband, and daughter(s) of the deceased, in that order, typically are most attentive at the deathbed and, presumably, suffer most from the death (Shanas, 1979). Furthermore, the greater longevity of women makes them more likely survivors than men, and therefore the ones whom society is most apt to think of as the bereaved. The state of *bereavement*, however, applies not only to people who were very close to the deceased at the time of death but to anyone for whom the death represents a loss or deprivation.

Grief, a mental state of sorrow and distress, is a natural reaction to bereavement, but it is not experienced by every bereaved person. The term *mourning* is frequently

applied in the same manner as *grief* to describe the feeling of sorrow resulting from bereavement. *Mourning*, however, is more appropriately used to designate the culturally prescribed pattern of behavior for expressing grief rather than as a synonym for grief.

Traditionally, the expected period of mourning varied with the relationship of the survivor to the deceased. It was specified in early Victorian England, for example, that a parent or spouse should be mourned for 12 months, a grandparent for 9 months, and an aunt or uncle for 3 months. By the end of the century, the mourning periods for grandparents and aunts or uncles had changed to 6 and 2 months, respectively. The Victorians also frowned upon uncontrolled expressions of grief: Calmness and fortitude shown by the survivors were signs of inward grace and were thought to set an example for others (Boyle & Morriss, 1987). Such calmness and fortitude in the face of death, as opposed to a conspicuous display of emotion, has come to be expected of most people in contemporary America, and upper-class people in particular.

Certain religious customs prescribe not only the way in which mourners are to conduct themselves but also the duration of the mourning period. For example, Orthodox Judaism provides for three mourning periods: shivah, shloshim, and avelut. The first period, *shivah* (seven), consists of the seven days after the funeral, during which mourners in the home of the deceased sit on low stools and do not wear leather shoes. Males let the hair on the face and head grow, females do not use cosmetics, all mourners avoid pleasures of any sort (bathing, sex, fresh clothing, etc.), and study only Job, Lamentations, parts of Jeremiah dealing with grief, and other sections of the Torah concerned with mourning.[1] The period from the end of shivah to the thirtieth day after burial is called *shloshim* (thirty). During this time, the mourner cannot attend parties, cannot get married, and does not shave or cut the hair. Shloshim concludes mourning for all relatives except the mother and father, who continue to mourn until 12 months after the burial (*avelut*). During this time, the parents avoid happy events, theaters, and concerts. Continuing to display grief after the year has passed is forbidden (Donin, 1972).

Bereavement has both emotional and practical repercussions. There are various problems and duties with which the bereaved individual must cope without the guidance and assistance of the deceased. For example, a surviving spouse must deal with household and business matters. In addition to taking care of one's own physical and psychological needs, there are often children and other relatives to be concerned with and financial matters that require attention. Medical, funeral, and legal bills, as well as one's routine bills, become due rather promptly. Inheritance, estate, gift, and income taxes must also be paid on time. Furthermore, the conditions of the decedent's will need to be understood and followed.

Other items of business that a surviving spouse or other close relative must attend to are bank accounts, insurance, and Social Security, all of which require specific actions on the part of the beneficiary and/or administrator (executor) of the estate. Joint bank accounts and safety deposit boxes, for example, are automatically closed at the time of a tenant's death, and the surviving tenant must be accompanied

by a legal official (e.g., a clerk of court) in order for the account or box to be reopened. Survivors should also be aware of the financial benefits to which they are entitled. Under the Social Security law, survivors are usually eligible for a lump-sum death benefit for burial expenses and a burial plot. If the deceased had a military service-connected disability, survivors may also be entitled to veterans' benefits; other monetary benefits are paid to survivors of deceased members of certain unions and fraternal organizations. All such benefits must be applied for and require proof of death (e.g., a death certificate) and the applicant's relationship to the deceased (e.g., a marriage or birth certificate).

In addition to financial and other practical matters associated with death and its aftermath, there are psychological and social concerns with which the survivors must contend. Whatever their relationships to the deceased may have been, the survivors now face the task of letting go. It takes time, typically a year or two in the case of a widow, to learn to cope with the death of a spouse or other loved one. This process is sometimes made easier when the survivors actively participate in the funeral—viewing the corpse and mourning. But funerals in which there is no body to mourn over, or in which the body is not displayed or viewed briefly, seem poorly designed to encourage the survivors' acceptance of the death and the recognition of the need to let go of the deceased.

The ability to let go of a deceased person and reorganize one's own life varies with a number of factors: the nature of the survivor's relationship with the deceased; the personality, age, and sex of the survivor; the manner in which death occurred and the duration of the illness or dying process; and the cultural context in which death occurred and in which the survivor must continue to live (Bornstein et al., 1973; Glick et al., 1974). Whether the recovery process is rapid or slow, the death of a loved one leaves scars that can last for a lifetime.

THE BEREAVEMENT PROCESS

Mourning and a moderate display of grief are socially accepted and expected behaviors during the wake and funeral. At this time, family members and friends usually provide both practical assistance and emotional support for the bereaved. Household chores are attended to, dependents are cared for, and various business matters are performed. The bereaved person is given a sympathetic ear, consoled, and provided with hope. Nevertheless, there comes a time—usually only a few days and at most a few weeks after the funeral—when such assistance is, for the most part, terminated. Relatives and friends are seen less often, and the bereaved individual is left alone for a large portion of the day. This is the quiet time, and often the time when the loss of a spouse or other loved one is felt most keenly. It is the period when real mourning begins, and therefore a time when the comfort of family and friends is needed at least as much as it was immediately after the death. The need for other people to share one's grief is particularly intense if the death was unexpected, and when a child dies or one loses a young husband or wife.

BOX 11-1 • Love and Loss

My life has lost its meaning since the hour
 you went away.
Now all I do is sit and wonder how to pass the
 day,
And how to spend the lonely nights without
 you near to me.
Why you were taken from me now is more
 than I can see.
For we had just begun to find the love we lost
 before.
We planned again to stay together now and
 evermore.

But suddenly misfortune struck, and our
 plans disappeared.
Despite our hopes, despite our prayers, it hap-
 pened—what we feared.
One long embrace, a promise sweet, a linger-
 ing goodbye,
Then you were gone and all that I could do
 was wonder why
Your life was taken from me when we learned
 to love again.
And now it seems to me that I shall never lose
 the pain.

Feelings and Behavior of the Bereaved

Mourning is a normal and necessary process that does not automatically cease when the funeral is over. Not only does it provide a way for the social group to reaffirm the value of the deceased, but the expression of grief during the mourning period helps pave the way for the letting-go process and the subsequent reaffirmation and reorganization of the survivor's own life. Friends and relatives frequently express concern that the survivor is mourning too long and would be better off to cheer up and get back into the swing of things as quickly as possible.

> Giving way to grief is stigmatized as morbid, unhealthy, demoralizing—very much the same terms are used to reprobate mourning as were used to reprobate sex; and the proper action of a friend and well-wisher is felt to be distraction of a mourner from his or her grief; taking them "out of themselves" by diversion, encouraging them to seek new scenes and experiences, preventing them "living in the past." (Gorer, 1965, p. 113)

People sometimes mourn for years, and in such instances the process is rightly viewed as abnormal or pathological. But the mourning period is typically too short rather than too long; bereaved people need time to sort out their feelings and recover from the loss. In fact, a greatly shortened mourning period may be just as pathological as prolonged mourning, or at least the forerunner of later pathology (Simpson, 1979).

Feelings of grief are a natural reaction to any loss, but the duration and intensity of these feelings vary with who or what is lost and when the loss occurs. Customarily, people grieve more when a close relative or friend dies than when an admired movie star or public figure dies. The intensity of grief is related to the degree of deprivation. The death of a parent, for example, may deprive us of many things—

love, advice, guidance, a parenting model, and even a psychological buffer between us and death. If death is expected or seen as likely to occur, as in an elderly invalid, the intensity and duration of grief are typically not as great as when a child or young adult dies.

Of course, the deceased does not have to be a person. Many people, especially the elderly, are very close to their dogs, cats, or other pets, and grieve intensely when the animal dies. According to Quackenbush (1985), the mourning process for owners of deceased pets is identical to that experienced when a human being dies. In some cases the animal is buried in a pet cemetery, including a ritual or procedure similar to that followed in the case of a human death, a grave marker, flowers, and even an obituary notice.

Grief is not the only emotion experienced by bereaved people. Combined with feelings of sorrow and regret are anger, anxiety, and guilt. Anger may be directed at anyone who might conceivably, by commission or omission, have contributed to the death of the deceased. Among the targets of anger are nurses, physicians, friends, and family members whom the bereaved person perceives as having been negligent in their treatment of the deceased. Anger frequently gives way to feelings of guilt, especially when the bereaved individual realizes that he or she might not have done everything possible for the deceased before death. Many grieving persons also experience feelings of hopelessness, depersonalization, disorientation, and unreality, as well as a lack of interest in things and an inability to concentrate or remember (see Figure 11-1). Somatic and behavioral symptoms such as crying, insomnia, loss of appetite and weight, lack of energy, and reliance on tranquilizers and alcohol are also commonplace (Clayton et al., 1971; Parkes, 1972).

Less common and seemingly more pathological reactions to a profound loss, but actually fairly normal responses, are regression, hallucinations, obsessional review, overidentification with the deceased, and idealization of the deceased. In *regression*, a common reaction to extreme stress, the bereaved person behaves childishly. The regression is not total, but rather alternates with periods of maturity. *Hallucinations* occur when, for example, a widow feels the touch or presence of the deceased, or interprets a creak of the floor as her husband moving about the house. She may even momentarily forget that he has died and begin talking or acting as if he were in another room. Such hallucinatory experiences are consequences of habits and preoccupation with the deceased, constantly thinking about him or her and the way it used to be. The deceased is not only seen, heard, and conversed with, but is dreamed about almost every night (Glick et al., 1974). And sometimes the dreams become confused with reality.

Another feature of bereavement, the *obsessional review*, happens when the bereaved person engages in frequent reviews of events leading up to and immediately following the death. *Overidentification with the deceased* is demonstrated, for example, by a widow who begins to talk and act like her dead husband—wearing his clothes, using his possessions, and so on. She may consult him, or at least her memory of him, about financial matters and other practical problems and attempt to reason the way that he did.

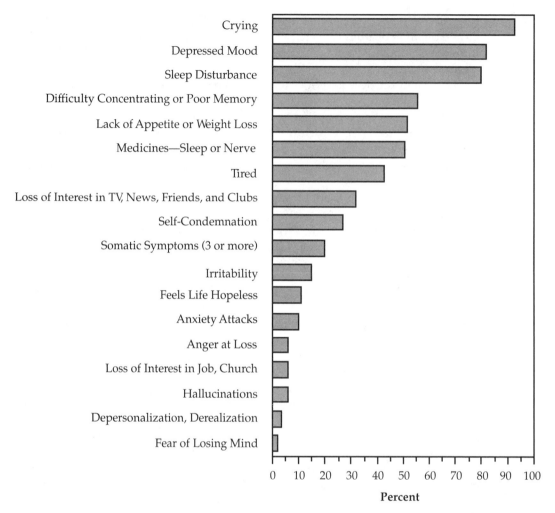

FIGURE 11-1 Percentages of Recently Widowed Persons Reporting Various Symptoms

Source: From "The bereavement of the widowed" by P. J. Clayton, J. A. Halikes, and W. L. Maurice, 1971, *Diseases of the Nervous System,* 32, pp. 597–604. Copyright 1971, Physicians Postgraduate Press. Reprinted by permission.

Idealization of the deceased occurs when only good things about the deceased are recalled. It is as if the survivor's memories of the deceased have been purified or sanctified, leaving only positive and pleasant recollections. This may occur even when the deceased was actually a reprobate who abused his spouse and whom the survivor actually hated. It is as if the survivor gained status by remembering only the good things and denying the occurrence of the bad.

Stages of Grief

The notion that the grieving process occurs in a series of stages, similar to Kübler-Ross's (1969) psychological stages in the dying process, has been proposed by a number of writers. As seen in Table 11-1, there are three-stage, four-stage, five-stage, and even seven-stage theories of grief or mourning. The first stage in almost all formulations is described as a period of shock, numbness, or disbelief, lasting a few days or at most a few weeks. Overwhelming sorrow, loss of self-control, reduced energy, lack of motivation, bewilderment, disorientation, and a loss of perspective characterize this initial period in the grieving process. Following the first stage is a long period of grief and related emotions (pining, depression, guilt, anger), in which the bereaved tries to find some meaning in the catastrophic loss. According to Worden (1982), every bereaved person must learn to accept the reality of the loss, endure the pain of grief, adjust to an environment without the deceased, and redirect emotional energy from the deceased toward other relationships. In a large percentage of cases, the bereavement process runs its course after approximately a year following the death. By that time, the bereaved individual has given up any hope of recovering the deceased and is ready to reorganize his or her life and focus on new objects of interest.

As with any theory of developmental stages or periods, there is a danger that the notion of stages of grief will be interpreted as a fixed sequence through which bereaved people must pass without exception. Bugen (1977) notes that the different stages of grief blend together and overlap, are not necessarily successive, vary in intensity and duration, and are not experienced by every bereaved person. Consequently, he argues against the interpretation of all stage theories of the grieving process as being anything other than descriptive accounts of various emotional stages experienced by bereaved people. In all fairness, it should be pointed out that most of the writers whose conceptualizations are summarized in Table 11-1 have recognized that a particular mourner need not go through all the stages and not necessarily in a specific order. Thus, it is advisable to be concerned about possible misinterpretations of stage theories. Research evidence supporting the concept of stages of grief is neither extensive nor convincing.

Individual Differences in Grieving

Although it is normal to grieve when a severe loss has been sustained, some people never go through this process but remain emotionally calm and efficient throughout the wake, the funeral, and the postfuneral period. At the other extreme are those who react with intense emotion and take years to recover or perhaps never recover. Individual differences in the intensity and duration of the grieving process are a function of many variables, including the age, sex, and personality of the bereaved, as well as the sociocultural context, the relationship of the bereaved to the deceased, and whether the death was expected.

TABLE 11-1 Stages of Grief According to Six Theories

Gorer (1967)
1. Initial shock (first few days)—characterized by loss of self-control, reduced energy, lack of motivation, bewilderment, disorientation, and loss of perspective
2. Intense grief (several months)—periodic crying, confusion, and inability to understand what has actually happened
3. Gradual reawakening of interest—acceptance of reality of loved one's death and all it means

Stephenson (1985)
1. Reaction—period of initial shock when news of death is encountered; shock followed by numbness and a dazed lack of feeling, bewilderment, anger, and attempts to make sense out of loss
2. Disorganization and reorganization—reality sets in; bereaved is disappointed that the loss cannot be recovered
3. Reorientation and recovery—person reorganizes the symbolic world and gives the deceased a new identity outside the world of the survivor

Glick, Weiss, and Parkes (1974)
1. Initial response—characterized first by shock and then by an overwhelming sorrow
2. Coping with anxiety and fear—characterized by worry of nervous breakdown; some people depend on tranquilizers
3. Intermediate phase—consists of obsessional review of how the death might have been prevented and a reviewing of old memories of times with the deceased
4. Recovery (begins after 1 year)—person is proud that he or she has survived an extreme trauma and begins to develop a positive outlook

Bowlby (1960)
1. Concentration directed toward the deceased
2. Anger or hostility toward the deceased or others
3. Appeals to others for support and help
4. Despair, withdrawal, and general disorganization
5. Reorganization and direction of the self toward a new love object

Hardt (1978–1979)
1. Denial (from time of death up to 1 month)
2. False acceptance (from 1–2 months)
3. Pseudoreorganization (from 2–3 months)
4. Depression (from 3–8 months)
5. Reorganization/acceptance (8 months and longer)

Kavanaugh (1974)
1. Shock—physical and emotional shock; real and unreal worlds collide
2. Disorganization—person feels totally out of touch with ordinary proceedings of life
3. Volatile emotions—mourner unleashes volatile emotions, upsetting those around him or her
4. Guilt—mourner feels guilty and depressed
5. Loss and loneliness—may be the most painful stage
6. Relief—may be difficult for mourner to acknowledge and openly adjust
7. Reestablishment—friends become important at this stage

Regarding the factor of age, children who sustain the loss of a close relative or friend experience grief just as adults do. Every year, several million American children and adolescents lose one or both parents. In general, these children have greater difficulty adjusting to the loss of a family member when relationships within the family are strained. With some notable exceptions, however, children tend to work through the problems of bereavement and get on with their lives more quickly than adults (Cohen, 1980).

Reactions to the death of a spouse or a child are typically the most traumatic losses for an adult. However, emotional reactions to the loss of a husband are usually less intense in older than in younger widows. Young adults tend to have more intense grief reactions to a spouse's death, at least in the short run. Ball (1977) found that widows in the 18–46-year bracket grieved more intensely than widows who were over age 46. On the other hand, older people reportedly have strong feelings of grief some months after the death (Sanders, 1980–1981; Wisocki & Averill, 1987).

One explanation for the age difference in grieving is that in the case of an older widow, the death of her (usually older) husband is more likely to have been expected, thus providing an opportunity to prepare for it. Regardless of the age of the survivor, it would seem that preparatory or anticipatory grieving might give the survivor a chance to begin working through the complex of emotions associated with a death and thus hasten the recovery process (Parkes, 1975).

Death is particularly shocking when it occurs suddenly or unexpectedly and the survivors have no opportunity to prepare psychologically for the loss. But a long period of anticipatory grieving, as when death occurs after a prolonged chronic illness, is often more predictive of poor recuperation by survivors than when the dying trajectory and hence the anticipatory grieving period are shorter (Gerber et al., 1975). In any event, the therapeutic effects of a preparatory period prior to the death of a loved one seem to be greater in the case of younger widows that older widows (Ball, 1977).

The duration and intensity of grief, as well as its quality, are also associated with the personality and sex of the bereaved individual. As noted previously, bereaved persons manifest a wide range of reactions. Although there is little consistency in the grief responses among different individuals, there is a substantial degree of consistency within individuals. Thus, the frequency and intensity of emotions and other behavioral manifestations shown shortly after a loss are positively related to symptoms present one year later (Bornstein et al., 1973). The sex of the bereaved is also a factor, in that men are expected to respond less emotionally than women. In addition, an older man is less likely than an older woman to have a confidant other than his spouse who can help him cope with bereavement stress (Powers et al., 1975). The death of a loved one also appears to mean different things to men and women; women tend to feel abandoned, whereas men feel dismembered (Glick et al., 1974). This is consistent with the fact that women are usually more concerned about relationships with other people, whereas men tend to be more interested in their jobs and other life ventures.

The effects that interpersonal or social factors have on grieving have also been investigated (Harvey & Bahr, 1974; Hutchison, 1975; Lopata, 1979). Included among these factors are such things as the relationship of the survivor to the deceased, the socioeconomic status of the family, and the presence of children in the home. As might be expected, the strength of the relationship between a married couple has a pronounced effect on the grief shown by the surviving member. The stronger the emotional bond, the more difficult is the recovery process (Lopata, 1973). Relationships characterized by extreme dependency or persisting conflict are indicative of a poor prognosis for recovery. But when the relationship is built on mutual trust and fulfillment, the bereaved person can more easily get on with the process of readjustment and self-renewal.

Social class has also been found to be related to the intensity of grief experienced by bereaved people. The popular stereotype is that widows of higher social status reveal less emotion in public than working-class widows. However, the middle-class widows in Lopata's (1973) Chicago study actually experienced more difficulty than their working-class counterparts in dealing with grief. Atchley (1991) notes that although middle-class women tend to have more problems than working-class women in dealing with grief, the former usually have a wider support network of friends.

It would seem that the presence of children in a family would affect the severity and duration of the grieving process, but this does not appear to be so (Glick et al., 1974; Lopata, 1973). However, lone parents frequently have difficulty meeting the needs of their children while continuing to cope with their own bereavement sorrow.

EFFECTS OF BEREAVEMENT ON ILLNESS AND MORTALITY

Caring for a chronically ill person is emotionally and physically taxing under the best of circumstances, and particularly so when the illness is terminal. In this case, the effects of prebereavement stress may combine with the shock and grief of bereavement in contributing to both mental and physical disorders.

Pathological Grief

Emotions such as anxiety, fear, depression, guilt, and anger are not in themselves abnormal responses to bereavement. Whether or not they are pathological depends on their intensity, how long they persist, and the presence of other behavioral and physical symptoms (Schulz, 1985). Most normal people react to bereavement with some combination of these symptoms and occasionally even experience hallucinations and suicidal thoughts. In pathological grief, however, the symptoms either persist in intensified form or become noteworthy by their total absence. Excessive

guilt and self-blame are common manifestations of pathological grief, but there are other signs as well.

In the great majority of cases, the grieving process is resolved by finding a new direction for one's life or engaging in some kind of creative endeavor (Pollock, 1978). A small percentage of bereaved individuals, however, find it impossible to accept the death of a loved one. One study indicated that these are more likely to be people with low self-esteem (Lund et al., 1985–1986). It seems equally likely that they are highly dependent, insecure persons who had an almost neurotic attachment to the deceased before the death. After the death they find it impossible to let go and reinvest their emotional energy in alternative sources of gratification.

In a study of parents who had lost an adult child in a traffic accident, Shanfield and Swain (1984) found that they grieved intensely and had psychotic symptoms and physical health complaints for months after the death. In another study, Rinear (1988) found that parents who had lost a child through homicide grieved for months and had lingering fears about what might happen to their other children. Rarely is the shock of bereavement so great that it immediately precipitates a severe mental disorder, but this can occur (see Box 11-2). More common pathological reactions are chronic grief, delayed grief, or even a permanent inhibition of grief.

In chronic, unresolved grief, the bereaved person yearns and sorrows for the lost loved one for years after the death. Chronic grief is more likely to occur when a spouse dies without warning, when death ends a troubled relationship, or when the survivor has strong feelings of dependency toward the deceased (Parkes & Weiss, 1983). Time does not heal the grief of such persons, who are deeply depressed and apathetic and have illogical fears, occasional hallucinatory experiences, and other symptoms of fragile contact with reality.

Another symptom of chronic, pathological grief is *mummification* of the deceased: Everything that the deceased owned is kept in order, his or her clothes are laid out every day, and the bereaved individual continues the routine of living just as if the deceased were still alive. Such was reportedly the mental state and behavior of England's Queen Victoria for years after her husband, Prince Albert, died. Chronic, unresolved grief is also seen in *anniversary reactions,* in which emotional responses recur on the anniversary of the death of a loved one. In other pathological cases, grief is delayed for 5, 10, or even as long as 40 years after the death (Pincus, 1976). This delay or permanent inhibition of grief is not without cost. Blocking feelings that are normally associated with death has repercussions in other areas, being expressed in physical and psychological disorders.

In most instances, repressed grief leads to neurotic and even psychotic behaviors of various kinds, including regression to earlier stages of development and suicide attempts. Suicide is believed to be almost always the result of some kind of loss—if not the death of a loved one, then the loss of a job or position of status, health, youth, or a close relationship. Because they are likely to have suffered several such losses in a year or so and consequently developed a *bereavement overload,* elderly people—and elderly widowers in particular—fall into the high-risk group of potential suicides. Postbereavement depression, which can lead to suicide

BOX 11-2 • A Pathological Grief Reaction with a Positive Outcome

Nadine, a 66-year-old former high school teacher, lived with Charles, age 67, her husband of 40 years (also a retired teacher). The couple had been nearly inseparable since they met—they even taught at the same schools during most of their teaching careers. They lived in a semirural community where they had worked and had raised their children, all of whom married and moved to a large metropolitan area about 100 miles away. For years they had planned their retirement and had hoped to travel around the country visiting friends. A week before their fortieth anniversary, Charles had a heart attack and, after five days in the intensive care unit, had a second heart attack and died.

Nadine took Charles's death quite hard. Even though she had a great deal of emotional support from her many friends and her children, she had great difficulty adjusting. Elaine, one of her daughters, came and stayed a few days and encouraged her to come to the city for a while. Nadine declined the persistent invitation even though she had little to do at home. Friends called on her frequently, but she seemed almost to resent their presence. In the months following the funeral, Nadine's reclusive behavior persisted. Several well-wishers reported to Elaine that her mother was not doing well and was not even leaving the house to go shopping. They reported that Nadine sat alone in the darkened house—not answering the phone and showing reluctance to come to the door. She had lost interest in activities she had once enjoyed.

Greatly worried about her mother's welfare, Elaine organized a campaign to get her mother out of the house and back to doing the things she had formerly enjoyed. Each of Nadine's children and their families took turns visiting and taking her places until she finally began to show interest in living again. In time, Nadine agreed to come to each of their homes for visits. This proved a therapeutic step since Nadine had always been fond of children and took pleasure in the time spent with her eight grandchildren—she actually extended the visits longer than she had planned.

Source: From *Abnormal psychology and modern life,* 9th edition, by Robert C. Carson and James N. Butcher. Copyright © 1992 by HarperCollins Publishers. Reprinted by permission.

attempts, is a particularly serious risk for men (Stroebe & Stroebe, 1987). The high risk of suicide among the widowed during the first year falls off sharply but continues to be higher than average during the second and subsequent years following the death of a spouse (Miller, 1978).

Pathological grief reactions are more common in certain situations than in others, for example, in the case of a child or young adult in apparently good health whose death was unanticipated. Because of their unexpected nature, suicide, homicide, stillbirth, and death caused by accident are especially likely to produce pathological reactions in the survivors. Relatives of suicide victims have special problems with guilt, shame, anger, and the need to find someone or something to blame for the tragedy. A pathological response is also more common when the bereaved has unresolved conflicts with and ambivalent feelings toward the deceased or lacks appropriate social and emotional supports (Hinton, 1972).

Physical Illness

In addition to loneliness, depression, anxiety, and other psychological symptoms, grief-stricken people suffer from various physical problems. Loss of appetite, weight loss, and sleep disturbances are particularly common during the first stages of grief (see Figure 11-1). General body pains, headaches, dizziness, muscle weakness, chills, tremors, choking sensations, shortness of breath, visual problems, and menstrual irregularities are also prevalent. These symptoms seem to occur more often in younger than in older adults, and they may be harbingers of further deterioration in health during the first year of bereavement and even afterward (Clayton et al., 1971).

Older research findings point to a higher incidence of asthma, arthritis, cancer, colitis, diabetes, cardiovascular disorders, leukemia, and tuberculosis among the recently bereaved (Carr & Schoenberg, 1970; Parkes, 1972). In a classic study, Parkes (1972) found that 75 percent of a group of widows whom he surveyed had seen a physician for physical and psychological problems associated with grief during the first six months or bereavement. Compared with the 6 months prior to bereavement, there was a 63 percent increase in visits to doctors' offices during the postbereavement period. Of course, it is possible that this increase was due to the fact that the survivors were simply attending to medical business that they had neglected during the prebereavement period.

An observed increase in physical disorders and visits to physicians after a death may also be caused, at least in part, by the cumulative effects on survivors of the prolonged illness of dying persons. Attending to a spouse during a long illness appears to have a debilitating effect on the health of the survivors. Although it might seem as if a long-term terminal illness would provide more opportunity than a short-term illness for the reputed beneficial effects of anticipatory grieving by survivors to occur, Gerber and colleagues (1975) found that the medical prognosis for survivors was better when the dying period in chronic terminal illness was short. Certainly, anticipatory grieving does not eliminate postbereavement grieving and may not even reduce it. Still, it may keep the loss from becoming overwhelming and give the survivors time to make plans and to cope with the grief after the death (Rando, 1986).

In attempting to account for the reported increase in infection and malignancy in bereaved people, Fredrick (1983–1984) implicated a group of hormones known as corticosteroids. High levels of these hormones, which increase during stress, appear to impair the functioning of the immune system and consequently increase the victim's vulnerability to disease processes. The extent to which bereavement affects physical health, however, is not entirely clear and is a source of some dispute (Thomas et al., 1988). Lundin (1984) found that whether or not survivors experienced health problems depended on whether the death was slow or sudden; those experiencing sudden death were more likely to suffer a decline in physical health. More recently, Norris and Murrell (1987) concluded that bereavement tends to increase psychological stress but not necessarily physical health problems.

Mortality Rate

During the fifteenth century, grief was a legally acceptable cause of death and could be listed as such on death certificates (DeSpelder & Strickland, 1992). Although it is no longer listed as a primary cause of death, the effects on mortality of the stress associated with grief has been studied extensively. The results of a number of studies (Clayton et al., 1971; Helsing et al., 1981; Parkes et al., 1969) indicate that bereaved persons have a higher rate of death than other individuals of comparable age.

In a study by Parkes, Benjamin, and Fitzgerald (1969) of 4,500 British widowers aged 55 and over, 213 died during the first 6 months after bereavement. The death rate was 40 percent higher than expected in the entire group during the first year, but it returned to normal after 5 years. Parkes referred to the heightened rate of death, most instances of which resulted from coronary thrombosis, arteriosclerotic heart disease, and other forms of heart disorder, as a "broken heart syndrome." Although the dynamics of this syndrome are not clearly understood, the condition has been known for centuries. Parkes argued that bereavement may produce changes in blood pressure and heart rate, as well as affect the circulation and chemistry of the blood, thereby acting as a precipitating factor for blood clotting in coronary arteries. Other investigators point to the role of stress on the functioning of the body's immune system, thereby permitting the effects of pathogens such as the Epstein-Barr virus to be expressed in disease (Fredrick, 1983–1984).

Increased mortality after bereavement appears to be related to several demographic variables, including age, sex, ethnicity, marital status, and living situation. The effects of bereavement on mortality are greater among people in their late fifties or early sixties than in those over 65. Postbereavement mortality is also greater in men than women and in nonwhites than whites (Helsing et al., 1981; Heyman & Gianturco, 1973; Lopata, 1973). With regard to sex differences, the same factors that make women live longer than men also apparently make them more resistant to the stresses of bereavement and widowhood.

Consistent with the physiological and psychological benefits of marriage discussed in Chapter 1, remarriage after the death of a spouse has been found to lower the mortality rate dramatically. The effects are particularly pronounced in men, for whom the marital state makes more of a difference in mortality than it does for women. Although a woman's chances of dying are essentially unaffected by the death of her husband, a man whose wife dies is much more likely to die within a few years than his counterpart whose wife goes on living. Helsing, Szklo, and Comstock (1981) found, for example, that widowed men between the ages of 55 and 65 died at a 60 percent higher rate than married men of the same age. On the other hand, widowers who remarry have an even lower mortality rate than their married counterparts whose wives have not died.

An important fact associated with marriage is the living situation of the widowed person. Compared with the marital situation, in which physical care as well as social and emotional supports apparently contribute to longer life, living alone contributes to a higher mortality rate. Moving into a nursing or retirement home is also highly related to increased morality (Helsing et al., 1981).

Earlier reports on the relationship of mortality to bereavement indicated that the mortality rate was higher, and hence the risk of death greater, during the first 6 months after bereavement (e.g., Clayton et al., 1971). However, a subsequent study of 1,204 men and 2,828 women in a semirural Maryland county who were widowed between 1963 and 1974 found no evidence that either widows or widowers were significantly more likely to die than nonbereaved persons during the early months after bereavement. But a higher mortality rate for these widowed persons, more specifically the widowers, was noted *after* the first few months following bereavement. This finding suggests that the important factor in promoting increased mortality is the stress of widowhood rather than the stress of bereavement.

The findings of Helsing and his associates are consistent with the *desolation-effects hypothesis* of Epstein, Weitz, Roback, and McKee (1975). This hypothesis states that both the event of widowhood and the circumstances stemming from it have deleterious effects in terms of grief, feelings of hopelessness, new worries and responsibilities, and changes in diet, work routine, and financial situation of the bereaved person. Epstein and associates (1975) also discuss four other hypotheses that propose to account for the increased postbereavement mortality. The two most plausible of these hypotheses, but perhaps not as convincing as the desolation-effects hypothesis, are the *nongrief-related behavior-change hypothesis* and the *joint unfavorable environment hypothesis.* According to the former hypothesis, survivors are more likely to die because they fail to eat properly, they do not take their medicines regularly, and they are less likely to visit the doctor when they are ill. The joint unfavorable environment hypothesis points out that by having shared a common unfavorable environment, widowed persons and their spouses are exposed to similar environmental risk factors. These three hypotheses are obviously not mutually exclusive; the factors described in any or all of them may influence mortality after bereavement.

GRIEF COUNSELING AND THERAPY

Time by itself does not heal all things, but it is a curative factor in grief. Given enough time, most people are able to adjust to the death of a loved one and reconstruct a life independent of the presence and support of the deceased. The first 6 months after bereavement are usually the most difficult, particularly the third to sixth months, when the shock has worn off and the reality of the loss and the pain associated with it come into focus.

The adjustment process is usually easier when there has been an opportunity to prepare for the loss, when the bereaved person feels that there is some meaning in the death, and/or when there is something left to live for. Thus, recovery from a severe loss can be facilitated by relying on religious or philosophical beliefs that emphasize the future (Peterson & Briley, 1977), intensifying old social relationships or forming new ones, and becoming actively involved with children, work, and other activities (Ball, 1977).

Sticking to a routine of getting up every morning, getting dressed, eating regular meals, pursuing work or hobbies, and making plans and lists of things to do and places to go can help in coping with feelings of depression and unreality. Holidays, which remind the survivor of good times with the deceased and provide time off from work to brood and meditate, may be especially difficult when spent alone. Despite the efforts of the bereaved themselves and others to "renormalize" the world of the bereaved, many survivors require special assistance in coping with bereavement and grief.

Interpersonal Relationships and Grief Groups

The understanding and support of other people are crucial following the death of a loved one. Warm, supportive family members and friends who appreciate the bereaved person's situation and feelings and who continue to visit him or her during the weeks and months after the funeral can have a definite therapeutic influence. In addition to family members and friends, the physicians, funeral directors, lawyers, clergy, and other professional persons with whom the bereaved person interacts can be helpful. Reviewing the circumstances of the death and the effects of it with any of these professionals or a trusted companion or confidant can be of therapeutic value to the bereaved. The presence of an interested, sympathetic, and understanding human being may do more than all the tranquilizers and other medications combined to assist the bereaved in coping with loss and grief.

Most people do not know how to act toward a bereaved person and are not very helpful in what they say. They may end up making well-intentioned but unhelpful statements such as "God had a purpose," "I know how you feel," "Time makes it easier," "You have to keep going," or "You're not the only one who suffers." More facilitative with respect to coping with grief are statements such as "You're being very strong," "It's okay to be angry at God," "It must be hard to accept," and "That must be very painful for you" (Berardo, 1988). In addition, efforts to assist the bereaved person by providing companionship, transportation, and help in other practical matters is appreciated if carried out with sensitivity and respect for the person's feelings.

In many localities, social and psychological assistance for bereaved persons is available from a number of public and private organizations. Churches, mental health clinics, community bereavement centers, and mutual aid societies (e.g., widow-to-widow programs, the Compassionate Friends, Parents Without Partners, Big Brothers/Big Sisters of America, Candlelighters) offer assistance to bereaved persons and their families. These organizations are staffed by professionally trained individuals who provide both individual and group counseling to assist people in dealing with personal and practical problems caused or aggravated by bereavement. Among these problems are alcoholism, sexual dysfunctions, marital discord, child behavior disorders, and other family difficulties.[2]

The Compassionate Friends, an organization that began in Great Britain and now has chapters in most regions of the United States, focuses on providing help for parents who have lost children. The counselors, or "befrienders," are often mothers

and fathers who themselves have lost a child and wish to help others learn to cope as they did (Cohen, 1980). It is often comforting to parents who have lost a child to be with other parents who have incurred a similar loss (Edelstein, 1984). As one parent said (Klass, 1988):

> *My friends didn't understand and I felt lonely. I felt I needed somebody or something but I didn't know what. I wanted to talk to someone who had gone through what I had gone through. . . . Finally, though, out of sheer desperation I had to do something. I couldn't survive the way I was going.*

In addition, parents in these groups often find that they can help themselves by reaching out to comfort other parents who have lost children.

The rationale and goals of peer counseling are basic to widow-to-widow counseling programs, in which newly bereaved widows are counseled by trained individuals who themselves have lost a spouse and have already completed their grief work. Counseling by other widows, either individually or in a group setting, is often more helpful than family support (Morgan, 1989). Young widows, for whom the death of a husband may have been unexpected and who are apt to take the death harder than older widows, receive particularly strong support from other widows. In addition to providing understanding and sympathy, these volunteer counselors make referrals to other sources when assistance and information beyond their training are needed. The effectiveness of these widow-to-widow counseling programs is enhanced when they are led by widows who have been trained in peer counseling, as by the Widowed Persons Service of the American Association of Retired Persons.

Social support for bereaved individuals, particularly during the critical 6 months after bereavement, is also provided by *grief groups*. These groups consist of a small number of persons who share the common trauma of having lost a loved one. Under the direction of a professional counselor, the members of a grief group talk about their feelings and how to survive bereavement. The role of the counselor-director is to provide both information and a focus for group discussion. Group counseling can be supplemented with individual counseling or psychotherapy for members who require it.

Individual Counseling and Psychotherapy

Although group counseling is often more efficient than individual counseling or psychotherapy and perhaps more effective in dealing with problems of human relationships and feelings of isolation, rather than representing separate approaches, individual and group techniques are complementary. As applied to the treatment of bereavement stress, both approaches emphasize the expression of feelings of depression, anger, shame, guilt, and other emotions associated with death and loss. With an empathic, supportive therapist or group leader, survivors come to accept these emotions as normal and that expressing them can serve a healing function. One organization that provides for such *postvention therapy* when

someone close dies is Hospice Outreach (Costa, 1989). In addition to encouraging the expression of emotions, postvention programs teach bereaved individuals to rely less on defense mechanisms such as denial. Participants in postvention therapy also come to realize that patience and time are needed to recover from the death of a spouse or other loved one and to cope with the resulting grief.

A number of special techniques have been devised for the individual psychotherapeutic treatment of grief. As with any form of psychological intervention, the specific techniques must be adapted to the personality, problems, circumstances, age, and sex of the bereaved person (Marmar, 1981). Directive techniques, such as providing advice and reassurance and giving the counselee homework assignments or tasks to test reality and to practice coping with frustration, are employed by some counselors. Recognizing that a major psychological problem associated with bereavement is an unwillingness to let go of the deceased, some form of reworking technique is fairly standard in grief therapy. An example is a therapeutic method known as *guided imagery*. In the first therapy sessions, the bereaved person is instructed to recall the affection that he or she shared with the deceased. At first this reexperiencing process is disturbing, but a sense of self-identity and worth is often revived by it. During the second session, the bereaved person closes his or her eyes and mentally goes through the experiences of receiving the news of the death, viewing the body, attending the funeral, and walking away from the grave. The person is told to describe these events out loud, exactly as if they were occurring right now. "Conversing" with the deceased, asking his or her permission to cultivate new relationships and a new life, is also encouraged. At the end of the session, the bereaved person is encouraged to say last goodbyes to the deceased and to finally let go (Melges, 1982).

Counseling Bereaved Children

Adults who are preoccupied with their own grief and reorganizing their lives after the death of a spouse or other loved one sometimes overlook the fact that surviving children also experience grief and other emotions associated with death. The death of a parent or sibling, in particular, can be quite distressing and confusing to a child who has little knowledge of death and has not been prepared by being taken into the confidence of adult survivors. Whatever the circumstances may be, a bereaved child should be permitted to ask questions and encouraged to express his or her feelings about the death and the deceased. Adults should take the time to answer the child's questions and acknowledge his or her feelings, including those of anger, guilt, anxiety, and sadness. Although negative feelings and memories should be accepted and worked through, adults should encourage the child to concentrate on happy moments shared with the deceased and to think about something that was done to please the deceased (Schlesinger, 1977). Throughout the counseling, the child should be given frequent reassurances of love and understanding.

When the deceased is a parent or other adult who was very close to the child, the bereaved child must learn to redirect his or her love toward another adult. It is important for the child's love not to be reinvested in just one person, such as the

surviving parent; otherwise, a condition of extreme dependency on that person may develop. The child should be encouraged to establish close relationships with several adults, especially those within the family circle (Schlesinger, 1977).

Effective counseling of bereaved children requires the cooperation of various adults—not only parents and other family members, but also teachers, doctors, and professional child therapists. Recommended counseling activities include reading and discussing fairy tales that refer to death in a nonthreatening manner, play therapy, role playing or reenacting a situation or story related to death and dying, and drawing pictures with the deceased in them (Ryerson, 1977). Fundamental to all therapeutic efforts with bereaved children, however, are patience, openness, understanding, and love.

WIDOWHOOD IN THE WESTERN WORLD

Widowhood is a state in which a man (a widower) or a woman (a widow) has lost his or her spouse by death and has not remarried. Statistics indicate that in 1991 approximately 13.7 million Americans, or 7.05 percent of the noninstitutionalized U.S. population 15 years and older, fell in this category. Of the 13.7 million widowed persons, 11.3 million were women and 11.5 million were white (Saluter, 1992). As shown in Figure 11-2, the number of widowed persons increases rapidly after age 55 and drops after age 84. However, the percentage of a specified age group who are widowed increases continuously with age.

The majority of widowed persons are white females (9.55 million in 1991), and in all racial groups widows outnumber widowers (Figure 11-3). Two reasons for the sex differences in the number of widowed persons are that women tend to live longer than men, and a greater percentage of widowers than widows terminate their widowed state by remarrying fairly soon after their spouses die. Consequently, widowhood in the United States is primarily a status occupied by women, and the problems of widowhood are by and large women's problems.

Family Relationships

The death of a spouse affects all the family relationships of a widowed person. If there are children in the home, the widow or widower may now have to play the roles of both mother and father. Although members of the extended family (brothers, sisters, aunts, uncles, etc.) are usually in close contact with the widowed person for a while after the death of the spouse, interactions with them become less frequent as time passes. This is particularly true if the children are grown.

Because of their lack of preparation for widowhood, the need to care for younger children, and assorted practical problems, younger widows usually have more difficulty adjusting than older widows (Blau, 1961; Glick et al., 1974; Lopata, 1973). The parents of a young widow are her most important source of social support, and widowhood can be extremely trying for a young woman who has no

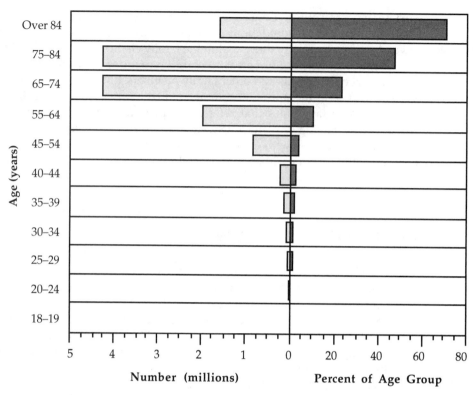

FIGURE 11-2 Widowed Persons in United States Age 18 Years and Over, 1991

Source: Data from Saluter, A. F. (1992). *Current Population Reports,* Series P-20, No. 461. *Marital status and living arrangements: March 1991.* Washington, DC: U.S. Department of Commerce, Bureau of the Census.

close relatives living nearby. Unlike the awkward social status of a young widow, however, widowhood in older women is considered more normal. Older widows tend to receive greater social support from family members and the wider community, making the transition from wife to widow less traumatic for older than for younger women (Blau, 1961).

Regardless of age, a widow who was not congenial with her in-laws while her husband was alive may now experience even greater problems with them. In any event, social support is more likely to come from the widow's own family. Older widows, for example, tend to grow closer to their own children, and their daughters in particular. Sometimes they move in with their children, but the potential for intergenerational conflict makes this situation an undesirable one for most people (Adams, 1968; Lopata, 1973). Vinick (1977) cites an example:

> *Never try to live with your children. It's no good. I stayed there [at her daughter's house] a couple of months and I couldn't stand it. The kids, you know, have to do*

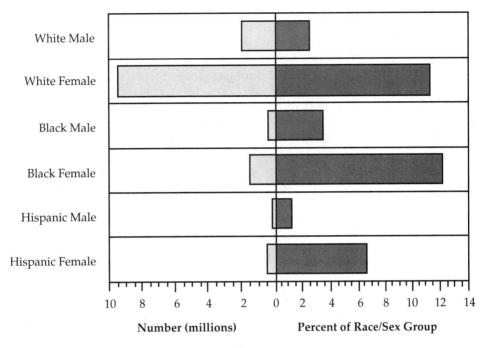

FIGURE 11-3 Widowed Persons in United States Age 15 Years and Over, 1991

Source: Data from Saluter, A. F. (1992). *Current Population Reports,* Series P-20, No. 461. *Marital status and living arrangements: March 1991.* Washington, DC: U.S. Department of Commerce, Bureau of the Census.

what they want to do. When I was listenin' to my TV, they were playin' games on the other side. . . . My daughter has a husband you can't take to, you know what I mean? The minute he come home, I went upstairs and I stayed there (p. 3).

A widow who lives with her adult son or daughter is expected to help with the household chores and take care of the grandchildren. Unfortunately, the widow's position in her son's or daughter's household usually carries no real status or authority, and the fear of intruding makes her feel uncomfortable.

In addition to their relationships with living family members, widows may still "consult" on what to do or whether they are "doing the right thing." Unfamiliarity with the family finances and lack of experience in managing money while their husbands were alive can lead to chronic uncertainty—about where and how to live, whether to buy or invest in this or that (O'Bryant & Morgan, 1989). A widow can become so desperate for advice and guidance that she may even try to communicate with her dead husband in the spirit world. Mediums and other spiritualists often exploit this uncertainty in areas where a large number of retirees have settled, holding séances and providing other hocus-pocus services for sizable fees. In most cases, however, living relatives and close friends are willing to serve as confidants and advisers.

Social Relations

A person who has recently lost a spouse is likely to disengage somewhat from social activities. In cases where the widow's social life was provided in large measure by her husband's occupational contacts, the reduction in social activities may continue for some time (Glick et al., 1974).

So where does a widow seek companionship, and how does she live if she is unwilling to search for a new husband or is unable to find one? The picture is not quite as bleak as one might imagine. Although widows, as a group, experience frequent loneliness, especially at first (Lopata, 1973), the great majority are able to cope with the loss of a husband. Usually it is not very difficult for a widow to establish friendships with other widows. Furthermore, churches, adult and senior centers, and various volunteer organizations provide opportunities for socialization. But widows are usually careful to avoid heterosexual situations in which they are apt to be perceived as predatory "swinging singles" or "merry widows" who are making a play for someone else's date or mate. In any event, perhaps because the death of a spouse is more expected in old age, widowhood is usually less traumatic for older women than for younger ones.

The loss of a husband obviously creates problems for many women. Among the greatest problems are finances, loneliness, and unfamiliar duties (e.g., home repairs and automobile maintenance) (Connidis, 1989; Kalish, 1985b). Income, social life, and living accommodations may all decline after the death of one's husband. But even widows who were happily married, and who are admittedly lonely at times, typically become more competent and independent with time. A widow may miss the companionship of her husband, but she now has time to devote to interests and to develop abilities that have not been properly cultivated. This is less likely to occur if a widow was extremely dependent on her husband or identified with him too closely. And strange as it may seem, widows who experienced the greatest amount of difficulty getting along with their husbands may find themselves least able to get along without them. Whatever the cause may be—feelings of guilt, abandonment, or anger—adjustment is often quite difficult for widows whose marriages were unhappy.

Although problems of adjusting to the death of a spouse are often worse for a woman than for a man, any man who has lost his wife by death or divorce is faced with loneliness and a need for companionship. A widow usually has more friends from whom she can seek sympathy and support than a widower. Pets, plants, and hobbies can also help to fill her time and assuage her grief. On the other hand, a widower may discover that he was more dependent on his wife for physical and emotional support than he realized. Compared with women, men are typically not as close to other people and find it more difficult to make friends with other bereaved persons. Even when her husband is alive, a woman is more likely to have a confidante or close friend of the same sex. Married men may also have close friendships with other men, but such is less often the case. And those men who failed to develop close relationships with other men while their wives were alive typically become even more socially isolated as widowers.

Remarriage

Widowers may have difficulties with both loneliness and homemaking duties (Connidis, 1989), the former because of a scarcity of same-sex widowed peers and the latter because of the lack of experience. There is, however, an up side to being a widower, especially when one considers the large number of widows who vie for the attention of a few widowers. The competition among widows for their favors can be embarrassing to some widowers, but other widowers are undoubtedly pleased by all the fuss and the many social-sexual outlets provided by it. In any event, the relatively larger number of available women presents more opportunities for elderly men to remarry. The majority of widowers remarry within 1–2 years after their wife's death (Treas & VanHilst, 1976), having discovered that the companionship, sex, and physical and emotional support provided by a wife are things they would rather not do without. Quite often they marry someone whom they have known for years, long before they were widowed, and usually someone quite a few years younger.

The ancient Hebrew custom of the *levirate,* according to which a widow married the brother of her deceased husband, was one way of coping with the fact that widows outnumber widowers. Unfortunately, a contemporary American widow who wishes to remarry cannot count on her brother-in-law to assume the responsibility. Finding herself in competition with a number of other women in similar circumstances, remarriage is not a highly probable event for an elderly widow. Even widows who eventually remarry tend to manifest greater loyalty to their departed spouse than widowers do, for when they remarry it is usually several years after the death of the husband. As might be expected, younger widows are more likely than older widows to remarry. The reason is not only a question of opportunity, but also a matter of social expectations: Older widows are expected to keep the memory of their husbands alive and to establish friendships with other widows rather than available men.

As difficult as remarriage in later years may seem, research suggests that it is easier for older men and women to remarry than one may think (Jacobs & Vinick, 1979). A typical couple might meet through friends at a dinner party or other social occasion, begin seeing each other, and eventually marry. Older men usually show greater eagerness to get involved and to remarry than older women, but in later life traditional sex roles are frequently reversed and the woman takes the initiative (Vinick, 1977):

> He was sitting near me at the Golden Agers, and I didn't even know him. He was looking so depressed. You could see that the man needs something. The trouble is, when I see someone lonely, I want to know what's the matter. He was sitting just like a chicken without a head [sic]. After that, he went his way. I went my way. So [the next meeting], he was sitting there again. So my friend said, "Let's sit down with him. It will warm him up a little." It was awfully windy. We sat down, and then we started to talk. You know the way it is (p. 6).

Living Alone and Loneliness

As a consequence of their changed status, widowed persons are faced with many problems and choices. One of these is where to live. To a great extent, the decision about where to live depends on the economic situation of the person. In some instances, the status of widowhood is accompanied by reduced income, which may be a factor in deciding to move to smaller living quarters. Many elderly widowed persons prefer to live alone rather than with a married child, and a small percentage own their own homes. However, the costs of maintenance and utility bills, possible health problems, and fear of crime and loneliness force many widows to move in with a married son or daughter or into a retirement home or rental quarters. Others may solve the problem by taking in tenants or, if the health or loneliness problems are more serious than the financial ones, hiring a live-in companion or nurse. For whatever reasons—habit, a desire to be free and independent, a concern with imposing on other people—a majority of widows who own their own homes remain in them as long as possible and prefer to do so by themselves.

Living alone should not be equated with loneliness. On the whole, widows become accustomed fairly quickly to living alone, especially when there is a high concentration of other widows in the neighborhood. Still, loneliness can be a problem for the widowed. As a group, older widowed people are lonelier than older married people, and younger widows are even lonelier than older ones (Atchley, 1975; Troll, 1982). In addition, working-class widows are generally lonelier than middle-class widows (Atchley, 1975). These differences are associated with the number of social contacts maintained or established by the widow. Older widows have more friends than younger widows, mainly because the pool of older widows is larger and they have had more time to make friends. It is noteworthy that older widows have even higher rates of social interaction than older married women (Atchley et al., 1975). Similarly, middle-class widows, like middle-class women in general, have more time and a greater tendency than working-class widows to establish friendships with individuals of their own sex and age group.

Comparisons between groups of widows and widowers indicate little or no sex difference in the degree of loneliness (Atchley, 1975). A majority of these comparisons are, however, not really fair because a much larger percentage of widows than widowers live alone (Murphy & Florio, 1978). Widowers are slightly more likely than widows to live in group quarters such as hotels and rooming houses (Troll, 1982). In any event, most widows and widowers find ways of coping with loneliness. A widow is more likely than a widower to maintain close relationships with other family members and to have at least one confidante (Lopata, 1975). Loneliness can also be lessened somewhat by owning a pet that can be cared for, talked to, and loved.

Financial and Identity Problems

Without question, widowhood is a major life crisis for most men and women. A widowed person loses more than a friend, a lover, a helpmate, and a part of his or her identity as a human being. In most instances there are also economic losses. The financial condition of a typical widow is far from good, although an exceptional

few—the recipients of windfall income from insurance policies, estate settlements, and profit-sharing trusts—are even better off than they were during their married lives. But the great majority of widows have to get by on small savings, a modest insurance or other death benefit, and Social Security payments that are less than those received when the husband was alive. Younger widows tend to have more financial woes than older widows, but both groups find that money and its management are serious problems (Wyly & Hulicka, 1975).

Decreased income has repercussions in many areas of living. Social and other interests and activities that cost money to pursue have to be reduced; the overall lower standard of living also has an effect on one's self-concept (Kaplan & Pokorny, 1970). Widows who depended almost totally on their husbands to keep the home, the car, and other possessions in good repair, to drive the car, and to manage their finances feel insecure and inadequate when they are forced to rely on their own resources. Some widows are unable to adapt successfully to their changed circumstances and the necessity of developing a new identity and different social roles. The resulting adjustment problems may be expressed through alcohol and drug addiction, mental illness, and even loss of the will to live. Widowers, for whom the role of husband was a central part of the self-concept, may experience similar identity and adjustment crises when they lose their wives (Glick et al., 1974).

Changes in Lifestyle

Despite the image of the widowed person as a poor, forlorn creature with bad health whom nobody cares about, only a small proportion of widows are physically impaired or emotionally incapacitated. For most people, widowhood is certainly not a highly desirable state, but its features are not all negative. It appears to be kinder to women than to men, but even for men the increased freedom and independence offered by widowhood can provide new opportunities and rewards. Understandably, most widows and widowers miss the deceased spouse's companionship. But many widows find that their housework is lightened, and they also have more time to travel and to devote to personal interests and the cultivation of talents and skills. In fact, two reasons why older women typically cope better than older men with widowhood are their greater social aptitude and the blossoming of special skills (Lopata, 1979; Seltzer, 1979). Perhaps for similar reasons, some surveys have found that older widows have even higher morale than older married women (Morgan, 1976).

Whether or not they choose to take advantage of them, a number of options are open to widows. Not all widows need to or do retreat into isolation, becoming what Lopata (1973) refers to as "social isolates." Many elect to continue the same levels of activity in similar roles and situations that were characteristic before widowhood. Another broad option, chosen by widows whom Lopata (1973) labels "self-initiating women," is to select new roles and develop new friends. For these women widowhood provides a long-awaited opportunity to control their lives. The majority are not poor old souls who are relegated to the rocking chair, but rather women who can look forward to living as long as another generation and getting much more joy out of life.

SUMMARY

Bereavement refers to the state of loss or deprivation resulting from the death of another person. *Grief* is the feeling of sorrow and distress that results from bereavement, and *mourning* is the culturally prescribed behavior pattern for expressing grief.

Numerous practical, psychological, and social considerations must be dealt with by bereaved persons. An important psychological process is learning how to let go of the deceased, which is rarely easy to do. Letting go completely may require a year or more of recovery from the loss and necessitate professional counseling.

Not only grief but also anger, anxiety, depression, guilt, and feelings of hopelessness are common emotional reactions to bereavement. Other reactions are disorientation, difficulties in concentrating and remembering, crying, insomnia, reliance on tranquilizers and alcohol, and losses of appetite, energy, and weight. Regression, hallucinations, obsessional review, in addition to overidentification with and idealization of the deceased are less common responses to bereavement, but they are not necessarily pathological.

Various stage theories of grief have been proposed, most of which conceptualize the process as beginning with a period of shock or numbness, giving way to a long period of grief and related emotions, and ending in recovery and life reorganization. Stage theories of grief are probably best viewed as descriptive accounts of emotional reactions experienced by grieving people rather than fixed sequences through which all bereaved individuals must pass on their way to recovery. Certainly there are wide individual differences in the intensity and quality of reactions to bereavement, depending on such factors as the age, sex, social class, and personality of the bereaved.

Whether or not grief is considered pathological depends on its intensity and duration and whether abnormal reactions are present. Abnormal reactions to bereavement include mummification, anniversary reactions, delayed grief, and suicide. Pathological grief is more likely when the death was unexpected, when the bereaved person has unresolved conflicts with or ambivalent feelings toward the deceased, or when social and emotional supports are lacking.

In addition to mental disorders, physical illness and even death may be caused or exacerbated by prolonged grieving. The "broken heart syndrome," in which a bereaved individual develops coronary thrombosis or some other form of heart disease, is most often cited as an important cause of the increased mortality rate observed after bereavement. The stress of caring for a dying person and the stress created by the adjustment problems of widowhood are undoubtedly as important as the stress of bereavement itself in the increased mortality rate of survivors. The desolation-effects hypothesis, according to which both the event of widowhood and the circumstances stemming from it have deleterious effects on the body, is the most plausible and popular explanation of the high mortality rate during the first year or so after bereavement.

Positive factors in recovery from bereavement include time and the emotional support of other people. Various organizations, such as the Compassionate Friends

and widow-to-widow programs in cities throughout the United States, offer assistance to bereaved people. Group-oriented bereavement counseling (*grief groups*) and individual counseling or psychotherapy for the bereaved employ a variety of techniques. Reworking through the events associated with the death and funeral is a common therapeutic approach, but the specific therapeutic techniques vary with the age and personality of the bereaved.

Although substantial numbers of men and blacks are widowed, the problems associated with widowhood in the United States are primarily those of elderly white women. The ratio of approximately five widows to every widower is a consequence of the fact that husbands tend to die before their wives and widowers remarry more often than widows. A large percentage of widows live alone, and loneliness is a problem for many of them. Widows are, however, more likely than widowers to have a number of same-sex friends of their own age and to participate in various social organizations.

In addition to loneliness, widows list money and its management as their most serious worries. Problems of identity—Who am I? What are my social roles? and so on—are also common in widowhood. Loneliness can be a problem for both widows and widowers, and especially the latter. Most widows adapt fairly well to their situation despite these problems, but others suffer serious adjustment difficulties. Drug and alcohol abuse, mental illness, and suicide may result from the unresolved grief and stresses of widowhood.

As they do at other times of life, widowed persons have a number of lifestyle options—to continue doing the same things as before widowhood, to select new roles and develop new friends, or to retreat into isolation. The options that are selected depend to some extent on economic and social supports, but to an even greater extent they are determined by the individual's personality and interest in controlling her or his own life and making the most of opportunities.

QUESTIONS AND ACTIVITIES

1. What are the various stage theories of grief, and how accurately do they describe the grieving process?

2. What rituals and customs play a part in the grieving process? Are these rituals and customs a source of comfort or discomfort to the bereaved?

3. What problems are encountered by widowed persons, and how can they be solved?

4. Can you remember an experience of grief when you lost a loved one or a pet? What emotions and physical symptoms did you experience? Did your experience correspond to any of the stage theories of grief outlined in this chapter? Do you think that the grief experience was beneficial to you; that is, did it help you to grow as a person and contribute to your personal well-being and philosophy of life?

5. What are the differences between a normal and a pathological grief reaction? Have you had experiences with either or both types of reaction?

6. How does the nature of grief vary with whether it was expected or unexpected? With the age of the person who dies? With the relationship of the person to you?

7. Are bereavement and widowhood more difficult for men or for women? Why?

8. The loss of any prized possession, animate or inanimate, can produce symptoms in the owner similar to those observed when a close relative or friend dies. Have you ever endured a loss that made you depressed, angry, and/or physically ill? If so, describe it.

9. Interview a half-dozen widows or widowers and obtain their answers to the following questions.

 a. How many years were you married?
 b. How many children do you have, and what are their ages?
 c. How long have you been widowed?
 d. How difficult was it for you to adjust to widowhood?
 e. Did your relatives help you to adjust to widowhood? In what ways?
 f. Do you live alone or with someone else? Where?
 g. Which of the following is the biggest problem that you have experienced in widowhood: loneliness, money, time on my hands, lack of skill in fixing things, lack of love, relationships with relatives, worries about the future, other problems.
 h. In your opinion, what are the major advantages to being a widow or widower?
 i. In your opinion, what are the major disadvantages to being a widow or widower?
 j. Would you like to get married again? Do you think you ever will get married again?
 k. What advantages would being remarried have over being a single widow or widower?
 l. Do you have many friends who are widows or widowers?

From the answers, what impressions did you obtain about the state of widowhood? Are widows (widowers) generally satisfied or dissatisfied with their situation? What are the relative advantages and disadvantages of being widowed?

ENDNOTES

1. In Orthodox Jewish families, shivah may be observed even when a family member is not biologically dead but rather has renounced Judaism in favor of another religion. To the family, the spiritually departed individual is for all intents and purposes dead.

2. Like the nationwide 911 telephone number for physical emergencies, the Grief Recovery Institute of Los Angeles maintains a toll-free grief hot line—800/445-4808—staffed by volunteers trained in grief-recovery counseling. This non-profit organization is dedicated to helping people cope with the sense of loss resulting from a death, a divorce, a job change, or even retirement.

SUGGESTED READINGS

Berardo, D. H. (1988). Bereavement and mourning. In H. Wass, F. M. Berardo, & R. A. Neimeyer (Eds.), *Dying: Facing the facts* (pp. 279–300). Washington, DC: Hemisphere Publishing.

Costa, B. (1988). *Handbook for the bereaved and those who want to help.* Fall River, MA: Hospice Outreach.

Edelstein, L. (1984). *Maternal bereavement.* New York: Praeger.

Lopata, H. Z. (1979). *Women as widows: Support systems.* New York: Elsevier.

Parachin, V. (1991). *Grief relief.* St. Louis, MO: CBP Press.

Parkes, C. M. (1987). *Bereavement: Studies of grief in adult life* (2d ed.). Madison, CT: International Universities Press.

Rando, T. A. (1988). *Grieving: How to go on living when someone you love dies.* Lexington, MA: Lexington Books.

Sanders, C. M. (1989). *Grief, the mourning after: Dealing with adult bereavement.* New York: Wiley.

Viorst, J. (1986). *Necessary losses.* New York: Simon & Schuster.

Appendix A

PERIODICALS CONCERNED WITH DEATH, BEREAVEMENT, AND WIDOWHOOD

Advances in Thanatology
Foundation of Thanatology
Foundation Book & Periodical Division
Box 1191
Brooklyn, NY 11202-1202
718/858-3026

Death
Bad Seed, Inc.
116 W. 14th Street
New York, NY 10011
212/898-8001

Death and Dying
Greenhaven Press Inc.
Box 289009
San Diego, CA 92198-0009
619/485-7424

Death and Dying A to Z
Croner Publications, Inc.
34 Jericho Turnpike
Jericho, NY 11753

Death Studies
Hemisphere Publication Corporation
Suite 101
1900 Frost Road
Bristol, PA 19007-1598
215/785-5515

Elderhostel
75 Federal Street
Boston, MA 92110-1940

Hastings Center Report
Hastings Center
255 Elm Road
Briarcliff Manor, NY 10510
914/762-8500

Hospice
National Hospice Organization
1901 N. Moore Street
Suite 901
Arlington, VA 22209
800/658-8898

Hospice Journal
Haworth Press, Inc.
10 Alice Street
Binghamton, NY 13904
800/342-9678

Hospice Letter
Health Resources Publishing
Brinley Professional Plaza
3100 Highway 138
Box 1442
Wall Township, NJ 07719-1442
908/681-0490

Hospice Today
Hospice Care, Inc.
300 E. Bay Drive
Largo, FL 34640

Journal of Palliative Care
Centre for Bioethics
Clinical Research Institute
110 Pine Street
Montreal, Que. H2W 1R7 Canada
514/987-5619

Omega: Journal of Death and Dying
Baywood Publishing Company, Inc.
26 Austin Avenue
Box 337
Amityville, NY 11701
516/691-1270

Second Opinion (Chicago)
676 N. St. Clair
Ste. 450
Chicago, IL 60611
312/266-2222

Series in Death Education, Aging, and Health Care
Hemisphere Publishing Company
Suite 101
1900 Frost Road
Bristol, PA 19007-1598
215/705-7800

Suicide and Life Threatening Behavior
American Association of Suicidology
Guilford Publications, Inc.
4th Floor
72 Spring Street
New York, NY 10012
212/431-9800

Thanatology Abstracts
Foundation of Thanatology
Foundation Book & Periodical Division
Box 1191
Brooklyn, NY 11202-1202

Thanatology Librarian
Center for Thanatology Research and
 Education, Inc.
391 Atlantic Avenue
Brooklyn, NY 11217-1701
718/858-3026

Appendix **B**

ORGANIZATIONS CONCERNED WITH DEATH, BEREAVEMENT, AND WIDOWHOOD

AIDS Action Council
2033 M Street, NW, Suite 801
Washington, DC 20036
703/821-8955

ALCOR Life Extension Foundation
12327 Doherty
Riverside, CA 92503
714/736-1703

Alzheimer's Disease and Related Disorders
 Association
919 North Michigan Avenue
Suite 1000
Chicago, IL 60611-1676
312/335-8700

American Association of Retired Persons
601 E Street, NW
Washington, D.C. 20049
202/434-2277

American Association of Suicidology
2459 S. Ash
Denver, CO 80222
303/692-0985

American Cancer Society, Inc.
(CanSurmount, Reach to Recovery, I Can Cope)
3340 Peachtree Road, NE
Atlanta, GA 30326
404/320-3333 or 800/227-2345

American Cryonics Society
P.O. Box 761
Cupertino, CA 95015
408/446-4425

American Heart Association
7320 Greenville Avenue
Dallas, TX 75231
214/373-6300

American Sudden Infant Death Syndrome
 Institute
275 Carpenter Drive NE
Atlanta, GA 30328
404/843-1030

Association for Death Education and
 Counseling
638 Prospect Avenue
Hartford, CT 06105-4298
203/232-4825

Big Brothers/Big Sisters of America
230 North 13th Street
Philadelphia, PA 19107
215/567-7000

Brass Ring Society
Suite 103
7020 South Yale Avenue
Tulsa, OK 74136

Cancer Information Service
National Cancer Institute
Building 31, Room 10A24
Bethesda, MD 20892
800/422-6237

Candlelighters Childhood Cancer Foundation
Suite 200
1312 18th St., NW
Washington, DC 20036
202/659-5136

Center for Death Education and Research
1167 Social Science Building
University of Minnesota
Minneapolis, MN 55455
612/624-1895

Center for the Rights of the Terminally Ill
2319 18th Avenue South
Fargo, ND 58103
701/237-5667

Children's Oncology Camps of America
c/o The Children's Memorial Hospital
2300 Children's Plaza
Chicago, IL 60614
312/880-4564

Choice in Dying, Inc.
200 Varick Street
New York, NY 10014-4810
212/366-5540

Compassionate Friends
P.O. Box 3696
Oak Brook, IL 60522-3696
312/990-0010

Cremation Association of North America
111 East Wacker Drive
Chicago, IL 60601
312/644-6610

Foundation of Thanatology
630 W. 168th Street
New York, NY 10032
212/928-2066

Grief Education Institute
2422 Downing Street
Denver, CO 80210
303/777-9234

Hemlock Society
P.O. Box 11830
Eugene, OR 97440
503/342-5748

HOPING (Helping Other Parents in Normal
 Grieving)
1215 East Michigan Avenue
Lansing, MI 48909
517/483-2344

Hospice Association of America
519 C Street, NE
Washington, DC 20002-5809
202/546-4759

Hospice Education Institute
Suite 3-B
5 Essex Square
P.O. Box 713
Essex, CT 06426
203/767-1620

Inter-National Association for Widowed
 People, Inc.
P.O. Box 3564
Springfield, IL 62708
217/787-0886

International Anti Euthanasia Task Force
Human Life Center
University of Steubenville
Steubenville, OH 43952
614/282-9953

International Association for Suicide Prevention
c/o Charlotte P. Ross
Suicide Prevention and Crisis Center
1811 Troudale Drive
Burlingame, CA 94010
305/435-2730

International Institute for the Study of Death
P.O. Box 8565
Pembroke Pines, Fl 33084
305/435-2730

Les Turner ALS Foundation
3325 West Main Street
Skokie, IL 60076
312/679-3311

Leukemia Society of America
733 Third Avenue, 14th Floor
New York, NY 10017
212/573-8484

Living/Dying Project
P.O. Box 357
Fairfax, CA 94978

Make A Wish Foundation
2600 North Central #936
Phoenix, AZ 85004
602/240-6600

Make Today Count
101 1/2 S. Union Street
Alexandria, VA 22314
703/548-9674

Mothers Against Drunk Driving (MADD)
669 Airport Freeway
Suite 310
Hurst, TX 76053
817/268-6233

National Coalition to Abolish the Death Penalty
Lower Level B
1325 G Street NW
Washington, DC 20005
202/347-2411

National Council of Guilds for Infant Survival
P.O. Box 3586
Davenport, IA 52808
319/322-4870

National Funeral Directors and Morticians
 Association
1800 E. Linwood
Kansas City, MO 64109
816/921-1800

National Funeral Directors Association
11121 W. Oklahoma Avenue
P.O. Box 27641
Milwaukee, WI 53227
414/541-2500

National Hospice Organization, Inc.
Suite 901
1901 N. Moore Street
Arlington, VA 22209
703/243-5900

National Safety Council
Central Regional Office
1121 Spring Lake Drive
Itasca, IL 60143-3201
800/621-7619

National Sudden Infant Death Syndrome
 Clearinghouse
Suite 600
8201 Greensboro Drive
McLean, VA 22102
703/821-8955

National Sudden Infant Death Syndrome
 Foundation
Suite 104
10500 Little Patuxent Parkway #420
Columbia, MD 21044-3505
301/964-8000

Parents of Murdered Children, Inc.
100 E. 8th Street
Cincinnati, Ohio 45202
513/721-5683

Parents Without Partners
8807 Colesville Road
Silver Spring, MD 20910
301/588-9354

Ronald McDonald House
Children's Oncology Services, Inc.
500 North Michigan Avenue
Chicago, IL 60611
312/575-7048

SIDS Alliance
10500 Little Patuxent Parkway
Suite 420
Columbia, MD 21044
800/221-SIDS

Sky High Hope Camp
Oncology Department
Denver Children's Hospital
Denver, Colorado
303/862-8888

Society for the Right to Die
250 W. 57th Street
New York, NY 10107
212/246-6973

Starlight Foundation
Suite 204
9021 Melrose Avenue
Los Angeles, CA 90069

Sunshine Foundation
2842 Normandy Drive
Philadelphia, PA 19154

Survival Research Foundation
P.O. Box 8565
Pembroke Pines, FL 33084
305/435-2730

Theos Foundation, Inc.
1301 Clark Building
717 Liberty Avenue
Pittsburgh, PA 15222
412/471-7779

Widow-to-Widow Program
Needham Community Council
51 Lincoln Street
Needham, MA 02149
617/444-2415

Widowed Persons Services
c/o American Association of Retired Persons
1909 K Street, NW
Washington, DC 20049
202/728-4370

GLOSSARY

Abortion Any procedure that results in the expulsion and death of a human fetus, usually during the first 12 weeks of pregnancy.

Acceptance According to Kübler-Ross, the final stage in a person's reactions to impending death. This phase is characterized by quiet expectation and acceptance of the inevitability of death. The dying persons wants to be alone with one or two loved ones and desires only freedom from pain.

Active euthanasia As contrasted with *passive euthanasia,* using active measures to end a suffering person's life.

Acute phase (of dying) The first phase in Pattison's three-phase model of psychological reactions during the living-dying interval. The anxiety and anger, which are at a peak during this phase, are reduced by defense mechanisms and other affective and cognitive responses of the dying person.

Age-adjusted death rate Death rate computed by applying the age-specific death rates for age groups to the standard (1940) population distribution by age.

Age-specific death rate Crude death rate computed on a designated chronological age group.

Aging The continuous process (biological, psychological, social), beginning with conception and ending with death, by which organisms mature and decline.

AIDS Acquired immune deficiency syndrome, a disease caused by the human immunodeficiency virus (HIV) that weakens the immune system by attacking T-helper cells.

Algor mortis Gradual decline, after death, of the body temperature to that of the external environment.

Altruistic suicide Durkheim's label for hara-kiri, suttee, and other "conventional" suicides.

Alzheimer's disease A chronic brain syndrome, usually occurring in later life, characterized by gradual deterioration of memory, disorientation, and other features of dementia.

Anger According to Kübler-Ross, the second stage in a person's reactions to impending death. During this stage, the person partially accepts the knowledge that he or she is going to die but becomes angry at the unfairness of having to die while others go on living.

Angina pectoris Chest pain, with feelings of suffocation and impending death, due most often to insufficient oxygen supply to heart tissue and brought on by effort or excitement.

Anniversary reaction A condition in which an emotional reaction in a survivor associated with the death of a loved one occurs on the anniversary of the death.

Anomic suicide Durkheim's label for suicide that is a personal response of an individual

to a loss of social equilibrium caused, for example, by a catastrophic event such as a stock market crash.

Anticipatory grief Grieving or mourning that begins in the survivor before the death of a loved one.

Apnea Stoppage of breathing during sleep.

Apoplexy See *Cerebrovascular accident.*

Ars Moriendi A written treatise, apparently prepared by German monks in the Middle Ages, providing details on how to die in a dignified, holy manner.

Arteriosclerosis Abnormal hardening and thickening of the walls of the arteries in old age.

Asceticism The practice of extreme self-denial or self-mortification for religious reasons.

Atherosclerosis A type of arteriosclerosis resulting from an accumulation of fat deposits on the walls of arteries; the arteries thicken and lose their elasticity.

Autoimmunity theory Theory that the immunological defenses of a person decrease with age, causing the body to "turn on itself" and consequently increasing the likelihood of autoimmune disease such as arthritis.

Autointoxication A state of being poisoned by toxic substances produced within the body.

Autopsy Postmortem examination and dissection of a body after death for purposes of determining the cause of death.

Bargaining According to Kübler-Ross, the third stage in a person's reactions to impending death. This stage is characterized by the patient's attempts to buy time by bargaining with the doctors, God, or with anyone or anything that the patient believes can protect him or her from death.

Benign tumor Nonmalignant but abnormal swelling or growth on any part of the body.

Bereavement The loss of a loved one by death.

Bier Frame or stand on which a corpse or coffin is laid before burial.

Biological death Somatic death; the irreversible breakdown of respiration and consequent loss of oxygen utilization by a living organism.

Black Death Form of bubonic plague that spread over Europe in the fourteenth century, killing an estimated one quarter of the European population.

Brain death Irreversible cessation of all functions of the entire brain, including the brainstem.

Breakdown theories Theories according to which aging is the result of wear and tear, stress, or exhaustion of body organs and cells.

Cadaver Dead human or animal body usually intended for dissection.

Calaveras As depicted in the art of Juan Posada, the Mexican Dance of Death of skeletons engaged in everyday human activities and illustrating the follies of human existence.

Capital punishment Punishment for a crime by the death penalty.

Carcinogen Cancer-causing substance.

Carcinoma Malignant tumor (cancer) that spreads and often recurs after being removed.

Cardiovascular diseases Diseases involving structural damage and malfunctioning of the heart and blood vessels.

Carpe diem Latin for "seize the day." Enjoy the present, instead of placing all hope in the future.

Catalogical thinking According to Shneidman and Farberow, a mode of thinking in certain suicides in which the person feels helpless, fearful, and pessimistic about involvement in personal relationships.

Catastrophic illness Fatal or terminal, frequently chronic, physical disorder.

Centenarian A person who is at least 100 years old.

Cerebral arteriosclerosis Chronic hardening and thickening of the arteries of the brain in old age.

Cerebrovascular accident (CVA) A sudden rupture (hemorrhage) or blockage (thrombosis) of a large cerebral blood vessel, leading to impairment of brain functioning (stroke, apoplexy).

Chronic living-dying phase Second phase in Pattison's three-phase descriptive model of the dying process. During this phase, anxiety is reduced and the patient asks questions about what will happen to him or her as well as family and friends after death.

Cirrhosis of the liver Chronic disease of the liver; one of the major causes of death in the United States.

Civil death In old English common law, refers to the loss of civil rights by a person who is still living.

Clearance rate Rate of solutions of particular crimes.

Cockayne's syndrome A childhood form of progeria (premature aging).

Codicil Supplement (addition or modification) to a will.

Coding A medical directive specifying the extent to which efforts at resuscitation should be made when the heart and lungs stop functioning.

Cohort A group of people of the same age, class membership, or culture (e.g., all people born in 1900).

Collagen Fibrous protein material found in the connective tissue, bones, and skin of vertebrates; becomes gelatinous when heated.

Columbarium A vault or other above-ground structure containing recesses in the walls to house cremated remains.

Compassionate realism When counseling the dying, refraining from unrealistic optimism as well as abject pessimism about the patient's condition.

Competency Legal determination that a person's judgment is sound and that he or she is able to manage his or her own property, enter into contracts, and so on.

Conspiracy of silence Tacit agreement on the part of family, friends, and medical personnel not to talk with a dying person about death.

Contaminated thinking According to Shneidman and Farberow, type of thinking, as represented by hara-kiri, that perceives suicide as a way of saving face of as a transition to a better life.

Coronary A heart attack, resulting from obstruction of a coronary artery and usually destroying heart muscle.

Coroner An official whose chief function is to investigate, by inquest, any death that is not clearly the result of natural causes.

Countershock Electric shock applied to the chest to restore heartbeat.

Cremation To reduce a dead body to "cremains" (ashes) by means of heat or direct flame.

Crematory Place or establishment for purposes of cremation.

Crib death Condition in which an infant, for unclear reasons, suddenly stops breathing, also known as *sudden infant death syndrome* (SIDS).

Cross-linkage Inadvertent coupling of large intracellular and extracellular molecules, causing connective tissue to stiffen.

Cross-sectional study Comparisons of the physical and psychological characteristics of people of different chronological ages.

Crude death rate Number of deaths per 1,000 or 100,000 population during a particular period of time, usually a year.

Cryonics Deep-freezing of human bodies at death for preservation and possible revival in the future.

Crypt Subterranean chamber or vault used as a burial place; a concrete chamber for a casket.

CVA See *Cerebrovascular accident.*

Dakhma (tower of silence) Circular platform, typically 30 feet high, on which the Parsee people of India leave their dead to be devoured by vultures.

Danse macabre ("dance of death") A symbolic dance in which Death, represented as a skeleton, leads people or skeletons to their graves; common representation in art, especially during the Middle Ages.

Death angel The angel Azrael.

Death anxiety Learned emotional response of extreme fear in response to death-related stimuli.

Death awareness movement Surge of interest in the previously taboo topic of death during the 1960s through the mid-1970s.

Death bell (death knell or passing bell) Bell announcing a death.

Death benefit Amount of money to be paid under the terms of an insurance policy to a designated beneficiary upon the death of the insured.

Death certificate Certificate signed by a physician giving identifying information (age, sex, etc.) and the time, place, and cause of death of a person.

Death duty An inheritance tax (British).

Death instinct Suicidal tendency or predisposition toward self-destruction. According to psychoanalysis, the instinct to die or destroy

(*Thanatos*), which opposes the instinct of survival and creation (*Eros*).

Death of the other According to Aries, prevailing attitude toward death during the early nineteenth century, in which death was viewed as a beautiful event leading to a happy reunion of disembodied spirits in paradise.

Death of the self According to Aries, prevailing attitude toward death during the late Middle Ages when individuality was minimized. The dead were believed to be judged at the moment of death, and hence that moment was especially feared.

Death rate Number of deaths per 1,000 or 100,000 population during a particular period of time, usually a year.

Death rattle A rattling or gurgling sound produced by air passing through mucus in the lungs and air passages of a dying person.

Death system Kastenbaum and Aisenberg's term for a conglomerate of rituals and beliefs by means of which a society attempts to cope with death and come to terms with it.

Death Total and permanent cessation of all vital functions of an organism.

Death warrant Official order authorizing the execution of a death sentence.

Death watch Vigil beside a dying, dead, or condemned person.

Death wish Suicidal desire, manifested by passivity, withdrawal, and absorption in thoughts of death. More generally a desire for the death of oneself or another person.

Death's head A human skull, a symbol of mortality.

Deathday Day or anniversary of the death of a person.

Defense mechanisms In psychodynamic theory, psychological techniques that defend the ego against anxiety, guilt, and loss of self-esteem resulting from awareness of certain impulses or realities.

Delusion A false belief, characteristic of paranoid disorder. Delusions of grandeur, persecution, and reference are common in these psychotic conditions.

Demography The science of vital and social statistics (births, marriages, deaths, diseases, etc.) of populations.

Denial According to Kübler-Ross, the first stage in a person's reactions to impending death. During this stage, the person refuses to accept the fact of death and seeks reassurance from other medical and nonmedical people.

Denial of death State of mind in the individual or society in which people are intellectually aware of death but act as if it could not occur to them or their loved ones.

Depersonalization Condition in which the reality of oneself or the environment is no longer perceived.

Depression According to Kübler-Ross, the fourth stage in a person's reactions to impending death. The person fully accepts the fact of death but becomes depressed by all that he or she has suffered and all that will have to be relinquished in dying.

Desolation-effects hypothesis Hypothesis by Epstein and colleagues that both the event of widowhood and the circumstances stemming from it have deleterious effects in terms of grief, feelings of hopelessness, new worries and responsibilities, and changes in the diet, work routine, and financial situation of the bereaved.

Diastole Period of dilation of the heart ventricles, occurring between the first and second heart sounds.

Differential association (principle of) Theory that criminal and deviant behavior is learned through close and frequent association with behavior patterns, norms, and values manifested by criminals and other social deviants.

Doctrine of assurance Early Protestant doctrine, related to the doctrine of predestination, that one can never be certain of salvation, regardless of one's "good works."

Double indemnity Clause in a life- or accident-insurance policy providing for payment of twice the face value of a policy when death is accidental.

Double-effect principle Principle espoused by the Catholic Church, according to which an action that has the primary effect of relieving human suffering may be justified even when it shortens human life.

Dying trajectory The rate of decline in function-

ing from health to death; can be fast or slow, with many starts and stops, depending on the nature of the disorder, the patient's age and lifestyle, the kinds of medical treatment received, and various psychosocial factors.

Egoistic suicide Durkheim's term for suicide committed by an individual who, through failure to become socially integrated, lacks social supports to help him or her through a crisis.

Elegy Funeral song or lament for the dead.

Embalming Treating a dead body with chemicals, drugs, or balsams in order to preserve it.

Embolism Obstruction of a blood vessel by an air bubble or other abnormal particle (*thrombosis*).

Endocannibalism Primitive rite in which the deceased is consumed by members of the family.

Endorphins Opiate substances produced by the brain and pituitary gland in response to stimulation or stress.

Epic of Gilgamesh A mythological tale from ancient Babylonian times, which deals with the adventures of a Sumerian king who is searching for the secret of eternal life.

Epicurean philosophy Philosophical doctrine espoused by Epicurus, who maintained that the highest good is pleasure, interpreted as freedom from disturbance or pain.

Epitaph Commemorative inscription on a tomb or mortuary monument; also a brief poem or writing praising a deceased person.

Eschatology Theological term for any system of doctrines concerning last, or final, matters, such as death, the Last Judgment, and so on.

Escheat Reverting of property of a decedent to the state when there are no legally qualified heirs.

Estate taxes Taxes imposed on a decedent's property, assessed on the gross estate before distribution to the heirs.

Eucharist Sacrament of Holy Communion; the Lord's Supper.

Euthanasia Either active or passive contribution to the death of a human being or animal suffering from a terminal illness or injury.

Executor (executrix) Person named in a will by the decedent to carry out the provisions of the will.

Exhumation Disinterment; removal of a corpse from its place of burial.

Existentialism Philosophical school that emphasizes the importance of the individual self as being responsible for its own choices and that stresses efforts to find meaning in a purposeless, irrational universe.

Extreme unction Roman Catholic ritual, now called "anointing of the sick," in which a dying person's eyes, nose, mouth, ears, hands, and feet are anointed with sacred olive oil while prayers are said for the person's health.

Fatalistic suicide Durkheim's term for suicide committed by an individual who has been overcontrolled or held to strict rules or oppressed by others and who, acting out of a sense of despair over a lack of opportunity to fulfill his or her needs and potentials, decides to end it all.

First-degree murder (murder one) Murder committed with malice aforethought, characterized by deliberation or premeditation or occurring during the commission of another serious crime, such as robbery or arson.

Free radicals Highly reactive molecules or parts of molecules, which may connect and damage other molecules; thought to play a role in the process of aging.

Geriatrics Branch of medicine dealing with the prevention and treatment of health problems of the elderly.

Gerontology A branch of knowledge (science) concerned with the characteristics and problems of the aged.

Gift tax Tax imposed on the transfer of money or property from one living person to another by gift, payable by the donor.

Gompertz law A statistical concept, proposed by British actuary Benjamin Gompertz in 1825, that holds that mortality rates increase exponentially with age.

Grave goods Food, weapons, valuables, and other materials placed in the grave and buried with the deceased.

Grief group A group consisting of a small number of persons who share the common

trauma of having lost a loved one and who, under the direction of a professional counselor, talk about their feelings and how to survive bereavement.

Grief Severe mental distress resulting from loss or affliction; acute sorrow or painful regret.

Grim Reaper Representation of death (in art, etc.) in which a skeleton is carrying a scythe.

Guided imagery Therapeutic process in which patients relive the loss of a loved one by mentally reexperiencing the death and learning to say goodbye.

Hades The Greek god of the dead; also the underworld inhabited by departed souls. The Revised Version of the New Testament refers to the abode or state of the dead as Hades.

Hallucination Perception of an object or situation in the absence of an external stimulus.

Hara-kiri (seppuku) Ceremonial suicide by ripping open the abdomen with a dagger or knife; formerly practiced by members of the Japanese warrior class when disgraced or sentenced to death.

Hel In Scandinavian mythology, the goddess ruling Niflheim, the home of the dead.

Hemorrhage Heavy discharge of blood from a blood vessel; uncontrollable bleeding. See also *Cerebrovascular accident*.

HIV Human immunodeficiency virus, exposure to which can lead to AIDS (acquired immune deficiency syndrome) or AIDS-related complex (ARC), an intermediate stage in which symptoms are represented and immunosuppression detectable but in which the intensity of the illness is more moderate than in AIDS.

Holographic will An unwitnessed will prepared in the testator's (legator's) own handwriting; recognized as valid in some states.

Homeostatic imbalance theory Theory that aging is an accumulation of homeostatic errors or faults and a consequent loss of the ability to maintain a steady homeostatic internal balance.

Homicide The killing of one human being by another, whether intentional or not.

Hormonal theories A group of theories that aging is caused by a decline in the secretions of one or more hormones by the thyroid gland, pituitary gland, hypothalamus, or some other glandular structure.

Hospice An organization that provides services to dying persons and their families.

Huntington's chorea A progressive disorder of the central nervous system, presumably hereditary, characterized by jerking movements and mental deterioration.

Hutchinson-Gilford syndrome See *Progeria*.

Hypertension Markedly elevated diastolic and systolic blood pressure.

Hypertensive heart disease Hypertension associated with a cardiac problem or with both heart and kidney problems (*hypertensive heart and renal disease*).

Idealization of the deceased When survivors remember only good things about a deceased person. Also called *sanctification of the deceased*.

Immortality Unending life; not subject to death.

Immunological theory Theory that biological aging is due to deterioration of the immune system, in which its level of protection against foreign substances and mutant cells declines, and the chances of cellular dysfunction and disease increase.

Incompetency Legal decision that a person is suffering from a mental disorder, causing a defect of judgment such that the person is unable to manage his or her own property, enter into contracts, or take care of other affairs.

Infant mortality Death before the age of 1 year.

Inheritance tax Tax levied on an heir, the rate being a percentage of the value of the property inherited by the heir.

Inhumation Interment; burial in the earth.

Initial shock The first stage of Gorer's three-stage conception of mourning. It lasts only a few days and is characterized by a loss of self-control, reduced energy, lack of motivation, bewilderment, disorientation, and loss of perspective by the mourner.

Inquest An investigation made by a coroner into the cause of a death.

Intense grief The second state of Gorer's three-stage conception of mourning. It often lasts for several months and is characterized by a

loss of self-control, reduced energy, lack of motivation, bewilderment, disorientation, and a loss of perspective by the mourner.

Interment Burial of a corpse in a grave or tomb.

Intestate To die without leaving a will.

Involuntary commitment Legal process by which a person is committed to a mental hospital against his or her will.

Involuntary manslaughter Nonwillful killing of another human being without malice aforethought, as during a misdemeanor (e.g., reckless driving).

Ischemic heart disease Disease caused by deficiency of blood supply to the heart, resulting from constriction or blockage of an artery and consequent reduction of blood flow to the heart.

Jihad A holy war undertaken by Moslems as a sacred duty.

Justifiable homicide Killing of a felon by a law enforcement officer in the line of duty or by a private citizen while a felony is being committed.

Ka In ancient Egyptian religion, a spirit believed to lie within the individual and to survive the body after death.

Karma In Hinduism or Buddhism, actions leading to inevitable good or bad results for the individual, either in the person's present life or in a reincarnation.

Last Judgment The final trial of all people, both living and dead, at the end of the world.

Learned helplessness Psychological state in which the individual feels that external events are uncontrollable; associated with depression and *parasympathetic death*.

Legal death (civil death) When a person is adjudged dead by a legal authority and his or her possessions are distributed accordingly.

Levirate Custom of marriage between a man and his brother's widow, required by the Hebrews in Biblical times under certain circumstances, such as when the deceased was childless.

Libido Psychic energy of the sexual drive.

Life expectancy The average life span of people born in a certain year; probable length of life of an individual.

Life review Reminiscence, or a split-second re-

view of one's life when in serious danger.

Life span Longevity of an individual or longest period of life of a member of a given species.

Limbo In Roman Catholic theology, a region on the border of hell or heaven that serves as the abode after death of unbaptized infants and righteous people who died before the coming of Christ.

Lingering trajectory Glaser and Strauss's term for dying over a long period of time, in which the patient seems to "drift out of the world, sometimes almost like an imperceptibly melting snowflake."

Lipofuscin ("age pigments") A pigmented granule containing lipids, carbohydrates, and protein. The number of lipofuscin granules in various body cells increases with aging.

Living will A document, legal in some states, instructing physicians, relatives, or other people to refrain from using extra-ordinary life-support measures to prolong one's life in case of a terminal illness.

Living-dying interval In Pattison's three-stage theory of dying, the interval between the initial death crisis and the actual time of death.

Livor mortis Purplish-red discoloration of the skin occurring after death.

Longevity Length of life; long duration of life.

Lymphoma Cancer of the lymph nodes.

Mahabharata An ancient Hindu poem in which Mara (or Mrtya), a beautiful, dark-eyed woman, came from within Brahma, creator of the world, and was ordered by him to kill all the world's creatures. Only by the intercession of the god Shiva were the deaths not made permanent, the slain individuals being reincarnated as other forms of life.

Major stroke Heart failure resulting from blockage of a large cerebral blood vessel. See also *Cerebrovascular accident*.

Manslaughter Illegally killing another human being without malice aforethought.

Mass murder Murder of several people, either simultaneously or individually over a period of time (*serial murder*).

Mausoleum Building or wall above ground for housing the bodies of many individuals, usually members of the same family.

Medical examiner Physician appointed by a county or municipality to investigate, by inspection of the corpse, autopsy, and so on, the causes and circumstances of death in individuals presumed to have died from unnatural causes.

Memento mori ("Remember, you must die") Any object, such as a human skull, that reminds one of death or mortality.

Memorial Something designed to preserve the memory of a person or an event, such as a monument or a holiday (e.g. Memorial Day).

Mercy killing See *Euthanasia.*

Metaphysics Branch of philosophy concerned with the nature of reality.

Metastatic tumor Cancerous cells transferred to another part of the body by way of the blood or lymphatic vessels or membranous surfaces.

Mitochondria Structures (organelles) in the cytoplasm of the cells that function in energy production.

Mortality rate Number of people per 1,000 or 100,000 in a specified population dying within a fixed period of time, usually 1 year.

Mortality table An actuarial table showing the percentage of people in a specified population dying at any given age.

Mortician A funeral director.

Mortuary cannibalism Eating the corpse of a deceased person, in whole or in part. See *Endocannibalism.*

Mourning Manifestation of sorrow or lamentation for the death of a person; usually indicated by wearing black clothes or a black armband, hanging flags at half mast, and other cultural rituals. The period during which people mourn.

Mummification of the deceased Everything that the deceased owned is kept in order, his or her clothes are laid out every day, and the bereaved individual continues the routine of living just as if the deceased were still alive.

Mummification Process of embalming and drying by which a dead body is made into a mummy.

Murder Killing another person with malice aforethought and (1) with deliberation, premeditation, or while committing another serious crime (*first-degree murder,* or *murder one*), or (2) with intent but without deliberation or premeditation (*second-degree murder* or *murder two*).

Mutual will Special type of will containing reciprocal provisions, as when a husband and wife decide to leave everything to each other without restrictions.

Myocardial infarction Damage to heart muscle deprived of oxygen, usually due to blockage of a coronary artery, accompanied by chest pain radiating down one or both arms.

Near-death experience (NDE) Paranormal experiences occurring when an individual almost dies; may include sensations of leaving the body (*out-of-body experiences*), meeting with dead relatives and supernatural beings, feelings of peacefulness, etc.

Necrology List of persons who have died within a certain time period.

Necromimesis Pathological state in which the person believes himself or herself to be dead.

Necrophilia ("love of the dead") A sexual attraction to corpses.

Necrophobia (thanaphobia) An abnormal fear of death.

Necropolis ("city of the dead") A large historic or prehistoric burial ground in an ancient city.

Necropsy See *Autopsy.*

Necrosis Death of a certain part of animal or plant tissue.

Nirvana (nibbana) In Buddhism, escape from the cycle of personal reincarnations and the associated suffering, as a result of the dissolution of delusion, passion, and hatred in the individual.

Nuncupative will A will made by an oral (unwritten) declaration of the testator; valid only under certain conditions.

Obituary Notice, as in a newspaper, of the death of a person, often including a biographical sketch.

Obolus In ancient Greece, a small coin placed in the mouth of the deceased to pay Charon, the boatman on the river (Styx) to Hades.

Obsessional review Frequent, periodic review by

the bereaved of the events leading up to and immediately following the death of the deceased.

Open communication Nondefensive communication about death or other matters of concern to a dying person.

Os resectum Severed finger joint of the deceased, buried after cremation of the body in ancient Roman funerals.

Ossuary A place or receptacle for the bones of the dead.

Out-of-body experience Hallucinatory experience of leaving the body that occurs in certain drugged states and as a part of a near-death experience. It appears to the individual as if he were floating above his body and observing it.

Overidentification with the deceased When a survivor identifies excessively with a deceased person, as, for example, when a widow begins to talk and act like her dead husband.

Paddle doll A doll, shaped from thin strips of board into small canoe paddles, placed in Egyptian tombs to act as a servant or friend to the deceased in the spirit world.

Paleological thinking According to Shneidman and Farberow, type of thinking in certain suicidal individuals in which the person responds with the act of suicide to accusatory delusions or hallucinations that involve shame and that promise redemption only through death.

Parasympathetic death Overactivity of the parasympathetic nervous system, resulting in an extreme reduction in heart action and a fatal lowering of blood pressure; may occur when a sick or despairing person feels so helpless or desperate that he or she simply gives up and quits trying to fight or live.

Passive euthanasia As contrasted with *active euthanasia,* simply letting a terminally ill person die without applying life saving measures of any kind.

Pathological grief Grief in which the typical symptoms persist in intensified form or become noteworthy by their total absence.

Plaque Accumulation of fatty tissue and calcified material in the cerebral blood vessels of old people, resulting in clogged arteries and interference with blood circulation.

Political murder Assassination of a political or religious leader; war, genocide, and other killings carried out for political purposes.

Postvention Therapeutic intervention for the bereaved, especially persons who have experienced very intense or prolonged grief.

Predestination Foreordaining by God of whatever comes to pass, such as foreordaining that certain souls will be saved and others not.

Prefunerary rites Ritualistic preparations for death and funerals, particularly characteristic of former times, as described, for example, in the Egyptian and Tibetan *Books of the Dead* and the *Ars Moriendi.*

Preneed funeral arrangements The prearranging and prefunding of a funeral.

Presumptive death Refers to a situation in which a person has been physically absent from his or her place of residence and out of contact with family and acquaintances for some reason for several years (usually 7).

Primary aging Refers to a genetically regulated set of biological processes that occur over time and result in gradual deterioration of the organism.

Probate Procedure followed by a probate court for determining the authenticity of a will.

Progeria A very rare disorder that mimics premature aging. A progeric child typically begins to look old as early as age 4. Also known as *Hutchinson-Gilford Syndrome.*

Prospective study Research investigation that follows up, over time, people with different characteristics or lifestyles to determine which ones develop a particular condition or disorder.

Psychological autopsy Postmortem analysis of the psychosocial aspects of a person's death.

Psychological death When the mind (seat of conscious experiencing and knowledge) ceases to function, even though the individual is biologically alive.

Purgatory According to Roman Catholicism and certain other religions, a place in which the souls of those who died penitent are purified from venial sins; middle ground between Heaven and Hell.

Pyre Pile of wood or other combustible material for burning a dead body, as in Hindu funeral rites.

Quick dying trajectory Strauss and Glaser's term for patients who die quickly, an event that may or may not have been expected by the hospital staff.

Regression Repetition of behavior more characteristic of an earlier stage of development.

Reincarnation Belief that when the body dies, the soul comes back to earth in another body or form.

Remote death According to Philippe Aries, the prevalent attitude toward death during the seventeenth and eighteenth centuries, in which death was perceived as a sorrowful but remote event.

Resurrection Act of rising from the dead.

Retrospective study Comparisons of the incidence of a disorder or other condition in two or more groups of people with different backgrounds, behaviors, or other characteristics.

Rigor mortis Stiffening of the muscles of the body after death.

Sarcoma Cancer of the bone.

Sarcophagus A stone coffin, usually bearing inscriptions, sculpture, and so on.

Second-degree murder (murder two) Murder by intent but without deliberation or premeditation.

Secondary aging Decrements in bodily structure and function produced by disease, trauma, and other environmental events that are not directly related to heredity.

Senescence The state of being old or the process of growing old.

Seppuku See *Hara-kiri*.

Sepulchral iconography Art of inscribing and sculpting an event in the life of the deceased, such as the deceased carrying out some action for the last time and the grieving of the survivors, as well as other artistic renditions on a stone monument or sepulcher.

She'ol In Hebrew theology, the abode of the dead or of departed spirits.

Shiva ("the Destroyer") Third member of the Hindu Trimurti, also including Brahma (the "Creator") and Vishnu (the "Preserver").

Shivah In traditional Judaism, a period of seven days after the funeral for mourning the death of a deceased parent, sibling, child, or spouse.

Small stroke Blockage of a small blood vessel in the brain.

Social death When others act toward a person as if he or she were dead even though the person is biologically alive.

Soul The spiritual part, or disembodied spirit, of a human being, distinguished from the physical part; the moral aspect that survives death and is subject to happiness or misery in a life to come.

Spiritual death Loss or absence of spiritual life.

Stoic philosophy Philosophical school founded by Zeno, who taught that people should be free from passion, unmoved by grief or joy, and submit without complaint to unavoidable necessity.

Stress theory Theory of aging (Selye) that holds that every person inherits a fixed amount of adaptation energy at birth and that the rate of aging varies directly with how liberally this energy is expended by the individual and the stresses to which the individual is subjected.

Stroke Condition with sudden onset caused by acute vascular lesion of the brain, such as hemorrhage or embolism. Also called *cerebrovascular accident*, or *CVA*.

Sudden infant death syndrome (SIDS) Death caused by the sudden cessation of breathing in a seemingly healthy infant, almost always during sleep; sometimes traceable to chronic oxygen deficiency. Also known as *crib death*.

Suttee Old Hindu custom in which a devoted wife is voluntarily cremated on the funeral pyre of her husband.

Sympathetic death Death resulting from extreme stress and fear, as in voodoo; extreme shock leads to excessive activity of the sympathetic nervous system and consequently dramatic increases in heart rate and blood pressure.

Systole Period of contraction of the ventricles of the heart.

Tahorah Ritualistic cleansing of a dead body in Orthodox Judaism; a burial society washes

the body in a special purification process.

Tame death According to Philippe Aries, the predominant attitude toward death during the Middle Ages, when death was accepted and expected as a terrible but necessary human misfortune.

Term life insurance Insurance policy providing coverage for a limited period of time. The value of the policy is paid only if the insured person dies within the term, nothing being paid on expiration of the policy.

Terminal drop Decline in mental functions (intelligence, memory, cognitive organization, sensorimotor abilities, personality) during the last few months of life; observed in many elderly people.

Testamentary capacity The legally determined competency of a person to make a will.

Testator A person who makes out a will.

Thanaphobia An unreasonable fear or dread of dying and death.

Thanatology A branch of knowledge concerned with the study of dying and death.

Thanatomimesis Case in which a person appears to be dead but is actually alive, as in catalepsy and certain other conditions.

Thanatos Ancient Greek personification of death; in psychoanalysis, the death instinct, as expressed in extreme aggression toward the self or other people.

Thrombosis See *Embolism.*

Transubstantiation Changing one substance into another, as the bread and wine into the body and blood of Christ in the Eucharist.

Triumph of death Theme in art, especially during the Middle Ages, depicting Death as triumphant over all, regardless of one's situation or station in life.

Trust A legal, fiduciary relationship in which one person (the trustee) holds the title to property (the trust estate or trust property) for the benefit of another (the beneficiary).

Type-A personality Personality pattern characterized by a combination of behaviors, including aggressiveness, competitiveness, hostility, quick actions, and constant striving; associated with a high incidence of coronary heart disease.

Type-B personality Personality pattern characterized by a relaxed, easygoing, patient, noncompetitive lifestyle; associated with a low incidence of coronary heart disease.

Urn A container for holding the cremated remains of a body.

Vanity theme Macabre theme in painting and frescoes, especially during the Middle Ages, that, no matter how attractive a person may be or how high his or her station in life, the person will soon be a rotting corpse.

Vault (grave liner) A burial chamber or container for holding a casket or urn for burial in the ground.

Vital statistics Statistics concerning human life, the conditions affecting it, and the maintenance of the population (e.g., births, marriages, divorces, and deaths) during a specified time period.

Voluntary manslaughter The killing of one human being by another without intent to kill but during the heat of passion.

Werner's syndrome A condition of arrested growth that has its onset between the ages of 15 and 20. The individual develops signs of aging, such as graying and falling hair, deteriorating skin, cataracts, tumors, and arteriosclerosis in early adulthood.

Whole life insurance Life insurance with premiums paid throughout the lifetime of the insured and redeemed at his or her death; also called *ordinary life insurance* or *straight life insurance.*

Will A legal declaration of a person's desires as to the disposition of his or her property after death; usually written and signed by the person (testator) and witnessed (attested to) by two or more witnesses.

Zoroastrianism An Iranian religion founded by Zoroaster around 600 BC. The principal beliefs are in a supreme being (Ahura Mazda) and a cosmic struggle between a spirit of good (Spenta Mainyu) and a spirit of evil (Angra Mainyu).

REFERENCES

Abrahamsen, D. (1973). *The murdering mind*. New York: Harper & Row.

Abramson, L. Y., Garber, J. & Seligman, M. E. P. (1980). Learned helplessness in humans: An attributional analysis. In J. Garber & M. E. P. Seligman (Eds.), *Human helplessness: Theory and applications* (pp. 3–34). New York: Academic Press.

Adams, B. N. (1968). *Kinship in an urban setting*. Chicago: Markham.

Adams, C. J. (1983). Islam. *The World Book Encyclopedia* (Vol. 10). Chicago: World Book.

Adams, C. J. (1992). Islam. *The World Book Encyclopedia* (Vol. 10, pp. 463–466). Chicago: World Book.

Aday, R. H. (1984–1985). Belief in afterlife and death anxiety: Correlates and comparisons. *Omega, 15*, 67–75.

Ad Hoc Committee of the Harvard Medical School to Examine the Definition of Brain Death. (1968). A definition of irreversible coma. *Journal of the American Medical Association, 205*, 337–340.

Aitken-Swan, J., & Easson, E C. (1959). Reactions of cancer patients on being told their diagnosis. *British Medical Journal, 1*, 770–783.

Alsop, S. (1973). *Stay of execution*. Philadelphia: Lippincott.

Altrocchi, J. (1980). *Abnormal behavior*. New York: Harcourt Brace Jovanovich.

Ambron, S. R., & Brodzinsky, D. (1979). *Lifespan human development*. New York: Holt, Rinehart & Winston.

American Heart Association. (1992). *Heart facts*. Dallas: Author.

Anthony, P. D. (1977). *The ideology of work*. London: Tavistock.

Anthony, S. (1972). *The discovery of death in childhood and after*. New York: Basic Books.

Archer, D., & Garner, R. (1976). Violent acts and violent times: A comparative approach to postwar homicide rates. *American Sociological Review, 4*, 937–963.

Arenson, J. T. (1991). Inheritance. *Encyclopedia Americana*. (Vol. 15, p. 176). Danbury, CT: Grolier.

Aries, P. (1962). *Centuries of childhood: A social history of family life*. (R. Baldick, Trans.). New York: Vintage Books.

Aries, P. (1974). *Western attitudes toward death: From the Middle Ages to the present*. Baltimore: Johns Hopkins University Press.

Aries, P. (1981). *The hour of our death*. (H. Weaver, Trans.). New York: Knopf.

Aronson, G. J. (1959). Treatment of the dying person. In H. Feifel (Ed.), *The meaning of death*. New York: McGraw-Hill.

Aronson, M. K., & Lipkowitz, R. (1981). Senile dementia, Alzheimer's type: The family and the health care delivery system. *Journal of the American Geriatrics Society, 29* (12), 568–571.

Arthur, B., & Kemme, M. L. (1964). Bereavement in childhood. *Journal of Child Psychology and Psychiatry, 5*, 37–45.

Atchley, R. C. (1975). Dimensions of widowhood in later life. *Gerontologist, 15*, 176–178.

Atchley, R. C. (1977). *The social forces in later life* (2d ed.) (Chapter 10). Belmont, CA: Wadsworth.

Atchley, R. C. (1991). *Social forces and aging* (6th ed.). Belmont, CA: Wadsworth.

Atchley, R. C., Pignatiello, L., & Shaw, E. (1975). *The effect of marital status on social interaction patterns of older women.* Oxford, OH: Scripps Foundation.

Auel, J. (1980). *The clan of the cave bear.* New York: Crown.

Back, K. W. (1971). Metaphors as a test of personal philosophy of aging. *Sociological Forces, 5,* 1–8.

Bad news for death row. (1989, July 10). *Time,* p. 48.

Ball, J. F. (1977). Widow's grief: The impact of age and mode of death. *Omega, 7,* 307–333.

Bardis, P. D. (1981). *History of thanatology.* Washington, DC: University Press of America.

Barinaga, M. (1992). Mortality: Overturning received wisdom. *Science, 258,* 398–399.

Barker, J. C. (1968). *Scared to death.* London: Frederick Muller.

Barnard, G. W., Vera, M. I., Vera, H., & Newman, G. (1981, October 15–18). *Till death do us part: A study of spouse murder.* Paper presented at the annual meeting of the American Academy of Psychiatry and the Law, San Diego, CA.

Barrow, G. M., & Smith, P. A. (1983). *Aging, the individual, and society* (2d ed.). St. Paul, MN: West.

Barry, H. (1939). A study of bereavement: An approach to problems in mental disease. *American Journal of Orthopsychiatry, 9,* 355–359.

Beck, A. T., Brown, G., & Steer, R. A. (1989). Prediction of eventual suicide in psychiatric inpatients by clinical ratings of hopelessness. *Journal of Consulting and Clinical Psychology, 57,* 309–310.

Beck, A. T., Hollon, S. D., Young, J. E., Bedrosian, R. C., & Budenz, D. (1985). Treatment of depression with cognitive therapy and amitriptyline. *Archives of General Psychiatry, 42,* 142–148.

Beck, A. T., Rush, A. J., Shaw, B, & Emery, G. (1979). *Cognitive therapy of depression: A treat-

ment manual.* New York: Guilford Press.

Beck, A. T., Sethi, B. B., & Tuthill, R. (1963). Childhood bereavement and adult depression. *Archives of General Psychiatry, 9,* 129–136.

Bell, C. A. (1991). Female homicides in United States work places, 1980–1985. *American Journal of Public Health, 81* (6), 729–732.

Bell, J. B. (1979). *Assassin!* New York: St. Martin's Press.

Bendiksen, R., & Fulton, R. (1975). Death and the child: An anterospective test of the childhood bereavement and later behavior disorder hypothesis. *Omega, Journal of Death and Dying, 6,* 45–60.

Bengston, V. L., Cuellar, J. B., & Ragan, P. K. (1977). Stratum contrasts and similarities in attitudes toward death. *Journal of Gerontology, 32* (1), 76–88.

Bennett, R. (1976). Attitudes of the young toward the old: A review of research. *Personnel and Guidance Journal, 55,* 136–139.

Berardo, D. H. (1988). Bereavement and mourning. In H. Wass, F. M. Berardo, & R. A. Neimeyer (Eds.), *Dying: Facing the facts* (pp. 279–300). Washington, DC: Hemisphere Publishing.

Berg, A. (1954). *The sadist* (O. Illner & G. Godwin, Trans.). New York: Medical Press of New York.

Berkman, L. E., & Syme, S. L. (1979). Social networks, host resistance, and mortality: A nine-year follow-up study of Alameda County residents. *American Journal of Epidemiology, 109,* 186–204.

Berkowitz, L. (1968). Impulse, aggression and the gun. *Psychology Today, 2* (4), 18–22.

Berkowitz, L. (1990). Biological roots: Are humans inherently violent? In B. Glad (Ed.), *Psychological dimensions of war* (pp. 24–40). Newbury Park, CA: Sage.

Berman, A. L. (1986). Helping suicidal adolescents: Needs and responses. In C. A. Carr & J. N. McNeil (Eds.), *Adolescence and death* (pp. 151–166). New York: Springer.

Binstock, J. (1974). Choosing to die: The decline of aggression and the rise of suicide. *The Futurist, 8* (2), 68–71.

Blacher, R. (1979). "To sleep, perchance to

dream . . ." *Journal of the American Medical Association, 242* (21), 2291–2292.

Blair, S. N., et al. (1989). Physical fitness and all-cause mortality. *Journal of the American Medical Association, 262* (17), 2395–2401.

Blau, Z. S. (1961). Structural constraints on friendship in old age. *American Sociological Review, 26,* 429–439.

Blauner, R. (1966). Death and social structure. *Psychiatry, 29* (4), 328–394.

Bloch, H. S. (1969). Army clinical psychiatry in the combat zone—1967–1968. *American Journal of Psychiatry, 126,* 289.

Bluebond-Langner, M. (1977). Meanings of death to children. In H. Feifel (Ed.), *New meanings of death.* New York: McGraw-Hill.

Bluebond-Langner, M. (1978). *The private worlds of dying children.* Princeton, NJ: Princeton University Press.

Blum, G. S., & Rosenzweig, S. (1944). The incidence of sibling and parental deaths in the anamnesis of female schizophrenics. *Journal of General Psychology, 31,* 3–13.

Boase, T. S. R. (1972). *Death in the Middle Ages.* New York: McGraw-Hill.

Boor, M. (1981). Effects of United States presidential elections on suicides and other causes of death. *American Sociological Review, 46,* 616–618.

Bootzin, R. R., & Acocella, J. K. (1980). *Abnormal psychology: Current perspectives.* New York: Random House.

Bornstein, P., Clayton, P., Halikes, J., Maurice, W., & Robins, E. (1973). The depression of widowhood after thirteen months. *British Journal of Psychiatry, 122,* 561–566.

Bouquet, A. C. (1991). Transmigration of the soul. *Encyclopedia Americana* (Vol. 27, p. 15). Danbury, CT: Grolier.

Bowlby, J. (1974). *Attachment and loss: Vol. II. Separation: Anxiety and anger.* New York: Basic Books.

Bowman, J. E. (1990). Disease. *Encyclopedia Americana* (Vol. 9, pp. 168–177). Danbury, CT: Grolier.

Boyar, J. I. (1964). *The construction and partial validation of a scale for the measurement of the fear of death.* Unpublished doctoral dissertation, University of Rochester.

Boyle, J. M., & Morriss, J. E. (1987). *The mirror of time: Images of aging and dying.* New York: Greenwood Press.

Brannon, L., & Feist, J. (1992). *Health psychology: An introduction to behavior and health* (2d ed.). Belmont, CA: Wadsworth.

Brody, J. E. (1987, January 13). Child suicides: Common causes. *New York Times,* p. 16.

Brown, F. (1961). Depression and childhood bereavement. *Journal of Mental Science, 107,* 754–777.

Brown. J. D., & Siegel, J. M. (1988). Exercise as a buffer of life stress: A prospective study of adolescent health. *Health Psychology, 7,* 341–353.

Brown, N. K., & Thompson, D. J. (1979). Nontreatment of fever in extended-care facilities. *New England Journal of Medicine, 300,* 1246–1250.

Bugen, L. A. (1977). Human grief: A model for prediction and intervention. *American Journal of Orthopsychiatry, 47,* 196–206.

Busse, E. W. (1969). Theories of aging. In E. W. Busse & E. Pfeiffer (Eds.), *Behavior and adaptation in late life.* Boston: Little, Brown.

Butler, R. N. (1971). Age: The life review. *Psychology Today, 5* (7), 49–55ff.

Butler, R. N. (1975). *Why survive? Being old in America.* New York: Harper & Row.

Butler, R. N., & Lewis, M. I. (1982). *Aging and mental health* (3d ed.). St. Louis: Mosby.

Caldicott, H. (1982, August 8). Growing up afraid. *Family Weekly,* pp. 4–7.

Caldwell, R. G. (1991). Capital punishment. *Encyclopedia Americana* (vol. 5, pp. 596–599). Danbury, CT: Grolier.

Camus, A. (1955). *The myth of Sisyphus.* (J. O'Brien, Trans.). New York: Knopf.

Carmichael, A. G. (1990). Plague. *Encyclopedia Americana* (Vol. 22, pp. 166–168). Danbury, CT: Grolier.

Carr, A. C., & Schoenberg, B. (1970). Object-loss and somatic symptom formation. In B. Schoenberg, A. C. Carr, D. Peretz & A. H. Kutscher (Eds.), *Psychological management in medical practice* (pp. 36–47). New York: Columbia University Press.

Carr, D. (1981, February 14). Endorphins at the approach of death. *Lancet,* 390.

Carson, R. C., & Butcher, J. N. (1992). *Abnormal psychology and modern life* (9th ed.). New York: HarperCollins.

Cartwright, A., Hockey, L., & Anderson, J. L. (1973). *Life before death*. London: Routledge & Kegan Paul.

Cassem, N. (1988). The person confronting death. In A. Nicholi (Ed.), *The new Harvard guide to psychiatry* (pp. 728–758). Cambridge, MA: Belknap.

Cavan, R. S. (1991). Suicide. *Encyclopedia Americana* (Vol. 25, pp. 857–859). Danbury, CT: Grolier.

Cavanaugh, D. (1991). Abortion: Medical aspects of abortion. *Encyclopedia Americana* (Vol. 1, pp. 44–45). Danbury, CT: Grolier.

Cavendish, R. (1970). Death. In R. Cavendish (Ed.), *Man, myth and magic* (Vol. 5). New York: Marshall Cavendish Corp.

Cavendish, R. (1977). *Visions of heaven and hell*. New York: Harmony Books.

Chalmers, S., & Reichen, M. (1954). Attitudes toward death and future life among normal and subnormal adolescent girls. *Exceptional Children, 20,* 259–262.

Cherico, D. J., & Margolis, O. S. (Eds.). (1976, 1978). *Thanatology course outlines*. New York: Irvington.

Childers, P., & Wimmer, M. (1971). The concept of death in early childhood. *Child Development, 42,* 1299–1301.

Choron, J. (1963). *Death and Western thought* (I. Barea, Trans.). New York: Macmillan.

Choron, J. (1972). *Suicide*. New York: Charles Scribner's Sons.

Cimons, M. (1989, July 18). Study says poor die needlessly from cancer. *Los Angeles Times,* pp. I-1, 16.

Clarke, J. W. (1982). *American assassins: The darker side of politics*. Princeton, NJ: Princeton University Press.

Clayton, P. J., Halikes, J. A., & Maurice, W. L. (1971). The bereavement of the widowed. *Diseases of the Nervous System, 32,* 597–604.

Coates, R. A., Soskoline, C. L., Calzavara, K., Rad, S. E., Fanning, M. M., Shepard, F. A., Klein, M. M., & Johnson, J. K. (1987). The reliability of sexual histories in AIDS-related research: Evaluation of an interview-adminustered questionnaire. *Canadian Journal of Public Health, 77* (5), 343–348.

Cohen, S. (1980, November 15). She turned grief into help for others. *Los Angeles Times,* p. IA-4.

Coleman, L. (1987). *Suicide clusters*. Boston: Faber & Faber.

Collett, L. J., & Lester, D. (1969). The fear of death and the fear of dying. *Journal of Psychology, 72,* 179–181.

Comer, N., Madow, L., & Dixon, J. (1967). Observations of sensory deprivation in a life-threatening situation. *American Journal of Psychiatry, 124,* 164–169.

Comfort, A. (1964). *Aging: The biology of senescence*. New York: Holt, Rinehart & Winston.

Connidis, I. A. (1989). *Family ties and aging*. Toronto: Butterworths.

Conroy, C. (1989). Suicide in the workplace: Incidence, victim characteristics, and external cause of death. *Journal of Occupational Medicine, 31* (10), 847–851.

Conte, H. A., Weiner, M. B., & Plutchik, R. (1982). Measuring death anxiety: Conceptual, psychometric, and psychoanalytic aspects. *Journal of Personality and Social Psychology, 43,* 775–785.

Cook, A. S., & Oltjenbruns, K. A. (1989). *Dying and grieving: Lifespan and family perspectives*. New York: Holt, Rinehart & Winston.

Cook, J. A. (1983). A death in the family: Parental bereavement in the first year. *Suicide and Life-Threatening Behavior, 13* (1), 42–61.

Cope, L. (1980, June 4). Research finding clues to crib deaths. *Minneapolis Tribune* (Minneapolis, MN).

Corcos, A., & Krupka, L. (1984). How death came to mankind: Myths and legends. In R. A. Kalish (Ed.), *The final transition* (pp. 165–177). Farmingdale, NY: Baywood.

Costa, B. J. (1989). *Handbook for the bereaved and those who want to help*. Fall River, MA: Hospice Outreach.

Cremation Association of North America. (1992, August 12-15). *1992 projections to the year 2010*. Presented at the 74th Annual Convention, San Francisco, CA.

Crichton, M. (1975). *The great train robbery*. New York: Knopf.

Crook, T., & Eliot, J. (1980). Parental death during childhood and adult depression: A critical review of the literature. *Psychological Bulletin, 87,* 252–259.

Curran, D. K. (1987). *Adolescent suicidal behavior.* Washington, DC: Hemisphere.

Cutler, R. G. (1976). Evolution of longevity in primates. *Journal of Human Evolution, 5,* 169–202.

Darling, J. (1992, November 3). Family reunion for the dead. *Los Angeles Times,* p. H-3.

Davis, E. W. (1983). The ethnobiology of the Haitian zombie. *Journal of Ethnopharmacology, 9,* 85.

Davis, E. W. (1988). *Passage of darkness: The ethnobiology of the Haitian zombie.* Chapel Hill, NC: University of North Carolina.

Dead, disposal of the. (1976). *Chamber's Encyclopedia* (Vol. 4, pp. 401–404). London: International Learning Systems.

Death. (1983). *Encyclopaedia Britannica* (Vol. 3). Chicago: Encyclopaedia Britannica.

Death masks. (1987). *Encyclopaedia Britannica* (Vol. 3). Chicago: Encyclopaedia Britannica.

Death rites and customs. (1983). *Encyclopaedia Britannica* (Vol. 5). Chicago: Encyclopedia Britannica.

DeBakey, M. E. (1990). Heart. *World Book Encyclopedia* (Vol. 9). Chicago: World Book.

DeFleur, M. L., & Quinney, R. (1966). A reformulation of Sutherland's differential association theory and a strategy for empirical verification. *Journal of Research in Crime and Delinquency, 3,* 1–22.

Denckla, W. D. (1974). Role of the pituitary and thyroid glands in the decline of minimal O_2 consumption with age. *Journal of Clinical Investigation, 53,* 572–581.

Derogatis, L. R., Abeloff, M. D., & Melisaratos, N. (1979). Psychological coping mechanisms and survival time in metastatic breast cancer. *Journal of the American Medical Association 242,* 1504–1508.

DeSpelder, L. A., & Strickland, A. L. (1992). *The last dance* (3d ed.). Mountain View, CA: Mayfield.

Dickinson, G. E., & Pearson, A. A. (1979). Differences in attitudes toward terminal patients among selected medical specialties of physicians. *Medical Care, 17,* 682–685.

Diekstra, R. F. W. (1987). Suicide should not always be prevented. In J. Rohr (Ed.), *Death and dying: Opposing viewpoints.* St. Paul, MN: Greenhaven Press.

Diggory, J. C., & Rothman, D. Z. (1961). Values destroyed by death. *Journal of Abnormal and Social Psychology, 63,* 205–210.

Donin, H. H. (1972). *To be a Jew: A guide to Jewish observance in contemporary life.* New York: Basic Books.

Douglas-Hamilton, L., & Douglas-Hamilton, O. (1975). *Among the elephants.* New York: Viking Press.

Dublin, L. L. (1963). *Suicide: A sociological and statistical study* (p. 211). New York: Ronald.

Dumont, R. G., & Foss, D. C. (1972). *The American view of death: Acceptance or denial?* Cambridge, MA: Schenkman.

Edelstein, L. (1984). *Maternal bereavement.* New York: Praeger.

Elizur, E., & Kaffman, M. (1982). Children's bereavement reactions following death of the father: II. *Journal of the American Academy of Child Psychiatry, 21,* 474–480.

Elwes, R. H. M. (Trans.). (1951). *The chief works of Benedict de Spinoza* (Vol. II). New York: Dover Press.

Engel, G. L. (1971). Sudden and rapid death during psychological stress. *Annals of Internal Medicine, 74,* 771–782.

Epstein, G. L., Weitz, L., Roback, H., & McKee, E. (1975). Research on bereavement: A selective and critical review. *Comprehensive Psychiatry, 16,* 537–546.

Erikson, E. H. (1976). Reflections on Dr. Borg's life cycle. *Daedalus, 105* (2), 1–28.

Ettinghausen, R. (1983). Islamic art. *World Book Encyclopedia* (Vol. 19). Chicago: World Book.

Ezell, G., Anspaugh, D. J., & Oaks, J. (1987). *Death and dying: From a health and sociological perspective.* Scottsdale, AZ: Gorsuch Scarisbrick.

Farberow, N. L. (1974). *Suicide.* Morristown, NJ: General Learning Press.

Farberow, N. L. (1975). Cultural history of suicide. In N. L. Farberow (Ed.), *Suicide in different cultures.* Baltimore: University Park Press.

Farberow, N. L., & Litman, R. E. (1970). *A comprehensive suicide prevention program.* Suicide Prevention Center of Los Angeles, 1958–1969. Unpublished final report DHEW NIMH Grant Nos. MH 14946 & MH 00128, Los Angeles.

Farlow, M., Ghetti, B., Benson, M. D., Farrow, J. S., Van Nostrand, W. E., & Wagner, S. L. (1992). Low cerebrospinal-fluid concentrations of soluble amyloid β-protein precursor in hereditary Alzheimer's disease. *Lancet, 340,* 453–454.

Feifel, H. (1959). Attitudes toward death in some normal and mentally ill populations. In H. Feifel (Ed.), *The meaning of death.* New York: McGraw-Hill.

Feifel, H. (1963). Death. In N. L. Farberow (Ed.), *Taboo topics.* New York: Atherton Press.

Feifel, H. (Ed.). (1977). *New meanings of death.* New York: McGraw-Hill.

Feifel, H., Hanson, S., & Jones, H. (1967). Physicians consider death. *Proceedings of the 75th Annual Convention of the American Psychological Association, 2,* 201–202.

Feifel, H., & Jones, R. (1968). Perception of death as related to nearness of death. *Proceedings of the 76th Annual Convention of the American Psychological Association, 3,* 545–546.

Feifel, H., & Nagy, V. T. (1981). Another look at fear of death. *Journal of Consulting and Clinical Psychology, 49,* 278–286.

Felsenfeld, O. (1990). Epidemic. *Encyclopedia Americana* (Vol. 10, pp. 506–507). Danbury, CT: Grolier.

Ferrare, N. A. (1962). *Institutionalization and attitude change in an aged population.* Unpublished doctoral dissertation, Western Reserve University.

Fischer, H. K., & Dlin, B. M. (1972). Psychogenic determination of time of illness on death by anniversary reactions and emotional deadlines. *Psychosomatics, 13,* 170–172.

Flexner, S. B. (Ed. in chief). (1987). *Random House dictionary of the English language* (2d ed.). New York: Random House.

Fowler, R. C., Rich, C. L., & Young, D. (1986). San Diego suicide study: Substance abuse in young cases. *Archives of General Psychiatry, 43,* 962–965.

Fraiberg, S. (1977). *Every child's birthright: In defense of mothering.* New York: Basic Books.

Franklin, J. H. (1956). *The militant South.* Cambridge, MA: Harvard University Press.

Fredrick, J. F. (1983–1984). The biochemistry of bereavement: Possible bias for chemotherapy. *Omega, 13,* 295–303.

Fremouw, W. J., De Perczel, M., & Ellis, T. E. (1990). *Suicide risk: Assessment and response guidelines.* Elmsford, NY: Pergamon.

Freud, S. (1933, reprinted 1950). Why war? In *Collected works* (Vol. 16). London: Imago.

Friedman, H., Schwartz, J. E., Tucker, J. S., Tomlinson-Keasey, C., Wingard, D. L., & Criqui, M. H. (1992). *Psychosocial factors in childhood as predictors of longevity.* Paper presented at Annual Meeting of the American Psychological Association, Washington, D.C.

Friedman, P., & Linn, L. (1957). Some psychiatric notes on the Andrea Doria disaster. *American Journal of Psychiatry, 114,* 426–432.

Fulton, R. (Ed.). (1965). *Death and identity.* New York: Wiley.

Fulton, R. (1971). The funeral and the funeral director: A contemporary analysis. In H. C. Raether (Ed.), *Successful funeral service practice.* Englewood Cliffs, NJ: Prentice-Hall.

Fulton, R. (Comp.). (1981). *A bibliography of death, grief, and bereavement, 1975–1980.* New York: Arno.

Fulton, R. (1992). Funeral customs. *World Book Encyclopedia* (Vol. 7, pp. 357–358). Chicago: World Book.

Funeral Industry Practice (Funeral Rule). (1985). 16 C.F.R., paragraph 453.

Futterman, E. H., & Hoffman, I. (1983). Mourning the fatally ill child. In J. E. Schowalter & P. R. Paterson (Eds.), *The child and death* (pp. 366–381). New York: Columbia University Press.

Gallup, G., & Proctor, W. (1982). *Adventures in immortality.* New York: McGraw-Hill.

Gambino, R. (1978). The murderous mind: Insanity vs. the law. *Saturday Review, 6* (12) 10-13.

Garfield, C. A. (1979). The dying patient's concern with "life after death." In R. Kastenbaum (Ed.), *Between life and death* (pp. 45–60). New York: Springer.

Garland, A. F., & Zigler, E. (1993). Adolescent suicide prevention: Current research and so-

cial policy implications. *American Psychologist, 48,* 169–182.

Garrett, D. N. (1978). The needs of the seriously ill and their families: The haven concept. *Aging, 6* (1) 12-19.

Gatch, M. M. (1969). *Death: Meaning and mortality in Christian thought and contemporary culture.* New York: Seabury Press.

Gatch, M. M. (1980). The Biblical tradition. In E. S. Shneidman (Ed.), *Death, current perspectives* (2d ed.). Palo Alto, CA: Mayfield.

Gerber, I., Rusalem, R., Hannon, N., Battin, D., & Arkin, A. (1975). Anticipatory grief and aged widows and widowers. *Journal of Gerontology, 30* (2), 225–229.

Gesser, G., Wong, P. T. P., & Reker, G. T. (1987–1988). Death attitudes across the lifespan: The development and validation of the Death Attitude Profile (DAP). *Omega: Journal of Death and Dying, 18* (2), 113–128.

Gilliland, J. C., & Templer, D. I. (1985). Relationship of death anxiety scale factors to subjective states. *Omega, 16,* 155–167.

Glaser, B. G., & Strauss, A. L. (1965). *Awareness of dying.* Chicago: Aldine.

Glaser, B. G., & Strauss, A. L. (1968). *Time for dying.* Chicago: Aldine.

Glick, I. O., Weiss, R. S., & Parkes, C. M. (1974). *The first year of bereavement.* New York: Wiley.

Glueck, S., & Glueck, E. T. (1956). *Physique and delinquency.* New York: Harper.

Goleman, D. (1985, November 24). Clues to suicide: A brain chemical is implicated. *New York Times,* pp. 13, 16.

Goleman, D. (1986, February 23). What colleges have learned about suicide. *New York Times,* pp. 13, 16.

Goodman, L. M. (1981). *Death and the creative life.* New York: Springer.

Gordon, A. K., & Klass, D. (1979). *The need to know: How to teach children about death.* Englewood Cliffs, NJ: Prentice Hall.

Gorer, G. (1965). *Death, grief and mourning.* New York: Doubleday Anchor Books.

Gorer, G. (1980). The pornography of death. In E. S. Shneidman (Ed.), *Death: Current perspectives* (2d ed., pp. 26–30). Palo Alto, CA: Mayfield.

Gottlieb, C. (1959). Modern art and death. In H.

Feifel (Ed.), *The meaning of death.* New York: McGraw-Hill.

Gould, R. L. (1980). Transformations during early and middle adult years. In N. J. Smelser & E. H. Erikson (Eds.), *Themes of work and love in adulthood.* Cambridge, MA: Harvard University Press.

Gove, W. (1973). Sex, marital status, and mortality. *American Journal of Sociology, 79* (1), 45–67.

Granick, S., & Patterson, R. D. (1972). *Human aging: II: An eleven year followup biomedical and behavioral study.* Washington, DC: U.S. Government Printing Office.

Green, M. (1966, November 17). Care of the dying child. In A. B. Berman & C. J. A. Schultle (Eds.), *Care of the child with cancer.* Proceedings of a conference conducted by the Association for Ambulatory Pediatric Services in conjunction with the Children's Cancer Study Group A.

Green, M., & Solnit, A. J. (1964). Reactions to the threatened loss of a child. A vulnerable child syndrome. Paediatric management of the dying child. *Paediatrics, 37,* 53–66.

Greer, D. S., Mor, V. Morris, J. N., Sherwood, S., Kidder, D., & Birnbaum, H. (1984). An alternative in terminal care: Results of the National Hospice Study. In L. H. Aiken & B. H. Kerer (Eds.), *Evaluation Studies Review Annual* (Vol. 11, pp. 146–158). Beverly Hills: Sage.

Grobstein, R. (1978). The effect of neonatal death on the family. In O. J. Sahler (Ed.), *The child and death.* St. Louis: Mosby.

Grof, S., & Halifax, J. (1977). *The human encounter with death.* New York: Dutton.

Gross, S. R. (1984). Determining the neutrality of death-qualified juries: Judicial appraisal of empirical data. *Law and Human Behavior, 8,* 7–30.

Grossarth-Maticek, R., Eysenck, H. J., Vetter, H., & Frentzel-Beyme, R. (1986). The Heidelberg Prospective Intervention Study. In W. J. Eylenbasch, A. M. Depoorter & N. van Larbeke (Eds.), *Primary prevention of cancer* (pp. 199–212). New York: Raven Press.

Guthmann, R. F., & Womack, S. K. (1978). *Death, dying and grief: A bibliography.* Lincoln, NE: Word Services & Pied Publishers.

Guttmacher, M. S. (1960). *The mind of the murderer.* New York: Farrar, Straus & Cudahy.

Halleck, S. L. (1971). *Psychiatry and the dilemmas of crime.* Berkeley: University of California Press.

Hambly, W. D. (1974). Funeral customs. *World Book Encyclopedia* (Vol. 9). Chicago: World Book.

Hamilton, J. (1978). Grandparents as grievers. In O. J. Sahler (Ed.), *The child and death.* St. Louis: Mosby.

Hardt, D. V. (1978–1979). An investigation of the stages of bereavement. *Omega, 9,* 279–285.

Hardt, D. V. (1979). *Death: The final frontier.* Englewood Cliffs, NJ: Prentice Hall.

Harman, D. (1981). The aging process. *Proceedings of the National Academy of Sciences of the USA, 78,* 7124–7128.

Harmer, R. M. (1963). *The high cost of dying.* New York: Crowell-Collier.

Hart, R. W., & Setlow, R. B. (1974). Correlation between deoxyribonucleic acid excision-repair and life-span in a number of mammalian species. *Proceedings of the National Academy of Sciences of the USA, 71,* 2169–2173.

Harvey, C., & Bahr, H. (1974). Widowhood, morale, and affiliation. *Journal of Marriage and the Family, 36,* 97–106.

Haskins, G. (1956). The capital laws of New England. *Harvard Law School Bulletin, 7,* 10.

Hastings Center. (1988). *Guidelines on the termination of life-sustaining treatment and the care of the dying.* Bloomington: Indiana University Press.

Havighurst, R. J. (1969). Suicide and education. In E. S. Shneidman (Ed.), *On the nature of suicide.* San Francisco: Jossey-Bass.

Hayflick, L. (1980). The cell biology of human aging. *Scientific American, 242,* 58–66.

Helsing, K. J., Szklo, M., & Comstock, G. W. (1981). Factors associated with mortality after widowhood. *American Journal of Public Health, 71,* 802–809.

Hendin, H. (1985). Suicide among the young: Psychodynamics and demography. In M. L. Peck, N. L. Farberow & R. E. Litman (Eds.), *Youth suicide* (pp. 19–38). New York: Springer.

Henry, A. F., & Short, J. F., Jr. (1954). *Suicide and homicide.* Glencoe, IL: Free Press.

Herr, J., & Weakland, J. H. (1979). *Counseling elders and their families* (Chapter 19). New York: Springer.

Heyman, D. K., & Gianturco, D. (1973). Long-term adaptation by the elderly to bereavement. *Journal of Gerontology, 28* (3), 359–362.

Hillinger, C. (1989, July 5). The sweet chariot swings low—A study of black burial rites. *Los Angeles Times,* pp. V-1, 4.

Hines, W. (1980, April 17). Crib death study saving lives. *Los Angeles Times,* pp. V-16, 17.

Hinton, J. (1972). *Dying* (2 d ed.). Baltimore: Penguin.

Hoelter, J. W. (1979). Multidimensional treatment of fear of death. *Journal of Consulting and Clinical Psychology, 47,* 996–999.

Hogan, R. A. (1970). Adolescent views of death. *Adolescence, 5,* 55–56.

Hogshead, H. P. (1978). The art of delivering bad news. In C. Garfield (Ed.), *Psychosocial care of the dying patient* (pp. 128–132). New York: McGraw-Hill.

Holden, C. (1980). The hospice movement and its implications. *Annals of the AAPSS, 447,* 59–63.

Holmes, R. (1985). *Acts of war.* New York: Free Press.

Homicide rates hit record highs. (1990, December 7). *News Chronicle* (Thousand Oaks, CA), p. A-5.

House, J. S., Robbins, C., & Metzner, H. L. (1982). The association of social relationships and activities with mortality: Prospective evidence from the Tecumseh Community Health Study. *American Journal of Epidemiology, 116,* 123–140.

Houston, J. P., Hammen, C., Padilla, A., & Bee, H. (1989). *Invitation to psychology* (3d ed.). San Diego: Harcourt Brace Jovanovich.

Howells, K., & Field, D. (1982). Fear of death and dying among medical students. *Social Science and Medicine, 16,* 1421–1424.

Humphry, D. (1991). *Final exit: Self-deliverance and assisted suicide for the dying.* Eugene, OR: Hemlock Society.

Hunter, E. J. (1978). The Vietnam POW veteran: Immediate and long-term effects. In C. R.

Figley (Ed.), *Stress disorders among Vietnam veterans*. New York: Brunner/Mazel.

Hunter, E. J. (1981). *Wartime stress: Family adjustment to loss* (USIU Report No. TR-USIU-81-07). San Diego, CA: United States International University.

Hurlock, E. B. (1980). *Developmental psychology* (5th ed.). New York: McGraw-Hill.

Hutchison, I. (1975). The significance of marital status for morale and life satisfaction among low-income elderly. *Journal of Marriage and the Family, 37,* 287–293.

Huyck, M. H., & Hoyer, W. J. (1982). *Adult development and aging*. Belmont, CA: Wadsworth.

Imara, M. (1989). Death: Psychological aspects of death. *Encyclopedia Americana* (Vol. 8). Danbury, CT: Grolier.

Jacobs, R. H., & Vinick, B. H. (1979). *Reengagement in later life: Re-employment and remarriage*. Stamford, CT: Greylock Publishers.

Jacobsen, P. B., Perry, S. W., & Hirsch, D. A. (1990). Behavioral and psychological responses to HIV antibody testing. *Journal of Consulting and Clinical Psychology, 58,* 31–37.

James, G. (1993, June 16). Ruled dead by medical workers, a Brooklyn woman, 40, is alive. *New York Times*, pp. B1-2.

Jameson, S. (1981, March 8). Japan's parent-child suicide phenomenon blamed on social change. *Los Angeles Times*, p. IA-1.

Jankovsky, K. (1979). Public execution in England in the late Middle Ages: The indignity and dignity of death. *Omega, Journal of Death & Dying, 10,* 433–458.

Johnson, R. (1982, August 20). Death row is no life, it's legalized torture. *Los Angeles Times*, p. II-11.

Jonas, D. T. (1976). Life, death, awareness, and concern: A progression. In A. Toynbee, A. Koestler & others (Eds.), *Life after death*. New York: McGraw-Hill.

Jones, B. (1967). *Design for death*. Indianapolis, IN: Bobbs-Merrill.

Juenker, D. (1977). Child's perception of his illness. In S. Steel (Eds.), *Nursing care of the child with long-term illness* (2d ed.). New York: Appleton-Century-Crofts.

Kaffman, M., & Elizur, E. (1979). Children's be-reavement reactions following death of father: The early months of bereavement. *International Journal of Therapy, 1,* 203–229.

Kalat, J. W. (1984). *Biological psychology* (2d ed.). Belmont, CA: Wadsworth.

Kalish, R. A. (1977). Dying and preparing for death: A view of families. In H. Feifel (Ed.), *New meanings of death*. New York: McGraw-Hill.

Kalish, R. A. (1985a). The social context of death and dying. In R. H. Binstock & E. Shanas (Eds.), *Handbook of aging and the social sciences* (2d ed.) (pp. 149–170). New York: Van Nostrand Reinhold.

Kalish, R. A. (1985b). *Death, grief, and caring relationships* (2d ed.). Belmont, CA: Brooks/Cole.

Kalish, R. A., & Reynolds, D. K. (1981). *Death and ethnicity: A psychocultural study*. Farmingdale, NY: Baywood. (Originally published by University of Southern California Press, 1976.)

Kallmann, F. J., & Jarvik, L. F. (1959). Individual differences in constitution and genetic background. In J. E. Birren (Ed.), *Handbook of aging and the individual* (pp. 216–263). Chicago: University of Chicago Press.

Kamerman, J. B. (1988). *Death in the midst of life*. Englewood Cliffs, NJ: Prentice Hall.

Kane, A. C., & Hogan, J. D. (1985). Death anxiety in physicians: Defensive style, medical specialty and exposure to death. *Omega, 16,* 11–22.

Kaplan, G. A., Seeman, T. E., Cohen, R. D., Knudsen, L. P., & Guralnik, J. (1987). Mortality among the elderly in the Alameda County study: Behavioral and demographic risk factors. *American Journal of Public Health, 77,* 307–312.

Kaplan, H. B., & Pokorny, A. P. (1970). Aging and self-attitude: A conditioned relationship. *International Journal of Aging and Human Development, 1,* 241–250.

Kastenbaum, R. J. (1959). Time and death in adolescence. In H. Feifel (Ed.), *The meaning of death* (pp. 99–113). New York: McGraw-Hill.

Kastenbaum, R. J. (1969). Psychological death. In L. Pearson (Ed.), *Death and dying: Current issues in the treatment of the dying person*.

Cleveland, OH: Case Western Reserve University.

Kastenbaum, R. J. (1971). Age: Getting there on time. *Psychology Today, 5* (7), 52–54.

Kastenbaum, R. J. (1977). *Death, society, and human experience.* St. Louis: Mosby.

Kastenbaum, R. J. (1981). *Death, society, and human experience* (2d ed.). St. Louis: Mosby.

Kastenbaum, R. J. (1985). Dying and death: A life-span approach. In J. Birren & W. Schaie (Eds.), *Handbook of the psychology of aging* (2d ed.) (pp. 619–643). New York: Van Nostrand Reinhold.

Kastenbaum, R. J. (1986). *Death, society and human experience* (3d ed.). Columbus, OH: Charles E. Merrill.

Kastenbaum, R. J. (1991). *Death, society, and human experience* (4th ed.). Columbus: Merrill Publishing.

Kastenbaum, R. J., & Aisenberg, R. (1972, 1976). *The psychology of death.* New York: Springer.

Kastenbaum, R. J., & Costa, P. T. (1977). Psychological perspectives on death. *Annual Review of Psychology, 8,* 225–249.

Kavanaugh, R. E. (1974). *Facing death.* Baltimore: Penguin.

Kearl, M. C. (1989). *Endings: A sociology of death and dying.* New York: Oxford University Press.

Keith, P. M. (1979). Life changes and perceptions of life and death among older men and women. *Journal of Gerontology, 34,* 870–878.

Kevles, B. (1986, August 27). Alzheimer's link to aluminum explored. *Los Angeles Times,* p. V-6.

Khleif, B. (1976). The sociology of the mortuary: Religion, sex, age and kinship variables. In V. R. Pine, A. H. Kutscher, D. Peretz, R. J. Slater, R. DeBellis, & D. J. Cherico (Eds.), *Acute grief and the funeral.* Springfield, IL: Thomas.

Kitagawa, E. M., & Hauser, P. M. (1973). *Differential mortality in the United States: A study of socioeconomic epidemiology.* Cambridge, MA: Harvard University Press.

Klass, D. (1988). *Parental grief. Solace and resolution.* New York: Springer.

Kletti, R., & Noyes, R. J. (1981). Mental states in mortal danger. *Issues in the Study of Aging,*

Dying, and Death, 5 (1), 5–20.

Kliman, G. (1979). Facilitation of mourning during childhood. In I. Gerber (Ed.) & L. G. Kutscher (editorial assistant), *Perspectives on bereavement.* New York: Arno Press.

Kobrin, F., & Hendershot, G. (1977). Do family ties reduce mortality? Evidence from the United States, 1966–68. *Journal of Marriage and the Family, 39,* 737–745.

Koocher, G. P. (1973). Childhood, death, and cognitive development. *Developmental Psychology, 9,* 369–375.

Koocher, G. P. (1974). Talking with children about death. *American Journal of Orthopsychiatry, 44,* 404–411.

Krakoff, I. H. (1991). Cancer. *Encyclopedia Americana* (Vol. 5, pp. 528–532). Danbury, CT: Grolier.

Kramer, S. N. (1989). Gilgamesh epic. *Encyclopedia Americana* (Vol. 12). Danbury, CT: Grolier.

Krauss, D. (1985, July 4). Beam me up, Scotty! Launching the remains of your loved one into orbit. *Gazette* (Greenwich, CT), p. 18.

Krieger, S. R., Epting, F. R., & Leitner, L. M. (1974). Personal constructs, threat, and attitudes toward death. *Omega, 5,* 299–310.

Krier, B. A. (1987, September 24). Suicide researchers take on holiday myth. *Los Angeles Times,* p. VI-6.

Krupnick, J. L. (1984). Bereavement during childhood and adolescence. In M. Osterweis, F. Solomon & M. Green (Eds.), *Bereavement: Reactions, consequences, and care* (pp. 99–141). Washington, DC: National Academy Press.

Krupnick, J. L. & Solomon, F. (1987). Death of a parent or sibling during childhood. In J. Bloom-Feshbach, S. Bloom-Feshbach, & associates (Eds.), *The psychology of separation and loss.* San Francisco: Jossey-Bass.

Kübler-Ross, E. (1969). *On death and dying.* New York: Macmillan.

Kübler-Ross, E. (1974). *Questions and answers on death and dying.* New York: Macmillan.

Kübler-Ross, E. (Ed.). (1975). *Death: The final stage of growth.* Englewood Cliffs, NJ: Prentice Hall.

Kull, S. (1990). War and attraction to destruction. In B. Glad (Ed.), *Psychological dimensions of*

war (pp. 41–55). Newbury Park, CA: Sage.

Kung, H. (1984). *Eternal life? Life after death as a medical, philosophical, and theological problem.* Garden City, NY: Doubleday.

Langer, E., & Rodin, J. (1976). The effects of choice and enhanced personal responsibility for the aged: A field experiment in an institutionalized setting. *Journal of Personality and Social Psychology, 34,* 191–198.

Lee, M., Zimbardo, P. G., & Bertholf, M. (1977). Shy murderers. *Psychology Today, 11* (6), 68–70.

Lefcourt, H. M. (1973). The function of illusions of control and freedom. *American Psychologist, 28,* 417–425.

Leming, M. R. (1980). Religion and death: A test of Homans' thesis. *Omega, 10,* 347–364.

Lerner, M. (1980). When, why, and where people die. In E. S. Shneidman (Ed.), *Death: Current perspectives* (2d ed., pp. 87–108). Palo Alto, CA: Mayfield.

Lesko, L. H. (1991). Pyramid. *Encyclopedia Americana* (Vol. 15, pp. 920–923). Chicago: Grolier.

Lessa, W. A. (1976). Death customs and rites. *Chamber's Encyclopedia* (Vol. 4). London: International Learning Systems.

Lester, D. (1973). Murder: A review. *Correctional Psychiatry, 19,* 40–50.

Levinson, D. J. (1978). *The seasons of a man's life.* New York: Knopf.

Leviton, D. (1977). Death education. In H. Feifel (Ed.), *New meanings of death* (pp. 253–272). New York: McGraw-Hill.

Leviton, D., & Forman, E. C. (1974). Death education for children and youth. *Journal of Clinical Psychology, 3,* 8–10.

Leyton, E. (1986). *Compulsive killers: The story of modern multiple murder.* New York: Washington Mews Books, New York University Press.

Lieber, C. S. (1991). Cirrhosis. *Encyclopedia Americana* (Vol. 6, pp. 739–740). Danbury, CT: Grolier.

Lieberman, M. A. (1965). Psychological correlates of impending death: Some preliminary observations. *Journal of Gerontology, 2,* 181–190.

Lieberman, M. A., & Coplan, A. S. (1969). Distance from death as a variable in the study of

aging. *Developmental Psychology, 2,* 181–190.

Lloyd, C. (1980). Life events and depressive disorder reviewed. II: Events as predisposing factors. *Archives of General Psychiatry, 37,* 529–535.

Lonetto, R., Mercer, G. W., Fleming, S., Bunting, B., & Clare, M. (1980). Death anxiety among university students in Northern Ireland and Canada. *Journal of Psychology, 104,* 75–82.

Long, C. H. (1990). Mythology. *Encyclopedia Americana* (Vol. 19). Danbury, CT: Grolier.

Long, J. B. (1987). Underworld. In M. Eliade (Ed.), *The encyclopedia of religion, 15,* 126–144. New York: Macmillan.

Lopata, H. Z. (1973). *Widowhood in an American city.* Cambridge, MA: Schenckman.

Lopata, H. Z. (1975). On widowhood: Grief, work, and identity reconstruction. *Journal of Geriatric Psychiatry, 8,* 41–55.

Lopata, H. Z. (1979). *Women as widows: Support systems.* New York: Elsevier North-Holland.

Lord, W. (1955). *A night to remember.* New York: Holt.

Lorenz, K. (1966). *On aggression.* New York: Harcourt, Brace & World.

Lund, D. A., Dimond, M. S., Caserta, M. F., Johnson, R. J., Poulton, J. L., & Connelly, J. R. (1985–1986). Identifying elderly with coping difficulties after two years of bereavement. *Omega, 16,* 213–224.

Lunde, D. T. (1976). *Murder and madness.* San Francisco: San Francisco Book Co.

Lundin, T. (1984). Morbidity following sudden and unexpected bereavement. *British Journal of Psychiatry, 144,* 84–88.

Lynch, J. J. (1977). *The broken heart: The medical consequences of loneliness.* New York: Basic Books.

Malcolm, A. (1986, March 16). Reassessing care of dying. *New York Times,* p. 8.

Margolick, D. (1985, November 14). 25 wrongfully executed in U.S., study finds. *New York Times,* p. 13.

Margolis, O. S. et al. (Eds.). (1978). *Thanatology course outlines* (Vol. 2). New York: Irvington.

Marmar, C. (1981). Age as a factor in widows' grief—and psychotherapy. *Behavior Today, 12* (42).

Marshall, J. R. (1978). Changes in aged white

male suicide: 1948–1972. *Journal of Gerontology, 33,* 763–768.

Marshall, J. R. (1981). Political integration and the effect of war on suicide: United States, 1933–76. *Social Forces, 59,* 771–778.

Mascaro, J. (Trans.). (1965). *The Upanishads.* New York: Penguin.

Masoro, E. J. (1988) Minireview: Food restriction in rodents—An evaluation of its role in the study of aging. *Journal of Gerontology: Biological Sciences, 43,* B59–B64.

Maugh, T. H. II. (1991, October 5). Discovery of Alzheimer's gene stirs ethics debate. *Los Angeles Times,* pp. A1, A26.

Mauksch, H. O. (1975). The organizational context of dying. In E. Kübler-Ross (Ed.), *Death: The final stage of growth* (pp. 7–24). Englewood Cliffs, NJ: Prentice Hall.

Maurer, A. (1964). Adolescent attitudes toward death. *Journal of Genetic Psychology, 105,* 79–90.

Mayrer, A. (1966). Maturation of concepts of death. *British Journal of Medicine and Psychology, 39,* 35–41.

McCarthy, M. (1991, August 27). Learning to accept the inevitable. *Los Angeles Times,* pp. E-1, E-5.

McCleary, R., Chew, K. S. Y., Hellsten, J. J., & Slynn-Bransford, M. (1991). Age and sex-specific cycles in United States suicides, 1973–1985. *American Journal of Public Health, 81* (11), 1494–1497.

McIntyre, M. S., Angle, C. R., & Struempler, L. J. (1972). The concept of death in midwestern children and youth. *American Journal of Diseases of Children, 123,* 527–532.

McKusick, L., Horstman, W., & Coates, T. (1985). AIDS and sexual behavior reported by gay men in San Francisco. *American Journal of Public Health, 75,* 493–496.

McKusick, L., Wiley, J. A., Coates, T. J., Stall, R., Saika, G., Morin, S., Charles, K., Horstman, W., & Conant, M. A. (1985). Reported changes in the sexual behavior of men at risk for AIDS, San Francisco, 1982–84—The AIDS behavioral research project. *Public Health Reports, 100,* 622–629.

McMordie, W. R. (1978). Improving measure-

ment of death anxiety. *Psychological Reports, 44,* 975–980.

McMordie, W. R. (1981). Religiosity and fear of death: Strength of belief system. *Psychological Reports, 49,* 921–922.

Medical Electronics and Data. (1977). *The heart watcher,* No. 25. Columbus, OH: United Color Press.

Melear, J. D. (1973). Children's conceptions of death. *Journal of Genetic Psychology, 123,* 527–532.

Melges, F. T. (1982). *Time and the inner future: A temporal approach to psychiatric disorders* (Chapter 10). New York: Wiley.

Mercer, N. A. (1991). Inheritance tax. *Encyclopedia Americana* (Vol. 15, pp. 176–177). Danbury, CT: Grolier.

Middleton, J. (1991). Death customs and rites. *Encyclopedia Americana* (Vol. 8). Danbury, CT: Grolier.

Miles, M. S., & Demi, A. S. (1983–1984). Toward a theory of bereavement guilt: Sources of guilt in bereaved parents. *Omega, 14,* 299–314.

Miller, G. H., & Gerstein, D. R. (1983). The life expectancy of nonsmoking men and women. *Public Health Reports, 98,* 343–349.

Miller, M. (1978). Geriatric suicide: The Arizona study. *Gerontologist, 18,* 488–496.

Mitford, J. (1963). *The American way of death.* Greenwich, CT: Fawcett.

Moody, R. A. (1975). *Life after life.* New York: Bantam.

Moody, R. A. (1976). *Reflections on life after life.* New York: Bantam.

Morgan, D. (1989). Adjusting to widowhood: Do social networks really make it easier? *Gerontologist, 29,* 101–107.

Morgan, L. A. (1976). A re-examination of widowhood and morale. *Journal of Gerontology, 31,* 687–695.

Morrissey, J. R. (1963). Children's adaptation to fatal illness. *Social Work, 12,* 210–214.

Mumma, C. M., & Benoliel, J. Q. (1984–1985). Care, cure, and hospital dying trajectories. *Omega, 15,* 275–288.

Murphy, J., & Florio, C. (1978). Older Americans: Facts and potential. In R. Gross, B. Gross &

S. Seidman (Eds.). *The new old: Struggling for decent aging.* Garden City, NY: Doubleday-Anchor.

NAACP Legal Defense and Educational Fund, Inc. (1992, Spring). *Death row, U.S.A.* Washington, DC: Author.

Nagy, M. H. (1948). The child's theories concerning death. *Journal of Genetic Psychology, 73,* 3–27.

National Center for Health Statistics. (1989). *Health United States 1988.* Hyattsville, MD: Public Health Service.

National Center for Health Statistics. (1991). *Monthly Vital Statistics Report, 39* (13). Hyattsville, MD: U.S. Department of Health and Human Services.

National Center for Health Statistics. (1992a). *Monthly Vital Statistics Report, 40* (13). Hyattsville, MD: U.S. Dept. of Health and Human Services.

National Center for Health Statistics. (1992b). *Monthly Vital Statistics Report, 41* (6). Hyattsville, MD: U.S. Dept. of Health and Human Services.

National Center for Health Statistics. (1993). *Monthly Vital Statistics Report, 41* (12). Hyattsville, MD: U.S. Dept. of Health and Human Services.

National Coalition to Abolish the Death Penalty (1992). *United States executions.* Washington, DC: Author.

National Hospice Organization (no date). *The basics of hospice.* Arlington, VA: Author.

National Hospice Organization. (1988). *The basics of hospice.* Arlington, VA: Author.

National Interreligious Task Force on Criminal Justice. (no date). *Capital punishment: What the religious community says.* New York: Author.

National Safety Council. (1992). *Accident facts, 1991 edition.* Chicago: Author.

Natterson, J. M., & Knudson, A. G. (1960). Observations concerning fear of death in fatally ill children and their mothers. *Psychosomatic Medicine, 22,* 456–466.

Neimeyer, R. A. (1988). Death anxiety. In H. Wass, F. M. Berardo & R. A. Neimeyer (Eds.), *Dying: Facing the facts* (2 d ed.) (pp.

97–136). Washington, DC: Hemisphere Publishing.

Neimeyer, R. A., Bagley, K. J., & Moore, M. K. (1986). Cognitive structure and death anxiety. *Death Studies, 10,* 273–288.

Nelson, B. (1982, July 7). Venereal, liver disease deaths higher in state. *Los Angeles Times,* p. I-15.

Nelson, L. P., & Nelson, V. (1973). *Religion and death anxiety.* Presentation to the annual joint meeting of the Society for the Scientific Study of Religion and Religious Research Association, San Francisco.

Norris, F. N., & Murrell, S. A. (1987). Older adult family stress and adaptation before and after bereavement. *Journal of Gerontology, 42,* 606–612.

Noyes, R. (1972). The experience of dying. *Psychiatry, 35,* 174–183.

Noyes, R. (1982–1983). The human experience of death or, what can we learn from near-death experiences? *Omega, 13,* 251–259.

Oates, W. J. (1940). *The Stoic and Epicurean philosophers.* New York: Random House.

O'Bryant, S. L., & Morgan, L. A. (1989). Financial experience and well-being among mature widowed women. *Gerontologist, 29,* 245–251.

O'Connell, P. (1976, Nov.). Trends in psychological adjustment: Observations made during successive psychiatric follow-up interviews of returned Navy-Marine Corps POWs. In R. Spaulding (Ed.), *Proceedings of the 3rd annual Joint meeting concerning POW/MIA matters* (pp. 16–22). San Diego.

Opie, P., & Opie, I. (Eds.). (1960). *Oxford nursery rhyme book.* Oxford: Oxford University Press.

Oskamp, S. (1984). *Applied social psychology.* Englewood Cliffs, NJ: Prentice Hall.

Osterfeld, A. (1968). Frequency and nature of health problems of retired persons. In F. M. Carp (Ed.), *The retirement process* (U.S. Public Health Service Pub. No. 1778, pp. 83–96). Washington, DC: U.S. Department of Health, Education & Welfare.

Paffenbarger, R. S., Jr., Hyde, R. T., Wing, A. L., & Hsieh, C. (1986). Physical activity, all-cause mortality, and longevity of college

alumni. *New England Journal of Medicine, 314,* 605–613.

Paffenbarger, R. S., Jr., Hyde, R. T., Wing, A. L., & Steinmetz, C. H. (1984). A natural history of athleticism and cardiovascular health. *Journal of the American Medical Association, 252,* 491–495.

Palmore, E. (1982). Prediction of the longevity difference: A 25-year follow-up. *Gerontologist, 225,* 513–518.

Palmore, E., & Cleveland, W. (1976). Aging, terminal decline, and terminal drop. *Journal of Gerontology, 31* (1), 76–86.

Pardi, M. (1977). *Death: An anthropological perspective.* Washington, DC: University Press of America.

Parkes, C. M. (1972). *Bereavement: Studies of grief in adult life.* New York: International Universities Press.

Parkes, C. M. (1975). Determinants of outcome following bereavement. *Omega, 6,* 303–323.

Parkes, C. M., Benjamin, B., & Fitzgerald, R. G. (1969). Broken heart: A statistical study of increased mortality among widowers. *British Medical Journal, 1,* 740–743.

Parkes, C. M., & Weiss, R. S. (1983). *Recovery from bereavement.* New York: Basic Books.

Parkin, M. (1974). Suicide and culture in Fairbanks: A comparison of three cultural groups in a small city of interior Alaska. *Psychiatry, 37* (1), 60–67.

Pattison, E. M. (1977). Death throughout the life cycle. In E. M. Pattison (Ed.), *The experience of dying.* Englewood Cliffs, NJ: Prentice Hall.

Peck, M. J., Farberow, N. L., & Litman, R. E. (Eds.). (1985). *Youth suicide.* New York: Springer.

Peck, R. C. (1968). Psychological development in the second half of life. In B. L. Neugarten (Ed.), *Middle age and aging.* Chicago: University of Chicago Press.

Peterson, J., & Briley, M. (1977). *Widows and widowhood: A creative approach to being alone.* New York: Association Press.

Phillips, D. P. (1975). Deathday and birthday: An unexpected connection. In K. W. C. Kammeyer (Ed.), *Population studies* (2d ed.). Skokie, IL: Rand McNally.

Phillips, D. P. (1979). Suicide, motor vehicle fa-

talities, and the mass media: Evidence toward a theory of suggestion. *American Journal of Sociology, 84,* 1150–1174.

Phillips, D. P. (1983). The impact of mass media violence on U.S. homicides. *American Sociological Review, 38,* 678–696.

Phillips, D. P., & Carstensen, L. L. (1986). Clustering of teenage suicides after television news stories about suicide. *New England Journal of Medicine, 315,* 685–689.

Phillips, D. P., & Feldman, K. A. (1973). A dip in deaths before ceremonial occasions: Some new relationships between social integration and mortality. *American Sociological Review, 38,* 678–696.

Phillips, D. P., & Smith, D. G. (1990). Postponement of death until symbolically meaningful occasions. *Journal of the American Medical Association, 263* (14), 1947–1951.

Phillips, D. P., & Wills, J. S. (1987). A drop in suicides around major national holidays. *Suicide and Life-Threatening Behavior, 17,* 1–12.

Pier, D. (1982, November 15). When a parent dies, the child stands alone. *News Chronicle* (Thousand Oaks, CA), p. 9.

Pincus, L. (1976). *Death and the family: The importance of mourning.* New York: Pantheon Books.

Pine, V. R., & Phillips, D. (1970). The cost of dying: A sociological analysis of funeral expenditure. *Social Problems, 17,* 405–417.

Pollack, J. M. (1979). Correlates of death anxiety: A review of empirical studies. *Omega, 10,* 97–121.

Pollock, G. (1978). On siblings, childhood sibling loss, and creativity. *Annals of Psychoanalysis, 6,* 443–481.

Population Reference Bureau. (1989). *1989 world population data sheet* (prepared by C. Haub & M. M. Kent, demographers). Washington, DC: Author.

Porterfield, A. L. (1949). Indices of suicide and homicide by states and cities: Some Southern-non-Southern contrasts with implications for research. *American Sociological Review, 14,* 481–490.

Post, A. (1944, January). Early efforts to abolish capital punishment in Pennsylvania. *Penn-*

sylvania Magazine of History and Biography.

Power, L. (1982, September 7). A second opinion on cancer/fat. *Los Angeles Times*, pp. V-3, 10.

Power, T. (1977). Learning to die. In S. H. Zarit (Ed.), *Readings in aging and death: Contemporary perspectives*. New York: Harper & Row.

Powers, E. A., Keith, P., & Goudy, W. H. (1975). Family relationships and friendships. In R. C. Atchley (Ed.), *Environments and the rural aged* (pp. 67–90). Washington, DC: The Gerontological Society.

Preston, C. E., & Williams, R. J. (1971). Views of the aged on the timing of death. *Gerontologist, 11*, 300–304.

Puner, M. (1974). *The good long life: What we know about growing old*. New York: Universe Books.

Quackenbush, J. (1985, August). Gates of heaven. *Psychology Today*, p. 65.

Quattlebaum, J. H. (1980, August 1). Use of heroin to ease pain of terminally ill. *Los Angeles Times*, p. II-2.

Radzinowicz, L. (1948). *A history of English criminal law*. London: Pilgrim Trust.

Raleigh, J. W. (1991). Emphysema. *Encyclopedia Americana* (Vol. 10, p. 312). Danbury, CT: Grolier.

Rando, T. A. (1984). *Grief, dying, and death: Clinical interventions for caregivers*. Champaign, IL: Research Press.

Rando, T. A. (1986). A comprehensive analysis of anticipatory grief: Perspectives, processes, promises, and problems. In T. A. Rando (Ed.), *Loss and anticipatory grief*. Lexington, MA: Lexington Books.

Random house dictionary of the English language (2d ed., unabridged). (1987). New York: Random House.

Raphael, B. (1983). *The anatomy of bereavement*. New York: Basic Books.

Rawlings, M. (1978). *Beyond death's door*. Nashville, TN: Thomas Nelson.

Rea, M. P., Greenspan, S., & Spilka, B. (1975). Physicians and the terminal patient: Some selected attitudes and behavior. *Omega, 6*, 291–305.

Rees, W. D. (1972). The distress of dying. *Nursing Times, 6*, 1479–1480.

Reimanis, G., & Green, R. F. (1971). Imminence

of death and intellectual decrement in the aging. *Developmental Psychology, 5*, 270–272.

Reker, G. T., Peacock, E. J., & Wang, T. P. (1987). Meaning and purpose in life and well-being: A life-span perspective. *Journal of Gerontology, 42*, 44–45.

Retherford, R. D. (1977). *The changing sex differential in mortality*. Westport, CT: Greenwood Press.

Rich, C. L., Young, D., & Fowler, R. C. (1986). San Diego suicide study: I. Young vs. old subjects. *Archives of General Psychiatry, 43*, 577–582.

Riegel, K. F., & Riegel, R. M. (1972). Development, drop, and death. *Developmental Psychology, 6*, 306–319.

Rigdon, M. A., & Epting, F. R. (1985). Reduction in death threat as a basis of optimal functioning. *Death Studies, 9*, 427–448.

Riley, J. W. (1968). Attitudes toward aging. In M. W. Riley et al. (Eds.), *Aging and society: An inventory of research findings*. New York: Russell Sage Foundation.

Riley, M. W., Foner, A., & Associates. (1968). *Aging and society*. New York: Russell Sage Foundation.

Rinear, E. E. (1988). Psychosocial aspects of parental response patterns to the death of a child by homicide. *Journal of Traumatic Stress, 1*, 305–322.

Ring, K. (1980). *Life at death: A scientific investigation of the near-death experience*. New York: Coward, McCann & Geoghegan.

Ring, K. (1982). Frequency and stages of the prototypic near-death experience. In C. R. Lundahl (Ed.), *A collection of near-death research readings* (pp. 110–147). Chicago: Nelson-Hall.

Rizza, R. A. (1991). Diabetes mellitus. *Encyclopedia Americana* (Vol. 9, pp. 52–53). Chicago: Grolier.

Roark, A. C. (1992, December 17). U.N. calls many child deaths preventable. *Los Angeles Times*, pp. A1, A34.

Rodin, J., & Langer, E. (1977). Long-term effects of a control-relevant intervention with institutionalized aged. *Journal of Personality and Social Psychology, 35*, 897–902.

Rosel, N. (1978). Toward a social theory of dying.

Omega, 9 (1), 49–55.

Rosenblatt, R. (1982, December 20). Do not go gently into the good night. *Time,* p. 88.

Rosenman, R. H., Brand, R. J., Jenkins, C. D., Friedman, M., Straus, R., & Wurm, M. (1975). Coronary heart disease in the Western Collaborative Group Study: Final follow-up 8 1/2 years. *Journal of the American Medical Association, 233,* 872–877.

Rosenzweig, S., & Bray, D. (1943). Sibling death in anamnesis of schizophrenic patients. *Archives of Neurology and Psychiatry, 49* (1), 71–92.

Rossiter, A. J. (1981, September 25). Technology brings need for new definition of death. *Los Angeles Times,* p. IA-3.

Rossman, I. (1977). Anatomic and body composition changes with aging. In C. E. Finch & L. Hayflick (Eds.), *Handbook of the biology of aging.* New York: Van Nostrand Reinhold.

Rudestam, K. E. (1971). Stockholm and Los Angeles: A cross-cultural study of the communication of suicidal intent. *Journal of Consulting and Clinical Psychology 36,* 82–90.

Rust, M. M. (no date). *The growth of children's concepts of time, space, and magnitude.* Unpublished, Teachers College, Columbia University, New York.

Ryerson, M. (1977). Death education and counseling for children. *Elementary School Guidance and Counseling, 11,* 165–174.

Sabom, M. (1983, January 16). "Clinically dead" patients reveal the peacefulness of dying. *Family Weekly,* pp. 11, 13.

Sabom, M., & Kreutziger, S. S. (1982). Physicians evaluate the near-death experience. In C. R. Lundahl (Ed.), *A collection of near-death research readings* (pp. 148–159). Chicago: Nelson-Hall.

Salomone, J. J. (1968). An empirical report on some controversial American funeral practices. *Sociological Symposium, 1,* 47–56.

Saluter, A. F. (1992). *Current Population Reports,* Series P-20, No. 461. *Marital status and living arrangements: March 1991.* Washington, DC: U.S. Department of Commerce, Bureau of the Census.

Sanders, C. M. (1980–1981). Comparison of younger and other spouses in bereavement outcome. *Omega, 11,* 217–232.

Satariano, W. A., & Syme, S. L. (1981). Life changes and disease in elderly populations: Coping with change. In J. L. McGaugh & S. B. Kiesler (Eds.), *Aging: Biology and behavior.* New York: Academic Press.

Saunders, C. (1980). St. Christopher's Hospice. In E. S. Shneidman (Ed.), *Death: Current perspectives* (2d ed.). Palo Alto, CA: Mayfield.

Savage, D. (1990, June 26). Court lets states place limits on the right to die. *Los Angeles Times,* pp. A1, A13.

Scheible, S. S. (1988). Death and the law. In H. Wass, F. M. Berardo, & R. A. Neimeyer (Eds.), *Dying: Facing the facts* (2d ed., pp. 301–319). Washington, DC: Hemisphere Publishing.

Schellenberg, G. D., Bird, T. D., Wijsman, E. M., et al. (1992). Genetic linkage evidence for a familial Alzheimer's disease locus on chromosome 14. *Science, 258,* 668–671.

Schlesinger, B. (1977). The crisis of widowhood in the family cycle. In *Issues in the study of aging, dying, and death* (Vol. 1). Atkinson College Press.

Schmale, A. H. (1971). Hopelessness as a predictor of cervical cancer. *Social Science and Medicine, 5,* 95–100.

Schmeck, H. M., Jr. (1987, November 17). Experts voice hope in Alzheimer's fight. *New York Times,* pp. C-1, 10.

Schneider, E. L., & Reed, J. D. (1985). Modulations of aging processes. In C. E. Finch & E. L. Schneider (Eds.), *Handbook of the biology of aging* (2d ed.). New York: Van Nostrand Reinhold.

Schroeder, O. (1989). Death: 1. Legal aspects of death. *Encyclopedia Americana* (Vol. 8, pp. 564–565). Danbury, CT: Grolier.

Schultz, D. P., & Schultz, S. E. (1990). *Psychology in industry today* (5th ed.). New York: Macmillan.

Schultz, R., & Bazerman, M. (1980). Ceremonial occasions and mortality: A second look. *American Psychologist, 35,* 253–261.

Schulz, R. (1978). *The psychology of death, dying, and bereavement.* Reading, MA: Addison-Wesley.

Schulz, R. (1985). Emotion and affect. In J. E.

Birren & K. W. Schaie (Eds.), *Handbook of the psychology of aging* (2d ed., pp. 531–543). New York: Van Nostrand Reinhold.

Schur, E. M. (1991). Abortion: Attitudes toward abortion. *Encyclopedia Americana* (vol. 1, pp. 43–44). Danbury, CT: Grolier.

Scott, G. R. (1950). *The history of capital punishment*. London: Torchstream Books.

Scott, J. (1989, December 6). Life style of Mormons cuts risks of death. *Los Angeles Times*, pp. A-1, A-28.

Seele, K. C. (1987). Sarcophagus. *World book encyclopedia* (Vol. 17). Chicago: World Book.

Seligman, M. E. P. (1975). *Helplessness: On depression, development and death*. San Francisco: Freeman.

Seligman, M. E. P. (1992). *Helplessness* (2d ed.). San Francisco: Freeman.

Sellin, T. (1980). *The penalty of death*. Beverly Hills: Sage.

Seltzer, M. M. (1979). The older woman: Facts, fantasies and fiction. *Research on Aging, 1* (2), 139–154.

Selwyn, P. A. (1986). AIDS—What is now known. Psychological aspects, treatment prospects. *Hospital Practice, 21* (6), 25.

Selye, H. (1976). *Stress in health and disease*. Reading, MA: Butterworths.

Sennholz, H. F. (1976). *Death and taxes*. Washington, DC: The Heritage Foundation.

Shaffer, T. L., & Rodes, R. E., Jr. (1977). Law for those who are to die. In H. Feifel (Ed.), *New meanings of death* (pp. 291–311). New York: McGraw-Hill.

Shanas, E. (1979). Social myth as hypothesis: The case of the family relations of old people. *Gerontologist, 19*, 3–9.

Shanas, E., & Maddox, G. L. (1985). Health, health resources, and the utilization of care. In R. H. Binstock & E. Shanas (Eds.), *Handbook of aging and the social sciences* (2d ed.). New York: Van Nostrand Reinhold.

Shanfield, S. B., & Swain, B. J. (1984). Death of adult children in traffic accidents. *Journal of Nervous and Mental Disorders, 172*, 533–538.

Shehan, C. L. (1987). Spouse support and Vietnam veterans' adjustment of post-traumatic stress disorder. *Family Relations, 36*, 55–60.

Shneidman, E. S. (1969). Fifty-eight years. In E. S. Shneidman (Ed.), *On the nature of suicide* (pp. 1–30). San Francisco: Jossey-Bass.

Shneidman, E. S. (1973). *Deaths of man*. New York: Quadrangle.

Shneidman, E. S. (1976). Death work and stages of dying. In E. S. Shneidman (Ed.), *Death: Current perspectives*. Palo Alto, CA: Mayfield.

Shneidman, E. S. (1980a). The death certificate. In E. S. Shneidman (Ed.), *Death: Current perspectives* (2d ed., pp. 148–156). Palo Alto, CA: Mayfield.

Shneidman, E. S. (1980b). *Voices of death* (Chapter 4). New York: Harper & Row.

Shneidman, E. S. (Ed.). (1984). *Death: Current perspectives* (3d ed.). Palo Alto, CA: Mayfield.

Shneidman, E. S. (1987, March). At the point of no return. *Psychology Today*, pp. 54–58.

Shneidman, E. S., & Farberow, N. L. (1970). The logic of suicide. In E. S. Shneidman, N. L. Farberow, & R. E. Litman (Eds.), *The psychology of suicide*. New York: Science House.

Shock, N. W. (1977). Biological theories of aging. In J. E. Birren & K. W. Schaie (Eds.), *Handbook of the psychology of aging* (pp. 103–115). New York: Van Nostrand Reinhold.

Shurkin, J. (February 1988). Modern terrorists are "anemic." *New Republic*, p. 6.

Siegel, R. K. (1980). The psychology of life after death. *American Psychologist, 35*, 911–1031.

Siegler, I. C., McCarty, S. M., & Logue, P. E. (1982). Wechsler Memory Scale scores, selective attribution, and distance from death. *Journal of Gerontology, 37*, 176–181.

Siegler, I. C., Nowlin, J. B., & Blumenthal, J. A. (1980). Health and behavior: Methodological considerations for adult development and aging. In L. W. Poon (Ed.), *Aging in the 1980s: Psychological issues*. Washington, DC: American Psychological Association.

Simonton, O. C., Matthews-Simonton, S., & Creighton, J. (1978). *Getting well again*. Los Angeles: J. P. Tarper (Dist. by St. Martin's Press, New York).

Simpson, M. A. (1976). Brought in dead. *Omega, 7*, 243–248.

Simpson, M. A. (1977). Death and modern poetry. In H. Feifel (Ed.), *New meanings of death* (pp. 313–333). New York: McGraw-Hill.

Simpson, M. A. (1979). *The facts of death*. Englewood Cliffs, NJ: Prentice Hall.

Slater, J., & Depue, R. A. (1981). The contribution of environmental events and social support to serious suicide attempts in primary depressive disorder. *Journal of Abnormal Psychology 90*, 275–285.

Specific instructions needed in living wills. (1989, August 27). *The Times Picayune* (New Orleans), p. 9F.

Speece, M. W., & Brent, S. B. (1984). Children's understanding of death: A review of three components of a death concept. *Child Development, 55*, 1671–1686.

Spinetta, J. J. (1974). The dying child's awareness of death: A review. *Psychological Bulletin, 81*, 256–260.

Spinetta, J. J., Rigler, D., & Karon, M. (1973). Anxiety in the dying child. *Pediatrics, 52*, 841–845.

Stannard, D. (1977). *The Puritan way of death: A study in religion, culture, and social change*. New York: Oxford.

Stein, S. B. (1974). *About dying, an open family book for parents and children together*. New York: Walker.

Steinbrook, R. (1989, July 20). Family's rights at heart of "right-to-die" question. *Los Angeles Times*, p. I-30.

Steinbrook, R. (1992, September 18). Study tells how disease varies among ethnic groups. *Los Angeles Times*, p. A3.

Stephenson, J. S. (1985). *Death, grief, and mourning*. New York: The Free Press.

Stewart, G. (1984). *Death sentences: Styles of dying in British fiction*. Cambridge, MA: Harvard University Press.

Stolberg, S. (1993, March 30). Affliction expected to kill 4 million annually by 2010. *Los Angeles Times*, p. A23.

Strange, R. E., & Brown, D. E., Jr. (1970). Home from the wars. *American Journal of Psychiatry, 127*, 488–492.

Strauss, A. L., & Glaser, B. G. (1970). Patterns of dying. In O. G. Brim, Jr., H. E. Freeman, S. Levine & N. A. Scotch (Eds.), *The dying patient* (pp. 129–155). New York: Russell Sage.

Stroebe, W., & Stroebe, M. (1987). *Bereavement and health: The psychological and physical consequences of partner loss*. New York: Cambridge University Press.

Sudnow, D. (1967). *Passing on: The social organization of dying*. Englewood Cliffs, NJ: Prentice Hall.

Suicide. (1983). *Encyclopaedia Britannica* (Vol. 17, pp. 777–782). Chicago: Encyclopaedia Britannica.

Suicide Prevention and Crisis Center of San Mateo County, California. (no date). *Suicide in youth and what you can do about it*. Denver, CO: American Association of Suicidology.

Sussman, M. B. (1985). The family life of old people. In R. H. Binstock & E. Shanas (Eds.), *Handbook of aging and the social sciences* (2d ed.). New York: Van Nostrand Reinhold.

Szasz, T. S. (1986). The case against suicide prevention. *American Psychologist, 41*, 806–812.

Tallmer, M., Formaneck, R., & Tallmer, J. (1974). Factors influencing children's concepts of death. *Journal of Clinical Child Psychology, 3* (2), 17–19.

Templer, D. I. (1970). The construction and validation of a death anxiety scale. *Journal of General Psychology, 82*, 165–177.

Templer, D. I., Ruff, C. F., & Franks, C. M. (1971). Death anxiety: Age, sex, and parental resemblance in diverse populations. *Developmental Psychology, 4*, 108.

Templer, D. I., Ruff, C. F., & Simpson, K. (1974). Alleviation of high death anxiety with symptomatic treatment of depression. *Psychological Reports, 54*, 216.

The anatomy of starvation. (1992, December 12). *Los Angeles Times*, p. A8.

Thomas, L. (1975). *Lives of a cell: Notes of a biology watcher*. New York: Bantam.

Thomas, L. E., DiGiulio, R. C., & Sheehan, N. W. (1988). Identity loss and psychological crisis in widowhood: A reevaluation. *International Journal of Aging and Human Development, 26*, 225–239.

Tobacyk, J., & Eckstein, D. 1980). Death threat and death concerns in the college student. *Omega, 11*, 139–155.

Tolstoy, L. (1960). The death of Ivan Ilych. In L. Tolstoy, *Death of Ivan Ilych and other stories*. New York: New American Library. (Original work published in 1886).

Toynbee, A. (1980). Various ways in which human beings have sought to reconcile themselves to the fact of death. In E. S. Shneidman (Ed.), *Death: Current perspectives* (2d ed., pp. 11–34). Palo Alto, CA: Mayfield.

Treas, J., & VanHilst, A. (1976). Marriage and remarriage rates among older Americans. *Gerontologist, 16*, 132–136.

Trelease, M. L. (1975). Dying among Alaskan Indians: A matter of choice. In E. Kübler-Ross (Ed.), *Death: The final stage of growth*. Englewood Cliffs, NJ: Prentice Hall.

Troll, L. E. (1982). *Continuations: Adult development and aging*. Monterey, CA: Brooks/Cole.

Tuchman, B. W. (1978). *A distant mirror*. New York: Knopf.

Tumulty, R. (1989, April 17). *Abortion's effect on women unclear*. Los Angeles Times, p. I-17.

Uniform Determination of Death Act. (1986). 12 U.L.A. 270 (Supp. 1986).

United Nations Children's Fund. (1993). *The state of the world's children 1993*. New York: Author.

U.S. Bureau of the Census (1989). *Current Population Reports*, Series P-25, No. 1018. Projections of the population of the United States, by age, sex, and race: 1988 to 2080. Washington, D.C.: Author.

U.S. Department of Health and Human Services. (1987). *Vital statistics of the United States, 1984: Vol. II. Mortality, Pt. A*. Hyattsville, MD: Author.

U.S. Department of Justice, Bureau of Justice Statistics. (1992). Capital punishment 1991. *Bureau of Justice Statistics Bulletin*. October. Washington, DC: Author.

U.S. Department of Justice, Federal Bureau of Investigation. (1992). *Uniform Crime Reports, Crime in the United States, 1991*. Washington, DC: U.S. Government Printing Office.

U.S. longevity at a standstill. (1992, July-September). *Statistical Bulletin*, Metropolitan Life Insurance Co.

U.S. Senate Special Committee on Aging et al. (1991). *Aging America*. Washington, DC: Author.

Veatch, R. M., & Tai, E. (1980). Talking about death: Patterns of lay and professional change. *Annals of the AAPSS, 447*, 29–45.

Vermeule, E. (1970). *Aspects of death in early Greek art and poetry*. Berkeley: University of California Press.

Vinick, B. (1977, September). *Remarriage in old age*. Paper presented at the annual meeting of the American Sociological Association.

Vital statistics. (1991). *Encyclopedia Americana* (Vol. 28, pp. 181–182). Danbury, CT: Grolier.

Von Clausewitz, C. (1982). *On war*. New York: Viking Penguin.

Von Hug, H. H. (1965). The child's concept of death. *Psychoanalytic Quarterly, 34*, 499–516.

Vorhaus, L. J. (1990). Starvation. *Encyclopedia Americana* (Vol. 25, pp. 615–616). Danbury, CT: Grolier.

Waechter, E. H. (1971). Children's awareness of fatal illness. *American Journal of Nursing, 71*, 1168–1172.

Waechter, E. H. (1984). Dying children: Patterns of coping. In H. Wass & C. A. Corr (Eds.), *Childhood and death* (pp. 51–68). Washington, DC: Hemisphere.

Waechter, E. H. (1985). Children's awareness of fatal illness. In S. G. Wilcox & M. Sutton (Eds.), *Understanding death and dying* (3d ed.) (pp. 299–306). Palo Alto, CA: Mayfield.

Walford, R. L. (1983). *Maximum life span*. New York: Norton.

Wallace, D. (1977). The biology of aging. *Journal of the American Geriatrics Society, 25* (3), 104–111.

Wanzer, S. H., et al. (1989). The physician's responsibility toward hopelessly ill patients. *New England Journal of Medicine, 32* (13), 844–849.

Warrick, P. (1993, March 30). Choosing not to die alone. *Los Angeles Times*, E1-2.

Wasmuth, C. E. (1991). Euthanasia. *Encyclopedia Americana* (Vol. 10, pp. 711–712). Danbury, CT: Grolier.

Wass, H. (1979). Death and the elderly. In H. Wass (Ed.), *Dying: Facing the facts*. Washington, DC: Hemisphere Publishing.

Wass, H., Miller, M. D., & Thornton, G. (1990). Death education and grief/suicide intervention in the public schools. *Death Studies, 14*, 253–268.

Wass, H., & Scott, M. (1978). Middle school students' death concepts and concerns. *Middle*

School Journal, 9 (1), 10–12.

Wass, H., & Sisler, H. (1978). *Death concern and views on various aspects of dying among elderly persons.* Paper presented at the International Symposium on the Dying Human, Tel Aviv, Israel (January).

Wass, H., & Stillion, J. M. (1988). Death in the lives of children and adolescents. In H. Wass, F. M. Berardo, & R. A. Neimeyer (Eds.), *Dying: Facing the facts* (2d ed.) (pp. 201–228). Washington, DC: Hemisphere Publishing.

Watkins, C., Gilbert, J. E., & Bass, W. (1969). The persistent suicidal patient. *American Journal of Psychiatry, 125,* 1590–1593.

Weber, M. (1958). *The Protestant ethic and the spirit of capitalism.* (T. Parsons, Trans). New York: Scribner's.

Weir, R. F. (Ed.). (1980). *Death in literature.* New York: Columbia University Press.

Weisman, A. D. (1972). *On dying and denying: A psychiatric study of terminality.* New York: Behavioral Publications.

Weisman, A. D. & Kastenbaum, R. (1968). The psychological autopsy: A study of the terminal phase of life. *Community Mental Health Journal,* Monograph No. 4.

Weisman, A. D., & Worden, J. W. (1975). Psychosocial analysis of cancer deaths. *Omega, 6,* 61–75.

Wekstein, L. (1979). *Handbook of suicidology: Principles, problems, and practice.* New York: Brunner/Mazel.

Wenestam, C. G., & Wass, H. (1987). Swedish and U.S. children's thinking about death: A qualitative study and cross-cultural comparison. *Death Studies, 11,* 99–121.

White, E., Elson, B., & Prawat, R. (1978). Children's conceptions of death. *Child Development, 49,* 307–310.

Whitley, G. (1983, September 15). Death: A $6-billion industry in U.S. *Los Angeles Times,* p. V-14.

Wilbur, R. S. (1973, June 2). POWS found to be much sicker than they looked upon release. *Los Angeles Times,* I-4.

Wilcox, S., & Sutton, M. (1985). *Understanding death and dying* (3d ed.). Palo Alto, CA: Mayfield.

Williams, G. L. (1989). Abortion. *Encyclopedia Americana* (Vol. 1). Danbury, CT: Grolier.

Willich, S. N., Löwel, H., Lewis, M., Arntz, R., Schubert, F., Schröder, R., & TRIMN Study Group. *Increased Monday risk of acute myocardial infarction in the working population.* Paper presented at the American Heart Association Scientific Meeting, December 12, 1992.

Wisocki, P. A., & Averill, J. R. (1987). The challenge of bereavement. In L. L. Carstensen & B. A. Edelstein (Eds.), *Handbook of Clinical Gerontology* (pp. 312–321). New York: Pergamon Press.

Wolfgang, M. E. (1969). Who kills whom. *Psychology Today, 3* (5), 54–56, 72–75.

Woodruff, D. S. (1977). *Can you live to be 100?* New York: Chatham Square.

Woolley, C. L. (1965). *Ur of the Chaldees.* New York: Norton.

Worden, J. W. (1982). *Grief counseling and grief therapy: A handbook for the mental health practitioner.* New York: Springer-Verlag.

World Health Organization. (1982). *EURO reports and studies.* Geneva: Author.

Wyly, M., & Hulicka, I. (1975, August). *Problems and compensations of widowhood: A comparison of age groups.* Paper presented at the meeting of the American Psychological Association, Chicago.

Yochelson, S., & Samenow, S. E. (1976). *The criminal personality* (Vol. 1). New York: Aronson.

Yudkin, S. (1967). Children and death. *Lancet, 1* (7480), 37–41.

Zatz, M. M., & Goldstein, A. L. (1985). Thymosins, lymphokines, and the immunology of aging. *Gerontology, 31,* 263–277.

AUTHOR INDEX

SUBJECT INDEX

A

abortion, 198, 200–201
accident-prone personality, 74
accidents, 69–77
 age and, 73
 how and where they occur,
 70–72
 when they occur, 72
 who has them, 73–74
afterlife, 278–279
aging, 37–47
 clock, 47
 exercise and, 43
 factors affecting, 42–44
 heredity and, 43
 individual differences, 39–40
 nutrition and, 42–43
 premature, 40
 primary, 38
 psychological factors, 44
 secondary, 38
 theories, 45–47
 breakdown, 45
 hormonal, 46
 substance, 45–46
AIDS, 12, 61–62
Alzheimer's disease, 41–42
anniversary reaction, 251, 335
anorexia nervosa, 64
anticipatory mourning, 249–250
Ars Moriendi, 144, 167, 204
arteriosclerosis, 39, 50
arts, death and, 163–180
asceticism, 157
assassination, 133

assurance (doctrine of), 157
athenaeum, 337
atherosclerosis, 38
attitudes toward death:
 assessment of, 268–271
 cultural differences and simi-
 larities, 274–275
 defensiveness and denial, 277
 educational differences, 275–
 276
 historical perspective, 273–274
 of medical personnel, 299–300
 occupational differences in,
 276
 of philosophers, 183
 religious beliefs and, 277
 sex differences, 275
autoimmunity theory (of aging),
 45
autopsy, 195

B

Battle of Good and Evil, 157
bereavement, 327–339
 effects on illness and mortal-
 ity, 337–339
 overload, 335
 process of, 327–334
Book of the Dead, 134, 144, 152
broken heart syndrome, 338
Brompton mix, 306

C

cancer, 54–57
 age differences in, 54

carcinogens and, 56
 early detection of, 56–57
 ethnic differences, 56
 geographical region, 56
 psychological factors, 57
 sex differences, 55
 treatment of, 57
capital punishment, 208–216
 attitudes toward, 224
 court decisions concerning,
 212
 pros and cons of, 214–216
cardiopulmonary resuscitation
 (CPR), 9
cardiovascular diseases, 49–54
 demographic factors and, 52–
 53
 lifestyle and, 52–53
carpe diem, 168
catastrophe, 74
catastrophic illness, 242
cerebrovascular accident (CVA),
 51
children:
 conceptions of death, 231–239
 stages of development in,
 232–233
 counseling for bereaved, 342–
 343
 diseases of, 59–60
 family reactions to death of,
 246–248
 fears of death, 236–239
 feelings when dying, 244–246
 games and sayings about